READING CALIFORNIA:
ART, IMAGE, AND IDENTITY, 1900–2000

READING CALIFORNIA:
ART, IMAGE, AND IDENTITY, 1900-2000

Edited by
Stephanie Barron
Sheri Bernstein
Ilene Susan Fort

Preface by
Stephanie Barron

Los Angeles County Museum of Art

University of California Press BERKELEY • LOS ANGELES • LONDON

This book was published in conjunction with the exhibition *Made in California: Art, Image, and Identity, 1900–2000*, organized by the Los Angeles County Museum of Art. The exhibition was made possible by a major grant from the S. Mark Taper Foundation, founded in 1989, a private family foundation dedicated to enhancing the quality of people's lives. Additional support was provided by the Donald Bren Foundation, the National Endowment for the Arts, Bank of America, Helen and Peter Bing, Peter Norton Family Foundation, See's Candies, the Brotman Foundation of California, and Farmers Insurance. Primary in-kind support for the exhibition was provided by FrameStore. Additional in-kind support was provided by KLON 88.1 FM, Gardner Lithograph, and Appleton Coated LLC.

Exhibition Schedule
Section 1:
October 22, 2000–March 18, 2001
Sections 2, 3, and 4:
October 22, 2000–February 25, 2001
Section 5:
November 12, 2000–February 25, 2001

Copublished by the Los Angeles County Museum of Art, 5905 Wilshire Boulevard, Los Angeles, California, 90036, and University of California Press, Berkeley, Los Angeles, and London.

Library of Congress Cataloging-in-Publication Data:

Reading California : art, image, and identity, 1900–2000 / edited by Stephanie Barron, Sheri Bernstein, Ilene Susan Fort.
 p. cm.
 Includes bibliographical references and index.
 ISBN 0-520-22766-2 (cloth : alk. paper) — ISBN 0-520-22767-0 (pbk. : alk. paper)
 1. Arts, American—California. 2. Arts, Modern—20th Century—California.
3. California—In art. I. Barron, Stephanie, 1950– II. Bernstein, Sheri, 1966– III. Fort, Ilene Susan.

NX510.C2 R43 2000
306.4'7'09794—dc21
 00-055971

Director of Publications: Garrett White
Editors: Nola Butler and Thomas Frick
Designer: Scott Taylor
Production coordinators: Rachel Ware Zooi and Chris Coniglio
Supervising photographer: Peter Brenner
Rights and Reproductions coordinator: Cheryle T. Robertson

Printed by Gardner Lithograph, Buena Park, California, on Appleton Utopia Two Matte Text

The typefaces used in this book, Minion (Adobe) and Tarzana (Emigre), were designed in California. The title font, based on the letterforms on a 1940 California license plate, was created for the exhibition.

Front cover, details, from left to right:

Crate label for Rose Brand Oranges, Redlands Orange Growers' Association, c. 1910. The McClelland Collection

Will Connell, *Make-Up*, from the publication *In Pictures*, c. 1937, gelatin-silver print. Photographic History Collection, National Museum of American History, Smithsonian Institution, © Will Connell Collection, UCR/ California Museum of Photography

Carlos Almaraz, *Suburban Nightmare*, 1983, oil on canvas. The Buck Collection, Laguna Hills, California, © The Carlos Almaraz Estate

Back cover, details, from left to right:

Underwood and Underwood Publishers, *Yosemite Valley*, 1902, printed c. 1905, stereograph. Collection of David Knaus

Millard Sheets, *Angel's Flight*, 1931, oil on canvas. LACMA, gift of Mrs. L. M. Maitland, © Estate of Millard Sheets

Roger Minick, *Woman with Scarf at Inspiration Point, Yosemite National Park*, 1980, dye-coupler print. Courtesy of the artist and Jan Kesner Gallery, © Roger Minick

Pages 2–3

Eileen Cowin, photographs from *Yearning for Perfection II*, 2000, billboard installation created for *Made in California: Art, Image, and Identity, 1900–2000*. Courtesy of the artist

CONTENTS

HERE...WHERE WE RUN OUT OF CONTINENT

PREFACE AND ACKNOWLEDGMENTS

A vast literature now exists in the field of California studies. In the first half of the century, many of these works, even those presented as objective histories, described a largely Edenic or booster image of the state. These optimistic views persisted well into the postwar era, and critical studies on a wide range of topics related to California have proliferated only in the past two decades. Recent publications have looked at the state and its various regions from the perspectives of art, architecture, design, craft, literature, music, film and television, cultural history, ethnic studies, sociology, geography, and urban planning. Today, scholarship on California has moved well beyond booster images of the state, which have been seen increasingly as tools of exclusion that echo a broader historical pattern of political and social domination, into critical assessments that explore views of the region ranging from the Edenic to the dystopic.

Reading California: Art, Image, and Identity, 1900–2000, was conceived in the course of research for the exhibition *Made in California: Art, Image, and Identity, 1900–2000,* held at the Los Angeles County Museum of Art from October 2000 to March 2001. The goal of the exhibition was to examine the myriad images that have come to define California in the popular consciousness over the past century. It explored the relationships between the arts and popular culture and between the arts and sub- or alternative cultures, and highlighted some of the many constituencies that have built, challenged, or altered prevailing views. With the aims of the exhibition in mind, the essays included here are intended to encourage a new understanding of familiar material and perhaps to suggest new ways of thinking about other topics in California studies beyond the scope of this book.

In planning the exhibition, the organizers were mindful of the great diversity that has always characterized the state, and of the fact that now, more than ever, the questions of whose California is being represented and which California is being shown must be given serious consideration. *Made in California* was organized collaboratively over a period of six years by LACMA curators and educators working in the fields of twentieth-century painting, sculpture, costume and textiles, decorative art, film, music, photography, and prints and drawings. To this mix were added the designers, who participated in discussions concerning the interpretation the show would offer to the public, and the editors, who helped to choose and shape the texts for the accompanying volumes. From the beginning, the project was guided by a desire to investigate the rich subject of California art in the twentieth century from many points of view and in many mediums. The result was an exhibition in which art, history, and material culture not only coexisted but also revealed the ways in which each has influenced or responded to the others.

At the outset, the organizers sought the advice and expertise of colleagues outside the museum. In the fall of 1997 twenty-three individuals, including artists, historians of art, literature, and film, educators, critical theorists and cultural studies scholars, anthropologists, filmmakers, philosophers, and librarians, were invited to assist the museum with refining the scope and approach of the exhibition. At an early stage, a fundamental decision was made not to attempt a survey exhibition; nor would the show be a succession of "greatest hits" or an uncritical celebration of California art. Rather, it was organized thematically and not according to medium or art historical considerations, even though this necessarily meant leaving out some artists or work by which an artist is usually known. Care was taken to represent Northern and Southern California, and it was decided that the exhibition should proceed chronologically, with the century divided into five twenty-year sections.

With these broad parameters in place, another group of scholars was invited to discuss and refine a structure for each of the twenty-year sections over the course of three months in the summer of 1998. As with the earlier gathering, this group espoused a variety of approaches to its subjects and formed no cohesive school of thought regarding California studies, though a number of the participants represented current trends in the new history of the American West, American studies, feminism, ethnic studies, and art history. During discussion of some of the innumerable topics that might have been addressed in the exhibition, several areas of study emerged as relevant

to the task of rethinking the interplay of art and other forms of material culture in twentieth-century California. It was from these sessions that several of the themes gradually developed.

The essays that follow are grouped loosely into three categories: The first explores aspects of the general historical background of California art and culture; the second examines issues related more directly to art history and popular culture; and the third addresses issues of politics and identity. Each essay considers in a different way how California has been promoted, decried, or otherwise portrayed and marketed to a variety of audiences, raising questions of interpretation and influence that continue to occupy scholars of California studies. What roles have literature, popular music, and Hollywood films played in promoting images of California? How have these images developed, and what roles have artists played in creating, challenging, or refuting such images? California's population has long been characterized by complex and even competing demographics. What roles have immigrants played in formulating and transmitting images of the state? What is the connection between California's spiritual seekers—from early-twentieth-century Theosophists to postwar Zen Buddhists and countercultural mystics—and the artistic temper of the state? Can a history be traced between the series of international expositions hosted by California early in the century and the state's emergence as the home of the theme park and the fantasy retail environment in the postwar era?

The selection of essays in this volume is not intended to be comprehensive. We hope, rather, that the topics treated here reveal a number of fruitful approaches to an understanding of California's complex cultural history. Our emphasis is on considering less-studied areas and bringing new scholarship to the fore. For this reason, a decision was made to include an essay on the subject of counterculture architecture, instead of revisiting, for example, the more familiar work of Rudolf Schindler and Richard Neutra or the Case Study House architects. Additionally, certain issues, while specific to a particular moment in California history, can by extension stand for a broader field of inquiry. By looking at contrasting photographic documentation strategies of the Japanese American internment at Manzanar, we can understand more about how differing goals and prejudices result in divergent images from the same set of historical events. By examining the ever-changing role the Watts Towers have played, we see them as an object of cultural investment, constantly recontextualized by the social, political, and economic changes happening around them.

In the visual arts, a frequent construct in the consideration of California art has been its relation to the art center of New York. While that has remained a popular way to think about certain developments—California plein air painting, California Surrealism, California Pop, California Cool, and California Conceptualism—such a dichotomy no longer seems valid today, when challenges to centers of art world power may come as readily from Shanghai, Kassel, Venice, São Paulo, or Johannesburg as from Los Angeles. At the moment, California continues to be promoted by some as a land of opportunity and denigrated by others as a place of social unrest and urban grit as well as a staging ground for an ugly and perhaps brutal future. It seems fair to say that this dynamic has itself become a part of the California myth. The long-standing question of which of these futures will prevail—the utopian or the dystopic—remains open. With increased attention to world cultures and associated issues of diversity, many critical studies now reveal a profound dissatisfaction with the ongoing influence of accepted canons, whether in art or in history, and argue against the acceptance of any single dominant point of view. It has been our aim to reflect that challenge in *Reading California.*

This book is the result of efforts by a number of people at the Los Angeles County Museum of Art. In the conceptualization of the contents of the volume and the selection of its authors, Curator of American Art Ilene Susan Fort and Exhibition Associate Sheri Bernstein played key roles. Editors Nola Butler and Thomas Frick attended to the manuscripts with a keen attention to detail, consistency, and thoroughness, assisted by outside editor Michelle Ghaffari. The book was designed by Scott Taylor, to whom we owe thanks for responding so sensitively to the task of designing both this and the exhibition catalogue volume. Taylor was assisted by LACMA designer Katherine Go and outside designer Theresa Velázquez. The job of assembling and acquiring the rights to the photographs in the present volume was accomplished by Rights and Reproductions Coordinator Cheryle Robertson and her assistants Shaula Coyl and Giselle Arteaga-Johnson. LACMA Director of Publications Garrett White oversaw production of the book.

The *Made in California* exhibition was made possible by a grant from the S. Mark Taper Foundation, founded in 1989, a private family foundation dedicated to enhancing the quality of people's lives. Additional support was provided by the Donald Bren Foundation, the National Endowment for the Arts, Bank of America, Helen and Peter Bing, Peter Norton Family

Foundation, See's Candies, the Brotman Foundation of California, and Farmers Insurance. Primary in-kind support for the exhibition was provided by FrameStore. Additional in-kind support was provided by KLON 88.1 FM, Gardner Lithograph, and Appleton Coated LLC.

Finally, we wish to thank the authors, many of whom played important roles in shaping the exhibition through their scholarship and their participation in a number of intensive seminars at LACMA.

Stephanie Barron

Vice President of Education and Public Programs

Senior Curator of Modern and Contemporary Art

Los Angeles County Museum of Art

THE WORLD MET ITSELF IN CALIFORNIA

Richard Rodriguez

Carey McWilliams,
c. 1933
Courtesy of Wilson
Carey McWilliams

Kevin Starr

CAREY MCWILLIAMS'S CALIFORNIA:
THE LIGHT AND THE DARK

When it comes to nonfiction accounts of California in the first half of the twentieth century, Carey McWilliams (1905–1980) is in a league of his own. More than any other single nonfiction writer, McWilliams—through prodigious research and heroic writing—came close to establishing the definitive story and image of the Golden State in the pre-1950 period. He did this through hundreds of articles in two score or more journals and newspapers. Many of these pieces were later included in his three best-known California books, *Factories in the Field: The Story of Migratory Farm Labor in California* (1939); *Southern California: An Island on the Land* (1946); and *California: The Great Exception* (1949). These three books, in fact, would make most lists of the ten best books on California. If such a list were restricted to twentieth-century nonfiction, the latter two titles would be at the top.

Throughout his work, Carey McWilliams assembled a definition of California—the place, the people, the weather, the culture, the politics, the economy (agriculture especially), the psychology and sociology, the promises and failures, the dreams and nightmares, the high orthodoxies and the sheer goofiness—and to this day his version remains the most compelling and comprehensive interpretation of the thirty-first state. All efforts to interpret California through narrative analysis are, in a sense, a series of footnotes to Carey McWilliams. Academic or popular, right wing or left, whether dealing with art, architecture, literature, agriculture, or politics: every writer on California becomes, in one degree or another, a toiler in the vineyard that McWilliams first surveyed and planted.

McWilliams's vision and range of reference are omnivorous and all-encompassing. Commentators on the Left, for example, can find much to corroborate their view of California as a case study in oligarchical hegemony and exploitation, especially in the realm of agriculture. At the same time,

McWilliams was among the very first, and among nonfiction writers the greatest, to discern in California the sporadic achievements of high art and the beginnings of a significant civilization. No writer of comparable stature looked more unflinchingly into the belly of the beast; yet no one— including philosopher Josiah Royce in the nineteenth century or historian Robert Glass Cleland in the twentieth (each of whom wrote extensively on the state)—encountered in California such a special energy, a special beauty.

In *Southern California: An Island on the Land,* McWilliams excavates, assembles, analyzes, annotates, condemns, and celebrates the raw materials of a civilization in the making. He wrote in midcentury, just on the verge of Southern California's post–World War II boom, and his formula is that of an historical fable (based on fact, of course!) possessed of great imaginative resonance. The region, first of all, is, as he says, an "island on the land." Were this the East Coast, Southern California would be a separate state; were it Europe, a separate nation. The formula of the region's history as discovered and structured by McWilliams—the Native American era, Spain and the missions, the American conquest and frontier, the boom of the 1880s, the Ramona myth, irrigation politics, the citrus industry, tourism and resort hotels, motion pictures, the coming of the Folks, boosterism and the improbable rise of Los Angeles—is no mere catalogue. It is, rather, an ongoing process. For McWilliams, the story of Southern California, despite its economic and political inequalities up to and including 1946 (the year of the book's publication), is most fundamentally a story of assimilative encounter. No one group ever fully repudiates what has gone before. Somehow, amid horrendous exploitation and inequality, a torrent kept running forward in which all elements of past and present remained part of the flow.

Self-invention is for McWilliams the region's most distinctive characteristic—hence his fascination when it veers into eccentricity. Each Southern California generation, moreover, seems to create itself out of the shattered fragments of the inherited past. Through the Ramona myth, Americans reappropriated the Native American and Hispanic past that they had displaced. Ramona-land, however spurious, was a utopia of sorts, even if only on the level of fantasy. This utopianism led to the resort hotel culture, with its own brand of utopianism; and the resort hotel culture, in turn, spread throughout the entire society of Southern California an intensified expectation for a better life by ordinary people; and this brought into Southern California vast phalanxes of Middle Americans in search of something more.

Thus the enforced utopianism of the mission, an institution intended by the Franciscans to serve as the preparation for a better life to come, was transmuted through the historical process into all the other modes of utopianism, including the most eccentric, of the successive Southern Californias. Mission San Juan Capistrano, in short, led to Abbot Kinney's Venice Beach and the Angelus Temple of Aimee Semple McPherson.

California: The Great Exception, which is in one sense McWilliams's farewell to California, extends this quest for formula and process throughout the entire state. However, California as a whole is even more elusive than the southern region alone. "The analyst of California," writes McWilliams, "is like a navigator who is trying to chart a course in a storm: the instruments will not work; the landmarks are lost; and the map makes little sense."[1] Whereas *Southern California: An Island on the Land* was written from a near-total control of materials, *California: The Great Exception* was, as the author describes, "the notes, the working papers, of a California journalist; the summation, not of California, but of my effort to understand California."[2]

Nonetheless, the state as a whole sustained a formula for McWilliams. As his subtitle suggests, California was the one state in the Union that constituted a regional culture unto itself, with its own distinctive geography, climate, and history, along with its own way of being American. Other states, of course—Massachusetts and Texas come immediately to mind, Texas especially—possess such distinctiveness; but in California's case, nearly everything from colonial times onward is characterized by the twists and turns and variations of a story that belongs to California alone. In *California: The Great Exception,* McWilliams deliberately detaches the story of California from the story of the Far West. He also—elusively, in the conclusion of the book— suggests that California must consider itself a Pacific commonwealth as well as a member of the American union.

Writing in 1949, McWilliams could not see completely the world colony that California would become by the end of the century; yet he understood and presented the dynamics, if not the scope, of this internationalism. If Southern California favored the process of self-invention, California as a whole served as a tabula rasa upon which not only Americans but the peoples of the world could project their aspirations and longings. McWilliams caught California on the verge of its greatest single boom. By 1962 it would be the most populous state in the nation. By the 1990s it would be a world-level commonwealth, with the seventh-largest economy on the planet.

In struggling toward a definition of California, Carey McWilliams was fully capable of seeing and presenting the noir and the apocalyptic. Yet one would make a mistake to pigeonhole him or his thought as reflexively leftist. He was much too subtle a thinker, and his theory of California much too comprehensive, to allow for such a one-sided interpretation. To understand the complexity of McWilliams's thought, we must go to his California experience; for, as he himself suggested, most of his writings, with all their wealth of documentation, their heroic forays into the world of dense and intractable fact, were motivated by his thirty-year-long effort to understand the society into which he had been thrust as a young man and which he chose to leave as a middle-aged adult.

In his 1979 autobiography, *The Education of Carey McWilliams* (which he modeled on *The Education of Henry Adams*), he divided his life into five phases: his boyhood on a cattle ranch in northwestern Colorado, Los Angeles in the 1920s, California in the 1930s, the war and postwar era, and the thirty years he spent in New York as editor of the *Nation*. California belonged to his middle period, and it was in the 1920s, 1930s, and 1940s that he produced his major books and his prodigal California journalism. Running through the cascade of prose by this lawyer-journalist (who could type as fast as he could think and who thought faster than anyone!) runs an ambivalence, a chiaroscuro of light and dark regarding life in the Golden State. Both because this chiaroscuro is true and because McWilliams was California's greatest social and cultural critic in the first half of the twentieth century, this ambivalence, these divided loyalties, this interplay of light and dark have remained fixed in the very formula of California itself. Even the most vociferous critics of the state, such as the formidable Mike Davis, are more than half in love with the California they so frequently excoriate.

To probe the nature and context of McWilliams's ambivalence, his divided image of California, is to come very close to the essential dynamics of California itself in the first half of the twentieth century, at least as far as cultural commentary is concerned. Here, after all, was an overnight society in search of its history, which it would both discover and manufacture. This very longing for a past—most visible, perhaps, in the various revivals of Mediterranean architecture—presupposed an orientation toward orthodoxy. As evidenced in their architecture, in fact, Californians hungered for the reverberations of Mediterranean Europe. They saw themselves building a new Italy, a new Spain, a new Greece on Pacific shores. Yet admixed with these urges were also forces that would make California, Southern California especially,

the most notable gathering of eccentrics in the nation. (Among McWilliams's earliest interests were the frequently bizarre cults and religious practices of the Southland. He had a lifelong fascination with the gurus, cultists, fakirs, and prophets of the region.) Then there were the more disturbing dynamics of California as racist hegemony: as a successive repression of people of color from the Gold Rush onward.

California was a challenging melange of highbrow and low, authenticity and pose, promising a better life for the masses, provided the masses were white, and bitter restrictions and impositions for those who were not. Most auspiciously, Carey McWilliams contained within himself such oppositions and paradoxes. He was a privileged preppie, a partner in a blue-chip law firm, who stood up for the downtrodden: farmworkers (both Dust Bowlers and people of color), interned Japanese Americans, Jews kept from their rightful place in society because they were perceived to exist in a permanent condition of otherness. He was an aesthete, shocked by the vulgarity of Southern California, yet appreciative beyond anyone else in his time of its possibilities as a dynamic American experiment. One can mine his writings for images of California as either the Greatest Show on Earth—or the City of Dreadful Night.

Like so many of his contemporaries—Nathanael West, F. Scott Fitzgerald, and John Fante come immediately to mind—McWilliams was both mesmerized and appalled by the demotic vigor of the Southland, its confusing profusion of people and half-baked ideas. The inherent tension, the ambivalence in McWilliams's response to the territory he was chronicling, is brought out when he touches on Southern California as a physical place. In his younger days, he would spend much of his leisure time (whatever that possibly could have been!) hiking in the mountains, canyons, and back trails of the region. His many evocations of the climate and terrain, flora and fauna, of the Southland account for some of his finest writing. Indeed, it often seems that only at such points does he allow emotion to flow freely into his prose. He among a very few others, for example, realized that Southern California possessed its own distinctive version of autumn. "But most often," he writes in *Southern California: An Island on the Land,*

I think of the first crisp days of fall after the "hot spell" which invariably ends the long summer. I think of the view from a favorite arroyo in the late afternoon, the east slope still bathed in sunlight, the far slope already full of dark shade and lengthening shadows. A cool breeze, as one can look back across the plains, out over miles of homes and trees, and hear the faraway hum of traffic on the highways and see the golden light filtering through the mist-laden air. [3]

The distinctive beauty and strategic position of Southern California, however, called for a comparably distinctive human civilization, and as of 1946, when *Southern California: An Island on the Land* appeared, McWilliams was uncertain as to whether or not such a civilization had been achieved. Meditating on the "soft-silent muffled slap of the waters along the coast, far above Malibu, on nights of thick wet fog and spray and the smell of the sea," he remained the social, cultural, and political critic concerned for the congruence of society and place. "It is then that I realize," he writes of such moments,

that this land deserves something better, in the way of inhabitants, than the swamis, the realtors, the motion-picture tycoons, the fakirs, the fat widows, the nondescript clerks, the bewildered ex-farmers, the corrupt pension-plan schemers, the tight-fisted "empire builders," and all the other curious migratory creatures who have flocked here from the far corners of the earth. For this strip of coast, this tiny region, seems to be looking westward across the Pacific, waiting for the future that one can somehow sense and feel and see.[4]

Carey McWilliams came from that class of Americans—the formerly privileged now in reduced circumstances—which has so leavened American literary and intellectual life. Of Scotch Irish, German, and French descent, with roots on his Presbyterian Scotch Irish side in pre–Revolutionary War America, McWilliams grew up in Steamboat Springs as the son of one of the area's wealthiest cattlemen, a longtime state senator in northwestern Colorado. Educated at the Wolfe Hall Military Academy in Denver before returning to Steamboat Springs High School because of his father's poor health, he won a scholarship to the University of Denver in 1921.

By that time, McWilliams needed the scholarship. His father had gone broke in the collapse of the cattle market following the end of World War I and had sunk into immediate decline, dying just a few months before McWilliams graduated from high school. While his brother stayed on the ranch to help liquidate their father's tangled affairs, his mother sought the protection of her brother in Los Angeles, while McWilliams went off to the University of Denver. He did so filled with rebellious attitudes. This was not a rebellion, however, nurtured by the political Left on behalf of the oppressed. It was, rather, an aesthetic and attitudinal rebellion, nurtured by a reading of F. Scott Fitzgerald's *This Side of Paradise* (1920) in the caboose of a cattle train between Steamboat Springs and Denver in his senior year of high school. Like Fitzgerald's hero Amory Blaine, McWilliams, then sixteen, resolved to burn the candle at both ends in hopes of achieving the hard gem-

like flame of pure experience, that is, to live it up in the Jazz Age and by doing
so to define himself against the stultifying smugness of the American middle
class. (Living well is the best revenge.)

 The politics of such a stance was vague, as was the overall ideology.
The program was hardly that of social reform. It consisted, rather, of a taste
for good looks, good tailoring, and
constant partying, preferably in colle-
giate circumstances. A spectacular
St. Patrick's Day bash hosted by
McWilliams in his freshman year
lost him his scholarship and his
standing at the University of Denver.
Fitzgerald, he later noted, had once
said that the Jazz Age had actually
peaked as early as 1922. It certainly
did for McWilliams. The expelled
freshman now found himself broke
and without prospects on a train
headed for Los Angeles, where his
mother, so recently the wife of the
leading citizen of Routt County,
Colorado, was running a boarding-
house off Sunset Boulevard.

 While older members of the
Lost Generation expatriated them-
selves to Europe, McWilliams was expatriating himself, so he later came to
believe, to an equally exotic locale. His arrival coincided with the promotion
of Los Angeles as the Great Gatsby of American cities, sprung from a Platonic
self-concept. No single decade in the history of Los Angeles has before or since
equaled the overdrive of the 1920s. In the process of absorbing more than a
million people, the vast majority of them from the Midwest, Los Angeles very
deliberately transformed itself from a regional marketing and business center
to the Chicago of the Pacific slope: vast like Chicago, and mid-American as
well, distinguished like Chicago in its architectural and public-works ambi-
tions (the Biltmore Hotel, the Coliseum, the Rose Bowl in nearby Pasadena,
City Hall, the Public Library, the Richfield Building, the Hollywood Bowl, a
half dozen major buildings at USC, the new UCLA campus in Westwood), and
Chicagoan, finally, in its total command of the regional economy.

Carey McWilliams,
c. 1943
Courtesy of Wilson
Carey McWilliams

This was the decade that saw the motion-picture and aviation industries center themselves in L.A. This was the decade in which Cal Tech reorganized itself as a scientific institute, soon to be of international importance. Each working day some 50,000 commuters poured into downtown via streetcar and interurban electric. Five newspapers in multiple daily editions served a city that could never satisfy its rage for news about itself, especially its oddities. What was Aimee Semple McPherson up to at the Angelus Temple? Who had the Reverend Robert Shuler condemned last night on the radio? Who could have possibly murdered Hollywood director William Desmond Taylor?

Going to work for the business department of the *Los Angeles Times,* where his typing skills served him magnificently as a copywriter and producer of dunning letters to nonpaying clients, McWilliams managed near-full-time employment in split shifts over the next seven years as he completed bachelor's and law degrees at USC. (Perhaps only his later criticisms of that university as a football factory have prevented USC from acknowledging Carey McWilliams as one of its foremost graduates.) In any event, he spent the 1920s busy as a hard-reading, hard-partying undergraduate and law student. He wrote for the *Daily Trojan* student newspaper, the *Wooden Horse* campus literary review, and the *Wampus* humor magazine, while working at the *Times* and maintaining good grades. He also contributed literary profiles at ten dollars apiece to *Saturday Night,* a talk-of-the-town review founded by former Chicagoan Samuel Clover, whose range and variety of topics suggested the burgeoning urbanism of the City of Angels. In these years McWilliams was also submitting innumerable articles and reviews to the *Los Angeles Times,* the *San Diego Union,* and such California-based magazines as the *Overland Monthly,* the *Argonaut,* and *Game and Gossip.*

The dualism of this decade is immediately apparent. On the one hand, McWilliams is a hardworking, self-supporting undergraduate and law student, heading for an establishment career at a university that fed directly into the downtown establishment. On the other hand, he was still playing Amory Blaine, still very much the aspiring litterateur and Tory bohemian. A famous passage from *Southern California: An Island on the Land* recalls this time:

I had spent an extremely active evening in Hollywood and had been deposited toward morning, by some kind soul, in a room at the Biltmore Hotel. Emerging next day from the hotel into the painfully bright sunlight, I started the rocky pilgrimage through Pershing Square to my office in a state of miserable decrepitude. In front of the hotel newsboys were shouting the headlines of the hour: an awful trunk murder had just been committed; the district attorney had been indicted for

bribery; Aimee Semple McPherson had once again stood the town on its ear by some spectacular caper; a University of Southern California football star had been caught robbing a bank; a love-mart had been discovered in the Los Feliz Hills; a motion-picture producer had just wired the Egyptian government a fancy offer for permission to illuminate the pyramids to advertise a forthcoming production; and, in the intervals between these revelations, there was news about another prophet, fresh from the desert, who had predicted the doom of the city, a prediction for which I was morbidly grateful. In the center of the park I stopped to watch, a little self-conscious of my evening clothes, a typical Pershing Square divertissement: an aged and frowsy blonde, skirts held high above her knees, cheered by a crowd of grimacing and leering old goats, was singing a gospel hymn as she danced gaily around the fountain. Then it suddenly occurred to me that, in all the world, there neither was nor would there ever be another place like this City of the Angels. Here the American people were erupting, like lava from a volcano; here, indeed, was the place for me—a ringside seat at the circus.[5]

His friends and party pals during this period constituted the creative forefront of the 1920s: Paul Jordan Smith, literary editor of the *Los Angeles Times;* Arthur Millier, art critic of that newspaper; *Westways* editor Phil Townsend Hanna; poet and bookseller Jake Zeitlin; poet Hildegarde Flanner; photographer Will Connell; architect Lloyd Wright; impresario Merle Armitage; designer Kem Weber; musicologist and radio commentator Jose Rodriquez; journalists Herbert Klein and Louis Adamic; architects Richard Neutra, R. W. Schindler, and Harwell Harris; librarian and critic Lawrence Clark Powell; painter Stanton MacDonald-Wright; fine printer Ward Ritchie; and bookseller and all-round Hollywood character Stanley Rose. While the stance of McWilliams and his friends was rebellious in the sense of rejecting philistine values, it was a stance on behalf of art, not politics. McWilliams's major interest in this period, in fact, was literary regionalism. He read voraciously every bit of fiction and nonfiction connected to Southern California and wrote a small pamphlet on the subject.

At the same time, however, McWilliams was no uncritical chronicler of the Southern California scene. To the intrinsic counterstance of the bohemian circles in which he moved (when not writing business letters for the *Times* or attending law lectures at USC) was added the powerful and eventually personal influence of H. L. Mencken, castigator and baiter par excellence of all that was dishonest, hypocritical, gauche, or humorous in the "booboisie" otherwise known as the middle class. Debuting in January 1924, Mencken's review the

American Mercury dominated the literary scene and McWilliams's attention during that decade, just as the *New Republic* and the *Nation* would do so in the 1930s. Learned, quirky, outspoken, Mencken was to American culture what McWilliams would soon become to California's: filled with paradox. On the one hand, Mencken took his stand outside American society. On the other hand, as McWilliams himself pointed out, "he was endlessly fascinated, to the point of obsession, with these United States."[6]

The example of Mencken—who managed to produce an exhaustively researched multivolume study of American linguistic usage in the midst of a prodigiously active journalistic and editorial career—only reinforced McWilliams's commitment to an equally omnivorous polymathism in things Californian. Soon he was writing for the *American Mercury,* debuting with an article on San Francisco satirist and short-story writer Ambrose Bierce, who had disappeared mysteriously in 1913 at age 71. Mencken, who also admired Bierce, suggested that McWilliams write a full-scale biography. Despite the fact that he was only a sophomore in college and otherwise heavily engaged, he began a lengthy stint of research, which included interviews with many who had known Bierce. The resulting biography, published in 1927, can legitimately be considered one of the founding texts of California literary history in the twentieth century. Had Carey McWilliams merely wished to be considered a literary historian, *Ambrose Bierce* would have secured his reputation.

In a sense, the Bierce biography summed up McWilliams's decade of involvement in the literary history of his adopted region. It also pointed to the future, to a crucial turnaround in his life and intellectual interests. Though Bierce was a talented poet and short-story writer, he was first and foremost a satirist and social critic, which is why Mencken and McWilliams were attracted to him in the first place. Bierce was a model of the impassioned man of letters, concerned with the disturbing realities behind the surface of things. Like McWilliams, he had establishment origins. The arc of his life was interrupted, however, by the long violence of the Civil War. Though he served with distinction in the Union army, rising from private to major in dozens of battles and innumerable skirmishes, the grim experiences of that war informed all his writing. He was also deeply troubled by the get-rich-quick-at-anybody's-cost ethos of the post–Civil War Gilded Age. McWilliams's biography was as much social criticism as it was belles lettres; and now, with the Great Depression gaining force in California, he was poised to change the direction of his writing career.

Still, however, remained the duality, indeed the multiplicity, of his identities and pursuits. By this time he was an up-and-coming member, and soon-to-be junior partner, of the heavily Princetonian law firm of Black, Hammack, and Black. This blue-chip partnership, headquartered downtown in the American Bank Building at Second and Spring, specialized in oil and real estate with a clientele drawn mainly from Pasadena and San Marino. In 1930, moreover, McWilliams married Dorothy Hedrick, the proper daughter of a UCLA mathematics professor and founding provost of the Westwood campus. He had, in short, joined the establishment.

Nor did he abandon his purely literary interests. From 1933 to 1939, McWilliams wrote "Tides West," a dense two-page column in *Westways*, the magazine of the Automobile Club of Southern California (and of the region's establishment culture). In significant measure "Tides West" dealt with California literature and other regional topics, and his sheer range of reference reveals McWilliams to be one of the two or three best-read and most accurately informed literary scholars writing on California topics in the twentieth century. The editor of *Westways*, Phil Townsend Hanna, was archconservative in his political beliefs; yet he and McWilliams shared a passion for the literature and history of the Southland.

Yet despite all this, the Depression was driving Carey McWilliams toward a critique of the Golden State. H. L. Mencken had helped him hone his critical skills, but if Mencken had any systematic political beliefs whatsoever, they were on the libertarian Right. It was Louis Adamic, a Slovenian immigrant to Los Angeles, who introduced McWilliams to leftist thought in the 1920s and set the stage for his muckraking of the following decade. McWilliams had interviewed the San Francisco–based poet George Sterling at the Bohemian Club regarding Sterling's mentor Ambrose Bierce. Sterling, who knew Adamic, recommended that he look up McWilliams. From 1926 to 1929 McWilliams and Adamic were close friends, each of them given to long literary conversations and rambling junkets through the esoteric realms of Southern California cults, whose gurus and prophets they observed, catalogued, and described in various journals with a mixture of ironic detachment and fascination. Adamic had fled the Austro-Hungarian Empire in 1913 to avoid military service, instead joining the American army during the First World War. A massively read freelance intellectual, he had settled in San Pedro after his discharge because of the Dalmatian fishing colony in the vicinity. At the time of their meeting, Adamic was supporting himself as a watchman in the pilot station office located on the breakwater at the entrance to San Pedro

Carey McWilliams,
c. 1975
Courtesy of Wilson
Carey McWilliams

harbor: a perfect occupation for an autodidact busy on short stories, a novel set in Byzantium, a history of theology, a life of Christ, and some of the best Los Angeles journalistic vignettes of the decade.

Adamic was also beginning to gather material for a history of class warfare in the United States, which was published in 1931 as *Dynamite: The Story of Class Violence in America*. However, though Adamic was a scholar of the Left and introduced McWilliams to a variety of European and American leftist thinkers and practitioners, neither man was a thoroughgoing Marxist. In fact, *A Mask for Privilege: Anti-Semitism in America* (1948), in which McWilliams propounded an explicitly Marxist explanation, by his own account later caused him much embarrassment. From Adamic, however, he absorbed an imaginative sympathy with many aspects of leftist thought, specifically in the matter of establishment control over minorities and working people, which struck something already latent in his imagination. As the 1930s progressed, McWilliams was taking more and more cases on behalf of labor unions that were far outside the province and preference of his law firm.

Upton Sinclair also played a role in McWilliams's political transition. From one perspective, Sinclair was a figure from H. L. Mencken's worst nightmare: a teetotaling, holier-than-thou crank. However, sent by Mencken to interview Sinclair in 1924, McWilliams found that, for all of Sinclair's faults,

he admired the courage and fundamental sincerity of the novelist-tractarian-reformer. The day that Sacco and Vanzetti were executed, August 23, 1927, McWilliams and Sinclair sat in a Long Beach cafeteria discussing the political implications of the anarchists' deaths at the hands of the Massachusetts oligarchy. When it came time to cover Sinclair's run for governor of California in 1934, McWilliams saw in Sinclair's End Poverty in California (EPIC) campaign not merely another instance of California's social utopianism (although there was some of that in the movement) but a sincere and intermittently intelligent effort to deal with the privation that had suddenly invaded the lives of so many Californians.

The pressures of the Depression, followed by the Sleepy Lagoon case, in which a group of young Mexican Americans in Los Angeles were railroaded on fake charges of murder, and the wholesale internment of Japanese Americans in the Far West, provoked the full flowering of McWilliams's power as a social critic. This writing includes dozens of articles for the *New Republic* and the *Nation* chronicling agricultural strikes and the violent suppression of strikers, the persecution of California radicals under the aegis of the Criminal Syndicalism Act, and numerous other clashes during a decade in which California seemed to offer to the rest of the nation an almost deliberate drama of Left versus Right, communism versus fascism, as if to act out these destructive European forces on an American stage in an ideological parallel to the Spanish Civil War. While McWilliams's journalism remains of historical importance, it is the books from this decade that established his reputation as a premier social commentator on the national level and the single most significant nonfiction writer to address California issues in the twentieth century.

These books include *Factories in the Field* (1939), a history and investigation of farm labor in California; *Ill Fares the Land* (1942), a nationally oriented examination of farm labor, with an emphasis upon the conflict between large and small farms; *Brothers under the Skin* (1943), a probe into the nature of prejudice in America; *Prejudice; Japanese-Americans: Symbol of Racial Intolerance* (1944); *A Mask for Privilege: Anti-Semitism in America* (1948); and *North from Mexico: The Spanish-Speaking People of the United States* (1949). Each of these books is about minorities. Taken together they present, among other things, a dire composite portrait of California as a difficult place for people of color or for religious minorities in the first half of the twentieth century. Here, most powerfully, do we encounter the other side, the noir, of McWilliams's vision of the state to which he was giving, across three decades, such extensive interpretation. Poured into these books were his experiences

as commissioner of housing and immigration under Governor Culbert Olson, as a member of the Sleepy Lagoon Defense Committee, as a horrified onlooker at the enforced evacuation of Japanese Americans into relocation/ concentration camps, as a continuing correspondent for the *New Republic* and the *Nation*. These are prophetic, angry books and, in the case of *A Mask for Privilege* especially, books touched by more than a few Marxist insights. Taken cumulatively, they anticipate a whole range of problems associated with the racial and ethnic diversification of California now gathering such strength.

In a subtle but discernible way, the departure of Carey McWilliams from California in 1951 for the editorship of the *Nation* and permanent residence in New York City represents some form of judgment on California. Ostensibly, if one is to believe *The Education of Carey McWilliams,* the move was almost accidental. Freda Kirchwey, publisher of the *Nation* and a close personal friend, called him to New York in late 1950 for a six-month stint of guest editing and fund-raising at the beleaguered magazine. The half year turned into a quarter century at the editorial helm. This, at any rate, was McWilliams's "explanation" for his move from the West Coast to the East. But did it signify other things? Did it mean that he had lost faith in California as a cutting-edge American experiment? As with most of the issues in his life, the answer is partly political. Chronicling California's tradition of democratic radicalism touched by utopian ambition had been one of his major accomplishments as a writer. Now, however, in the alarming years of 1949 and 1950, as a joint assembly-state subcommittee headed by Los Angeles assemblyman Jack B. Tenney (otherwise distinguished as the author of the song "Mexicali Rose") scoured the state in search of Communists, McWilliams feared that a long dark night of political repression was settling on California. The novelist Thomas Mann, who had fled to Southern California from Hitler's Germany, told McWilliams that he was thinking of returning to Europe because he saw the same things happening in the United States, California especially, as happened in Germany in the 1930s.

In the time before his departure for New York, as the Tenney Committee gathered its evidence and named its names, McWilliams found himself barred from certain circles, with lecture engagements abruptly canceled. Already he had experienced the shock of being fired from his *Westways* column because of his political opinions. During the gubernatorial campaign of 1941, Attorney General Earl Warren had expressly stated that the first thing he would do if elected would be to fire McWilliams from his position as Commissioner of Immigration and Housing. When Warren was elected, McWilliams resigned. California, he knew, could be a narrow, even paranoid place. By 1950 he most

likely felt that New York City and the *Nation* offered a better-defended position in which to remain a man of the Left in Joe McCarthy's America.

Yet McWilliams's critiques of California suggest, even in their negativity, their chronicle of collective misbehavior, a finer California. To chronicle misbehavior, after all, one must have a vision of how people should behave. To chronicle prejudice, discrimination, and exploitation of every sort is by definition to have a vision of how men and women should treat one another. McWilliams's California criticism functions as a grand corrective and anticipates a better California to come. Carey McWilliams, like F. Scott Fitzgerald, whose *This Side of Paradise* had galvanized him into self-awareness, could never fully extricate himself from the society he chronicled. Its dreams were flawed, but they were his dreams as well. Nurtured in his youth by a mixture of Menckenism and an American tradition of dissent that was flourishing long before Karl Marx, he brought to his effort to chronicle and define California, to correct its faults and orient it toward a better future, a belief that to be a Californian was to be on the cutting edge of the American experience. Although he loved his adopted state, Carey McWilliams was no booster. He was something far better: a prophet. And prophets love as well as judge.

Kevin Starr is state librarian of California and is the author of numerous celebrated volumes on the history of the state, including *Inventing the Dream: California through the Progressive Era* (1985) and *The Dream Endures: California Enters the 1940s* (1997).

1 Carey McWilliams, "Discovering California," in *California: The Great Exception* (1949; reprint, Santa Barbara and Salt Lake City: Peregrine Smith, 1976), 6–7.
2 Ibid., 7.
3 Carey McWilliams, *Southern California: An Island on the Land* (1946; reprint, Santa Barbara and Salt Lake City: Peregrine Smith, 1973), 377.
4 Ibid.
5 Ibid., 375–76.
6 Carey McWilliams, *The Education of Carey McWilliams* (New York: Simon and Schuster, 1979), 54.

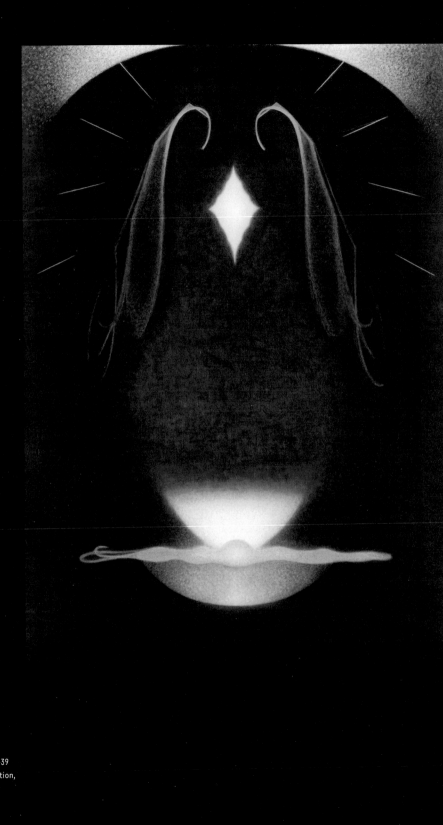

Agnes Pelton,
Alchemy, 1937–39
The Buck Collection,
Laguna Hills

Ilene Susan Fort

ALTERED STATE(S):
CALIFORNIA ART AND THE INNER WORLD

Here on the West Coast . . . perhaps the most poignant time of day is when the sun slowly sinks
behind the horizon of the Pacific Ocean. It marks the passage of day into night, and suggests the
passage of the conscious into the unconscious. Here on the West Coast we are well situated to
investigate the Inner-Worlds of the unconscious.

Gordon Onslow Ford, "The Dynaton," 1992

A strong fascination with metaphysics has distinguished twentieth-century
California art from that produced on the East Coast.[1] The grandeur of the
state's landscape, its border on the vastness of the Pacific Ocean, its moun-
tains, deserts, and limitless sky all encouraged soul-searching and mystical
pursuits. According to writer Aldous Huxley, who moved to Hollywood in
1938, such investigations foster a better understanding of oneself and the
universe, and ultimately allow one to lead a more creative life, "to escape
from the prison of our individuality" in a process of "self transcendence."[2]
California has long been the refuge for many seeking various forms of libera-
tion, whether freedom from social constraints, gender prohibitions, or reli-
gious intolerance.

California has offered people an environment in which they could
start a new life on their own terms, a place where they could pursue their
lives unhampered by the restrictive, tradition-based society of the eastern
and Midwestern United States. Some of the men and women who came—
Will Levington Comfort, Aimee Semple McPherson, Katherine Tingley,
and Alan Watts, for instance—were self-proclaimed spiritual messiahs who
demonstrated a dissatisfaction with society, rejected conventions, and ignored
established Western religious institutions to pursue personal inquiries into
the meaning of existence. In the process, some founded movements with

numerous followers. Their search for transcendence formed a religious coun-
terculture and ultimately contributed to the development of the modern state
of California.

California's identification as the "psychic state" has an ancient history,
according to occult lore.[3] Occultists believe that the West Coast is the remnant
of the fabled continent of Lemuria, which originally covered the entire Pacific
Ocean and was populated by a race endowed with strong psychic abilities.
As their continent sank, the last of the Lemurians sought refuge in four areas
of California: present-day San Jose, Santa Barbara, Carmel, and Mount Shasta.
In historical times, before 1900 the occult prospered primarily in Northern
California: three mediums were listed in the 1856 San Francisco directory, and
in 1860 a man named Samuel Cohen began a twenty-five-year career there as
an astrologer. Spiritualism, which teaches of the survival of human personali-
ties after death and their intervention in human affairs, had emerged as a
movement in the late 1840s and quickly captured the hearts of hundreds of
thousands of Americans. Mrs. M. U. Upham established Sacramento's first
Spiritualist church in 1858. In Petaluma George Rosa began photographing
spirits. By 1880 San Francisco boasted five mediums, twenty-one clairvoyants,
and three astrologers. In this milieu so many charlatans claimed to have psy-
chic powers that a San Francisco newspaper, the *Carrier Dove,* investigated and
accredited the honest mediums and sponsored West Coast camp meetings
where metaphysics, palm reading, singing, and medium sessions were taught.

California was also home to more utopian colonies than any other
state, and of the fifteen established by 1920, one-third were religious in
nature. Situated throughout the state, they often broadened the dissemina-
tion of esoteric beliefs. Unlike most settlers moving West, some metaphysi-
cally inclined colonists were drawn to California not only because of its mild
climate and fecund natural resources but also because of the magnetic forces
supposedly within the soil, which they believed were conducive to successful
spiritual exploration. Most colonies were fated not to survive more than a few
years. The Esoteric Fraternity, founded by Hiram Butler in 1887 in Applegate,
and Point Loma, established by Katherine Tingley outside San Diego in the
late 1890s, were two exceptions.[4]

By the early 1920s Southern California had developed into a major pub-
lishing center for the metaphysical and occult. The colonies and religious
centers issued hundreds of newspapers, articles, and pamphlets, and various
small presses published books. By the Depression, several new religious organ-
izations had become major industries, such as McPherson's Church of the

Foursquare Gospel, headquartered in the magnificent Angelus Temple in
Los Angeles. McPherson broadcast nationally her message about the healing
power of faith from the church's own radio station. Channelers, astrologers,
tarot readers, reborn spirits, and strange sects thrived. Their followers num-
bered many creative talents—movie stars as well as poets, painters, and writ-
ers. For instance, the novelist Hamlin Garland and his circle of friends in
Los Angeles held nightly seances during the mid-1920s; later the English-born
poet and artist Jeanne d'Orge hosted them in Carmel. By then California's
identity as the psychic state was secured.

 The religious counterculture in California was mainly a white, middle-
class phenomenon. Many of the early spiritualists were mainstream, native-born
Americans trying to escape the influx of what they considered "undesirables"
(mostly Catholic and Jewish immigrants), who flooded the East and Midwest
from the turn of the century until the 1920s, when new immigration laws
stopped the flow. Ironically, in seeking new lifestyles and belief systems in a
purer place, they migrated to a region with large Asian and Hispanic commu-
nities. Moreover, they often found spiritual enlightenment in the philosophies
of the cultures they reviled. Several occult leaders, however, believed Califor-
nia's ethnically diverse community crucial for the future of mankind: Tingley
insisted it was the perfect home for the dominant "southern Pacific root race"
she forecast, and Comfort taught that the blending of the East and West would
encourage an improved "New Race."[5]

IN 1914 CHICAGO LAWYER AND AUTHOR Arthur Jerome Eddy claimed that
the art of the future would be more spiritual, explaining that the key to
the modern movement would be "the expression of the inner self, as distin-
guished from the representation of the outer world."[6] Many twentieth-century
artists considered certain spiritual practices as the vehicle to this inner world.
Often these artists explored several religions or metaphysical philosophies
concurrently, borrowing ideas from each of them in developing their per-
sonal belief systems. Usually they rejected established, institutionalized West-
ern religions. Some were devoted disciples of their chosen path throughout
their careers, while for others spiritual exploration was simply a phase of their
artistic development.

 Hinduism, Taoism, and Vedantism, along with spiritualism, mysticism,
and other occult practices were investigated, but Theosophy and Zen
Buddhism had the greatest impact on California's artists. Theosophy is a
philosophical system of occult traditions and revelation that teaches the prin-

ciples necessary for achieving truth and spiritual oneness. Although a synthesis of many different religions, it is heavily based on Eastern philosophies, especially those of India. Consequently, the impact of both Theosophy and Zen were significantly linked to political developments such as wars and immigration laws. Theosophy was the dominant influence prior to World War II, to be succeeded by Zen in the following decades.

None of the other so-called new religions seemed as enticing to creative minds, partly because they were often merely revisions of established Western faiths. For example, McPherson's Foursquare Gospel, which appealed to residents newly immigrated from small towns and farms in the Midwest rather than to artists,[7] was part of a national revival of religious fundamentalism that occurred during the 1920s and 1930s. Through such organizations Protestants sought answers to the moral and social conflicts of the day in the "old-time religion" (with the emotional displays of mass revivals) rather than in more intellectual, modern manifestations.[8] Indeed, McPherson saw her evangelism as waging a bloody war against "modernism" along with "infidelity," "evolution," and "higher criticism."[9] Progressive artists in California were as liberated from rigid biblical doctrines as were religious modernists.

Among Californian followers of Theosophy were painters Mabel Alvarez, Maurice Braun, Agnes Pelton, and Frederick Schwankovsky, filmmaker Dudley Murphy, writer L. Frank Baum of "Oz" fame, and in the postwar years Beat poet Robert Duncan. Founded in 1875 by Helena P. Blavatsky in New York, the Theosophical Society quickly thrived internationally, attracting large numbers of artists, including Wassily Kandinsky and Piet Mondrian, who found meaning for their new art of abstraction in its spiritual teachings. After Blavatsky's death in 1891, a power struggle splintered the organization. Tingley led the largest dissident group, the Universal Brotherhood and Theosophical Society. Searching for new headquarters that would be the center of an alternative lifestyle and inaugurate a new religious and political era, she established Lomaland in 1897 at Point Loma, a 132-acre property overlooking the bay of San Diego. Although Lomaland existed for over forty years, further dissent soon arose over Tingley's leadership and policies: Halcyon, the Temple of the People at Pismo Beach, was established in 1903; six years later Robert Crosbie, originally a disciple of Tingley, founded the United Lodge of Theosophists in Los Angeles.[10] The

Krotona Institute
of Theosophy in the
hills of Hollywood,
postcard, c. 1920
Collection of Joseph E.
Ross, Ojai

original society, under the leadership of Annie Besant in Adyar, India, maintained an active American section, especially in California, holding its annual convention in San Francisco in 1915 and at Krotona in 1918. The latter had been established in 1912 by A. P. Warrington, a Besant follower, as the Krotona Institute of Theosophy and remained in the hills of Hollywood until 1924, when it moved to Ojai, north of Los Angeles.[11] There Besant had acquired land for Jiddu Krishnamurti, considered by the Theosophists to be the future spiritual leader of the world. Krishnamurti would continue to attract followers, including Huxley and ceramist Beatrice Wood, long after he renounced the Theosophical Society in 1929.

Although it claimed that all religions stemmed from the same ancient sources and consequently shared myths and symbols, Theosophy spawned no single iconography. Nor did it encourage a single aesthetic point of view. A traditional art school was established at Point Loma, and most of the artists associated with the colony were conservative, practicing a romantic art derived from European symbolism.

A devout Theosophist, Maurice Braun had left New York City in 1909 specifically to settle at Point Loma. He was actively involved in the organization as writer and illustrator for the society's magazine the *Theosophical Path* and later as head of the art department of Lomaland's university. Nevertheless, Braun remained somewhat separate from the commune, working in a downtown San Diego studio provided by Tingley. Braun's expansive landscapes, often infused with a soft golden haze, have been considered in theosophical

terms a *gayatri*, a sacred homage or prayer addressed to the sun. California plein-air painting has long been considered a descendant of the perceptual realism of French Impressionism, yet Braun was not concerned with atmospheric effects and weather conditions per se, nor did he always paint outdoors. His paintings stood as a metaphor for a central tenet of Theosophical doctrine: "Light is the first begotten, and the first emanation of the Supreme, and Light is Life, says the Evangelist and the Kabbalist. Both are electricity— the life principle . . . pervading the universe . . . From its swelling, electric bosom, spring *matter* and *spirit*." [12]

Will Levington Comfort was a writer who lectured after the war in private homes throughout the Los Angeles area before associating with the Krotona Theosophists. An inspiring personality, he quickly became a Hollywood guru. He claimed not to be a Theosophist but borrowed heavily from various Asian cultures as well as from Theosophy, Christian Science, and the mental self-discipline of New Thought. Artists Mabel Alvarez, William Cahill, Knud Merrild, Agnes Pelton, and Millard Sheets heard him lecture and read his publications, and some knew him personally. Perhaps even more important than his books were his periodicals the *Reconstruction Letter* and the *Glass Hive*. Comfort did not so much promote a specific religion or doctrine as he did a way of life. In her fictionalized account of her father, Jane Levington

Maurice Braun,
*Moonrise over
San Diego Bay*, 1915
Collection of Joseph
Ambrose Jr. and
Michael D. Feddersen,
Laguna Beach

Comfort has Wilton Crosby (Will Comfort) state, "God is the creative spark in man. Without God, the urge to paint, to write, to compose, to teach, even to appreciate—are impossible."[13]

Alvarez referred to Comfort's "vibrations" and frequently noted in her diary that her self-confidence and her painting improved after hearing him speak. Comfort believed that the way to a purified soul was through meditation, vegetarianism, and mystical breathing exercises. Through his encouragement, Alvarez began practicing meditation and yoga; she may have been the first California artist to study the latter seriously and to have it affect her art.

Alvarez first encountered yoga in the 1920s. An ancient Eastern, anti-intellectual philosophy, yoga encourages spiritual and physical discipline as the path to self-awareness. Experienced in different ways—through physical action, meditation, concentration, and mantras—its most popular form in the West has been hatha yoga, in which spiritual purification of the body is achieved through physical postures and controlled breathing. Yoga did not reach the West until the late nineteenth century, encouraged by the Theosophical Society and various Indian mystics such as Paramahansa Yogananda (1893–1952), who settled permanently in California in 1922, around the time Alvarez began her exploration.[14] During the next decade, Pelton became a devotee of agni yoga, a Hindi form that was popularized in the United States by the painter Nicholas Roerich and his wife Helena. As did Alvarez, Pelton sought enlightenment in esoteric philosophies and art. Striving for the "vital flame"—a metaphor for spiritual energy—became central to her life as well as an important motif in her abstractions. Many other later artists, especially the Dynaton group and the Beat generation, would also consider yoga valuable to their art.

Both Alvarez and Pelton suffered from the plight of the New Woman— educated, articulate, independent, and highly creative, they had no comfortable role in established society. California attracted many such freethinkers, who sought a way of life difficult to maintain in most other parts of the nation. The openness of its society, particularly in terms of religious beliefs and gender-proscribed activities, encouraged women to examine their traditional role as conveyor of faith and to expand upon it in unorthodox ways. Upham's early appearance in Sacramento and Tingley's and McPherson's leadership of two major religious movements demonstrate this. Not surprisingly, Alvarez and Pelton found the spiritual world comforting and through it learned to accept their difference. They represented what Theosophist Claude Bragdon referred to as Delphic Women—females who exhibited exceptional

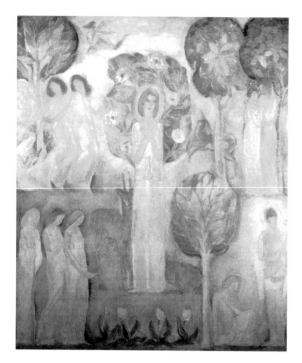

Mabel Alvarez, *The Dream of Youth*, 1925 Collection of Jeri L. Waxenberg, courtesy of Adamson-Duvannes Galleries

psychic ability and who could reach elevated levels of consciousness.

Alvarez was greatly swayed by Comfort's seminal lecture "Follow That Dream," originally presented in 1917. Later she produced a series of small "dreamscapes," in which a woman in a lotus position floats near young standing females. *The Dream of Youth* was the culmination of this series and of her self-exploration through yoga. She painted the entire canvas in soft tones, with celadon green as the primary hue, creating a calm, gentle mood suggestive of the spiritual harmony she felt she had finally achieved.

Alvarez was surely aware of the religious as well as aesthetic and philosophical theories that equated the effects of color with human emotions. Her delicate green is close to the shade marked number 4 ("adaptability") in the first row of the "Key to the Meanings of Colors," as espoused by Theosophists Annie Besant and C. W. Leadbeater in their 1901 treatise *Thought-Forms*. Besant and Leadbeater considered this shade emotive of sympathy and adaptability. Alvarez may have also been familiar with Frederick Schwankovsky's color theory, which would have reaffirmed her choice. Schwankovsky was an unconventional teacher at Manual Arts High School in Los Angeles, who explored Buddhism, Hinduism, and Rosicrucianism before adopting Theosophy. He invented and sold a color wheel and published a treatise on color in which he equated each hue's aura with a specific musical note, emotion, and astrological symbol.[15]

Pelton believed that art should not be a literal representation of the material world, but rather serve as "little windows, opening to a view . . . a region not yet visited consciously."[16] The unusual shapes that float through her abstractions may have been encouraged by the occultist belief in thought-forms. These are distinctive patterns and colors generated in the human aura by the vibrations of a person's thoughts and emotions as visible to clairvoyants. Some of Pelton's shapes parallel those given specific identifications in Besant and Leadbeater's popular book. But it was not until Pelton settled in

California that her mystical art matured. The desert near Palm Springs and the boundless sky above offered her the tranquillity she had been searching for and served as a vehicle for contemplation and mystical visions. She would go out into the desert at twilight and during the predawn hours to study the stars and commune with nature. Many of her abstractions were populated by shapes that suggested rays, stars, orbs, and other heavenly lights. After seeing the recently discovered planet Pluto in the heavens on January 1, 1937, she painted *Alchemy,* describing the experience as truly a "revelation."[17] She believed that the harmonious movements of the heavens formed a telling contrast to the feelings of spiritual agitation that so many people, including herself, experienced. The stars came to serve as a personal metaphor for her newfound spiritual calm. Pelton's sublime abstractions of the 1930s and early 1940s were the first cosmic images created by a trained modernist in prewar California.

Grounded deeply in metaphysical thought as well as Asian philosophy and aesthetics, Alvarez, Braun, and Pelton read widely and studied many other related fields. An openness to non-Western cultures would become a hallmark of most California artists involved in spiritual pursuits. All were searchers for self-knowledge and universal truths. Not surprisingly, several were also teachers who inspired similar interests in their students: William Cahill discussed Theosophy with Alvarez, and Schwankovsky introduced the young Jackson Pollock to Theosophical concepts and the teaching of Krishnamurti, ideas that would ferment until Pollock produced his mature work in New York City.

DESPITE THE PRESENCE OF THEOSOPHY, Asian religions received their greatest single impetus in the United States with the International Parliament of Religions, held at the Chicago Columbian Exposition of 1893. Speakers from all over the globe introduced many of the world's Asian philosophies to Americans.[18] For instance, the Hindu monk Swami Vivekananda was so well received at the parliament that he toured the country proselytizing Vedantism. His brief stay in Pasadena at the end of the decade led his hostesses to later establish a Vedanta center in Southern California, and it was to their temple in Hollywood that the British intellectuals Huxley, Gerald Heard, and Christopher Isherwood came to study and meditate in the 1940s and 1950s.

Buddhism, in particular Zen, did not thrive, however, until the 1930s.[19] Although the Japanese Zen master Soyen Shaku spoke at the 1893 fair and returned in 1905 at the invitation of a wealthy San Franciscan, it would be his disciple Nyogen Senzaki who was the first true Zen missionary, teaching in San Francisco from 1922 to 1930, and in Los Angeles thereafter. Although there

was little contact between the Japanese Buddhists of California and their Caucasian counterparts,[20] Senzaki's students included Manly P. Hall, the esoteric philosopher who founded the influential Philosophical Research Society and Library in Los Angeles. But with World War II everything Japanese was suspect, and even Senzaki was forced into an internment camp.

The war and ensuing military occupation transformed the situation dramatically, as American forces and diplomatic corps in the Pacific arena encountered Asian cultures. Zen not only became a new fascination among the intelligentsia but by the late 1950s was even the topic of cocktail party conversations. It was introduced to the general public through magazine articles such as "What Is Zen?" in the January 1958 issue of *Mademoiselle*. Although New York artists and writers enthusiastically explored Zen, West Coast practitioners had an advantage because of their geographical proximity and historical ties to Asian cultures. As Wolfgang Paalen noted of San Francisco, "The incomparable city holds, so to speak, a strategic position of inspiration between the currents of the great old cultures of the Pacific and the stirring forces of America."[21]

Many encountered Asian philosophies through schools, public lectures, and publications. Eastern philosophies became a popular topic of discussion in the California School of Fine Arts. But Alan Watts more than anyone else was instrumental in introducing California artists to Zen. He moved to San Francisco in 1951 to teach at the newly established American Academy of Asian Studies, but also lectured on radio, television, and in person throughout the state. Moreover, his numerous publications, especially *Spirit of Zen* (1936; repr. 1948), were widely read. Gordon Onslow Ford and Jean Varda knew him well, while others—Stanton MacDonald-Wright and Lee Mullican, for example—heard him lecture and studied his books. John McLaughlin and MacDonald-Wright were first introduced to Zen through Asian art. Along with poet Gary Snyder, they became so serious about the subject that they went to Asia to pursue its teachings.

Equally crucial were the informal networks of artists, writers, poets, and philosophers who congregated in bars, clubs, and private homes around Los Angeles and the Bay Area. For example, soon after arriving in San Francisco, Mullican became acquainted with Asian philosophy, in particular Buddhism, through Stanford professor Frederick Spiegelberg, writer Kenneth Rexroth, filmmaker James Broughton, and painter Onslow Ford. Years later in Los Angeles, after hearing Watts speak in a public lecture, Mullican pursued a more serious study of Zen, often discussing ideas with artist Rico Lebrun.[22]

D. T. Suzuki, the foremost promoter of Zen Buddhism in the English-speaking world, explained that the discipline of Zen consisted in "opening the mental eye in order to look into the very reason of existence."[23] This element of transcendence appealed to many during the postwar years, as they sought to comprehend the devastation of World War II and find meaning in existence. Zen was a discipline that answered the spiritual needs of certain creative people in particular. As Paalen explained, "a work of art has to bring about an awareness of universal concerns."[24]

According to Suzuki, Zen was neither a religion, nor a philosophy, nor meditation per se. "The basic idea of Zen is to come in touch with the inner workings of our being, and to do this in the most direct way possible, without resorting to anything external or superadded. Therefore anything that has the semblance of an external authority is rejected by Zen." Most California visionary art from the early decades of the century had been representational, the creation in paint of a spiritual dimension that resembled the forms of life on earth. As abstract as Pelton's poetic visions were, they always retained some references to the physical world. Because Zen had no mythology or pantheon, no visual imagery was attached to its practice. Zen thereby enabled artists to relinquish all ties to the material, a desire that was central to most postwar painters.

Mullican, Onslow Ford, and Paalen, exhibiting as the Dynaton in San Francisco in 1951, demonstrated the important role Zen and related philosophical ideas would play in California postwar art. The three derived their name from the Greek *dyn* (which they translated as "the possible"). Dynaton fused their fascination with Native American cultures, shamanism, and Buddhism to demonstrate the transformative aspect of their art. According to their manifesto, their "metaplastic painting" went beyond what a person saw and beyond form itself to embody a new world that was universally accessible.[25]

Zen emphasized that the role of the individual and the use of intuition were essential in attaining an elevated state of consciousness. The Asian worldview placed importance not on things but on process; the here and now as a dynamic, constantly changing universe. Along with similar ideas concerning flux found in Hinduism, Taoism, and the *I Ching*, it encouraged spontaneity.[26] Onslow Ford believed that the creative process was instantaneous: "Painting in the instant is the direct manifestation of the unknown through the painter as an instrument . . . there is no pre-image in mind. It is not known what will appear until it is down."[27] Later several San Francisco Abstract Expressionists,

Gordon Onslow Ford,
*Fragment of an
Endless (II)*, 1952
Collection of the artist

among them Ernest Briggs, Jack Jefferson, and William Morehouse, also
became particularly interested in the philosophical connections between the
Zen concept of spontaneity and the act of painting.[28]

Each Dynaton artist developed his own written language: Paalen with
incandescent *taches* (touches) of paint, Onslow Ford with long strokes and
short dabs of paint (usually white and black with some green to suggest nature)
that he orchestrated into a tapestry pattern, and Mullican with thin colored
rays emanating from a central core.[29] To varying degrees, a significant number
of California artists experimented with calligraphy. Watts encouraged the prac-
tice, since it was a discipline of Zen and Taoism.[30] Onslow Ford was perhaps
the most devoted to calligraphy, studying it with Zen master and calligrapher
Hodo Tobase Roshi for five years. During this period he further developed
his own personal calligraphic script into a shorthand he referred to as "line—
circle—dot." He considered these three elements the fastest marks possible,
"where movement is brought to stillness."[31] This visual language enabled
Onslow Ford to move freely from the anthropomorphic toward the cosmic.[32]

Unlike prewar visionary art, Dynaton imagery invoked space rather than
the earth, for the three artists strove to create cosmic realms. Dynaton's all-
over compositions of colored light suggest the idea of an unlimited cosmos
and a never-ending source of energy. For the Zen practitioner, light is the
awakening to the Buddha, to the attainment of satori (enlightenment). But
Dynaton was definitely a mid-twentieth-century phenomenon, so its paintings
were also influenced by the birth of space exploration then being heralded in
the popular press.

Yet Dynaton also revealed the inner cosmos of the individual artist, what Spiegelberg noted had previously been referred to as "the soul."[33] Painting accessed that dimension, for Dynaton believed the process of creating art was equivalent to the Eastern discipline of meditation. In Zen, *mu* (emptiness, or nothingness) is pure experience and refers to the detachment required to achieve enlightenment. McLaughlin believed that his search for a deeper metaphysical reality was only attainable in a state of stillness and total receptivity. Onslow Ford also required absolute privacy and no distractions: the artist "must be at peace with himself and the world—To attain this mood a great humility is necessary that is akin to prayer. I look attentively at all I see and sometimes contemplate a scene or an object for hours."[34]

Both artists withdrew from large cities and settled in remote areas more conducive to contemplation, McLaughlin at Dana Point and Onslow Ford at Inverness. A similar process was described by Aldous Huxley. Having experienced years of vision problems, he claimed that he saw better after meditation sessions with Swami Prabhavananda: "Vision is not won by making an effort to get it. It comes to those who have learned to put their minds and eyes into a state of alert passivity, of dynamic relaxation."[35]

Meditation was not only important for the creative process but also for the experience of the spectator. Just as yoga often served to assist in contemplation, the painting itself became a meditation tool for the viewer. MacDonald-Wright advised the spectator to "empty [his] mind and let the picture do the work."[36] McLaughlin explained, "I have gone to considerable pains to eliminate from my work any trace of my own identity with the view to making the observer the subject of the painting."[37] Unlike the Dynaton, he rejected all references to nature as subject matter, both the cosmic (macrocosm) and the atomic (microcosm). McLaughlin constructed compositions of rectangles with a minimalist palette (that became more reductive over the course of his career), which appear superficially similar to those of Mondrian. But the artist was not concerned with the utopian idealism of neoconstructivism, nor did he share Mondrian's interest in Theosophy. He sought to exorcise any suggestion of "thingness" in order to create neutral forms. Thus he worked in the manner of Zen artists: "Certain Japanese painters of centuries ago found the means to overcome the demands imposed by the object by the use of large areas of empty space. This space was described by Sesshu as the 'Marvelous Void.' Thus the viewer was induced to 'enter' the painting, unconscious of the dominance of the object . . . enabled to seek his own identity free of the suffocating finality of the conclusive statement."[38] Later the Beats would

continue to celebrate ideas of neutrality and the void, as elaborated in Jack Kerouac's 1958 novel *The Dharma Bums.*

Other California artists considered sacred geometrical forms, in particular the mandala (Sanskrit for "circle"), the preferred meditation tool for enlightenment. Mullican's brilliant vibrating lines suggest mandalas; Beat artist Jay DeFeo's *The Jewel* also partakes of the form, its strong center and divergent rays suggesting divine light and energy at the moment of cosmic creation.[39] At times DeFeo's imagery also alludes to human eyes, symbolizing the inner vision achieved through meditation. In Hinduism and Buddhism the mandala serves as a ritual instrument (*yantra*) for contemplation and meditation. Western interest in the mandala was due primarily to the psychiatrist Carl G. Jung, who identified it as an archetype, a symbol of the collective unconscious that appeared in dreams as a means of bringing inner order to psychic chaos. Traditional mantras are highly detailed geometric diagrams with religious significance, a configuration symbolizing the macrocosm in microcosmic terms. By meditating on them from the outer border inward, the viewer moves toward the center of reality and toward his own center, the Hindu Brahma, or Buddhist nirvana.

With the addition of the dimension of time, early visionary filmmakers re-created the stages of this mental process. Working in Los Angeles Oskar Fischinger made *Radio Dynamics* (1941–43), a silent film, to serve as a "contemplative, meditational aid." His mandalas, presented in the form of eyes, became hypnotic in their stroboscopic flickering.[40] Californians were among the first innovators in the creation of abstract film and, as film historian William Moritz has noted, Fischinger and others—James Whitney in Pasadena, and Jordan Belson and Harry Smith in San Francisco—shared a broad base of spiritual influences including alchemy, Buddhism, Taoism, and Vedantism.[41] Whitney believed in the power of film to communicate difficult mystical concepts. He limited his abstract form to the dot—symbolic of the oneness of Buddhism and the one-pointedness of meditation. By adding sound to the visual sensations of color and movement Whitney invented a meditative process comparable to synesthesia. In *Yantra* (1955), he combined centric configurations with irregular shapes suggestive of the "thought-forms" of Theosophists Besant and Leadbeater to create a visionary experience similar to that induced by mescaline. Although none of Belson's early films are traditional mandalas, the filmmaker acknowledged his debt to Whitney for introducing him to the mandalic potential of abstract film. His objective was to create filmic vehicles of meditation in the Asian tradition, as demonstrated in

Mandala (1953) and *Allures* (1961). Although Belson gave up cinema for
a few years in the early 1960s to practice hatha yoga, he returned to create
more personal films whose abstract cinematic structures are based on his
internalization of wide-ranging cosmological imagery derived from yogic
and Buddhist texts.

According to Jung, modern mandalas "express the totality of the indi-
vidual in his inner or outer experience of the world."[42] Underground artist
and poet Keith Sanzenbach began a series of mandala *sumi* drawings during
1958 while living in isolation in the Santa Cruz mountains. Having read
esoteric literature and Jung and experimented with drugs, Sanzenbach was
obsessed with the supernatural and the concept of chaos. In his immense
mandala canvases, sweeping gestural strokes on the periphery of the circle
convey this chaos. The mandala became
one of the most popular motifs for the
hippie generation, and Sanzenbach
served as an important catalyst. Bruce
Conner designed one of the first psy-
chedelic mandala posters for the his-
toric 1966 San Francisco Trips Festival.
It was there that friends of Sanzenbach,
Bill Hamm and Elias Romero, intro-
duced the psychedelic light perform-
ance. Hamm and Romero displayed the
mandala as an amorphic, globular form

James Whitney, from
the film *Yantra*, 1955
Courtesy of Dr. William
Moritz and the iota
Foundation

in a field of color by projecting onto a screen images derived from emulsions
floating in water.[43] By inventing the light show, which often accompanied
rock-music concerts, Hamm and Romero elevated the quiet cerebral activity
of self-exploration into a loud, mind-altering group experience.

Mysticism—the doctrine that it is possible to achieve communion with
God and attain spiritual truth through contemplation and love—is nearly
universal and unites most Eastern and Western religions. Aldous Huxley
investigated the reality of mystical experience and presented his findings in
The Perennial Philosophy (1945), a book so popular it doubled the number of
Westerners who were interested in the topic.[44] A mystical experience transcends
the bounds of ordinary consciousness; though it can occur spontaneously, it
is usually self-induced. Many in the Beat and hippie generations used medita-
tion, yoga, hallucinogenic drugs, or the act of painting or writing itself to
achieve a mystical state. By doing so they believed they could transcend the

banality of middle-class culture, which to them signified spiritual death. Although Zen and other Asian belief systems emphasizing tranquillity and oneness were crucial to Jack Kerouac and other Beats, a spiritual quest that incorporated extreme emotional experiences was equally compelling to some. Traditional Western mystical beliefs fascinated Charles Dockum (creator of "mobile-color" performances), the sculptor Peter Krasnow, and Beat artists Wallace Berman and Wally Hedrick. Robert Duncan, Kenneth Rexroth, and Berman were particularly steeped in pre-eighteenth-century hermetic philosophers and a variety of gnostic authors.

Berman embraced the Kabbalah, preferring it to other occult traditions. The Kabbalah presents a highly arcane theology describing an unknowable Godhead and its representation in "emanations." According to Jewish mysticism, it was through the twenty-two letters of the Hebrew alphabet that God created the universe, so to know that alphabet was to understand the creative act. A mysticism based on Hebrew letters and their numerical equivalents evolved into a complex system of exegesis known as gematria. For Berman it was a sense of mystery, the endless possibilities of interpretation, that he celebrated. In some works he inscribed Hebrew letters on rocks and parchment (alluding to the Dead Sea Scrolls, first discovered in 1947), though these letters never form actual words.[45] The stones were sometimes encased in boxes or attached to chains or pedestals, perhaps referring to the Jewish practice of placing small rocks on a gravestone as a symbol of remembrance or alluding to the fate of Jews during the Holocaust.[46]

Wallace Berman, *Untitled*, 1956–57 © Estate of Wallace Berman, courtesy of L.A. Louver Gallery, Venice, California

Artist George Herms described Berman's 1957 Ferus Gallery installation as the transformation of an art gallery into a temple and said that his art was "religious in a way little mainstream modern art had been."[47] Although by not supporting institutional religious doctrines his work seemed blasphemous to conventional postwar American culture, Berman brought art in California a step further in its twentieth-century spiritual quest. No more just a path toward the attainment of spiritual truth, art itself became godly. Berman's

epigram "Art is Love is God," which first appeared in *Semina Seven* (1961), became his generation's battle cry.

Berman, Conner, Allen Ginsberg, Kerouac, and their fellow Beats used peyote, marijuana, LSD, and other psychedelic drugs to intensify their existential explorations. But it was Huxley's book *The Doors of Perception* (1954), a description of his first mescaline experience, as well as other articles he wrote for popular magazines such as *Saturday Evening Post*, that brought the use of hallucinogens to the attention of a wide audience. With Ginsberg and Watts, Huxley introduced Timothy Leary to the long tradition of using mind-altering drugs as part of sacramental practice. He classified the "mind changers," as he referred to them, and meditation as merely different means of producing effects that enable a person to transcend his physicality and enter a spiritual realm. Huxley believed that drugs, rather than organized religion or evangelicalism, would deepen people's perception of life and thereby improve the world.[48] When Huxley's manifesto was adopted by the hippie generation, the Californian spiritual quest in art and life that had commenced at the beginning of the century with a few isolated figures, colonies, and cults reached national proportions. California culture would forever be linked to psychic explorations.

Ilene Susan Fort is curator of American art at the Los Angeles County Museum of Art. Among the exhibitions she has curated are *The Figure in American Sculpture: A Question of Modernity* (1995), *American Paintings in Southern California Collections: From Gilbert Stuart to Georgia O'Keeffe* (1996), and *Jacques Schnier: Art Deco and Beyond* (1998). Her books include *Childe Hassam's New York* (1993) and *Paintings of California* (1997).

1 In 1977 Harvey Jones noted that California visionary art was a significant alternative to the New York Abstract Expressionist trend of the 1950s, and in 1990 Rebecca Solnit discussed such art in terms of the Beats. More recently Richard Cándida Smith has expounded at length on this post–World War II trend in California arts.

2 Aldous Huxley, "Adventures of the Mind 12: Drugs That Shape Men's Minds," *Saturday Evening Post*, Oct. 18, 1958: 108.

3 David St. Clair, *The Psychic World of California* (Garden City, N.Y.: Doubleday, 1972), 1–5. The author is indebted to this study for many of the

details concerning nineteenth-century California and the occult.

4 St. Clair, *The Psychic World of California*, 36–37; and Robert V. Hine, *California's Utopian Colonies* (1953; reprint, Berkeley: University of California Press, 1983), 6–7, 10.

5 Will Levington Comfort, "The Lifting Spine," in *Nine Great Little Books: The Story of a Quest through a Myriad Books and Days to Find the Book of the Heart Which is Humanity* (Los Angeles: the author, 1920), n.p.; and Peter Washington, *Madame Blavatsky's Baboon: A History of the Mystics, Mediums, and Misfits Who*

Brought Spiritualism to America (New York: Schocken Books, 1995), 216.

6 Arthur Jerome Eddy, *Cubists and Post-Impressionism* (Chicago: A. C. McClurg, 1914), 112; noted in Martin Green, *New York 1913* (New York: Charles Scribner's Sons, 1988), 177.

7 Carey McWilliams, "1921, Aimee Semple McPherson: 'Sunlight in My Soul,'" in *The Aspirin Age, 1919–1941*, ed. Isabel Leighton (New York: Touchstone, 1949), 59.

8 See Robert L. Gambone, *Art and Popular Religion in Evangelical America, 1915–1940* (Knoxville: University

of Tennessee Press, 1989), for a thoughtful analysis of the relationship of fundamentalism and art.

9 "Enlist Now" advertisement issued by International Institute of Foursquare Evangelism, c. late 1920s, The McClelland collection.

10 Hine, *California's Utopian Colonies,* 54–55; and M. K. Ramados, "Robert Crosbie Biography, Part 2," *Theosophy World—Archives,* at www.theosophy.com/theos-talk (Mar. 1, 1998).

11 Joseph E. Ross, *Krotona of Old Hollywood, Volume I, 1866–1913* (Montecito: El Montecito Oaks Press, 1989), 110–64; and Joy Mills, *100 Years of Theosophy: A History of the Theosophical Society in America* (Wheaton, Ill.: Theosophical Publishing House, 1987), 66.

12 Joachim Smith, "The Splendid, Silent Sun: Reflections on the Light and Color of Southern California," in Patricia Trenton and William Gerdts, *California Light, 1900–1930* (Laguna Beach: Laguna Art Museum, 1990), 88–89. Smith quotes from Helena Blavatsky's *The Secret Doctrine* (1897; reprint, Los Angeles: Theosophical Publishing House, 1928), 579.

13 Jane Levington Comfort, *From These Beginnings* (New York: Dutton, 1937), 103.

14 "Yoga," in Rosemary Ellen Guiley, *Harper's Encyclopedia of Mystical and Paranormal Experience* (Edison, N.J.: Castle Books, 1991). Paramahansa Yogananda's *Autobiography of a Yogi* (New York: Philosophical Library, 1946), a classic in the literature, would have a strong impact on the post–World War II generation.

15 Frederick Schwankovsky, *The Use and Power of Color* (Los Angeles: Duncan, Vail, 1931).

16 Agnes Pelton, "Abstract Paintings," n.d., typescript, Agnes Pelton Papers, Archives of American Art, Smithsonian Institution, roll 3,427, frame 180.

17 See the author's fuller explanation of Pelton's experience and comments concerning this painting in "The Adventuresome, the Eccentrics, and the Dreamers: Women Modernists of Southern California," in *Independent Spirits: Women Painters of the American West, 1890–1945,* ed. Patricia Trenton (Los Angeles: Autry Museum of Western Heritage with University of California Press, 1995), 95.

18 There was so much interest that the proceedings constituted a thousand-page book that went through several editions: *Neely's History of the Parliament of Religions and Religious Congresses at the World's Columbian Exposition,* ed. Walter R. Houghton, 3rd ed. (Chicago: Alice B. Stockham, 1893).

19 *The Buddhist Ray,* the first Buddhist journal, was published by Philangi Dasa in the hills of Santa Cruz from 1887 to 1894; a *Bukkyo Seinenkai* (young men's Buddhist association) was founded in San Francisco by Japanese missionaries in 1898, and the following year teachers were sent first to that city then into central California to teach the new Japanese immigrants; the Reverend Mazzinanda established a Buddhist church in Sacramento in the first decade of the twentieth century.

20 Rick Fields, *How the Swans Came to the Lake: A Narrative History of Buddhism in America,* 3rd ed., rev. (Boston: Shambhala, 1992), 145.

21 Wolfgang Paalen in *Lee Mullican* (San Francisco: San Francisco Museum of Art, 1949), n.p.

22 "Los Angeles Art Community: Group Portrait— Lee Mullican," interview by Joann Phillips, Oral History Program, University of California, Los Angeles, 1977, 51–53, 57, 105.

23 Daisetz T. Suzuki, *An Introduction to Zen Buddhism,* foreword by Carl Jung (1934; reprint, New York: Grove Press, 1991), 44.

24 Wolfgang Paalen, "Metaplastic," in *Dynaton* (San Francisco: San Francisco Museum of Art, 1951), 10.

25 Paalen, "Metaplastic," 10–11, 26.

26 Although Onslow Ford and Paalen had both practiced Surrealist automatism, they insisted that Dynaton spontaneity differed in that the individual ego of the artist disappeared as the true nature of the world arose.

27 Gordon Onslow Ford, *Painting in the Instant* (London: Thames and Hudson, 1964), 39.

28 Susan Landauer interview with Morehouse, Apr. 1, 1989, mentioned in Landauer, *The San Francisco School of Abstract Expressionism* (Berkeley: University of California Press, 1996), 218, n. 116.

29 Mullican's rays often were in alternating short-long patterns that suggest he also knew the *I Ching,* an ancient Chinese system of divination in which oracular fortune-telling is determined by hexagrams composed of short and long lines.

30 McLaughlin prized Japanese calligraphy but did little himself, believing it was misleading to consider *sumi-e* painting easy. "Los Angeles Art Community: Group Portrait— John McLaughlin," interview by Fidel Danieli, Oral History Program, University of California, Los Angeles, 1977, 24–25.

31 Alan Watts, *In My Own Way: An Autobiography, 1915–1965*

(New York: Pantheon, 1972), 252; and Fariba Bogzaran, "Gordon Onslow Ford: Exploration of Consciousness in Painting and Meeting the Assian [sic] Scholars in California," in *Gordon Onslow Ford: Mirando en lo profundo* (Santiago de Compostela: Fundación Eugenio Granell, 1998), 213–14.

32 Onslow Ford, *Painting in the Instant*, 79.

33 Frederick Spiegelberg, "Welcome to a New Concept of Being," in *Gordon Onslow Ford: Retrospective* (Oakland: Oakland Museum, 1977), 19.

34 Gordon Onslow Ford, *Towards a New Subject in Painting* (San Francisco: San Francisco Museum of Art, 1948), 39.

35 Aldous Huxley, *The Art of Seeing* (New York: Harper and Brothers, 1942), 96, quoted in David King Dunaway, *Huxley in Hollywood* (New York: Harper and Row, 1989), 134.

36 Stanton MacDonald-Wright, "Observation," in *Stanton Macdonald-Wright: A Retrospective Exhibition, 1911–1970*, exh. cat. (Los Angeles: University of California at Los Angeles Art Galleries, 1970).

37 John McLaughlin Papers, Archives of American Art, Smithsonian Institution, roll 1,141, frame 993, quoted in Susan C. Larsen, *John McLaughlin: Western Modernism, Eastern Thought* (Laguna Beach: Laguna Art Museum, 1996), 28.

38 McLaughlin, quoted in *McLaughlin Retrospective*, exh. cat. (Pasadena: Pasadena Art Museum, 1963), [3]; also in *John McLaughlin: Retrospective Exhibition* (Washington, D.C.: Corcoran Gallery of Art, 1968), 9.

39 Bill Berkson notes that DeFeo's *The Rose* (Whitney Museum of American Art, New York) has eighteen rays that correspond in kabbalistic numerology to the Hebrew word *chai*, which means life.

40 Fischinger was too independent to follow any single religion, but he did study widely (including at Ding le Mei's ashram, the Institute of Mental Physics in Los Angeles), and shared his ideas with many other spiritually inclined people, including Brigitta Valentiner, the wife of sculptor Harry Bertoia and author of books on mysticism. Information on and quotes of Fischinger from the published writings of William Moritz, especially "The Films of Oskar Fischinger," *Film Culture*, nos. 58–60 (1974): 37–188.

41 The author is indebted to the following for the discussion of abstract film and the spiritual: P. Adams Sitney, *Visionary Film: The American Avant-Garde, 1943–1978*, 2nd ed. (Oxford: Oxford University Press, 1974); William Moritz, "Abstract Film and Color Music," in *The Spiritual in Art: Abstract Painting, 1890–1985* (Los Angeles and New York: Los Angeles County Museum of Art and Abbeville Press, 1986), 296–311; and William Moritz, "Visual Music and Film-as-an-Art before 1950," in *On the Edge of America: California Modernist Art, 1900–1950*, ed. Paul J. Karlstrom (Berkeley and Los Angeles: University of California Press, 1996), 210–41.

42 Carl G. Jung, *Mandala Symbolism*, trans. R. F. C. Hull, Bollingen Series 20 (Princeton: Princeton University Press, 1972), 5.

43 Thomas Albright, *Art in the San Francisco Bay Area, 1945–1980: An Illustrated History* (Berkeley: University of California Press, 1985), 170.

44 Gai Eaton, *The Richest Vein: Eastern Tradition and Modern Thought* (London: Faber and Faber, 1949), 167, noted in June Deery, *Aldous Huxley and the Mysticism of Science* (New York: St. Martin's Press, 1996), 105.

45 Charles Knight, "Instant Artifact," in *Wallace Berman: Support the Revolution* (Amsterdam: Institute of Contemporary Art, c. 1992), 39.

46 Many of the stones have plaques with numbers that may allude to Holocaust victims, some of whom were tattooed with numbers on their arms for inventory purposes.

47 George Herms quoted in Rebecca Solnit, *Secret Exhibition* (San Francisco: City Lights, 1991), 20–21.

48 Aldous Huxley, "Adventures of the Mind," 113.

TOURING
TOPICS

FOR DECEMBER 1929

CALIFORNIA CACTI

IN THIS ISSUE

Prison Days on the Arizona Frontier
Don of the Archives • *Pueblos of the Rio Grande*

20 CENTS A COPY

John Ott

LANDSCAPES OF CONSUMPTION:
AUTO TOURISM AND VISUAL CULTURE IN CALIFORNIA, 1920–1940

The eponymous roar of the Roaring Twenties might well have been the sound of an unprecedented number of car engines. Before then, most Americans considered the automobile a luxurious land yacht that terrorized the country's thoroughfares. But by 1927, the Fordist manufacturing revolution had saturated the middle-class market, thanks in part to the promotional efforts of car companies: One-eighth of all mass-market print advertisements were for automobiles in 1910, and one-fourth in 1917. Road production purred along almost as quickly, especially after the passage of the Federal Highways Act of 1921, which evenly matched state allocations for public roads.[1]

Southern California led this burgeoning automotive convoy. Voters in the Golden State passed highway bond issues in 1910, 1916, and 1919 for a staggering total of seventy-three million dollars. By 1929, California residents had registered almost two million automobiles, while Los Angeles boasted the highest per capita car ownership of any major metropolis: one car for every eight residents in 1915 (compared to a 1:43 national ratio), and two for every three on the eve of the Depression (while the country languished at 1:5.3).[2] The Southland's leadership in automobile consumption also manifested itself in its premier drivers' association, the Automobile Club of Southern California. Incorporated in December 1900, the club began as a sort of tony fraternal order on wheels. But as its membership exploded from 2,500 in 1911 to 100,000 in 1924, the ACSC made the necessary transition from social club to service organization. With over a thousand employees in 1923, it was the largest regional body of its kind.[3]

Yet the Auto Club of Southern California did more than offer its members affordable car insurance, trip maps, and travel advice; it also contributed significantly to the region's impressive booster industry. The chronicle of Southern California's self-promotion and its tourist industries has been well

documented, with numerous studies of individual promoters and institutions.[4] Founded in 1921 to combat the off-season tourist slump, the All-Year Club emerged as one of the most well-funded and vociferous of the booster organizations. At the helm were local oligarchs with substantial interests in hotels and real estate, such as *Los Angeles Times* publisher Harry Chandler and president of Security Trust Bank Joseph F. Sartori.[5]

During the twenties, the ACSC essentially became an arm of the All-Year Club. Chandler and Sartori served on the board of directors of the ACSC, and it was not uncommon to find editorials in *Touring Topics,* the ACSC magazine, trumpeting the agenda of the All-Year Club.[6] The ACSC, in effect, subsidized the tourist industry with members' dues by advertising the region's wonders in ads in national mass-market publications like the *Saturday Evening Post* and offering its service to out-of-state tourists for free.[7] From its genesis in 1909, *Touring Topics* featured more articles on auto touring than those concerning quotidian uses of the car.

The key figure behind this was Phil Townsend Hanna, editor of *Touring Topics* from December 1926 until his death in June 1957, who showcased the regional arts in his magazine. He regularly included commentary by *Los Angeles Times* art critic Arthur Millier in his monthly editorial column. He also purchased or commissioned artwork for *Touring Topics* from a number of Southern California artists, including painters Henrietta Shore, William Wendt, Carl Oscar Borg, and Millard Sheets; photographers Karl Struss, Will Connell, Ansel Adams, and Edward Weston; and printmakers Paul Landacre, Frank Geritz, Grace Marion Brown, and Richard Day. Even architectural drawings by Richard Neutra found their way into the pages of the magazine.

The decision to promote the arts in a motoring magazine was not as exceptional as appears at first glance. By this period, as a number of scholars have convincingly argued, the boundaries between art and advertising had become permeable. Marginalized in the nineteenth century as the province of confidence tricksters and tonic-water salesmen, the field of advertising came to flourish during the Jazz Age. Color reproduction of artworks, ads by "name" artists, and the appropriation of painterly vocabulary all helped endow advertising with the patina of high culture, good taste, and, thus, legitimacy. At the same time, many avant-garde American artists like Charles Demuth and Stuart Davis—self-styled "new vulgarians"—eagerly adopted the visual language of commerce (billboards, neon signs, print ads, and advertising copy) in their work to produce what they considered truly homegrown art forms and styles.[8]

Because of its alleged sincerity and fidelity, modernist "straight" photography seemed most suited to this fusion of business and high culture. On the national level, photographers like Margaret Bourke-White and Edward Steichen regarded their ad work as compatible with their modernist tenets.[9] In California, mass-market advertising and tourism advanced the career of Ansel Adams, who also felt that commercial techniques could be borrowed and retooled to promote his own personal vision, although he would express resentment at being labeled a Yosemite "resort photographer" by *Life* magazine in 1937.[10]

This marriage of convenience between art and commerce helps explain the presence of the fine arts in the pages of *Touring Topics,* a journal tirelessly dedicated to the selling of Southern California. A *Touring Topics* cover by Ray Winters from November 1924 suggests how the very category of "fine art" could be marshaled to legitimize tourism as an expression of good taste and a kind of rarefied aesthetics. The scene takes place in an ambiguous space occupied by six well-dressed figures, a touring car, and what might be construed as a framed landscape painting. Though it is unclear whether the protagonists are engaged in aesthetic contemplation of the landscape depicted or of the sleek, stylish automobile, Winters's work nonetheless implies a connection between gallery going and motor touring. The artist rhymes the frame of the "painting" with the windows of the sedan as if to associate touristic spectatorship with art appreciation. But in order to account for the particular kinds of art that came to find such a large audience, we must examine changes in the nature, purpose, mode, and practitioners of tourism, and the development and proliferation of consumer culture.

The second industrial revolution generated not only a welter of mass-produced goods but also an entirely new relationship between goods and their consumers. With the ability to produce an endless supply of products, the business world now needed to find buyers for them. "Under the regime of

Ray Winters, cover of *Touring Topics,* November, 1924 Automobile Club of Southern California Archives

production," wrote Stuart Chase in 1929, "the problem was to supply consumers with commodities. The problem now is to supply commodities with consumers."[11] This ethos of "consumptionism," as cultural historian William Leach puts it, elevates a commodity's consumption over its production, its appearance over its function, and the buyer over the product.[12] Over the course of the twenties, advertisements made an important transition from text-heavy, "reason-why" rhetoric to suggestive, image-based promotionals. This accompanied and fueled a broader discursive shift in dominant attitudes toward labor and leisure, as the Protestant work ethic became tempered by this new, therapeutic consumerism that promised self-transformation, happiness, and eternal youth. Increasingly prominent in both consumer consciousness and ads were the so-called glamour industries like radio, movies, cosmetics, and, of course, the automobile.[13]

In many ways the automobile represented the apotheosis of the nascent culture of mass consumption. The car at once was a mass-produced good, facilitated the rapid accumulation of other goods, and offered drivers easy escape from the pressures of modern life. Cars seemed to grant their drivers feelings of control, efficiency, and autonomy that may have been missing from their working environments. Although urban tourists strove to leave the dizzying maelstrom of modernity behind when they went on vacation, they could not help but bring their consumerist sensibilities along. Even the pattern of road building revealed the prevalent consumerism of which the automobile was product and cause; the ever-numerous "magic asphalt carpets"[14] catered to interurban rather than local travel, while the adoption of a numbered highway system best served an automobiling constituency that traveled long distances and was unfamiliar with local road names—that is, tourists. These roads, moreover, accelerated the process of urbanization in the United States by incorporating the hinterlands into the sphere of urban centers.[15]

As early as 1929, sociologists Robert and Helen Lynd recognized that the automobile had revolutionized leisure time in their case study community of Muncie, Indiana.[16] Mass tourism by car—which was still limited to the middle and upper classes at this time—encouraged the experience of natural landscapes as consumer goods. While tourists of previous generations were often prospective settlers and investors or seasonal residents, motoring gave rise to what Earl Pomeroy has called the "tourist-as-tourist."[17] For example, another sociologist of the period discovered that postcards sent from campgrounds for auto travelers chiefly concerned themselves with the number of miles covered rather than specific destinations.[18] This species of leisure travel—travel for

Thomas Hill,
Yosemite Valley, 1876
The Oakland Museum
of California, Kahn
Collection, 68.133.1

travel's sake—was explicitly and proudly nonutilitarian; as opposed to jour-
ney by rail, it was also private and individualized, like other forms of middle-
class consumption. And the most coveted consumable seemed to be California.
"The almost unbroken caravan of cars on the perfectly paved highways is con-
vincing evidence," boasted Rockwell Hunt in 1929, "that California in actuality
has become the world's chief playground."[19] In contrast to the quests of earlier
gold seekers and homesteaders, overland journeys to the Golden State by
motoring tourists more often than not had no purpose other than recreation.

This perception of California's environment, as it became sanctioned
by images in boosterist periodicals like *Touring Topics,* accordingly departed
from established landscape idioms. Heretofore, paintings like Thomas Hill's
Yosemite Valley (1876) had represented and promoted the Western wilderness
through the convention of the sublime or picturesque.[20] Artists often enlarged
or exaggerated natural features to underscore the grandeur of God's creations;
frequently this was achieved though wall-size paintings and panoramic effects.
Human presence was usually diminished or eliminated. The auto-touristic
view of nature also had no use for tropes of the pastoral landscape, in which
artists celebrated the harmonious union of humans and the land through
balanced compositions and the quiet restraint of middle distance.[21]

One of many useful examples of this new mode of auto-touristic land-
scape appears on the cover of the May 1929 *Standard Oil Bulletin,* a monthly
publication of yet another regional booster. This watercolor is one of about a

PUBLISHED BY THE STANDARD OIL COMPANY OF CALIFORNIA
MAY 1929

Maynard Dixon,
cover of *Standard Oil
Bulletin,* May 1929
Research Library,
Natural History
Museum of Los Angeles
County

dozen such covers created for Standard Oil of
California by Maynard Dixon, whose involve-
ment in tourist promotionals also included
work for the magazines *Land of Sunshine,
Sunset,* and *Touring Topics,* as well as various
billboards.[22] This generic California roadscape
depicts, according to the magazine, "a stretch
of highway traversing a springtime landscape
that many city-dwelling motorists would find
a gladsome change from their accustomed sur-
roundings."[23] Thus interpreted, the beckoning
image bespeaks an urban perspective of nature
as recreational, therapeutic, and easily pene-
trated for consumption. Dixon conveys the
scene's availability through a more manageable
scale and the foreshortened roadway that
seems about to intrude into the viewer's space.
The splayed and flattened perspective further
draws the viewer into the landscape. At the
same time, the work achieves a subtle spatial
disquiet through close cropping, strong diagonals, off-center composition, and
energetic line. As Roland Marchand has convincingly argued, advertisers regu-
larly and consciously employed these modernist visual devices to create in the
viewer a feeling of anticipation and suspense that compelled consumption.[24]
In this case, the viewer feels the desire to see what lies around the next bend
of the road.

I employ the word *scenic* to characterize both this new mode of land-
scape appreciation and its translation to canvas. The term is appropriate here,
not only because it appears so frequently in the tourist literature of the day
but also because of its associations with two other loci of urban visual con-
sumption, theater and film. "Scenic" implies seriality and movement from
one visual setting to another, unlike the static connotations of the picturesque
("like a picture").[25] Within the regime of consumerism, the scenic view was
often mobilized to suggest boundless consumer choice. This comment from
Standard Oil Bulletin in 1921 is typical: "At a turn of the driver's wheel one
may revel in scenic delights from forest to farmland, mountain to ocean, crag
or wooded lake."[26] The steering wheel becomes the handle of a shopping cart,
the natural world a showroom with infinite consumer possibility.

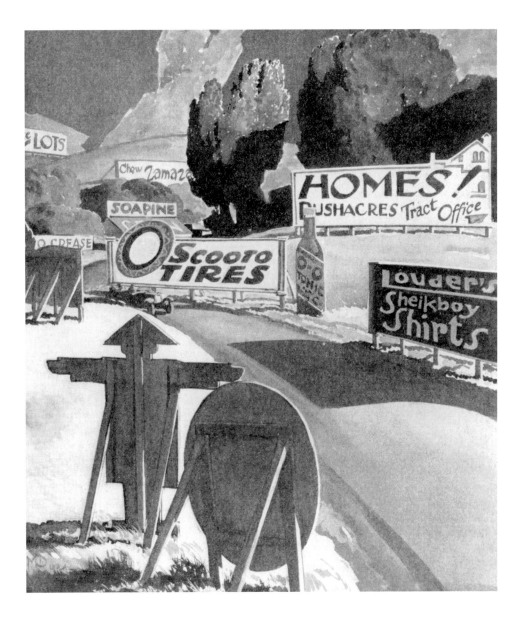

Maynard Dixon,
illustration from
Standard Oil Bulletin,
May 1929
Research Library,
Natural History
Museum of Los Angeles
County

Touring Topics likewise promoted the landscapes of greater California like a line of products that could cater to every possible taste. As early as 1921 it featured a series of articles, each accompanied by numerous photographs, on the various Southland counties. This pattern continued when Phil Townsend Hanna took the helm and began to commission cycles of paintings for front-page reproduction. For example, throughout 1928 the magazine's covers showcased paintings by name-brand California artists, including Maurice Braun's *Half Dome, Yosemite,* that enticed readers to name-brand tourist destinations.[27] The March issue proclaimed: "From the battlemented coast of Del Norte County to the grottos of La Jolla; from mysterious Death Valley to the noble Mt. Whitney, virtually every phase of the glorious southwestern scene will be depicted by a painter renowned for his conceptions of the subject he has painted."[28] The use of high-art images allowed the reader and potential tourist/consumer to take pride in the possession of good taste. Moreover, Hanna marketed and sold these series as distinct portfolios, a kind of ready-made high-culture scrapbook.

The promotion and consumption of landscape through the medium of the fine arts sanctified what was, at heart, an extremely profitable industry of auto tourism. At this time, consumerism still required legitimation, whether through associations with high culture or some other means, because no matter how exhilarating and liberating the consumerist revolution seemed, elation was often accompanied by anxiety over the apparent erosion of the production-oriented values of the Protestant work ethic.[29] The scenic landscape, therefore, necessarily fell short of taking the form of an overtly commercial landscape.

Tourists balked, for example, at the proliferation of billboards and other commercial intrusions onto scenic routes. Many boosters followed suit; in 1924, Standard Oil of California removed all roadside advertising—some 1,200 signs—reasoning that views obstructed by such publicity would discourage motor tourism. Subsequently, the company repeatedly spoke out against billboards.[30] The May 1929 issue of *Standard Oil Bulletin* discussed above also published as a frontispiece a modified version of Dixon's watercolor to demonstrate what happens when "the scenery has become signery."[31] Dixon's thicket of billboards occludes the locale's natural features and even casts an ominous shadow on the asphalt. By cropping further the background hills, the artist aggravates the scene's sense of overcrowding, while the signs' colors jar and clash with the soft hues of the land. The plywood cutout of a human figure in the foreground, seen from the rear, seems not only to signal the oncoming roadster to slow down, but also to bar viewer engagement with the scene.

Dixon's twin images clearly inscribe the limits of the scenic by counterposing an aestheticized gaze to the clouded vision of unmasked economic interest.

The consumerist revolution suffered serious setbacks following the stock market crash of October 1929. Mass consumption became available to far fewer Americans and also became a less desirable practice. As the Depression deepened, a growing number of blame seekers targeted advertisers for overstimulating consumer desires. Such censure was justifiable, as the Depression resulted in part from consumer debt and a crisis of overproduction in leading economic sectors like the automotive industry.[32] The economic downturn proved devastating to auto tourism and the Auto Club of Southern California. After cresting in June 1930 at 136,000 members, the number of ACSC subscribers plummeted to a nadir of 77,000 over the next four years. Plaintive, panicky editorials by Hanna—"Go Somewhere . . . Soon!"— fell on deaf ears.[33]

The makeup of long-distance motor travelers underwent change. In the teens and twenties, auto tourists envisioned themselves as latter-day pioneers and practitioners of the strenuous life. Due to the primitive conditions of roads and dearth of automotive services in the hinterlands, autocamping at that time shared few of the conveniences of present-day car travel. Motor tourism thus constituted a conscious rejection of overcivilized city life, even if only on a temporary basis.[34] Tourists fashioned themselves "vagabonds" who heeded "the gypsy call of nomadic ancestors," as Elon Jessup described it in his 1921 *The Motor Camping Book*.[35] Other auto-touring handbooks, with titles like *Westward Hoboes,* further testify to the antimodern impulse of these (largely urban) travelers.[36]

Yet as early as 1921, studies began to reveal a growing number of "real" transients, mostly itinerant farm laborers seeking seasonal employment in the heavily industrialized sector of California agribusiness. Accordingly, a deep anxiety grew among recreational hoboes over the ability to distinguish autocamping from mere vagrancy.[37] Frederic Van de Water, in a 1927 chronicle of his family's transcontinental odyssey by car, typifies auto tourists' disdain for lower-class "auto tramps" when he equates them with "swarms" of "pests" like grasshoppers.[38] Although Van de Water places blame on the "imaginative artists" and "lyrical composers of advertising copy" for the presence of "motor hoboes," he also cheers the practice by an anonymous California county of marking the cars of vagrants with red paint to prevent recidivism.[39] Even before the onset of the Depression, autocamps started to charge fees in order to weed out working-class auto travelers.

This trickle of migrants that drove for work rather than leisure became a raging torrent in the wake of the stock market crash and the Dust Bowl disaster. Faced with accusations of encouraging migrant laborers to drive to California, the booster infrastructure endeavored to dam the stream of non-tourist drivers. From 1930 to 1941, all advertisements generated by the All-Year Club contained a variant of the notorious Depression clause: "While attractions for tourists are unlimited, please advise anyone seeking employment not to come to Southern California, as natural attractions have already drawn so many capable, experienced people that the present demand is more than satisfied."[40] Meanwhile, increased vehicle inspection over the course of the thirties at California's borders accelerated into an all-out "Bum Blockade"; from February until mid-April of 1936, the Los Angeles Police Department, far outside of its jurisdiction, turned away the most financially stricken segment of the incoming traffic at sixteen state border checkpoints.[41] In promotional booklets the All-Year Club tried to absolve itself by insisting that 93% of California-bound automobiles carried affluent passengers. Nor did *Touring Topics* take an especially sympathetic stance toward migrant laborers.[42] Only in the wake of Steinbeck's *Grapes of Wrath* would articles, illustrated by Paul Dorsey's photographs, appear that admitted that the situation was "tragic"—but nonetheless "costly."[43]

The erosion of middle-class tourism and the insistent presence of impoverished motor migrants impelled booster agencies upmarket. The All-Year Club shifted its promotional strategies to entice a middle-aged business class rather than middle-class retirees; throughout the thirties, it targeted upscale periodicals with an affluent and highly educated readership.[44] *Touring Topics* also moved upscale: it changed its name to *Westways* and its function to a self-styled "journal of entertainment," providing wider coverage of fiction, the arts, and expressions of the California lifestyle, such as gardening, often only tangentially related to the automobile.[45] In the early years of the decade Hanna experimented with the look and feel of the publication, consciously adopting the luxurious paper and dimensions of *Fortune* to signal its sophistication.

An illustrated pamphlet created sometime in the late thirties for potential *Westways* advertisers epitomizes Hanna's resolve to cultivate an elite readership: "No, it won't reach our large Mexican market. No, it won't completely cover the farmers. No, it won't do a job with the 'trades.' And no, it won't reach the masses! But to reach Southern California's rich 'Upper Crust' a thousand times yes, yes, yes, yes."[46] Hanna goes on to gloat that *Westways*, "the one

magazine in Southern California that goes where the 'dough' is," boasts over 60,000 members of this upper crust. The blunt prose of Hanna's solicitation sufficiently alarmed Auto Club official Standish Mitchell to send Hanna a lengthy memo advising against insinuations about the lower crust since, wrote Mitchell, "I dislike to think what our membership rolls would look like without them."[47] Yet despite Mitchell's concerns, Hanna's strategy seemed to succeed. In the November 1937 issue the editor of *Westways* cheerfully reported that a membership study revealed that "Mr. Average Westways" possessed a net income that was four times the average motorist's and many times more than the average American's.[48] This more narrow constituency accompanied an increasingly conservative tone in the journal: Hanna and the board of directors used the platform of *Westways* to rail against the "Ham and Eggs" initiative, which would have established a statewide pension plan for the elderly, as a scheme to redistribute wealth in California. Hanna even would put the word *depression* in quotes as if it were some unconfirmed rumor.[49]

The artwork featured in *Westways* both reflected and contributed to these shifting reader demographics. Generally speaking, Hanna increasingly published works in a modernist vein, although he still preferred the mild modernism of a Maynard Dixon or a Henrietta Shore to the more radical abstraction of a Stanton MacDonald-Wright or anything approaching Surrealism. With regard to art photography, Hanna gradually abandoned Pictorialist works

Ansel Adams, *Crag on Castle Cliffs*, from *Touring Topics*, February 1931 Photograph © 2000 by the Trustees of the Ansel Adams Publishing Rights Trust. All rights reserved. Cover courtesy of Automobile Club of Southern California Archives

STANDARD OIL
B U L L E T I N

PUBLISHED BY THE STANDARD OIL COMPANY OF CALIFORNIA
JANUARY 1934

Maynard Dixon,
cover of *Standard Oil
Bulletin,* January 1934
Department of
Special Collections,
Charles E. Young
Research Library, UCLA

for images by straight photographers; he first
published Edward Weston's work in June 1930,
and Ansel Adams's in February 1931. In an
address to the Los Angeles Ad Club in 1927,
Hanna offered advice on "putting the story into
physical form" and in so doing reveals to us what
artwork he thought best for *Westways.* Calling
for "simplicity in design," Hanna also argued
that "symbolism has no place in advertising
design."[50] At the same time, as he revealed in
a speech to the Southern California Camera
Club that same year, he eschewed purely "aes-
thetic" photographs for more "utilitarian" art
photos—preferably those, presumably, that
could induce auto tourism.[51] Thus the dominant
aesthetic idiom of *Westways* entailed clean, cool,
and highly formalist images of the countryside.
These works sold a viewer on a California scene
not in a braying pitch but sotto voce. During
the thirties, this style dominated corporate
advertising, infusing products with an aura of novelty, dynamism, urbanity,
and high culture.[52]

Other booster publications spoke in the same pictorial language.
Another Maynard Dixon cover for *Standard Oil Bulletin,* from January 1934,
depicts a view of the distant Panamint Mountains from across the brilliant,
multicolored foothills of the Funeral Mountains. The text of the accompany-
ing article celebrates Death Valley as a "colorful beauty of a new kind," readily
available for consumption.[53]

The *Standard Oil Bulletin*'s choice of a desert scene was a popular one in
the tourist literature of the time; *Westways* also often highlighted the desert
regions of California in articles and special pictorial sections. The thirties
marked the onset of the vogue for the deserts of the Southwest.[54] These seem-
ingly useless landscapes were readily subjected to and seemed perfectly suited
for the disinterested aesthetics of a formalist vocabulary. Appreciation of this
"colorful beauty of a new kind," however, is a relatively recent phenomenon.
In the nineteenth century, the desert inspired fear at worst and boredom and
discomfort at best. Where once travelers hoped only to survive these waste-
lands, by the early twentieth century, urban visitors began to value these areas

as a kind of last refuge for the sophisticated or adventurous tourist. In the
desert, wrote J. Smeaton Chase in 1919, "hardship looks attractive, scarcity
becomes desirable, [and] starkness turns an unexpected side of beauty."[55] An
important transitional figure here is George Wharton James, who extolled at
once the sublime virtues of California's hot spots, their salubrious effects, and
their tourist potential in books like *The Wonders of the Colorado Desert* (1906).
Proclamations that the desert was "God's divine exhibition showroom to
which He freely invites all men" fused the sublime and the scenic, the spiritual
and the commercial.[56] By the thirties, tourists expressed their admiration in
consumerist language: "As some people collect snuff boxes and others first edi-
tions," wrote Zephine Humphrey in 1938, "we decided this winter to collect as
many deserts as possible."[57]

Edward Weston,
*20 Mule Team Canyon,
Death Valley*, 1938
© 1981 Collection
Center for Creative
Photography,
The University of
Arizona

 Another xerophile was photographer Edward Weston, who lauded "the
stark and simplified form of the desert" in the pages of *Camera Craft* in 1939.[58]
Although he first trekked to the Mojave in 1928, Weston's romance with
California wastelands matured during his tenure as a Guggenheim Fellow

(April 1937–March 1939). Weston's project during these two years involved photographing the natural landscapes of California and neighboring regions with the aid of future wife Charis Wilson. Roughly half of their twenty trips to California and other western destinations were desert sojourns, with three separate excursions to Death Valley alone.[59]

Before embarking on the project, Weston and Wilson consulted Phil Townsend Hanna, who selected a half dozen routes for the couple (other, later guidance would come from Ansel Adams). Hanna contracted with them for eight to ten captioned photos a month for $65. Although the generous fellowship covered travel expenses, the *Westways* money allowed the pair to make payments on a new Ford V-8. Over 130 photographs appeared in *Westways* in a string of twenty-one two-page photo-essays, beginning in August 1937.[60] Weston and Wilson's travelogue was so successful that the ACSC published the entire series as a separate volume, *Seeing California with Edward Weston* (1939). Weston's work was quite popular with Mr. Average Westways, who enumerated photography as his third-favorite feature, after the "natural science" and "lore" of California.[61]

By no means did Weston and Wilson intend to conduct the fellowship as foot soldiers for the Southland's booster army. In fact, Wilson's chronicle in the 1940 volume unfailingly and snidely laments the sporadic and inevitable emergence of slack-jawed, noisy tourists who "dash up, snap, and dash away, faster than you can keep count."[62] Nonetheless, within the context of *Westways*, these photographs operate equally well as inducements for the consumption of California scenes by urban sophisticates. Nor, ultimately, could the photographer himself escape from the prevailing economy of scenic consumption, however couched in the rhetoric of formalism. Moreover, the serial nature of the *Westways* spreads (like the couple's motor trips themselves) both proceeds from and fosters the compulsory consumption of landscape.

The peculiarities of this scenic mode of vision are further illustrated by a telling exchange between Weston and a local ("Jack") at the Wonderland of Rocks, outside of Twentynine Palms. As recounted by Wilson, Weston proclaimed, "'What a place to live, among these magnificent rocks!' The man looked carefully at Edward, suspecting he hadn't heard right, sent a brief glance to the clustered boulders that towered above us and said feelingly, 'I guess you wouldn't think so if you'd lived here as long as I have.'"[63] The perceptual gap between Jack and Weston exemplifies how far removed urban, scenic vision was from the perspective of backcountry residents trying to make a livelihood off the land. Weston's project demonstrates that the scenic also necessitates a

certain psychic distance from the landscape; it renders the land useless, save for aesthetic contemplation or touristic consumption.

Thus modernist works were not only compatible with but proliferated within consumer culture. Though valued today for their formal properties, scenic landscapes were in essence booster landscapes, particularly when situated between the pages of motoring magazines. This scenic view starkly contrasted with other Depression pictures of injustice and human frailty. A final vignette from the pages of *Westways* bears witness to a rare collision between these booster and dystopic visions of the Golden State. After publishing his exposé of California agribusiness, *Factories in the Field*, Carey McWilliams lost his "Tides West" column (1934–39) in *Westways* because of pressure from Standish Mitchell's brother-in-law, a prominent California grower, and other ACSC board members.[64] Politics aside, however, it is difficult to picture McWilliams's critical view alongside the sunny, enticing tableaux of a Dixon or a Weston. While the subject matter is the same, these are entirely different surveys of the land.

John Ott is a Ph.D. candidate in American art history at the University of California, Los Angeles, specializing in the visual cultures of California and the U.S. Southwest. His dissertation, "The Gilded Rush," addresses art patronage and cultural authority in late-nineteenth-century California.

1 This overview of the spread of the automobile and roads during the twenties draws from James J. Flink, *The Automobile Age* (Cambridge: MIT Press, 1988), esp. 129–87, and Clay McShane, *Down the Asphalt Path: The Automobile and the American City* (New York: Columbia University Press, 1994), 125–48. See also Christopher Finch, *Highways to Heaven: The Auto Biography of America* (New York: HarperCollins Publishers, 1992), 77–141. The advertising statistics come from McShane, 134.
2 State trends are traced by Flink, *The Automobile Age*, 140–45; Ben Blow, *California Highways* (San Francisco: H. S. Crocker, 1920); Ashleigh Brilliant, *The Great Car Craze: How Southern California*

Collided with the Automobile in the 1920s (Santa Barbara: Woodbridge Press, 1989); and Scott L. Bottles, *Los Angeles and the Automobile: The Making of the Modern City* (Berkeley and Los Angeles: University of California Press, 1987). The statistics are from Bottles, 93.
3 On the ACSC, see Richard R. Mathison, *Three Cars in Every Garage* (New York: Doubleday, 1968); J. Allen Davis, *The Friend to All Motorists: The Story of the Auto Club of Southern California; the 65 Years 1900–1965* (Los Angeles: Auto Club of Southern California, 1967); and Edward Hungerford, "California Takes to the Road," *Saturday Evening Post* (Sept. 22, 1923): 113.
4 A partial list would include Carey McWilliams, *Southern*

California: An Island on the Land (1949; reprint, Santa Barbara and Salt Lake City: Peregrine Smith, 1973), passim; Kevin Starr, *Material Dreams: Southern California through the 1920s* (New York and Oxford: Oxford University Press, 1990), 90–119; Tom Zimmerman, "Paradise Promoted: Boosterism and the Los Angeles Chamber of Commerce," *California History* 64 (winter 1985): 22–33; James J. Rawls, "The California Mission as Symbol and Myth," *California History* 71 (fall 1992): 343–60; and Bruce Henstell, *Sunshine and Wealth: Los Angeles in the Twenties and Thirties* (San Francisco: Chronicle, 1984), esp. 13–29.
5 On the All-Year Club, see Starr, *Material Dreams*, 94–95,

101–2; Henstell, *Sunshine and Wealth*, 19–20; and Melinda Elizabeth Kashuba, "Tourist Landscapes of Los Angeles County, California" (Ph.D. diss., University of California, Los Angeles, 1986).

6 See, for example, "The End of the Rainbow," *Touring Topics* 14 (Oct. 1922): 15; and "Towards the Setting Sun," *Touring Topics* 15 (Nov. 1923): 13.

7 The Oct. 30, 1926, Nov. 12, 1927, and Apr. 13, 1929, issues of *The Saturday Evening Post*, for example, each contain one of these ads.

8 This paragraph synthesizes Roland Marchand, *Advertising the American Dream: Making Way for Modernity, 1920–1940* (Berkeley and Los Angeles: University of California Press, 1985); T. J. Jackson Lears, "From Salvation to Self-Realization," in *The Culture of Consumption: Critical Essays in American History, 1880–1920*, eds. Richard Wrightman Fox and T. J. Jackson Lears, 3–21 (New York: Pantheon, 1983); T. J. Jackson Lears, *Fables of Abundance: A Cultural History of Advertising in America* (New York: Basic, 1994); William Leach, *Land of Desire: Merchants, Power, and the Rise of a New American Culture* (New York: Pantheon, 1993); and Michele Helene Bogart, *Artists, Advertising, and the Borders of Art* (Chicago: University of Chicago Press, 1995). An excellent discussion of Demuth's interest in advertising is in Wanda Corn, *In the American Grain: The Billboard Poetics of Charles Demuth* (Poughkeepsie, N.Y.: Vassar University Press, 1991).

9 Marchand, *Advertising the American Dream*, 149–51; Bogart, *Artists, Advertising, and the Borders of Art*, 171–204.

10 See Jonathan Spaulding, *Ansel Adams and the American Landscape: A Biography*

(Berkeley and Los Angeles: University of California Press, 1995). The *Life* anecdote appears on p. 168.

11 Quoted in Fredrik Chr. Brøgger, "Grinding the Gears of Consumption: Representational versus Nonrepresentational Advertising for Automobiles in the Mid-1920s," *Prospects* 15 (1990): 204.

12 Leach, *Land of Desire*, 265.

13 This discussion of the consumer ethic relies on Brøgger, "Grinding the Gears of Consumption," 197–224; Leach, *Land of Desire*, 1–29; Lears, "From Salvation to Self-Realization"; and Marchand, *Advertising the American Dream*, passim.

14 "Western Highways, Take a Bow," *Standard Oil Bulletin* 27 (Jan. 1939): 12.

15 My interpretation of the connections between automobiles and consumer culture is indebted to McShane, *Down the Asphalt Path*, 125–48; Peter J. Ling, *America and the Automobile: Technology, Reform, and Social Change* (Manchester and New York: Manchester University Press, 1990), esp. 1–33; Wolfgang Sachs, *For Love of the Automobile: Looking Back into the History of Our Desires*, trans. Don Reneau (Berkeley and Los Angeles: University of California Press, 1984); and John A. Jakle, *The Tourist: Travel in Twentieth-Century North America* (Lincoln: University of Nebraska Press, 1985), 120–70.

16 Robert S. and Helen H. Lynd, *Middletown: A Study in Modern American Culture* (New York: Harcourt Brace, 1929).

17 Earl Pomeroy, *In Search of the Golden West: The Tourist in Modern America* (New York: Alfred A. Knopf, 1957), 133.

18 Norman S. Hayner, "Auto Camps in the Evergreen Playground," *Social Forces* 9

(Dec. 1930): 257. See also Pomeroy, *In Search of the Golden West*, 211.

19 Rockwell Dennis Hunt and William Sheffield Ament, *Oxcart to Airplane* (Los Angeles: Powell Publishing Co., 1929), 214.

20 The literature on nineteenth-century landscape conventions is extensive. Two excellent cultural histories I found useful here are Anne Farrar Hyde, *An American Vision: Far Western Landscape and National Culture, 1820–1920* (New York: New York University Press, 1990); and John Kenneth Myers, "On the Cultural Construction of Landscape Experience: Contact to 1830," in *American Iconology*, ed. David Miller, 58–79 (New Haven, Conn.: Yale University Press, 1993).

21 The best authority here is Sarah Burns, *Pastoral Inventions: Rural Life in Nineteenth-Century American Art and Culture* (Philadelphia: Temple University Press, 1989).

22 The most thorough account of Dixon's career is Donald J. Hagerty, *Desert Dreams: The Art and Life of Maynard Dixon* (Salt Lake City: Gibbs-Smith, 1998).

23 "Scenic or Sign-ic Highways," *Standard Oil Bulletin* 17 (May 1929): 2.

24 Marchand, *Advertising the American Dream*, 140–48.

25 At least one other cultural historian contrasts the side view of railroad travel with the movielike effect of the windshield. See Chester Liebs, *Main Street to Miracle Mile: American Roadside Architecture* (Boston: Little, Brown, 1985), 3–7.

26 "At the Turn of the Wheel," *Standard Oil Bulletin* 9 (June 1921): 3.

27 Braun's work appears on the May 1928 cover of *Touring Topics*.

28 *Touring Topics* 20 (Mar. 1928): 41.

29 This ambivalence is discussed in Marchand, *Advertising the American Dream,* esp. 1–24.

30 The debate over roadside aesthetics is featured in Brilliant, *The Great Car Craze,* 136–43. See also "Scenic or Sign-ic," 2–10ff.

31 "Scenic or Sign-ic," 2.

32 On the relationship between cars and the Depression, see Harvey Green, *The Uncertainty of Everyday Life, 1915–1945* (New York: HarperCollins, 1992), 71–90; Flink, *The Automobile Age,* 188–228.

33 "Go Somewhere . . . Soon!" *Touring Topics* 25 (June 1933): 7. See also Mathison, *Three Cars in Every Garage,* 99–101.

34 The antimodernism of early autocamping is addressed by Warren James Belasco, *Americans on the Road: From Autocamp to Motel, 1910–1945* (Cambridge: MIT Press, 1979).

35 Elon Jessup, *The Motor Camping Book* (New York: G. P. Putnam's Sons, 1921), 3. A good primary source is Frank E. Brimmer, "Auto-camping—the Fastest Growing Sport," *Outlook* 137 (16 July 1924): 437–40.

36 Winifred Hawkridge Dixon, *Westward Hoboes* (New York: Charles Scribner's Sons, 1921).

37 Belasco, *Americans on the Road,* 105–27.

38 Frederic F. Van de Water, *The Family Flivvers to Frisco* (New York and London: D. Appleton, 1927), 105.

39 Ibid., 106–7.

40 Quoted from the inside front cover of *All-Year Club Official Guide, 1935* (Los Angeles: All-Year Club of Southern California, 1935). See also Kashuba, "Tourist Landscapes," 116.

41 See Kevin Starr, *Endangered Dreams: The Great Depression in California* (New York and

Oxford: Oxford University Press, 1996), 176–79.

42 Jim Tully, "Hitch-Hikers," *Touring Topics* 22 (Apr. 1930): 20–21ff; and Jim Tully, "Gasoline Rolling Stones," *Touring Topics* 24 (Feb. 1932): 14–15ff.

43 For example, "Waifs of the Winds," *Westways* 31 (June 1939): 23–24.

44 Kashuba, "Tourist Landscapes," 112–13.

45 "Its Name Shall Be Westways," *Touring Topics* 25 (Dec. 1933): 8–9.

46 *No, a Thousand Times No! No! No!* (Los Angeles: n.p., n.d.). Phil Townsend Hanna Papers, box 1, folder 4: Department of Special Collections, University Research Library, University of California, Los Angeles.

47 Standish Mitchell to Phil Townsend Hanna, n.d. Phil Townsend Hanna Papers, box 1, folder 4: Department of Special Collections, University Research Library, University of California, Los Angeles.

48 Phil Townsend Hanna, "Etc. by the Editor," *Westways* 29 (Nov. 1937): 41.

49 See, for example, Hanna, "Etc. by the Editor," *Touring Topics* 25 (Febr. 1933): 6.

50 Phil Townsend Hanna, *Putting the Story into Physical Form: A Paper Read before the Direct Advertising Department of the Los Angeles Ad Club* (Los Angeles: n.p., 1927), 12, 18.

51 Phil Townsend Hanna, "New Photographic Fields to Conquer," typescript, Apr. 28, 1927. Phil Townsend Hanna Collection, Miscellaneous Manuscripts, vol. 1: Ella Strong Denison Library, Scripps College, Claremont, California.

52 Marchand, *Advertising the American Dream,* 140–48.

53 "Death Valley Beckons," *Standard Oil Bulletin* 22 (Jan. 1934): 2.

54 Cultural histories of desert

appreciation include Hyde, *An American Vision,* 219–29; Pomeroy, *In Search of the Golden West,* 158–62; and Patricia Nelson Limerick, *Desert Passages: Encounters with the American Deserts* (Albuquerque: University of New Mexico Press, 1985).

55 J. Smeaton Chase, *California Desert Trails* (1919; reprint, Palo Alto: Tioga Publishing Co., 1987), 4.

56 George Wharton James, *The Wonders of the Colorado Desert,* 2 vols. (Boston: Little, Brown and Co., 1906), 144.

57 Zephine Humphrey, *Cactus Forest* (New York: E. P. Dutton, 1938), 194.

58 Quoted in James L. Enyeart, *Edward Weston's California Landscapes* (Boston: Little, Brown, 1984), 13.

59 For a terse overview of Weston's Guggenheim period, see Karen E. Quinn, *Weston's Westons: California and the West* (Boston: Little, Brown, 1994), 19–35.

60 See Quinn, *Weston's Westons,* 21; Charis Wilson and Edward Weston, *California and the West* (1940; reprint, New York: Aperture, 1978), 11.

61 Phil Townsend Hanna, "Etc. by the Editor," *Westways* 29 (Nov. 1937): 41.

62 Wilson and Weston, *California and the West,* 25.

63 Ibid., 50–51.

64 See Carey McWilliams, *The Education of Carey McWilliams* (New York: Simon and Schuster, 1978), xvii.

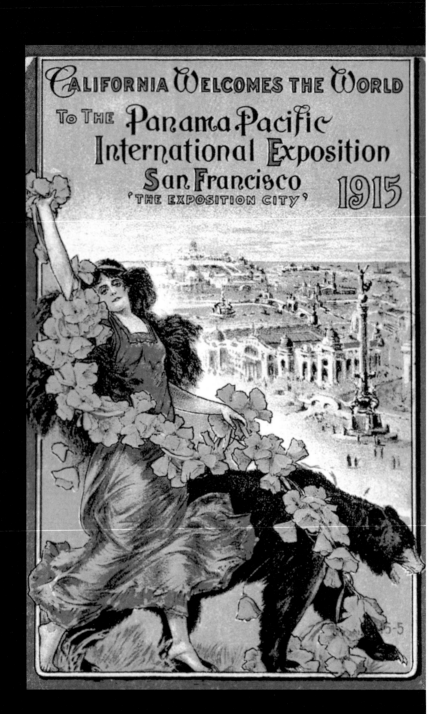

Carolyn Peter

CALIFORNIA WELCOMES THE WORLD:
INTERNATIONAL EXPOSITIONS, 1894–1940, AND THE SELLING OF A STATE

In the marvelous city of towers, minarets, domes and castles, whose lights glistened on the waters of the Pacific, there was a reflection of the spirit of California . . . The magic city exemplified the freedom, the liberality, the open-handed hospitality, which are proverbially Californian characteristics . . . To Californians the Midwinter International Exposition of 1894 will live as the creator of a new epoch. [1]

More than sixty years before the gates of Disneyland opened, California was creating cities of dreams, complete with castles, rides, and costumed characters. Between 1894 and 1940, California held five world's fairs on its soil:

THE MIDWINTER INTERNATIONAL EXPOSITION
Golden Gate Park, San Francisco, January 27–July 4, 1894

THE PANAMA CALIFORNIA INTERNATIONAL EXPOSITION
Balboa Park, San Diego, January 1, 1915–January 1, 1917

THE PANAMA PACIFIC INTERNATIONAL EXPOSITION
Harbor View (the Marina), San Francisco, February 20–
December 4, 1915

THE CALIFORNIA PACIFIC INTERNATIONAL EXPOSITION
Balboa Park, San Diego, May 29–November 11, 1935, and
February 12–September 9, 1936

THE GOLDEN GATE INTERNATIONAL EXPOSITION
Treasure Island, San Francisco, February 18–October 29, 1939,
and May 25–September 29, 1940

These fairs were spectacular theatrical extravaganzas where visitors could, among other things, view the most up-to-date, state-of-the-art inventions, eat foods and see art and entertainment from around the world, and listen to lectures given by luminaries of the era. The stakes were high for these fantasy worlds. The business, political, and cultural leaders of California invested a great deal of energy into the expositions, with the primary interest of bringing prestige and money to their state. Consequently, they pulled out all the stops to show California in its best light as a state of natural and cultural wealth, with a rich history as well as a finger on the pulse of progress and the future. They wanted to educate and entertain visitors and to leave them with memorable impressions of California. Like Disneyland, the world's fairs were highly ordered, controlled environments where the organizers could structure the visitors' experience. From the locations, layouts, and general themes of the expositions, to the architectural designs, types of exhibits, and products shown, the fair directors chose to present their state in distinct ways. In the process, they created and reinforced powerful images and ideas about California.[2] As the state matured through this forty-six-year period, the prevailing images of California also evolved and changed in certain ways. There was a shift in focus, as reflected in the fairs, from an agricultural land of opportunity to a center of trade for the Pacific Rim, Latin America, and the rest of the world.

Each of the California world's fairs was held at a crucial time in the history of the state, at a time when it was important to promote the unique and marketable qualities of California. Organizing a world's fair was a giant undertaking that required the financial backing and moral support of the business, political, and cultural leaders of the host city, state, and nation. Involving as much strategic planning as a political campaign, the expositions were ultimately financed by a combination of subscriptions, municipal bonds, and federal and state funding.

The Midwinter Fair of 1894 was successfully organized and financed on a local and state level. By the 1890s, San Francisco was a well-established city, but it was still rather isolated from the nation's centers of commerce. Like the rest of the country, it was also suffering through a depression. While visiting Chicago's 1893 Columbian World's Fair, M. H. de Young, the owner and publisher of the *San Francisco Chronicle*, had the brainstorm of creating an international exposition in San Francisco to bring the nation and the world to the West and to give an economic boost to the region. De Young convinced San Francisco and California leaders to jump into action quickly. This speed

enabled them to organize the entire Midwinter Fair in just six months by taking advantage of the fact that many Chicago exhibitors were willing to bring their already prepared exhibits to San Francisco before returning home. In his speech at the groundbreaking ceremony, de Young proclaimed, "Think! Here we stand on the edge of this American Continent, . . . with stagnation, lack of confidence, and depression all over the land. Yet California does not cower. She steps forward and says: 'We will not be downed by you, but will stand erect.'"[3]

Both San Francisco's Panama-Pacific International Exposition and San Diego's Panama-California International Exposition celebrated the opening of the Panama Canal in 1915. The idea of holding an international exposition in San Francisco to commemorate this historic event was first proposed by businessman Reuben Hale in 1904. As one of the key ports bound to benefit from this major change in shipping routes, San Francisco wanted to show the world what it had to offer. It became doubly important, after suffering the devastation of the 1906 earthquake and fire, for San Francisco to show the world that it had risen from the ashes and rebuilt itself. By 1909 it was clear that both San Francisco and San Diego were vying to be the site of an international exposition to celebrate the opening of the Panama Canal. When New Orleans announced that it also wanted to host the next world's fair, boosters from both California cities came together to present a fairly united front before federal leaders. New Orleans's promoters argued that the world's fair did not belong in a frontier outpost but, rather, closer to the heart of the country's traditions and the center of the nation's population.[4] After much lobbying and effort, San Francisco received President William Taft's blessing and federal financial backing as the recognized site of America's 1915 International Exposition.

Postcard, Panama-Pacific International Exposition, 1915 Courtesy of Donna Ewald

Despite less support from the federal and state governments, San Diego promoters decided to organize a smaller-scale world's fair in 1915. Like San Francisco, the city of San Diego stood to gain a great deal from the opening of the Panama Canal. San Diego's business leaders, particularly the real

estate owners, were keen to present their city to the world, to encourage commerce, and to entice people to move there.

By the mid-1930s, the atmosphere in California, as well as in the United States and the rest of the world, had shifted. Coming out of the depths of the 1929 stock market crash and the subsequent Depression with some consciousness of the political unrest again brewing in Europe, the organizers of San Diego's 1935–36 World's Fair and San Francisco's 1939–40 Golden Gate International Exposition were seeking to boost the general morale, to create new jobs, to promote the tourist industry, and to gain a foothold in new industries and markets in the Pacific Basin. With the recent engineering achievements of the Golden Gate Bridge and the Bay Bridge, which had both opened by 1937, San Francisco had a perfect excuse once again to invite the world to celebrate.

Upon arriving in California, visitors were immediately confronted with the state's most striking features—its climate and natural beauty—before ever stepping foot on the grounds of the fairs. So distinct from other parts of the country and the world, the weather and landscape were two of the state's richest commodities, and the savvy fair promoters chose to highlight them at every turn. The organizers of the Midwinter Fair exploited this asset by opening the exposition in January. They made the climate a focus of their publicity campaign, as seen in images that juxtaposed a California maiden bedecked in flowers with an East Coast snowman.[5] In Eugen Neuhaus's reminiscences of the Panama-California Exposition, he declared, "I know it is generally considered in poor taste to speak of climate in relation to California, but I cannot help but speak of the truly ideal weather conditions I encountered during my visits, both in May of 1915 and in January of 1916. Such skies and soft breezes—they are not the lot of mortals everywhere."[6]

The organizers of all five expositions chose locations that took advantage of the picturesque landscape, the proximity to water, and the ideal growing conditions. The 1894 Midwinter Fair was held in Golden Gate Park, a newly developed site on the outskirts of the city near the Pacific Ocean. The 1915 Panama-Pacific International Exposition was located in an area of San Francisco known as Harbor View, with vistas of the bay, the ocean, and the city. The 1915–16 Panama-California International Exposition and the 1935–36 California-Pacific International Exposition sat high on a mesa looking down across the city of San Diego and out to the coastline. The most ambitious site was the four-hundred-acre man-made Treasure Island in the middle of San Francisco Bay, created for the 1939–40 Golden Gate International

Exposition.[7] Making use of federal Work Projects Administration funds and workers to build it, San Francisco's leaders planned to convert the island into an international airport when the fair ended. With superb views of the bay, it was a perfect location to commemorate the completion of the two bridges and to reinforce the image of California as the gateway to the Pacific.

With each exposition the organizers created a dream city, a cohesive, monumental, ordered, and beautiful—albeit temporary—world, where it seemed that anything was possible. The physical designs and layouts of the fairs, including the architecture, landscaping, coloring, and lighting, conveyed potent messages about the host city's and state's natural, material, and cultural wealth. Beginning with the Midwinter Fair, an image of California emerged that strongly linked it to the past. As Grey Brechin points out, the past evoked by the expositions was often one that never existed.[8] It was rather an amalgam of cultures, both real and imagined. The fairs' organizers chose to emphasize different aspects of California's rich, though complicated, history including the Spanish explorers, the missionaries, and to some extent the state's Mexican and Latin heritage. At the same time, they also wanted to reinforce the perception that California's history and culture were tied to the larger history of Western civilization. It is important, as well, to note the cultural aspects of California history that the organizers chose to ignore. Though Native Americans and Chinese Americans had a strong presence in California, their cultures were not privileged in the design of the expositions until the 1930s. Rather, they were put on display as exoticized entertainment in the amusement-park sections of the fairs.

When it came to designing the 1894 Midwinter Exposition in San Francisco, the fair's management was very self-conscious about opening so soon after Chicago's Columbian Exposition. They wanted to present a unique image of California and stressed that "there should be no copies nor anything in the line of imitations, particularly in imitation of the buildings that had been seen at Chicago."[9] M. H. de Young suggested that the architects and designers look back to the antique.[10] Unlike Chicago's stark "White City," the Midwinter Fair used bright colors to ornament the buildings. Following de Young's wishes, there was little architectural uniformity. The motifs of the main buildings ranged from Indian to Egyptian to Moorish to Mission, with an emphasis on the latter two styles. Perhaps this was influenced by Arthur Page Brown, who played a key role in the Midwinter Fair by designing several structures, including the largest one, the Manufactures and Liberal Arts Building. It was Moorish in style, with strong California Mission elements.

Its cream-colored façade was lavishly decorated with a gold cupola, turquoise dome, and red tiled roof.

Covering six hundred thirty-five acres along San Francisco's bay front, the Panama-Pacific International Exposition was also eclectic in architectural style, though once again the Mission and Spanish Revival styles prevailed in important structures, such as the California Building. One of the most remarked-upon and memorable buildings of the exposition was California architect Bernard Maybeck's Palace of Fine Arts. In the style of a Mediterranean temple, it was an open-air rotunda supported by neoclassical columns draped with sculptural weeping women. The palace sat at the edge of a lagoon and was flanked by an arched colonnade and the fine-arts exhibition building. The heavy plantings of the entire area added to the romantic atmosphere. Maybeck proclaimed that it was meant to suggest "an old Roman ruin, away from civilization, which two thousand years before was the center of action and full of life and now is partly overgrown with bushes and trees."[11] Described by Kevin Starr as "nostalgic, time drenched, and evocative of a yearning for lost loveliness,"[12] the Palace of Fine Arts rooted the relatively young culture of California in the lineage of ancient Western civilization.

A major unifying element of the overall design of the Panama-Pacific Exposition was Jules Guerin's color scheme. Known for his theater designs and romantic watercolors, Guerin chose colors for the exposition that complemented and highlighted those found in California's natural landscape and created by its unique light. A specially blended plaster material in the hues of old ivory, closely mimicking the travertine marble used in ancient Rome, was applied over almost all buildings, statues, and walls at the fair. Eight accent colors, including cerulean blue, golden burnt orange, and terra-cotta, were then added to architectural elements throughout.[13] John McClaren's well-orchestrated landscaping complemented Guerin's color scheme and highlighted California's domesticated vegetation.

Conscious of the fact that San Francisco's exposition was going to be larger and have more global support and attention, the organizers of the Panama-California International Exposition decided to focus thematically on Southern California's strong ties to Spanish and Mission cultures. Even the name they gave to the exposition site, Balboa Park, which honored the Spanish explorer Vasco Nuñoz de Balboa, echoed a connection to the Old World and to Spain in particular. According to the directors of the San Diego fair, the typical visitor entered "the rose trellised gateway and—presto!... He has stepped back three or four centuries, full into a city of Old Spain."[14]

Uniform in style and color (white with occasional accents), the buildings stood out in the landscaping of colorful, constantly blooming subtropical trees and flowers, vines, and citrus orchards.[15]

Located on the same site at Balboa Park, the California-Pacific International Exposition of 1935–36 refurbished and reused many of the buildings of the 1915 exposition. Again, the outside spaces and gardens were just as important as the building façades and interiors. Richard Requa, the architect for the 1935 fair, designed three popular gardens in the styles of gardens from Andalusia, Seville, and Mexico. He also oversaw the addition of some buildings that reflected California's newfound interest in, and desire to associate itself with, things southwestern and Latin American. The Hollywood Hall of Fame, the Palisades Cafe, and the Palace of Education all had Pueblo-style features, "including a flat roof, rounded contours and projecting vigas."[16] Requa and his colleague Juan Larringa added vaguely Mayan or Aztec decorative elements to buildings such as the California State Building, the Federal Building, and the Water and Transportation Building.[17] Both the art deco Standard Oil Tower of the Sun, with its Mayan decorative elements, and the art deco Ford Building embodied contemporary ideas of

East entrance to Agriculture Building at the Panama–California Exposition, 1915 San Diego Historical Society Research Archives, Photography Collection, ref. 3166

progress and modernity and reinforced California's image of being at the forefront of invention and technology.

In the same vein, the design of San Francisco's Golden Gate International Exposition manifested the organizers' desire to present an image of California as a gateway to Latin America as well as the modern world. They added another dimension by promoting the state as a hub of the Pan-Asian world. Eclectic in architectural design, the scheme combined Mayan, Cambodian, Cubist, and art deco styles. At the center of the exposition, in the Court of Honor, was the monumental thirty-story deco-gothic Tower of

the Sun. In a 1939 promotional packet for the exposition, the architecture was described as "a new 'Pacific' style ... [that] has been devised to exalt the visitor spiritually into a 'Never-Never Land' where romance is in the air."[18]

John McClaren, who had landscaped the Panama-Pacific Exposition, consulted on the creation of this large-scale natural environment on a man-made island. With a $1.8-million grant from the Work Projects Administration, he had more than 4,000 trees, 70,000 shrubs, and millions of flowering plants shipped in.[19] Newly created orchards, gardens, and parks evoked California's diverse landscapes, ranging from coast to mountain to desert. One of the landscaping highlights was the twenty-five-acre "Magic Carpet" of multicolored flowering ice plant along the front entrance façade.[20] Simply stated, the promoters wanted to show that "California is a wonderland and a gardenland."[21]

Bringing the 1915 color scheme in line with the shifting focus, Jules Guerin borrowed from the palette of California wildflowers, as well as tying the scheme to the Pacific Basin. The colors included Sun-of-Dawn and Pagoda Yellow, Imperial Dragon Red, Hawaiian Emerald Green, and three blues— Pacific, China Clipper, and Southern Cross.[22]

When visitors stepped inside many of the exposition buildings, they encountered opulent worlds with agricultural, industrial, and cultural treasures from every corner of the globe. One of the predominant images featured was that of agricultural abundance. The counties and state created exhibits displaying overwhelming and dramatic arrays of fruits, vegetables, wines, nuts, dried fruit, jams and jellies, olives, and other agricultural products from the diverse regions of California. The exhibitors tried to outdo one another by creating giant towers and temples of citrus fruit, a horse and rider made of prunes, an elephant made of walnuts, a twenty-eight-foot ear of corn, and even Ferris wheels of oranges.[23]

The state's agricultural bounty was found consistently at all of California's international expositions; however, there was a shift in the importance placed on it through the forty-six-year period. In the 1890s and the early part

of this century, it was highlighted as one of California's most marketable products. Not only could the state's produce and wines be exported throughout the world, the agricultural goods also stood as proof of a great land of opportunity for anyone who chose to come and work it. By the 1930s, California's population had grown significantly, and the state had matured economically and had established new industries. As a consequence, in the exhibits at the 1935–36 and 1939–40 expositions the state's agricultural wealth took a backseat to its industrial, technological, and cultural developments.

One of the main attractions at Treasure Island was Pan American Airways's China Clipper, which made weekly trips to Hong Kong, landing and taking off from a runway at the fair. The plane was maintained in a hangar in the Hall of Air Transportation, where visitors could watch "every operation 'under glass.'"[24] This spectacular exhibition in action reinforced images of California as being on the cutting edge of the transportation industry, at the hub of the Pacific Basin, and an excellent point of departure for touring the world.

While many exhibits were geared to selling and promoting goods and services, others aimed to educate and entertain. Among the latter were fine-arts displays as well as anthropological and ethnographic exhibitions. The art of California was a prominent part of all five international expositions. While celebrating the artists' talent and California's cultural riches, the organizers were also promoting the state's past and its natural beauty, as many of the pieces depicted scenes from California's history or its picturesque landscape. For instance, at the Midwinter Fair, Charles Nahl's Gold Rush scene *Sunday in California in the Olden Days* and Arthur Mathews's landscape *A Winter Morning in San Francisco* were exhibited.[25] In the official history of the Midwinter Fair, the author reported, "No visitor to the Fine Arts Building could escape the impression that California was indeed a land of flowers. Violets and roses gladdened the eyes wherever one turned in the California section."[26]

The expositions also featured art from around the world. At the fairs before the 1930s, the focus was European and American art. Showing contemporary art as well as works by old masters, these exhibitions included artists such as Rembrandt, Ingres, and Degas,[27] conveying the idea that the culture of California recognized the established aesthetic canon of Western civilization.

Concordant with the general theme of "A Pageant of the Pacific," the Golden Gate International Exposition also included extensive exhibitions of art from Latin American countries bordering the Pacific, as well as that of

other Pacific cultures. In the official catalogue of the art of the 1940 exposition, the organizers expressed a desire to harbor cultural exchanges, explaining that the exhibition of contemporary Latin American art

provides for Exposition visitors a profound review of contemporary Mexican art and an introduction to the little-known painting of South and Central America . . . for there is no better way to understand another people in a different environment with different cultural and racial heritage than to learn through their art how they see, feel and think.[28]

Another very popular attraction at the Golden Gate International Exposition was the "Art in Action" show, which spotlighted living painters, sculptors, weavers, ceramists, and others in the act of creating works of art. Described by *Time* magazine as "the show's star performer,"[29] Mexican muralist Diego Rivera painted a huge fresco entitled *Pan American Unity*. In the center it portrayed the Aztec goddess Coatlicue metamorphosing into a machine, with scenes of ancient Mexican culture to her right and depictions of skyscrapers, modern industry, and the San Francisco Bay to her left.[30] Rivera declared, "American art has to be the result of a conjunction between the creative power of mechanism of the North and the creative power of the South coming from traditional, deep-rooted Southern Indian forms."[31] These art exhibits emphasized the idea that California had strong ties to its

neighboring countries and that it was at the center of Pacific Basin economic and cultural trade.

The California world's fairs also included ethnographic and anthropological exhibits, such as Chinatowns; American Indian, Mexican, and Samoan villages; Japanese tea gardens; and exhibits tracing the evolution of mankind. Though often found in the amusement sections of the fairs, they were frequently couched in educational terms and were meant to teach visitors about the different cultures on display. These "ethnological concessions,"[32] as labeled by Robert Rydell, "conveyed the message of evolutionary national and international progress."[33] They reinforced commonly accepted stereotypes and conceptions about different races and cultures and at the same time validated the white race as the strongest. In upholding these ideas, the organizers of the fairs were again aligning California with dominant national and international opinions and were imparting an image of the state as a culturally savvy, fully evolved society.

As described by Rydell, one such attraction was "Underground Chinatown" in the Panama-Pacific International Exposition's amusement zone, operated by theater owner Sid Grauman. With perhaps some elements of truth and a great deal of imagination, it played up some of the most exotic, dangerous, and intriguing conceptions of Chinatown, re-creating a "chamber of horrors"[34] that included opium dens. "Underground Chinatown" was closed in response to objections raised by members of the local Chinese business community and by the Chinese consul; it was replaced by a new show called "Underground Slumming." Rydell commented, "although it contained no Chinese entertainers, it conjured up fantasies of finding illicit amusement in the Chinese Village—a village that stood out as just one more nonwhite ghetto among many others on the outskirts of the utopia planned by the exposition directors."[35]

The organizers of all five California world's fairs also included exhibits of California and Southwest Indians. Native Americans were a highly marketable image associated with California. One of the most commented-upon exhibits of Indians was the elaborate "Painted Desert" at the Panama-California Exposition in San Diego, which was sponsored by the Santa Fe Railway.[36] The ten-acre exhibit sought to reconstruct the environment and lifestyle of Native Americans from the Southwest. Described by a journalist at the time as "a flawless reproduction of real Pueblo Indian life,"[37] it included buildings resembling Taos and Zuñi pueblos, as well as Navajo hogans and Apache tepees.[38] Visitors could buy authentic crafts at the trading post and could see

ritual Indian dances performed by the exhibit's residents, almost three hundred members of several Southwestern tribes who had been brought in for the duration of the fair. The exhibit focused on the backward-looking nature of the Indian cultures. As Phoebe Kropp wrote, the "Painted Desert" exhibit "froze the Indians in a primitive time, tying their authenticity to the age and crudeness of their traditions . . . and worked to deny them a contemporary social presence, much like the Spanish Fantasy Past."[39] At the same time, by juxtaposing the "Painted Desert" with the adjacent five-acre "Model Farm" showing Southern California's agricultural abundance, a California-style bungalow, and the latest farming techniques in action,[40] it reinforced conceptions of progress and the superiority of California's white population. Similarly, the prevailing perception of the Indian as a dying race of the past was visually depicted in James Earl Fraser's popular sculpture *The End of the Trail*, which was shown at the Panama-Pacific International Exposition. It portrayed an

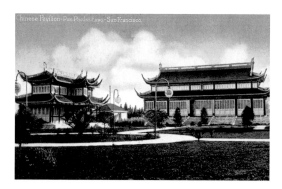

exhausted, near-death Indian on his equally tired horse, in contrast to the spectacular buildings and exhibits created by the white man all around it.

Though many of the same types of ethnographic exhibits could be found at the California world's fairs of the 1930s, some degree of change can be detected in the overall presentation of, and general

Chinese Pavilion, Panama-Pacific Exposition, 1915 UCLA Library, Department of Special Collections

"The Painted Desert" exhibit at the Panama-California Exposition, 1915 San Diego Historical Society Research Archives, Photography Collection, ref.8978A

H-1033 BLANKET WEAVERS. "THE PAINTED DESERT", SAN DIEGO, CALIF. "PANAMA-CALIFORNIA EXPOSITION"

attitudes toward, the different ethnic groups. There were still overriding messages of the white race's dominance and the perceived distinct and exotic qualities of other cultures. However, following the organizers' desire to establish and strengthen economic relationships with California's Latin and Asian neighbors, the cultural, economic, and natural riches of these different cultures were highlighted in new ways that emphasized their cultural presence in the here and now. For example, the central visual icon of the Golden Gate International Exposition was Ralph Stackpole's eighty-foot-tall statue *Pacifica*, a female figure meant to represent a

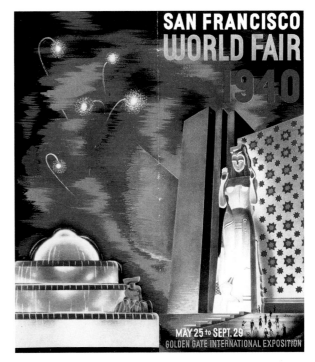

Cover of program for the Golden Gate International Exposition, 1940, showing the Ralph Stackpole statue *Pacifica* Courtesy of Jim Heimann

physical blend of the many cultures bordering the Pacific.[41] Likewise, Miguel Covarrubias's series of pictorial map murals, in the Pacific House at the Golden Gate International Exposition, detailed and celebrated the peoples, foods, housing, transportation, arts, economies, and natural resources of the Pacific Basin cultures.[42] The federal exhibit at the Golden Gate International Exposition presented, as described in promotional materials, "the six distinct civilizations of the American Indian ... together with artisans producing the Indian handicrafts that rank with the finest imported articles." With some consciousness of the present condition and existence of Native Americans, the promoters wrote that the exhibit "is expected to establish a 'vogue' for native craftsmanship that will help the Indian to stand on his feet financially."[43]

Visitors went home from the fairs with arms full of souvenirs and heads full of images, ideas, and memories. For this forty-six-year period, the international expositions were an important and effective forum used by the leaders of California to market their state. Approaching the challenge from many angles, they successfully created and reinforced powerful images, myths, and ideas about California's history and heritage, the beauty and bounty of the land, the state's industrial and economic achievements, its cultural and intellectual wealth, and its leadership role for the future. Since 1940, no world's fair has been held on California soil. However, many of these popular images and

ideas persist today and can be found in venues such as Disneyland, shopping malls, and museums of art, anthropology, and technology. It is interesting to ponder what an international exposition in California today would look like. What would the leaders of California choose to highlight? Perhaps one would find exhibits and images of Silicon Valley, the state's role in the Pacific Rim, the state's cultural diversity, the California lifestyle—or perhaps the tried-and-true image of the state's natural beauty.

Carolyn Peter is currently assistant curator at the Grunwald Center for the Graphic Arts at the UCLA Hammer Museum in Los Angeles. She wrote her master's thesis at the Courtauld Institute of Art on the 1855 Universal Exposition in Paris and the status of photography as an art form in the 1850s.

1 *The Official History of the California Midwinter International Exposition* (San Francisco: H. S. Crocker Co., 1894), 4.

2 See Burton Benedict, *The Anthropology of World's Fairs: San Francisco's Panama Pacific International Exposition of 1915* (London and Berkeley: Lowie Museum of Anthropology in association with Scolar Press, 1983), 2. Benedict points out, "The fairs were not only selling goods, they were selling ideas: ideas about the relations between nations, the spread of education, the advancement of science, the form of the cities, the nature of domestic life, the place of art in society. They were presenting an ordered world."

3 *The Official History of the California Midwinter International Exposition*, 43.

4 Marjorie M. Dobkin, "A Twenty-five Million Dollar Mirage," in Benedict, *The Anthropology of World's Fairs*, 81.

5 See *The Fantastic Fair* (videotape), copyright 1983 by the Fine Fellows (Roger Birt, Arthur Chandler, Steve Dobbs, Marvin Nathan, Richard Sammons).

6 Eugen Neuhaus, *The San Diego Garden Fair* (San Francisco:

Paul Elder and Co., 1916), xiii.

7 See Kevin Starr, *Endangered Dreams: The Great Depression in California* (Oxford: Oxford University Press, 1996), 343.

8 Gray Brechin, "Sailing to Byzantium: The Architecture of the Fair," in Benedict, *The Anthropology of World's Fairs*, 95.

9 *The Official History of the California Midwinter International Exposition*, 47.

10 Ibid.

11 Quoted in Kevin Starr, *Americans and the California Dream* (Oxford: Oxford University Press, 1973), 297–98.

12 Ibid., 298.

13 Frank Morton Todd, *The Story of the Exposition* (New York and London: Panama-Pacific International Exposition Co., 1921), 1:347.

14 Robert W. Rydell, *All the World's a Fair* (Chicago: University of Chicago Press, 1980), 209.

15 See Richard Amero, *Panama-California Exposition—San Diego—1915–1916*, on the San Diego Historical Society's Web site at *www.edwebsdsu.edu/sdhs/pancal/sdexpo* (Aug. 6, 1999).

16 Richard S. Requa, *Inside Lights on the Building of San Diego's Exposition: 1935* (San Diego: [self-published],

1937), 55.

17 Ibid.

18 Promotional Department, Golden Gate International Exposition, *Pageant of the Pacific—A General Summary* (San Francisco, rev. Oct. 1, 1939), 9, San Francisco Misc. GGIE, box 89, California Historical Society, San Francisco; see also Lisa Rubens, "Re-presenting the Nation: The Golden Gate International Exhibition," in Robert W. Rydell and Nancy Gwinn, eds., *Fair Representations: World's Fairs and the Modern World* (Amsterdam: UV University Press, 1994), 131; and Kevin Starr, *Endangered Dreams*, 343–49.

19 *Pageant of the Pacific*, 11.

20 Ibid., 11.

21 Ibid., 13.

22 Starr, *Endangered Dreams*, 350; *Pageant of the Pacific*, 9–10.

23 *The Official History of the California Midwinter International Exposition*, 85–111.

24 *Official Guide Book, Golden Gate International Exposition on San Francisco Bay*, rev. ed. (San Francisco: H. S. Crocker Co., 1939), 45, 47–49, 61; *Pageant of the Pacific*, 14.

25 *The Official History of the California Midwinter International Exposition*, 120–21.

26 Ibid., 121.

27 Rembrandt's and Ingres's works were shown at the Golden Gate International Exposition, *Golden Gate International Exposition San Francisco—1940 Art Official Catalogue, Palace of Fine Arts* (San Francisco: H. S. Crocker Co., 1940), 15, 96. Degas's work was shown at the Panama-Pacific International Exposition, *The Official Catalogue of the Department of Fine Arts, Panama Pacific International Exposition* (San Francisco: Wahlgreen Co., 1915), 15.

28 *Golden Gate International Exposition San Francisco— 1940 Art Official Catalogue*, 105–9.

29 "Artists on Parade," *Time*, June 24, 1940: 69. *Pan American Unity* is located today in the Diego Rivera Theater Arts Building at City College of San Francisco.

30 As was the case with many of his murals, Rivera's *Pan American Unity* created a stir. The City and County Federation of Women's Clubs condemned the mural because it portrayed Hitler and Stalin as they were to be caricatured in Charlie Chaplin's upcoming film *The Dictator*. See Alfred Frankenstein, "Art on Treasure Island," *San Francisco Chronicle*, Sept. 8, 1940: 24.

31 "Artists on Parade," 69.

32 Rydell, *All the World's a Fair*, 219. Chapter 8, "The Expositions in San Francisco and San Diego: Toward the World of Tomorrow" (pp. 199–232), focuses on the anthropological and ethnographic exhibits at the 1915 expositions in San Francisco and San Diego.

33 Ibid., 228. Rydell cites Pauline Jacobson, "Seeing a Stamboul [sic] on the Zone," *San Francisco Bulletin*, May 22, 1915; Todd, *The Story of the Exposition*, 2:362–63; and others.

34 Rydell, *All the World's a Fair*, 219.

35 Ibid., 228–30.

36 See Phoebe S. Kropp, "'There is a little sermon in that': Constructing the Native Southwest at the San Diego Panama-California Exposition of 1915," in *The Great Southwest of the Fred Harvey Company and the Santa Fe Railway*, Marta Weigle and Barbara A. Babcock, eds. (Phoenix: Heard Museum, 1996), 36–46; and "Magic Spanish City at San Diego," *Out West*, Dec. 1914: 302–3, for detailed descriptions of "Painted Desert."

37 "Magic Spanish City at San Diego," 302.

38 Kropp, "'There is a little sermon,'" 46.

39 Ibid., 39, 41.

40 "Magic Spanish City at San Diego," 297–98; see also Walter V. Woehlke, "Staging the Big Show," *Sunset Magazine*, Aug. 23, 1914: 342.

41 Rubens, "Re-presenting the Nation," 129.

42 *Official Guide Book, Golden Gate International Exposition on San Francisco Bay*, 79.

43 *Pageant of the Pacific*, 14.

Acknowledgments
I wish to thank John W. Ott for sharing his ideas and resources with me. Thanks also to Mary Daniel Hobson and Jeffrey Ventrella for their careful and insightful readings of early drafts and to Thomas Frick for his editing. Lastly, thank you to Sally and Vivian Blevins for the perfect place to write.

Courtyard of the
California School of
Fine Arts
San Francisco Art
Institute Archives

Paul J. Karlstrom

ART SCHOOL SKETCHES:
NOTES ON THE CENTRAL ROLE OF SCHOOLS
IN CALIFORNIA ART AND CULTURE

In California, more than in New York and other art centers, schools have been and remain the basis for the creation and maintenance of a viable art culture. An understanding of the development of the art and culture of California in the twentieth century demands a critical look at the nature and extent of the role played by its art schools, colleges, and university departments. There are a number of ways in which one could approach this complex subject; this method tells the story through the experiences and recollections of artists who have both studied and taught in the schools and institutions under consideration.[1]

Art education in California remains the central factor in the continuing development of an art world traditionally disadvantaged in terms of galleries, market, and criticism—the components of philosopher Arthur Danto's essential "discourse."[2] If anything, discourse has typically taken place in California almost exclusively in the state's educational institutions. Museums have increasingly played important roles, but to a greater extent than in any other region with a large population of internationally recognized artists and a history of significant movements and art production, the schools in California have stepped in to fill the void. By providing an institutional infrastructure in which ideas are exchanged and creative experimentation encouraged (not to mention teacher salaries), schools have indeed emerged as the primary patrons of California art and artists.

I will attempt to show that in California, art history has been dependent upon educational entities more than on other traditional components of cultural strength: museums, galleries, collectors, and critical attention. Established in the late nineteenth and early twentieth centuries, a handful of private art schools were joined by public college and university studio programs that slowly emerged or expanded during the 1920s and 1930s. Their appearance provided geographically distributed foci for cultural life that assumed full proportions with the unprecedented rise and proliferation of

public-supported departments and galleries within the local community colleges and, especially, the massive state college and university systems. In many communities these were not just the leading but the only venues for development of a genuine visual arts intellectual and cultural life. The circumstances and conditions that gave rise to the schools, along with their underlying philosophical and economic goals and objectives, are the subjects of this essay. The big question is just where would art—and artists—in California be without the state's elaborate infrastructure of art schools and departments?

The University of California (UC), in particular, represents throughout its several campuses a source of support for artists and local art activity probably unequaled elsewhere. By the 1960s, if not earlier, California's vast system of public higher education came to be the leading consistent force in nurturing and forming the rapidly expanding art and cultural life of the state. Furthermore, the main developments in twentieth-century American art, at least since the mid-1940s rise of Abstract Expressionism at the California School of Fine Arts (CSFA)—now the San Francisco Art Institute (SFAI)— are not only reflected in California art schools but also, in a few important cases, actually drew from them some of their vitality and direction.[3] Among the movements created or nurtured by California schools are feminist art and Conceptualism. Along with the California Institute of the Arts (CalArts), the Berkeley, Davis, Irvine, San Diego, and Los Angeles (UCLA) campuses of the UC system have, to varying degrees, played key roles in both movements. These and other functions raise the seldom addressed question of just whose interests have been served by what amounts to an institutional art industry and culture in California.

According to artist Chris Burden, a graduate of Pomona College and now a member of the UCLA faculty, "People think collectors support artists. But it's universities that support artists."[4] With salaries of more than $100,000 plus benefits, he and his tenured colleagues are in a position to know. And Burden is just one of hundreds of artists in California whose frequently avant-garde art and reputations are in effect supported by the state. Perhaps never before have so many self-described nonmainstream artists been embraced by the academic establishment. Yet in California this is hardly a new phenomenon. Many prominent artists—among them Eleanor Antin, John Baldessari, Robert Bechtle, Joan Brown, Richard Diebenkorn, David Hockney, R. B. Kitaj, Mel Ramos, Wayne Thiebaud, Peter Voulkos, William Wiley, and even nonconformist Llyn Foulkes—have supported themselves or augmented their incomes from art sales by teaching at California schools. Unlike in New York

City, where few of the leading artists can be found in the classroom, at one time or another most of California's best-known figures have ventured there. Conceptualist Barbara Kruger, also currently on the faculty at UCLA, observed that "in New York, you don't get teachers who have large careers."[5] This view underlines the close connection between artists and schools that exists on the West Coast, a mutual dependency for the most part alien to the New York art world. The effects of this dependency, beyond the obvious advantages of a steady income and the ability to influence students, have yet to be thoughtfully addressed. Painter Nathan Oliveira is among the artists who have commented upon the negative aspects of the security offered by a university appointment.[6]

Whatever the consequences for artists and their creative productivity, there is little question that California schools have traditionally provided a focus for art community activity. Quoting two prominent contemporary artist-educators on the subject of the possible positive aspects of benign neglect in terms of a critical and gallery infrastructure, critic Terry Myers notes that they had identified a distinguishing aspect of the development of art in California: "Both Lari Pittman and Hal Glicksman explicitly hit upon major themes that run through the history of L.A. art from the sixties to the present: art is *made* in L.A., it is bought, sold, discussed, written about somewhere else; art is *produced* in L.A., and it 'lives' somewhere else—unless of course it is 'at' or 'in' school."[7]

Myers himself is even more explicit in crediting schools for providing the institutional bedrock upon which the California art world rests when he writes that Otis and Chouinard, "along with Art Center School of Design, Claremont, UC Irvine, and UCLA, in particular, continue to provide a foundation upon which the L.A. art world is perpetually built and rebuilt from the ground up. For example, much of today's gallery 'scene' for emerging artists is more often than not directly connected to the support structure of the schools."[8]

The same could certainly be said of the San Francisco Bay Area. Historically, the role of at least one art school has gone well beyond providing salaries for artists and a convenient place for the art world to gather and exchange ideas. The ancestor of all art schools in the western United States, the California School of Design—now the San Francisco Art Institute (SFAI)—was founded in 1874 by the San Francisco Art Association (SFAA), with landscape painter Virgil Williams as its first director.[9] The stated goals of the SFAA, in addition to the creation of an art gallery and art library, were "the promotion of Painting, Sculpture, and Fine Arts akin thereto, the diffusion of a

cultivated taste for art in the community at large, and the establishment of an Academy or School of Design."[10] At the time there were no other art schools west of Chicago, and, in fact, the California School of Design was just the fourth such institution in the country. Its establishment represented a bold attempt to create the lineaments of culture in a youthful San Francisco only two decades removed from the Gold Rush. Seldom, if ever, has a cosmopolitan urban environment been developed so quickly. And the SFAA, along with the artist-and-writer-founded Bohemian Club, was a critical agent of that overnight transformation.[11] The association, of which Albert Bierstadt was strategically named first honorary member, and its academy stood for the cultural aspirations of the community, serving symbolic as well as practical functions. The same could be said of many of the art schools, university departments, and galleries that were to appear throughout the following century up and down the state. As part of an institutional infrastructure, they provided the reassurance that culture was indeed a part of the California Dream.

For much of its history, the present successor to the California School of Design, the SFAI, has been the leading art school in the West, a position it held at least through the "golden era" that began with the arrival in 1945 of director Douglas MacAgy (at that time the school was called the California School of Fine Arts [CSFA]) and, in the following year, of Clyfford Still as instructor of painting. There are those who maintain that serious art activity in California actually began with MacAgy, Still, and the advent of gestural painting. Another prevalent view holds that Los Angeles was a cultural tabula rasa prior to the 1957 appearance of the Ferus Gallery and the avant-garde artists associated with it, many of whom attended Chouinard Art Institute in the late 1950s and early 1960s. Both views are distortions of history, as evidenced by recent scholarship. What is interesting for our purposes is that the key events in the unfolding of the region's art history are associated with schools. This is certainly the case with the rise of Abstract Expressionism as the defining style at CSFA and the source of an art school–based gestural movement that now is seen as distinct and independent from New York School painting.[12] With the influx of GI Bill students and the presence, as regular and visiting faculty, of Still, Ad Reinhardt, Mark Rothko, and others with national reputations, the school reasserted its dominant position and became for artists throughout the West, among them many Southern Californians, the place to go. The school's bohemian, romantic reputation continued into the 1950s, 1960s, and 1970s, when stronger programs emerged at UC campuses such as Davis, Irvine, and San Diego, as well as at CalArts and, with its pioneer-

ing and influential feminist art activity, California State College at Fresno.[13] CSFA's mystique endured, however, and its allure is evident in the recollections of artists such as Joan Brown, who in 1955, at the age of seventeen, was attracted by the bohemian spirit of the diminished and floundering school: "I remember walking into the patio and here were these guys in sandals with turtlenecks and long hair and beards, playing bongo drums . . . and I thought, 'Oh, my God, this is where I belong, I really want to go here.'"[14]

In 1890 the school came under the directorship of Arthur Frank Mathews, the embodiment of the Arts and Crafts movement and the most influential California artist at the turn of the century. By then, rival art schools had appeared in San Francisco, notably the Art Students League, whose liberal teaching schedule attracted prominent artists to its faculty. Mathews's stern directorship, frequently described as dictatorial, coincided with the phase of the school's evolution that began in the upscale Mark Hopkins mansion on Nob Hill and ultimately led to the present SFAI Chestnut Street facility. But the main change that began during the Mathews period was the development of an identity at odds with the school's traditional SFAA origins and close connections to the conservative Bohemian Club. Two antagonistic camps developed, divided (as in much of the art world) between traditionalism and modernism. For all the poetic ethereality of his arcadian idylls, Mathews stood for the former. The development of the San Francisco art world, particularly the tug-of-war between conservative and progressive forces, may be read in the changes and events at SFAI during this period.

Among Mathews's students was Maynard Dixon, who found his teacher's unsympathetic style so distressing he left the Mark Hopkins after only three months. Dixon recalled that Mathews's teaching method "was to pounce upon our work, so like a growling dog he scared me out of my boots. He had me too scared to know what he was talking about."[15] While not strictly speaking a modernist, Dixon nonetheless represents a progressive tendency in that direction, one that increasingly set the terms for a twentieth-century art of self-expression and stylistic experimentation. It is tempting—and entirely in accord with modernist thinking—to see this shift as marked by the destruction of the old. On April 18, 1906, the Mark Hopkins mansion and much of San Francisco were devastated by the great earthquake and ensuing fire. Flames destroyed what the SFAA had created over almost thirty-five years. The result was an artistic diaspora. Artists relocated to Monterey and to as far away as Los Angeles, enriching the younger Southern California art community.

Society of Six member Maurice Logan, reportedly the first student to enroll in 1907 in a temporary facility on the same Nob Hill site, later referred to the renamed San Francisco Institute of Art as "my home; my cradle."[16] But the reality of the classroom experience fell short of that ideal. Paul Carey remembers little to praise from the instruction he received in 1924 and 1925. According to Carey, Lee Randolph, then-director of CSFA and its main painting instructor, "did nothing; with a great flourish he picked up some chalk, made a few marks, then walked out."[17] Leo Holub, who returned to CSFA to teach from 1956 to 1958 before establishing the photography department at Stanford ten years later, recalls that when he was a student the emphasis was on commercial art, but that the emphasis changed with the arrival of MacAgy. And he had this to say about dean of faculty Spencer Mackey: "He didn't pay much attention to his male students. When he came to me he might make a few corrections, pause long enough to say something helpful like 'Hard, isn't it,' then move on to an attractive girl with whom he invariably spent an attentive half hour."[18] Holub's future wife, Florence Mickelson, was one of those young women, and her recollections of the instruction at CSFA are more positive. According to her, "All students received a solid training in the fine arts—classes in art history, anatomy, painting, sculpture, lithography, and printmaking. Students who wished to become art teachers in the public schools then went on for further training at UC Berkeley."[19]

Retrospective complaints such as those of Carey and Leo Holub are, in fact, not unusual. In the many interviews I have conducted with artists for the Archives of American Art, all of the subjects discussed their art education experiences, and the majority expressed reservations about their value. A number of them are now teaching, and the one general point of agreement is that the MFA degree is useful, as Florence Holub suggests, not so much for establishing a career as an artist as for securing a teaching position. The art education system is circular and self-reinforcing: the institutions exist to provide jobs for artists and to derive income from those who want to be trained, and validated, as practicing artists.

Conceptual artist Charles Linder, a 1990 graduate of SFAI and founder of San Francisco's avant-garde Refusalon Gallery, is among those who question the efficacy of the art school program in preparing students to function in the market- and media-driven art world that awaits them. Critical of a hands-off, almost laissez-faire approach to teaching, in which very little is imparted beyond an outdated bohemian concept of the artistic life, Linder described the late 1980s SFAI as providing "therapy day care for credit card punkers . . .

Visa goths with a Dungeons and Dragons aesthetic."[20] On the other hand, like so many artists recalling their student days, Linder qualifies his negative critique with appreciative words for at least one influential teacher: Beat filmmaker-collagist Larry Jordan.

Linder is not alone among younger art school graduates who fault their distinguished alma maters for ignoring career guidance and the harsh realities of life as an artist without the benefit of a teaching position. Sculptor David Jones, a graduate assistant to Peter Voulkos when at Berkeley in the early 1970s, describes his experience at UC in terms of "false promises and hope."[21] In his view, the institutional art culture simply is not transferable to a consumer world in which making a living depends upon selling works of art. Neither Jones nor Linder (who also received an MFA at UC Berkeley) believes that art school experience created their careers, agreeing quite emphatically that they did so themselves. Interestingly, they both mention the Art Academy College in San Francisco, now the largest art school in the state if not the world, as somehow more "honest" in meeting legitimate student expectations in providing digital training and other technical tools for a media world dominated by electronic images and design.

CALIFORNIA SCHOOL OF FINE ARTS SAN FRANCISCO AUGUST 14 • MAY 17

REGULAR SESSION 1939-1940

California School of Fine Arts class bulletin, 1939–40 Leo Holub Papers, Archives of American Art, Smithsonian Institution. Photograph © 2000 by the Trustees of the Ansel Adams Publishing Rights Trust. All rights reserved

By the 1990s fine arts programs such as that at SFAI were increasingly viewed as outdated and even unresponsive to the demands of professional life. Programs embracing and encouraging the romantic idea—one fostered during the MacAgy era—of the heroic individual standing alone outside conventional society, deeply engaged in his or her dialogue with art and individual experience of contemporary life, appeared antiquated to many in the art world. Responsible art education seemed, at least to some administrators and trustees, better embodied in the programs of the California College of Arts and Crafts (CCAC) in Oakland and Pasadena's Art Center College of Design, both of which date to 1930 and have successfully integrated fine and applied arts in their curricula. Prior to MacAgy, CSFA had a program closer to the more typical vocation-focused schools such as CCAC, Art Center, or Chouinard

and Otis in Los Angeles, all of which offered commercially oriented classes such as design, illustration, and animation. Examinations of earlier course offerings reinforce Leo Holub's characterization of CSFA as a vocational school with a strong fine-arts component.

With the advent of the various New Deal federal arts projects, notably the Treasury Department's Section of Painting and Sculpture (1934–43), decoration of public buildings had become a growth industry, and mural painting was offered as a career objective. The 1939–40 CSFA bulletin proclaimed that "with renewed interest the world is asking for sound, creative art, and increasing the demand for mural decoration. Modern life opens up many exciting fields for the painter with imagination, sincerity, and *craftsmanship* [emphasis added]."[22] At about the same time, Berkeley established a similar program under the direction of John Haley. And in Southern California, mural painting was introduced by Scripps College instructor Millard Sheets, perhaps the most influential exponent of a design- and craft-based art education. In fact, the Claremont Colleges, along with CSFA and City College of San Francisco (with their murals by Rivera), were major campus sites for Mexican murals in

Alfredo Ramos Martínez painting in the Margaret Fowler Memorial Garden, Scripps College, Claremont, 1946 Millard Sheets Papers, Archives of American Art, Smithsonian Institution, photograph by Max Yavno, © 1998 Collection Center for Creative Photography, The University of Arizona

the United States. José Clemente Orozco's *Prometheus* (1930), in Frary Hall at Pomona College, and Alfredo Ramos Martínez's Margaret Fowler Memorial Garden mural (1946) at Scripps provide compelling evidence of the role schools played in fostering this artistic practice in California.

In my view, one need only look to the art schools and their mutating philosophies of what constitutes sound, responsible training of artists to grasp the profound and historic confusion regarding the significance of artistic occupation and its value to national life. There has been an ongoing effort in the schools to reconcile the competing demands of the practical (job training) and the ideal (fine art). The issue of school image and identity almost destroyed CSFA after the departure of MacAgy. The faculty had philosophical differences about the place of fine art in the training of artists, as well as about the proper function of art in society. MacAgy's resignation triggered the exodus of Still and most of the other fine-arts faculty, including Clay Spohn, Elmer Bischoff, David Park, Hassel Smith, and Minor White. Ernest Mundt, MacAgy's successor, was determined to recast CSFA as a vocational training school rather than, in the words of intellectual historian Richard Cándida Smith, "a source of generalized cultural innovation."[23] What followed was a battle to determine the fate of one of the few (advertised somewhat later as the *only*) pure fine-arts schools in the country. With the departure of star faculty, enrollment dropped from 325 full-time students in 1951, to 61 the following year. In an effort to stanch the exodus, Mundt and his board initiated a degree program in the fall of 1953 and secured provisional accreditation for the BFA degree. But the attempt to solve CSFA's financial problems by abandoning what Mundt described as its "elitist, neoromantic" fine-arts program in favor of one devoted to advertising and commercial art was a failure. The board, led by painter Nell Sinton, responded by replacing Mundt with Gurdon Woods, who began restoring the program with the hiring of Frank Lobdell, a Clyfford Still student and disciple, and a number of the former fine-arts faculty. The stage was set for the next phase of CSFA preeminence in California, with the leaders of the Bay Area Figurative movement (Park, Bischoff, and Diebenkorn) as faculty and the subsequent settling in of the Beat-era bohemian underground (represented by artists such as William Allen, Joan Brown, Bruce Conner, Jay DeFeo, Wally Hedrick, Robert Hudson, Manuel Neri, and William Wiley). From an art historical standpoint, judging from the number of prominent California artists associated with the school, CSFA retained its position of leadership. And it did so by rejecting the practical trend toward development of applied skills and technique necessary for careers in advertising and commercial art.

During the period of crisis at CSFA, Mundt entered into negotiations with Los Angeles's very successful Art Center School (now Art Center College of Design) for a merger that would strengthen the San Francisco school's commercial art and design program—areas in which Art Center was renowned—and presumably increase enrollment. The deal fell through when Art Center refused to support the CSFA fine-arts program (their own program, directed by Lorser Feitelson, was well established but secondary) and assume the San Francisco school's debts.[24] What is instructive is the extent to which art schools (in the past as well as in the present) operate as businesses for which bottom-line economics, rather than cultural ideals, determine directions and programs.

There are those who believe that CCAC has now eclipsed SFAI as the Bay Area's leading art school. Pasadena's Art Center, with former Los Angeles Museum of Contemporary Art director Richard Koshalek as newly appointed president, plans to relocate to downtown Los Angeles and seems poised to challenge CalArts and UCLA as a leading avant-garde center for Conceptual art and theory-based practice. None of these programs, however, reflects the hermetic, Beat-era romantic idealism still lingering in the atmosphere at SFAI. At the end of the 1990s, these art schools—following the lead of CalArts— are aggressively careerist in their strategic approach to the making of art, and

New York–style reputations, as part of participation in a consumerist art world. The idealism of choosing to be an artist, the notion of creating something ineffable and transcendent, appears to have given way to motives and methods considerably less elevated but more pragmatic.

Nonetheless, for all the graduates who feel that their art school educations left them unprepared to function in the real world, there are those who remain closely attached to the institutions in which they were allowed to grow and mature as artists. Second-generation Abstract Expressionist Charles Strong found his spiritual home at CSFA and his inspiration in the legacy of Clyfford Still. He remembers the school when he enrolled in 1959 as a perfect fit: "I was ready for the intuitive, painterly style when I got there. And I was independent . . . We [students] went there for the energy, to find a place where you could develop."[25] This reinforcing environment, a potent source of encouragement and validation, seems to be what fine-arts students value most in their art school experience. Where that is missing, as in overly academic or commercial programs lacking inspirational faculty who embody the dedicated art life, the memory is almost entirely negative. Such is the case with a fairly adamant group of successful artists who found little worth in their art school experiences.

Robert Colescott, who began his training in 1946 under Ed Corbett at San Francisco State College (now San Francisco State University), remembers that the art program was limited, being directed to education majors, as was typical of many state schools. At his teacher's suggestion, he transferred to Berkeley the following year to major in art, "which in those days pretty much meant painting."[26] His observations on the program and faculty at UC Berkeley point up the philosophical differences between the two major art programs (one public and the other private) in the Bay Area at the time: "The people at Berkeley like [John] Haley, [James] McCray, and [Erle] Loran . . . had this kind of fake academic interpretation of Cézanne . . . that ended up working on the surface as a kind of arrangement of decorative shapes that somehow had a modern look to it. [And] there was real division between Berkeley—which seemed overly academic—and the students who went to the California School of Fine Arts."[27] Despite reservations about the value of the program to him as a fine artist, Colescott nonetheless found some faculty—notably Worth Ryder (who gets the credit for bringing Hans Hofmann to Berkeley in 1930) and Glen Wessels—more "flexible." He also joins Jay DeFeo and others in praising Margaret O'Hagen as probably the best teacher in the department.[28]

Figurative painter Raimonds Staprans, who attended graduate school at Berkeley, where he studied with Erle Loran and Karl Kasten in the early 1950s, is representative of the graduates most critical of the department there and, indeed, of the value of a university art education in general. In Staprans's rather extreme view, "art school at a university level . . . should be eliminated."[29] He expands on this belief by invoking the difference between two basic learning approaches: mentorship (formerly known as studying with a "master") and generalizing by working with a number of faculty. Art, he says, is about personal vision, which the structured university program tends to subvert: "If you want to graduate, to get a good grade . . . your work has to be done within the framework of the teacher's vision."[30] Staprans also explained that he was attracted to UC Berkeley for its reputation as a center for Hans Hofmannesque abstraction and for its academic standing, a combination that other art schools did not share. Furthermore, he remembers being told that "our school has the highest standards on the Coast . . . and while other schools produce graduates in painting, we produce competent artists who are able to hold their own in any New York show"[31]—a questionable claim at the time and now a patently false one.

The programs at UC Berkeley and CSFA were distinguished by marked differences in style as well as in philosophies of art training. Elmer Bischoff, a graduate of Berkeley's art department who subsequently taught on both sides of the San Francisco Bay, commented on the relationship between the two types of institutions: "The university has been a little embarrassed by the fact that it's drawn so much of its faculty from the Art Institute . . . and it's the Art Institute which has produced the people who've gotten the best jobs and have the biggest names."[32] The more avant-garde San Francisco school's reputation as the West Coast home of Abstract Expressionism made it a magnet for students throughout the West. A number of Southern Californians were drawn by the bohemian image of San Francisco and the reported experimental nature of the school. Despite the fact that Peter Voulkos had left Otis Art Institute to establish his influential clay program at UC Berkeley, ceramic sculptor Richard Shaw chose SFAI because "being a real artist, living the art life . . . could only happen in San Francisco and at the Art Institute."[33] However, Shaw also recalls that he could not get into the classes of the painters with whom he wanted to study and had to settle for looking in on their classes. Within a year or so, his "heroes" Richard Diebenkorn, Nathan Oliveira, and Elmer Bischoff departed for UCLA, Stanford, and Berkeley. "They were all gone. The place was, you know, 'hello, hello, hello.' No one was there."[34]

Shaw moved to the Bay Area in 1963, at a time when the power center
of the California art world was beginning to shift south. Chouinard Art
Institute in Los Angeles was rivaling SFAI as (in Shaw's words) "a *real* art
school," a West Coast bohemian fine-art alternative. On the faculty, which
numbered almost seventy during this period, were Billy Al Bengston, Hans
Burkhardt, John Coplans, Conner Everts, Frederick Hammersley, Vivika
Heino, Shiro Ikegawa, Robert Irwin, Herbert Jepson, Jules Langsner, John
Lautner, Philip Leider, Richards Ruben, Stephan Von Heune, Emerson Woelffer,
Norman Zammitt, and Jirayr Zorthian. As at other schools where such courses
were offered, most of the women instructors at Chouinard taught in the areas
of design and fashion illustration. The faculty was as distinguished as that of
SFAI, and among the 500 or so students were several future California art and
design stars, including Terry Allen, Larry Bell, Mary Corse, Llyn Foulkes, Joe
Goode, Bob Mackie, Allen Ruppersberg, and Edward Ruscha.[35]

Chouinard Art Institute (founded 1921) and Otis Art Institute (founded
1918) had emerged during the 1920s as Los Angeles's most important schools
for the training of artists. Once again, in both schools, the emphasis was
on preparation for commercial careers rather than on the development of fine
artists. However, Mrs. Nelbert Chouinard's program was from the beginning

Chouinard class
brochure, 1930–31
California Institute
of the Arts Archives,
photographs by
Robert Perine

THE CHOUINARD SCHOOL OF ART

SCHOOL ENTRANCE, GRANDVIEW STREET

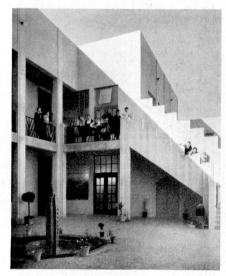

STUDENTS' COURT

the more experimental. Among the impressive faculty and visitors she attracted to her new Grandview Street facility in the 1930s were Alexander Archipenko, Hans Hofmann, Rico Lebrun, Stanton MacDonald-Wright, Richard Neutra, Morgan Russell, and Rudolph Schindler. David Alfaro Siqueiros taught mural painting at Chouinard in 1931 while painting his controversial *Tropical America* on Olvera Street. The following year he completed *The Workers Meeting* in the school's outdoor patio-studio.[36] The presence of this Mexican fresco master (and of Orozco and his then-recent *Prometheus* fresco in Frary Hall at Pomona College) brings to mind Diego Rivera's concurrent residence in San Francisco, where he was painting *The Making of a Fresco Showing the Building of a City* at CSFA. California schools were at the vanguard of the Mexican mural movement as it entered the United States and determined the stylistic (and frequently ideological) direction of public art projects during the WPA era.[37]

In a recent interview, Emerson Woelffer recalled the years prior to Chouinard's forced transformation into CalArts in 1970.[38] He contrasted the emphasis on drawing at the Art Institute of Chicago, where he studied, and the experimental atmosphere at Chouinard, where the best students were "way out." Woelffer acknowledges that he did not recognize at first how good or how dedicated they were: "I had to forget the whole background of my way of doing it [teaching]. I thought, Here's L.A., let them express themselves. It was not teaching them. I let 'em go their own ways."[39] And the most interesting students, those who went on to successful careers, responded. Among them were Foulkes, Goode, and Ruscha, who in separate interviews singled out Woelffer for having been a model of the committed professional artist and for his openness to work and ideas that he did not necessarily approve of or even understand. According to Ruscha, Woelffer, along with Robert Irwin, had the strongest influence on him. Ruscha went on to say that "the instructors were almost not as important as the students . . . being surrounded by students who were really aggressive and inventive and full of life had more of an influence." Nonetheless, in the same interview, Ruscha cited the exchange with certain teachers as an important part of the Chouinard experience: "The influence was not by their work but by the aura they created about the whole thing [making art, being an artist]."[40] This is a sentiment shared by many artists as well as by the more insightful teachers.

Despite these progressive developments, the passing of Chouinard represented a dramatic break with the old-style craft-technique-skill art school and the advent of the strategic art-career professional institution of the present day—what Miriam Schapiro spoke of when describing CalArts of the

early 1970s as "the most avant-garde art school in the country."[41] The "bridge" group, those faculty who were associated with both Chouinard and CalArts, provide the best insight into that change and into a subsequent loss of historical identity. Certainly the New Yorkers—Paul Brach, Allan Kaprow, Max Kozloff, Emmett Williams, and others—who appeared at the Valencia campus to initiate what was viewed as a great experiment in education, had no sense of connection to the old school or, for that matter, to the twenty-mile-distant city of Los Angeles, where Chouinard had provided art training for half a century. CalArts became the West's first truly international art school, looking more to the galleries of New York than to the developing art world of the region where it happened to exist (most inconveniently, in the eyes of newly arrived faculty from the East).[42]

With certain notable exceptions, such as the Chicano muralists, the leading individuals and groups in the development of California art have tended to be associated with teaching institutions, typically the main sites for artistic community and for the development of ideas and movements. Perhaps

Chris Burden, *Shoot*, F-Space, Santa Ana, November 19, 1971 Courtesy of the artist

the most noteworthy—and historically significant—example of this phenomenon is the rise of the feminist art movement at California State College, Fresno, and at CalArts around 1970. More than any other art-related event, Judy Chicago's feminist program at Fresno embodied the acceptance of activism and the nurturing of social change within an educational setting.[43] Why Fresno? one may well ask. Among the various possible answers, the one that seems most promising is that these new institutions—of which there were dozens in the expansive California of the 1960s and 1970s—provided a freedom for experimentation, hoping to garner the attention that would make a name for the school and attract students.

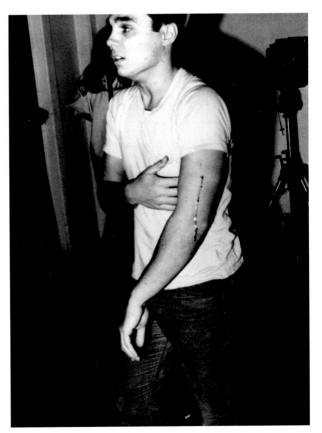

Combined with the presence of imaginative and committed faculty, this may explain a California educational environment characterized by innovation. Newer campuses such as UC San Diego and especially UC Irvine, once a center for the most avant-garde art and cultural theory in the state, thus had a certain advantage over more established university programs, such as those at the University of Southern California, UCLA, Stanford, and UC Berkeley. Along with CalArts, Irvine was the California home of Conceptualism in the early 1970s. Ample funds for visiting professors brought philosophers Jacques Derrida and Michel Foucault, critics Phil Leider and Barbara Rose, and artists Tony DeLap and Robert Irwin, and the school became the true successor to UC Davis as the campus with the most interesting and sophisticated art program in the public university system. Irvine is, after all, the school that awarded Chris Burden an MFA for spending five days in his school locker, creating one of the defining legends of Conceptual and performance art.

In the early and mid-1960s, UC Davis had occupied center stage because of what was then perhaps the most impressive fine-arts faculty of any California institution. Robert Arneson, Roy de Forest, Manuel Neri, Wayne Thiebaud, and William T. Wiley headed a group of art stars to rival any assembled since. And where the famous artist-teachers go, the students follow. As a result, Wiley found himself in charge of former math and music major turned art graduate student Bruce Nauman. In a 1997 interview, Wiley recalled Nauman and described the extremely productive interaction between teachers and students at Davis: "Bruce was important for me, as many students were at different times, in terms of who gives you what and who gains from that . . . I think Bruce's approach clarified things for me in my own work, things I hadn't been able to resolve."[44]

Wiley also spoke of the traditional balance maintained at Davis with, as he put it, Wayne Thiebaud on the right and me on the left,[45] offering students a range of creative avenues to explore. At the time, Wiley may have been the single most influential artist for students in American art schools. His cartoon drawing and watercolor style were imitated in classrooms around the country during the late 1960s and early 1970s. As fond as he was of his experience at SFAI, from which he received a BFA (then CSFA; 1960) and MFA (1962), he found the fairly open academic environment at Davis more stimulating intellectually and more conducive to Conceptualist experimentation.[46] It seems probable that Conceptualism was more developed at California schools than elsewhere in the country in large part because of this productive teacher-student collaboration. Starting in the 1960s, students at the newer UC and

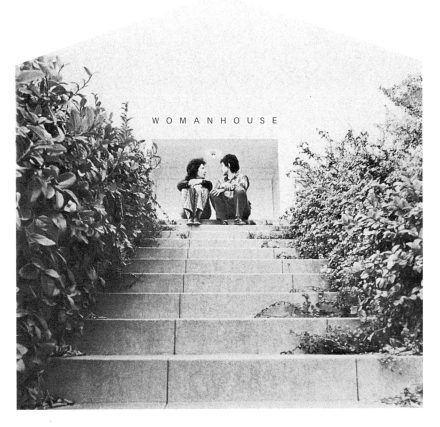

Miriam Schapiro and
Judy Chicago on the
cover of Womanhouse
catalogue, designed
by Sheila Levrant
de Bretteville, 1972
Through the Flower
Archives

state college system campuses felt not only free but encouraged to experiment
and move outside traditional art school categories and materials.

The greatest contribution of California arts education, as suggested
above, was the feminist art movement introduced at Fresno and developed at
CalArts though Judy Chicago and Miriam Schapiro's Womanhouse collabora-
tion in Los Angeles in 1972. The two have been credited with being the "first . . .
to theorize and develop a form of education in the visual arts based on femi-
nism."[47] Judy Chicago established the Feminist Art Program at Fresno in 1969,
and in 1971 Paul Brach and Miriam Schapiro invited her to bring the program
to fledgling CalArts. Recalling those early days, Chicago describes the impetus
for her activities at Fresno and the source for her famous "central-core"
imagery: "During the sixties, it was simply impossible in the L.A. art scene to
make art that revealed your gender and still be taken seriously. The formal
language of art had become its subject matter, and personal content had to be
submerged or coded in a visual language intended [for] a small audience."[48]
She went on to say that many early feminist art issues—personal content, the

body—have moved into the mainstream without their origins having been credited. Those origins include not only several feminist artists and their students but also the California schools—notably Fresno and CalArts—that provided support for what Schapiro now acknowledges as extremely radical programs.[49] These feminist activities played a role in further opening the doors of American academia to identity programs based not only on gender but also on ethnicity, race, and sexual orientation.

Nonetheless, and despite the acknowledged support of Brach and Schapiro, Chicago does not view the move of her program to CalArts, a "male-dominated" institution, as a success. She believes that it was "impossible for my students to stand up to the pressure of the institution."[50] Schapiro, however, has a less gender-polarized interpretation of the situation: "The Fresno students were unsteady in the face of those hip students they encountered at the most avant-garde art school in the country. The irony is that *they* were the *true* avant-gardists [emphasis added]. They created Womanhouse, a historical phenomenon for students in an art school."[51] However memory and scholarship arrange the details of this history, the fact remains that events centered in California schools and art programs anticipated, embodied, and extended important social and cultural developments unfolding elsewhere in America.

Among the major art education programs in California, too frequently overlooked despite a history going back to 1888, when Miss Caribel Stiles was listed in the first Pomona College catalogue as teacher of drawing and painting, are those of the Claremont Colleges—Pomona, Scripps College, and Claremont Graduate University.[52] A recent interview with Roland Reiss, chair of the art department at Claremont Graduate University from 1971 to the present, provides an illuminating survey of the innovative art consortium growing out of the early programs at Pomona and, especially, Scripps during the years from 1932 to 1960.[53] Millard Sheets, director of the Scripps art department from 1936 to 1955, established Claremont as a center for regionalism in Southern California and simultaneously became a towering presence in California art of that period.[54] In the 1930s, Sheets may have been California's best-known artist, bringing unprecedented national attention to the state as a center for art. He was a founder of the California school of watercolorists and an advocate of a practical professional art training focused on architectural decoration, including murals, mosaics, ceramics, and sculpture.

In this respect Sheets was the leading (and, in his own professional life, by far the most successful) proponent of the commercial and applied arts

emphasis established in most California art schools prior to the 1960s.[55] Despite the reactionary, antimodernist reputation bestowed upon him by a too-cozy relationship with powerful patrons such as Howard Ahmanson, and the onus of having fired Peter Voulkos from his position at Otis, thereby closing the school's now-historic "pot shop," Sheets played one of the most important roles in the history of art education in California.[56] Sheets created a basis for fine-arts training at the Claremont Colleges. Under his direction, the Scripps program was oriented toward crafts, but his curriculum was balanced by that of the intellectual art theorists at Pomona—including, a few years later, critics and historians such as Nicolai Cikovsky, Bates Lowry, Peter Selz, and Seymour Slive.

The Claremont Graduate University art department was established in 1971 as the country's first art program devoted exclusively to graduate study, and it has developed into one of the leading advanced training programs. Among the features that distinguish the program is a democratic approach that involves students in most of the departmental decisions, including the awarding of fellowships, admissions, and even the selection of adjunct professors. Based upon the Black Mountain College model, the program's philosophy is a hands-on approach in which student interaction is a critical part of the learning experience. Roland Reiss notes that his program has been criticized

Members of the faculty, School of the Arts and Architecture at UCLA, 1999 Photograph courtesy of the Department of Art, UCLA, © 2000 by George Lange

for having no philosophy, and he agrees in that there is no single idea of what art—or the teaching of art in terms of specific goals—should be. The curriculum concentrates on studio practice—especially painting, installation, and performance art—but has a commitment to critical theory as well. According to Reiss, "At Claremont we're trying to do it all."[57]

In contrast to the mentoring system at CalArts, Claremont requires students to interact with as many faculty as possible while taking responsibility for their own education. Among the graduates are Greg Colson, Kim Dingle, John Frame, Hap Tivey, and James Turrell, a reminder that CalArts, CCAC, SFAI, UC Davis, and UCLA have no monopoly on attracting and graduating the most promising students. From his vantage point as program chair, Reiss describes the role of art schools in California in a way that is distinctive, if not entirely unique:

The larger theme is why the schools are so powerful in the professional life of the whole area. There was no market . . . so artists had to live mainly off teaching. The schools became a base from which artists could operate. At least there were exhibitions. [A few] publications were coming out of these institutions. And I think that's carried through to the present time— that tradition of the school being an important player in the [art] professional life of Los Angeles.[58]

The balance of power among California art schools continues to shift. Artist-educators move from one private school or public university campus to another, provoking changes in emphasis and approach—and prominence. However, the centrality of California art schools and their crucial role in shaping the state's art historical and cultural development remain constant. This pattern now seems unlikely to change, despite the remarkable growth and strengthening of the state's cultural infrastructure in the form of museums, exhibitions, and even collecting activity. The lack of contemporary critical writing and publishing, along with a relatively weak commercial gallery system, tarnish the picture of what otherwise might be a complete, balanced, and dynamic art world; those long-held California aspirations may well be realized in the future. In the meantime, the art schools and universities will continue to be, as they have been throughout the twentieth century, the main venues of support for artists and important sources of the innovation and change that continue to shape visual culture in the West.

Paul J. Karlstrom is West Coast regional director, Archives of American Art, Smithsonian Institution. Among his many publications are *The Spirit in the Stone: The Visionary Art of James W. Washington Jr.* (1989); *Turning the Tide: Early Los Angeles Modernists, 1920–1955,* with Susan Ehrlich (1990); and *On the Edge of America: California Modernist Art, 1900–1950* (1996). He has most recently contributed to the volumes *Diego Rivera, Art and Revolution* (1999) and *Over the Line: The Art and Life of Jacob Lawrence* (2000).

1 This essay relies on interviews conducted by the author, in his capacity as West Coast regional director for the oral history program of the Smithsonian Institution's Archives of American Art (AAA), primarily over the past twenty-six years. Unless otherwise noted, all quotations are from interviews conducted by the author for the AAA.

2 Arthur Danto's idea of an art world that involves participation in what he calls the "discourse of reasons" is particularly useful as art has become more conceptual and as earlier notions of what defines a work of art have been abandoned. His points of reference for these discussions are Marcel Duchamp and Andy Warhol, both of whom exerted important influences in California that eventually determined the direction of several influential art programs. See Arthur C. Danto, "The Art World Revisited," in *Beyond the Brillo Box: The Visual Arts in Post-Historical Perspective* (New York: Farrar, Straus and Giroux, 1992), esp. 40–42. For Duchamp's impact on one significant line of development, see Bonnie Clearwater, ed., *West Coast Duchamp* (Miami Beach, Fla.: Grassfield Press, 1991). The idea of art as a historically aware *intellectual* activity, involving "discourse" among members of an art world, would seem to require a gathering place, a role the university department or art school is ideally suited to fill.

3 In the 1970s the California Institute of the Arts (CalArts) assumed a primary position among art schools in advancing the cause of Conceptual art. Many of its star graduates, among them Ross Bleckner, Eric Fischl, David Salle, Mike Kelley, and Matt Mullican, were attracted to a well-connected faculty that included John Baldessari (now at UCLA) and that could provide valuable art world career contacts. The old apprentice-master system, one in which technique and craft were passed on by experienced teachers, has been almost entirely replaced by an educational culture of networking and connections.

4 Chris Burden quoted in Deborah Solomon, "How to Succeed in Art," *New York Times Magazine,* June 27, 1999, sect. 6, p. 38.

5 Barbara Kruger quoted in Solomon, "How to Succeed," 40.

6 Nathan Oliveira, now retired from Stanford University after a thirty-year teaching career there (following stints at SFAI; California College of Arts and Crafts [CCAC]; University of Illinois, Urbana; UCLA), confided in an interview that the security of a teaching position and what that implies in terms of maintaining the status quo could adversely affect work in the studio. He himself suffered a block when he arrived at Stanford in 1964. Oliveira, interviewed by the author, Aug. 9 and Oct. 6, 1978, Sept. 7, 1980, AAA, 58–61. The possible negative effect on students within a

self-perpetuating academy, which—many believe—poorly prepares them for the consumer art world waiting for them, is a serious related issue.

7 Terry R. Myers, "Art School Rules," in Lars Nittve and Helle Crenzien, *Sunshine and Noir: Art in L.A., 1960–1997,* exh. cat. (Humlebaek, Denmark: Louisiana Museum of Modern Art, 1997), 205. It is interesting that sophisticated contemporary Los Angeles artists such as Lari Pittman, a graduate of CalArts and currently on the UCLA art department faculty, appears to value the now frequently questioned notion of benign neglect: "I think here you can grow like a weed—with sweet neglect. That's really been part of the history of Los Angeles, thriving like a weed. Maybe that difference actually fuels production to a degree" (quoted in Myers, "Art School Rules," 202; roundtable discussion "Los Angeles, Jardin d'herbes folles/Growing Weeds in L.A.," *Blocnotes* 7 [fall 1994]: 124). Pittman's career is one of the strongest cases for the central position of the art school in California.

8 Myers, "Art School Rules," 202.

9 *Constitution, By-Laws, and List of Members of the San Francisco Art Association* (San Francisco: San Francisco Art Association, 1872). The San Francisco Art Association was founded in 1871 by a group of prominent artists and civic leaders. Among the early members were painters Thomas Hill

and William Keith, cable car inventor Andrew Hallidie, future U.S. Senator James D. Phelan, and Big Four railroad tycoon Charles Crocker.

10 Ibid. Over its long history, the San Francisco Art Institute has had a number of incarnations: established as the California School of Design (1874–93), then the Mark Hopkins Institute of Art (1893–1906), San Francisco Institute of Art (1907–16), the California School of Fine Arts (1916–61), and SFAI (1961–present).

11 The SFAA and the Bohemian Club (founded 1872) counted among their (usually shared) memberships most of the leading artists of the day, including, during the early period, most of the directors of the school, in addition to Williams, Emil Carlsen, Arthur Mathews, Theodore Wores, Spencer Mackey, and Frank Van Sloun. For a summary of this historic relationship, see the author's "Creeping Towards Modernism, 1871–1945," in San Francisco Art Institute: Illustrious History, 1871–Present, exh. cat. (San Francisco: San Francisco Art Institute, 1996); and "Turn of the Century," in James Earl Jewell, ed., The Visual Arts in Bohemia: 125 Years of Artistic Creativity in the Bohemian Club, annals, vol. 8 (San Francisco: Bohemian Club, 1997), 5–74. For a general history of the SFAI, see Mark Dobbs, "A Glorious Century of Art Education: San Francisco's Art Institute," Art Education (Jan. 1976): 13–18. The best account of the early period of the school appears in Raymond L. Wilson, "The First Art School in the West: The San Francisco Art Association's California School of Design," American Art Journal (winter 1982): 42–55. See also Kent Seavey, Artist-Teachers and

Pupils: San Francisco Art Association and California School of Design, The First Fifty Years, 1871–1921 (San Francisco: California Historical Society, 1971).

12 Among the studies that document and critically discuss the MacAgy era at the CSFA, three are essential to the subject: Thomas Albright, Art in the San Francisco Bay Area: 1945–1980 (Berkeley and Los Angeles: University of California Press, 1985), esp. chaps. 3 and 4; Mary Fuller McChesney, A Period of Exploration: San Francisco 1945–1950 (Oakland: Oakland Museum, 1973); and Susan Landauer, The San Francisco School of Abstract Expressionism (Berkeley and Los Angeles: University of California Press, 1996). Also informative is Richard Cándida Smith's account, especially regarding the ideological struggle following MacAgy's resignation in 1950 and whether or not "neoromantic" abstraction or Bauhaus design would determine the direction of the school. See "Revolution at the California School of Fine Arts: Abstract Expressionism in San Francisco," chap. 4 in Cándida Smith's Utopia and Dissent: Art, Poetry, and Politics in California (Berkeley and Los Angeles: University of California Press, 1995), esp. 119–32. While each writer notes differences between the New York and San Francisco brands of action painting, Landauer argues most persuasively for the nonderivative independence of the West Coast movement.

13 The romance that attached itself to Clyfford Still as a presence at CSFA attained mythic proportions and was traded on by the school, and by the San Francisco art community, for years after the artist departed in response to

MacAgy's 1950 resignation. Richard Cándida Smith's explanation that Still "saw no reason for serious artists to stay in California" (Utopia and Dissent, 128) is entirely consistent with what we know of the artist's low opinion of San Francisco and its art world. In fact, there is more than a bit of irony in invoking Still as a measure of the art historical power of the Bay Area, as is still frequently done. Critic Thomas Albright, especially, marked Still's years at the school as the high point of art in the Bay Area, judging subsequent artists and developments in terms of a fall from grace: see the author's review of Albright's Art in the San Francisco Bay Area in Archives of American Art Journal 25, no. 4 (1985): 24–29. At any rate, SFAI has benefited greatly from this association and enhanced reputation. For a recent discussion of the feminist art movement in California, notably its connection to CalArts and Fresno, see Faith Wilding, "The Feminist Art Programs at Fresno and CalArts, 1970–75," in Norma Broude and Mary D. Garrard, eds., The Power of Feminist Art: The American Movement of the 1970s, History and Impact (New York: Harry N. Abrams, 1994), 32–47. See also Laura Meyer, "From Finish Fetish to Feminism: Judy Chicago's Dinner Party in California Art History," in Amelia Jones, ed., Sexual Politics: Judy Chicago's "Dinner Party" in Feminist Art History (Berkeley and Los Angeles: University of California Press, 1996), 46–74.

14 Interview with Joan Brown, July 1, July 15, and Sept. 9, 1975, AAA, 35. Several other revealing points emerged from this interview, including a prefeminist acceptance of the habits of the "predatory" male teacher,

as evidenced in Brown's friendship with notorious womanizer Jean Varda: "I liked him, and he loved young women! My God, I was seventeen years old, and he and I were just the greatest buddies" (37). On the other hand, the support she received from Elmer Bischoff at CSFA and his mentorship over the years were critical to establishing her self-confidence and to her growth as an artist. Bischoff's supportive regard for Brown and her talent is evident in his interview (Aug. 10, Aug. 24, and Sept. 1, 1977, AAA, 58). This relationship no doubt contributed to Brown's impatience with feminist complaints about male oppression. When asked if she resented having no female role models, she responded, "I never thought of that, male or female. Art, things I'm struck by, could be done by a gorilla, and I don't give a damn. Whatever goes into it, we're all from the same species" (Brown interview, 41).

15 Maynard Dixon, quoted by Donald J. Hagerty in *Desert Dreams: The Art and Life of Maynard Dixon* (Layton, Utah: Gibbs Smith Publishers, 1993), 10.

16 Maurice Logan interview (taped) by Rene Weaver, June 14, 1984; quoted in Nancy Boas, *The Society of Six: California Colorists* (San Francisco: Bedford Arts, 1988), 36.

17 Paul Carey interview, Dec. 3, 1993, AAA (conversation off tape). Confirmed with subject, June 7, 2000.

18 Leo Holub interview, July 3, 1997, AAA, 7.

19 Florence (Mickelson) Holub in phone interview with author, Nov. 9, 1999, expanded upon the statement quoted from her column "Florence's Family Album: Illustrated Reminiscences," in *The Noe Valley Voice,* Nov. 10, 1999, p. 41. She also confirms the

prevalent view that, despite the teaching career objectives mentioned, many female students in the 1930s—in contrast to the majority of male students—were attending art school for social as well as professional reasons. Hassel Smith, a teacher at CSFA from 1945 to 1951, recalls his own earlier experience: "When I was a student at the school [1936–38], it was a debutante kind of place. It was just crawling with socialites. The GI Bill was a godsend" (Hassel Smith interview by Mary Fuller McChesney [tapes and transcripts at AAA], quoted in McChesney, *A Period of Exploration,* 9.

20 Charles Linder interview, July 10, 1999, AAA, 11–12. Linder created Refusalon as a Conceptual art "performance" piece, in which his own competing idealism and material practicality, an entrepreneurial counterbalance to the anarchical artist image promoted at SFAI, find expression and may even achieve some balance in the world beyond art school. Having turned the gallery over to his partner, Linder has yet to evaluate the results of his experiment.

21 David Jones, in a telephone interview conducted by the author, July 8, 1999. Armed with an MA (1971) and an MFA (1973) from UC Berkeley, Jones embarked upon a promising career with a SECA award (given by the Society for Encouragement of Contemporary Art, San Francisco Museum of Art, 1974), an NEA individual artist grant, a solo show in New York, and an appearance in the Whitney Biennial, all in 1975. He was among the four youngest artists (the others were Darryl Sapien, Greg Renfrow, and Tom Wudl) to be included in the exhibition *Painting and Sculpture in California: The*

Modern Era. Organized by Henry Hopkins and Walter Hopps for the San Francisco Museum of Modern Art, where it appeared in the fall of 1976, the show traveled to the Smithsonian Institution's National Collection of American Art the following year. Jones continues to exhibit and sell work, augmenting his income with a commercial design and fabrication business he operates from his Emeryville studio. The necessary technical skills were acquired not at Berkeley but during his first two years at the Kansas City Art Institute.

22 CSFA class bulletin (1939–40), unpaginated. José Moya del Piño was listed as instructor of mural painting. The radical departure introduced by MacAgy at the school had its metaphorical expression in the neglect and disinterested treatment of Diego Rivera's mural *The Making of a Fresco Showing the Building of a City* (1931) in the CSFA gallery. The mural was partially obscured from view by a screen placed a few feet from its surface, which remained in place from about 1949 to 1956. Classes in muralism were expunged from the curriculum at about the same time (late 1940s), marking the shift of emphasis from a career-oriented program to one of fine-art "neoromantic" expressionism. Later, in the 1960s, Fred Martin (dean of the college from 1965 to 1975) and other faculty moved to eliminate all vestiges of the commercial program, including crafts and design.

23 Cándida Smith (*Utopia and Dissent,* 128) identifies what was at stake, besides the survival of CSFA, in this debate. His discussion correctly places the school at the center of what should be regarded as the most important *cultural* issue in

relation to art education in California and elsewhere. Most private schools and academies have remained philosophically ambivalent on this question, while in practice they have come down on the side of practical career training.

24 Ibid., 131. The success of Art Center College of Design—quality of faculty and teaching program aside—comes from its close connections to corporate America, notably the automobile industry, for which its students were and are superbly trained in car design. Ford, General Motors, Chrysler, and many advertising agencies have provided grants and looked to Art Center for their future design department staff members.

25 Charles Strong interview, Mar. 30, 1998, AAA, 8, 13. Strong returned the favor to CSFA by extending the Abstract Expressionist ethos in his own work over most of his career. See the author's "Painterly Intuition: The Early Paintings of Charles Strong," in *Fire and Flux, An Undaunted Vision: The Art of Charles Strong* (Belmont, Calif.: College of Notre Dame, 1998).

26 Robert Colescott interview, Apr. 14, 1999, AAA, 3.

27 Ibid., 11.

28 Ibid., 6. See also AAA interviews with Jay DeFeo, June 3, 1975, 19–22, and Elmer Bischoff, 9–10. Both interviews—but especially DeFeo's (15–30)—are rich in descriptions of CSFA and UC Berkeley art programs and faculty.

29 Raimonds Staprans interview, Aug. 25, 1997, AAA, 33.

30 Ibid.

31 Ibid., 29.

32 Bischoff interview, 74.

33 Richard Shaw video interview, Apr. 3 and 6, 1998, AAA, Apr. 6, tape 3; audio track transcript, 22, time code 03:11:40.

34 Shaw, audio track transcript, 28, time code 03:14:55.

35 The definitive account of the history of Chouinard Art Institute is Robert Perine's *Chouinard, An Art Vision Betrayed: The Story of the Chouinard Art Institute, 1921–1972* (Encinitas, Calif.: Artra Publishing, 1985). For the early 1960s faculty-student group, see especially 178–81 and the account of the battle over Joe Goode's display of a collage of cigarette butts (misattributed in Perine to Ed Ruscha). The piece was objected to by instructor Donald Moore, who actually burned a corner of the work with his cigarette lighter, an act that polarized the faculty and incited a student protest. See interviews with Joe Goode (Jan. 5, 1999) and Emerson Woelffer (Mar. 26, 1999) conducted by the author (AAA).

36 Ibid. Discussion of distinguished faculty appears primarily in chap. 4, "Matron of the Arts": Feitelson and MacDonald-Wright (74–76); Neutra, Schindler, Archipenko, et al. (71ff.); Siqueiros and Orozco (67–69).

37 A number of publications have appeared on the Mexican muralists in the United States, especially on Diego Rivera, and on the draw of Mexico for Americans. A main source is Francis V. O'Conner, "The Influence of Diego Rivera on the Art of the United States during the 1930s and After" in *Diego Rivera: A Retrospective,* exh. cat. (Detroit: Detroit Institute of Arts in association with W. W. Norton, New York, 1986), 157–83. For studies devoted exclusively to California, see Anthony W. Lee, *Painting on the Left: Diego Rivera, Radical Politics, and San Francisco's Public Murals* (Berkeley and Los Angeles: University of California Press,

1999); Margarita Nieto, "Mexican Art and Los Angeles, 1920–1940," in *On the Edge of America: California Modernist Art, 1900–1950,* edited by the author (Berkeley and Los Angeles: University of California Press, 1996), 121–35; and the author's "Rivera, Mexico, and Modernism in California Art," in *Diego Rivera: Art and Revolution,* exh. cat. (Mexico City: Instituto Nacional de Bellas Artes and Landucci Editores, 1999), 219–33.

38 Endowed with more than $30 million from the Walt Disney family, Chouinard built a 60-acre campus in Valencia (which opened in 1971) and changed its name to California Institute of the Arts. For an interesting commentary on CalArts from a prominent artist-educator, see Roland Reiss interview, June 11, 1999, AAA, 91–94.

39 Emerson Woelffer interview, Mar. 26, 1999, AAA, 15. Among the few Chouinard faculty who were briefly at CalArts, Woelffer was fired by Paul Brach after only one year, then went to Otis Art Institute (19–21).

40 Ed Ruscha interview, Oct. 29, 1980, AAA, 20, 22. Ruscha also discusses the dynamic presence of John Altoon and his impact as a role model (29). For further appreciative mention of Woelffer, see also Joe Goode interview (Jan. 5, 1999 [untranscribed], tape 1, side A) and Llyn Foulkes interview (June 25 and July 17, 1997, and Dec. 2, 1998) conducted by the author (AAA). Foulkes credits the influence of his teacher, an acknowledgment that he is usually inclined to withhold (Dec. 2, 1998 [untranscribed], tape 3, side A). Ruscha's account of his experience at Chouinard, including his original intention to study

commercial art at Art Center College of Design and his reasons for switching to fine art, appears in his interview (19–31).

41 Miriam Schapiro quoted in Norma Broude and Mary D. Garrard, "Conversations with Judy Chicago and Miriam Schapiro," in Broude and Garrard, eds., *The Power of Feminist Art,* 75.

42 In conversation with the author, May 30, 2000, John Baldessari recalled with pride his role in recruiting prominent New York artists during his early days at CalArts. In Christopher Knight's interview with Baldessari (Apr. 4–5, 1992, AAA, 48), the artist remembers looking around the CalArts parking lot and noticing that "ninety percent of the plates were New York or New Jersey. And then you realize[d] that this was going to be a sort of total import of New York culture into California."

43 See Wilding, "The Feminist Art Programs" and Meyer, "From Finish Fetish to Feminism."

44 William T. Wiley interview, Nov. 17, 1997, AAA, 137–38.

45 Ibid., 142.

46 Ibid., 141.

47 Broude and Garrard, "Conversations with Judy Chicago and Miriam Schapiro," 66.

48 Ibid., 70.

49 Ibid., 74. Schapiro describes how the art dean at CalArts, her husband Paul Brach, thought the feminist program was too "radical" for him to accept without involving the art faculty, of which Schapiro was the only female member. She remembers employing an age-old political strategy by inviting the faculty (including John Baldessari, Allan Kaprow, and Stephan von Heune) individually to dinner to present her case. Her method was successful, and Judy Chicago

was subsequently invited to bring her Fresno students to CalArts.

50 Ibid., 67.

51 Ibid., 75.

52 Brochure quoted in Marjorie Harth Beebe, *Art at Pomona, 1887–1987: A Centennial Celebration* (Pomona: Montgomery Gallery, 1997), 11. For a thorough listing and comprehensive discussion of the early Los Angeles–area art schools, see Nancy Dustin Wall Moure, *Drawings and Illustrations by Southern California Artists before 1950,* exh. cat. (Laguna Beach: Laguna Museum of Art, 1982), esp. 5–13. Also extremely relevant and informative is Susan Ehrlich's "The Jepson Group: The School, Its Major Teachers, and Their Drawings" in the same exhibition catalogue, 44–55.

53 Reiss interview, AAA. Also, Reiss handwritten statement on the history of the Claremont art programs (1999), Roland Reiss Papers, AAA.

54 On Sheets, see Mary Davis MacNaughton, *Art at Scripps: The Early Years,* exh. cat. (Claremont: Scripps College, 1988), and Millard Sheets interview, Oct. 1986, AAA.

55 For Reiss on Sheets's emphasis on applied arts and design, see Reiss, 80.

56 Sheets, 65–68, for Sheets's version of firing Peter Voulkos from Otis. For other views on Sheets's attitude toward modernism and a critical appraisal of his prominence in Southern California, see Peter Selz interview, July 28, 1992, AAA, 19–23.

57 Reiss, 100. Reiss believes that Claremont provides an unusual range of choices, in comparison with other California programs at UCLA, CalArts, and elsewhere, reflecting the belief that artists need to be prepared for careers. According to Reiss, 40 percent

of Claremont graduates are teaching at colleges, universities, and art schools—one result of the school's commitment to practical professional training within a fine-art environment. Reiss feels that the programs at CalArts and Art Center differ from that at Claremont because at those schools there is more focus on theory. This could well explain the prevalent view that art coming out of art schools is almost entirely strategic, in a careerist sense.

58 Ibid., 79.

WE HAD COME, WITHOUT

KNOWING IT, TO OUR INEVITABLE PLACE

Robinson Jeffers

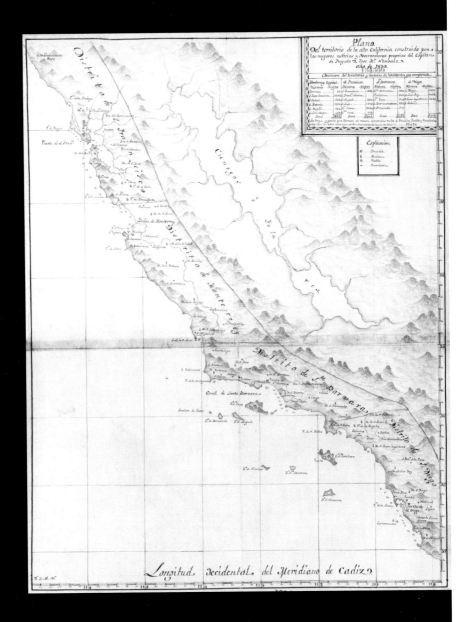

José María Narvárez,
*Plano del Territorio
de la Alta California,*
1830
California History Room,
California State Library,
Sacramento, California

Blake Allmendinger

ALL ABOUT EDEN

Throughout time, California has been objectified by artists and writers, politicians and kings, missionaries and military explorers, and dream-seeking settlers and immigrants. In the year 1500, the Spanish novelist Garci Ordóñez de Montalvo envisioned California as an "island of Amazons," mythically located "near to the terrestrial paradise."[1] **Subsequent Spanish missionaries, in the** seventeenth and eighteenth centuries, attempted to transform California into a divine earthly outpost where men of God rescued the souls of "savage" Native Americans. In the early nineteenth century, when Mexico secured its independence from Spain, the missions were secularized and transformed into ranchos run by the wealthy elite. The commercial exploitation of California continued in the mid-nineteenth century, when gold miners rushed into the new U.S. territory in the late 1840s. Ever since then, California has beckoned to millions of hopeful new citizens, who come to the state looking for job opportunities, sunshine and surf, safe refuge, or stardom.

Versions of the California Dream are as various as the people who come here in search of fulfillment. Yet every dream, it seems, has a similar sequel, one that spells disillusion. For every invader who conquers the land, there is a native or previous occupant who must be displaced. For every gold miner, movie star, or high-tech entrepreneur who succeeds, there are many more who don't strike it rich. While California has been depicted as an Edenic utopia, as an exotic tropical paradise, as the ultimate cash prize and end point of Manifest Destiny, and as a glamorous celebrity haven, it has also witnessed a history of oppression, disappointment, and failure that contradicts the success stories. The enslavement of Native Americans, the ridicule of Chinese, the persecution of Okies, the exploitation of migrant farmworkers, and the tensions that led to race riots in Watts and greater Los Angeles are reminders that the California Dream often mocks the reality.

Nowhere is this more true than in literature. In the late nineteenth century, two landmark novels, written by women from dissimilar backgrounds, both indicted the dream. *Ramona* (1884), by Helen Hunt Jackson, addressed the removal and persecution of an Indian peasantry, while *The Squatter and the Don* (1885), by María Amparo Ruiz de Burton, dealt with the subsequent sufferings of the Mexican gentry, who were displaced in their turn by white U.S. settlers. Published within a year of each other, both novels depicted a bucolic world that had been invaded by foraging outsiders who sought to deprive the region's previous inhabitants of their land and their lives.

As time passed and the region developed, California remained a contested terrain whose symbolic landscape changed only superficially. *The Big Sleep* (1939), by Raymond Chandler, and *If He Hollers Let Him Go* (1945), by Chester Himes, take place in a modern metropolitan locale very different, it seems, from the rustic scenes described by Helen Hunt Jackson and María Amparo Ruiz de Burton. Philip Marlowe, Chandler's detective, spends most of his time traversing the mean streets of Los Angeles; like Bob Jones, Himes's protagonist, Marlowe finds no redemption in the City of Angels, but instead becomes part of its nastiness. All four novels portray California as a postlapsarian world tainted by racism, interclass warfare, and greed. But whereas Jackson and Ruiz de Burton are earnestly outraged by the wrongs done to impoverished Native Americans and wealthy rancheros alike, Chandler and Himes, as literary exponents of white and African American noir, seem cynically resigned to the defeat of their white and black characters.

The California Dream—deferred or defeated—is a trope that recurs not just in fiction but in fact-based writings as well. *Epitaph for a Peach* (1995), by Donald Mas Masumoto, and *Fields without Dreams* (1996), by Victor Davis Hanson, recount real-life struggles to keep the region's family farms going, in spite of threats posed by surrounding cities and the presence of corporate competitors. Like the pastoral elegies by Jackson and Ruiz de Burton, and the urban pulp fiction by Chandler and Himes, the autobiographies by Masumoto and Hanson are dystopic narratives. Although they vary in tone—Masumoto's calm meditation reads like a eulogy, while Hanson's work draws inspiration from ancient Greek tragedy—the books share the same depressed outlook, as their titles suggest. Whether a white man or woman, a member of the Mexican upper class, an African American bluecollar worker, or a Japanese immigrant, the writers assembled here all face the same challenge: to reconcile some version of the California Dream with the actual or imagined reality.

THE GARDEN

Helen Hunt Jackson's novel tells the story of Ramona, a half-breed, who falls
in love with Alessandro, a native boy. Ramona is disowned by her Mexican
stepmother for choosing to marry an Indian. She and her husband, along with
their children, are forced from Indian lands and chased by Anglo invaders
until Alessandro and their oldest child eventually die. The picturesque rural
locations—featuring Mexican ranchos, native villages, and remote mountain
hideaways—provide romantic backdrops against which the action plays out.
But the landscape does more than merely function as scenery. It forms the basis
of a dispute between the United States and Mexico over control of the region.
For in order to lay claim to Mexican territory, as Jackson points out, the
United States must conquer California itself, not just its residents.[2] In *Ramona*,
natural landscapes are cultivated, tamed, and subdued, just as the Indians are.

The novel begins prior to U.S. invasion, when Mexico dominated
California and its native inhabitants. In this pre-Anglo era, California appears
as a leisurely, civilized paradise. But Jackson suggests that the romantic world
of the Mexican landowning gentry is a carefully constructed façade. Señora
Moreno, Ramona's Mexican stepmother, runs a feudal estate that at first
appears picturesque. On the front veranda, the Señora grows potted plants
and keeps flowers in water jars (15), and from the porch roof she hangs cages
of songbirds (16). But her domestication of nature extends to human nature
as well. Behind the hacienda, in the inner courtyard, the servants prepare food
and sew (14). In this natural setting the labor seems unforced and festive.
But the courtyard—outside, yet enclosed—permits the Señora to supervise
her servants without standing over them. From any window inside the house,
the mistress can look outdoors to see whether her servants are performing
their duties.

The rectangular courtyard contains and frames nature, including gar-
dens, orange groves, and orchards, which end at the banks of a brook. Here
the maids do the washing, under the Señora's strict supervision, in a con-
trolled rustic setting that cultivates nature while it tames native women.
"No long dawdling, and no running away from work on the part of the
maids, thus close to the eye of the Señora at the upper end of the garden,"
writes Jackson, who ironically adds, "if [the women] had known how
picturesque they looked," beating laundry against stones in the brook, "they
would have been content to stay at the washing day in and day out" (16).

The wicked stepmother, Señora Moreno, treats the Cinderella half-breed,
Ramona, like one of the servants. When she goes to the brook to cleanse the

Catholic altar cloth (47), Jackson suggests, Ramona is not only subject to a domestic system of slavery within a Mexican household but implicated in a process of religious indoctrination as well. Considering the Catholic Church's history of enslaving the Indians, in part by preaching a doctrine based on meek subjugation, Ramona's association with the soiled altar cloth becomes doubly meaningful. Ramona seems suited to domestic subservience, from the point of view of the Church and the Mexican upper class, because of her racial impurity. Like the altar cloth, she is sullied—in her case because of her mixed European and Indian ancestry.

Ultimately, Ramona rebels against Mexican maternal and religious authority. While pretending to launder "a bit of lace or a handkerchief," she lingers by the brook in hopes of meeting the shepherd boy. When Alessandro sees her there, wearing "a white reboso [draped] coquettishly over her head" (82), he begins to view her as a woman, not as the Señora's meek hand-maiden (111). Ramona transgresses class boundaries, using her performance of a domestic task as an excuse to elude her stepmother's authority and to consort with an Indian servant who is beneath her in rank. At the same time, her romance with Alessandro and their subsequent marriage, an act of miscegenation, are portrayed as a fall from grace, from the point of view of Christian morality. The white reboso suggests Ramona's virginal innocence, although she wears it while she flirts with Alessandro "coquettishly." The dirty laundry that she washes at the brook symbolizes the sacrilegious nature of Ramona's indiscreet enterprise. As Margarita, a rival for Alessandro's affec-tion, says: "A nice place it is for a lady to meet her lover, at the washing-stones! It will take swifter water than any in that brook, Señorita Ramona, to wash you white in the Señora's eyes" (111). Ramona's disobedience, as the Señora's stepdaughter-servant, is equated in this speech with her sexual and religious impurity.

Nestled within the heart of the Moreno estate, the garden where the two lovers meet is a post-Edenic paradise. The flowering vines, singing birds, and picturesque workers, although they appear in seemingly natural settings, are all closely supervised. Ramona and Alessandro, like the landscape itself, are subjects of Mexican feudalism and mission-style slavery: a half-breed and a full-blooded Indian whom the ruling class dominates. The lovers elope, escaping from a constructed false Eden, where the Señora shelters but also controls her dependents. Eventually, however, they will be dispossessed of their true Eden, by Anglo invaders who claim the native village and farmland that Ramona and Alessandro call home.

Whereas *Ramona* concentrates on the victimization of Native Americans, *The Squatter and the Don* dwells on the displacement of Mexicans, who, like the Spaniards before them, subjugated the Indians, only to be removed from the land by later white immigrants. After the Mexican-American War, U.S. citizens ventured into California, contested Mexican land grants, and staked their claims to the region by instigating lawsuits, boundary disputes, property surveys, and political schemes designed to invalidate Mexican land titles. In the novel, Don Mariano, one of the Mexican gentry, explains why white settlers who squat on his land wish to prolong litigation, "since it is '*the natives*' who must bear the burden of taxation, while the titles are in the courts, and thus the pre-emptors hold the land free."[3]

The don asserts his prior claim to the land by describing himself, and the rest of the Mexican gentry, as natives. But the ruling elite bear little resemblance to the poor indigenous tribes that once lived on the land, and the fact that the don puts the term in quotation marks means that rancheros are natives, not in the true sense, but only compared to more recent arrivals. While the plight of the gentry is dramatized, the fate of the Indians, California's first natives, is minimized.[4] In the novel, Indian vaqueros are among the few indigenous peoples who have survived colonization by Spain and then Mexico. Banished to the margins of the text, they appear in one or two scenes as dependents who herd the don's cattle. In one scene, which takes place at a cow camp in winter, the men are "seen through the falling snow as if behind a thick, mysterious veil." Like shadowy reminders of a long-vanished past, the "enchanted" and "ghostly" vaqueros seem to exist in a magical valley, one "which must disappear with the first rays of day" (279).

Jackson and Ruiz de Burton both write about the disruption of "native" California societies and the loss of a region that is rightfully theirs. But whereas the land plays a central role in *Ramona*, as do Jackson's Indian characters, the land in *The Squatter and the Don* seems to have already vanished, like the vaqueros and their soon-to-be-displaced Mexican overlords. Writing about U.S. invasion in historical retrospect, nearly forty years after Mexico lost California in the Mexican-American War, Ruiz de Burton treats the loss of the land as a fait accompli. Her focus on racist U.S. government policies and dishonest capitalist practices—by corporate oligarchies and railroad monopolies that vie with white settlers for control of the region—transforms the land into the subject of an abstract debate. Every attempt to make California seem palpably real soon evaporates. In one chapter, in which several of her characters visit Yosemite, the author begins by describing their

leave-taking. The natural wonders, like the beautiful ranchos or man-made estates, must be "left behind." Looking backwards, the men and women cast a "last lingering look towards the glorious rainbows" cast by a waterfall. They take with them a "memory of the mirror lakes," as well as a final impression that all joys are fleeting (153).

Helen Hunt Jackson, a white woman who visited California in the late nineteenth century, and María Amparo Ruiz de Burton, a Mexican citizen born and raised on the West Coast, were separated by race and were familiar with the region to different degrees. In addition, they focused on different cultures in California and different historical periods. But the two writers produced similar dystopic narratives. In *Ramona*, a false Mexican Eden ensnares the two native lovers. In *The Squatter and the Don*, the "rainbows" that arch over Yosemite and, by extension, over the region, represent broken or unfulfilled promises. The men and women, who look back regretfully as they exit the beautiful area, symbolize the Mexican gentry who will shortly be dispossessed of their gracious estates.

THE CITY

If Jackson and Ruiz de Burton mourn the passing of paradisiacal agrarian landscapes, Raymond Chandler and Chester Himes usher in the notion of the city as fallen world, tolling the death knell on the California Dream as civilization moves through the twentieth century. Through noir—in which bootlegging, drug smuggling, illegal gambling, blackmail, adultery, and murder advertise civic corruption and human depravity—Los Angeles transforms itself into a treacherous labyrinth that the hero must navigate.

In his pursuit of criminals, Chandler's private eye, Philip Marlowe, tries not to stray from the righteous path, though in the course of his journey he encounters obstacles on the road, hairpin curves, and dead ends.[5] Reading *The Big Sleep*, one is reminded that Los Angeles had become predominantly a car culture by the late 1930s. Much of the action involves Marlowe tailing suspects in taxis,[6] pursuing men in his car (16, 20), and being shadowed by drivers (77, 97). In Chandler, plot equals action: giving chase (101), running red lights and making illegal turns (20), and weaving in and out of traffic to outwit an antagonist (33) are choreographed sequences that give the book momentum. Driving provides a means of escape and often keeps one alive, whereas death is equated with roads that terminate and cars that can't move. In chapter 9, Owen Taylor, a chauffeur by trade, takes a cruise off the pier and ends up dead in the water. His "black and chromium car," like a hearse with him in it,

Kirby Kean, *Night
Scene near Victorville*,
c. 1937
The J. Paul Getty
Museum, Los Angeles

is hoisted from the ocean, while motorists park "on both sides of the highway to watch" (28). In chapter 29, another character comes symbolically to the end of the road. Outside a garage, Marlowe encounters Canino, a criminal. Before Canino can get away in his car, Marlowe hops on the running board and shoots through the window. The car, like Camino, halts dead in its tracks (122).

In Jackson and Ruiz de Burton, the displacement of Indian and Mexican residents is portrayed as a gradual historical process that takes place over time, as a preindustrial region becomes reconfigured and settled. In Chandler, however, people in an urban environment are perpetually on the move, on the make. How they drive—how they negotiate their way through a nightmarish cityscape—indicates how well they adapt to their urban environment and predicts what chance they have to survive. Marlowe becomes our trustworthy guide as he charts a course through the asphalt maze of Los Angeles. Fighting traffic and visiting tough parts of town, he tries to stay on the straight and narrow path as he pursues truth and justice. Significantly, on the rare occasions when Marlowe strays allegorically, he risks losing his life. Seeking information that might shed light on a case, the detective follows a suspect east of Realito and heads toward the foothills. Recklessly negotiating a curve on the road, Marlowe drives too close to the shoulder, skids, and blows a front tire. The accident forces him off his charted course and into the forest of error, leading him to a house where the suspect is waiting to ambush him (109–12). *The Big Sleep* produces what Fredric Jameson calls a "cognitive map" of Los Angeles,[7] an epistemology in which a knowledge of urban geography is equated with an understanding of human nature, both good and evil. When Marlowe leaves the city and ventures into the foothills, he wanders out of his depth and falls victim to predators.

If He Hollers Let Him Go also imagines the city as a mechanized grid in which movement is everything. During World War II, thousands of blacks moved to the West Coast, where many of them took jobs in the aircraft and shipbuilding industries.[8] For these men and women, migration symbolized new opportunities. But for Bob Jones, one of these new arrivals, life becomes a series of obstacles. Although he gets a job in a shipyard, buys a new Buick, and starts dating "the finest coloured chick west of Chicago,"[9] he soon discovers the difference between the California Dream and reality. (In the novel, each day begins with Jones waking up from a nightmare.) The world is even more dangerous in Himes than in Chandler, because in addition to the normal vices that one encounters in noir, Jones must also face racism.

Life in Los Angeles and work as a shipbuilder lead to discrimination, segregation, and a feeling of intense claustrophobia. Jones rents a cramped room in a small house in South Central. The police keep an eye on him, and whites stare at him every time Jones leaves the neighborhood. Racial segregation and an invisible ceiling mean that promotions at work are impossible, a fact symbolized by the restriction of even simple physical activity. Jones and his all-black crew are exiled to the ship's deep interior. In the dark, Jones, who is tall and broad shouldered, tries not to "tear off an ear or knock out an eye" while he looks for "a foot-size clearance of deck space" to step upon (16). The third deck is "a labyrinth of narrow, hard-angled companionways," where "contortionists" toil in poorly lit places without much ventilation (20). Like the ship, which is dry-docked while under construction, Jones has a dead-end job and a life that doesn't lead anywhere. Fittingly, his career and his hopes end in a series of increasingly smaller and more depressed spaces—in a cabin room, where a white female coworker frames him for rape, and in a jail cell "stinking with urine" and "crawling with lice" (196).

Jones only feels secure and at ease when he drives his new car. The aptly named Roadmaster gives him a sense of male and racial empowerment. He gets an erotic lift as he sits in "the soft springy seat," guides the car into traffic, and smells the "pungent, tantalizing" fumes of "the big Diesel trailers" (162). After a tense day at work, the Buick relaxes him. With his fingers "resting lightly on the steering wheel, just idling along," Jones feels friendly toward whites again (37–38). When he is angry, he takes out his frustrations by racing other motorists in order to prove himself. On his way to the shipyard one morning, he challenges a "v-8 full of white guys," nearly sideswipes a Packard, and almost collides with a white man driving a sporty coupe. According to Jones, the contest is racial: "I wanted . . . to push my Buick Roadmaster over some peckerwood's face" (12–14). The car fuels such fantasies and makes reality bearable. But in his nightmares, Jones lacks his own transportation. In his worst dreams, he appears as a streetcar passenger (1), as a pedestrian (69), as a runner (100), and as an innocent bystander implicated in a criminal incident (149). In real life, without his own vehicle, Jones feels personally handicapped, "as if a car had run over me" (99).

Although the highway serves as an outlet, providing physical escape and emotional release from the pressures of life in Los Angeles, the regular city streets form a web that entangles the hero and limits his freedom. When Jones and his girlfriend are out on the town, for example, they stray into the West-side, where blacks are forbidden. The tension accelerates, in Chandleresque

fashion, as Himes describes the street-by-street course that the couple takes. With Jones in the passenger seat, helpless to stop her, Alice takes Hill to Washington, turns right on Western, and proceeds north to Sunset, becoming more and more reckless, "jerking" the car as she shifts into high. Weaving through traffic, she rides the dividing line, tailgates, and continues to speed "as if something was after her." Racing west on Sunset across Vine, she drives past the Garden of Allah apartments and tears down the Strip, going "seventy, eighty, back to seventy for a bend, up to ninety again." At the intersection of Sunset and Sepulveda, she speeds south, then west onto Santa Monica Boulevard, driving on borrowed time, and heads toward the ocean. The police finally stop her, put her in her place by telling the "coons" to leave Santa Monica, and threaten to give her a ticket for trespassing (61–63). Unlike Marlowe, who views Los Angeles cynically from the beginning of the novel, Jones gradually relinquishes the dream as he comes to embrace California's bitter reality. Although urbanization and industrialization tempt black immigrants with rich opportunities, they finally betray blacks who put their faith in these processes. The wartime economy transforms blacks into cogs within the industrial wheel, just as the city segregates residents according to racial identity.

In some ways, Chester Himes couldn't have been more unlike Raymond Chandler. Although both men were born in the Midwest and moved to Los Angeles when they were down on their luck, Chandler was white, reared in privilege, and able to work in the film industry, if not very happily. Himes, who was black, came to Los Angeles in the 1940s, thirty years later than Chandler, and took odd jobs when he was unable to find employment as a screenwriter.[10] Both men, however, viewed California through a glass darkly because of their noir sensibilities. Like Jackson and Ruiz de Burton, who came from divergent points on the compass yet met on the page, Chandler and Himes, in spite of their differences, jointly envisioned a California anti-utopia.

THE FARM

If it seems that California literature conforms to one of two extreme types— nostalgia for a prelapsarian bucolic tradition or stylized, urban-based noir— or that critiques of the California Dream exist only in fiction, then it is useful to recall a recent article published in the *Los Angeles Times*. The article, reporting on farmers who struggle to preserve traditional lifestyles in a postmodern age, suggests an ongoing and very real tension between the California ideal and an imperfect reality. Entitled "The Good Earth," it focuses on Donald Mas Masumoto and Victor Davis Hanson, who have taken up writing as a way of

The San Joaquin Valley,
1994
United States
Geological Survey,
EROS Data Center

calling attention to the plight of the small family farm. Masumoto and Hanson react differently to threats posed by urban encroachment, environmental restrictions, competition from corporate rivals, and adverse government policies. While Masumoto remains somewhat optimistic, Hanson believes that family farms are "a goner and that the nation is worse off because of it."[11]

Masumoto owns an eighty-acre organic farm outside Del Rey, California, fifteen miles southeast of Fresno. In *Epitaph for a Peach*, his autobiography, Masumoto views his occupation romantically. He claims that farmwork provides an escape from the soulless drudgery of civilization.[12] Planting trees and harvesting peaches become sacred seasonal rituals (56). Growing fruit fills him with mystical awe. New leaves unfold and flutter like "wings" (61), while young branches extend over orchard rows, creating "a natural cathedral" to worship in (74). The book invites us to experience life's simpler pleasures, to reconnect with our inner selves and to shrug off routine travails. Masumoto creates a modern-day pastoral—part bonsai garden, part New Age retreat—which promises a holistic cure for what ails us. Hanson, however, diagnoses a bleaker reality, having toiled for years on an unsuccessful farm in the San Joaquin Valley. In *Fields without Dreams*, an account of his struggles between 1981 and 1993, he admits that farming provides "rehabilitation and therapy"—complete independence, contact with nature, and isolation from the ills of society—but he emphasizes that farming also involves financial hardship, brute labor, and loneliness.[13] If Masumoto has a poetic inclination to celebrate farming in bouts of lyrical prose, Hanson has a naturalistic tendency to view life as tragedy. The qualities he admires in farmers are stoicism, epic resilience, and grim self-sufficiency.

In *Epitaph for a Peach*, the family farm is equated with cultural continuity, inclusiveness, and domestic security. Masumoto works the land with his parents, his wife (who is white), and their biracial children. The land provides occasions both for reaffirming his Japanese heritage and for recognizing his multicultural identity. His annual harvest "corresponds with the season for Obon," a Japanese festival that honors the family (128). But his family is represented by racial diversity as well as by ancestral lineage. Masumoto acknowledges this fact by planting a colorful "patchwork" of crops (9) and by weaving "the texture of life" into his fields (11). The patchwork quilt, as a metaphor, suggests a heterogeneous totality. Hanson, however, exchanges the quilt for a concept of California in which each farmer has "his own square." He discusses the city-state, the ancient Greek notion that "each citizen would live and work on a uniformly sized plot" (121). The American yeoman derives from this

model of the democratic Greek citizen, and although the yeoman is nearly extinct, Hanson claims that he still exists in the individual farmer who chooses "to go it alone," who represents "the critical counter voice to a material and uniform culture that at its basis is neither democratic nor egalitarian" (xii).

While Masumoto is an artist who revels in metaphors, Hanson's farmer is more down-to-earth. In addition to quilting a patchwork of crops, Masumoto paints his fields with colorful flowers (13), sculpts his peach trees (75), and stacks the pruned limbs in "haystacks" that resemble Monet's famous paintings (165). Like Masumoto, Hanson describes the farmer as someone who improves upon nature (93). But according to Hanson, the typical farmer isn't romantic and lyrical. More often than not, he's pragmatic, unpleasant, set in his ways, and insensitive. "Most agrarians are obtuse and blunt," he observes. They aren't "physically attractive" or "clever in speech" (213); they tend to be "downright uncouth and unkind"; and they "track mud on your linoleum and leave dirt on your sofa" (215). They're politically incorrect and curmudgeonly, capable of referring to the young homosexual who grew up down the road as the boy who "went queer" (215). But Hanson's farmers are the true nonconformists: principled, hard-headed, gruff, and unsociable.

If Masumoto and Hanson view farming differently, they nonetheless share similar opinions concerning the fate of the land. In a recent book, *Harvest Son* (1998), Masumoto reveals that his farm was once owned by Japanese immigrants who lost their property during World War II when they were sent to internment camps.[14] Although Masumoto, a second-generation American, writes with hope for the future, even he expresses doubts in his literature. *Epitaph for a Peach,* after all, is an elegy—a tribute to small farms, family enterprise, and rural traditions that may not survive.

Masumoto and Hanson—like Jackson and Ruiz de Burton, and like Chandler and Himes—share perspectives on California that differ only in degrees, not in kind. Evident in all of their works—regardless of genre or historical period; regardless of the writer's gender, background, or race—is a tendency to mourn the loss of an ideal past and to herald the arrival of an imperfect present or future. The California Dream always seems to be receding, an impression that can best be glimpsed in historical retrospect. To reinforce that impression, writers seem willing at times to create an even greater fictional distance between the past and the present or future. Hence, Jackson writes about Indians as if they were a vanishing race in order to make their plight seem romantic. Ruiz de Burton refers to the Mexican gentry as natives, equating their history of oppression, which is relatively recent, with that of

Native Americans. Masumoto describes a present that is past in his elegy, while Hanson, who eschews romance and sentiment, nevertheless compares the farmer to the nearly extinct aborigine (24), emphasizing evolutions in agricultural technology that have made the small-time farmer passé. Himes displays the cynicism of a failed romantic who has lost his faith in the future, while Chandler makes Marlowe into a mythical hero, an Arthurian knight engaged in an allegorical quest for truth in 1930s Los Angeles. Although the quest may prove elusive, in California literature, the pursuit of the dream no doubt will continue to motivate writers throughout the twenty-first century.

Blake Allmendinger is professor of American literature in the English Department at the University of California, Los Angeles, where he specializes in literature of the American West. His books include *The Cowboy: Representations of Labor in an American Work Culture* (1992), *Ten Most Wanted: The New Western Literature* (1998), and, with Valerie Matsumoto, *Over the Edge: Remapping the American West* (1998).

1 Howard R. Lamar, ed., *The Reader's Encyclopedia of the American West* (New York: Harper and Row, 1977), 149.

2 Helen Hunt Jackson, *Ramona* (1884; reprint, New York: Signet, 1988), 12. Subsequent citations refer to this edition.

3 María Amparo Ruiz de Burton, *The Squatter and the Don*, Rosaura Sánchez and Beatrice Pita, eds. (1885; reprint, Houston: Arte Público Press, 1997), 74. Subsequent references to this edition appear in the text.

4 Anne E. Goldman prefers Ruiz de Burton's "deglamorized" portrayal of the injustice to Mexicans over Jackson's nostalgic lament for indigenous Indians. See "'I Think Our Romance Is Spoiled,' or, Crossing Genres: California History in Helen Hunt Jackson's *Ramona* and María Amparo Ruiz de Burton's *The Squatter and the Don*," in Valerie J. Matsumoto and Blake Allmendinger, eds., *Over the Edge: Remapping the American West* (Berkeley and Los Angeles: University of California Press, 1998), 65–85.

David Luis-Brown disagrees, believing that Jackson takes Indian issues seriously, while Ruiz de Burton dismisses them. See "'White Slaves' and the 'Arrogant *Mestiza*': Reconfiguring Whiteness in *The Squatter and the Don* and *Ramona*," *American Literature* 69 (Dec. 1997): 813–39.

5 In "On Raymond Chandler," Fredric Jameson describes Los Angeles as "a new centerless city." Philip Marlowe's "routine and life-pattern serve somehow to tie its separate and isolated parts together" (*Southern Review* 6 [summer 1970]: 629). In *The City in Literature: An Intellectual and Cultural History*, Richard Lehan says that the hero "helps personalize the city; he cuts through its anonymity and assembles the pieces of the narrative's mystery" (Berkeley and Los Angeles: University of California Press, 1998), 252.

6 Raymond Chandler, *The Big Sleep* (1939; reprint, New York: Vintage, 1988), 32. Subsequent references to this edition appear in the text.

7 "The Synoptic Chandler," in

Joan Copjec, ed., *Shades of Noir: A Reader* (London: Verso, 1993), 53.

8 Quintard Taylor, *In Search of the Racial Frontier: African Americans in the American West, 1528–1990* (New York: Norton, 1998), 254, 259.

9 Chester Himes, *If He Hollers Let Him Go* (1945; reprint, New York: Thunder's Mouth, 1986), 153. Subsequent references to this edition appear in the text.

10 Raymond Chandler was born in Chicago in 1888. After being educated in England, he returned to the United States. In 1912 he moved to Los Angeles, where he worked in the oil industry and later in Hollywood, without much success. Chester Himes was born in Jefferson City, Missouri, in 1909. He came to Los Angeles in 1942 with hopes of becoming a screenwriter. Instead, he was forced to take a job building ships in San Pedro.

11 Quoted in Martha Groves, "The Good Earth," *Los Angeles Times*, Dec. 12, 1998, A22.

12 Donald Mas Masumoto, *Epitaph for a Peach: Four*

Seasons on My Family Farm
(New York: Harper Collins,
1995), 17. Subsequent references
to this edition appear in
the text.

13 Victor Davis Hanson, *Fields
without Dreams: Defending
the Agrarian Idea* (New York:
Free Press, 1996), 117–20.
Subsequent references to this
edition appear in the text.

14 Donald Mas Masumoto,
*Harvest Son: Planting Roots
in American Soil* (New York:
Norton, 1998), 37.

A Star Is Born, 1937
Courtesy of Academy
of Motion Picture Arts
and Sciences

Dana Polan

CALIFORNIA THROUGH THE LENS OF HOLLYWOOD

From the cartoons that I watched on television in my East Coast childhood, I remember what was for me a primary image of California. Several cartoon characters were on their way to California and passed through torrential rain—a terrible downpour complemented by intensely dark skies and ear-shattering thunder. When they reached the border (literally a line on the terrain), the California side was instantly revealed as pure sunshine, a land of beautiful and resplendent weather (all of this no doubt to the accompaniment of a celebratory anthem like "California, Here I Come").

My first awareness of an idea of California may have come, however, from yet another vastly influential televisual source—*The Wonderful World of Disney,* hosted by Walt Disney. In its early astuteness about the synergy required of modern media enterprises, this popular TV show promoted Disney movies and, most especially, the relatively new Disneyland theme park. For many children of the 1950s and 1960s, California *was* Disneyland, the goal of a quest for ultimate ludic happiness (a quest parodied in *National Lampoon's Vacation,* in which a middle-American family will endure anything to visit Wally World, only to find the amusement park closed for the season).

It is a trivial question, perhaps, but I sometimes wonder which cartoon was the source of my memory of an abruptly sunny California. My suspicion, based on other recollections, is that there were similar scenes in any number of cartoons. This is just one example of a process that has gone on, to far more profound global effect, throughout the entire history of the cinema in California. Images of California circulate; modified, critiqued, or replaced, they float from film to film, often reinvigorated or reinvested with earlier mythic associations.

In a country in which one of the establishing myths is the pioneer quest, the move "out West," it has been easy in the realm of film to associate the journey into the frontier in general with a journey toward Los Angeles and

Hollywood in particular. Indeed, one of the most famous movies about Hollywood filmmaking, the 1937 version of *A Star Is Born,* directly maps pioneer mythology onto the birthing of the star: wilting in the Midwest, Esther Blodgett (Janet Gaynor) takes inspiration from her granny, an old frontier woman who reminds Esther about the wagon trains and implores her to fulfill her Manifest Destiny. She must go west and realize her acting dreams in Hollywood. Esther takes Granny's advice and becomes a big star. But she falters in her devotion to the myth of success after the suicide of her husband, and the elderly granny must make her own heroic journey to the West Coast to inspire her granddaughter and to triumph with her at the film's finale at Grauman's Chinese Theatre, where the gleaming spotlights evoke the glittering gold that impelled earlier adventurers to California.

The pioneer mythology that imagines California to be a site central or even inevitable and necessary to American self-realization has been tenacious in American cinema. A recent striking and somewhat surprising example of this is *Clockers* (1995), directed by inveterate New Yorker Spike Lee. The young hero of the story finally escapes the ills of East Coast ghetto life by hopping a train to California. In the film's final images, the golden gleam of a radiant sunset plays across the young man's face, investing him with well-deserved hope and expectation. It seems that even an ostensible independent like Lee cannot resist the seduction of California.

In the following pages, I will trace some of the meanings California has come to acquire in the popular imagination of Hollywood cinema, including such radiant seductions. My goal, however, will be less to offer a catalogue of what California has meant in film than to suggest some of the dominant trends in the construction of a cinematic mythology. There is in fact no single overriding cultural representation of California in film. The state's image has been in flux across genres and as the film industry responds to changing social conditions. We will see, for instance, that the sunshine offered up in so many Hollywood pictures is only one side of the California experience, and that quite a number of other films from the dream factory turn to darker, less positive images. On the one hand, there is a long history of Hollywood (and California) self-promotion—what tradition has named "boosterism." On the other hand, there is an undercurrent of discontent regarding optimistic mythologies that ranges from personal dissatisfaction (California as the place where individual destinies are doomed, as in the film noir of California-based filmmaking in the 1940s and 1950s) to apocalypse (California as the place where everything will end or fall apart). The history

of these dual representations describes the arc of the unique mythology of California film.

ARE HOLLYWOOD FILMS CALIFORNIAN?

We might begin our investigation with a question that will at first seem paradoxical: Are Hollywood films Californian? We could raise this question on several levels: style (is there a particular look to some films that we might characterize as "Californian"?); content (is there a specifically Californian subject matter?); and even artistic material (are there materials that we might refer to as Californian, as we could in the case of certain building elements in California Arts and Crafts?). Such questions can seem curious given the extent to which California and Hollywood blur in the popular imagination. In a state that has few widely shared urban or geographic icons (the Golden Gate Bridge? the pointy spire of San Francisco's Transamerica Pyramid? the beach?), there is no doubt that for many, the Hollywood sign sums up the California experience. (It is one of the many ironies of Hollywood cinema that the sign originally had nothing to do with the film industry but instead had to do with real estate promotion; in the shortening of the original "Hollywoodland" to "Hollywood," an entire art and culture of cinematic imagination sprang up.)

To be sure, Hollywood may easily seem to have been the movies' destiny. In a 1927 lecture to business students at Harvard, Joseph Kennedy (then the owner of a film company) noted, "I suppose one of the things that may strike you as odd is that the distribution offices of all the companies are in New York City, while all the production is on the West Coast ... The truth is that nature has given to California certain advantages which make it the ideal center for motion picture production. It has sunlight, a good climate, with little rain. Within a short radius of Hollywood there are mountains, plains, deserts, rivers, ruins, city streets, the sea, picturesque old Mexico. New York, on the other hand, remains the financial center."[1] To Kennedy's list of advantages, we could add more politicized ones, such as Los Angeles's long history of open-shop or even antiunion labor practices, which made it a company town with a labor pool that was easy to hire and to exploit.

And yet the geographical advantages of Los Angeles do not necessarily lead to the notion of a uniquely Californian cinematic style. Indeed, other locales possessed many of the same qualities that Kennedy outlined. The earliest years in the consolidation of the American film industry coincided with the industry's far-flung search for places in which to situate large-scale productions, from woody New Jersey, which was the site for a number of early

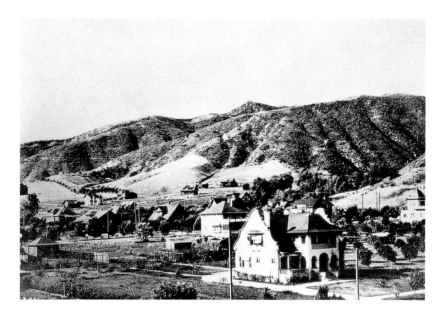

Westerns (including Edwin S. Porter's breakthrough 1903 film, *The Great Train Robbery*) and remained a major locale for outdoor filming, to upstate New York (where D. W. Griffith filmed many adventure tales before heading west), Florida, and Cuba (sites of many productions and attempts at establishing permanent studios). American cinema was in transit, trying out many options before it settled on the Los Angeles region.[2] Moreover, as Kevin Starr notes, even if California were one logical destination for filmmaking, there was a moment in which Northern California might have become the dominant locale for West Coast cinematic production. As Starr recounts in *Inventing the Dream: California through the Progressive Era*,

In 1908 Essanay of Chicago established its studio outside of Southern California altogether, in Niles Canyon outside of Oakland in the San Francisco Bay area. Three years later Essanay was joined in the Niles by the Flying A Company, which produced Westerns. Had this Niles venture taken hold, [screenwriter] Anita Loos later speculated, the film industry would have developed—to everyone's benefit— in close contact with San Francisco's flourishing theatrical, literary, and artistic communities. A San Francisco-based film industry, Miss Loos believed, would have enjoyed California's excellent weather along with an urban sophistication lost when films migrated from the East.[3]

Elsewhere in the same volume, Starr repeats the legendary anecdote in which Cecil B. DeMille is said to have come to the city by accident: According to an often-told story, he decided to break into the lucrative business of filmmaking

with a Western tale—*The Squaw Man*—which he had every intention of filming in Flagstaff, Arizona. A storm forced him further west to California, which he ending up making his long-term base of operations.

From the start, filmmakers extolled the environments around Los Angeles for their potential to represent so many places. The move into massive indoor sound stages on the vast studio lots provided even greater power to construct realities far removed from California. To take just one example, much of the cinematic image of New York in the 1930s—those magical scenes in which someone steps out onto the balcony of an apartment, beyond which a joyous image of the Big Apple rises up as so many tiny lights and foreshortened skyscrapers—was created in the magical world of the West Coast studios. Hence the perception in 1949 that the Gene Kelly film *On the Town* had revolutionized musicals, and escapist cinematic entertainment in general, by actually filming in the outdoor spaces of New York, starting with its docks.

Of course, if California can be enlisted in the representation of other geographies, it is also true that an imagination of California can be constructed

Broadway Melody, 1936
Courtesy of Bison
Archives

elsewhere. Billy Wilder's *Double Indemnity* (1944), a film in which Los Angeles seems so central that critic Richard Schickel declares, in a nice phrase, "You could charge L.A. as a co-conspirator in the crimes this movie relates,"[4] was partly shot in Phoenix, Arizona, due to wartime blackout restrictions on the coast.[5] Nevertheless, what is perhaps most Californian about Hollywood films is not necessarily the specific representation of California locales or experiences but the very ability of the place, indoors or outdoors, to represent any experience whatsoever. Moreover, the fabricated environments of the studio system frequently share an imaginary quality that we readily associate with Hollywood style, no matter which locale is supposedly represented. Filmed "entirely in Hollywood, USA," the end title of *An American in Paris* proudly announces. Whether Paris or New York, these re-created locales are now part of our mental image of the real places, yet they also seem to have something to do with qualities we attribute to California: a gleam, an ethereal artificiality, a magic that captivates by rendering its subject unreal yet imbued with a golden luster. Indeed, in one of the major attempts to argue that there is a definable uniqueness to California—what he calls its exceptionalism—the classic California writer Carey McWilliams finds one form of California specificity to lie in a sparkling luminosity, a certain glow (although he also points to the social and political ills only partially concealed by the magic). "There is a golden haze over the land," McWilliams writes, "the dust of gold is in the air—and the atmosphere is magical and mirrors many tricks, visions, and wondrous deceptions."[6] As such, and as part of its deception, California-based film appears as the culmination, the end point, of worldly mythologies and an inevitable force that absorbs all other experiences and realizes their implicit mythological import, gives them their ultimate meaning.

The movie industry may have settled in California only after a number of detours that seem to render the final location of its capital somewhat arbitrary, but early in its history, in film as well as in its publicity and self-promotion, the industry worked to build a theme of destiny, of Hollywood as the natural apotheosis of the American Dream. Clearly, by accident or design, the unique qualities of California and the advent of the film industry there have long had a powerfully causal relationship. Note, for instance, the way in which the language used by historian Kevin Starr to describe the history of Southern California suggests a sort of natural coming together of California and its movie industry:

Southern California—meaning Los Angeles, meaning Hollywood—possessed an
affinity between medium and place that would soon attract the entire industry to
it like a powerful magnet . . . In a very real sense the entire society [of Southern
California] was a stage set, a visualization of dream and illusion which was, like
film, at once true and not true. New York City, upstate New York, suburban and
rural New Jersey . . . offered locations and scenery aplenty, but Southern California
offered certain energizing affinities between art and location . . . Within a few short
years this interaction between the medium of film and the society of Southern
California would develop a symbiosis called Hollywood that would be of major
importance to both the region and the film industry.[7]

To use a language of "affinity" and thereby to imply a necessary connec-
tion between Californian meanings and the look and subject of the Hollywood
film requires a number of assumptions. For example, this implies that there
is an overall identity to Hollywood cinema and that there is a pool of stable
meanings that can be attributed to the idea of California (and beyond this,
that the meaning of Hollywood and the meaning of California are always
buoyantly about magic and mythology). At the same time, we find that
escapism into a world of magic is not always the dominant representation in
Hollywood; indeed, there is a Hollywood tradition of California films that
allow little escape and tie their fatalism to specifically Californian themes.

CALIFORNIA NOIR

There is of course a standard model of the Hollywood film that includes
narratives and styles of diverting luminosity and vitality—qualities, perhaps
not incidentally, that Carey McWilliams and others have also attributed to the
state of California. However, the history of California cinema makes it clear
that this standard was never as monolithic as it seemed. Importantly, for our
purposes, increased attention by scholars to the tough-minded film noir of
the 1940s and 1950s— one of the pivotal genres of California-based filmmak-
ing—has been key to a reevaluation of the meaning of California. In opposition
to the cliché of California optimism, film noir offers an alternate tradition
of Hollywood filmmaking that is not always about happy endings, lightness,
or magical realizations of a pioneer American Dream.

Flourishing in the postwar period and into the early 1950s, film noir
chronicles the misadventures of losers and loners who try to follow their
dreams and desires—often to the point of criminality—and frequently end up
either ruined or dead. Where earlier writings on film noir read the bleakness

of the genre as somehow metaphysical or existential, it is now apparent that much of the pessimistic tone of noir comes from perceptions of the American experience that are fully sociological in nature, positing that there are flaws in the perfection and realization of the American Dream. Such films offer up a fatalism that has less to do with the terrors of the general human condition than with the grimness of the options available to many Americans in contemporary society.

Given that the state was so crucial to the imagining of the American Dream in the 1940s and 1950s, California became central to film noir. As the focus of westward expansion, the state had long been a symbol for the realization of the American Dream, so it is not surprising that a cinema of cynicism of the sort we find in film noir would center so many of its shattering narratives on a California experience that implies the impossibility of grand dreams. "There are no second acts in American lives," wrote F. Scott Fitzgerald in the notes for his Hollywood novel, *The Last Tycoon,* and it is appropriate that he wrote this about Hollywood in Hollywood, where he failed at a career as a screenwriter. Defeat here is endemic to the American quest narrative, and failure at the California experience is seen as the summation of all other American(ist) failures.

Indeed, the effort to understand the tough films of the 1930s, 1940s, and 1950s as about American conditions rather than some abstract and generalized human condition has led at least two analysts of the films of this period, Noel Burch and Thom Anderson, to posit a subgenre they call *film gris* (gray film). Such films eschew the exoticism often characteristic of film noir, which tended to feature rarefied subjects like the private detective and femme fatale, to concentrate instead on ordinary figures caught up in criminality when mainstream options in American life fail them.[8] Here, too, California is a place where average citizens try to pull ahead of the rat race. For example, *Double Indemnity*—often classified as a tough-guy film for its style (trenchcoats in the night, snappy dialogue, harder than nails femmes fatales)—is in many ways not about special ways of life, the exoticism of the hard-boiled milieu, but quite directly concerned with ordinary experience and the desperate attempt by a regular Joe to beat the system. Insurance salesman Walter Neff (Fred MacMurray) and bored suburban housewife Phyllis Dietrich (Barbara Stanwyck) are both recognizable American figures rooted in a stifled version of the American Dream that they try to manipulate to their own ends.

In film gris (and this is what "grayness" alludes to), plain Americans caught in dreary lives try to break through the dead end imposed on them by

resorting to desperate means. Symptomatic in this respect is a 1950 film, *The Prowler*, directed by Joseph Losey, who would soon after leave Los Angeles to escape the blacklist. For our purposes, *The Prowler* is significant for its revision of the California myth of westward progress, the myth that by going to California one can achieve a pioneer dream of self-realization. In this film, an ordinary Los Angeles cop named Webb Garwood (Van Heflin) dreams of a better life (crystallized in a scene in his seedy apartment in which he reads muscle magazines that offer an image of enviable masculinity). He thinks he's found his chance when he begins an affair with the bored wife of a rich media figure and decides to kill the husband (played, in a deliberately ironic cameo, by blacklisted writer Dalton Trumbo, who wrote the film's script under a pseudonym). Garwood's ultimate desire is both ambitious and meager, as if a man of limited means could only have limited dreams: By killing the husband and marrying the wife with her inheritance, Garwood plans to buy a motel on the route to Las Vegas and benefit thereby from the money-hungry dreams of others not so different from himself. In this way, Garwood inverts the California pioneer dream by moving away from Los Angeles, east toward a new city that incarnates the magic luster of money but that also reveals the emptiness of its promise. In the barrenness of the Nevada desert, Garwood is trapped and shot down by the police, his body now just a dead weight that rolls unceremoniously down a hill.

The 1992 film *Bugsy*, directed by and starring Warren Beatty, also plays on the tensions between California and Las Vegas variants of the American Dream and the pioneer quest. Gangster Bugsy Siegel comes to California from New York and immediately is entranced by the glamour of the film world. After failing in his attempt to become an actor, Bugsy shifts the focus of his dreams from Hollywood to Las Vegas, where he envisions the first large-scale casino. Like a producer or director fighting the front office, Bugsy has to struggle with his bosses as the budget goes out of control and his project threatens to unravel. The dream fails, and Bugsy returns to the West Coast, where, alone with his movie audition reel unraveling in his private screening room, he is shot dead.

Even as it maintains the westerly direction of the pioneer narrative, another classic of film noir, the 1945 film *Detour* directed by the German emigré director Edgar G. Ulmer, goes even further in dismantling standard booster images of the California Dream. *Detour* is one of the most savage interpretations of California experience in the ways it specifically rewrites positive Los Angeles images to turn the California Dream into a nightmare. In this film, pianist Al Roberts (Tom Neal) works in sleazy New York bars,

dreaming of a better life and believing that his musical talents are unappreciated and going to waste. When his girlfriend Sue understands that she too cannot realize her dreams in such a place, she announces to Al that she is going to Los Angeles to try to break into the movies. But neither Sue nor Al are destined to succeed. When Sue informs Al by phone that she has failed at becoming an actress and has ended up a waitress slinging hash, he sets out to hitchhike to her and pool their efforts. Soon, however, Al gets caught up in the tragic narrative of the deaths he causes along the way and that now prevent him from ever innocently realizing his dream (hence, the "detour" of the film's title). One of these deaths occurs in the claustrophobic space of a sleazy Los Angeles hotel room, an occurrence that, though accidental, Al knows he will not be able to explain to the police. (In a strange but not unprecedented confirmation of the ways in which cinema and life can blur in Hollywood, actor Tom Neal himself became a has-been and was eventually convicted of a death he claimed was accidental. While working as a gardener, he shot a rich L.A. woman with whom he was carrying on an affair.)

Detour, 1945
Courtesy of Academy
of Motion Picture Arts
and Sciences

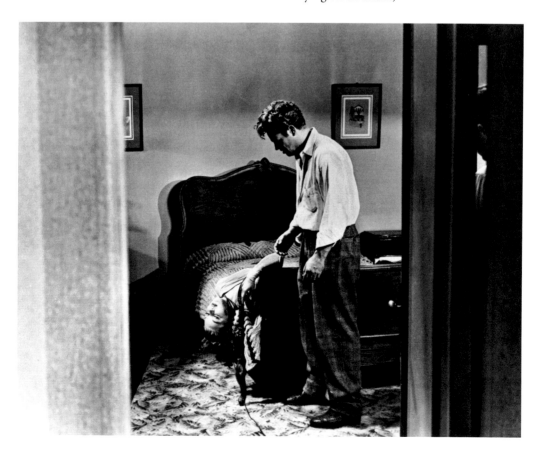

In virtually every way, *Detour* is a dismantling of optimistic myths about California. The film's process of deconstruction starts even before Al leaves for the West Coast. As Alex Barris notes in his *Hollywood According to Hollywood,* one strand of the affirmative tradition often recounts the story of people discovered elsewhere and brought to Hollywood to realize their talents (the pioneer allegory of *A Star Is Born* is in keeping with this tradition).⁹ *Detour* very clearly establishes Al and Sue as losers in the game from the start. They will never get a break, never be discovered for their talent. Their ill-fated destiny is established at the outset. There is here no way to claw oneself to the top, and California does not serve as the culmination of an American success story. Indeed, if the notion of California exceptionalism imagines the state— for better or worse—as somehow set apart from the meanings and values of the rest of the country, *Detour* falls into a tradition that imagines California to be the place where the fatalism that one carries within, through the simple fact of trying unsuccessfully to live the American Dream, reaches its logical and inevitable conclusion. *Detour*'s characters—Al, Sue, and Vera, the femme fatale hitchhiker whom Al picks up and who is already dying of consumption before he accidentally strangles her in Los Angeles—are all like the Middle Americans in Nathanael West's *The Day of the Locust,* who mill around Hollywood because, as the novelist's narrator declares, "they had come here to die."

This fatalism accounts for the particularly bleak image of westward travel and arrival in Los Angeles that *Detour* depicts. Throughout the journey, *Detour*'s desert is no romantic space of discovery (as opposed, for example, to *A Star Is Born,* in which radiant Technicolor makes the transition to the West glow with the delight of discovery) but an empty, immaterial wasteland (not unlike the desert of nothingness and mute alienation from which the antihero emerges at the beginning of *Paris, Texas,* a film by another German director, Wim Wenders). If anything, the transition into California is at best a move from the natural inhumanity of the desert into the human-produced inhumanity of a social world ruled by commerce and exploitative human relations: *Detour*'s Los Angeles is not a place of wonder—of sandy beaches or movie studios or elegant night spots—but endless commercial streets filled with ratty businesses. Los Angeles here is a universe of used-car lots (where Al and Vera have to try to get rid of their hot car) and fleabag hotels (where Al and Vera hole up and spend their time lashing out at each other until their verbal and physical spats end in death).

But if it is common to think of film noir—as well as film gris, with its even more social-realist concern for ordinary schnooks in average walks

of life—as a cinematic form about the difficulty of *urban* existence (with Los Angeles as one of its primary locales, along with a few other choice cities such as New York and San Francisco), it must be noted that film noir is also important in the history of California representation for its suggestion that the experience of the state is more than just increasing urbanization and the compacting of destinies into the oppressive site of the city. If film noir matters first of all because it reminds us of a different Hollywood cinema than the magical buoyant one, the genre is also of interest in its depiction of a California that has no single identity and cannot be reduced to Los Angeles (and to a very specific Los Angeles at that). Central to film noir as it evolves through the 1940s and 1950s is the fact that its subject matter—the modernity of postwar America—is evolving, and not just in urban directions.

In this respect, the 1949 film *Thieves' Highway,* normally classified as film noir but closer to film gris in its emphasis on ordinary workers who just want to make a buck, is key to the history of cinematic representations of California life for its recognition of a world beyond the urban experience of Los Angeles. The film narrates the bleak and often fatal experiences of fruit and vegetable truckers who go from the state's valleys to the wholesale markets of the Bay Area, where they encounter all sorts of hucksters and harlots out to plunder their meager gains even by means of violence. From its opening shot in which we see a tractor plowing farmlands up above a city, *Thieves' Highway* suggests that urban experience is inextricably linked to other geographies— the life of the farm, the transition from country to city—and presents the source of this linkage as the certainty of toil, the pressures of the system on the dreams and desires of the individual. *Thieves' Highway* chronicles the stages of capitalist production—from the harvesting of produce to its con-sumption in the restaurants of the state—and implies that at every point in the chain of production, the worker's dream of success is vulnerable to weak-ness, to accident, to systematic exploitation. California here is not the golden achievement of a dream (as the hero discovers when even his radiantly blond girlfriend deserts him) but the blunt realization of the fact that dreams matter less than inescapable entrapment in oppression and exploitation (this, despite the fact that *Thieves' Highway* has a happy ending, since even the cheerfully hokey, tacked-on conclusion—*Thieves' Market,* the book on which the film is based was much bleaker—seems to imply that an optimistic out-come can only be artificial, a forced magical solution).[10]

HARD-BOILED MOBILITY AND THE CALIFORNIA IMAGE

From the start, both film noir and film gris, as well as a major part of the pulp and detective fiction that fed into them, avoided a univocal representation of urban California experience. For example, San Francisco, with its sense of old-world mystery, became just as logical a locale for film noir as the more modern city of Los Angeles. Indeed, one of the works frequently cited as initiating the film noir cycle, John Huston's 1941 *The Maltese Falcon,* is very pointedly a *San Francisco* film, playing on alternative myths of that northern city as a space of flux (a port city with all sorts of curious personages in transition) and as a site of exoticism. San Francisco here is not a place where dreams are realized but where all projects and hopes are betrayed and subverted. The progression from *The Maltese Falcon* to later San Francisco–based film noir like *Out of the Past* (1947) is a logical one. In the latter film, Jeff Bailey (Robert Mitchum) is a former San Francisco private eye who is drawn back into intrigue in the big city but also forced to wander endlessly between city and country, as if to suggest that there is no longer any fixed space for the experience of self and that California's function is not so much to fix or free identity as to turn it into something errant (and Bailey himself will have several identities as he tries to hide out from a destiny that, in the film's title, will come "out of the past" to haunt and pursue him).

Indeed, if California can serve in boosterist mythology as the final desired place of stability and of self-realization in the American pioneer dream, a city like San Francisco, with its connotations of exoticism, can increasingly come to figure as a marker of difference and of the dismantling of a confident image of the California experience. Granny's pioneer lesson in *A Star Is Born* is unambiguous in the clarity of its optimism about Los Angeles as the place where American Dreams come true. In contrast, San Francisco comes to represent a geography beyond understanding, a site so given over to the transitory (as for the crooks just passing through in *The Maltese Falcon*) that the possibility for clear and fixed meanings is rendered difficult. Take, for instance, the 1986 film, *Big Trouble in Little China,* directed by John Carpenter, a director trained in a film school (USC) and who is quite aware of the history of American film, its perfection in the classic studio system, and eventual deconstruction in a postclassic period. A kung-fu science-fiction horror film, *Big Trouble in Little China* is an unstable hybrid work. What is intriguing for our purposes is the way in which the film's eclecticism has also to do with its subject: macho Caucasian truck driver Jack Burton (Kurt Russell) discovers that for all his boldly overexpressed confidence, San Francisco represents an experience

beyond his understanding, one that endlessly comes to challenge his confident self-image of assured masculinity. To be sure, like the Los Angeles film *Chinatown*, with its suggestion that what undoes the quest for white male truth comes in large degree from impenetrable "Asian" mystery ("forget it, Jake, it's Chinatown"), *Big Trouble in Little China* is not free of its own reifying exoticism in its image of an inscrutable Chinatown that will teach Jack his own relative place in the world. (In this respect, in passing, we might note how important has been the attempt in Californian independent filmmaking to construct nonexoticizing representations of the Asian American experience. For filmmakers as varied as Wayne Wang and Rea Tajiri, an investigation of what it means to be Asian in California becomes a way of interrogating just what California as a privileged site for the American Dream means as well.)

But for all its own vulnerability to cliches of the exotic, *Big Trouble in Little China* is important for the ways it does dismantle sustaining myths of pioneer masculinity. Kurt Russell plays Jack Burton as a near parody of John Wayne and, in its depiction of the clashes and confusions that arise when this swaggering masculinity finds out how limited its sway and power really are, the film becomes an allegory of the fate of all optimistic and affirmative myths when they bump up against universes of meaning too complex to be held within the boundaries of simple mythologies. To come to California is not to realize the pioneer mythology but to lose hold of it.

It is significant to *Big Trouble in Little China*'s allegory that Jack Burton be a truck driver. Through this, the film suggests first of all that for all his swaggering attempt to play out male conquest fantasies, Jack is an ersatz, even fallen, version of the frontiersman. As with *Thieves' Highway*, with its theme of the inevitable exploitation of wildcat truckers (as its very title suggests), *Big Trouble in Little China* offers no romance of the road, no uplifting mythology of the trucker as modern-day frontier hero. Just as he cannot be John Wayne, Jack Burton cannot be a cowboy but only a derivative clichéd rendition of the now-faded romantic image of the Westerner. California is not (or is no longer) a place that sustains pioneer ambition but, quite the contrary, a force of modernization and multiculturalism that shows up boosterist machismo as an anachronism (just as Jack's big truck seems a clumsy intrusion as it gets stuck in the fog in the tight and narrow streets of Chinatown).

The trucker image is important too for its emphasis on movement, on an experience of identity that is itself transitory (the film begins and ends with Jack in his truck, unable to settle down, forced to be always on the move, not able to make California his end-point home). If pioneer mythology

figures California as the site of destiny and destination—the place where one comes into identity and builds up a future—the flip side of this mythology is that no place can be stable. California is then not so much the site of assured values as the extreme rendition of the instability of all value systems, of a geography so much in flux that it can never be settled. One of the ultimate Los Angeles films, Ridley Scott's *Blade Runner,* represents the city precisely in opposition to booster mythology that would see it as the culmination or realization of the pioneer quest. Los Angeles here is not a place one would willingly voyage to in hopes of realizing a dream. On the one hand, those who stay in *Blade Runner's* Los Angeles are portrayed as the flotsam and jetsam of a society that has gone beyond them; the city has become a backwater filled with scavengers, the ill, and the ill-fated (as in *The Day of the Locust,* so many of the city's people are "here to die"). On the other hand, the aerial ships that glide over the darkened city and speak of a better life elsewhere, "off-world," indicate that for privileged pioneers, Los Angeles can only be an ephemeral point of transit, no longer a destiny or a destination but one more memory to be cast off as one continues the quest elsewhere.

THE PARADOX OF THE PIONEER

In this respect, it is important to note that from its very founding, there is something contradictory and even self-destructive or self-defeating about the pioneer myth as a defining structure of the American experience. If it succeeds, the pioneer mission fails: to be precise, if the point of pioneering is to quest after a site of settlement, the achievement of that quest implies that there is no longer any place for pioneering. The pioneer cannot settle down without becoming something other than a pioneer. Numerous works in the history of American culture play on this paradox—for example, James Fenimore Cooper's Natty Bumppo enables others to go on to settlement even as he knows the new America he is helping to build can have no place for him. The Hollywood epic *How the West Was Won* (1962) no doubt intends to celebrate the western spirit, but its euphoria is undercut by an irony specifically linked to the film's depiction of the West Coast as an inevitable and unsurpassable end point. As the past tense of the title suggests, *How the West Was Won* is a film of nostalgia, of fixation on the past (the past of a golden age of Hollywood in the process of fading away as much as the past of the pioneer quest). Winning the West means the termination of the ongoing vitality of the mythology of western conquest. The film's triumphalist depiction of the American spirit is tinged with sadness and even regret as it dissolves from the

fictional story of one-time pioneers at the end of their narrative to documentary footage of a Southern California freeway alongside the ocean.

It is not accidental that many films after the decline of the old Hollywood studio system make central reference to another Western, John Ford's *The Searchers*. That film's image of the errant frontiersman Ethan Edwards (John Wayne), who can know no sustaining home life, is also a metaphor for a cinema that admits the limitations of optimistic myths and can do no more than narrate them with sad nostalgia. Characters like Ethan Edwards and Jack Burton can rescue kidnapped or strayed figures and return them to the fold of community, but these men themselves can belong to no community and must always, like Huck Finn, light out ahead of civilization. Wim Wenders's *The State of Things* (1982) strikingly captures the paradox of quest narratives like *The Searchers*—if you stop moving, you're out of business—and maps it specifically into a bleak representation of the California experience. In this film, the searching hero (a filmmaker who has run out of funds for a pet project) tracks down and stays with a Hollywood producer on the run from gangsters he owes money to and who hides out in a mobile home that endlessly winds its way through the streets of Los Angeles (passing, at one point, a movie theater showing *The Searchers*). Such endless transit sustains a barren and desperate survival, and it is only when the "caravan" comes to rest for just a moment that the pursuers are able to catch up and the nomads are gunned down. To settle down is to die. (But to be on the move is to live in a constant state of paranoia.)

For all its sadness at the errancy of the loner hero, *The Searchers* also appeals no doubt for the optimism of its belief that errant heroes can indeed be heroic—helping to build civilization by restoring its lost children to it—even as they can find no place in the civilization they have aided. And yet, as things become more desperate and constrained for would-be heroes in a non-heroic age, heroism itself can turn into an irrational fixation on quirky acts of violence that supposedly give one's life meaning but are really signs of meaninglessness. Stuck on the West Coast, with no place to go, no new frontier to conquer, ersatz frontiersmen turn inward, confronting inner demons and manifesting their fatalism as inevitable violence.

Emblematic in its sense that the old mythologies of salvation no longer work in a new California is the controversial ending of Robert Altman's *The Long Goodbye* (1973) in which L.A. detective Philip Marlowe's discovery that he has been a patsy all along for a get-rich scheme by his supposed buddy, Terry Malloy, leads Marlowe to ingloriously shoot Malloy down and walk off.

Many viewers found this conclusion to be a betrayal of novelist Raymond Chandler's insistence on Marlowe as a man of honor ("Down these mean streets a man must go . . .") but Altman's point seems to be that the 1970s version is more in touch with the demythologizing impulses of the age. There is no longer any honor in heroism, and the new antiheroes have internalized the ugliness of the mean streets that they used to wander down. In *The Long Goodbye,* as Marlowe walks away from his act of violence, the melody of "Hooray for Hollywood" comes up on the sound track. If boosterist films like *A Star Is Born* celebrate Hollywood as an ostensibly natural conclusion to the pioneer quest, cinema since the breakup of the classic studio system looks back on Hollywood with pessimistic and ironic attitudes ranging from bittersweet nostalgia to hard-edged and relentless cynicism.

ON THE ROAD IN SEARCH OF THE CALIFORNIA DREAM: FROM FILM NOIR TO *PSYCHO*

Seen in the light of the pioneer paradox, film noir becomes important to the analysis of California mythologies less for its image of fixed spaces of alienation than for its instabilities, its images of transitoriness, its recognition that movement as well as stasis is fraught with fatalism. For instance, so much of the modern experience of California is intimately connected with the automobile and with the changes in perspective and position that being on the move can enable. Film noir catches this mobile sense of California in several ways. First, it looks at the city and shows its vulnerability to the modernizing influence of the car. Those aspects of city life that cannot keep up with vehicular modernization will be left behind, turned—like all of Los Angeles in *Blade Runner*—into so much refuse and rubble. Thus, as Edward Dimendberg notes, the 1955 film noir *Kiss Me Deadly,* a classic of the genre that is considered by some scholars to constitute an apocalyptic implosion of the genre as it falls apart under the sway of modernity, is among other things a depiction of a side of Los Angeles that has not been able to keep up, that has been unable to modernize. *Kiss Me Deadly* depicts the conversion of the once-romantic Bunker Hill area of Los Angeles into a site ravaged by decay and inhabited by losers who do not have the will or the power to be on the move.[11]

By the 1950s, film noir increasingly depicts the city as taken over by the car. The car can enable a new freedom, a new power, as *Kiss Me Deadly*'s Mike Hammer realizes when he tools around in his sports car (described by his mechanic as possessing "va va voom," a term invented for the film). But if the car can give new social subjects a feeling of power and mobility, that sense of

accomplishment is often undone by the very speed at which things happen, by the sheer diversity and excessive richness of new experiences that come flooding in as one takes to the road and opens up to movement. It is part of the logic of film noir that so many of its California narratives revolve around vehicular motion and tie their images of transit to themes of dreams projected and dreams shattered—for example, Garwood's dream of motel success crushed in *The Prowler;* Al Roberts's quest for golden Sue and golden Los Angeles turning out to be a voyage through fleabag hotels and used-car lots in *Detour;* gumshoe Jeff Bailey's attempt to stay ahead of the game, leading to his being killed ignominiously in a car in *Out of the Past.* Indeed, if it has been typical to see the end of film noir in classic works like *Kiss Me Deadly* (the detective trying desperately to make sense of a modern world that ends in apocalyptic atomic explosion) or 1957's *Touch of Evil* (the detective now a fallen, dissipated figure playing out downtrodden dreams of nostalgia in a backwater border town between California and Mexico), Dimendberg takes another, lesser-known late 1950s film to sum up the logical outcome of film noir in its bitter depiction of just what happens when someone literally tries to "outrun" the system: In the 1957 low-budget film noir *Plunder Road,* a gang of small-time crooks tries to beat the odds by stealing a railroad shipment of gold that they plan to smuggle out of Los Angeles by melting it down into parts of their car, only to find their dreams of success along the "road of plunder" dashed miserably when their overburdened car gets stuck in a freeway traffic jam and the head henchman is shot down on the asphalt of the highway system. From the hubris of crooks who bring a speeding train to a standstill to the banality of the traffic jam that comes in ironically to dash their hopes, *Plunder Road* treats California mobility as a metaphor for human rise and fall.

If one culmination of the boosterist mythology of California is the optimistic "architecture of reassurance"[12] embodied in Disneyland (whose opening is coincident with the dedication of the 1950s interstate highway system that will enable Americans to "see the USA in their Chevrolet" on their way to their theme-park destination), the 1950s are also important as a period in which the cynical side of the American Dream and California's central role in its formulation and perfection are insisted upon. Note, for instance, how one of the great works of American horror at the end of the period—Alfred Hitchcock's 1960 *Psycho*—is in large part readable, for all its Gothic emphasis on strange people at the edge of society, as a specifically California narrative about the dangers of life on the road for ordinary Americans whose ambitions

Plunder Road, 1957
Courtesy of Academy
of Motion Picture Arts
and Sciences

outrun them. Dreaming, like so many film noir characters, of making a big score, Marion Crane leaves Arizona and heads west in her car for what she hopes will be the joys of small-town California, passing along the way through the used-car consumer culture of Bakersfield into the rural valleys and coming to her dismal end in a trashy motel off the main highway. The shock of *Psycho* comes as much from its ordinariness as from its weird nature. For all the bizarreness of its story, it is also about touchingly real people—Marion, Norman, Sam—caught up in some very average social dilemmas about getting by with the American Dream. It may be the film's unromanticized look at ordinary losers that accounts for some of its impact in the period. Only a few short years after the exuberant dedication of the interstate highway system, *Psycho* shows the danger of getting on the road, of moving out into the dangers of unknown territory.

It is not common to think of *Psycho* as a California film—Californian, that is, in its depiction of meanings typically associated with the state. But seen in this sociological light, the film gains in resonance, and certain of its details take on symbolic overtones. For example, the rain that obscures Marion's vision and forces her off the main highway to the Bates motel has

Psycho, 1960
Courtesy of Academy
of Motion Picture Arts
and Sciences

an immediate narrative function (it causes her to get lost and it increases the shock of seeing the motel come up out of drenched obscurity), but it also serves as a poignant reminder of this film's bleak and nonboosterist vision of things. Like the rain that endlessly drenches the Los Angeles of *Blade Runner,* and unlike the exuberant and eternal sunshine that greets voyagers at the border in boosterist mythology, *Psycho*'s California rain is a cruel commentary on pioneer dreams. From the downpour that cuts across her windshield and blinds her vision, to the supposedly purifying shower stream soon to be broken by the slashes of a knife, to the lonely tear that glides down her cheek in death, to the muck of the swamp her body will end up in, Marion is caught in a watery world that puts the lie to the dream of golden splendor in the dry radiant sunshine of California. Marion has come west to realize a dream— just as Norman Bates's family had earlier taken the same trail in search of success, only to be pushed aside by the progress of modernity (the new highway that has turned the Bates motel into a relic)—but all she gets is a violent shattering of hope.

Of course, the message of *Psycho* is not the truth of California any more than the booster narratives were. Just as boosterist narratives can become false and overbearing, so too can the narratives of California nightmare become extreme, luxuriating in a pessimism that becomes chic fashion and blocks real analysis of the contradictions of life in the state. Indeed, if a film like *Blade Runner* can be thought of simultaneously as film noir and apocalyptic cyberpunk science fiction (what has been called the science fiction of the "Near Bad Future"), this is so because the cynicism of both genres overlaps: They chronicle the dead ends faced by ordinary citizens who find their personal projects unrealizable in spaces of modernity. Where film noir culminates in anarchic acts of random, desperate violence—as in Marlowe's unceremonious shooting down of Terry in Altman's *The Long Goodbye*—the apocalyptic film shows violence erupting everywhere, spreading through all walks of life. From film noir narratives of personal doom to ones of larger, geographic doom (California as site of the apocalypse), the distance is not so great. *Blade Runner* already suggested that its Los Angeles rain was part of a toxic ecological backfire, but there the ecological theme was secondary to a personal narrative (the hero Deckard's existential crisis about the killing of androids). For all its fatalism, film noir at least contains images of individual human will, even if such will could only manifest itself as failure, as erratic violence, as ersatz parody of optimistic heroism. In the narrative of apocalypse, however, agency drops out (or reappears only in heavily romanticized fashion, as in the cowboyish hero of *Volcano* who solves urban disaster and reinvents the family unit at the same time), and analysis surrenders to paranoia. Destruction is everywhere and has causes both cultural and natural. In the apocalyptic narrative of films like *Independence Day* (and earlier ones like *Earthquake*), an entire region suffers, rather than just isolated individuals.[13]

Perhaps, then, the point is not to settle in on any one cinematic image of California but to take meaning from the fact that no single image is adequate. The history of Hollywood's California is complicated, even contradictory, but it is not random. Film style and subject are governed, as we have seen, by convention, cliché, and myth, and there are regularities in the representation that can be categorized. On the one hand, for example, I have suggested that there are overarching narratives about the founding of the Los Angeles film industry and its exploitation of the pioneer myth, of California as a migratory destination full of promise, and of the rise of Hollywood and its mythology of fame and stardom in the sun as a dream destination in itself. On the other hand, opposed to the radiant image of buoyant California possibility, there are

depictions of losers and outcasts whose narratives represent a dark side of the Hollywood-California Dream. Nearly a century after the perhaps arbitrary but feted founding of Hollywood, and long after the bitter breakdown of the studio system in the postwar period, these two strands of light and dark in the history of Hollywood cinema form a permanent part of a still-evolving mythology that continues to speak to the triumphs, tragedies, and contradictions in the California experience.

Dana Polan is professor of critical studies in the School of Cinema-Television, University of Southern California. His publications include *The Political Language of Film and the Avant-Garde* (1985), *Power and Paranoia: History, Narrative, and the American Cinema, 1940–1950* (1986), *In a Lonely Place* (1993), *Pulp Fiction* (2000), and forthcoming books on directors Jim Jarmusch and Jane Campion.

1 "General Introduction" to Joseph P. Kennedy, ed., *The Story of the Films; as Told by Leaders of the Industry to the Students of the Graduate School of Business Administration, George F. Baker Foundation, Harvard University* (Chicago and New York: A. W. Shaw Co., 1927), 21–22.

2 For an excellent discussion of alternative sites on the way to Hollywood, see Richard Koszarski's *An Evening's Entertainment: The Age of the Silent Feature Picture, 1915–1928* (New York: Scribner, 1990).

3 Kevin Starr, *Inventing the Dream: California through the Progressive Era* (New York: Oxford University Press, 1985), 288.

4 Richard Schickel, *Double Indemnity* (London: British Film Institute, 1992), 10.

5 *Hollywood Reporter* (Sept. 14, 1943), 2.

6 Carey McWilliams, *California: The Great Exception* (1949; reprint, Berkeley: University of California Press, 1999), 4.

7 Starr, *Inventing the Dream*, 293.

8 Noel Burch and Thom Anderson, *Les Communistes d'Hollywood: Autre chose que des martyres?* (Paris: Presses Universitaires de la Nouvelle Sorbonne, 1995).

9 Alex Barris, *Hollywood According to Hollywood* (New Brunswick, N.J.: A. S. Barnes, 1978).

10 A. I. Bezzerides, *Thieves' Market* (1949; reprint, Berkeley and Los Angeles: University of California Press, 1997).

11 See Edward Dimendberg, *Film Noir and the Spaces of Modernity* (Harvard University Press, forthcoming) and his published essays on films that I discuss (with grateful acknowledgment of having borrowed from him): "Kiss the City Goodbye" *Lusitania* 7 (1995): 56–66 (on *Kiss Me Deadly*); and "The Will to Motorization: Cinema, Highways, and Modernity," *October* 73 (summer 1995): 90–137 (on *Plunder Road*).

12 Karel Ann Marling, ed., *Designing Disney's Theme Parks: The Architecture of Reassurance* (Montreal: Centre Canadien d'Architecture; Paris and New York: Flammarion, 1997).

13 For a catalogue of California apocalypse narratives in film and fiction, see Mike Davis, *Ecology of Fear: Los Angeles and the Imagination of Disaster* (New York: Metropolitan Books, 1998).

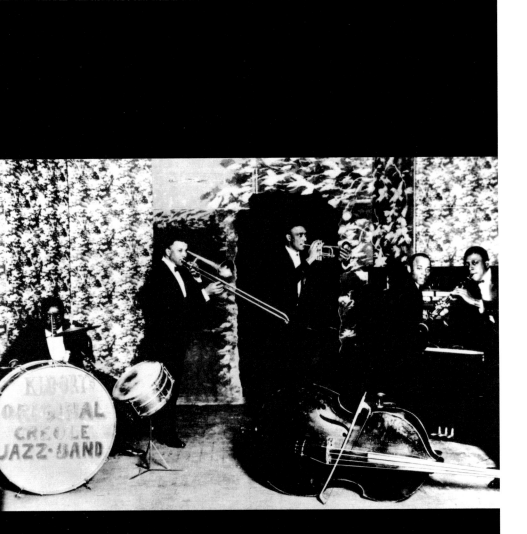

Kid Ory's Original
Creole Jazz Band,
c. 1922
Hogan Jazz Archive,
Howard Tilton
Memorial Library,
Tulane University

George Lipsitz

MUSIC, MIGRATION, AND MYTH:
THE CALIFORNIA CONNECTION

Identity is best defined in terms of culture, and the culture of the nation over which the white Anglo-Saxon power elite exercises such exclusive political, economic, and social control is not all white by any measurement ever devised. American culture, even in its most rigidly segregated precincts, is patently and irrevocably composite. It is, regardless of all the hysterical protestations of those who would have it otherwise, incontestably mulatto.

Albert Murray, *The Omni-Americans: Black Experience and American Culture,* 1983

California is both a place and an ideal. Its stunning scenery, ecological diversity, and cultural complexity have long attracted the attention of artists, whose creations have made many of the state's sites and spaces familiar to people around the world. Cultural practices, social trends, and political movements originating in California have often taken on iconic status as widely understood symbols encapsulating the specific challenges of particular historical moments.[1] The powerful cultural institutions and industries headquartered in the state generate a seemingly endless stream of images and interpretations of California. As a crossroads where diverse cultures have collided, competed, and cooperated, the state holds emblematic status as the home of incomparable cultural complexity and creativity. The most vicious forms of racial and ethnic exclusion have a long history in the state, but Californians have also drawn upon their dynamic differences to create humane ways of living that have been reflected by artists through complex and compelling sounds, sights, and symbols.

People who come to California for the first time often have an already rich inventory of references about the state—its places, people, and politics—because of the power of popular music. They know that swallows come back to Capistrano, that you can lose your love in Avalon, and that life is "such a

groove" in Mendocino.[2] They have heard about the city of San Jose in songs by Count Basie, Dionne Warwick, and Freddie King.[3] Merle Haggard's lyrics have educated them about the beauties of Mount Shasta and the Kern River.[4] They know something about the history of black entertainment in Los Angeles because of tributes to Central Avenue recorded by Helen Humes, Pee Wee Crayton, and Lionel Hampton.[5] From the offerings of Tony Bennett, Joe Simon, and the Village People, they have been introduced to a picture of life in San Francisco.[6] Bakersfield, Redlands, and Compton are not generally considered tourist destinations, but they will not be unfamiliar to fans of Dwight Yoakam, the Waitresses, and NWA.[7]

From Al Jolson's "California, Here I Come" to the Eagles' "Hotel California," from "California Blues" by Jimmie Rodgers to "California Über Alles" by the Dead Kennedys, popular songs have both celebrated and skewered the state's culture and customs for much of the twentieth century. Yet much of this "native" California music has been made by migrants. The composers of "When the Swallows Come Back to Capistrano" came to California from New Orleans.[8] The members of the Eagles who cowrote "Hotel California" came to the West Coast from Gilmer, Texas, and Detroit. Migrations from Texas, Louisiana, and Oklahoma have been an especially productive source of artists identified with California's diverse musical cultures, including Rose Maddox, Janis Joplin, Woody Guthrie, Ornette Coleman, and Chet Baker.[9]

The relationship between culture and place is always complicated, and it is especially so in California. The state has long been a crossroads and a destination for people coming from many other places. Its emblematic cultural creations have often emerged from experiences with migration. For example, few artists have done as much to publicize California as did Al Jolson, who performed and received songwriter credits for "California, Here I Come" and "Avalon." His 1924 and 1946 recordings of "California, Here I Come" attained great popularity and played an important role in advertising the charms of the state to potential migrants. The song's lyrics contained biographical significance for Jolson as well: He first emerged as a star in show business during the 1906–7 theatrical season in San Francisco. Consequently, he could sing lyrics describing California as "right back where I started from" with personal conviction. But like so many artists associated with California, Jolson was not a native of the state. He actually "started" in Russia, where he was born in 1886. Jolson's family moved to New York when he was a child, and he came to San Francisco as an itinerant vaudeville entertainer.[10]

New Orleans jazz musicians—and
a significant part of their audience—
made the West Coast their own through
a process of migration similar to that of
Jolson. As delineated in the excellent
collection *California Soul* (edited by
Jacqueline Cogdell DjeDje and Eddie S.
Meadows) and other recent works on the
early history of jazz, touring musicians
from the Crescent City played a promi-
nent role in the cultural life of California
in the years before World War I, and
their story is indicative of a broader
pattern—the way in which so much
local culture in California comes from
people who have migrated to the state
from somewhere else.

String bass player Bill Johnson
brought a jazz band to San Francisco as
early as 1908. New arrivals from New

Cover of lyrics to
"California Here
I Come," n.d.
Courtesy of Bill
Edwards

Orleans secured jobs in Los Angeles performing in Wayside Park, where they
would play music while cooking buckets of red beans and rice on the job.[11]
In 1913, the first published reference to jazz music anywhere appeared in a
San Francisco newspaper. Freddie Keppard brought his band to the West
Coast the next year, and Kid Ory began a six-year stay in Los Angeles and
Oakland in 1919.[12] A dance called the "Texas Tommy" enjoyed extraordinary
popularity in New York City in 1917, but despite the name it did not come
from Texas; it had been invented in black cabarets in the Barbary Coast dis-
trict of San Francisco.[13] The first sound recording of New Orleans "Dixieland"
jazz by black musicians anywhere took place in 1922 in the Sunshine Records
studio in Santa Monica.[14] Thus, a significant part of the cultural history of
New Orleans took place in San Francisco and Los Angeles during the early
decades of the twentieth century.

Musicians performing New Orleans music in California were neither
confused nor lost; they made the trip to the West Coast because it afforded
them opportunities to play their music under favorable conditions. In
California they discovered receptive performance venues owned by African
Americans, including Purcell's in San Francisco and Dreamland Hall, Cadillac

Cafe, and Murray's Cafe in Los Angeles.[15] New Orleans piano virtuoso Jelly Roll Morton came to the West Coast often, playing professional engagements in both San Francisco and Los Angeles. In 1917 he invited musicians Buddy Petit, Wade Whaley, and Frank Dusen to leave Louisiana and join his band in Los Angeles. Yet while Morton wanted them to bring New Orleans music with them, he was less certain that New Orleans clothing styles and work habits would succeed on the West Coast. When the three got off the train wearing box coats and tight pants, Morton took them directly to a tailor to purchase outfits more in keeping with the look on the West Coast. In addition, he scolded them for bringing a bucket of red beans and rice to work and cooking it on the job. Appalled by Morton's transformation into a Californian, Petit, Whaley, and Dusen immediately returned to New Orleans in disgust.[16] Morton and many other New Orleans musicians remained on the West Coast, however. Despite occasional forays to other cities, in the 1930s Morton returned to Los Angeles, where he died in 1941.

Kid Ory followed a similar path, performing in Oakland and Los Angeles during the 1920s and running a California chicken ranch with his brother during the 1930s. In the 1940s he spearheaded a Dixieland revival on the strength of club engagements on Sunset Boulevard in Los Angeles, accompanied by fellow New Orleanian Barney Bigard on clarinet; successful concerts in the This Is Jazz series; publicized appearances on Orson Welles's radio show; and brief but memorable contributions to the sound tracks of the Hollywood films *New Orleans* and *Crossfire*. In the 1950s Ory appeared regularly at Disneyland in a band that included Caughey Roberts and Teddy Buckner.[17]

Reb and John Spikes came to California from Texas as children in 1897. They grew up in Los Angeles but left in 1907 as professional musicians touring the Southwest. Reb Spikes played baritone saxophone for various bands, including Sid LeProtti's So Different Orchestra, a favorite in the dance halls and clubs along San Francisco's Pacific Street (renamed Terrific Street by musicians), in the area known as the Barbary Coast. The Spikes Brothers resettled in Los Angeles in 1919 and opened a music store downtown, at Central Avenue and Twelfth Street, that served as a central meeting place for the city's black musicians. Their store grew into a booking agency, which in turn developed into the local union for black musicians. It also served as the focal point for the Spikes Brothers' Sunshine Records studio, where they made the first sound recording by a black Dixieland band—Kid Ory and other New Orleans migrants playing "Ory's Creole Trombone."[18]

Even in those early years, the concentration of entertainment industries in one place created a synergy with positive commercial consequences. Bill Johnson's Creole Band formed in 1911 but got its first big break in Los Angeles in 1914, when they performed for fans attending a heavyweight boxing match between Leach Cross and "Mexican" Joe Rivers (Jose Ybarra). Their playing impressed Carl Walker, regional manager for the Pantages Theatrical Company, who then hired them to play on the Pantages vaudeville circuit.[19] The Creole Band introduced vaudeville audiences around the country to New Orleans jazz between 1914 and 1918, helping plant seeds that would blossom later, when the closing of the Storyville red-light district in New Orleans and the opening up of phonograph recording to jazz musicians helped create a national market for the genre. Hollywood film studios generally refused to hire black musicians to compose or perform film scores, but from time to time jazz musicians were able to test those barriers. New Orleans musicians Ory, Mutt Carey, and the Black and Tan Orchestra sometimes found work on Hollywood sound stages providing "mood music." Others found occasional employment as extras.[20]

Subsequent musical migrants playing jazz in California benefited similarly from the links that could be made on the West Coast with other entertainment enterprises. The Dunbar Hotel and the Club Alabam in Los Angeles and the Hotel Douglas in San Diego established themselves as particularly important businesses in the black community. Former heavyweight champion Jack Johnson owned the Show Boat Cafe in the Dunbar Hotel in the early 1930s, where he employed New Orleans migrant Mutt Carey, a veteran of the Kid Ory ensemble, as the leader of the house band.[21] Otis Rene owned a pharmacy on Central Avenue, while his brother Leon Rene led his own band. The Rene Brothers enjoyed some commercial success as songwriters; they also produced and wrote stage musicals, arranged music and wrote songs for Hollywood films, and eventually ran a series of successful small recording studios.[22]

The appeal of black-owned and -operated performance venues, ancillary services, and the synergy made possible by the concentration of entertainment industries in California all played a role in luring New Orleans musicians to the West Coast. Yet little of value would have awaited them had it not been for the larger migration to the West Coast in which they participated. If California offered them work, it was in part because the state was inhabited by their fellow workers, who craved music from home. The Golden State also offered black musicians from New Orleans an opportunity to play before white audiences with large disposable incomes, because of the boom generated by

economic expansion. The jazz musicians who traveled to California in the first decades of the twentieth century did so as part of a global shakeup that brought workers to the West Coast from Mexico, Asia, Europe, and the southern and Midwestern sections of the United States. Expenditures by the government on railroads, harbors, highways, irrigation, and military bases created the infrastructure that made mass migration to California feasible. They also facilitated a growing effort to incorporate the islands of the Pacific and the rimlands of Asia into the United States economy, an effort that necessitated increased immigration, even after the passage of exclusion acts designed to bar Chinese and Japanese workers from entry into the United States. Anti-labor strategies by employers encouraged migration by Mexican, black, and poor white workers so that they could be played off against one another. If New Orleans jazz spoke to the emergent cosmopolitanism of twentieth-century California, it did so in part because the cultural diversity of the state had important parallels with the mixed-race, multinational society created in New Orleans in the previous century via westward expansion and trade with Europe and the Caribbean.[23]

The vibrant jazz scene created by New Orleans expatriates in California set the stage for subsequent migrations by musicians from Louisiana, Texas, and Oklahoma who played in a wide variety of styles. Indeed, much of the history of California as a place for music in the twentieth century has been a history of displacement, of other places having a part of their histories made in the Golden State. This, in turn, has changed California culture, inflecting it with resonances from other regions.

Ferde Grofé, for example, would one day evoke the landscapes of Death Valley and the Grand Canyon for millions of listeners with his semi-classical compositions. But he began his musical career in San Francisco as a dance band musician. Born into a cultured German immigrant family, Grofé had a grandfather who had been a musician with the Metropolitan Opera Company in New York. His uncle played with the Los Angeles Symphony, and his parents were both musically inclined. Although well versed in the classical tradition, Grofé found that the only way he could earn a living from music in San Francisco in 1915 was to play in some of the many dance bands that formed in the wake of the popularity of touring New Orleans ensembles on the West Coast. He arranged "jazz" scores that alternated solo voices with choruses, grouped instruments in choirs to emphasize harmonies, and added countervoices to lead melody lines. Working with Art Hickman's band, Grofé hired saxophonists Bert Ralton and

Clyde Doerr and wrote arrangements for them that demonstrated the tonal possibilities of section playing.

When Denver-born band leader Paul Whiteman heard Hickman's group on one of his many visits to San Francisco's Barbary Coast, he hired Grofé to be pianist and arranger in the Paul Whiteman Orchestra. The Whiteman aggregation attained great success and played a key role in defining jazz and big-band styles for national and international audiences. At a time when African American musicians received neither material reward nor critical acclaim, the success of the artistically uninspired Paul Whiteman Orchestra constituted yet another episode of racialized injustice in United States society. Paul Whiteman and Ferde Grofé could reap benefits from commercial culture unavailable to the Creole Band, Reb Spikes, or Jelly Roll Morton. Many of the strengths that the Whiteman band did possess, however, owed a great deal to the transformations in California culture set in motion by the presence of New Orleans bands in San Francisco and Los Angeles in the first decades of the century.[24]

When Dixieland music enjoyed a commercial revival during the 1940s, it offered renewed exposure to Kid Ory, Mutt Carey, Bunk Johnson, Barney Bigard, and other transplanted New Orleanians. Yet the revival also displayed the talents of native Californians, who experienced New Orleans jazz as part of their local culture. Lu Watters (born in Santa Cruz, California, in 1911) played New Orleans–style music at Sweet's Ballroom in Oakland and at the Dawn Club in San Francisco in the late 1930s. He formed the Yerba Buena Jazz Band, featuring the talents of trombonist Turk Murphy (born in Palermo, California, in 1915), who later headlined his own group in San Francisco clubs.[25]

Musical migrants brought the cultures of other places to California but also found themselves profoundly altered by the cultures they encountered in the state. Bandleader and piano player Sonny Clay, an African American born in Chapel Hill, Texas, came to California from Phoenix. Impressed by the "Latin tinge" in New Orleans music and by Mexican music, Clay became a binational artist. He performed duets with clarinet player Charlie Green in border towns in Mexico, including Tijuana, Mexicali, and Calexico. For a time he resided in Tijuana but performed most of his music across the border in San Diego.[26] His music seemed distinctly Mexican to many of his listeners. Sonny Clay brought musical traditions from Texas and Arizona to California, only to blend them there with Mexican figures, devices, and performance styles.

The rowdy and ribald lives of many New Orleans jazz musicians and the location of many of their performance venues in urban red-light districts can make Dixieland jazz seem like a completely countercultural and underworld music, obscuring its organic links to broader cultural currents and musical forms. Yet New Orleans musicians in California demonstrated familiarity with a broad range of musical styles. Jelly Roll Morton made a ragtime piece out of Verdi's "Miserere" from *Il Trovatore*.[27] Leon and Otis Rene wrote and produced a successful musical-theater presentation, *Lucky Day*.[28] "When the Saints Go Marching In," the best-known song in the New Orleans jazz repertoire, originated as a gospel "shout" in sanctified churches designed to identify those who follow Jesus all the way as "saints."[29] Indeed, the parallels between the emergence of gospel music in California and the emergence of New Orleans jazz illuminate the connections that link these seemingly opposite forms of expression to the same social and historical moment.

At about the same time that Bill Johnson brought the first New Orleans jazz band to the West Coast in 1908, religious revival services featuring the preaching of William J. Seymour attracted thousands of people to a two-story wooden building on Azusa Street in Los Angeles. From 1906 to 1908, the "Azusa Street Revival" drew people of diverse races, nationalities, and cultures to an impoverished African American neighborhood to hear Seymour preach. An African American born in Centerville, Louisiana, in 1870, Seymour had lived in Indianapolis and Houston before moving to Los Angeles. Supported by a core group of black female domestic workers, he argued that the Pentecostal movement had to manifest its commitment to equality and justice by practicing interracial worship and accepting women as preachers. After Seymour's death in 1922, his work was carried on by Bishop Charles Harrison Mason, who had attended the Azusa Street Revival for a month and who subsequently founded the Church of God in Christ (COGIC).[30]

The Azusa Street Revival responded to the same dynamic realities of migration and community building that shaped the early years of New Orleans music in California. Both appealed to working-class migrant constituencies by transforming traditions from home into new social spaces. The state soon became a destination for gospel performers, in much the same way that it appealed to jazz musicians. The Paul Quinn Singers and the Stars of Harmony moved to Los Angeles from Texas. Bessie Griffin migrated from New Orleans. The synergy of the entertainment industries that meant so much to jazz artists also attracted gospel musicians to California, who hoped to secure economic opportunities not available through the church.[31]

Many of the most important performers of gospel music in California have been associated with the tradition established by Seymour and Mason through the Church of God in Christ, including Los Angeles's Andrae Crouch and the Bay Area's Hawkins Family Singers. Crouch's father served as pastor at Christ Memorial COGIC, where Andrae sang in the choir at an early age in the 1940s. In the 1960s the artist formed his first gospel group, the Cogics, featuring his twin sister Sandra. When backup musician Billy Preston and several singing members of the Cogics left the gospel field, Crouch formed Andrae Crouch and the Disciples in 1965. Yet Sandra Crouch sang backup for pop singer Diana Ross, while rhythm and blues and pop artists made guest appearances on recordings by Andrae Crouch and the Disciples.[32] This group enjoyed so much crossover success with rock and pop audiences that it took the producing skills of Sandra Crouch, who recorded him with their father's choir, to regain credibility with churchgoing gospel enthusiasts.

Edwin Hawkins moved to the Bay Area from his native Newark, New Jersey. In 1968, while serving as pianist and director for the Northern California COGIC Youth Choir, he arranged and directed a version of "Oh Happy Day," a British hymn from 1755, last revised in 1855 and found in standard Baptist hymnals. Recorded and released by a major label, "Oh Happy Day" became the best-selling gospel song ever. When the choir's popularity faded, the group returned to church. Edwin's brother Walter Hawkins became pastor of the Love Center COGIC in Berkeley and married the choir's soprano, Tramaine Davis. Andrae Crouch produced a recording of the Hawkins family featuring Walter's preaching, Tramaine's singing, and Edwin's piano playing. The album helped Walter Hawkins and the Hawkins family to become one of the most successful acts in their field.[33]

For most of the twentieth century, gospel music has been a lively and dynamic part of local and regional culture in California. The distinctive sounds made by Andrae Crouch and the Disciples, the Hawkins Family Singers, Bessie Griffin, the Mighty Clouds of Joy, and the Andrews Sisters Gospel Singers (among others) have secured approval from congregations and audiences around the world. Successful California musicians working in many different genres got their first musical training within the gospel tradition. Thus, an important part of what audiences recognize as California music comes from the cultural ferment initiated by William J. Seymour at the Azusa Street Revival and continued by Bishop Mason and subsequent gospel singers from the Church of God in Christ, as well as from other denominations.

As in gospel, cultural figures and fusions created in California went on to influence the wider world in jazz, when West Coast musicians traveled overseas. Bands led by Sonny Clay, Jack Carter, Earl Whaley, Bob Hill, and Frank Shievers carried the musical hybrids developing in California to Asia in the 1920s. Bill Powers, Gene Powers, and Buck Campbell brought a jazz band to Yokohama, Japan. Pianist Bill Hegamin and dancer Freddie McWilliams performed in China.[34] Teddy Weatherford toured Asia as a member of Jack Carter's band. He remained in Shanghai, where he continued his jazz career. Weatherford played professional engagements in Singapore and China, recruited trumpet player Buck Clayton to China to play with his group in 1934, and later worked in India.[35] Sid LeProtti and Reb Spikes left San Francisco to play jazz in Hawaii. Scat singer Bo Didley performed in Japan. Sonny Clay and His Orchestra performed in Australia.[36] When these artists brought "California" culture to other countries, they took along with them a part of New Orleans, a city many of them had never seen.

The centrality of New Orleans Dixieland jazz within California music may seem like a picturesque anomaly, but similar cases of migration and inter-regional connections permeate the histories of rock and roll, blues, folk music, and modern jazz in the state. Sometimes the actual forms of New Orleans jazz survived in these musics—in the 2/4 time signatures favored by the western swing orchestras of Spade Cooley and Bob Wills; in the ensemble playing of folk, jazz, and rock groups; in the one-four-five chord progressions and three-line, twelve-bar blues deployed overtly by blues musicians and covertly by modern-jazz players. Yet even when California musicians played styles with no structural affinities to New Orleans jazz, they operated in a social and cultural milieu shaped by migration and displacement.

Western swing band leader Spade Cooley came to California from Oklahoma, but so did folksinger Woody Guthrie, blues artist Lowell Fulson, jazz

Handbill from Janis Joplin and the Kosmic Blues concert at the Swing Auditorium in San Bernardino, California, March 28, 1966
Courtesy of Jim Heimann

trumpeter Chet Baker, and pop rocker David Gates. Gram Parsons and Jim Morrison were born in Florida, Sugar Pie DeSanto, Gerry Mulligan, and Joan Baez in New York. Horace Tapscott's neighbors in Houston included Floyd Dixon, Amos Milburn, Johnny Guitar Watson, and Edwin Pleasant— all of whom later became California musicians. Performers who grew up in California could not help being influenced by these migrations, as evidenced by the Louisiana imprints on the very different musical styles of Creedence Clearwater Revival, Turk Murphy, the Blasters, and Redbone.

Unexpected affiliations characterize cultures created by mass migrations. For example, few stylistic or cultural similarities would appear to unite Rose Maddox—California's most popular female country music performer from the 1940s to the 1960s—and Janis Joplin, the emblematic representative of San Francisco's Haight Ashbury counterculture of the 1960s. Yet Maddox came to California with her family from Alabama in the 1930s for many of the same reasons that Janis Joplin left Texas during the 1960s. Dime novels and short stories about the West influenced Lula Maddox. "She read only Western stories," Rose's sister Alta told a reporter about their mother. "It just sounded so good to her. It was exactly the way she wanted her life."[37] Joplin idealized the West as well, although Hollywood films, television programs, and journalistic accounts of North Beach Beats were the vehicles that alerted her to the possibility of a better life in California. But more than this symmetry unites Maddox and Joplin. As a teenager in Texas, Joplin made it a point to attend every concert she could by Rose Maddox in order to learn how to sing professionally.[38]

Similarly, few artists seem as opposite as Bakersfield's Merle Haggard and "Country" Joe McDonald from El Monte and, later, San Francisco. During the 1960s especially, Haggard offered eloquent testimony to the traditionalism and cultural conservatism in California through his songs "Okie from Muskogee" and "Fightin' Side," both protests against the protest culture of hippies and antiwar demonstrators. Country Joe, on the other hand, drew upon San Francisco's legacy of political radicalism and Beat bohemianism by writing and performing antiwar songs, especially "I-Feel-Like-I'm-Fixin'-to-Die Rag." Yet both Californians treasured the memory of Woody Guthrie, whose song "Pretty Boy Floyd" was a childhood favorite of Haggard's; it was also recorded by McDonald on a tribute album to Guthrie. Nothing from the past ever goes away completely, even in a place like California, where rapid and dramatic change is the norm. Just as traces of Dixieland jazz and the Azusa Street Revival permeated subsequent cultural creations in jazz, popular music, and gospel, so the state's long histories of migration, labor exploitation,

racial repression, and intercultural creativity continue to inflect contemporary California culture.

For most of the twentieth century, popular music made by, for, and about Californians has played an unparalleled role in generating images that define larger social, cultural, and historical realities. The Depression years of the 1930s found some of their most powerful expressions in the traveling blues sung on Central Avenue in Los Angeles by T-Bone Walker, the songs of Dust Bowl migration performed in Central Valley migrant camps by Woody Guthrie, the *corridos* of Pedro Gonzales and Los Madrugadores, and the alternating sensibilities of resignation ("Brother Can You Spare a Dime") and resolve ("Wrap Your Troubles in Dreams") in the music of Bing Crosby. The 1960s saw popular songs about the 1965 Watts riots ("No Way to Delay That Trouble Coming Every Day," by the Mothers of Invention in 1967) and the 1966 "youth riots" on the Sunset Strip ("For What It's Worth" by Buffalo Springfield). In the 1990s, songs by Los Angeles hip-hop artists Ice Cube and Ice-T and by the Bay Area's Tupac Shakur and Paris offered extraordinary insight into the conditions facing inner-city youths.

These expressly political songs stand in for a much larger dynamic— the ways in which musicians and the communities from which they come face realities off the bandstand and outside the recording studios. In 1940, Los Angeles Police Department officials prevented the Benny Goodman Orchestra from playing at a dance at the Shrine Auditorium because they feared interracial dancing among the band's white, Filipino, black, and Mexican fans.[39] African American musicians were subjected routinely to police escort back to black neighborhoods after playing music in white neighborhoods.[40] The emerging social formations that made Los Angeles a center for bebop music in the late 1940s also led Los Angeles police officers to intimidate interracial couples along Central Avenue. Trumpeter Howard McGhee and his blond wife Dorothy faced constant harassment of this sort; once a police officer arrested the couple for sitting side by side at a showing of a James Cagney movie in downtown Los Angeles.[41] Law enforcement officers raided after-hours jazz clubs and set up roadblocks on Central Avenue. Trumpeter Clora Bryant remembers "Central Avenue closed up when they found out how much money was being dropped over there and City Hall started sending the cops out there to heckle the white people."[42] According to pianist Hampton Hawes, on any weekend night mixed-race couples would be frog-marched from Central Avenue to the Newton Street police station for "inspection."[43]

Today in California, ghetto-
centric hip-hop from Compton,
Long Beach, Marin City, and
Oakland preserves traces of previous
triumphs by African American
artists and communities, as well as
the continuing legacy of residential
and educational segregation, police
brutality, discrimination in employ-
ment, and cultural suppression
in the lives of inner-city dwellers.
The extraordinary dynamism of

Eleanor Academia
performing Philippine
traditional *kulintang*
with her rock band,
1999
Photograph © Marty
Temme, courtesy of
Black Swan Records

contemporary *rock en español, banda, ranchera,* and other Mexican and Latino
regional musics echoes the *corridos* of Las Madrugadores and Pedro Gonzales,
as well as the politicized satires of Lalo Guerrero and the raw energy of
Chicano punk rock. Spanish-language lyrics in these songs identify aspects of
intercultural cooperation and conflict in California that are both old and new
at the same time. Improvisational traditions from many different cultures
inform the music of Asian American pianists Jon Jang and Glen Horiuchi,
kotoist Miya Masaoka, bassist Mark Izu, and saxophonists Gerald Oshita and
Russel Baba. For these artists, overt and covert musical links across ethnic lines
contain the seeds of interethnic antiracism in the realms of politics, social
structure, and intercultural coalition and cooperation.[44]

The common stock of images about sea, sand, and sunshine that appear
in songs about California cannot possibly begin to capture the complexities
of the state's places and people. One would not know from this repertoire, for
example, that Ravi Shankar, one of the greatest South Asian sitar virtuosos,
lives in Encinitas in north San Diego County. One could not guess from song
titles or lyrics about California that the members of Los Tigres del Norte, one
of the most popular musical groups in the world, make their homes near San
Jose. Los Tigres have appeared in nearly a dozen motion pictures, sold mil-
lions of albums, and performed before sellout crowds in their native Mexico.[45]

To what song titles or lyrics do we turn to acknowledge the presence in
Reseda of the World Kulintang Institute, devoted to Filipino gong and drum
music from the third century? Hawaiian-born Eleanor Academia founded the
institute because she felt that growing up in San Diego and living in California
led her to lose touch with her family's Filipino heritage. In addition to her
conservationist work with *kulintang,* Academia contributes to music making

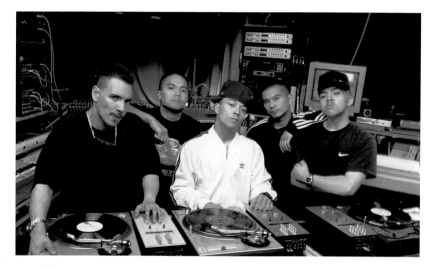

Invisibl Skratch Piklz,
1997
Photograph © 1997
Karen Miller, courtesy
of Invisibl Skratch
Piklz, Inc.

in California as a celebrated composer, performer, and instrumentalist of
dance music, a veteran of ensembles featuring rhythm and blues, rock fusion,
and blues music, a former musical director for the Quincy Jones jazz work-
shops, and a onetime orchestra conductor for an off-Broadway play. Academia
combines her career as a commercial musician with the work of the institute,
reminding her students of the social dimensions of the culture they study.
Kulintang may be seen as an important folk form, but it also has a revolution-
ary history in the southern Philippines, originating as a music designed to
disguise martial arts training as dance in order to fool the Spanish colonizers
of the Philippine Islands. Academia's students learn music at the institute, but
in order to understand the full context from which the music emerged, they
must also understand Filipino history and global politics.[46]

African American hip-hop artists Ice Cube, Snoop Doggy Dog, and
Tupac Shakur have fashioned memorable song lyrics about life in California's
inner cities. But some of the most significant creations within hip-hop at
this time come from Asian and Pacific Islander communities, whose artists
have life histories that tell as much about contemporary California as do their
song lyrics. Self-conscious statements about living in the Golden State rarely
appear in the music of the Boo Yaa Tribe from Carson. But these Samoan
immigrants—who once lived in Japan and worked as a dance and rap act in
Tokyo before attaining success performing hip-hop before largely black and
Latino audiences in Los Angeles—create music that speaks powerfully to
the cultural complexity of the present moment in California.[47] Five Filipino
American youths from the Excelsior district in San Francisco calling them-
selves the Invisibl Skratch Piklz have emerged as the leading turntablists and

mixmasters in the Bay Area hip-hop scene.[48] In Yuba City, South Asian hip-hop artists blend African American rhythm and bass tracks with *bhangra* music from Punjab.[49]

The suburbs of Orange County, at one time home to the core audience for the Beach Boys, now house one of the largest and most vibrant Vietnamese immigrant/refugee communities in the world. Its members attend concerts and purchase recordings by a wide range of Vietnamese-language singers from Vietnam, France, and the United States. One of the most popular is Dalena, a monolingual English speaker from a Scandinavian and Scotch-Irish background. Born in Muncie, Indiana, and raised in Orlando, Florida, Dalena touches her audiences deeply, even though she is not Vietnamese and does not know the meaning of the words she sings.[50] At the same time, the Vietnamese American musicians in El grupo musical Lac Hong from Orange County entertain and educate audiences by performing songs with Spanish-language lyrics about movement, migration, and war, songs that inevitably highlight the similarities between refugees from Central America and refugees from Southeast Asia.[51]

To think of Ravi Shankar, Los Tigres del Norte, Eleanor Academia, the Boo Yaa Tribe, the Invisibl Skratch Piklz, Dalena, or El grupo musical Lac Hong as makers of California music is to confront the slippage between culture and place that seems to characterize so much of contemporary cultural production and reception.[52]

The rhetorical California constructed in so many song lyrics, feature films, and television programs offers only a faint insinuation of the historical California created through cultural conflict and collision, as well as through cooperation and coalition during much of the twentieth century. The productions of popular musicians do not provide a transparent window into the past, but they do have much to teach us about the social and historical contexts from which they emerged. They contain pieces of the past that are still here; they prefigure parts of the future that have not yet arrived. They remind us of how hard life has been—and continues to be—for so many in this state. But at their best, they perform the important task that art historian Robert Farris Thompson associates with African art: "They illumine the world with intuitions of power to make right things come to pass."[53]

George Lipsitz is professor of ethnic studies at the University of California, San Diego. He is author of *Dangerous Crossroads: Popular Music, Postmodernism, and the Poetics of Place* (1994) and *The Possessive Investment in Whiteness: How White People Profit from Identity Politics* (1998).

168

1 It is difficult, for example, *not* to think of California when envisioning the poverty and social movements of the Great Depression, mobilization for World War II, suburbanization and the growth of the military-industrial complex of the 1950s, the political and cultural movements of the 1960s, the rise of "balanced budget conservatism" in the 1970s, the cultural conflicts of the 1980s, or the dimensions of globalization in the 1990s.

2 The Ink Spots, "When the Swallows Come Back to Capistrano"; Al Jolson, "Avalon"; The Sir Douglas Quintet, "Mendocino."

3 Count Basie and Tadd Dameron, "San Jose"; Dionne Warwick, "Do You Know the Way to San Jose?"; Freddie King, "San Ho-Zay."

4 Merle Haggard, "Kern River," "Tulare Dust."

5 Helen Humes, "Central Avenue Blues"; Pee Wee Crayton, "Central Avenue Blues"; Lionel Hampton, "Central Avenue Breakdown."

6 Tony Bennett, "I Left My Heart in San Francisco"; Joe Simon, "San Francisco Is a Lonely Town."; Village People, "San Francisco."

7 Dwight Yoakam, "Streets of Bakersfield"; Waitresses, "Redlands"; NWA, "Straight Outta Compton."

8 Michael B. Bakan, "Way Out West on Central: Jazz in the African American Community of Los Angeles before 1930," in Jacqueline Cogdell DjeDje and Eddie S. Meadows, eds., *California Soul: Music of African Americans in the West* (Berkeley and Los Angeles: University of California Press, 1998), 86–87.

9 Eagles, "Hotel California," Asylum Records, 103-2 EUR 253-051; *The Penguin Encyclopedia of Popular Music* (London: Penguin Books,

1990), 370, 753, 630, 497, 260, 63.

10 *The Penguin Encyclopedia of Popular Music,* 621. Herbert Goldman, "Al Jolson: The Best of the Decca Years," liner notes, MCAD-10505, 8, 10.

11 Bakan, "Way Out West on Central," 27, 38; Rex Harris, *The Story of Jazz* (New York: Grosset & Dunlap, 1955), 70.

12 Burton Peretti, *The Creation of Jazz: Music, Race, and Culture in Urban America* (Urbana: University of Illinois Press, 1994), 22, 41; Harris, *The Story of Jazz,* 70–71.

13 Marshall and Jean Stearns, *Jazz Dance: The Story of an American Vernacular Dance* (New York: Da Capo Press, 1994), 96.

14 Peretti, *The Creation of Jazz,* 22, 41; Bakan, "Way Out West on Central," 24.

15 Tom Stoddard, *Jazz on the Barbary Coast* (Berkeley: Heyday Books, 1998), 10; Bakan, "Way Out West on Central," 33.

16 Harris, *The Story of Jazz,* 151–52.

17 *The Penguin Encyclopedia of Popular Music,* 879; Harris, *The Story of Jazz,* 161, 237; Clora Bryant et al., eds., *Central Avenue Sounds: Jazz in Los Angeles* (Berkeley and Los Angeles: University of California Press, 1998), 226.

18 Stoddard, *Jazz on the Barbary Coast,* 110, 112; Bakan, "Way Out West on Central," 26, 41, 57–58; Harris, *The Story of Jazz,* 80.

19 Harris, *The Story of Jazz,* 70. In 1913 drummer and piano player Art Hickman organized a "jazz band" imitating the black groups that had been coming to the West Coast for five years. Hickman's band accompanied the San Francisco Seals baseball team to their spring training camp, and their performance there provoked the newspaper account that scholars generally consider the

first printed mention of jazz. See James Lincoln Collier, *Jazz: The American Theme Song* (New York: Oxford University Press, 1993), 167–68; Bakan, "Way Out West on Central," 31.

20 Bryant et al., eds., *Central Avenue Sounds,* 13.

21 Ralph Eastman, "'Pitchin' Up a Boogie': African-American Musicians, Nightlife, and Music Venues in Los Angeles, 1930–1945," in DjeDje and Meadows, eds., *California Soul,* 82.

22 Bakan, "Way Out West on Central," 66; Eastman, "'Pitchin' Up a Boogie,'" 86–87.

23 George Lipsitz, *Dangerous Crossroads* (London: Verso, 1994), 19.

24 Collier, *Jazz: The American Theme Song,* 166–70.

25 Harris, *The Story of Jazz,* 233–5; *The Penguin Encyclopedia of Popular Music,* 838, 1219.

26 Bakan, "Way Out West on Central," 47–48.

27 Scott DeVeaux, *The Birth of Bebop: A Social and Musical History* (Berkeley: University of California Press, 1997), 57.

28 Eastman, "'Pitchin' Up a Boogie,'" 86.

29 Anthony Heilbut, *The Gospel Sound: Good News and Bad Times* (New York: Limelight Editions, 1992), 176.

30 Cheryl J. Sanders, *Saints in Exile: The Holiness-Pentecostal Experience in African American Religion and Culture* (New York: Oxford University Press, 1996), 27–31.

31 Jacqueline Cogdell DjeDje, "The California Black Gospel Music Tradition: A Confluence of Musical Styles and Cultures," in DjeDje and Meadows, eds., *California Soul,* 136, 141, 143.

32 *The Penguin Encyclopedia of Popular Music,* 303.

33 Heilbut, *The Gospel Sound,* 248; Sanders, *Saints in Exile,* 76.

34 Stoddard, *Jazz on the Barbary Coast,* 203–4.

35 *The Penguin Encyclopedia of*

Popular Music, 1220; Stoddard, *Jazz on the Barbary Coast,* 112.

36 Stoddard, *Jazz on the Barbary Coast,* x.

37 Jonny Whiteside, "The Manifest Destiny of the Maddox Brothers and Rose," *Journal of Country Music* 6, no. 2 (1986): 9.

38 Joanna Cazden, "The Rose of the West, Rose Maddox," *Sing Out* 6 (1980): 3. For Joplin, see the extraordinary biography by Alice Echols, *Scars of Sweet Paradise: The Life and Times of Janis Joplin* (New York: Metropolitan Books, 1999).

39 Eastman, "'Pitchin' Up a Boogie,'" 80.

40 Barney Hoskyns, *Waiting for the Sun: Strange Days, Weird Scenes, and the Sound of Los Angeles* (New York: St. Martin's Press, 1996), 8.

41 Robert Gordon, *Jazz West Coast* (London: Quartet Books, 1986), 16.

42 Bryant et al., eds., *Central Avenue Sounds,* 365.

43 Hoskyns, *Waiting for the Sun,* 8.

44 George E. Lewis, "Improvised Music after 1950: Afrological and Eurological Perspectives," *Black Music Research Journal* 16, no. 1 (spring 1996): 113.

45 Carolyn Jung, "S.J. Band's Rhythms Transcend Borders," *San Jose Mercury News,* March 5, 1994.

46 Devorah L. Knaff, "Bang a Gong," *Riverside Press-Enterprise,* January 23, 1998; *http://members.tripod.com/ eleanor_academia/blues_ea.html* (Mar. 14, 2000).

47 Brian Cross, *It's Not about a Salary . . . : Rap, Race, and Resistance in Los Angeles* (London and New York: Verso, 1993), 151.

48 Dave Tompkins and James Tai, "Science Friction," *Urb* 57 (1998): 42–47. The author thanks Antonio Tiongson for first calling his attention to Q-Bert and the Invisibl Skratch Piklz.

49 Gayatri Gopinath, "'Bombay, the U.K., Yuba City': Bhangra Music and the Engendering of Diaspora," *Diaspora* 4, no. 3 (winter 1995).

50 Seth Mydans, "Miss Saigon, U.S.A.," *New York Times,* Sept. 19, 1993; "Dalena": *http://www.vietscape.com/music/ singers/dalena/biography.html* (Mar. 14, 2000).

51 Mary Cappellini, *El grupo musical Lac Hong* (Crystal Lake, Ill.: Rigby), 1997.

52 Lipsitz, *Dangerous Crossroads.*

53 Robert Farris Thompson, *Flash of the Spirit: African and Afro-American Art and Philosophy* (New York: Vintage, 1984), 93.

Plate XXVIII : Landscape—*Half Dome, Yosemite Valley*. 8 by 10 camera, 12 in. lens, K2 filter, full exposure and development ; print on normal paper, full development.

Plate XXIX : Photo-document by Dorothea Lange of San Francisco—*"Bread-line*, 1933." 3¼ by 4¼ Graflex, 7½ in. lens, Defender film. Made late in afternoon. Normal development ; print on Eastman Vitava B, normal development.

Sally Stein

ON LOCATION:

THE PLACEMENT (AND REPLACEMENT) OF CALIFORNIA IN 1930S PHOTOGRAPHY

California's impact on photography was never so great as in the 1930s. The effect was also reciprocal, for photography in this period played a prominent role shaping the state's public image and programs. The evidence to support these sweeping assertions is as diverse as it is abundant, ranging from art photography to photography in the service of labor struggles.

Group f/64 formed in the San Francisco Bay Area in 1932, and, though short-lived, this organization of self-consciously modernist photographers served in the first half of the 1930s as the most visible and vocal locus for "straight photography" in the United States. Two leading figures in this group, Edward Weston and Ansel Adams, were featured in major 1930s exhibitions in New York, Chicago, and San Francisco, along with numerous smaller cities, and in these cosmopolitan venues their photographs offered contemporary views of California at its most sublime.[1] Of comparable influence was Adams's *Making a Photograph* (1935), widely regarded as the first systematic effort to codify the principles and methods of postpictorial, realist photography. This book, though not published in California or indeed anywhere in the United States but rather in London, featured exceptionally fine reproductions of a number of his California landscapes and also one example of a new "photo-document" from the same state, Dorothea Lange's *Bread-line, 1933* (subsequently known as *White Angel Breadline*).[2] The double-page juxtaposition of his stately landscape and her gritty street scene effectively restaged old debates about photography's relative affinity for fixity or flux, nature or culture. However jarring the clash of subject matter (though here it was skillfully offset by some formal echoes across the double-page spread), the pairing of plates also represented the active dialogue taking place among California photographers, a dialogue that led most participants to strengthen, refine, alter, and/or broaden their practice and conception of photography.

In practice, both Adams and Lange had briefly explored dramatically different uses of the medium—Adams producing portraits of farmworkers that were published in a sociological article by Paul S. Taylor, and Lange attempting nature studies in the Sierras—and the largely unsuccessful crossover experience left each more deeply committed: to social photography in Lange's case and nature studies in Adams's.[3]

Though Adams did not share Lange's progressive commitment to social intervention and reform, in matters of wilderness conservation he was an ardent activist. Three years after *Making a Photograph,* he published *Sierra Nevada: The John Muir Trail* (1938), his first book composed entirely of landscapes, most of which were made in California's Kings River Canyon. He had used some of these photographs while lobbying Congress in 1936 on behalf of the Sierra Club's preservation efforts, and the subsequent book offered more sustained argument for the establishment of the Kings Canyon National Park, which was legislated in 1940.[4]

Some of Dorothea Lange's photographs, most notably *White Angel Breadline* (1933) and *Migrant Mother* (1936), became reigning symbols of the nation's Great Depression and of Depression-era documentary concerns with the "down and out." But these iconic images are only one measure of the impact of her photography in California and across the nation. Her work in the field with Paul S. Taylor (a socially active University of California, Berkeley, labor economist, who became her second husband in December 1935) served as a model for the emerging procedures of New Deal documentary practice, combining very empathic photographs with more impersonal reports about prevailing regional conditions. It also led to concrete efforts to improve the living and working conditions of migrant laborers. So far-reaching was the influence of Lange and Taylor's collaborative fieldwork that it can be credited as a primary source for John Steinbeck's best-selling novel *The Grapes of Wrath* (1939) and the exceptionally prolabor, antibusiness Hollywood film by John Ford that followed on its heels in 1940.[5]

The labor unrest for which California in this period was renowned not only constituted a recurrent subject for mass media depictions; on at least one occasion it led photojournalists to coordinate their efforts to report on the brutal repression mounted by paramilitary forces during the Salinas lettuce strike of 1936.[6] As for uses of photography by organized labor, the Maritime Federation of the Pacific surpassed the media efforts of nearly all other unions with its publication of *Men and Ships* (1937). This sophisticated commemoration of labor's hard-won victory on the West Coast docks drew eclectically on

the simplified style of the new mainstream picture weekly *Life* and on the
trenchant militancy of such earlier European left-wing graphic periodicals as
AIZ.[7] Likewise, photomontage, though far more common in European mod-
ernist practice than in the United States, found new application in a popular
satiric exposé of the Hollywood film industry, Will Connell's *In Pictures* (1937).[8]

The list of innovations could be extended, but it is more interesting to
consider why such varied manifestations of California photography seemed
to come of age almost simultaneously in this era. And why did they cluster
in California, of all places? Asking what might be specific and perhaps also
common to 1930s California photography risks overemphasizing established
notions of California as a place apart, "west of the West,"[9] with a culture
that developed according to its own internal logic. But the reasons for such
widespread change in California photography over a short period of time
may have less to do with the distinctive integrity of the region than with the
ways this decade of protracted crisis punctured the region's insularity. The
demand for national responses to nationwide problems added a comparative
dimension to local issues and viewpoints. Mass media thrived in this era,
in part because photography became an integral part of everyday commu-
nication in print. Of course, photography had the prestige of immediacy
and particularity, but the proliferation of photographs in popular print
culture also laid the ground for more comparative ways of looking at, pre-
senting, and weighing the evidence captured by the camera. As all sorts
of photographs made in California had increasing opportunity to enter
a national arena, they engendered debates about both the state of photogra-
phy in California and the state of California. Thus many photographers in
California felt challenged to reexamine the nature of their medium and the
ways it might specify both one's immediate location and, when desired, one's
coordinates in the larger world.

AT THE START OF THE 1930S, California photography seemed poised to inau-
gurate the Depression era with new modes of representation. This is not to say
that California was in the vanguard. Quite the contrary: the West Coast was
relatively late in embracing straight photography, which for a decade had
flourished in modernist circles in Europe and New York.[10] Why photographic
modernism was slow to make its way to California raises other questions, but
the fuzzy print style that was the trademark of the older Pictorialist move-
ment lingered like the perennial fog on the Pacific, so maybe climate served to
"naturalize" its extended life on the West Coast.

Whatever the ultimate explanation for its delayed arrival, the heralding of photographic modernism in San Francisco was especially timely in 1932. There was a collective embrace of sharpness and clarity, as if these were the visual hallmarks of more sweeping reforms. The name adopted by the group of self-styled photographic modernists, f/64, stood literally for the smallest lens aperture, which provided maximum depth of field while requiring the longest exposure.[11] This abbreviated moniker already conveyed the emphasis placed on rigorous photographic technique, but it also shared the snappy rhythm of "FDR," initials constantly invoked on the eve of the presidential election as consonant with change.

Like FDR, f/64 could not have chosen a better moment for its debut in the United States. Yet unlike the reform Democrat, f/64 never aimed to become a national movement. Rather, it remained defensively local in its orientation, focusing crisply on those motifs in nature that seemed uniquely characteristic of the region. It was in this sense both resolutely modern and provincial, and this disjunction aptly expressed California's anomalous position within the nation.

Largely for reasons of geography and history, California had long stood apart from the rest of the country, and the state's national image continued into the first decades of the twentieth century to be associated with the frontier. However, after the film industry was firmly established in Southern California, the very word "Hollywood" began to eclipse all other names and symbols that previously bespoke the state, to the dismay of those, particularly in the north, who much preferred the frontier associations. When Ansel Adams in 1933 sought to persuade New York–based photographer Paul Strand to exhibit his work in Adams's short-lived San Francisco gallery, he assumed that Strand's view of California from across the nation was gravely distorted: "Despite a certain sneering attitude in the east about California," Adams acknowledged, "I would rather live here [in San Francisco] and work than in any other American city I have seen—and I have seen most of them." Adams was quick to elaborate his reasons: "There is a vitality and a purpose, and a magnificent landscape," before adding parenthetically: "Hollywood, etc. has ruined the reputation of all California."[12] In this pitch, which did not sway Strand back East, landscape held the secret to the region's vitality and purpose. By implication, only artful recourse to the same unspoiled landscape might reclaim both photography and the state from the taint of vulgar showmanship.

For Adams, the process of clarifying his conception of photography began quite literally as a peak experience, high up in the Sierras. For the rest

of his life he would recall the exact date, April 27, 1927, when he commenced
the process he later called "visualization" (more recently it has come to be
known as "previsualization," an amalgamation of Adams's term with Weston's
related concept of "prevision").[13] In his 1935 book on photographic technique
Adams declared that a photograph's structure "follows ideas."[14] According to
this prescription, the photographer should envision a priori how the photo-
graph would best express his or her perception and proceed to use all techni-
cal means available to make the picture correspond to that perception. Toward
the end of his life Adams would restate the concept:

*The image forms in the mind—is visualized—and another part of the mind calcu-
lates the physical processes involved in determining the exposure and development
of the image of the negative and anticipates the qualities of the final print. The cre-
ative artist is constantly roving the world without, and creating new worlds within.* [15]

Defined in this way, visualization was a late California variant on Emerson's
transcendentalism, with ideas supplying the generative force in the encounter
with nature.

In many respects visualization could be as manipulative as the Pictorial-
ist technique of manual embellishment it sought to supplant. It was certainly
more calculating, while the appearance of manipulation was far more subtle,
embedded in the range of mechanical controls so that all effects seemed to
emanate from the scene rather than being externally imposed.[16] Given Adams's
abiding love of unspoiled nature, it was only fitting that the photographs he
made should appear to be wholly natural, that is, direct, "objective" recordings
of the natural scene.

Adams would recall his seminal act of visualization in the mode of reve-
lation. In Yosemite park he had ascended to the Diving Board, at the summit
of Grizzly Peak, in order to face head-on the prow of Half Dome. When he
arrived the monolith was in shadow, and he nearly used up his film in making
other pictures while waiting for the light to change. With only two unexposed
sheets left when the rock face emerged from shadow, scarcity served as mother
of invention. He made one relatively straightforward exposure using the
conventional yellow filter to prevent the brilliant sky that formed the back-
ground from looking bleached from overexposure. Then, with his remaining
exposure, he went for broke, deciding that what he really wanted was to
"dramatically darken the sky and shadows on the great cliff."[17] With the sim-
ple use of a deep-red filter, he radically altered the tonal values. The striking
results matched his quest for awesome power.

In his 1985 autobiography Adams reproduced both exposures, while giving greater space to the second. The only slightly filtered exposure possesses the subtle tonal gradations of a Chinese landscape painting, with the rocky peak threatening to dissolve into thin air. The dreamlike quality of this first view gives way in the second to rock-solid presence, for the snow at the summit is here rendered as a thin white outline, against which the mass of Half Dome competes for density with the nearly blackened sky. Thus Adams discovered a heroic monochrome palette with which to set the force of rock against the weight of apparent night. Ironically, in a few decades this photographic form of simulating darkness would be associated with the vulgar showmanship of Hollywood.[18]

Adams was perfectly right to insist in his 1985 memoir that "visualization is not simply choosing the best filter." But it is understandable why he added that caveat, for filters played a key role in the development of his technical system. Particularly during his first decade of practicing visualization, he used intense tonal contrast to create pictures in which strips of pristine nature are bordered above and below by horizontal bands of darkness. *High Country*

Crags and Moon, Sunrise, King's Canyon, circa 1935, is an extreme example of
his tendency to make photographs at the crack of dawn. But even when work-
ing at other times of day, Adams relied on filters to simulate the sense of magic
one can experience when something just begins to be illuminated, as if created
for the first time, or, conversely, when it is poised on the threshold of obscurity
at the end of the day. It was a brilliant way to dramatize the idea of nature
squeezed (yet also secured) in a vise of impenetrable darkness, while holding
its own through sheer force of illumination.

By enveloping nature so protectively, Adams also designated a refuge
for himself that he considered ever more necessary in the increasingly polar-
ized social landscape of California. From his perspective, the Depression
era only added new corrupting forces to those already posed by Hollywood.
An admittedly conservative liberal, Adams distrusted not only the Left but
even at times the New Deal as a potentially dangerous force of regimenta-
tion.[19] With notable regularity, the pictures he made in this period carve out
a place quite literally in the middle, to stand for the beleaguered habitat of
"true," "timeless" California. In the Cold War era, another conservative liberal,
Arthur M. Schlesinger Jr., would extol "the vital center" of liberal individual-
ism in American politics as the only ground capable of fending off totalitarian
threats from the Left and the Right.[20] Already in the 1930s Adams responded
to the specter of extremism by composing a symbolic topography in which
the core position of nature was ably fortified to contain a host of dramatic
effects with perfect equipoise.

STARTING IN THE EARLY 1930s Edward Weston shared Adams's fascination
with the drama produced by extreme tonal manipulation. In Mexico in the
mid-1920s he had worked in harsh sunlight and quickly learned how the
power of light alone could produce radical simplification of forms. Back in
California at the end of the decade, he began to orchestrate comparable effects
by pushing the contrast of the negative and/or the print. At nearly the same
time as Adams, Weston independently began to reverse the traditional figure-
ground relationship of his images. At the end of 1929 he recorded in his
journal great satisfaction with a print of "two white trunks brilliantly white,
against the overcorrected sky." In this instance, the photographer took pains to
note, he had exposed the negative conventionally but then chose high-contrast
paper to intensify the difference between "the sky very dark, the trees very
white." The effect Weston declared "aesthetically thrilling."[21]

How to comprehend the immense appeal of such reversal? Purity is certainly one factor, combined paradoxically with eroticism, for the trunks whitened may have summoned thoughts of unblemished chastity and also of naked sexual availability, especially if the limbs were made to resemble those of the white female models Weston loved equally to photograph and, in photographic close-up, transform. Likewise, the reversal may be said to have an uncanny effect, with the living organic material depicted as bordering on the bone-dead. And as with Adams, the tonal reversal enabled Weston to encapsulate the central subject; the "thing itself" was an expression he frequently employed as a way of alluding to the quintessential quality he was after.[22] His creation of a black ground insisted on the condition of isolated itself-ness, of near absolute self-reflexivity.

During the early 1930s Weston pushed this decontextualizing effect to its limit; some of his friends argued strenuously that he pushed it beyond all reasonable limits when in 1931 he made his *Shell and Rock* study. Five years later, Arthur Rothstein provoked a storm of political controversy when, while documenting drought conditions on the High Plains for the Farm Security Administration, he moved a cow's skull from dry grassland to utterly parched dirt in order to render more dramatic the desperate farm situation in the Midwest. In so doing, he inadvertently fueled Republican attacks on New Deal programs, thereby jeopardizing the status and funding of FSA publicity operation.[23] A half decade earlier, Weston had taken similar liberties with *Shell and Rock*. His 1931 manipulations produced no indignant cries in newspapers but they did provoke tempestuous debate among his most fervent admirers. By coincidence, Weston had even experimented repositioning a cow's skull on the beach, though he much preferred the results he achieved when he placed the conch shell not in a neutral studio setting (as had been his habitual technique) but outdoors where, nestled in a hollow of dark rock, it virtually glowed.

Those objecting to such blatant artifice included even Weston's son Cole, and in the frank dialogue characteristic of that time and place they let him know it.[24] In the privacy of his journal, Weston admitted some doubts. Nevertheless, he found the picture sufficiently compelling that he insisted on including it in the 1932 survey of his work, *The Art of Edward Weston*. In that publication he added "Arrangement" to the title, "to forestall criticism from *naturalists* that I was 'nature-faking.'" By incorporating this photograph in his official oeuvre, which previously had been praised for allowing "nature to talk her own language," Weston was asserting his need to defy theory and dogma

Edward Weston, *Shell and Rock Arrangement*, 1931
© 2000 Collection Center for Creative Photography, the University of Arizona

about himself and about the proper path for photography. Not only was he defending his prerogative to arrange, but also the very idea of active arrangement as fundamental to art. As his work changed over the decade, he seemed to accept that all photography, indeed all perception and representation, had of necessity an element of "nature-faking."

And still, we might ask, why this form of nature-faking? What was Weston after when he placed the shell anew so that it was both inserted into yet at odds with its environment? Beyond the sexual uncanny, which Freud argued was ultimately womb-driven, was there not also a social politics in this move? For if Weston was less dogmatic than Adams, he felt equally threatened by the vulgar imperative of the "box office" and the alternative prospect of Left rule in the name of the "sovereign mass."[25] With such a polarized vision of likely cultural possibilities, the space of nature offered the safest sanctuary, in which difference—between rock and shell, roughness and smoothness, darkness and luminosity, mass and individual, as well as femininity and masculinity—might be permitted maximum play within a fundamentally homeostatic environment.

OF COURSE MANY PHOTOGRAPHERS of the period did not share this fearfully polarized vision of the situation in California and its likely outcome. For them, the changes wrought by the prolonged depression opened up radically new ways of thinking about and viewing their surroundings. At a time when the map of power across the nation was being redrawn, some photographers, including a few whose first affiliation was with f/64, resisted insular tendencies by trying to connect the local to a larger world in transition. By no means, however, were the connections immediately self-evident, which only provoked some photographers to use the medium to draw them out.

Numerous scholars have characterized the rise of mass media as a vehicle of Americanization, producing a shared sense of national identity by disseminating a common lexicon of language and images.[26] In the 1920s photography played an increasing role in the periodical press and thus in the standardization of culture. But the same revolution in communication made ever more conspicuous not just the pace of change but also the unevenness of change across the nation. Throughout the 1920s, New York enjoyed national eminence as the financial capital as well as the acknowledged center of culture and communications. But after the collapse of the stock market, the nation turned to Washington for answers as it had never done before except in rare times of war. With the inauguration of the New Deal in 1933, which radically expanded government programs, Washington vied with New York as the "nerve center" of the nation.[27] In California, however, this southward shift of power raised more expectations than it fulfilled. As California historian Kevin Starr argues, the New Deal made its presence felt in California only at the end of the decade.[28] In many respects, then, this change only reinforced California's sense of isolation on the other side of the continent.

Even the historic General Strike of 1934 depended as much on Washington's distance from San Francisco as on the impetus provided by early New Deal legislation. The National Industrial Recovery Act, passed by Congress in 1933, gave legal sanction to independent unions, but a year later the specific terms covering hiring, wages, and hours had yet to be finalized in the port and shipping industries. Strikes began on the San Francisco docks in May 1934 and quickly spread to related transport industries. Local efforts to break the strikes by force resulted in three deaths, scores of injuries, and growing outrage with the brutal response. The Roosevelt administration tacitly demonstrated its own measure of solidarity when it ignored calls from local authorities for massive federal intervention to restore law and order. By the third week of July, organized labor demonstrated its capacity to shut down the entire city,

and this disciplined show of strength enabled maritime workers to compel a new stage of bargaining for significant improvements in working conditions. But months later, Roosevelt's hands-off policy with respect to California had a very different outcome: the narrow defeat of Upton Sinclair's gubernatorial campaign on the End Poverty in California (EPIC) platform. Though conservative opposition in the state was fierce, the populist campaign was so strong that Sinclair probably would have defeated the Republican sitting governor had Roosevelt disregarded the conservative Democrats in California and offered even lukewarm endorsement of the official Democratic candidate.[29]

The resulting retention of the Republican governor in Sacramento made many progressives disillusioned with the New Deal's plans to effect reform in California. Photographer Willard Van Dyke, who helped found f/64 in 1932, offers a case in point. Though specifics of his political development remain hazy, the season of the General Strike produced a radical change in his conception of photography and society. Weston had been and remained his aesthetic hero—Van Dyke made a film about him in 1947—but starting in 1934 his aesthetic concerns were reshaped by a sense of social urgency.[30] Just around the time of the strike, Van Dyke grew so impressed with Dorothea Lange's photographs made on the streets of San Francisco and at demonstrations of radicals that he gave her an exhibit in his modest Oakland gallery, 683 Brockhurst, which previously had shown only the work of f/64 members. As groundbreaking as Lange's street portraiture was, Van Dyke's role championing her work had an enormous effect on the subsequent development of photography in California. It was, after all, this publicity that brought her to the attention of Adams (who included only one photograph not by himself in *Making a Photograph*). More importantly, it alerted progressive academic Paul S. Taylor, who immediately arranged to publish some of her May Day photographs in *Survey Graphic*. Taylor soon began inviting Lange to work with him, which led to her photography becoming an integral part of the world of social reform.[31] Thus in his own turn to a socially engaged cultural practice, Van Dyke proved to be a pivotal figure for others.

Van Dyke's 1934 essay in *Camera Craft* on Lange's photography emphasized its remarkable value as a topical record, while noting the way still photography would always isolate and decontextualize the moment. This criticism reflected his growing personal interest in documenting the political events of the day in the more fluid medium of motion pictures.[32] In 1935 he moved to New York to pursue his plans to make documentary films and to become more involved politically (a 1935 trip to the Soviet Union left him disillusioned

Willard Van Dyke,
*Untitled (White
House)*, c. 1935
The Oakland Museum
of California

with revolutionary change though still committed to socially engaged film-
making). But before pulling up stakes and moving east, he made a parting
shot of the place he was leaving.

This untitled 1935 photograph bears all the technical hallmarks of f/64
schooling, including precise use of a view camera for maximum detail. But
the hypersharpness that depends on stasis here carries a barbed message. The
bright light on the plain rectilinear façade emphasizes the flatness of the archi-
tecture to the point of mockery. Indeed, the whole building might be a façade,
except that the dark windows indicate a certain amount of depth as well as
vacancy. Van Dyke titled most of his photographs, but he pointedly refrained
in this case, for the building conspicuously supplies its own. As vernacular sig-
nage, "White House" is either a comic stab at pretense or else a name so literal
in its reference to the building's exterior as to proclaim its own narrow frame
of reference. But seen by Van Dyke shortly after he had become politically
engaged—championing the 1934 strike and strike-related photography, and
then the EPIC campaign that hung on the support of FDR—this deserted ram-
shackle structure might well stand for *the* White House, or at least its most rep-
resentative West Coast surrogate. Using his old craft of still photography, Van
Dyke all but declared his mounting doubts about the adequacy of the medium,
the rather rarefied f/64 circle, and a state that, at least for the time being, had
been ceded by Washington to archconservative Republican interests.

Other photographs made in 1930s California were presented in ways
that also produced mixed messages about the West Coast's relation to the
rest of the nation. *Life* magazine, to take one prominent example, sought to
depict San Francisco not as a site of working-class solidarity but instead as
just another city with typical urban problems. Less than two months after
its debut as a popular weekly, *Life*'s January 11, 1937, issue carried on one page
seven shots of San Francisco street life at its seediest. Below the headline
"BUM" unfolds a short sequence in which a man lies on the sidewalk ignored
by passersby, then attracts a small crowd, and finally is moved to the stoop of
a flophouse bearing the name "Comfort," which permits the resumption of
pedestrian traffic. In all respects it was a dated photo story. Hansel Mieth had
shot the sequence in 1934, after emigrating from Germany and proceeding,
with her lifelong partner Otto Hagel, to California. On its own, the sequence
can be seen as evidence either of community or desperate anomie. Mieth's
reaction was probably mixed, for she was surprised to discover from personal
experience how hard life could be in America. But both she and Hagel consis-
tently held Marxist views that saw such widespread privation as a precondi-
tion for revolutionary change.[33]

We should not be surprised that *Life* framed the series in 1937 to empha-
size the ubiquitous "urban instinct" to avoid getting involved. From its pre-
miere issue in November 1936, the magazine had demonstrated its preference
for stories featuring monarchic dramas in the House of Windsor rather than
domestic stories about the house of labor. Particularly at a time when mar-
itime workers were once again on strike in the Bay Area and a new militancy
was being displayed by autoworkers in Detroit, *Life* took every opportunity
to douse the flames of class struggle. More surprising is that Mieth appears to
have accepted such treatment of her pictures: shortly afterward she moved
to New York when *Life* offered her a job on staff.

Mieth's partner, Otto Hagel, maintained his independent status, while
dividing his time between the two coasts after Mieth joined the staff of *Life*.
In the East he free-lanced for *Fortune*; on the West Coast he publicized contin-
uing labor battles. Hagel supplied photographs and helped put together the
Maritime Federation's magazine-like commemoration of its victory on the
docks, *Men and Ships* (1937). Location was the underlying theme in this picture
story of labor's triumph. With a headline declaring that the scenes depicted
were from "CALIFORNIA—NOT SPAIN," one preliminary page spread established
California's reactionary climate with an array of dramatic photographs of
striking workers facing brutal attack. To drive home the point of the repressive

CALIFORNIA—NOT SPAIN

Tear Gas Salesman Ignatius McCarthy (wearing a mask) demonstrates his product to armed deputies. Many times McCarthy has personally taken part in gas assaults on California strikers. A purveyor of misery and death. Part of his face blown away by the full charge of a shotgun blast. Sam Adams, a member of the Stockton ILA, was carried from the battlefield by his comrades. Another victim in the fight for economic freedom.

State police about to fire on strikers.

Scene: Stockton, California, April 23, 1937 . . . Cannery workers who insisted on their rights to collective bargaining faced an army of 500 vigilantes, composed of farmers, merchants and hired gunmen, armed with guns, clubs and tear gas. Pretending to "maintain law and order," these strikebreakers shot down 46 brave unionists, many of whom will be permanently disabled.

Otto Hagel, *California—Not Spain*, half page from *Men and Ships: A Pictorial of the Maritime Industry, 1936–1937* © 2000 Collection Center for Creative Photography, the University of Arizona, courtesy of the Maritime Federation of the Pacific and the International Longshore and Warehouse Union Library

atmosphere in the Wild West, that page is paired with a large portrait of labor leader Tom Mooney behind bars. A concluding spread contrasts continued "East Coast Violence" in the struggle to control the docks with "West Coast Peace." In pictures, text, and layout the polemic worked as an emphatic retort to *Life*'s attempt to give San Francisco a "bum rap," using the photographs that Hansel Mieth had made with class struggle in mind.

Not all those photographers who stayed relished the struggle Hagel celebrated wholeheartedly. "We are certainly living in strange times," Adams wrote to Alfred Stieglitz in March 1936, asking solicitously whether Stieglitz was bothered by the New York elevator strike he had read about in the San Francisco papers. (Adams's concern was not unreasonable; the aging Stieglitz lived high up in a tall New York apartment building.)[34] In the same letter Adams worried about events closer to home. The Golden Gate Bridge, nearing completion, threatened to "open up a vast territory in which all the miserable fungus of 'development' will flourish." While conceding that the bridge's architecture was magnificent, Adams reported that his immediate response was to make just one satisfying photograph of an "old fence with moss on it." The fence in question was near Tomales Bay, a region that risked exposure to urban blight once the bridge was completed. It was obvious even to Adams that this photograph was a symptom of his desire to "live in the past," with photography permitting him to "fence off" that which he hoped to freeze in time from any further transformation.

Adams later came to terms with the new bridge and made a stately photograph of it. But while he was bemoaning its completion, Peter Stackpole, who previously had been associated with f/64, began documenting all phases of its construction. Notwithstanding the monumental subject, he had to relinquish the large view-camera format favored by Adams and Weston and work more flexibly. While sacrificing detail, he gained in his adoption of a miniature 35 mm Leica the mobility to capture the bridge builders as they were weaving the bridge together high above the bay, relying on cable alone to keep them suspended. The most vertiginous photographs communicate quite cannily some of the risks involved in this work, along with the sheer thrill of transforming the landscape so dramatically.

On the basis of this breathtaking photoreportage, *Life* invited Stackpole to join Mieth on its staff, though the magazine kept him on the West Coast. *Life*'s quest for sensation led it to concentrate on Hollywood, which provided more than enough glitter and excess for the weekly to repackage endlessly. The editorial commentary was typically bemused, though actual criticism of the movie industry was rare, for *Life* catered to fans, and Hollywood's successful capture of a nearly global audience was the magazine's beau ideal.[35] As early as 1938, Hollywood became Stackpole's regular beat, and the shock involved in this reorientation shows in his work. Nothing could be more different from his bridge pictures than Stackpole's close-up of a screenwriter's head peering at a script, while the rest of his body is enclosed in a steam box. What it shares, however, is a continuing interest in the way work is physically embodied. But as the magazine preferred conventional glamour over the slightly macabre, the new assignment likewise shaped Stackpole, who ceased to view the industry with any critical edge.[36]

A few photographers working more independently in California attempted to not just cover Hollywood but take it on. The task was evidently daunting, as these efforts tended to mix decidedly critical points of view with hints of adulation. For *In Pictures* (1937) Will Connell adopted the technique of photomontage to illustrate a previously published satiric text on the

Ansel Adams, *Fence near Tomales Bay, California,* 1936
© 2000 by the Trustees of the Ansel Adams Publishing Rights Trust. All rights reserved

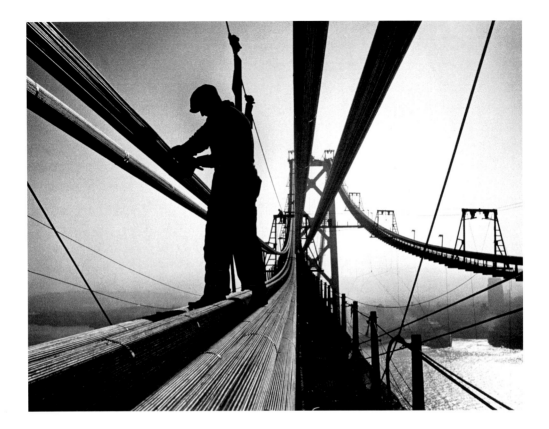

Peter Stackpole,
*In-Between Gallows
Frames, a Bridgeman
Straightens Wires
before Banding,*
from the Bridge series,
1934–36
© 2000 Collection
Center for Creative
Photography, the
University of Arizona

ill-starred genesis of a movie. Intercut with texts devoted to spoofing each stage of production, the montages worked especially well as emblems of the complex assembly process that is central to the making of motion pictures. Connell's background in advertising shows in his frequent use of heavy-handed staging, but many of the montages achieve an elegant economy, relying on simple disjunctions for dystopic effects. The best montages offer memorable swipes at the gigantic scale and vacuity of a cultural enterprise requiring consensus not only of a mass audience but also of participants at every stage in the production process. As such, the book constitutes an argu-ment for the relative autonomy enjoyed by photographers—an autonomy, the book argues, impossible in the motion-picture business.

At the close of the 1930s Weston arranged to visit the MGM storage lot in Los Angeles as part of his Guggenheim-funded photographic survey of California and the West. The most widely reproduced picture from his visit is the view of two rubber dummies. However, the arrangements of staircases in this open-air warehouse attracted him more than the overly cute pair of mannequins. Charis Wilson Weston, the photographer's wife and literary

collaborator in this period, reported that they found "a whole street full of stairways leading to nowhere." The resulting pictures are indeed about that quality of "leading to nowhere," for these passageways, so crucial for Hollywood drama, are robbed of beginning and ending points in their dismantled state. The composition Weston published first was of an assemblage of stair sections piled in such a way that they form a nearly flat, upright circuit.[37] He reprised his old love of circular formations, yet employed that formal motif to mock the shallow artifice of commercial film culture.

Though Hollywood was the immediate target in this photograph, Weston was also aiming more broadly, reflecting critically on any construction (including his own) that closes so neatly onto itself. Numerous scholars have noted in his work from the late 1930s a marked move away from concentric containment and have sought to explain it in various ways. Andy Grundberg, following a passing observation of John Szarkowski, considers it a sign of Weston's late acceptance of broad and deep space, which this critic links to Weston's shift in preoccupation from Eros to Thanatos. While underscoring the big themes of sex and death, Grundberg also acknowledges the more prosaic influence of *Westways*, house organ of the Automobile Club of Southern California, with whom Weston had contracted to supply scenic pictures from his Guggenheim tour. Mike Weaver notes distinct stages in the kinds of compositions Weston made—from symmetrical to concentric configurations, which in turn evolve into spiral patterns, often bearing a countertwist. Weaver

Will Connell, cover of *In Pictures*, 1937 National Museum of American History, Smithsonian Institution, © Will Connell Collection, UCR/California Museum of Photography

correlates this alteration of spatial models with Weston's initial attraction to the idea of an essential typology that, over time, gave way to ideas of development shaped dialectically by nature and culture, order and chance, predestination and less predictable evolution. Regarding the last stage of Weston's photographic adaptations, Alan Trachtenberg returns to the issue of the photographer's extended travels during the period, not just as a job but as a profound experiential change affecting all sense of temporality. Accordingly, the photographer's depictions of space come to represent time, or, given the intrinsic limits of the photographic medium, to indicate its elusive effects: "One senses not the timeless

realm of the earlier pictures," Trachtenberg reflects, "but space *as* time, as duration beyond the capture of a camera."[38]

According to Trachtenberg, Weston's shift in emphasis from significant detail to breadth of landscape reflects a belated recognition of the shaping power of the land, and this observation might be extended dialectically. The land shapes the course of movement, but the developing network of modern highways arguably shapes even the lay of the land and what is found there. Literally, the highways permitted a new kind of exploration, and in his final long-distance travels, Weston came to view the highways in an unconventional fashion, not as subject but as linear force, reconfiguring both land and landscape.

Weston of course did not wholly reject his old motifs or his modes of framing and finding significance in a scene.[39] But on his travels in the late 1930s he also mined the environment for new tropes, and more fundamentally for new ways of seeing the region in tremendous flux. Consider two photographs from this period, not so much for their typicality as for their radical eccentricity in both sensibility and form. They were not widely seen at the time, but Weston considered each significant enough to include in the portfolio of prints acquired by the Huntington Library in the 1940s. In one from 1940 the hills near Hayward, California, appear as three gray humps. Like mature animals, each shows the marks of time: old fences in the foreground, recent indentations from mechanical mowing, and, most incisively, a road that girds the foremost hill. The road is so freshly cut that one might easily mistake it for a rustic trail. But a lone telephone pole at the left indicates that it is just the first cut in a process of development sure to transform this landscape. Calling it a cut, however, overdramatizes its intrusive presence. Like a well-fitting belt, the arc of the road appears perfectly congruent with the shape of the hills, with the result that the photograph offers less protest than speculative curiosity about the prospect of change. Nothing could be further from the adamant resistance to nearly all forms of development that Weston's close friend Ansel Adams staunchly maintained.[40]

In like manner, looking down from Yosemite Weston made a number of topographic views of the valley where the Merced River winds through dense woods. Again a road enters the picture, and this road too appears as if it still might be in progress, for at first glance one sees only two short strips of asphalt emerging from a stand of trees. Closer viewing reveals very small cars, indicating that the highway continues through the trees and, by implication, well beyond the frame. Photographed from above in bright sun, the road competes with the river for highlights, and its abrupt shift in direction makes it far more visually interesting than the utterly conventional inverted S-curve cut by the Merced. There seems little doubt that Weston here was working to include the roads, in the process challenging all residual notions of a landscape worthy of depiction. On the lower right edge of the picture the road intersects the frame. The viewer following the course of the road will probably conclude that the same band of asphalt leads fairly directly to the prospect where the photographer frames his view. As landscape becomes roadscape, the photograph subtly challenges the idea of a uniquely privileged viewpoint and by extension the notion that any portion of California is secure against similar forms of penetration. If Weston's 1940 picture has a subject, it is the utter instability of all modern spaces.

Edward Weston,
*Yosemite Valley from
Glacier Point,* 1940
© 2000 Collection
Center for Creative
Photography, the
University of Arizona;
photograph courtesy of
the Huntington Library,
Art Collections, and
Botanical Gardens,
San Marino, California

The impact of roads on the landscape became even more of a preoccupation for Dorothea Lange, who made it her mission to personalize the effects of a society undergoing rapid transition. Quite early in her collaborative work with Paul Taylor, she witnessed at California's border with Arizona what seemed to her "the first wave" of a new influx of migrants. For the rest of her life she recalled "that Sunday in April of 1935," for it validated her role as significant witness to history: "No one noticed what was happening, no one recognized it. A month later they were trying to close the border."[41]

As a kind of pendant to her photographs of migrants making their way west in small groups, pictures quite reminiscent of Lewis Hine's turn-of-the-century portraits of immigrants at Ellis Island, Lange also depicted the road itself on which they traveled in hapless fashion. She photographed a long stretch of New Mexico highway in 1938 so that it appears to be a funnel pulling everything in its wide mouth into a single channel. That photograph has become an American icon of the open road. But with its title, *The Road West,* the photographer sought to anchor its meanings; at a time when the most conservative residents of California wanted to seal the borders against all newcomers, the highway, Lange all but declared, was a force more potent than either the migrants or the state. The photograph's meanings are specified further in the 1939 book Lange coauthored with Taylor, *An American Exodus.* In that context it was paired with a view of a more rural road on which a family walks, suggesting that this country road will soon join others, all feeding into the highway of mass migration.

Portraits still figure prominently in *An American Exodus,* making it very much a "human document" (Hine's term for the social photography he advocated), but Lange resisted including *Migrant Mother* (1936) to avoid any "stars" upstaging the epic story of a modern exodus told in pictures and words. "The old West is gone," the text in the book observes. "The opportunity which the new emigrants find is more in the tradition of industry than of the pioneers on the prairies . . . The pattern of labor conflict familiar in industry for decades has now spread to the land, but without the tempering effect which the growth of trade unions and long experience in collective bargaining have exerted in industry."[42]

Ansel Adams panicked at the prospect of regimentation at the beginning of the New Deal. Over the course of the 1930s, Lange explored new ways to confront the peculiar forms of rural industrialization in California. As with Weston, her pictures became less centered in the process, more about lines and the way the lines themselves extended far beyond the picture

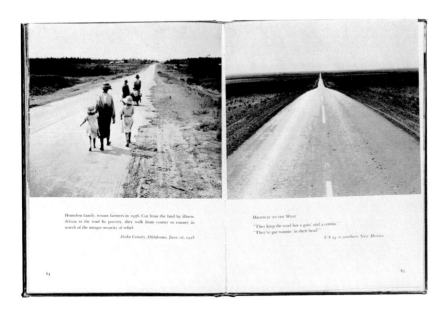

Homeless family, tenant farmers in 1936. Cut from the land by illness, driven to the road by poverty, they walk from county to county in search of the meagre security of relief.
Atoka County, Oklahoma. June 16, 1938

HIGHWAY TO THE WEST
"They keep the road hot a goin' and a comin'."
"They've got roamin' in their head."
U S 54 in southern New Mexico

frame, emphasizing the larger reality that the photograph can only point to in approximate fashion. Her portraits of people in transit increasingly came to emphasize the movement across a location that no longer offered any promise of settlement.

THROUGHOUT THE DEPRESSION, photographers working in other parts of the country treated Hollywood billboards as a foil to accentuate the contrast between "image" and "reality." (Perhaps the most famous example is Walker Evans's inclusion of *Love before Breakfast* in his 1936 architectural study of a poor residential neighborhood in Atlanta, but there are countless others in which Hollywood appears, formulaically, as an alien force.) In view of this general tendency, it is especially noteworthy that huge movie ads, though especially common in California, rarely figured in the photographs made within the state. Of course comparable effects could be obtained by incorporating other forms of commercial signage (for example, Lange's widely reproduced roadside picture of two hitchhikers outside Los Angeles approaching a sign proclaiming the comforts of train travel). Yet Lange, like other California photographers, avoided movie signage during most of the Depression. She made an exception in 1940, when she stopped on a rural highway to photograph, from across the road, a shed and a billboard advertising a local screening of *The Grapes of Wrath*.

It is a divided picture, but not in the way that had become typical of the Depression documentary genre, with spectacular signage and prosaic

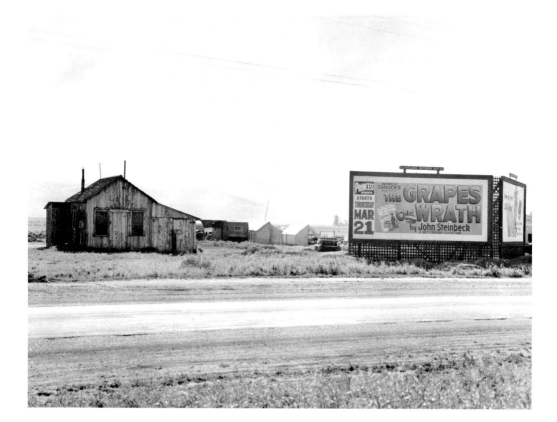

Dorothea Lange,
*Grapes of Wrath,
Billboard, California,
1940,* 1940
© The Dorothea Lange
Collection, the Oakland
Museum of California,
City of Oakland, gift
of Paul S. Taylor

reality stacked on top of each other. This picture instead is laterally split, nearly broken into two parts, even though there seems to have been no physical obstruction preventing Lange from placing farm structure and billboard in a coherent synthesis. She wanted that break in the foreground: it allows room for a few more temporary structures and vehicles to appear in the middle ground, with low mountains rising behind, while leaving the billboard at the margin of her frame.

Indirectly, Lange had a role in making a place for the billboard in this scene. One measure of the effect of her Depression-era photography in California was that it had inspired John Steinbeck to pursue the story of the "harvest gypsies," as he first called them in extended reportage he produced for the San Francisco *News*.[43] Her pictures first suggested the dramatic possibilities of such a story and also guided Steinbeck to additional sources, notably the labor camps and camp supervisors Lange had documented. Moreover, her pictures probably served as sources for some of the sets, costumes, and casting of the subsequent film,[44] and it is certain that photographs inspired by her work served directly in production design.[45]

What, then, are we to make of Lange's disjointed scene, accentuated by her equidistance from the two prominent elements? Indeed, her manifestly removed position across the road produces a triangulated field, underscoring the photographer's presence as well as the act, and material effect, of photographing. The photograph documents not only the contradictions between found elements but also its own role mediating difference and, for better or worse, intensifying it.

Surely there was irony in Lange's making this document, which derives, in the complex genealogy of mass culture, from her earlier pictures. But it was irony mixed with more searching self-reflection on her own role in the process of media penetration. The photograph's somewhat awkward juggling act leaves us to wonder whether her work had less impact on rural people than on Hollywood sagas. And how could such a modest place manage its embodiment as mythic spectacle? Moreover, if ordinary rural laborers might claim credit as the "original actors" in the film and in her prior photographic studies, in what ways might they also feel betrayed by these various portrayals?[46] Like the landscape that opens out before the road—mixing buildings, tents, and vehicles, mountains and flat farmland, and publicity for film stories about the common lives led working the land—the photograph offers no categorical answers, only questions about the complexity of all attempts to define a place, to frame it definitively. To make pictures on and about location was to risk misrepresenting that place while leaving it irreversibly altered, pried open to an endless process of further transformation.

Sally Stein writes about United States photography and mass media, with particular interest in the interwar period. She is an associate professor in the Department of Art History and the Graduate Program in Visual Studies at the University of California, Irvine.

1 Concise chronologies of the photographic activities of both Weston and Adams (along with all other members of Group f/64) appear in the biographic back matter of the very useful catalogue of this photographic group: Therese Thau Heyman, *Seeing Straight: The f.64 Revolution in Photography* (Oakland: Oakland Museum, 1992), 150–55; Adams's 1936 one-man exhibition at Stieglitz's New York gallery is reconstructed in Andrea Gray, *Ansel Adams: An American Place, 1936* (Tucson: Center for Creative Photography/ University of Arizona, 1982).

2 Lange's photograph is reproduced as plate 24, facing one of Adams's photographs of Half Dome, Yosemite Valley (plate 28), in Ansel Adams, *Making a Photograph* (London: The Studio Limited, 1935), 92–93.

3 On Adams's early 1930s documentary efforts, which resulted in one publication with Paul S. Taylor (who would later team up with and then marry Lange) in the May 1931 issue of *Survey Graphic* (a venue where Lange's work would frequently appear starting in 1934), see Richard Steven Street, "Paul S. Taylor and the Origins of Documentary Photography in California, 1927–1934," *History of Photography* (Oct.–Dec. 1983), 299–301. On Lange's photographic oscillations between urban streets and mountain retreats in the first years of the Depression, see Milton Meltzer, *Dorothea Lange: A Photographer's Life* (New York: Farrar, Straus, Giroux, 1978), 70–84.

4 Mary Street Alinder, *Ansel Adams* (New York: Henry Holt, 1996), 104–6.

5 See Therese Thau Heyman, *Celebrating a Collection: The Work of Dorothea Lange* (Oakland: Oakland Museum, 1978). See also Heyman's essay in *Seeing Straight*, 19–33.

6 For an excellent analytic account of this struggle and its photographic coverage, see Richard Steven Street, "Salinas on Strike," *History of Photography* 20, Apr.–June 1988: 165–74.

7 The publication was produced chiefly by Otto Hagel, a leftist emigré from Germany. The process of making the pictorial record has yet to be researched, the collected papers of Otto Hagel and Hansel Mieth having been transferred only recently to the archives of the Center for Creative Photography, Tucson, Arizona, following Mieth's death in 1998. An interview with Mieth that makes brief reference to this work with the union was conducted by Csaba Polony and published in *Left Curve* 13 (1989), 4–18. On the *Arbeiter illustrierte Zeitung* (Workers' Illustrated Times), see Maud Lavin, "Heartfield in Context," *Art in America* 73, no. 2 (Febr. 1985): 89.

8 On the quite limited use of photomontage in interwar American culture, see my essay "'Good fences make good neighbors': American Resistance to Photomontage between the Wars," in Matthew Teitelbaum, ed., *Montage and Modern Life* (Cambridge: MIT Press, 1992), 128–89. Connell's work awaits systematic study; a brief discussion appears in Michael G. Wilson and Dennis Reed, *Pictorialism in California* (Los Angeles: J. Paul Getty Museum and Henry E. Huntington Library and Art Gallery, 1994), 81–83.

9 "When I am in California, I am not in the West, I am west of the West" was the turn-of-the-century geographical view offered by Theodore Roosevelt; the quotation figures as epigraph as well as title source in Leonard Michaels, David Reid, and Raquel Scherr, eds., *West of the West: Imagining California* (San Francisco: North Point Press, 1989).

10 In her essay "f.64 and Modernism," Naomi Rosenblum places California modernism in an international context to emphasize its relatively late, unoriginal character; in Heyman, *Seeing Straight*, 34–41.

11 In her biography of Adams, Alinder rehearses the baptismal debates, recounting that the smallest lens aperture was traditionally known as US 256, but Adams had rejected using that name for fear that it sounded like a highway; Alinder, *Ansel Adams*, 86.

12 Adams to Strand, Sept. 12, 1933, reprinted in Ansel Adams, *Letters and Images, 1916–1984* (Boston: Little Brown, 1988), 57–58.

13 On Weston's concept, see David Travis, "Setting Out from Lobos: 1925–1950," in *Watkins to Weston: 101 Years of California Photography, 1849–1950* (Niwot, Colo.: Roberts Rinehart, 1992), 117.

14 Adams, *Making a Photograph*, 64.

15 Ansel Adams with Mary Street Alinder, *Ansel Adams: An Autobiography* (Boston: Little, Brown, 1985), 78.

16 French cultural critic Roland Barthes would define this embedding of values as photography's "message without a code." Roland Barthes, "The Photographic Message," in Barthes, *Image, Music, Text,* trans. Stephen Heath (New York: Hill and Wang, 1977), 15–31.

17 Adams and Alinder, *Ansel Adams: An Autobiography*, 76–77.

18 The French have come to call such practice in filmmaking *la nuit Americaine,* the original title for François Truffaut's 1973 film about the business of making films. The

English-language version was titled more neutrally *Day for Night,* which sidesteps the pejorative American label that enabled the French to keep this and similar industrial techniques at arm's length, by aligning them with all things Hollywood.

19 The letter most revealing of Adams's anxiety about even the reformist New Deal was one he chose not publish in his 1988 collection of lifelong personal correspondence (cited below). His archive at the Center for Creative Photography at the University of Arizona in Tucson contains a copy of a letter to Edward Weston dated May 17, 1934, written after Adams attended a meeting of photographers in San Francisco, who in concert wondered whether the New Deal's wage and price codes that were provoking militant struggles by dockworkers might soon extend from heavy industry and large enterprises to the photographic trades. Such an extension never came to pass (and the codes themselves were ruled unconstitutional a year later), but the day after this meeting Adams sounded uncharacteristically jittery at the prospect that his industrial-style hypersharp photography might be subjected to industrial regulation.

20 Though Schlesinger's mid-century polemic focused primarily on the need for liberals' militant offense against Communism, there was a conservationist caveat in his argument. Despite his call to arms against Communists, he allowed an immediate need for international mediation, if only because the growing ecological crisis demanded staunch countermeasures "to restore man to his foundations in nature." Arthur M. Schlesinger Jr., *The Vital Center: The Politics of Freedom* (Boston: Houghton Mifflin, 1949), 241–42.

21 See Weston's daybook entry for Nov. 29, 1929; in Edward Weston, *Daybooks of Edward Weston,* ed. Nancy Newhall (Millerton: Aperture, 1973), 137. The trees are described as eucalyptus, but from this description I have not succeeded in identifying the 1929 photograph (apparently part of a commission for UC Berkeley), which does not appear in the most comprehensive catalogue of his work, Amy Conger's *Edward Weston: Photographs* (University of Arizona/Center for Creative Photography, 1992).

22 As Ben Maddow notes in his biography of the photographer, Weston encountered the Kantian concept via Barbara Morgan, who referred to it when she mounted an exhibition of Weston's work at UCLA in 1927; Ben Maddow, *Edward Weston, His Life* (Millerton: Aperture, 1989), 236–37.

23 On the FSA "skull controversy," see F. Jack Hurley, *Portrait of a Decade: Roy Stryker and the Development of Documentary Photography in the Thirties* (Baton Rouge: Louisiana State University Press, 1972), 86–92.

24 For an excellent summary of the conch-shell arrangement debate, see Conger, *Edward Weston: Photographs,* unpaginated entry for figure 655/1931, and also Weston's *Daybooks,* vol. II, 226, 266–67.

25 These issues crop up repeatedly in Weston's correspondence with Adams, and in his daybooks, where these terms appear; for the relevant entries, see vol. II, 244, 262.

26 For example, Robert S. Lynd and Helen Merrell Lynd, *Middletown: A Study in Modern American Culture* (New York: Harcourt Brace, 1929), 490–91; Stuart Ewen, *Captains of Consciousness: Advertising and the Social Roots of the Consumer Culture* (New York: McGraw-Hill, 1976), 64, 211.

27 The term "nerve center" is borrowed from the title of Edwin Rosskam's book *Washington Nerve Center* (New York: Alliance, 1939), made as part of his Face of America series before he began working for the FSA; but the idea that Washington had seized the reins of the country was expressed as early as 1934 in the anonymously authored *The New Dealers* (New York: Simon and Schuster, 1934), vii.

28 See Kevin Starr, *Endangered Dreams: The Great Depression in California* (New York: Oxford, 1996), particularly the section "Efforts at Recovery," 197–271.

29 A good synopsis of the escalation of labor conflict that led to the General Strike is provided in Starr's *Endangered Dreams,* 84–120. For a comprehensive history of the EPIC campaign, with excellent analysis of the reactionary role played by Hollywood moguls, see Greg Mitchell, *The Campaign of the Century: Upton Sinclair's Race for Governor of California and the Birth of Media Politics* (New York: Random House, 1992); for a concise summary, see Starr, *Endangered Dreams,* 121–55.

30 According to some accounts, Van Dyke may have lost his day job as a gas station attendant during the strike. Other accounts suggest he quit the job earlier, in which case his subsequent linkage of the two events may be more reflective of his general memory of the way the General Strike seemed to change everything in his life. In an excellent essay on contradictions in the ideology, practice, and historiography

of the f/64 group, Michel Oren lays out what partial facts have been recovered on this aspect of Van Dyke's biography: "On the 'Impurity' of Group f/64 Photography," *History of Photography* 15:2 (summer 1991), 119–27. Additional details are gathered in Leslie Squyres Calmes carefully researched study of the Weston–Van Dyke correspondence, *The Letters between Edward Weston and Willard Van Dyke* (Tucson: University of Arizona/Center for Creative Photography, 1992), particularly 57, n. 56. In her introduction to the Weston–Van Dyke correspondence, Calmes offers a sketch of the latter's life, vii–x; another skeletal chronology appears in the back matter of Heyman, *Seeing Straight*, 154–55.

31 Meltzer's biography of Lange recounts in detail this historic chain of events; though Meltzer does not treat Van Dyke as the pivotal figure for Lange (a role he reserves for Taylor), he does reprint in full Van Dyke's 1934 essay in *Camera Craft* that constituted the first published response to Lange's photography; Meltzer, *Dorothea Lange*, 84–86.

32 Ibid.

33 In concert with Hagel's efforts to make an independent documentary film about the 1933 cotton strike, Mieth originally made this set of photographs as part of a larger series she provisionally called The Great Hunger, which included photographs of Hoovervilles in Sacramento, casual port laborers scrambling for work, and migrant workers struggling to subsist in the fields. Salient details about Mieth and Hagel's varied working lives as photographers committed to Left politics (and thoroughly marginalized in the postwar anti-Communist witch hunt)

are recounted in Susan Ehrens's interview with Mieth, published with a strong selection of photographs, in *Photo Metro* 5:49 (May 1987), 5–12.

34 Ansel Adams to Alfred Stieglitz, Mar. 15, 1936; reprinted, along with *Fence near Tomales Bay*, in Adams, *Letters and Images, 1916–1984* (Little, Brown, 1988), 82–83.

35 In its first of hundreds of cover stories on Hollywood, the editors of the new picture magazine sounded as if they had finally found a subject even more enviable and picture worthy than British royalty, stories of which dominated the earliest issues of *Life*'s publication in the fall of 1936 and the winter of 1937: "Its ruling class is the Peerage of the Box Office, which changes with the winds of public favor. Its stock in trade is Glamour." "Hollywood Is a Wonderful Place," *Life*, May 3, 1937, 28–38.

36 For biographic information on Stackpole, see L. Thomas Frye and Therese Heyman, *Peacetime, Wartime and Hollywood: Photographs of Peter Stackpole* (Oakland: Oakland Museum, 1992), 41.

37 For the entire series of MGM pictures as well as the publication history of Weston's photographs of the rubber dummies and the stair sections, see Conger, *Edward Weston: Photographs*, unpaginated entries for figs. 1428–40.

38 Alan Trachtenberg, "Edward Weston's America," in Peter C. Bunnell and David Featherstone, eds., *EW: 100, Centennial Essays in Honor of Edward Weston* (Carmel, Calif.: Untitled 41/Friends of Photography, 1986), 111. In this article Trachtenberg focuses on Weston's photographic survey of America, a project commissioned by the Limited Editions Club to provide illustrations for its 1942 edition of *Leaves*

of Grass. Trachtenberg makes a point of distinguishing the impersonal character of this work from Weston's California photographs made in the late 1930s, when, Trachtenberg argues, Weston is still insisting on *his* vision and *his* California. This distinction should not be overstated; though Weston obviously knew the California landscape far more intimately than he did the rest of the country, which he traversed in the early 1940s, he had already begun to adopt an impersonal stance in his late photographs of the state, as Grundberg also argues. The same centennial collection of essays on Weston includes Grundberg's "Edward Weston's Late Landscapes" and Weaver's "Curves of Art," 93–101 and 81–91, respectively.

39 One 1937 photograph of a lone house perched above the Pacific, standing out like an incandescent beacon, returns to the familiar theme of solitary retreat. Readily recalling the conch-shell photograph, *Surf, Bodega Coast, 1937* (reproduced as fig. 1162 in Conger, *Edward Weston: Photographs*) revives old tropes for a traditional California supremely isolated by natural barriers.

40 I have not seen this photograph reproduced, but *Hills near Hayward, 1940* is accessioned as #175 in the Huntington's collection of Weston photographs.

41 Dorothea Lange, *The Making of a Documentary Photographer,* an interview conducted in 1960 and 1961 by Suzanne Riess (Regional Oral History Office, University of California, Berkeley, 1968), 175.

42 Lines excerpted from the concluding "Last West" section of the collaborative book by Dorothea Lange and Paul Schuster Taylor, *An American Exodus: A Record of Human Erosion* (New York: Reynal and

Hitchcock, 1939), 144–49.

43 Starr recounts the genesis of Steinbeck's *Grapes of Wrath* as beginning with the "Harvest Gypsies" reports he wrote in 1936 for publication in the *San Francisco News*; in Starr, *Endangered Dreams*, 251–62.

44 See Heyman, *Celebrating a Collection*, 77–78.

45 *Life* ran two stories on the camps featuring photographs by Horace Bristol, a younger photographer who readily acknowledged Lange's influence. Bristol accompanied Steinbeck on a research trip to migrant labor camps with plans for a joint publication; the collaborative reportage never materialized, as Steinbeck after this trip decided to concentrate on his novel rather than on another journalistic essay. However, the magazine published some of Bristol's visual material after Steinbeck's novel was proclaimed a masterpiece; *Life*, June 5, 1939, 66–67. Eight months later, following the much-heralded debut of the film, the magazine ran many of the same pictures again, this time pairing Bristol's photographs with stills from the John Ford movie; *Life*, Feb. 19, 1940, 10–11. This second spread enabled *Life* to boast about its apparent influence on the motion picture while simultaneously providing comparative evidence that the production lacked the authentic grit of the magazine's reportage. On Bristol's work with Steinbeck and his prior work with Lange, see Ken Conner and Debra Heimerdinger, *Horace Bristol: An American View* (San Francisco: Chronicle, 1996), 55–57.

46 In her thoughtful book on photography and the American writer, literary critic Carol Schloss offers an extended comparison of the working methods and effects of Lange and Steinbeck, but the results of this comparison are too Manichaean, with the novelist condemned for his bad faith and the documentary photographer extolled for her good faith; Carol Schloss, *In Visible Light* (New York: Oxford, 1987), 200–31. As numerous writers on photography have begun to note, Lange also took artistic license with her subjects, and certainly the composition of this 1940 photograph suggests that she held a complex view of her thoroughly mediated role in the process of representation.

Acknowledgments
Thanks to Kaucyila Brooke, Leslie Calmes, Michael Dawson, Drew Johnson, David Joselit, Laurie Monahan, David Paskin, Allan Sekula, Richard Street, and Thomas Frick for their assistance, advice, and criticism at various stages of the research and writing of this essay.

The Tai Sings, dance
team of Wilbur and
Mae Tai Sing, n.d.
Courtesy of the John
[]rau Collection

Anthony W. Lee

CROONING KINGS AND DANCING QUEENS:
SAN FRANCISCO'S CHINATOWN
AND THE FORBIDDEN CITY THEATER

Named after the fabled walled city in Beijing, the Forbidden City was an enormously popular night-club in downtown San Francisco. Throughout its long life, beginning in 1938 and lasting until 1962, the Forbidden City staged a wide variety of acts: song-and-dance routines, slapstick, musical duets and solo performances, tap dancing, magic acts, tumbling and sword routines, cancans, and even erotic "bubble" and "feather" dancing (so called because the dancers used bubbles and feathers as playthings around their otherwise unclothed bodies). It drew its inspiration from any number of movie sources, including the raunchy burlesque of early vaudeville films, the blackface performances of Al Jolson, the elaborate sets and costumes of 1940s Hollywood musicals, the athletic auteur dancing of Fred Astaire and Gene Kelly, and even the signature crooning of Bing Crosby and Frank Sinatra. Such was the club's prodigious variety and eclecticism that its owner, Charlie Low, could never quite adequately describe the performances and preferred to call them, in the parlance of the day, "floor shows."[1] The acts captured enough national media attention that by the early 1940s the Forbidden City players took their elaborate show on the road. They hired an agent, booked stops from Vancouver to Providence, and during World War II toured as part of the USO entertainment. Charlie Low became fantastically rich, reputedly becoming a millionaire within the first decade of the club's existence and alternately making and squandering several fortunes. Although all of the Forbidden City players earned far more modest incomes than he, a few went on to win roles and gain moderate fame in films. Some went on to have long careers on and off Broadway.

All of this—the apparent success of a local nightclub and its players—would not seem so remarkable but for the simple, important fact that the Forbidden City was composed almost entirely of an Asian American ensemble. What was compellingly "forbidden" about it was not the gaze of the outsider,

as it was for Beijing's walled city, but the performance by nonwhite players of what had previously been considered white forms of entertainment. The club burst onto the entertainment scene during a historical moment in California's race relations, when the conventional terms of a Chinese racial identity were put under considerable pressure by national and international events. During that time of transformation, two words could at last be spoken together: "Chinese American." But the tentativeness of these words and the lingering difficulty of saying them brought the acts in the Forbidden City a special meaning.

To many contemporaries, the club staged racial cross-dressing for white American audiences (at first, soldiers and sailors passing through a port city; later, the local middle classes). In what follows, I suggest how this cut at least two ways. First, the Forbidden City nurtured role-playing in the conventional sense of stage performance and, in so doing, simply updated a long-standing theme of racial difference and Otherness as a form of entertainment for its audience. But second, it enabled a critical practice on the part of the performers themselves, who could parse the distinction between the race of the performer and the race being performed in ways that enabled them to explore their place between the two. This second aspect of performance suggests that, in Chinatown, Chinese Americans discovered an important hold on an American identity. They did so by working through harsh stereotypes about racial behavior and, in playing with them, refused to satisfy the viewer's expectations completely; they refused, in the words of postcolonialist theorist Homi Bhabha, to satisfy the "colonizer's narrative demand."[2] The stage itself was a place not only for pleasure but also for resistance. "How we move, the music that accompanies our daily activities and that we create and refashion," the anthropologist Dorinne Kondo writes, "do matter and can be included in a repertoire of oppositional strategies."[3]

To prepare us for that second possibility, I will make a number of detours: a brief description of the nightclub scene in San Francisco; a brief description of tensions between Japan and China, which had a bearing on definitions of "Orientalness" that could be ascribed to the performers; and a comparison between representations in the Forbidden City and those in contemporaneous documentary photography, easily the most widely distributed images of the people of Chinatown. They will allow me to close with a brief study of a single club performer, Jack Mei Ling, whose acts at the Forbidden City represent the liberating and critical practices made possible by racial role-playing.

CHARLIE LOW'S FORBIDDEN CITY OPENED just outside Chinatown at 363 Sutter Street on the northern edge of downtown San Francisco. It opened in the midst of the Depression and on the heels of Prohibition's repeal, in the era that San Francisco *Call Bulletin* writer Jerry Flamm named the "good life in hard times."[4] Like many other enterprising entrepreneurs in the city, Low took advantage of a resurgence of nightclubs and a renewed respectability for them, as they shed their underground and speakeasy reputations. As Low tells it, the choice of location had little to do with an attempt to expand beyond the general tourist industry that Chinatown had already established and more to do with the kind of floor space that big band performances required, available only outside of Chinatown.[5] But in fact, to look outside was an indication of ambitions that Chinatown could not easily accommodate either physically or, just as important, culturally. Not that Chinatown in the late 1930s was devoid of a musical nightlife. It already contained two resident dance orchestras and a modest but active group of independent singers and musicians. By and large, however, Chinatown's economy depended on a specific kind of tourist trade, in which curios and the intensely sinocized streets—the glib signs of a transplanted, "authentic" Chinese culture—drew the interested, not its young, seemingly Americanized musical performers and dancers.

From the beginning, Low envisioned a nightclub with enough square footage for a 300-seat restaurant (not the more usual noodle shop), a kitchen to prepare separate "Chinese" and "American" menus, and a bar to hold rows of patrons four or five deep. He needed stage space for complicated dance routines and dressing rooms for the regular cast of men and women, as well as for guest celebrities.[6] He wanted an elaborate reception area, complete with a series of arched gateways, temple awnings, and decorative wall paintings. And he envisioned a long walkway where he could display dozens of pictures of himself and his celebrity friends, so that patrons who lined up to enter the club could survey Low's myriad social connections. These are familiar features to any casual observer of the New York and San Francisco nightclub scenes of the 1940s, down to the ubiquitous handshake portrait, but they are unprecedented for Chinatown of the 1930s—thus, Low's significance to the city's cultural history, and thus also contemporaneous critical concern about his venture from Chinatown's old-guard merchant class.

Low's stage ideas for the Forbidden City were in fact shaped by Hollywood films, in which the club floor could be used as a stage set and the entertainment imagined as a series of vignettes in an overall production theme. Show programs displayed a remarkable consistency throughout the club's early

years. Every evening, the players put on three one-hour shows, performed on a large open floor space in the midst of dinner tables, and backed by five- and six-piece bands on a raised stage. The programs consisted of alternating musical and dance acts by soloists and duos, and these were usually bridged by quick dance numbers performed by a chorus line of five or six women and two or three men. At first, most of the individual performances had little to do with one another. Tap dancing might be followed by a magic act or a vaude- ville skit, for example, with cancans by the chorus in between. In the aggre- gate, these ranged "from slumberous oriental moods to hot Western swing," as a *Life* magazine writer first observed.[7] Eventually, the entire cast regularly arranged its acts around production themes: the Gay Nineties, for example, or the Western. In these, the Forbidden City departed from the big band focus of most clubs in both thematic complexity and potential narrative drive. But by and large, the club's entertainment fit the general mold of San Francisco's nightclub offerings.

However, it would be a mistake to compare the Forbidden City shows too closely with those at other nightclubs, since this could serve to normalize the attentions of the Forbidden City's audience and downplay the racial basis of the club's popularity. For what is clear is that the Forbidden City achieved more fame than any of its non-Chinese competitors because of its apparent race-based novelty. The acts played upon racial difference by being organized around decidedly non-Chinese production and film themes and drawing attention to the irony or parody of Chinese performers taking on those roles. Low added show titles like "Chinese Follies," "Chinese Capers," and "Celestial Scandals" to publicize and emphasize this racial role-playing. And while the performers sang and danced in the styles of Hollywood films and musicals, their attractiveness lay in how near or far they came to their models, how competently or more awkwardly they could replicate a familiar style or rou- tine, and how much they could provoke a sense of wonder at the unexpected- ness of their behavior in the minds of their audience. Their novelty, at least from the point of view of those in attendance, lay in the assumption that the performers copied the entertainment of a culture that was not their own. To judge from written commentary, it never occurred to most patrons that the performers, most of whom were born in the United States, were simply exploring the acts of a culture they considered theirs by birth.[8]

Part of the audience's pleasure derived from observing how cultural and racial difference could be thematized and managed, but that pleasure was only possible if the performances did not transgress or completely confuse

the borders of difference. Pleasure was obtained when the performers retained their "Chineseness" even while acting, with more or less competence, like whites. Some acts offered this affirmation of difference more readily than others, but in each case we find similar kinds of binarizing responses on the part of viewers. In the case of the singers, for example, the routines were remarkably polished and the crooning mellifluous. Old recordings suggest how singers such as Larry Ching and Toy Yat Mar could control the pitch and timbre of their voices with great ease and delicacy, from the breathy style of Ching to the throaty, husky manner of Mar. Yet their abilities earned them reputations (the "Chinese Frank Sinatra" for Ching and the "Chinese Sophie Tucker" for Mar) that erased their own crafted skills, relegated their voices to imitation, and attempted to reaffirm the superiority and primacy of popular culture's acknowledged (non-Chinese) models. In the case of the featured dancers, such as the Tai Sings, the Mei Lings, or the team of Dorothy Toy and Paul Wing, the distinct stylistic moves that distinguished them from one another and made them occupy different rungs in the show's hierarchy of performers could not overcome a larger distinction that kept them grouped as Chinese dancers. When they obtained short film parts, as Toy and Wing did in *Happiness Ahead* and *With Best Dishes*, they were required, as they never were at the Forbidden City, to open their routines dressed in Chinese costume before disrobing to reveal their dancing personas and display their skills. They literally enacted a narrative of difference, whereby they avowed their racial origins before being allowed to dance as whites.

In the case of the chorus dancers, the performances were far from expert, at least initially, and it was on them that most critical and journalistic attention was focused. The audience's fascination lay partially in the erotic appeal of young women in feathers and bubbles. But part of this, I would suggest, also lay in the simple fact that the dancers were the least polished of the performers and therefore presented the clearest evidence of the "pretense" of their acts. Most of the chorus line dancers had no previous experience and had to be taught simple steps and arm movements. Their timing to the music was off, and their synchronization with one another, as one early photograph suggests, was far from crisp. Low hired Walton Biggerstaff, a veteran producer and choreographer of stage shows, to drill the dancers and organize their routines.[9] He hired a series of bands made up of white musicians (when there were quite experienced Chinese American bands available) to set a consistent musical background. And he sent the young women to ballet and other dance classes to improve their agility and flexibility. Their timing improved and their movements

204

The original Forbidden
City chorus line, 1939
Courtesy of the John
Grau Collection

became more fluid. Yet, despite the increasing synchronicity and polish of their dancing, they made "no effort to be Occidental," as an early visitor happily concluded, a shorthand way to describe the continuing gap between the race of the performer and the race being performed, no matter the skill of the act.[10]

Readers might well mistake my observations about the Forbidden City performances as uncritical or, worse, unkind. In particular, they may point to the overly neat symmetry about racial and cultural difference I have described, between "Chinese" performers and "white" entertainment and the seemingly unbridgeable gap between the two. They may also point to the performances themselves and wonder why they need to be regarded as instantiating difference and not something more complex and ambiguous, perhaps something more hybrid, and why their attractiveness lay in a strange dialogue between two cultures and not in the competency and quality of performers working their craft. Let me say straightaway that in the preceding pages I have followed the implicit claims of Low and his non-Chinese contemporaries in the press but that in the following pages I will subject them and the ideology they represent to precisely these kinds of critiques. What was at stake, I will ask, in insisting on two separate cultures brought together in such a way that one was always revealed as foreign and largely absent and the other as native and present in reproduced form? What kinds of attitudes were being buttressed

through the viewing of nightly floor shows and happy comedy that, to the audience, seemed to emphasize pantomime and, because of that, was interpreted by them as that "snaky stuff from the Far East"?[11] What kind of anxiety about difference was being managed? And what, within this thrall of non-Chinese expectation, did it permit the performers themselves?

ONE SIMPLE ANSWER TO THESE QUESTIONS is that the people of Chinatown began to occupy a more ambiguous place in the social order, which required a means by which non-Chinese San Francisco could try to reinscribe difference and inequality. This consisted of a set of performances that could thematize and reveal the unequal nature of race relations and offer regular evidence that American-born Chinese could not really lay claim to the country's "native" culture. Without doubt, the Chinese in California were still the victims of a harsh Immigration Act, signed into law in 1924 and, as carried out in the decades that followed, intended to suffocate Chinatown by preventing further immigration or naturalization.[12] But Chinatown was also transforming from within, led by a younger, newer breed of merchants, most of whom, like Low, were born in the United States. They attempted to build a more sophisticated tourist quarter and earn a living by spectacularizing Chinatown and its people. This meant, however, distancing themselves from the caricatures they produced for tourists and conceiving of themselves as American businessmen who marketed racial and cultural difference. "A new generation is rising in Chinatown," a journalist wrote, and he portended a complete breakdown of previous characterizations of the quarter's inhabitants. "They think in English; they work, speak and act as Americans ... Already, under the impact of their spirit, the walls of old Chinatown are crumbling."[13]

We could easily detail much further the effects of this entrepreneurial ambition on the perceptions of non-Chinese writers; there is no shortage of evidence to suggest a widespread anxiety over the crumbling walls of San Francisco's Chinatown. But I will point us in another, perhaps unexpected direction, to the international sphere, to help frame the breakdown in terms of a wider debate and to suggest that problems with Chinatown's image also lay in the problem of the image of China itself.[14] Indeed, with the Sino-Japanese War during the 1930s and eventually the United States–Japanese war in the 1940s, the entire image of Asia began to change, becoming more carefully differentiated and differently valued in the Western imagination. These changes made previous characterizations of the Chinese in this country, which had always depended on an Orientalist discourse of China, difficult to

sustain.[15] The old caricature of the Chinese man as inscrutable, repressed, and impotent, for example, whose ritualized social graces and expressions were conventionally read as signs of a cultural emasculation, could hardly be maintained when China itself was at war, and its army made up of Western-styled soldiers.

In 1931 Japan invaded China in the so-called Mukden Incident. This new aggression played on old rifts between Chinese Nationalists and Communists and took advantage of a civil war within the country that had already divided Chinese armies and loyalties. Within months, Japanese troops occupied most of northeastern China and attacked and took the important port city of Shanghai, effectively controlling China's trade with the West. By 1937 the Japanese occupied not only Shanghai but also a huge arc of land running north to south, from Beijing to Nanking to Canton. The occupation was by most accounts brutal. Missionaries in Nanking and Shanghai reported mass looting, rape, and murder by Japanese soldiers.[16] From the point of view of non-Chinese America, where once the Japanese and Chinese were grouped indiscriminately as the Oriental, the Sino-Japanese War enabled, indeed demanded, more detailed attention to cultural and social difference. This hardly resulted in nuanced analyses. *Life* magazine, for example, ran a feature on how to distinguish Chinese from Japanese Americans. American mass media still preferred stock metaphors of difference, playing upon the image of the brutal Japanese soldier, for example, and conferring on him all of the invidious (often contradictory) attributes once reserved for the Chinese coolie. But while the war and its coverage signaled a new attentiveness to the variety of Asian peoples and cultures and portended a shift in political relations with the East, it left what may be described as a momentary crisis in representation. The transfer of racial hostilities from the Chinese to the Japanese meant that the Chinese required new forms of invidious characterization, not all of which were immediately available.

For the Chinese in America, the invasion and occupation reopened discussions about their own loyalties and brought into focus the unresolved tensions between life in a harshly unequal American society and allegiance to a "motherland" that most young American Chinese had in fact never seen. Take, for example, a famous 1936 essay contest for Chinese American youths, sponsored by the Ging Hawk Club of New York, on the redolent question, "Does My Future Lie in China or America?"[17] "Ever since I can remember," Robert Dunn, the winning essayist wrote, "I have been taught by my parents, by my Chinese friends, and by my teacher in Chinese school, that I must be

patriotic to China." But Dunn had no wish to venture to China, take up arms
against the Japanese, or see his future outside a life in America. "It is possible,"
he wrote, "to pay the debt one owes to China and show one's allegiance to
Chinese even while living in America." He was never especially clear about
how one could show allegiance by remaining in the United States, nor did he
allude anywhere in his essay to China as an occupied country, which made
it once again a colonized land and an unsavory place to resettle. But while his
assertions were vague, they were expressions of a more general resistance to
the beliefs espoused by conservative factions within the Chinese American
community. The essay brought about severe rebuttals. "Your fallacies in rea-
soning, your ignorance of China's needs, your misconceptions of Chinese
culture and civilization, your biased viewpoint," wrote the self-proclaimed
Stanford Chinese Students' Club, "all reveal how poorly qualified you were to
correctly evaluate the factors involved . . . Your essay shows a psychology of
fear."[18] Harsh words, and the sting was felt. Others in Chinatown concurred.
To aid in the war effort, and to counter segments of Chinatown's population
that Dunn's essay represented, conservative merchants organized compulsory
support of China. They arranged for boycotts of Japanese goods (which were
often not observed),[19] formed the Chinese War Relief Association (CWRA) and
set quotas for "donations" from Chinatown's working adults, organized war
bond sales, and punished those who did not comply by boycotting their stores
and imposing heavy fines.[20] In two cases, Chinese Americans who refused to
donate were paraded through Chinatown's streets like sinners in a medieval
flogging. It is a conflicted image: During the Depression when most working
men earned barely enough to survive, the CWRA compelled them to donate to
each fund-raising drive (a minimum of thirty dollars for one drive alone, in
1937) or face public humiliation. It also suggests the difficulties Chinatown's
youth faced in working out the social meanings of "Chinese American" under
the pressure of generational and international disputes, and why popular cul-
ture became one avenue of inquiry.

While the Mukden Incident and its aftermath generated complicated
debates within Chinatown, creating discord among some and renewed loyalty
among others, calling into focus the nature of nationalism and nationalist
feeling, and dramatizing the hardships of the Depression, they enabled a more
formulaic response on the part of most non-Chinese observers about the
status of citizenship for the Chinese. This pervaded the sentiments of even
the most liberal observers. Take, for example, the Chinatown photographs of
John Gutmann. In them we find the pressure of compulsory loyalty to China

John Gutmann,
The Hand of Authority,
1934
Fraenkel Gallery,
San Francisco,
© The Estate of John
Gutmann

structuring his representations of the Chinese in Chinatown. In *The Hand of Authority,* four young boys are pictured against a simple apartment entry, and while the event may be nothing more complicated or insidious than an off-screen figure (a doting father? an attentive mother?) gesturing to direct the boys' attention, the title ascribes more weighty, metaphorical concerns to the scene. And if the subtext were not clear enough, we need only consider Gutmann's *Chinese Boy Looking at Display of Warplane Models* to understand the issues he saw facing Chinatown's youth. Gutmann was sensitive to the tensions caused by racial difference and the conflicting loyalties of the socially oppressed. The son of middle-class Jews, he was born in Germany and immigrated to California only after his career as a photographer and painter was brought to an abrupt end with the rise of Hitler and the Third Reich.[21] He continued to work for German periodicals, sending his pictures back to *Der Welt Spiegel* and *Berliner Illustrierte Zeitung,* in which he presented San Francisco as a city of racial mixture. But he saw the predicament of the Chinese in Chinatown as ironic, as in *The Artist Lives Dangerously,* in which a young Chinese boy draws a blindfolded Native American on the asphalt of a busy street. The boy's place within American society was as fated as the figure he chalked, and if Gutmann's pictures were prescriptive, that boy's future lay in international, not domestic, events.

Or consider other photographs by another German-born photographer, Hansel Mieth, a self-professed liberal reformer who flirted with socialist causes. She went to Chinatown in 1936 to photograph a visiting general, who came to the city to stir up support for China's war against Japan (and also in his case to emphasize Communist causes and counter the efforts of the Nationalist Chiang Kai-shek). He was only the latest of a long line of Chinese visitors to the city on similar missions, from the celebrated General Tsai Ting-kai (treated to a hero's welcome) to Madame Chiang Kai-shek herself. Mieth also captured the responses of those who came to hear the general, from the eager merchants and young entrepreneurs to those who appeared numbed by

the constant series of harangues. Events like this allowed her to picture the range of classes within Chinatown and their interaction, which was her particular interest. And something of that diversity and social awkwardness is captured in *Chinatown,* in which a fence separates those who were admitted to the general's compound (actually, a playground) and those who gathered in the alley outside. And while we should underestimate neither the complexity of Mieth's or even Gutmann's work in forging an image of the Chinese in Chinatown nor the sympathy and pathos with which they often created their images, we should recognize the parameters of their imaginations, hemmed in as they were by the popular belief that the Chinese were noncitizens best pictured in relation to a motherland.

LIKE SO MANY OF HIS PEERS IN CHINATOWN, Low believed that the Forbidden City acts needed to present hyperethnic forms for their audience, despite or perhaps because of the Sino-Japanese War. This not only included the interior decoration and wardrobe but also, in the case of the Forbidden City performers, a compulsory Chinese identity. Indeed, many of Low's performers were not of Chinese descent at all but were in fact Japanese, Korean, Eskimo, and Filipino. In two of the more celebrated cases, Low required the dancer Dorothy Takahashi to become Dorothy Toy and the dancer Tony Costa, of Chinese-Filipino-Portuguese-Spanish blood, to become Tony Wing. The masquerade produced a bizarre scenario: some Asian American players performing ethnicity (Chinese) in order to perform race (white). It would be easy for us to attribute Low's requirements for Chinese stage identities to yet more

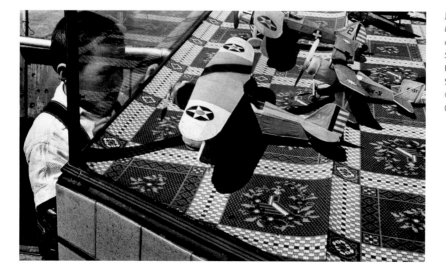

John Gutmann, *Chinese Boy Looking at Display of Warplane Models, San Francisco,* 1938 Fraenkel Gallery, San Francisco, © The Estate of John Gutmann

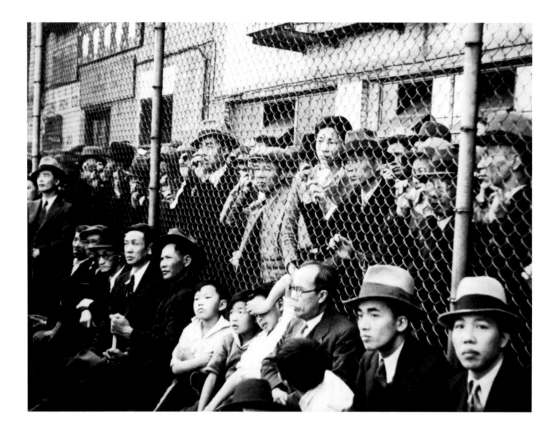

Hansel Mieth,
Chinatown, 1936
© 2000 Collection
Center for Creative
Photography, The
University of Arizona

evidence of a racial divide, where being Asian in San Francisco meant acceding to the demands of a racist culture and where the Sino-Japanese conflict gave rise to reactionary responses on the part of some non-Chinese, who preferred to return to a simple homogenizing of the Orient. And it would be equally easy for us to attribute them to Low's own social aspirations, in which he was willing to subject his dancers to racist and sexist forms of entertainment in order to further his own efforts to reach high society.

But we can suggest another possibility by taking into consideration the ambitions of the performers themselves. For it is possible to understand the acts at the Forbidden City as doing double work. They provide not only evidence of racial difference imposed on the performers by a culture that wanted desperately to resolve their appearance but also evidence of a more complex racial identity constructed by the players—that is, the working out of "Chinese American" by Chinese Americans themselves. Chinese American identity in the 1930s and 1940s was not simply concocted by the gaze of the white audience but constructed and performed by individual people within its glare.

We can well imagine the kinds of complex identities each of the per-
formers constructed. Let me take one particularly complicated example, the
case of the Forbidden City dancer Jack Mei Ling, who was by no means typi-
cal of the other performers but perhaps typical of the possibilities for self-
fashioning they each possessed. Ling was one of the earliest players at the club
and also one of the most enduring. Notoriously difficult to work with (one
reason he had so many different partners), Ling was also acknowledged as an
extremely talented choreographer and dancer who designed not only complex
dance sequences for himself and his partners but also the elaborate costumes
for each of their performances. His dance routines neither followed a pre-
ferred model nor seemed to possess any particular stylistic unity. Hence, Ling
was able to escape the fate of Larry Ching and Toy Yat Mar—he was never
known as the "Chinese Gene Kelly" or the "Chinese Fred Astaire"—and for
this reason was never given as much publicity as other club dancers in critical
reviews. But another reason for Jack Mei Ling's relative invisibility—the
reason he escaped critics' comparisons to white, male, canonical dancers—
is that he was a gay man, a fact well known by all of his partners, the other
club players, and probably by the critics but not, of course, publicized to club
patrons or easily addressed in reviews in the mainstream press. Although
already providing an urban scene in which some gay men found community,
San Francisco in the 1930s and 1940s was still not a place where those same
men could easily emerge from the closet in public discussion, still less a place
for critics and reporters to celebrate their work.[22] Public disclosure was even
less possible for gay Chinese American men in the notoriously homophobic
Chinatown community. Ling's status as a gay man is significant to our account
for two reasons. First, it reveals the actual unity behind the seemingly wide
range of his dance numbers—a conceptual and performative as opposed to
stylistic unity. Second, it helps us to understand how a performer in the racially
fraught environment of the Forbidden City actually used the general confusion
about racial identity to stage an even more marginalized (closeted) identity.

Ling was born in Utah but raised from a very early age in San Francisco's
Chinatown. His mother had aspirations for a career on the stage, but although
these were thwarted, she instilled those same ambitions in her son and took
him to the movies—every afternoon, legend has it—where he viewed and
reviewed Hollywood's extravagant musicals and dance numbers, exotic stage
sets, and overwrought costumes as the early models for his own work.[23] The
film historian Gaylyn Studlar calls the period between 1916 and 1926 the great
age of "Hollywood Orientalism."[24] To the films from this era, we might add

Jack Mei Ling, n.d.
Courtesy of the John
Grau Collection

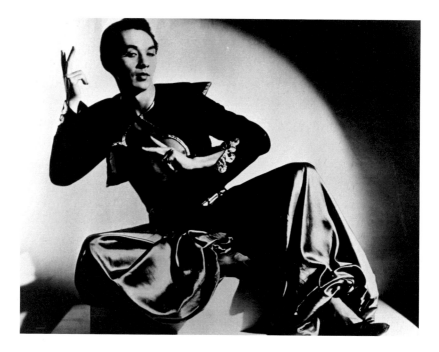

the enormously influential appearance of Sergei Diaghilev's Ballets Russes in
the late 1910s and its nationwide tours of *Cleopatra, Thamar,* and *Scheherazade,*
and, slightly later, the equally influential appearance of the densely stylized
Shanghai Express (1932) with Marlene Dietrich, herself destined to become a
key figure for a gay subculture.[25] In addition to dramatic features, Hollywood
cultivated an Orientalist dance aesthetic by hiring performers from the cele-
brated Denishawn dance studio, which based its repertoire on a pastiche of
"Eastern" dance styles.[26] These films elaborated what today we easily recognize
as the fundamental aspects of the Orientalist vision: the Orient as the site of
romantic melodrama, sexual intrigue, and lavish decor; Orientals as either
predatory (male) or oversexualized (female); and the relation between the races
as either one of conflict (rape, war, or pillage) or subservience (the doting
slave, the melting harem girl). It hardly needs saying that such characteriza-
tions were displacements of patriarchal fantasies and cinematic representa-
tions of more fraught tensions between the imperial West and the uneasily
colonized East.[27]

But we can also suggest that the production of the Orient was nothing
so ideologically straightforward for its early moviegoers.[28] The spectacular
appearance of a highly sexualized, yet deeply marginalized, culture also pro-
vided the means for personal fantasy at a time when that was not easily
obtainable in other venues. When Hollywood instituted its harsh Hays Office

Codes in the 1920s and even harsher Production Codes in the 1930s, which governed among other things how the races and sexes interacted on screen, often the only characters who *could* suggest forbidden pleasures and outlawed sexuality were those Orientalized figures. "Shriek for the Sheik!" an advertisement urged, and thousands did.[29] Orientalism, therefore, provided a basic vocabulary to explore the imaginative hold exerted by the East as well as, in the case of Jack Mei Ling, the hinterland of nonnormative sexuality. In this latter sense Orientalism permitted a queer discourse, in that it enabled an exploration of difference from the normal, the legitimate, the dominant. Moreover, it gave the fashions and dances associated with it a highly charged, potentially transgressive and liberating meaning.

What made Ling's work complex was that his performances worked both with and sometimes self-consciously against Orientalist conventions and the queer discourse they enabled. Some of his dance numbers, for example, are explicit refusals of the more Orientalist styles reserved for Chinese American dancers and relied instead on a ballroom style. He outfitted himself in long coattails, stiff collars, and broad lapels, and his partners in sumptuous evening gowns, with cinched waists, long skirts, and broad shoulder straps. In these numbers, he preferred choreography that accentuated the flowing, elegant lines that he and his partners cut—arms extended to just below shoulder height in slightly curving arcs, legs raised to just below knee level to outline the smooth surface of the evening gown. The music was slow and lyrical, the movements deliberate and repetitive. A central motif in these dances was the lift and turn, in which Ling raised his partners a few inches off the ground and twirled them in slow motion. This sequence offered an occasion to highlight the long lines of the women's gowns as they streamed and fluttered in the air, as well as a chance to display Ling's tremendous athleticism.

Other numbers suggest an almost opposite choreographic sense in which Orientalist conventions were accommodated. These numbers were more balletic. The dancers maintained much more rigid postures, with toes pointed and bodies erect, than in their ballroom style. Their spines held a vertical axis and their arms became the primary expressive device, waving and fanning around a stable center. These dances required the couple to move in highly synchronized patterns, as both man and woman faced the audience frontally, rather than being pressed against each other as in ballroom work. Whereas Ling's ballroom numbers required both dancers to perform as a fluid, nearly undifferentiated pair, these dances required a high level of autonomy

and separation, in which the couple presented themselves as two independent figures engaged in a stylized dialogue of gestures.

Still other numbers suggest an even more self-conscious accommodation of Orientalist devices. In his celebrated performances with Joy Ching, known as "The Girl in the Gilded Cage," Ling played the role of harem master. He dressed in highly ornate sinocized costumes and danced in abrupt, jerky motions around a bamboo cage in which Ching, imprisoned and clad in a primitivistic robe and bikini, stripped to a driving musical beat. But whereas Joy Ching's striptease was most often the object of the audience's attention ("Miss Ching, who poses almost n-k-d at times, has a very fine appendicitis scar two and one-eighth inches in length," wrote one very attentive observer, and "no customer ever has complained"),[30] it was in fact Jack Mei Ling's dance that was the most energetic feature of the performance. He contorted his body into angular postures, legs flared and arms and wrists working in a series of staccato gestures. Whereas the balletic dances were built on fanning, upright movements, with the dancers' bodies propelled upward, the momentum of this dance pushed downward, as Ling's low center of gravity shifted from one leg to another in a series of knee drops and slides. Often, his upper body moved in a manner distinct from his lower body.

These latter two styles of dance—the arm-waving ballet and the bamboo-cage strut—derived from Orientalist films. What could be more glibly "Eastern" than the image of Ling as harem master, whose chicken dance around the gilded cage framed the gaudy striptease of Joy Ching? Or consider the expressive details in his routine with Jade Ling, in which exaggerated fanning gestures were an adaptation and pastiche of Hollywood's (often Denishawn's) conceptions of Indian and North African dance, and in which both he and his partner performed in outrageous, sinocized costumes. In both styles, Ling reproduced the most dazzling (albeit the most hackneyed) theatrical effects associated with Oriental dance. But rather than see his use of them as mere imitation or, worse, simple reaffirmation of sexist and racist conventions, we can suggest that Ling's highly elaborate dance numbers and costumes, which varied from show to show, were also a means for him to explore a repertoire associated with outlawed sexuality as offered in Hollywood film and dance. The fact that he also appeared in chorus numbers, where he was often the central dancer and where his muscular, oiled body could be accentuated with revealing costumes, gave him even more opportunity for experimentation and display. The various dances and vignettes provided him a nightly means by which he could, quite literally, perform a queer identity on stage.

Without claiming too much for the subversive potential of Ling's various performances, we can readily suggest that they constituted a "camp" practice, in the sense proposed by Susan Sontag. To practice camp is "to understand Being-as-Playing-a-Role," in this case the roles offered by Orientalism.[31] For gay men, camp held special appeal since, as the historian George Chauncey notes, it was "at once a cultural *style* and a cultural *strategy,* for it helped gay men make sense of, respond to and undermine the social categories of gender and sexuality that served to marginalize them."[32] What made Ling's camp unique—what gives it a historicity and pathos—was that it made the Forbidden City stage, normally conceived of by its audience as a space for understanding racial identities, also a space for its performers to work out sexual identities. It allowed the "Chineseness" offered there to carry multiple unstable meanings.

Ling's considerable talents as a dancer and choreographer were sought out by other club owners, including Andy Wong, Charlie Low's major competitor in the Chinese revue scene. We find Ling and one of his partners, Kim Wong, gracing an early brochure for the Shangri-La club, where, as the cover suggests, the two were a headline act. He had no difficulty finding work, eventually touring in shows in Los Angeles, Portland, Seattle, Vancouver, Chicago, and New York. He consistently returned to the Forbidden City, however, and was one of Charlie Low's most reliable draws. Through the years, Ling's dances and partners changed, but the Orientalist aspects continually reappeared. In the context of the Forbidden City and its proximity to his home in Chinatown,

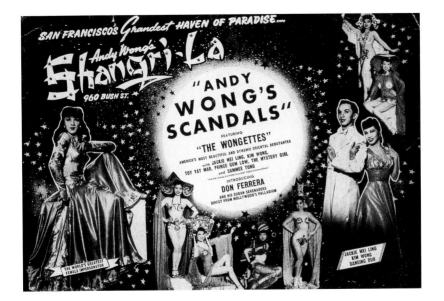

Brochure for the
Shangri-La, 1942
Private collection

Ling's camp use of Hollywood Orientalist film models was particularly powerful because it was often so closely associated with burlesque, irony, even with what today we would consider kitsch humor—the club's staples. Its queer discourse could be masked even as it was being narrated, and the club's general over-the-top attitude to the shows allowed Ling to retain a closeted identity in homophobic Chinatown even as he explored a gay identity on stage.

Unlike Charlie Low's Forbidden City, Andy Wong's Shangri-La occasionally permitted Ling another stage persona pertinent to this discussion. On the same cover that includes a photograph of Jack Mei Ling in coattails and tie at right, we can also spot, at left, Ling in drag, as the "World's Greatest Female Impersonator." With arms elegantly akimbo and a gown as glittering and silky as anything he designed for his female partners, Ling is nearly unrecognizable and could easily pass as a woman. His cross-dressing and camp performances belonged to a general enactment of queer identity and, moreover, were related to the performance of whiteness in the Forbidden City. That is, they constituted a discourse involving role-playing, passing, masquerade, fantasy, and pantomime, and shared a common historical base. With the very identity of Chinatown's young Americans put up to intense scrutiny, when previous characterizations did not obtain and when others were proposed for size, some courageous individuals found ways to explore and fashion their place in a shifting social order.

GIVEN WHAT WE NOW KNOW of the acts at the Forbidden City and their relationship to wider national and international debates, I propose the following brief conclusions, speculative to be sure and in need of more concrete historical inquiry. San Francisco's Chinatown at midcentury was a battleground of representation, in which competing arguments and images had at stake the very terms by which Chinese Americans could be recognized by a non-Chinese audience and, indeed, by Chinese Americans themselves. The whole period is evidence of what observers today recognize as the great possibilities within the in-betweenness of cultures, the "diverse modalities of hybridity," as postcolonial critic Ella Shohat has proclaimed, ranging from the "forced assimilation, internalized self-rejection, political co-optation, [and] social conformism" of a people, to "cultural mimicry and creative transcendence" by them.[33] Indeed, hybridity is Chinatown's most powerful legacy.

I have wanted to show that the attributes of difference and belonging often ascribed to and explored by Chinese Americans were contained within what might seem the least felicitous forum for such questions, the clichés of

popular culture and the nightclub. But how could it be otherwise? After the
1924 Immigration Act, Chinatown's economy had largely been limited to
tourism and the restaurant trade, where marketing racial and cultural differ-
ence was one of the few means of earning a living available to Chinatown's
second generation. And given the intense, often rancorous relations between
Chinatown's older and younger generations around questions of nationalist
commitment and community, popular culture offered an arena seemingly out-
side the terms of debate. From our vantage, we can say that popular culture
was never really outside the debate but was another means of approaching it.
Within that space, some Chinese Americans found a means to explore the
identities ascribed to them, and they did so simply by indulging in the pleas-
ures and possibilities of the stage. All it took was a quick foot or a strong voice.

Anthony W. Lee is assistant professor of art history at Mt. Holyoke College. His publications
include *Painting on the Left: Diego Rivera, Radical Politics, and San Francisco's Public
Murals* (1999).

1 Low's comments are recorded
in Arthur Dong's film *Forbid-
den City USA* (Deep Focus
Productions, 1989). This essay
owes a considerable lot to the
original performers at the
Forbidden City who graciously
invited me into their homes,
patiently answered all of my
questions, and generously
shared their scrapbooks and
photographs with me. I will
note specific performers and
interviews in the notes that fol-
low, but I wish to express my
special thanks here to Mary
Mammon Amo, Larry Ching,
Frances Chun Kan, Jack Mei
Ling, Jade Ling, Diane Shinn
McLean, Lily Pon, and Stanley
Toy. I also wish to thank John
Grau and Kim Searcy, who
arranged for me to meet with
the Forbidden City players and
shared their large photographic
archive of the club with me.
2 Homi K. Bhabha, "Sly
Civility," *October* 34 (1985): 78.
3 Dorinne Kondo, *About Face:
Performing Race in Fashion
and Theater* (New York and

London: Routledge, 1997), 13.
My argument draws on a wide
range of theories about "per-
formance," a huge subject in
its own right. I offer only the
briefest glimpse here, as it
informs this study. Performance
is, as Judith Butler first argued
(*Gender Trouble: Feminism
and the Subversion of Identity*
[New York and London:
Routledge, 1990]), a repetition
of acts, gestures, and enact-
ments that are constitutive of
identity, not simply attributes
of some predetermined human
essence. This not only refers to
questions of gender, which was
Butler's initial project, but also
to race. Individuals fashion or
perform their racial identities
out of social, cultural, and his-
torical materials, all of which
are subject to constraints. In the
case of Chinese Americans, the
formidable constraint in the
mid-twentieth century was
the widespread belief among
non-Chinese of their unequiv-
ocal and often inscrutable
Otherness, their inferiority to

(also constructed, also per-
formed) male, white, bourgeois
identities. The performance
of racialized subjects, under
these conditions, at turns
accommodates and contests
social constructions of
"Chinese American."
4 Jerry Flamm, *Good Life in
Hard Times: San Francisco in
the '20s and '30s* (1978; reprint,
San Francisco: Chronicle
Books, 1999).
5 Charlie Low, interview by
John Grau and Kim Searcy,
San Francisco, 1979, 5. The
interview is recorded on audio-
tape and is in the collection of
Grau and Searcy. They kindly
allowed me to make a tran-
script, to which my page
numbers in the notes refer.
6 Low maintained that the
impetus for the club came from
him and not from his wife,
Li Tei Ming, who had already
been performing in clubs
around town (see, for example,
Low, interview by Grau and
Searcy, 5). But in its initial
days, the club was clearly a

showcase for his wife, who not only was its undisputed star but who also organized the program of decorative motifs and wall paintings.

7 "*Life* Goes to the 'Forbidden City,'" *Life*, Dec. 9, 1940, 125.

8 Of the original club performers, only one, Stanley Toy, was born on mainland China. He arrived in San Francisco as a "paper son" (a man whose claim to legitimate immigration was fraudulent, based on fabricated papers), worked as a youth in Chinatown's restaurants, studied ballet at the San Francisco School of Ballet, and became the club's first resident tap dancer. Stanley Toy, interview with the author, San Francisco, June 2, 1999. The other original performers were born and raised in Hawaii or the continental United States. Charlie Low was born in Winnemucca, Nevada, but spent most of his life in San Francisco.

9 Because Stan Kahn and Pat Mason are presented as the club's production team in Dong's documentary of the Forbidden City, Biggerstaff's importance has been considerably downplayed. Biggerstaff in fact played a much more significant role in designing and choreographing the shows, not only in the Forbidden City but also for other clubs in Chinatown, such as the Kubla Khan. The dancer Mary Mammon Amo, who was one of the original chorus members in 1938 and worked on and off at the club until it closed in 1962, does not recall ever working with Kahn and Mason. Mary Mammon Amo, interview with the author, Berkeley, May 30, 1999.

10 Title missing (subtitled "San Francisco's Charlie Low is the Oriental Billy Rose, complete with swimming pool and cheesecake. But did Billy Rose ever own polo ponies?"), date missing (but probably 1945–46), 35–36; clipping from the collection of Diane Shinn.

11 "*Life* Goes to the Forbidden City," 125.

12 The 1924 Immigration Act was the latest and most encompassing legislation aimed at excluding the Chinese from the United States. Beginning in 1882, under the pressure of working-class protest, state and federal legislators passed a series of ordinances designed to curtail Chinese laborers from entering the country and made provisions instead for Chinese merchants, students, and their wives (and thereby maintained economic relations with the merchants of mainland China). The 1924 act was unprecedented in that it excluded all Chinese from entry and, in effect, condemned the Chinese American population already in the States to slow suffocation. The relevant passages in the 1924 act: "No alien ineligible to citizenship shall be admitted to the United States . . . The term 'ineligible to citizenship,' when used in reference to any individual, includes an individual who is debarred from becoming a citizen of the United States . . . [as stated in] 'An Act to Execute Certain Treaty Stipulations Relating to Chinese.'"

13 Arnold Hauser, "Chinaman's Chance," *Saturday Evening Post*, Dec. 7, 1940, 86, 87.

14 In the larger study from which this essay is drawn, I relate international developments to national developments and link the representational crisis brought about by the Sino-Japanese War with the orchestration of a new tourist quarter, as only briefly introduced here. See chap. 6 in my forthcoming *Picturing Chinatown: Difference and Desire in San Francisco* (Berkeley and Los Angeles: University of California Press, 2001).

15 In Edward Said's classic work (*Orientalism* [New York: Random House, 1978]), Orientalism is the total body of representations by the West of the East as a way to deal with the Orient, "dealing with it by making statements about it, by teaching it, settling it, ruling over it: in short, Orientalism as a Western style for dominating, restructuring, and having authority over the Orient" (3). Since its first appearance more than twenty years ago, Said's description of Orientalism has undergone analysis and revision, most usefully by Lisa Lowe, *Critical Terrains: French and British Orientalisms* (Ithaca: Cornell University Press, 1991), and Reina Lewis, *Gendering Orientalism: Race, Femininity, and Representation* (New York and London: Routledge, 1996). In these revisions, Orientalism is regarded less as a one-way project of domination (based on Michel Foucault's notions of discourse and power) and more as a multiple project of hegemony (based on Antonio Gramsci's theory that domination is achieved by shifting yet still-imbalanced negotiations between colonizers and colonized). Though still oppressive, Orientalism in more recent analyses is understood as an ongoing construction, not only subject to destabilization and contestation, and not only deeply unstable and contradictory in its very fabric, but also a method by which Orientalized individuals can find a means of self-representation.

16 For a recent account of the Japanese occupation, see Iris Chang, *The Rape of Nanking: The Forgotten Holocaust of World War II* (New York: Basic Books, 1997).

17 The winning and second-place essays were originally published in the *Chinese Digest* on May 15 and 22, 1936. Both essays, as well as the flurry of rebuttals they provoked, are reprinted as "Ging Hawk Club Essay Contest: 'Does My Future Lie in China or America?'" in *Chinese America: History and Perspectives 1992* (San Francisco: Chinese Historical Society of America, 1992), 149–75, from which subsequent quotations in the text are taken.

18 Ibid., 157.

19 See, for example, Alice Fong Yu's complaints about women who refused to refrain from wearing Japanese silk stockings in *Chinese Digest,* Nov. 1938, 6.

20 I am summarizing a complex set of developments, where factions from both the merchant and working classes fell on different sides of the question of war relief and fund-raising. For a more developed discussion, see Judy Yung, *Unbound Feet: A Social History of Chinese Women in San Francisco* (Berkeley and Los Angeles: University of California Press, 1995), 224–45.

21 A brief account of Gutmann's early career in San Francisco can be found in Max Kozloff, "The Extravagant Depression," in Lew Thomas, ed., *The Restless Decade: John Gutmann's Photographs of the Thirties* (New York: Harry N. Abrams, 1984), esp. 7–10.

22 For a brief but useful history of San Francisco's pre-1950 gay subculture, see Susan Stryker and Jim Van Buskirk, *Gay by the Bay: A History of Queer Culture in the San Francisco Bay Area* (San Francisco: Chronicle Books, 1996), 9–41.

23 Frances Chun Kan, interview with the author, Oakland, May 31, 1999.

24 Gaylyn Studlar, "'Out-Salomeing Salome': Dance, the New Woman, and Fan Magazine Orientalism," in Matthew Bernstein and Gaylyn Studlar, eds., *Visions of the East: Orientalism in Film* (New Brunswick, N.J.: Rutgers University Press, 1997), 99–100. A brief list might include D. W. Griffith's *Intolerance* (1916); *Aladdin and His Wonderful Lamp* (1917); *Cleopatra* (1917) and *Salome* (1918), both starring Theda Bara; *Ali Baba and the Forty Thieves* (1918); Otis Skinner's *Kismet* (1920); *The Sheik* (1921), starring Rudolph Valentino; *The Thief of Bagdad* (1924), with Douglas Fairbanks; and *The Son of the Sheik* (1926), Valentino's last film.

25 For the importance of the Ballets Russes on American art and popular culture, see Peter Wollen, "Fashion/Orientalism/The Body," *New Formations* (spring 1987): 5–33.

26 For the "Eastern" influences, see Ted Shawn's own account of his explorations in the East in *Gods Who Dance* (New York: Dutton, 1929).

27 For a general discussion, see Gina Marchetti, *Romance and the "Yellow Peril": Race, Sex, and Discursive Strategies in Hollywood Fiction* (Berkeley and Los Angeles: University of California Press, 1993).

28 Here I take my cues from Michael Moon, "Flaming Closets," *October* 51 (1989): 19–54.

29 "The Sheik," *Los Angeles Record,* Oct. 29, 1921. On the relation between early spectatorship of Orientalist films and an emergent and transgressive femininity, see Studlar, "'Out-Salomeing Salome,'" 99–129.

30 Jim Marshall, "Cathay Hey-Hey!" *Collier's,* Feb. 28, 1942, 53.

31 Susan Sontag, "Notes on 'Camp,'" in *Against Interpretation* (New York: Anchor Books, 1990), 280.

32 George Chauncey, *Gay New York: Gender, Urban Culture, and the Making of the Gay Male World, 1890–1940* (New York: Basic Books, 1994), 290.

33 Ella Shohat, "Notes on the Post-colonial," *Social Text* 31/32 (1993): 110.

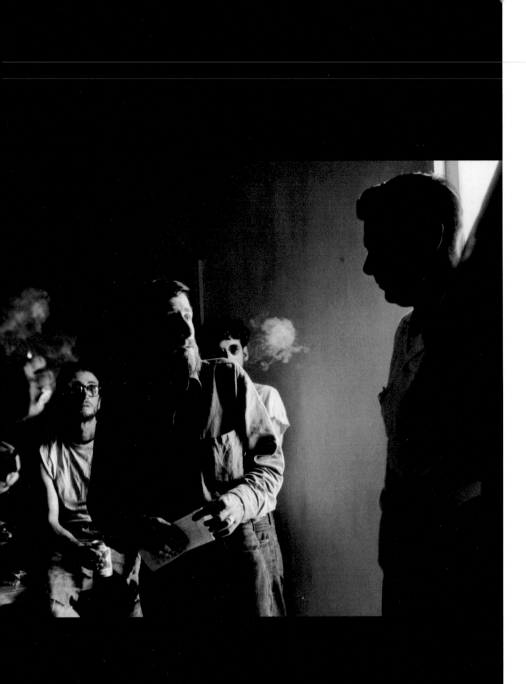

Wallace Berman's
arrest at the Ferus
Gallery, June 1957
Photograph by Charles
Brittin, courtesy of
the photographer and
Craig Krull Gallery,
Santa Monica

John P. Bowles

"SHOCKING 'BEAT' ART DISPLAYED": CALIFORNIA ARTISTS AND THE BEAT IMAGE

I don't know any artist that would call himself a beat artist . . . If somebody did, you'd consider him to be a fake, a fraud running a scam.

Bruce Conner, November 1995

In November 1959 an *Oakland Tribune* art critic decried *The Individual and His World,* an exhibition of art from San Francisco, as "deliberately shocking," and the review's title warned of "Shocking 'Beat' Art Displayed."[1] The artwork in the exhibition was accompanied by photographs by Jerry Burchard of the artists at home. One of these photographs—a portrait of Jay DeFeo in her dark apartment, seated on a paint-covered stool before her towering, abstract star-burst painting, *The Jewel*—was published in the review. The artist (cigarette in hand, wearing a turtleneck, short paint-splattered jeans, and sandals) glares tauntingly at the viewer, exuding risqué *bohème* and seeming the exemplary Beat type. Ironically, the reviewer reserves the distinction "the 'beatest'" in the show for Bruce Conner's sculptures, despite Burchard's "photographs of the handsome, clean-shaven young Bruce Conner in his tidy studio."[2] This review represents not the first time these artists were characterized by the press as Beat, and it is an explicit example of how images of artists and their artworks coalesced as Beat in critics' eyes, as if to confirm their expectations and those of their readers.

To be labeled Beat presented a dilemma for DeFeo, Conner, and others, such as the artist Jess (formerly Burgess Collins). Although the Beat image drew attention to an artist's work and consequently attracted a larger audience, it also carried heavy value judgments. Despite the efforts of leading Beat figures Allen Ginsberg and Jack Kerouac to define the art and literature of the Beat generation as the positive expression of an alternative philosophy,

the nation's print media reduced their ideas to a stereotype—the "beatnik," a figure of unfettered amorality whom the conservative culture of 1950s America deemed immoral. In San Francisco, media attention resulted not only in an expanding audience, but also in increased police scrutiny and social aversion. For artists already largely isolated from the mainstream institutions of the art market, this unwelcome attention—which varied depending on the artist's gender and sexual orientation—often outweighed the rewards of publicity.

The idea of a Beat generation took hold in the popular imagination and was used to define a set of very specific social roles, and thus determined how the artists and their work were received in the 1950s and 1960s. For example, the Beat was portrayed in the mainstream media as socially transgressive in many ways but was still expected to comply with the requirements of norma-tive heterosexuality. Many different kinds of artists participated in the com-munity labeled Beat, but this characterization has proven inadequate to define them. Recent efforts to identify a group of California artists as engaged in a common Beat project have risked, at forty years' distance, obscuring beneath the stereotype the ways in which the artists themselves embraced or avoided the identification, and their possible reasons for doing so. The group occupies a near-mythic position in the history of art in California, having provided the impetus for art historians to create histories of the so-called California assemblage and Funk art movements, which consequently has led to misrep-resentations of their artwork.[3] This is not to say that the term "Beat" can satisfactorily describe some artists and not others. Instead, it must be under-stood as a construction of the popular discourse in late-1950s and early-1960s America, which served, through collective affirmation and debate, to produce and disavow specific behaviors. Artists such as Jess, Jay DeFeo, and Bruce Conner participated in this construction, even as they made efforts to disas-sociate themselves from it.

Beginning in the fall of 1956, with national media attention keenly focused on the Beat generation, a disparate community of poets and artists emerged in the San Francisco Bay Area. Despite their individual projects, these artists and writers were lumped together by both the mass-circulation and the literary presses as a regional movement. The city as a whole, and the neighborhood of North Beach specifically, became widely identified as "the international headquarters of the so-called 'Beat Generation,'" even though its best-known public spokesmen, Ginsberg and Kerouac, both left in 1957.[4] The community of poets and artists who formed around Kenneth Rexroth's, Robert Duncan's, and Jack Spicer's long-established anarchist and literary

circles, Lawrence Ferlinghetti's City Lights bookstore, Ruth Witt-Diamant's San Francisco Poetry Center, a handful of small poetry presses, and such cooperative art galleries as the King Ubu Gallery and its successor the 6 Gallery became Beats in the eyes of reporters from *Life, Time, Playboy,* and the local newspapers.

A Beat, according to the mainstream-media definition, was a drug-using dropout—indolent, sexually deviant, and perhaps criminal—but the term sometimes evoked admiration as well, for Beats were supposed to have understood and turned away from the failings and entrapments of middle-class white America (the Beat was almost always *from* but only tenuously *of* the middle class). The term also implied the manly and heterosexual lifestyle portrayed in Kerouac's novels, around which discussion of the Beat generation centered. On the surface, the term was used as an epithet to criticize a perceived threat to middle-class American values. This was indicated by the addition of the Russian suffix, Sputniklike, on "beatnik," which served a cautionary purpose. Richard Cándida Smith has argued that for young men, the Beat set an example of irresponsibility

"against which the true male could be defined by his ability to overcome rebellious desires and accept the necessity of responsibility."[5] Conversely, as Barbara Ehrenreich has pointed out, the figure of the beatnik served as a foil to judge another media caricature, the "square," a maternally dominated Man in the Gray Flannel Suit.[6] In either case, however, amelioration came through observing the Beat, not through becoming him. At a time when the mainstream press published debates about how postwar consumerism, Cold War suburbia, and corporate jobs were causing a crisis in American masculinity, Hollywood movies and popular magazines employed the virile figure of the Beat to prescribe

"Squaresville U.S.A. vs. Beatsville," Life magazine, September, 1959 © 1959 Time, Inc., reprinted by permission

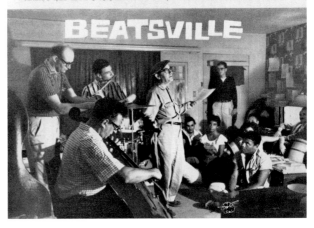

healthy, gender-appropriate sexuality.[7] As heterosexual male fantasy, the lifestyle could be vicariously desired, as when, for example, *Playboy* published its "Beat Playmate" centerfold in 1959 to accompany a selection of Beat poetry.[8] Despite the presence of several women artists and poets among the San Francisco community, the only Beat roles allowed women in either the writings of Kerouac or the mainstream press were the promiscuous "chick" or the sexually undesirable but gainfully employed wife of the freeloading beatnik.[9] Some reviewers did criticize Kerouac for his limited—and limiting—portrayal of women.[10] Nevertheless, the advances of the women's movement were not to come for more than a decade. While the Beat man could be redeemed by marriage, even this was not a possibility for the Beat woman.[11]

Homosexuality, on the other hand, was almost absent from popular discussions of the Beats. Kerouac had removed references to his friends' homosexuality from his novels and never identified himself as such (the revelations that he and Ginsberg and that Neal Cassady—the model for Dean Moriarty, hero of Kerouac's *On the Road*—and Ginsberg had been lovers came years later). In 1959 Ginsberg became the first Beat to openly identify himself as homosexual in the national press since Robert Duncan had published his essay "The Homosexual in Society" in 1944. Ginsberg announced, "I sleep . . . with men and with women. I am neither queer nor not queer, nor am I bisexual. My name is Allen Ginsberg and I sleep with whoever I want."[12] None of the San Francisco artists or poets, including Duncan, was identified as homosexual in the popular media during the late 1950s, but classification as Beat required a presence before the media, and most homosexual artists and poets, like Jess and Duncan, retreated from the hostile scrutiny of the press at this moment.

If a community of poets and writers gathered in pursuit of common artistic and political interests, by the late 1950s their congregation was equally determined by the persecution that they feared and felt. Embarrassed by the national media's portrayal of San Francisco's North Beach as a beatnik enclave of drugs and sex—heterosexual and homosexual, the latter of which was illegal in most states in the 1950s—the local police department mounted a campaign to intimidate the supposed perpetrators and drive them from sight. Press vilification amplified police scrutiny, and the number of arrests rose in response to the media's escalating interest in beatniks. San Francisco chief of police Thomas J. Cahill characterized beatniks as childlike and blamed the media for encouraging a situation that necessitated paternal supervision by police: "We had no trouble with the beatniks at all until the newspapers

started writing them up . . . Then they learned they had some type of identity, so they began to gather . . . and put on a show in their own way, drinking, dancing, acting like kids do when someone comments on them. What happened was that they attracted young people, and young people, naturally, attracted police."[13] Uniformed officers made a show of force, and increasing numbers of undercover police searched North Beach, entrapping drug users and homosexual men. Ginsberg was arrested in 1954 by police searching a coffeehouse for drugs (he was released without being charged), and in 1958 Neal Cassady and artists George Herms and Arthur Richer were arrested on drug charges.[14] Poet Michael Rumaker has recalled that undercover policemen targeted homosexual men both as figures of desire and of repulsion: "Gay males had a double lookout not only for nosy narcs trying to pump them, often in more ways than one, but for the usual undercover cops in the Vice Squad, who were also everywhere."[15]

Obscenity prosecutions of San Francisco artists and poets extended police vigilance to their so-called Beat artwork, provoking a general trepidation and, in some cases, a reluctance to publish or exhibit anything that might expose the artist to prosecution. The persecution of homosexuality, in particular, extended to its representations.[16] In May 1957 undercover San Francisco police arrested Lawrence Ferlinghetti on obscenity charges for selling Ginsberg's *Howl and Other Poems* at City Lights. Ferlinghetti was acquitted, but not until the prosecution had made it clear that it was the descriptions of drug use and vivid sexuality—especially references to gay sex—that had provoked their action. Recognizing the danger in further provoking a police chief eager to make bold statements, Ferlinghetti subsequently turned down the opportunity to publish William Burroughs's novels, fearing that their explicitly gay imagery would invite further trouble.[17]

News came from Los Angeles, too, of artists facing the threat of police action. A Wallace Berman exhibition at the Ferus Gallery (June 1957) was closed when the artist was arrested and convicted on obscenity charges. Berman responded to the verdict by writing, "There is no justice, only revenge" on the courtroom blackboard. Berman left Los Angeles, calling it "this city of degenerate angels," and moved his family to San Francisco.[18] Obviously, moving to the Bay Area would not provide an escape from the watchfulness of the police. Nevertheless, Berman inscribed a copy of the second issue of his journal *Semina* (which he completed in San Francisco) to Kenneth Rexroth: "this is a beautiful city."[19] Why would Berman seek refuge there? The answer may be that the community of artists and poets centered around the city

provided a safe haven, a semisecluded and nurturing environment where they could share their work privately with an appreciative audience, beyond the scrutiny of the police, the public, and the press.

During this period of tremendous scrutiny, Jess, as a homosexual artist, particularly sought such an audience. The household he shared with his lover, poet Robert Duncan, offered greater security from the harassment endured by their single homosexual friends, and simultaneously represented an artistic and intellectual project pursued in common. From 1956 to 1959, Jess withdrew from publicly exhibiting his art. During that time he continued to produce collages but displayed them only in his home. He also illustrated friends' books of poetry, which were published in very small editions by the cooperative White Rabbit Press.[20] These drawings, like his collages, would have been seen primarily by friends and readers of small West Coast poetry publications— an audience likely to be sympathetic.

Private art making as community building became a subversive and unpoliceable activity for Jess and his friends. According to Duncan, "we began to see ourselves fashioning unnamed contexts, contexts of a new life way in the making, a secret mission." A measure of secrecy became a necessity within the San Francisco artist community during the late 1950s. Reflecting on the context of his and Jess's creative friendship with Berman, Duncan defined it as a defensive maneuver as much as an artistic one: "The emergence of a new art and a new painting arising from new lifeways in those years was to be written in police attacks and court proceedings against sexual images and the rites of personal mystery cults as 'pornography.'"[21] Jess's adaptation of his artistic practice in response to the changing atmosphere in San Francisco is similar to artist Charles Demuth's efforts earlier in the century to express his own homosexuality in ways that avoided prosecution. Art historian Jonathan Weinberg has emphasized the importance of "this awareness of audience—the consciousness of what is permitted and not permitted depending on certain settings and viewers is probably [most] telling of Demuth's homosexuality."[22] Jess's work of the 1950s acknowledges the viewers for whom—and sometimes with whom—it was made as participants in a community parallel to the one threatening persecution outside his front door. An artist did not have to be homosexual to face intimidation and harassment in San Francisco, but the threat was probably greatest for one who was. It is therefore not surprising that Jess's withdrawal from public exhibition and into his home is the most complete among his peers.

The history of Jess's career is inextricable from the household he kept
with Robert Duncan for nearly forty years, and his work is the product of a
relationship that was at once romantic, artistic, and intellectual. Michael
Rumaker has written that their household provided both protection and free-
dom, one the result of the other, "in a city which was then . . . permeated
with the shrinkage of conformity and repression."[23] Poet Robin Blaser recalls
how Duncan made art "in response to the rooms and furniture Jess magically
painted in their first years of house-imagining," and he argues that their art
making was integral to their homemaking and vice versa.[24] Jess and Duncan
also collaborated on a series of books and broadsides—most of which they
gave to friends rather than sold—and although each developed as an artist in
his own right, their careers became intertwined within what Duncan called
in 1971, "our household, our way of living," and in an earlier poem, their "mar-
riage."[25] These collaborations provide not only evidence, but the basis for an
intimate symposium articulating an audience of friends.[26] As Christopher
Wagstaff has argued, the gift giving involved in these projects demonstrated
an intimate knowledge between the givers and the receivers because the work
was "not made for galleries or museums but for the modest spaces of homes."[27]

It is perhaps not coincidental that Jess credits the childhood scrapbooks
he kept with his aunt as the inspiration for his collaged "Paste-ups": "I used
to paste up things with my aunt and that experience is probably more central
to my love of this kind of work than the modern development of collage."[28]
Jess thus emphasizes the playfulness and homeyness of these collages. In a
series of Paste-ups from the mid-1950s titled Goddess Because, Jess paired
images of elegantly dressed fashion models from women's magazines with
out-of-place accoutrements to make parodies of advertisements for Moddess
feminine napkins. By identifying these collages with the domestic realm of
home and family, a space that self-proclaimed Beat writers such as Kerouac
identified as inhospitable for men, Jess takes on 1950s assumptions regarding
masculinity, the Beats, and the professional artist's studio. As Mary Kelly
has argued of the twentieth-century avant-garde, for a male artist to present
himself as both formally transgressive and feminized is to challenge and
exceed the authority with which his artistic predecessors—in this case, the
Abstract Expressionists engaged in what Jess derided as "New Yorkery paint-
ing"—presented themselves.[29]

Some of Jess's artwork, however, questions the association of the domes-
tic with the feminine. Perhaps the best example of this is the series of Tricky
Cad collages Jess made from Dick Tracy comic strips and displayed in his

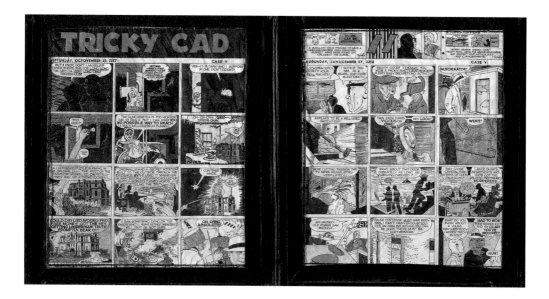

home over a number of years (from 1953 to 1958). Jess cut comics apart and reconfigured them in pages that look like the conventional comic-book format but in which the text and images no longer make narrative sense. Filled with wordplay—such as that found in some of the rearranged titles, *Tricky Cad, Dick Racy, Kid Rat, Icky Tar*—the pages were sometimes bound as books for the focused attention of a lone reader. In a rare statement about his work, Jess identified his household of men as the milieu from which his cartoon series emerged on "one surprisingly curmudgeony [*sic*] Fraternity Sunday in 1953."[30] The fraternal atmosphere—one into which Jess and Duncan's many women friends were also frequently invited—was reinforced by the way one collage was displayed. According to the eyewitness account of Michael Rumaker, who visited their home in 1956 and 1957, "In the bathroom you could read Jess' cutup and reassembled Dick Tracy comic strips, mounted on the wall over the toilet, while you pissed."[31] By displaying this Tricky Cad Paste-up where male viewers would see it while urinating, Jess emphasized the sometimes scatological character of the series. At the same time, he confirmed the small community of male intimates welcomed into the artist's household to share such a private and, for the 1950s, nonnormative art-viewing experience.

Rumaker recalled seeing the Tricky Cad collage in Jess and Duncan's bathroom between the fall of 1956, when the two returned to San Francisco from travels to visit poet Robert Creeley and Black Mountain College, and the fall of 1958, when they left the city again for the coastal town of Stinson Beach. During this period, Jess did not exhibit his work in art galleries. Tellingly, this

two-year period begins only one month before Allen Ginsberg's famous first reading of *Howl* at the 6 Gallery, an event that marked not only a moment of startling productivity for the San Francisco artists and poets, but also of increasing attention from the national news media and the local police. While Ginsberg's outspokenness about his homosexuality set one example of how to address the new circumstances, Duncan had had his own earlier experiences with openness, and they offered quite a different example. In 1944 Duncan had published a stunningly candid essay, "The Homosexual in Society," in which he declared his own homosexuality and argued for an end to what he perceived as the paired threats of the general persecution of homosexuals and the elitism of those aloof intellectuals who privately claimed "a cult of homo-sexual superiority to the human race." Duncan proposed that the best writers are those whose work draws on "their humanity" rather than their sexuality; homosexual writers could learn from their specific experiences as homo-sexuals but should express these experiences as universal.[32] After the essay's appearance—despite Duncan's universalizing aim—previously solicitous edi-tors now refused to publish his poems. John Crowe Ransom of the *Kenyon Review,* for example, wrote Duncan that he now read one poem "as an obvi-ous advertisement·or notice of homosexuality."[33] As Kevin Ray has argued, the editor's new reading of Duncan's poem resulted "not [from] the fact of obscenity, but [from] the decision of obscenity."[34] In the face of Ginsberg's and Berman's troubles with censorship, mounting attacks against beatniks in the press, and increasingly common police raids, Duncan's experience must have informed Jess's withdrawal into the security of their home.

At Stinson Beach in the fall of 1958, Jess and Duncan embarked on new projects for broader audiences. A half hour removed from San Francisco, they may have felt more secure and therefore emboldened to address a public outside their circle of friends. At Stinson Beach, Duncan reworked "The Homosexual in Society" for publication in an anthology of Beat writings.[35] Duncan also began his own imprint, Enkidu Surrogate, to publish his and his friends' works in small editions; and Jess illustrated Enkidu's first two books. In 1959 Jess published works in poet Jack Spicer's little maga-zine, *J,* and began exhibiting in San Francisco again with three solo shows, including one at the Dilexi Gallery from which Bruce and Jean Conner bought *Tricky Cad: Case VII.*[36] Most significantly, that same year, Jess marked his and Duncan's move by beginning a new series of paintings of found images, the Translations, which were suited for both private viewing and gallery exhibition.

In Translations Jess continued his practice of household and community building with a deliberation not attributable to beatnik art, which at the time was associated with junk sculpture and assemblage. Each Translation is painted in a thick impasto, with little regard for the coloring of the original. On the reverse of each painting, Jess printed an excerpt from various scientific, literary, and poetic texts. In statements and interviews, Duncan and, more recently, Jess have provided personal meanings for some of the combinations of texts and images that point again to their relationship and to the close community in which they and their works circulated. In *The Enamord Mage: Translation #6* (1965), for example, Jess included a painted photograph of Duncan, surrounded by books and other objects that they had collected together, in the San Francisco home to which they moved in 1961. The intensive labor Jess undertook in painting this picture indicates the degree of his devotion to his subject and suggests the care with which he and Duncan made their home. However, Jess also prepared this painting for public exhibition by painting the initials "RD" in the corner of the composition. Appearing as if carved into a wooden bookshelf, Duncan's initials ensure that his identity will be clear to a select audience. At the same time, the initials conceal Duncan's identity from potentially hostile viewers unfamiliar with his work. The text on the back is from Duncan's "The Ballad of the Enamord Mage," a love poem that addresses Jess. To close the circle of references: This poem had been published in Duncan's *The Opening of the Field* (1960), his first publication with a national poetry press, for which Jess had drawn and collaged a cover design.[37] The history of *The Enamord Mage* is thus a love story told by one of its principal characters in the creative language he and his lover had developed together. While its intimate significance would be understood by their friends, it could also be safely released into the world for an audience of strangers.

In 1958, at roughly the same moment when Jess and Wallace Berman shared their artwork only with friends, Jay DeFeo began work on a pair of paintings—the culmination of a series of monumentally scaled mandala drawings—that would occupy her for the next eight years.[38] DeFeo showed these two paintings, *The Jewel* and *The Rose*, to friends who visited the apartment she shared with her husband, artist Wally Hedrick, but she refused to exhibit *The Rose*. Largely because of the extent to which DeFeo became so closely associated with this single painting, she has come to represent the quintessential Beat artist. As such, she is widely imagined to have been uninterested in material gain or career, self-absorbedly pursuing her art in an ultimately self-destructive manner. This mythic image is due partly to the

way she was promoted in the press between 1959 and 1962, when published photographs of her with *The Jewel* or with *The Rose* enabled viewers to imagine she was the beatnik of their stereotype.

Images of so-called Beat artists in the press, like the one of DeFeo that appeared in the *Oakland Tribune*'s review of *The Individual and His World* (which I discussed at the beginning of this essay), played an important role in influencing viewers' perceptions. The *Tribune*'s art critic Miriam Dungan Cross, for example, relied on DeFeo's beatnik look to support the idea that she was a Beat artist. Efforts on behalf of the artist by well-meaning friend and dealer Walter Hopps of the Ferus Gallery also contributed to creating this image. Hopps pursued opportunities to keep DeFeo in the public eye and to support her while she worked nearly exclusively on *The Rose*.[39] In 1961 he arranged for DeFeo to pose for Magnum agency photographer Burt Glinn while painting *The Rose*. Glinn's pictures appeared in three periodicals, *Look, Holiday,* and *Art in America,* and in the book *Creative America*.[40] Even as each publication presented DeFeo as a serious, academically trained professional—as in *Art in America,* where it accompanied a statement by the artist and a brief biography detailing her education and exhibitions—her image, dwarfed by the mammoth abstract painting, was manipulated within a contrived context to present her as a beatnik.[41] Another of Glinn's photographs was published beside an image of a raucous Beat "pad" party in a sensationalist photo-essay, "San Francisco: The Rebels," a *Holiday* article on "the Beat phenomenon." Despite being identified in the caption as "J. deFeo [*sic*], B.A., M.A., one of San Francisco's most successful younger artists," by her inclusion in this article, DeFeo became a sexualized attraction by association—the Beat "chick"—for curious tourists. The mainstream media frequently presented the Beats as sexually promiscuous, and this article describes a "communal and weirdly selfless" Beat lifestyle of "unmarried monogamy" (pointedly ignoring DeFeo's marriage).[42] The Beat chick, a constant presence in the beatnik's pad, was typically portrayed in the popular press as sexually available. The chick is available in such representations, however, primarily for the reader—in this case for the prospective tourist—not for the beatnik. And if the nihilistic beatnik was incapable of enjoying sex, as *Playboy* presented him, so much the better for the playboy, to whom the beatnik's chick was presumably therefore available.[43]

DeFeo's promotion to a wide audience in *Look* and *Holiday* magazines seems antithetical to the nature of the artistic community that she belonged to. In contrast to DeFeo and her friends, whose reminiscences celebrate shar-

ing in the development of *The Rose* as a process, the collectors who expressed an interest in acquiring the work upon its much-anticipated completion valued the finished product much more than its realization. Partly because of this, the commonly told story of the making of *The Rose* presents DeFeo as withdrawn from the world, struggling alone with her painting at the expense of her career. While this mythological account is based on the same anecdotal sources that I draw from, it largely ignores her friends' statements about the painting's communal importance. The standard history of DeFeo's career presents *The Rose* as tragedy: The artist's career was disrupted by squandered opportunities; her ruined health and premature death resulting from years of handling lead paint. In retrospect, catastrophe has overtaken accomplishment. For DeFeo's friends, however, the process she pursued in her work was more important than the publicly exhibited result.[44]

By the time DeFeo began *The Rose* and *The Jewel,* she was already locally recognized as one of the most important young painters in the Bay Area, and national recognition soon followed. DeFeo and Hedrick had been actively involved in the group of artists and poets gathered around the 6 Gallery since they had moved to San Francisco from Berkeley in 1954. It is clear from a series of letters DeFeo wrote her friend Fred Martin, declining his offer of a solo exhibition for the San Francisco Art Association, that she felt most comfortable exhibiting for friends at "the 6," protected from the judgment of strangers: "I will never be able to paint because I think art history next century needs me in the files."[45] Her intended audience for *The Rose* consisted primarily of her circle of friends, Hedrick, and the few collectors and curators invited to her apartment. Indeed, *The Rose* seems to have not been intended for exhibition in a museum or gallery. The painting grew to fit the height and width of the central pane of her apartment's bay window (10'9" x 7'8") and, repeatedly covered with thick layers of paint, reached an awesome weight of more than a ton. DeFeo wrote a curator at the Whitney Museum of American Art that the size of her work "to some extent has to be determined by the environment in which I am working."[46] When DeFeo carved away at the accumulated paint, making the work sculptural, she must have been responding to the sidelight coming in from the bay window's flanking panes, which is visible in photographs of *The Rose* in situ. For Bruce Conner, the mound of paint drippings that formed on the floor beneath *The Rose* resembled "the back of a whale," extending into the room and making "a prehistoric cave" of the apartment.[47] Fred Martin recalls that *The Rose* transformed DeFeo's small apartment into a "cathedral."[48]

Jay DeFeo painting
The Rose, 1962
Photograph © Burt
Glinn, courtesy of
Magnum Photos, Inc.

Jay DeFeo and Wallace
Berman, *Untitled,* from
the series Portraits of
Jay DeFeo, 1959
Collection of the
Whitney Museum of
American Art, Gift of
the Lannan Foundation,
96.243.9, © 2000
Estate of Jay DeFeo/
Artists Rights Society
(ARS), New York,

© 2000 Estate of
Wallace Berman,
courtesy of L.A. Louver
Gallery, Venice,
California, photograph
© 2000 Whitney
Museum of American
Art

With national attention in the art press and the mass-circulation news media between 1959 and 1962, photographs of DeFeo with her paintings became elemental in establishing her public reputation as a Beat, a process lamented by friends from that time. In December 1968 Fred Martin wrote what amounts to a eulogy for *The Rose* in the brochure published on the occasion of its first public exhibition in 1969. Martin mourns the painting's removal from its domestic setting and notes the resulting estrangement he feels on its exhibition. Martin writes, "the flower of the initiates was ravished into public spectacle, sales item, prestige pitch." He distinguishes between the early states of the painting's progress, when artist and painting had seemed as one and "it was known among the initiates that Jay was that flower," and later stages when artist and artwork seemed alienated from each other and "the flower was two."[49] Martin's history of *The Rose* as a heroic gesture turned self-destructive marks a change from earlier presentations. With his essay, Martin seems to have set the tone for succeeding accounts of DeFeo's career, discussing *The Rose* both as DeFeo's triumph and as her downfall.

In sharp contrast with the photographs of DeFeo and *The Rose* in the national press are Wallace Berman's photographs of DeFeo posed naked before the painting, which were seen only by friends. Berman's pictures offer an alternative image of the artist in relationship to her work and her audience—an image that is sexualized but that also recognizes the artist as integral to a close-knit community. In one pair of photographs from 1959 from a series of posed portraits on which DeFeo and Berman collaborated, the diminutive artist stands in front of *The Rose,* alternately facing the painting and with her back to it. In the frontal view, DeFeo's head is positioned over the center of the painting so that its rays appear to emanate from the artist, and Berman has superimposed the Hebrew character *tzaddi* over her chest, making reference to the Jewish Shekhinah, an important female creative force associated with God.[50] As in the Magnum photographs, DeFeo is presented in bodily relationship to her painting, but with a different aim. Here the sexual is significant as an expression of the spiritual, at least for Berman, who later wrote DeFeo that when looking at the picture he took of her with her back to the camera, he was "having a universal trip of yr [*sic*] body in relation to 'rose.'"[51] According to Constance Lewallen, DeFeo said these photographs "represented a kind of communion and rapport that she and Berman felt for each other."[52] Robert Berg has discussed these images as a convergence of DeFeo's Christianity with Berman's interest in Jewish mysticism and the Kabbalah.

The mandala imagery suggests a further interest in Eastern spirituality. The pictures were produced in the context of a mailed dialogue between Berman and DeFeo and are part of a series of photographs in which DeFeo's image is superimposed on her work. They were exhibited only once at the time, in Berman's San Francisco apartment in 1959, and there are no remaining negatives.[53] They are further removed from depictions of DeFeo in glossy newsmagazines by a patina of craquelure that Berman used on many of his photographs from this period. The technique has the effect of making a single, cohesive figure of the artist and her work. The value of *The Rose,* in this dialogue, depended upon its communal significance, which derived not from an artist in isolation but from one in concert with her friends and colleagues.

Bruce Conner commemorated his own friendship with DeFeo in a seven-minute-long film THE WHITE ROSE (1968), an account of the removal of *The Rose* from DeFeo's apartment. In the film, Conner associates the painting with DeFeo and her home by contrasting shots of the painting in situ with shots of the movers attempting to displace it. These are intercut with shots of DeFeo caressing the dislocated painting and climbing atop it. Though Conner called the movers "angelic hosts," as if they were the bearers of a relic with the power to enlighten the world, a sense of loss provides the film's narrative thread.[54] Like Fred Martin's catalogue essay, Conner's roughly contemporary film eulogizes DeFeo's circle, the same community of artists and poets that had accepted Conner and his wife into their midst when they first arrived in San Francisco more than ten years earlier, in 1957. Conner became active in this community almost immediately, participating in a group show at the 6 Gallery within two months and beginning a film society with filmmaker Larry Jordan, but he also arrived eager to find an audience for his work beyond this group of friends.[55]

Perhaps recognizing the ways in which an artist could be pigeonholed as Beat, Conner developed an artistic practice that exploited the media's obsessive interest in beatniks, thus allowing his socially critical art to reach a broad public. Consequently, some critics saw his spectacular sculptures composed of discarded consumer objects as being the work of a beatnik, and on occasion Conner played the part, as when he posed wearing his RAT BACK PACK for a photograph published in the *San Francisco Chronicle.*[56]

Between 1957 and 1962, the "beatest" artworks by Conner, which drew the most virulent attacks from the local newspapers and the art press, were those that reiterated the heterosexual gender roles affirmed by popular discussions of masculinity—and of the Beats—but in a way that raised questions

about social conformity. Some of the materials deemed most provocative in
Conner's art—pinups of naked women, prophylactics, lacy undergarments,
nylon stockings—referred to the intimate realm of the middle-class American
home and evoked those things that men hid from their wives, that parents hid
from their children, and that women supposedly endured for men, hinting at
how normative sexuality in America was maintained by a regime of socially
established prescriptions and prohibitions. Conner also decorated some of
his most controversial constructions, such as PORTRAIT OF ALLEN GINSBERG,
with pendulous sacks of torn paper, lace, and costume jewelry that resembled
human sexual and internal organs—breasts, testicles, intestines. When these
materials and the consumer objects that defined heterosexual roles in Ameri-
can culture were treated violently—as, for example, when the work was
wrapped in stretched and torn nylons and secured by rusty nails—or pre-
sented in a context suggesting religious ritual—as when exhibited with lit
candles on top—the resulting combinations suggested a kind of morality play.
They enacted the violence with which conformity was enforced and exposed
the seediness of society's compulsory behaviors, including heterosexuality, to

Bruce Conner with *RAT
BACK PACK* (no longer
extant) at 1205 Oak
Street Studio, 1959
Courtesy of the artist

ridicule. Through these complex juxtapositions of form and content, Conner created situations in which viewers were seduced and repulsed by their own illicit desires, and perhaps those of the artist as well.

In 1958 Conner's first solo exhibition, at San Francisco's Designer's Gallery, provoked a confrontation with the local police, and his response to the controversy reveals his intention to expose viewers' values to questioning. *VENUS*, a painting of a female nude exhibited in the gallery's front window, caught the attention of a passing policeman who ordered that the work be removed. The San Franciso Police Department ultimately dropped the matter, but shortly after this incident Conner wrote his New York dealer that he was sending some new collages including one entitled *TITLE REMOVED BY ORDER OF SFPD* "or you can say NYPD, or you can say NO TITLE." Conner also shipped *SECRET TITLE, TITLE LOST IN TRANSIT,* and *VENUS,* which he noted was "the one the dirty mind cop talked to the news" about.[57] Conner's characterization of the policeman suggests that he had learned to rely on viewers to find in his

Bruce Conner,
PORTRAIT OF ALLEN GINSBERG, 1960
Collection of the Whitney Museum of American Art, Purchase, with funds from the Contemporary Painting and Sculpture Committee, 96.48, photograph © 2000 Whitney Museum of American Art

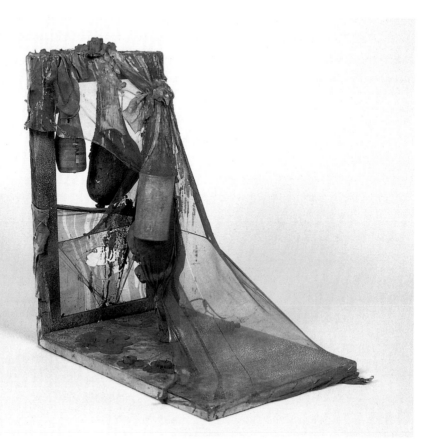

artworks what they want to find, and not necessarily what he had intended—
it is the policeman's mind and not the painting that is "dirty." Furthermore, by
suggesting in some collages' titles that the police oversaw his work, Conner
declares his own innocence while playing into viewers' prurient expectations.

Rather than withdrawing from the hostility directed toward Beats, as
some of his friends had done, Conner confronted it through public exhibi-
tions of deliberately "shocking" work. At the same time, he acknowledged the
security he had found in the community by making and circulating among his
friends a series of collages that paid tribute to some of them. Poet Michael
McClure has recalled, "in my flat there was an ongoing show of assemblage art
by Bruce Conner, George Herms, and Wallace Berman."[58] Conner also asserted
the group's solidarity, albeit somewhat tongue in cheek, by founding the Rat
Bastard Protective Association (RBP). The mock secrecy and exclusiveness of
the RBP—the acronym referred to the nineteenth-century artists' society, the
Pre-Raphaelite Brotherhood (PRB)—parodied what Conner has described as
the "in-crowd art-world sort of thing, where things did not depend on what it
was that you actually created, but on what your pedigree might be or who had
your work."[59] If acceptance by the art world depended upon one's relationship
to the "in-crowd," membership in the RBP was reserved for Conner's friends,
including Berman, DeFeo, Hedrick, Martin, McClure, Joan Brown, Manuel
Neri, Dave Haselwood, and Robert LaVigne. To emphasize how ostracized the
artist-members of the RBP felt from society generally, Conner says he also
derived the group's name from that of a local cooperative garbage collection
company, the Scavenger's Protective Association, Inc.[60] Conner told RBP mem-
bers that "they could use the approved stamp on their works. Or they could
just initial the work with the letters R.B.P." Presumably only members would
have understood the seal's significance.[61] In lieu of institutional acceptance,
members' artworks automatically received their friends' approval if they bore
the RBP stamp. Although Conner says that "it was not taken seriously by any
of us" and for most members the RBP never amounted to more than informal
monthly parties at members' homes, the RBP served as an early manifestation
of self-determination.[62]

The RBP also represented a critique of materialist society and the het-
erosexual norms it enforced. As if outfitting an army of Ratbastards, between
1958 and 1962 Conner made and exhibited a series of constructions: *RAT UNI-
FORM, RAT WAR UNIFORM, WALKIE TALKIE, RAT SECRET WEAPON, RAT BACK
PACK, RAT MEDICAL CORPS, RAT USO,* and *RAT HAND GRENADE.*[63] The implicit
Ratbastard threat turned sexual in *CHINGADERA/RATBASTARD,* a work that

Conner made while living in Mexico in 1962. The title, which equates the group's moniker with a Mexican obscenity that literally means the act of "fucking someone over," suggests that violent rape and betrayal are inevitable conditions of existence.[64] The title of an earlier collage MA JOLIE/RATBASTARD pairs *Ratbastard* with a French term of endearment, exposing how romantic platitudes conceal the spiritual emptiness of the mass media's promises of love, and how violence can result from their unnatural pursuit. By borrowing the title from a well-known series of Picasso's paintings, each of which incorporates the words *ma jolie,* the work also suggests something of the way art can elide difficult issues of sexuality—here perhaps the sexual peccadillos of the famously manly, and heterosexual, Picasso.

Conner's early films and his collages often draw parallels between such manly aggressiveness and media spectacle, consumerism, and sexuality. For example, on the reverse of a two-sided collage (UNTITLED, 1954–61), Conner juxtaposed his draft notice with brutally graphic newsmagazine photographs, images of naked women from men's magazines, and consumer organizations' seals of approval from women's magazines. It is notable that this collage made connections that were literally repressed in the art museum. The first time Conner exhibited this work, it was hung flat against the wall of the San Francisco Museum of Art so that only the side with a rather formal collage of wood, cardboard, and tin was visible.[65] Conner's Ratbastard seal of approval, although not present on this particular collage, offers a humorous yet ominous alternative to the consumerist ones here, satirically challenging viewers to choose between value systems and conventions.

Conner treated the sensationalist objects in his collages and sculptures in such an obviously violent and sexualized way that he must have realized his work would provoke controversy. In response to a letter from his New York dealer, who expressed enthusiasm for one of Conner's assemblages by calling it "spectacular," Conner wrote that he considered spectacular those works of his that "some peoples would think it in 'bad taste' but is like the 'obscene' BLACK DAHLIA, SPIDER LADY, HOMAGE TO JAY DEFEO, like I done before with prophylactics, neked lady pictures, nylon stockings, panties etc."[66] Conner's work, like that of other artists who made what Museum of Modern Art curator William Seitz would label "assemblage" in 1961, was identified as Beat for its obvious sexual content and for its incorporation of consumer culture's castoffs. He deliberately put on display what most museum-goers considered to be in bad taste. A photo-essay at the back of Lawrence Lipton's *The Holy Barbarians* (1959), a sensationalist account of the Los Angeles Beat community

that the author had brought together, reported that for the Beats, "anything, including nuts and bolts, is material for 'junk sculpture.'"[67] And Seitz specifically associated assemblage with an international "generation" of artists, including Conner, who "cultivate attitudes that could be labeled 'angry,' 'beat,' or 'sick.'"[68]

Reactions to Conner's artwork could be so vehement that the serious social issues his work might have raised sometimes went unmentioned, as in December 1959 and January 1960, when the local press and visitors to a San Francisco Art Association exhibition demanded that Conner's CHILD be removed from view. CHILD consists of a life-size figure of an infant, which is sculpted in reddish brown wax and bound to a high chair by stretched and torn nylon stockings. Its limbs are cut short, its head is thrown back in a scream, and its oversize penis lies limply on the seat. After two weeks of news coverage, Conner explained in an interview with *San Francisco Examiner* art critic Alexander Fried that CHILD was a response to the impending execution of convicted rapist Caryl Chessman, whose case had provoked a worldwide protest against the death penalty. Fried had been the first to criticize the sculpture in print, advising the visitor to "turn his back on the grisly Conner object." *Chronicle* columnist Herb Caen had complained that "despite protests and horrified outcries, the most ghastly entry in the de Young Museum's current show . . . will not be removed." The *News-Call Bulletin* had run an article titled "The Unliked 'Child': Art, or Grave-Robber's Nightmare?" and the *Chronicle* ran another facetiously titled "It's Not Murder—It's Art." By the time Conner was interviewed by the *Examiner,* CHILD had been thoroughly eviscerated in the local press, yet the possible social and artistic implications of this highly original work had not once been debated. Instead, the press reported on the controversy, which it had contributed to from the beginning, and took for granted that since the work had disturbed viewers, it should therefore be removed from the exhibition. Fried seemed vindicated when he reported, "Incidentally, it doesn't look any prettier to Conner than to any one else. 'When I have it at home,' [Conner] admitted, 'I myself can't stand to have it around. I have to put it in the closet.'" Conner's statement not only suggests that this work was made for public exhibition and not for his home, but also decries what he identifies as society's imposition on the individual.[69] Some art critics expressed the reductive attitude that the sexual violence in Conner's work could only be attributed to the artist's deviant personality. For example, a few months after the CHILD protests, *New York Times* art critic John Canaday wrote of Conner's SPIDER LADY (1959), a collage that includes garter belts and

nylons stretched over magazine photographs of naked women, "Mr. Conner ... lives in halcyon San Francisco with his wife, happily I am certain. But I cannot help wondering whether Mrs. Conner does not experience moments of unease when confronted by her husband's 'Spider Lady.'"[70]

Even in a later article sympathetic to Conner's project, art critic Philip Leider gives the example of two viewers, himself and an unidentified woman, attributing the misogyny they see in Conner's work to the artist. Referring to Conner's BLACK DAHLIA (1960), an assemblage that treats the rape and murder of a would-be Hollywood starlet turned prostitute, Leider had wondered whether Conner ever imagined reenacting the Black Dahlia's murder on his wife:

"I would hate," said a woman at one of his openings, "to be his wife." One can appreciate her uneasiness: could he not transform her most enticing postures into a "Black Dahlia," with its nail pounded maniacally into the heart of the matter? What must he see as she draws on those nylons, those silken underthings, those bangles and gee-gaws which he discards into his works like a skid-row bargain store? Looking at his work, one conceives a mentality which must obsessively re-cast all it observes into the imagery of the most unutterable horrors of our times.[71]

Leider presents Conner as a symptom of a troubled society, "which does not have the moral authority to question [Conner's] bad taste." His backhanded compliment implicates Conner in the crimes enacted in the assemblage. Given the commonly held belief that an artwork is the expression of its maker's psyche, it is not surprising that Conner's work was interpreted this way. What Leider sees in BLACK DAHLIA, however, is a projection of the violence latent in Cold War America. Partly in response to the hostility Conner felt from his critics, and partly because galleries and museums wanted to exhibit only his assemblages to the exclusion of the drawings and films he had begun making, Conner stopped creating assemblages in 1964 and withdrew all of his artwork from exhibition in 1967.[72]

I HAVE TRIED TO SHOW THE VARIED WAYS in which three San Francisco artists responded to the Beat label in their work. Efforts to define a Beat art movement have neglected the specific circumstances these artists faced in San Francisco during the late 1950s and early 1960s. Derogatory media images of beatniks engaged in drug use, illicit sex, and the self-indulgent production of art and poetry, along with a strong police backlash, intimidated some artists into an apparently reclusive lifestyle, while provoking others to confront

beatnik stereotypes with their work. Each of these artists pursued a practice that involved expectations of gender and sexuality and challenged conformity. If, indeed, over the years some of the issues raised by the work of Jess, DeFeo, and Conner have been obscured, then it is important to consider how and why that may have happened. By articulating some of the intersections between norms of gender and sexuality in the media's image of the Beats and the ways artists engaged with or avoided these, I hope to have begun that reconsideration.

John P. Bowles is a Ph.D. candidate in art history at the University of California, Los Angeles, where he is writing his dissertation, "Bodies of Work: Autobiography and Identity in the Performances of Adrian Piper." His publications include "The Rembrandt Research Project: Corrupting or Creating a Corpus?" published by the Instituto de Investigaciones Estéticas of the National Autonomous University of Mexico.

1 Miriam Dungan Cross, "Shocking 'Beat' Art Displayed," *Oakland Tribune,* Nov. 29, 1959. *The Individual and His World,* a traveling exhibition, was curated by Fred Martin for the San Francisco Art Association's Art Bank and was first shown at the San Francisco Art Association Gallery at the California School of Fine Arts (now the San Francisco Art Institute).

2 According to Conner, Dungan Cross was mistaken— the photograph depicted Conner in his living room, rather than in the studio he describes as having been "chaotic with piled canvasses, etc." Conner, letter to author, Oct. 13, 1999.

3 This situation can be specifically attributed to a series of articles published by John Coplans between 1962 and 1964 in *Artforum,* as well as to the advocacy of Philip Leider. On the Funk art exhibition, curated by Peter Selz at the University Art Museum at Berkeley in 1967, see the author's master's thesis, "Bruce Conner: The Author Talks Back" (University of California,

Los Angeles, 1994). The author wishes to acknowledge conversations with Damon Willick about this history.

4 Kenneth Tynan, "San Francisco: The Rebels," *Holiday,* Apr. 1961, 93.

5 Richard Cándida Smith, *Utopia and Dissent: Art, Poetry, and Politics in California* (Berkeley and Los Angeles: University of California Press, 1995), 154.

6 Barbara Ehrenreich, *The Hearts of Men: American Dreams and the Flight from Commitment* (Garden City, N.Y.: Doubleday, 1983), 63–67.

7 David Sterritt, *Mad to Be Saved: The Beats, the '50s, and Film* (Carbondale: Southern Illinois University Press, 1998).

8 "The Sound of Beat" and "Beat Playmate," *Playboy,* July 1959, 44–45, 47–51.

9 Helen McNeil, "The Archaeology of Gender in the Beat Movement," in A. Robert Lee, ed., *The Beat Generation Writers* (London: Pluto Press, 1996), 189.

10 Michael Schumacher, *Dharma Lion: A Critical Biography of Allen Ginsberg* (New York: St. Martin's Press,

1992), 293.

11 See Cándida Smith on the anomalous representation of artist Wallace Berman as a family man, in *Utopia and Dissent,* 212–69.

12 Alfred G. Aronowitz, "The Poet and the Prophet," part 4 of the series The Beat Generation, *New York Post,* Mar. 13, 1959. During Lawrence Ferlinghetti's 1957 trial on obscenity charges for selling Ginsberg's *Howl and Other Poems,* a brash declaration of the poet's homosexuality, references to homosexuality had been defended as necessary only for the portrayal of a decadent lifestyle—a dismissal not sanctioned by Ginsberg, who was traveling at the time.

13 Alfred G. Aronowitz, "San Francisco Scene," part 6 of the series The Beat Generation, *New York Post,* Mar. 15, 1959.

14 Sandra Leonard Starr, "Assemblage Art in California: A Collective Memoir, 1940– 1969," in *Lost and Found in California: Four Decades of Assemblage Art* (Santa Monica: James Corcoran Gallery, Shoshona Wayne Gallery, and

Pence Gallery, 1988), 99. See also Schumacher, *Dharma Lion,* 183, 285, 303.

15 Michael Rumaker, *Robert Duncan in San Francisco* (San Francisco: Grey Fox Press, 1996), 51.

16 Maurice Berger, "Libraries Full of Tears: The Beats and the Law," in Lisa Phillips, ed., *Beat Culture and the New America: 1950–1965,* exh. cat. (New York: Whitney Museum of American Art in association with Flammarion, Paris, 1995), 128.

17 Schumacher, *Dharma Lion,* 286.

18 For an account of Berman's arrest and conviction, as well as the most thorough description of the work included in the Ferus exhibition, see Rebecca Solnit, *Secret Exhibition: Six California Artists of the Cold War Era* (San Francisco: City Lights Books, 1990), 19–23.

19 *Semina* 2 (1957), n.p. Inscribed to Kenneth Rexroth by Berman. Collection 1000, Department of Special Collections, Young Research Library, University of California, Los Angeles.

20 Alastair Johnston, *A Bibliography of the White Rabbit Press by the Compiler of the Auerhahn Press Bibliography* (Berkeley: Poltroon Press, 1985), 29.

21 Robert Duncan, "Wallace Berman: The Fashioning Spirit," in *Wallace Berman Retrospective,* exh. cat. (Los Angeles: Fellows of Contemporary Art, 1978), 19–20.

22 Jonathan Weinberg, *Speaking for Vice: Homosexuality in the Art of Charles Demuth, Marsden Hartley, and the First American Avant-Garde,* Yale Publications in the History of Art, ed. Walter Cahn (New Haven: Yale University Press, 1993), 54.

23 Rumaker, *Robert Duncan in San Francisco,* 17.

24 Robin Blaser, "For the 'Elf'

of It,'" in Christopher Wagstaff, ed., *Robert Duncan: Drawings and Decorated Books,* exh. cat. (Berkeley: Rose Books, 1992), 21–23.

25 Robert Duncan, *Translations by Jess* (New York: Odyssia Gallery and Black Sparrow Press, 1971), i; Robert Peters and Paul Trachtenberg, "A Conversation with Robert Duncan (1976)," part 1, *Chicago Review* 54 (fall 1997): 91, 99.

26 The idea of "symposium" is borrowed from Robert Bertholf's *A Symposium of the Imagination: Robert Duncan in Word and Image* (Buffalo: Poetry/Rare Books Collection, University of Buffalo, State University of New York, 1993).

27 Christopher Wagstaff, "An Interior Light," in Wagstaff, ed., *Robert Duncan: Drawings and Decorated Books,* 17.

28 Jess, "An Interview with Jess," interview by Michael Auping, in *Jess: A Grand Collage, 1951–1993,* exh. cat. (Buffalo: Albright-Knox Art Gallery, 1993), 26.

29 Mary Kelly, "Miming the Master: Boy-Things, Bad Girls, and Femmes Vitales," in *Imaging Desire* (Cambridge: MIT Press, 1996), 203–30. Jess quoted in "An Interview with Jess," 35.

30 Jess Collins, "A Tricky Cad," in John Russell and Suzi Gablik, *Pop Art Redefined* (New York: Frederick A. Praeger, 1969), 61.

31 Rumaker, *Robert Duncan in San Francisco,* 16.

32 Robert Duncan, "The Homosexual In Society," *Politics* 1 (Aug. 1944): 209–11 (a correction appeared in *Politics* 1 [Oct. 1944]: 286).

33 See Robert Duncan, "The Homosexual in Society (1944, 1959)," *Jimmy & Lucy's House of "K"* 3 (Jan. 1985): 58.

34 Kevin Ray, "Obvious Advertisement: Robert Duncan and the *Kenyon Review,*" *Fiction International* 22 (1992):

288–90. See also Ekbert Faas, *Young Robert Duncan: Portrait of the Poet as Homosexual in Society* (Santa Barbara: Black Sparrow Press, 1983): 145–60, and Robert Peters and Paul Trachtenberg, "A Conversation with Robert Duncan (1976)," part 2, *Chicago Review* 44 (1998): 97–101, 104–6.

35 Seymour Krim, editor of the anthology (*The Beats* [Greenwich, Conn.: Gold Medal Books, 1960]), ultimately rejected Duncan's essay. In it, Duncan criticized Ginsberg, Philip Lamantia, and Michael McClure for too readily embracing the Beat image of "pariah (as it is done in beat mythology)" by describing themselves as "junkies" and poets, "queer" and straight (see Duncan, "The Homosexual in Society [1944, 1959]": 51, 56).

36 Conner, telephone conversation with author, Oct. 15, 1999.

37 The publisher, Grove Press, instead used the drawing on the title page. See Robert J. Bertholf, *Robert Duncan: A Descriptive Bibliography* (Santa Rosa: Black Sparrow Press, 1986), 55.

38 Solnit, *Secret Exhibition,* 77.

39 Cándida Smith, *Utopia and Dissent,* 198.

40 John F. Kennedy, "Creative America: The Arts in America," *Look,* Dec. 18, 1962, 120; Kenneth Tynan, "San Francisco: The Rebels," *Holiday,* Apr. 1961, 93; "New Talent, U.S.A.," *Art in America,* spring 1961, 30; and *Creative America* (New York: National Cultural Center and Ridge Press, 1962), 116.

41 "New Talent, U.S.A.," 30.

42 Tynan, "San Francisco: The Rebels," 92–94. In the book *Creative America* DeFeo's photograph appears in a photo-essay opposite that of another legendary rebel of the American West: the cowboy on horseback. In the *Look* piece, DeFeo's photograph illustrates

an extract from President Kennedy's article for *Creative America*. Her image appears opposite that of a woman dancing frantically in a red sequined dress.

43 Ehrenreich, *The Hearts of Men*, 60–62.

44 Friends of DeFeo continue to express how impressed they were with her commitment to *The Rose*. The artist did, however, complete other works during this period—for example, *Incision* (1958–61). See Bill Berkson, "In the Heat of the Rose," *Art in America*, Mar. 1996, 70.

45 DeFeo to Martin, undated letters, Fred Martin Papers, Archives of American Art, Smithsonian Institution.

46 DeFeo, untitled statement about *The Rose*, Artist Files, Frances Mulhall Achilles Library, Whitney Museum of American Art, New York, undated.

47 Berkson, "In the Heat of the Rose," 71.

48 Martin quoted in Solnit, *Secret Exhibition*, 78.

49 Fred Martin, "For the Death Rose," in *J. DeFeo: The Rose*, exh. cat. (Pasadena: Pasadena Art Museum and San Francisco Museum of Art, 1969).

50 Robert Berg, "Jay DeFeo: The Transcendental Rose," *American Art* 12 (fall 1998): 68, 75.

51 Berman to DeFeo, undated letter, Jay DeFeo Papers, Archives of American Art, Smithsonian Institution.

52 Constance Lewallen, "Mountain Climbing," in *Jay DeFeo: Selected Works, 1952– 1989*, exh. cat. (Philadelphia: Goldie Paley Gallery, Moore College of Art and Design, 1996), 13.

53 Berg, "Jay DeFeo," 68–77.

54 Conner's earliest published description of THE WHITE ROSE dates the film to 1968 and reads in its entirety: "The painting by Jay DeFeo as it was removed from her studio to the Pasadena Art Museum by angelic hosts." "Canyon Cinema Cooperative Catalog Supplement," in *Canyon Cinemanews* 68, no. 5 (July 15–Aug. 15, 1968): n.p.

55 By earnestly taking his portfolio and framed paintings door-to-door in New York during the summer of 1955, Conner had already found an art gallery there, the Alan Gallery, which would represent him until 1967. Once settled in San Francisco, Conner continued to pursue opportunities for exhibition throughout the United States and abroad.

56 Alfred Frankenstein, "The Batman Makes Its Bow with Modern 'Junk,'" *San Francisco Chronicle*, Nov. 13, 1960. At other times, Conner attended openings dressed in a tuxedo or simply refused to pose for photographs for publication.

57 Conner to Charles Alan, Sept. 24 [1958], Alan Gallery Papers, New York. The work was eventually called TITLE REMOVED BY ORDER OF POLICE and was also exhibited as TITLE ORDERED REMOVED BY ORDER OF SAN FRANCISCO POLICE DEPARTMENT. Conner to Alan, undated letter, Alan Gallery Papers, New York.

58 Michael McClure, "Painting Beat by Numbers," in Holly George-Warren, ed., *The Rolling Stone Book of the Beats: The Beat Generation and American Culture* (New York: Hyperion, 1999), 35.

59 "Bruce Conner: The Assemblage Years," interview by Rebecca Solnit, *Expo-See* (Jan.–Feb. 1985).

60 See Peter Boswell, "Beat and Beyond: The Rise of Assemblage Sculpture in California," in *Forty Years of California Assemblage*, exh. cat. (Los Angeles: Wight Art Gallery, University of California, Los Angeles, 1989), 67. Contrary to what Cándida Smith has proposed (*Utopia and Dissent*, 168–69), the RBP was not specifically an alternative to the designation "Beat."

61 Conner, "Tape Recorded Interview with Bruce Conner," transcription of interview by Paul J. Karlstrom, Aug. 12, 1974, Archives of American Art, Smithsonian Institution, 36.

62 The author has found no evidence that any artist other than Conner marked his or her work in this way. Conner says, "I am the only one that ever used the Ratbastard stamp and produced works that referred to the concept." Conner, letter to author, Oct. 13, 1999.

63 The titles are found in Conner's correspondence with Charles Alan. Alan Gallery Papers, New York.

64 The author thanks Esther Gabara and Ellen Fernandez-Sacco for their assistance in translating this term and explaining its long historical and literary significance in Mexico.

65 This was noted by *San Francisco Chronicle* art critic Alfred Frankenstein in a review written the second time the work was exhibited, when both sides were visible. Frankenstein, "Music and Art," *San Francisco Chronicle*, June 15, 1958.

66 Conner to Alan, May 10, 1962, Alan Gallery Papers, New York.

67 Austin Anton, "Venice West Picture Essay," in Lawrence Lipton, *The Holy Barbarians* (New York: Julian Messner, 1959), 322.

68 Although Seitz does not name the artists he is discussing, Conner's sculpture LAST SUPPER (1961) is illustrated in the section of the catalogue in which he makes this statement. William C. Seitz, *The Art of Assemblage*, exh. cat. (New York: Museum of Modern Art, 1961), 87, 89.

69 Alexander Fried, "Paint Explodes in a Violent Exhibit," *San Francisco Examiner,* Dec. 27, 1959; Herb Caen, "Pocketful of Notes," *San Francisco Chronicle,* Jan. 13, 1960; Andrew Curtin, "The Unliked 'Child': Art, or Grave-Robber's Nightmare?" *San Francisco News-Call Bulletin,* Jan. 14, 1960; Elmont Waite, "'Horror' at the de Young: That's Not Murder—That's Art," *San Francisco Chronicle,* Jan. 14, 1960; Alexander Fried, "Strange Sculpture: Artist Defines 'Child' Meaning," *San Francisco Examiner,* Jan. 14, 1960.

70 John Canaday, "Art: A Wild, but Curious, End-of-Season Treat," review of *New Forms, New Media* at the Martha Jackson Gallery, *New York Times,* June 7, 1960.

71 Philip Leider, "Bruce Conner: A New Sensibility," *Artforum* 1 (Nov. 1962): 30.

72 For a discussion of Conner's withdrawal from exhibiting his art publicly, and his continuing engagement with experimental film, light shows, and illustration in the period after 1967, see the author's master's thesis, "Bruce Conner: The Author Talks Back."

Acknowledgments

I wish to thank Sheri Bernstein, Ellen Fernandez-Sacco, Esther Gabara, Patty Mannix, and Cécile Whiting for their helpful comments on this paper's various drafts. I am indebted to Bruce Conner for his openness, astute questions, and rigorous attention to detail, and to Nola Butler for lengthy discussions about each draft. I owe a special debt to Emily Meyer for her support and thoughtful suggestions throughout my pursuit of this project. I must also acknowledge the assistance that Donald Preziosi and Albert Boime lent this project in its earlier stages.

I have discussed the Beat image of California artists with Damon Willick, who is preparing a dissertation at UCLA on Edward Kienholz's relationship to the history of the Beat image. I also thank Claire Daigle, Matthew Bakkom, Andrea Frank, Rene Gabri, Emily Jacir, and Craig Smith for their comments. Over the years, the assistance of Jeff Rankin and Octavio Olivera at the UCLA Department of Special Collections, and the staff of the reference area of the Getty Research Institute Research Library have been of invaluable help.

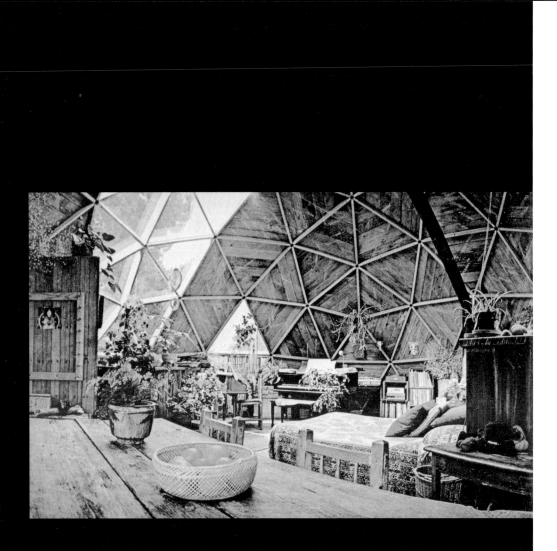

Interior of Lloyd Kahn's
Sun Dome, 1972
© 1972 Time, Inc.
Reprinted by permis-
sion; photograph
courtesy of Lloyd Kahn

Margaret Crawford

ALTERNATIVE SHELTER:
COUNTERCULTURE ARCHITECTURE IN NORTHERN CALIFORNIA

Even before 1967, when the heavily advertised Summer of Love signaled the commercialization of the Haight Ashbury counterculture, hippies began to leave San Francisco. Searching for cheap land in remote locales, they sought more fertile ground to create radical alternatives to the middle-class American way of life. By the mid 1970s, the rural fringes of Northern California were dotted with communes and experimental households of various types. Since new ways of living demanded new forms of housing, as different as possible from the conformity of the suburban tract or the isolation of the urban apartment, an array of new building subcultures emerged. The *Whole Earth Catalog* was the first of a series of publications to function as a clearinghouse connecting an ever-wider network of self-builders. Between 1965 and 1975, these texts propagated a do-it-yourself ethic intended to undermine the style, organization, and economics of conventional American housing. In retrospect, it is evident that such experiments never constituted real alternatives, and, in fact, barely challenged mainstream housing. Nevertheless, they must be considered significant counterpractices, forms of building whose symbolic importance far outweighed their actual numbers or practical impact. Although countercultural architecture has largely disappeared, its values remain surprisingly strong in California's building culture and still shape many Californians' aspirations for better living.

The sixties generation was not the first in California to try to reinvent its relationship to the world. For more than a century there had existed a California of the mind,[1] a vision of the state as a site of liberation and opportunity, a place where Americans could search out new values and ways of living. This dream became a self-fulfilling prophecy, and every generation produced a group of dissatisfied people who "dropped out" to rethink their own lives with the hope that, somehow, their personal process of discovery

would affect the larger society. Historically these urges for self- and social transformation have taken two contradictory directions. One posited revolutionary and utopian changes based on technology and visions of the future. Its advocates saw California, at the far edge of the Western world, as the ultimate frontier, a place unbound by tradition and convention, where they were free to imagine unprecedented prospects.[2] The other, more reformist approach interpreted the state's apparent absence of history as a way to reconnect with nature. These seekers looked backward, searching for simpler and more authentic lives. Counterculture builders reflected this dichotomy, proposing two diametrically opposed forms of dwelling: the geodesic dome and the handmade house.

THE RISE AND FALL OF THE DOME

The emergence of the geodesic dome as the first countercultural architectural form was the result of the encounter between the *Whole Earth Catalog* (WEC) and the maverick inventor Buckminster (Bucky) Fuller. Their interaction proved to be, in one of Fuller's favorite words, "synergistic"—a product greater than the sum of its parts. A renegade engineer, Fuller had been developing a radical critique of architecture, technology, and society since the mid-1920s. By the 1960s his vision of transcendent science had made him an unlikely hero to young people searching for alternatives. According to its founder Stewart Brand, the *Whole Earth Catalog* was a cross between the *Old Farmer's Almanac* and an L. L. Bean catalogue. Aimed at the counterculture and the back-to-the-land folks who were attempting to live "outside of the system," its slogan was "access to tools." Its mission statement expanded on this: "A realm of intimate, personal power is developing—the power of individuals to conduct their own education, find their own inspiration, shape their own environment, and share the adventure with whoever is interested. Tools that aid this process are sought and promoted by the *Whole Earth Catalog.*" In spite of its apparent openness to new ideas, however, the WEC reflected Brand's philosophy, which was modeled after Fuller's assertion that technology could solve any problem: "Science offers us total mastery over our environment and over our destiny." Another WEC slogan offered this confident advice: "We are as gods and might as well get good at it."[3]

Self-publishing was Brand's own version of empowerment. The WEC was one of many new independent publications springing up in the San Francisco Bay Area to promote alternative points of view. In the fall of 1968, Brand put the first WEC together in a garage in La Honda, with a leased IBM Selectric

Composer, backing from the Portola Institute (a nonprofit corporation in nearby Menlo Park that sponsored innovative educational projects), and $10,000 of his own money.[4] The offspring of a wealthy Illinois family, Brand had been educated at Exeter and Stanford, then served as a paratroop officer in the U.S. Army. In the early 1960s, his experiences with peyote and LSD made him a regular in the San Francisco hippie subculture. Brand displayed a talent for entrepreneurship and a gift for making money rare in the tripped-out psychedelic scene. In early 1966, with an artist friend, Brand decided to put together the Trips Festival. This was to be a bigger and better organized version of the celebrated Acid Tests, an impromptu series of psychedelic happenings. Featuring a barrage of multimedia effects, Day-Glo light shows, several bands, and voice-over commentary by the Merry Pranksters, the Trips Festival was advertised as "the LSD experience without drugs." The first hippie event created for a paying audience, it was a financial success, grossing more than $12,000 in two nights.[5] The *WEC* was even more successful. It was in the black in less than a year, and by its second year of publication its income was more than double its costs.[6]

The first sentence of the first issue of the *WEC* read: "The insights of Buckminster Fuller initiated this catalog." This was followed by a full page devoted to Fuller's books. Now at the height of his visionary powers, Fuller promised an attainable utopia built on the pure logic of engineering principles. Promoting a comprehensive design strategy that could address problems ranging from housing to global forecasting, Fuller hoped to streamline society through the systematic management of the earth's resources. He envisioned a world in which efficient technology would eliminate national boundaries and make politics obsolete. His visionary pronouncements, framed in poetic and often cryptic slogans, were delivered with absolute certainty. By the late 1960s, convinced that humanity's future depended on implementing his ideas, he spent most of his time traveling, preaching to anyone who would listen.

Housing production played a central role in Fuller's vision of social transformation. In 1927 and 1944 he produced versions of the Dymaxion house, circular aluminum dwellings that bore no resemblance to any existing domicile. These lightweight structures exemplified Fuller's Dymaxion principle, "dynamism plus efficiency," and were designed to extract the best performance from available technology. Fuller believed that his portable dwellings would encourage new forms of independent, self-sufficient living. Despising both suburbs and cities, Fuller favored rapid decentralization in order to

Sun Dome

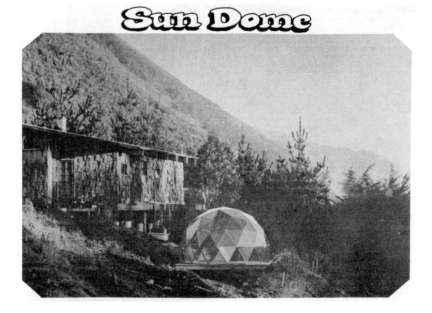

Sun Dome, 1973
Courtesy of Lloyd Kahn

disperse the population in an even pattern across the country. However, in spite of his arguments, Dymaxion houses were never put into production.

Fuller remained a marginal figure until another structural innovation made him famous: the geodesic dome. Based on an ingenious geometrical approach to engineering, the domes were lightweight structures composed of elements that were connected in an intersecting pattern of arcs, forming a network of triangles held largely in tension. The arcs were "geodesic"—the shortest distance between any two points on a sphere.[7] Fuller did not invent the geodesic dome. Initially interested in geodesics for their abstract and purely structural properties, he quickly realized their practical potential and claimed patent rights. Beginning with shelters for the U.S. Marine Corps, Fuller designed a series of ever larger and more complex domes. In 1958 his shallow dome built to enclose the Union Tank Car Company's service facilities in Baton Rouge, Louisiana, at more than ten stories tall, was the largest free-span structure in the world. Later, Fuller's nearly spherical design for the U.S. pavilion at Expo '67 in Montreal, incorporating high-tech materials such as aluminum, plastic, and pneumatic nylon, conveyed a compelling image of the future that captured the public's imagination.[8] Claiming that the dome was the most efficient structure yet invented, Fuller was convinced of its universal applicability. In 1968 he proposed erecting a gigantic dome, two miles in diameter, over Manhattan, to keep out weather, pollution, and nuclear fallout. At the other end of the scale, he advocated dome homes and even composed a

song, "Roam Home to a Dome," sung to the chorus of "Home on the Range." He built and lived in his own plywood Pease dome in Carbondale, Illinois.[9] Despite his efforts, however, for a time the dome remained an exotic and high-tech building type.

Domes finally achieved popular success in an unexpected and dramatic fashion. In May 1966, when *Popular Science* magazine offered the first mail-order plans for a do-it-yourself Sun Dome, there was a ready audience of counterculture enthusiasts.[10] Lloyd Kahn, a builder who had abandoned heavy post-and-beam houses after hearing Fuller lecture about architectural lightness at Big Sur Hot Springs, immediately began constructing the first of a series of domes. Kahn's interest in alternative structures led him to Pacific

High School, a Summerhill-like "free school" in the Santa Cruz Mountains. The school had already started moving in a communal direction but needed to house the students and teachers. One day Kahn started an impromptu dome class. Using models but no architectural drawings, Kahn and a group of students built seven domes in three months. These initial structures, all twenty-four-foot geodesics used as classrooms and living quarters, were simply constructed from wood struts and sheathed in pieces of triangular plywood. Building their own dormitory domes, the students introduced other innovations, such as inventive entrances and windows in a continuous arc that followed the path of the sun.

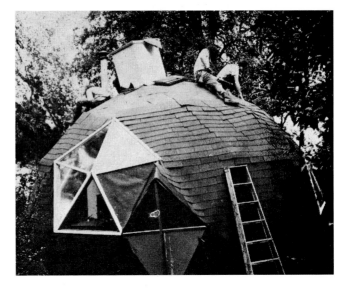

Dome-building, 1973
Courtesy of Lloyd Kahn

After this initial success, the school turned into a laboratory for geodesics. Kahn and the students experimented with different materials, constructing extremely lightweight domes from thin sheets of aluminum without any framing structures. They covered others in asphalt shingles, wood shakes, and translucent fiberglass panels. Kahn was particularly intrigued with new materials and incorporated space-age plastics whenever feasible, using flexible vinyl and Plexiglas for windows, neoprene tape to seal seams, and interiors sprayed with insulating urethane or Styrofoam. Going beyond geodesics, they explored

other geometries, such as icosahedra and octahedra. As more domebuilders joined the group, their repertoire expanded further. Aspiring architect Peter Calthorpe stretched geodesic mathematics into elliptical forms to create an asymmetrical egg dome covered with foam. He also supervised the building of an igloolike latrine dome constructed with hand-applied thin-shelled ferro-cement, a technique adapted from boatbuilding. Jay Baldwin, a designer who had built domes and worked with Fuller at Southern Illinois University, and Kathleen Whitacre built one of Pacific High's most radical domes. They filled in a frame constructed from metal-alloy tubes with triangular pneumatic pillows made of transparent vinyl and inflated with nitrogen to avoid condensation. This created a semipermeable geodesic membrane that let light in while keeping rain and cold out.[11] A visiting fifteen-year-old provided the mathematical calculations. After two years and several visits from Buckminster Fuller, the Pacific High group, with seventeen domes to their credit, were the most experienced dome builders in the country.

All over Northern California people were experimenting with homemade domes. The area's benign climate and seasonal rainfall were forgiving to beginning dome builders, many of whom were without previous construction experience. In Ananda, a spiritual community in the foothills of the Sierra Nevada, Swami Kriyananda, who had erected one of the first Sun Domes, embarked on an ambitious dome-building project. Two former Pacific High teachers helped him set up four large Pease domes. When their temple dome burned down, they replaced it with a more complex structure using foam over burlap. Smaller icosahedra domes were used for both temporary and permanent living spaces. Like many dome builders, Bob Easton (who had studied architecture at Berkeley), after constructing his first aluminum tube and plastic dome, couldn't stop; he produced domes for every imaginable purpose.[12]

The Southwest generated another critical mass of dome builders. In Phoenix, Bill Woods manufactured the Dyna Dome, a low-cost fiberglass and plywood dome kit. In New Mexico Steve Baer, a self-taught designer inspired by Fuller, created a domelike architecture derived from semiregular Archimedean solids, more variable and flexible than geodesics, that could be extended and combined with other forms. In 1971 in Coralles he built a cluster of ten different-sized exploded rhombic dodecahedra, which he called Zomes. Heated by ingenious solar devices, they combined energy conservation with practicality and livability. In 1965, at Drop City, a commune near Trinidad, Colorado, a group of former art students, returning from a Fuller lecture in Boulder, immediately started building domes from salvaged materials. Too

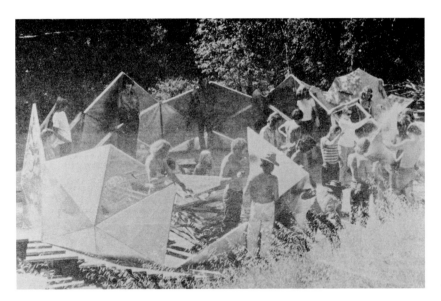

Pacific High dome,
1973
Courtesy of Lloyd Kahn

excited to fully work out the math, they actually built a dodecahedric dome
rather than the geodesic dome they had intended. Later, with the help of
Steve Baer, they developed a fully fledged salvage aesthetic, building domes
with the tops of junked cars for as little as $150 each. Their exuberance so
impressed Fuller that he invented a Dymaxion award to acknowledge their
ingenuity. Baer went on to become a design consultant to other communes in
New Mexico and Colorado.[13]

As the momentum of the dome movement grew, the close-knit group
of dome builders went public. In 1968, Jay Baldwin introduced Lloyd Kahn to
Stewart Brand, who immediately invited him to edit the "Shelter and Land
Use" section of the new WEC. As might be expected, Kahn focused on domes,
suggesting books on geodesics, copies of Fuller's dome patents, and the
addresses of Dyna Domes and Zomeworks. Kahn quickly recognized the need
for a detailed instructional manual based on practical experience. One week-
end in 1970, he borrowed the WEC's equipment and put together *Domebook 1,*
an account of his experiences at Pacific High School. *Domebook 2,* an expanded
version packed with even more information, came out the following year
and included considerable feedback from other dome builders. Steve Baer had
already published *Dome Cookbook* (1968) and *Zome Primer* (1970). These
cheap self-published books (*Dome Cookbook* cost a dollar, including postage)
attracted a surprisingly wide readership. Prominently featured in the WEC, they
were made available through a new network of alternative book distributors,
such as Book People in Berkeley, specializing in counterculture publications.[14]

The ubiquity of these books (which were purchased by many nonbuilders as well) established the dome as the primary domestic symbol of the hippie lifestyle.

Counterculture builders began to hold their own gatherings, more communal events than design conferences. In 1969, Steve Baer organized Alloy, an intensive two-day meeting held—in a dome of course—in the desert near La Luz, New Mexico, during the vernal equinox. One hundred fifty participants exchanged ideas on subjects ranging from materials and structures to evolution and consciousness, in a seminar made up of equal parts practical information and philosophical speculation.[15] Three years later a bicoastal event, Whiz Bang Quick City, East and West, held simultaneously in Pasadena and the Catskills, demonstrated how widespread the alternative building movement had become. Taking themselves less seriously than Alloy, participants created an "instant city" with pop-culture flair. The diversity of the structures they erected to house themselves for the event represented an encyclopedia of alternative building and included all kinds of domes, Zomes, inflatables, teepees, tensile structures, space frames, and inhabitable foam shapes.[16]

The dome's spherical form and circular plan explicitly broke with the design dictates of conventional culture, encouraging builders to see it as a blank slate, a neutral scaffolding on which to erect a new way of life. As architect William Chaitkin noted, this allowed almost unlimited free allusion.[17] Domes could be both new and old. They had "a structure that didn't remind us of anything," as one group of communards put it, providing "a new kind of space in which to create new selves."[18] At the same time, their circularity, frame-and-skin construction, and portability linked them with nomadic dwellings such as Native American teepees or Mongolian yurts. *Domebook 2* began with a quote from Black Elk, comparing the physical and spiritual circularity of the Native American universe with the prisonlike square boxes imposed by white culture. In *Understanding Media* Marshall McLuhan went further,[19] claiming that tribal, nomadic peoples live in round houses, adopting rectilinear forms only where they become sedentary and introduce specialized labor, an assertion also made by Fuller in *Ideas and Integrities.*[20] In general, rectilinear and cubic forms were seen as symbolic of everything bad in American culture, from Bank of America skyscrapers and dollar bills to the urban grid and the "little boxes made of ticky-tacky" that Pete Seeger sang about.

Dome builders interpreted the mathematical basis of dome structures as a kind of magic geometry, capable of reconciling the apparent polarities of science and spirituality. To Swami Kriyananda domes expressed a new

approach to the universe: in harmony with the scientific concept that space itself is curved, their roundness represented the modern desire for continuous mental expansion, humans reaching out to the universe instead of boxing themselves in protectively against its immensity. Thus, he concluded, domes were conducive to mental and spiritual harmony, since their more natural shape attuned them with nature rather than alienating them from it.[21] Similarly, dome builder Bill Boyd believed that the dome's lack of corners could open the mind to new dimensions, expanding man's perceptions and enhancing his creativity. To live in a dome was to be in closer harmony with natural structure.[22] Other dome dwellers reported positive psychological effects: "Living in a spherical single-unit home makes us more whole and centered."[23] To many the dome's geodesic structure was a striking metaphor for a new communal society, collectively constructed, self-supporting, and made up of many single facets.[24] Steve Baer saw the Zome as prefiguring a new society that would be "load sharing, and intelligently put together."[25]

Despite their rejection of "expert culture" and professional architects, the dome builders shared many concerns with mainstream architecture. As builders and designers, both confronted the demise of the modernist paradigm. By the 1960s, the modern movement in architecture was clearly depleted; its reductive forms had become arid, its machine-age ideology exhausted. In his seminal study *Theory and Design in the First Machine Age,* published in 1960, the British architectural critic Reyner Banham demolished modernism's claims to technological rationalism and functionality. He convincingly demonstrated that modern masters such as Mies van der Rohe, Walter Gropius, and Le Corbusier had addressed these issues in ways that were merely symbolic and largely artistic. Banham contrasted their timidity with Buckminster Fuller's daring. Correctly perceiving that Fuller's single-minded approach to architectural problem solving ran counter to the constraints of professionalism, Banham issued a warning: "The architect who proposes to run with technology knows now that he will be in fast company, and that, in order to keep up, he may have to emulate the Futurists and discard his whole cultural load including the professional garments by which he is known as an architect."[26] Few American architects were willing to do this, but counterculture builders, not bound by social or professional roles, took up Banham's challenge. Adopting Fuller's technological ethos, they represented the last gasp of modernism, functionalist aesthetics, and machine technology.

Domes also found a ready audience in universities and art schools. Architecture departments, in contrast to corporate architectural firms, were

less dependent on practical results and could afford to be open to these new ideas. Students, uninspired by a future in the corporate world, were among the most enthusiastic fans of counterculture architecture. Fuller had been a regular on the university lecture circuit for years, building domes with groups of architecture students. By the early 1970s Lloyd Kahn and Steve Baer had also become popular speakers. Teachers found dome-building an appealing alternative to curricula that had lost touch with hands-on construction. Similarly, the holistic requirements of dome-building were a useful corrective to increasing specialization. The experimental college at the University of California, Davis, built a collection of domes, and at UC Berkeley students calculated, modeled, and constructed a series of increasingly complex dome-based structures.[27] By the mid-1970s domes were a pedagogical staple in many architecture programs.

Domes were widely and successfully employed as quick, cheap, and easily erected structures for temporary public events. Beginning in the summer of 1968, when Kahn and Jay Baldwin built a seventy-foot dome frame for the Wild West Rock Festival in Golden Gate Park, painted blue to blend with the sky, domes housed any number of counterculture happenings. In 1971, Bob Easton and Chip Chappell built and transported an elliptical dome to Aspen for an international design conference. Ben Cartright built cheap bamboo domes for performers at a Joan Baez farmworkers benefit.[28] In Northern California, dome houses began to take on the qualities of their woodsy settings, as the crisp facets and futuristic aspect typical of early domes were replaced by a funkier look. Martin Bartlett's nongeodesic pod dome at Pacific High, constructed from sections of thin, flexible plywood covered with shaggy cedar shingles in irregular patterns, prefigured numerous later dwellings. Summoning up images of pinecones or feathered owls, it spoke of an organic aesthetic far removed from Fuller's high-tech engineering sensibility.

Domes became the height of counterculture fashion. Those unwilling to commit to the rigors of full-time dome life built specialized, single-space structures. Grace Slick and Paul Kantner of the Bay Area psychedelic band Jefferson Airplane commissioned the Jefferson Stardome from dome builder Roy Buckman. A wooden base crowned with a crystalline structure of transparent glass facets, it was more an art object than a living environment.[29] Other builders expanded their domes into complex multiroomed dwellings. After leaving Pacific High, Kahn built a single-family dome home on a ridge overlooking the Pacific in western Marin County. A beautifully crafted structure with an exposed wooden framework and a rough-sawn Douglas fir

interior, covered with redwood shakes that Kahn split by hand from driftwood logs, it represents the apotheosis of the dome house. Designed for family life, it was far more domestic than Kahn's experimental Pacific High domes and incorporated a kitchen, a sleeping loft, and a skylight aimed at a pine tree outside.[30] Prominently featured in *Life* magazine, it was a demonstration of how rapidly domes seemed to be entering mainstream culture.

Some of these changes represented attempts to address practical concerns. With more and more domes being lived in, builders were encountering a host of seemingly unresolvable problems. Kahn had always been honest about the difficulties of dome-building, but in 1973 he expressed his increasing disillusion with domes, plastics, and technological approaches to construction. In "Smart but Not Wise," an essay based on his own experience and feedback from other dome builders, he concluded that domes were difficult to build correctly, ill suited for dwelling, and even potentially dangerous. Most of the construction problems stemmed from their polyhedral and triangular components. Since building materials, products, and codes were based on rectangular measures, constructing a precision dome involved difficult and costly alterations, wasting both time and materials. Weatherproofing them was almost impossible. Since they were almost entirely roof and constructed of multiple panels, they invariably leaked unless they were completely covered with asphalt shingles.

Living in a dome was no easier: interior partitions created awkward wedge-shaped rooms; the dome's unified space amplified light, sounds, and smells, making privacy difficult. The integral structure of geodesic domes made them difficult to expand or add onto. Out of sync with a largely orthogonal world, they had difficulty accommodating conventional appliances, furniture, rugs, and pictures. Finally, a lot of the promising new materials used in domes turned out to have practical and aesthetic disadvantages. Plastics were expensive and deteriorated rapidly. Vinyl molecules covered nearby surfaces with a sticky film. Urethane foams were dangerously flammable and on occasion poisonous, releasing cyanide gas when they burned. Plexiglas did not age well, scratching and discoloring easily. In addition to all of these problems, according to Kahn's calculations domes used as permanent structures turned out to be no cheaper than conventional construction.

Underlying these practical problems was Kahn's increasing discomfort with Fuller's all-encompassing technological worldview. The final straw was a conference he attended at the Massachusetts Institute of Technology in May 1972. After encountering the Architecture Machine, a computer programmed

to design and operate buildings that were flashy plastic pneumatic structures embodying total disdain for their users, Kahn publicly renounced his earlier interests in the future and modern technology. Rejecting his former fascination with domes, video and computer art, the space program, and electronic music, he now saw them as representing a kind of fetishism of newness for its own sake. Already disturbed by Fuller's egotism and insistence on dictating the way people should live, he began to suspect that Fuller, rather than exemplifying counterculture values, was actually more closely aligned with the technological optimism of mainstream 1960s culture, which exalted the conquest of space, the invention of the computer, and the spread of mass consumption. He dismantled and sold his dome, and although *Domebook 2* was still selling well, he discontinued publication.

HANDMADE HOUSES

By 1973, as the counterculture's love affair with domes began to fade, a far more widespread building practice became visible: the handmade house. Handmade houses, like domes, were the product of a do-it-yourself ethos, but in every other respect they represented a completely different sensibility. If dome-building was based on a single concept and required complicated mathematics and demanding construction techniques, handmade houses were highly personal, wildly inventive, and utilized any method that caught the owners' whim. In contrast to the space-age materials favored by dome builders, handmade houses were a celebration of a single organic material—wood— whose qualities were exploited in every conceivable way. Rather than collective enterprises, they were the product of the painstaking labor of single craftsmen using, as much as possible, artisanal and handcraft methods. In many respects this was an extension of the American do-it-yourself tradition.[31] Finally, unlike the dome's radically futuristic look, the handmade house projected an almost exaggerated image of traditional domesticity, visually connected to mythic archetypes of "home." They drew on sources ranging from frontier cabins and vernacular farm homesteads to fairy-tale cottages. Rejecting the revolutionary approach of the dome builders, handmade house builders were reformists, looking backward to preindustrial times, hoping to return to a more natural and more authentic life based on handwork.

Initially, part of the appeal of the handmade house was its frontier ethos. They were almost exclusively single-family houses located in isolated settings. The geography of the handmade house depended on several factors including the cost of land, the severity of building inspection, and, increasingly, loose

communities of like-minded people. The earliest of these houses were built relatively close to San Francisco. By 1973 there were significant pockets of self-building in western Marin County, around Inverness, on Bolinas Ridge, and in Canyon, a settlement hidden in the hills behind Berkeley. As real estate prices increased, new settlers moved north, although there was an outpost to the south in the Santa Cruz Mountains. Gradually the northern exodus extended into the forests of Mendocino and Humboldt counties, with offshoots that continued on to Oregon, Washington, and as far north as Hornby Island off the coast of British Columbia, which became a haven for self-building.[32]

In 1973 this regional subculture became nationally visible with the publication of two popular books: *Handmade Houses: A Guide to the Wood-butcher's Art* and *Shelter*. These took very different approaches. *Handmade Houses*, a slim book with carefully selected color photographs of thirty Northern California wooden houses and minimal text, was the outcome of Art Boericke's home-building experiences.[33] Boericke was an unusual figure on the San Francisco hippie scene. Educated at Stanford, Black Mountain College, and the Institute of Design in Chicago, he worked as a carpenter, contractor, and commercial fisherman in Marin County. Known as the "working hippie," he was part of the anarchist Digger community and would haul a truckload of produce into the Haight district every weekend to contribute to the free meals provided by the Diggers. After building his own house in the Fairfax Hills out of salvaged wood, he heard of other interesting self-built houses around Northern California through his networks in the building trades and began searching them out and photographing them.[34] The book presented a highly coherent aesthetic vision. With the exception of two adobe houses, Boericke's selections vividly demonstrated the book's subtitle. The houses celebrated the qualities of wood in interior and exterior construction, wooden furniture, and woodsy settings. Wood was employed in every conceivable form—shingles, logs, beams, massive timbers, reused lumber, and carving. Since Boericke had selected the houses for their innovative aesthetic and structural qualities, there was no common form or technique; rather, the essence of the handmade house was in its ad hoc experimentation, eccentricity, and expressiveness. There were A-frames, log cabins, hexagonal houses; even more normal rectilinear structures had eccentrically placed windows and rooflines. If the exteriors presented the "woodbutchery," the interiors revealed an even more compelling vision of the back-to-the-land lifestyle. In comparison to the diversity of the structures, the interiors were surprisingly similar in their cozy domesticity. Most of the surfaces were wood, and virtually all of

these dwellings incorporated stained-glass windows and contained a profusion of houseplants. Furniture, whether homemade or used, was antique-looking rather than modern. There were generally candles and kerosene lanterns. The craft aesthetic was in evidence in handwoven textiles and folk art, such as Mexican pottery, Indian bedspreads, Peruvian weavings, and Moroccan rugs. The kitchen, the antithesis of the hygienic modern American style, was dominated by wood-burning stoves and jars of beans, grains, and other organic foodstuffs. The book's symbolic frontispiece presented a naked, smiling small blonde girl standing at the end of a wooden suspension bridge, signifying freedom, domesticity, and a natural setting. However, few of the builders were actually hippies. Most were craftspeople who made a living from their work, including an architect and an engineer.

Shelter represented Lloyd Kahn's new belief in traditional forms of building knowledge. It created a dense encyclopedic historical and anthropological context for the hand-built house. It was packed with visual and textual information including letters, poems, construction details, interviews, and quotations.[35] Its underlying philosophy was an antimodern ethos derived from a variety of sources. This rationale reflected the ideas of the nineteenth-century British writers John Ruskin and William Morris. Horrified by the capitalist division of labor, which separated people into either "morbid thinkers or miserable workers," Ruskin and Morris advocated handwork as a way of reintegrating modern society, insisting on the moral answerability of each building and object. Their position that handcrafts, no matter how awkward, were always superior to machine-made products, no matter how sophisticated, became the conventional wisdom not only of architects and designers, but also of the larger Anglo-American culture. By the early twentieth century, they had influenced the American Craftsman movement, which called for new ways of life and building based on closeness to nature, sincerity, and truth in materials. Mission furniture and bungalow-style houses, even if they were manufactured in factories, became popular symbols of an anti-industrial lifestyle.[36]

Another variant of these ideas appeared in 1964 with Bernard Rudofsky's book and exhibition, *Architecture without Architects.*[37] This immensely popular book was a survey of vernacular architecture, landscape, and urban forms. Although its elegant black-and-white photographs presented these structures within the aesthetic norms of modernism, many readers interpreted the book's romantic depiction of the vernacular as a critique of modernist architecture and an act of resistance against technology. Rudofsky's captions suggested that these preindustrial and non-Western forms of building offered a

timeless, genuinely functional, and ecologically appropriate alternative to contemporary architecture. Subtitled *A Short Introduction to Non-Pedigreed Architecture,* the book also celebrated anonymous builders rather than architects and patrons. Boericke, Kahn, and Easton were deeply influenced by Rudofsky,[38] and *Shelter* covered every conceivable form of vernacular dwelling, including caves, yurts, log cabins, igloos, and gypsy carts, and dealt with materials from dirt, straw, and adobe to bamboo and a huge range of timber structures.

Shelter also embraced what has since come to be known as "outsider architecture." Frequently considered a variant of folk art, this consisted of unique hand-built structures, often constructed over decades by eccentric, even obsessed individuals out of strange and unusual materials. During the 1960s interest peaked in this type of building.[39] Examples such as Sabato (Simon) Rodia's Watts Towers in Los Angeles and Clarence Schmidt's house in Woodstock, New York, had become icons of self-expression and amateur creativity. *Shelter* included an interview with Dr. Tinkerpaw (aka Art Beal) who built, over a forty-five-year period, a nine-level house in West Cambria Pines, below Big Sur, out of abalone shells, rocks, and other salvaged materials. Hippie writer Richard Brautigan's poem "Let's Voyage into the New American House," reprinted in *Shelter,* evoked a similarly explosive combination of natural forces and fantastic construction:

There are doors that want to be free from their hinges to fly with
> *perfect clouds.*
There are windows that want to be released from their frames to run
> *with the deer.*
There are walls that want to prowl with the mountains through the early
> *morning dark.*
There are floors that want to digest their furniture into flowers
> *and trees.*
There are roofs that want to travel gracefully with the stars through
> *circles of darkness.*[40]

However, *Shelter*'s arguments for universal, almost biologically derived building instincts obscured more specific local lineages, derived from early-twentieth-century Bay Area Arts and Crafts architecture and the Funk aesthetic of the late fifties. By 1906 critic Herbert Croly had identified the unique characteristics of Northern California domestic architecture as "small, anti-urban, and woodsy—usually sheathed in redwood inside and out."[41] This aesthetic can be seen as early as 1894 in the interior of Charles Schweinfurth's deliberately

rustic and primitivist Church of the New Jerusalem in San Francisco, with its rough logs of native madrone used as columns and braces. The Berkeley architect Bernard Maybeck pushed this tendency in an even more romantic and eclectic direction. The son of a wood-carver, Maybeck had a craftsman's feel for his own buildings—he carved, painted, and tinkered with them.[42] Amazingly open and inventive, he happily mixed old and new materials, forms, and styles. The result, as David Gebhard has pointed out, went far beyond the Craftsman dedication to shingles and exposed beams, creating a kind of storybook illusion suggestive of the mythical qualities of the past.[43] Inspired by Maybeck's houses, his friend and contemporary, Berkeley writer Charles Keeler, wrote *The Simple Home,* articulating a Northern California lifestyle remarkably similar to those celebrated in *Shelter* and *Handmade Houses.* This described a way of naturally artful living, based on simplicity, communion with the California landscape, and homemaking as one of the sacred tasks of life.[44]

Funk art was another local form of eclectic assemblage. Although best known as the title of a 1967 exhibition at the University Art Museum at UC Berkeley, it also characterizes much of the work produced by Bay Area artists during the fifties and sixties.[45] As practiced by assemblage artist Bruce Conner, ceramist Robert Arneson, and sculptor Jeremy Anderson, Funk was San Francisco's artistic alternative to New York's intellectual Minimalism and Los Angeles's cultural consumerism. Characterized by free association and brash juxtaposition, it resembled the antiformalism of the San Francisco Beat poets. Its anti-intellectual and bohemian attitude moved easily into the hippie movement. The counterculture adopted the word "funk" as a positive attribute, describing anything eccentric, improvised, and soulful. *Native Funk and Flash* was one of the earliest compendiums of the San Francisco hippie style, featuring handcrafted clothing and accessories.[46]

The boundaries separating inspired amateurs from professional designers were never firm. *Handmade Houses* and *Shelter* had a major impact on architects, many of whom began designing more coherent renditions of the spontaneous structures pictured in Boericke's book. The sixties taste for organic form and natural materials overlapped with the school of architecture generated by the wilder pupils and devotees of Frank Lloyd Wright, such as Bruce Goff and Herb Green. Marin County architect Valentine Agnoli's sculptural and structurally daring houses, for example, appeared both in *Shelter* and in an exhibition of California architecture held at the San Francisco Museum of Art in 1976.[47] Surveying the state's architecture, curators David Gebhard and Susan

King designated "woodbutchery" as one of seven major contemporary currents. The look if not the craft of handmade houses was quickly and widely adapted across Northern California. Even architects such as Charles Moore, who remained committed to abstract geometry, shared many of the same interests. His famous Condominium #1 at Sea Ranch, built in 1965 on the Sonoma County coast, also explores issues of community, the natural landscape, and the California vernacular. The look trickled even further down into the redwood shingles and fern decor of innumerable organic restaurants.

Other architects took the concept of the handmade house beyond aesthetics to address more fundamental environmental issues. *Shelter* included a section on energy, food, water, and waste, taking up where the WEC had left off. Many countercultural builders had already moved in this direction. Solar energy had become Steve Baer's major interest, and Jay Baldwin and Kathleen Whitacre joined Integrated Life Support Systems Laboratories to explore wind and solar power.[48] Attempting to create a self-reliant and sustainable way of life, architect Sim Van der Ryn turned his own household into a far-ranging educational experiment. His self-published account of building his own house in western Marin County, *Farallones Scrapbook*,[49] attracted a wide audience. A professor at UC Berkeley, Van der Ryn organized studios in which students

Art Carpenter's
kitchen/library, 1999
Photograph
© Peter DaSilva

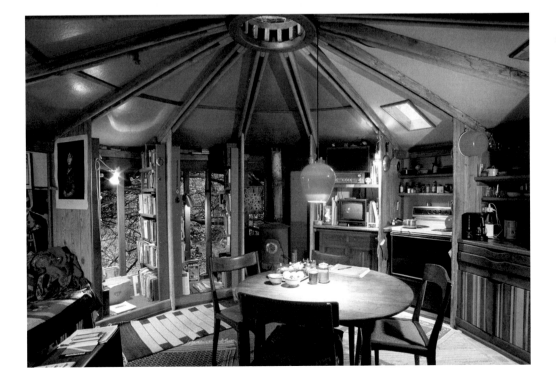

foraged for food and salvaged materials to build their own individual and communal dwellings.[50] His students self-published their own journal, *Outlaw Building News,* which led to a 1973 conference at the university attended by more than a thousand people, a demonstration of how widespread interest in alternative building had become. The energy crisis of 1973 gave these ideas even more immediacy. In 1974 Governor Jerry Brown appointed Van der Ryn California State Architect and director of the new Governor's Office of Appropriate Technology. By the end of the seventies, the handmade house movement had become a national phenomenon, although increasingly mediated by the demands of building codes, day jobs, and "real life."[51]

FROM COUNTERCULTURE TO OVER-THE-COUNTER CULTURE

As was inevitable, by the early 1980s the project of changing life had turned into a lifestyle, and like all lifestyles, it became outmoded. As the economy boomed, yuppies replaced hippies as a visible social type. By the end of the decade, the accoutrements of counterculture lifestyles had become laughable clichés. However, it took only another five years for them to become fashionably retro, with beads and bell bottoms now being worn by the sixties generation's teenage children. Along with LSD and the peace sign, domes reappeared on the horizon. In spite of Lloyd Kahn's 1989 *Refried Domes,* a scathing critique of dome-building, a new generation of back-to-the-landers began promoting them as an amazingly quick and cheap way to build houses. Unaware that they are repeating history, these dome builders now use the Internet rather than self-publishing to create their networks.[52]

Surprisingly, however, many aspects of counterculture building, if no longer in opposition, still exist as one of many subcultures that flourish in postmodern society. Environmental concerns, in particular, have led to a continued exploration of alternative building materials, such as straw bales, tires, or adobe, and new types of energy creation and conservation. Although these methods are not yet widely utilized, they have attracted a serious core of supporters. Issues of sustainability and "green architecture" have significantly challenged existing values. For many architects, self-building has become a reputable form of professional practice known as "design-build," a way of expanding the architect's hands-on involvement in the building process. For nonprofessionals, magazines like *Fine Homebuilding* have taken the concept of self-building to new levels of skill, technique, and expense. For innumerable Northern California households, the woodsy, crafted house still remains the domestic style of choice.

The original creators of the movement can still be found in Northern California, having found niches that allow them to continue pursuing their interests, albeit in somewhat altered forms. After publishing several magazines (*Co-Evolution Quarterly, Whole Earth Review*), a book about building, and *The Millennium* WEC, Stewart Brand now advocates electronic communications as the network of the future. Lloyd Kahn adopted publishing rather than building as a way of life. Using the low-cost methods he pioneered in the WEC, his company, Shelter Publications, publishes everything from stretching manuals to accounts of his trips to Baja California. Jay Baldwin, still an adherent of Bucky Fuller, teaches design at California College of Arts and Crafts. Bob Easton, an architect in Santa Barbara, coauthored an important book on Native American architecture. Peter Calthorpe, just twenty-one when he built domes at Pacific High School, is a founder and successful practitioner of the New Urbanism, a movement promoting large-scale regional planning and neotraditional neighborhoods. Sim Van der Ryn, now retired, is an important voice in the ecology movement. Only Art Boericke is still a hippie. Without a fixed address, he roams the West in search of interesting handmade houses.

In retrospect, the weaknesses of counterculture building, like the rest of the counterculture, have become increasingly visible. The sexual politics of the movement now look far more traditional than revolutionary. *Handmade Houses,* for example, is dedicated "to the builders and their old ladies." After the short-lived commune era ended, the movement reverted almost entirely to building single-family houses, occupied by their owners and set on large plots of land. In spite of their evident stylistic differences, these dwellings were not that distant from the suburban houses they repudiated. Although there were a few female housebuilders, overall the lifestyles projected by these dwellings conveyed an image of hyperdomesticity that maintained highly conventional gender structures and roles. The elitist character of the movement is equally apparent. As Easton has pointed out, most of the men involved in the alternative building culture are the product of highly privileged backgrounds.[53] Many of them attended Stanford University, the traditional breeding ground for California's upper classes. Their social and economic security gave them the freedom to experiment with nontraditional careers and new lifestyles without seriously jeopardizing their futures.

Set in a larger social context, the unique qualities of domes and handmade houses can now be identified as markers of "distinction." Sociologist Pierre Bourdieu has demonstrated how social groups use sophisticated and difficult modes of consumption to distinguish themselves from others with

similar class backgrounds.[54] In the mass-production and -consumption culture of the sixties, countercultural styles and products allowed hippies to separate themselves from the masses and to recognize each other. Rather than rejecting material goods altogether, they simply replaced conventional products with an alternative set of commodities. One counterculture crafts entrepreneur remembered the sixties as the last time a person could make a good living with his hands, adding, "Thank God for hippies. You could sell them anything."[55] In this sense the period marks the beginning of niche marketing, a form of product differentiation that has now replaced the mass market and that, according to Thomas Frank, thrives on images of social and political opposition.[56] Counterculture aesthetics can also be seen historically as performing the same social function as the artifacts produced by the Arts and Crafts movement. Their uncomfortable chairs and unreadable books led sociologist Thorstein Veblen to call them contradictory status symbols, whose apparent artlessness demanded the sophisticated appreciation of an educated elite.[57]

In spite of their interest in radical change, the *Whole Earth Catalog,* dome, and hand-built-house movements demonstrated very little allegiance with parallel movements that addressed the housing problems of the urban and rural poor.[58] Yet during these years major social and political coalitions were forming, supporting tenants' unions, community design centers, and other types of housing reform.[59] These struggles were particularly focused on black, Asian, Hispanic, and Native American groups, few of whom were visible (except as symbolic "others") in the primarily white counterculture. In this respect, counterculture building represents what historian Todd Gitlin has designated as the libertarian strain of the sixties: the cult of the self-sufficient individual, searching for maximum personal freedom. Gitlin sees this as the opposite of the more political strain, which emphasized solidarity with the poor and collective community action.[60] Yet, as Gitlin acknowledges, in practice these two strains often overlapped. In the end, like most other aspects of those years, the legacy of the counterculture builders is ambiguous and contradictory. Like previous generations of Californians who sought to change themselves and society at the same time, they were both self-indulgent and visionary. And, like them, they left a lasting mark on California's culture. Twenty-five years later, one thing about them remains absolutely clear: they are still worth remembering.

Margaret Crawford is currently professor of urban planning and design theory at the Graduate School of Design, Harvard University. She has written extensively about the history and theory of the American built environment. Her publications include *The Car and the City: The Automobile, the Built Environment, and Daily Urban Life* (1990), *Building the Workingman's Paradise: The History of the American Company Town* (1992), and *Everyday Urbanism* (1999).

1 Kevin Starr, *Americans and the California Dream* (New York: Oxford University Press, 1973), 46–47.

2 Ibid., 417.

3 "Whole Earth Review Manifesto," *Whole Earth Review* 74 (spring 1992): 4.

4 *The Last Whole Earth Catalog* (Menlo Park, Calif.: Portola Institute, 1971), 436.

5 Tom Wolfe, *The Electric Kool-Aid Acid Test* (New York: Bantam Books, 1966), 222–37; Warren Hinckle. "A Social History of the Hippies," in Jonathan Eisen and David Fine, eds., *Unknown California* (New York: Macmillan, 1985), 104–6.

6 Brand, to his credit, published a history of the publication, along with complete financial information, in *The Last Whole Earth Catalog,* 434–42.

7 See Edward Popko, *Geodesics* (Detroit: University of Detroit Press, 1968), for explanations of geodesic principles.

8 Shoji Sadao was Fuller's codesigner for the Montreal Expo dome. See Robert W. Marks, *The Dymaxion World of Buckminster Fuller* (New York: Anchor Books, 1973). For an updated view see the issue of *ANY* magazine on Fuller: *ANY* 17 (July 1997).

9 Fuller franchised the Pease company to produce prefabricated plywood kits for thirty-nine-foot-diameter domes.

10 It was advertised as a pool cover or greenhouse.

11 *Domebook 2* (Bolinas, Calif.: Shelter Publications, 1970), 20–30. Lloyd Kahn, interview by author, San Francisco, Apr. 7, 1999.

12 *Domebook 2,* 96. Bob Easton, telephone interview by author, Oct. 11, 1999.

13 For Drop City, see Bill Boyd, "Funk Architecture," in Paul Oliver, ed., *Shelter and Society* (New York: Praeger, 1969); Peter Rabbit, *Drop City* (New York: Olympia Press, 1971). For a good summary of Steve Baer's career, see William Chaitkin, "The Commune Builders," in *Architecture Today,* 224–33.

14 Sim Van der Ryn, e-mail to author, Oct. 18, 1999.

15 *The Last Whole Earth Catalog,* 112–17.

16 William Chaitkin, "Beyond the Fringe," in *Architecture Today,* 287–88.

17 William Chaitkin, "Great Circles," in *Architecture Today,* 234.

18 Red Rockers communards quoted in *Domebook 2,* 61.

19 Marshall McLuhan, *Understanding Media: The Extensions of Man* (Cambridge, Mass.: MIT Press, 1994), 59.

20 Buckminster Fuller, *Ideas and Integrities: A Spontaneous Autobiographical Disclosure* (New York: Collier Books, 1969).

21 *Domebook 2,* 97.

22 Paul Oliver, ed., *Shelter and Society.*

23 *Domebook 2,* 96–97.

24 Chaitkin, "Great Circles," 239.

25 Steve Baer, *Dome Cookbook* (Corrales, N.M.: Lama Foundation, 1968), 40.

26 Reyner Banham, *Theory and Design in the First Machine Age* (New York: Praeger, 1960), 329–30.

27 Peter Hjersman, *Dome Notes* (Berkeley: Erewhon Press, 1975), 178–81.

28 *Domebook 2,* 95.

29 Ibid., 45.

30 Lloyd Kahn, *Refried Domes* (Bolinas, Calif.: Shelter Publications, 1989), 14.

31 Several detailed house-building manuals, such as Ken Kern's *The Owner-Built Home* (Oakhurst, Calif.: Ken Kern, 1961) and Rex Roberts's *Your Engineered House* (Philadelphia: Lippincott, 1964) had become staples of the WEC "Shelter" section.

32 One of the few critical discussions of handmade houses can be found in *Architectural Design* 48 (July 1978). The issue, titled "Handbuilt Hornby," includes an interesting article by Tony Ward, "Hand-Made Houses: A Search for Identity," discussing the history of West Coast hand-building. Also see William Chaitkin, "Handmades," in *Architecture Today,* 246–60.

33 Boericke later published two additional volumes with photographer Barry Shapiro: *The Craftsman Builder* (New York: Delacorte Press, 1977) and *Handmade Homes* (New York: Delacorte Press, 1981).

34 Art Boericke, telephone interview by author, Oct. 16, 1999.

35 *Shelter* (Bolinas, Calif.: Shelter Publications, 1973).

36 See Wendy Kaplan, *"The Art That Is Life": The Arts and Crafts Movement in America, 1875–1920* (Boston: Bulfinch Press, 1987), and Eileen Boris,

Art and Labor: Ruskin, Morris, and the Craftsman Ideal in America (Philadelphia: Temple University Press, 1986).

37 Bernard Rudofsky, *Architecture without Architects* (New York: Museum of Modern Art, 1964).

38 Art Boericke, telephone interview by author, Oct. 16, 1999; e-mail from Lloyd Kahn, Oct. 13, 1999; Bob Easton, telephone interview by author, Oct. 11, 1999.

39 See, for example, Jan Wampler, *All Their Own: People and the Places They Build* (New York: Oxford University Press, 1977).

40 *Shelter*, 58–59.

41 Quoted in David Gebhard, "Introduction," Sally Woodbridge, ed., *Bay Area Houses* (New York: Oxford University Press, 1976), 3.

42 John Beach, "The Bay Area Tradition," in *Bay Area Houses*, 38.

43 David Gebhard, "Life in the Dollhouse," in *Bay Area Houses*, 102.

44 Charles Keeler, *The Simple Home* (San Francisco: Paul Elder and Co., 1904).

45 See Peter Selz, *Funk* (Berkeley: University Art Museum, 1967), and Peter Plagens, *Sunshine Muse: Art on the West Coast, 1945–70* (New York: Praeger, 1974), 74–94.

46 Alexandra Jacopetti, *Native Funk and Flash: An Emerging Folk Art* (San Francisco: Chronicle Books, 1970).

47 David Gebhard and Susan King, *A View of California Architecture: 1960–1976* (San Francisco: San Francisco Museum of Art, 1976), 6.

48 *Shelter*, 164.

49 Sim Van der Ryn, *Farallones Scrapbook* (Point Reyes, Calif: Sim Van der Ryn, 1970).

50 E-mail from Sim Van der Ryn, Oct. 26, 1999.

51 Van der Ryn tried to deal with these realities in the Integral Urban House, an existing house in Berkeley that was renovated to be more energy-efficient and self-reliant.

52 See, for example, *www.hoflin.com/Dome.html* (Oct. 16, 1999) or *Dome Magazine,* from Denver.

53 Bob Easton, telephone interview with author, Oct. 11, 1999.

54 Pierre Bourdieu, *Distinction: A Social Critique of the Judgement of Taste* (Cambridge: Harvard University Press, 1984).

55 Garry Knox Bennett, quoted in Patricia Leigh Brown, "Museum Gives Hippie Stuff the Acid Test," *New York Times,* Dec. 16, 1999, B1. This is a review of *Far Out: Bay Area Design, 1967–73,* an exhibition at the San Francisco Museum of Modern Art that contained handmade furniture, roach clips, rock posters, hand-embroidered blue jeans, and other examples of hippie paraphernalia.

56 Thomas Frank, *The Conquest of Cool: Business Culture, Counterculture, and the Rise of Hip Consumerism* (Chicago: University of Chicago Press, 1997).

57 Boris, *Art and Labor,* 140.

58 *Shelter II* included an article on housing rehabilitation in the South Bronx (Bolinas, Calif.: Shelter Publications, 1987), 182–87.

59 See *Source Catalog, Communities/Housing,* no. 2 (Chicago: Swallow Press, 1972).

60 Todd Gitlin, "Afterword," in *Reassessing the Sixties* (New York: Norton, 1997), 291–92.

Acknowledgments
There are very few secondary sources on the subject of counterculture building. The only thorough and critical review of these structures can be found in the section "Alternatives," written by William Chaitkin, that appears only in the first edition of *Architecture Today,* by Charles Jencks (London: Academy Editions, 1982). Chaitkin also covers other important topics, such as inflatables, houseboats, vans and campers, and conceptual structures by Ant Farm and others. In view of this lack of material, I depended greatly on the writers and builders who generously shared their information and memories with me. Many thanks to Lloyd Kahn, Bob Easton, Art Boericke, and Sim Van der Ryn.

LOOKING EAST ON 4TH AND C
CHULA VISTA, CALIF.

Howard N. Fox

DREAMWORKS:
A CONCEPT OF CONCEPT ART IN CALIFORNIA

The contributions of California artists to the development of Conceptual art are widely acknowledged and well documented. Such pioneers as Eleanor Antin, John Baldessari, Terry Fox, Helen Mayer Harrison and Newton Harrison, Douglas Huebler, Tom Marioni, Bruce Nauman, Allen Ruppersberg, and Alexis Smith (and many others who worked in California) figure prominently in any account of the flourishing of concept- and text-based art, a movement that ranged from Europe to South America to New York to Japan, beginning in the mid-1960s.

What has been less noted and little discussed are the distinctive characteristics of much California-based Conceptual art—specifically the inherent social, political, and psychological content of its often narrative constructs and the impulse toward idealism—that set it off from its East Coast and European counterparts, which tended to be more analytic and based on the investigation of language and informational systems.

It is curious that there has been so little differentiation with regard to concept-based art in California, for such is certainly not the case with painting and sculpture of the same period. In his perceptive, if somewhat boosterist, assessment of West Coast art of the 1960s, *Sunshine Muse*, critic and painter Peter Plagens explored a sensibility and an approach to the enterprise of making art that was rather at odds with prevailing East Coast presumptions and predilections:

If you believe in Modern Art History and its obligatory riders (that good art deals with dialectically derived "issues," that good art bends the short-run course of future Modern Art History), it follows that the best breeding ground for good art is where competing ideas, esthetics, and artists are thickest and where regional niceties are thinnest—New York . . . The "regions" (provinces, outposts, boondocks, heartlands, Middle America, etc.), on the other hand, are short on white-hot overpopulation, edifice complexes, and career fights-to-the-death. The art they

produce is either initially schizophrenic or rendered so when it hits the big time.
Should it be gauged against the "mainstream" (deliberately art-historical art
produced where it counts—New York) or should it be sized up from exactly the
opposite point of view (quaintness, funkiness, antihistoricality—in short for its
regional character)?[1]

Plagens posited his questions fairly and squarely to a factionalized
national forum in which not only the hegemony of New York was beginning
to erode but also, far more insidious, the very tenets and overarching prin-
ciples of modernism itself—its self-reflexiveness, its formalism, its aspired-
to immunity from all that is not art, its perceived logical progression—
were beginning to lose their authority in the imaginations of a new genera-
tion of artists nationally and internationally. West Coast artists, Plagens
argued throughout his tract, are somewhat removed from—and as well
are liberated from—the parochial (and generally academic) "discourse"
that churns the dialectical apparatus of the East Coast–oriented art world.
And in their liberation, West Coast artists had produced, by the 1960s, three
major aesthetic foci: the Zen-inflected naturalism of the Pacific Northwest;
San Francisco Bay Area abstraction and figuration (both heavily influenced
by New York Abstract Expressionism); and Finish Fetish sculpture with an
"L.A. Look."[2]

Plagens in fact credited the identification of that triad to the art critic
and curator Barbara Rose, who herself had further asserted that there is a per-
ceptible "L.A. sensibility," variously inspired, she claimed, by "the brilliantly
sunny, palm-studded, Day-Glo-spangled Los Angeles landscape," Disneyland,
and "the unfocused eroticism of the movieland Babylon."[3] Whether or not
Rose's analysis is valid can be debated, but the critical literature of the mid-
1960s and 1970s plainly reveals a growing consensus that there was something
distinctive about art in the West.

Indeed, by the 1990s, the perception had become so widely accepted that
Rosalind Krauss, writing in the inaugural issue of the Museum of Modern
Art's *Studies in Modern Art,* felt behooved to annex West Coast Minimalism,
and its peculiar spirit that she called "the California Sublime," into the anointed
canon of East Coast Minimalist art. This she did by tracing its pedigree to Ad
Reinhardt's search for "the perceptual nothing, the visual sublime." Specifically,
she pointed to Robert Irwin, whose art was shaped by "rides into the desert
in his shiny Fleetwood convertible, the sun glinting equally off the Cadillac's
chrome and the far shimmer of the sand," and to James Turrell, "the most
effective exponent of the California Sublime," whose awe-provoking light

installations "produce an intense illusion of density and substance accompanied by an acknowledgment of the 'nothing' that is insistently there."[4]

Krauss is quite persuasive in her argument and the sheer sinew of her prose. Her stated purpose is to broaden the erstwhile narrow interpretation of (New York) Minimalism. Yet there is something specious in her arguing the case in the first place. What is suspect about Krauss's strategy is not that she traces a connection—it is unlikely that either Irwin or Turrell would refute so clear and so profound a relationship—but rather that she explains their relevance to Minimalism in terms of a historical continuity within the established modernist core. One wonders if there was something that these artists were doing that had kept them rather segregated, in the contemporaneous critical purview, from the very tradition into which Krauss, proposing a latter-day revision, finally expropriates them.

The New York artists with whom Krauss compares (and, to be accurate, contrasts) Irwin and Turrell, artists such as Carl Andre, Dan Flavin, Donald Judd, Robert Morris, and Richard Serra, are empiricists (literalists, really) whose works aggressively assert their specific properties, their particular materials—indeed, their materialism—and their obdurate occupation of real space in real time. They exist, always, in the here and now, having been fabricated of exactly the materials they appear to be fabricated of. How different are the elusive and confounding light works of Irwin, Turrell, Larry Bell, Ron Cooper, Maria Nordman, Eric Orr, and Doug Wheeler, with their alchemical interfusions of ever-changing sunlight, refracted color, transient shadow, evanescent vapors, gases, and mists—everything and anything that cannot be physically fixed. Their works fairly yearn toward ethereality and seem virtually to aspire to become not part of, but apart from, the banal and corporeal world of wood floors and white-painted drywall that define the physical environs of the art gallery—what Brian O'Doherty calls the "white cube,"[5] in which art of the modernist era is habitually exhibited.

Oddly, with all the attention focused on the upsurge of "California art" and the clamor to establish its "defining" characteristics and probable causes during the 1960s and well after, almost no such effort was turned upon what, in retrospect, appears to have been the most original and revolutionary art produced in California. In its broadest description, it was a nascent constellation of activities for which a critical vocabulary did not yet exist to explain or even name them, but they were decidedly concept-based and made free use of what later would come to be known as Conceptual, performance, video, and installation art. It was not that this new experimental and freewheeling

James Turrell, *Afrum Proto*, 1966
Courtesy of the artist,
© James Turrell

art went unnoticed or unremarked upon; some of it generated early attention and even notoriety, as when Chris Burden positioned himself as a target and had a friend shoot a bullet through his left arm. And many who began their mature artistic careers in California at various times during the period of the mid-1960s through the mid-1970s, such as Eleanor Antin, John Baldessari, Judy Chicago, Bruce Nauman, and Dennis Oppenheim, enjoyed some good critical and popular support from the get-go. Nor were these new directions exclusive to California: concept-based art in myriad attitudes and manifestations was burgeoning internationally. Yet in the robust critical literature that has grown up around Conceptual art over the decades, there is no Greek chorus about Conceptual art in California comparable to the (admittedly boosterist) din about West Coast painting and sculpture. Perhaps the issues in painting and sculpture were more apprehensible at the time, or maybe concept-based activity was too new and radical for observers at the moment to differentiate between different strains; in any case, until very recently, American Conceptual art has been discussed and historicized as if it were all of one ilk, with New York functioning as Command Central.

But as Peter Wollen has rightly asserted:

The historic role of conceptual art cannot be understood simply by rehearsing the early work of its avant-garde pioneers. It very rapidly burst its Lower Manhattan bounds and became the site of an extremely complex and dynamic movement, with far-reaching implications geographically, politically, and semiologically. It was as if the original New York cohort created a crack in a dam that eventually broke and released a flood of innovative new art . . . Consequently, the picture that emerges, taken as an ensemble, is that of a complex movement with very different roots—in Europe, in Japan, in North America—which branched out with the second generation in new and exciting directions. . . Conceptual art cannot and should not be compressed into a movement with an unproblematic origin and a single master trajectory. [6]

The particular ways in which concept-based art developed in California are of a discernibly different tenor than what was being done in New York— or in Europe, South America, and Japan, for that matter. Just as many West Coast painters and sculptors strove to break from the literalism and materialism of the more dour East Coast work, so did early Conceptualists in California quest beyond the scope of art about art. An example of contrasting works illuminates the differing intentions.

In 1965 New York–based Joseph Kosuth created a signature piece of Conceptual art, *One and Three Chairs,* consisting of the display of an ordinary wood chair, and, flanking either side, a black-and-white photograph of the same chair and a photograph of the text of a dictionary definition of the word *chair.* The intent of this work was to point up the question of what we suppose to be the "real" chair and, in the words of the artist, to come to an "understanding of the linguistic nature of all art propositions."[7] For quite a

few years, Kosuth's project as an artist consisted of, as he put it, "a series of investigations which are comprised of propositions on/about/of 'art.'"[8] Kosuth purported to break with formalism and its elevation of aesthetic response and issues of taste in order to reveal that the nature of art has little to do with the innate aesthetic properties of the art object and everything to do with definition, context, and language.

Joseph Kosuth,
One and Three Chairs,
1967
Leo Castelli Gallery,
© 2000 Joseph Kosuth/
Artists Rights Society
(ARS), New York

He professes a certain radicalism in this standpoint. Ironic, then, that his philosophical, quasi-scientific undertaking may represent an extreme strategy, a sort of endgame, in the evolution of the modernist position that art be about itself—self-reflexive, dialectical, and, in essence, formalistic.

In some sense, Kosuth's years-long artistic monologue is the apotheosis of the modern interest in reductivism, the effort to distill art to its most essential components; for him that essence was the sheer ideation about the definition of art itself. No artistic effort could be more essentialist, more turned in upon itself, more fundamentalist than Kosuth's practice during those years. (Unless it was that of Kosuth's colleague Lawrence Weiner, who thought it sufficient to propose artistic projects without any necessity of realizing them,

and who thereby invoked a big and complicated idea in Western civilization—raising Platonic issues and questioning Romantic values about the creative process—and a very vainglorious idea as well.) Kosuth's Conceptualism may be the ultimate artistic solipsism. And if his art stands as an extreme—the most extreme—example of analytic Conceptual art, it did have an enormous influence on a cadre of mostly New York–based figures whose art tended to be preoccupied with its own nature.

Just three years later, San Diego–based Eleanor Antin, a New York transplant who credits her move to California as a significant influence on her art, created a series of works, collectively titled *California Lives*, that was inspired by her fascination with the lifestyles and individuals she discovered there. These "portraits" of fictitious people were composed of arrangements of commonplace household objects—for instance, a folding TV snack table on which are scattered a hair curler, a melamine plastic coffee cup and saucer, a king-size filter-tipped cigarette, and a matchbook from a low-life bar-and-grill—that she annotated with brief anecdotal texts to evoke her subject's character and personal history. Antin intended to suggest recognizable character types, familiar from theater, novels, and other art forms: "They're kind of sociological types," she commented. "With these iconic people it was like I was casting a movie, a Southern California movie. If you saw them in a movie you'd recognize them."[9] Everything about these portraits is externally referential to imagined lives and intuited histories and places and events—so much so that Antin reports that gallerygoers didn't understand these pieces.[10] Perhaps so. Yet for whatever uncertain response these cryptic portraits demanded from viewers encountering this uncharted art for the first time, these works were certainly not solipsistic, at least not by intent. They required the viewer to perceive just about anything that was not present in the gallery. Given the then-prevailing presumptions about the phenomenology of art—that the art object controls the space—and how viewers were expected to behave in the presence of the art object—visually, viscerally, and not verbally—it is hardly surprising that these works might have elicited blank stares when they were first shown.

Like Kosuth, Antin combined ordinary objects with descriptive passages of text, but that is almost where the similarity stops. Whereas Kosuth's self-reflexive juxtaposition of components was structuralist and analytic in intent, Antin's gathering together of consumer goods that plainly reflected their source in daily life and popular culture was narrative, anecdotal, and intuitive. Kosuth's project was rooted in art; Antin's in life. Indeed, in ensuing decades

She worked nights, late. Liked to watch the surf in the mornings. She
didnt get much sleep then but she didnt really care about that. She
worried about her little girl. Maybe her mother would send money from
Idaho but she never did. Twice a week the lifeguard with the moustache
would visit and they went inside the house. Later he came out alone and
trotted back down to the beach. Much later she became a masseuse and
her mother sent the granddaughter a red Camaro. She smashed it up on
the freeway but she wasn't hurt.

Eleanor Antin, *Jeannie*,
1969
Courtesy of the artist

Antin went on to develop a new art form involving the creation of fictitious personae, or alternate "selves," whose life histories and personalities she acted out as the content of her work. At a time when many artists were beginning to sense that reductive strategies had exhausted themselves and were leading to an increasingly effete, specialized, academized art, Antin, among the most eccentric and genuinely experimental artists of her generation, moved out— outwardly, that is—from the modernist orthodoxies of clarification, unity, and essentialism to outlandish hybrid forms that eventually came to combine photography, performance, stagecraft, video, filmmaking, literary text, sound tracks, and plain old-fashioned drawing—sometimes all together in a single installation that filled an entire art gallery—in an artistic enterprise that was so concept driven that many critics, pro and con, described it as literature-cum-theater. Yet Antin did all of this primarily in the context of the visual arts, in galleries and museums. Though she was long a New York resident, she discovered that leaving The City and moving to California granted her a cer-tain freedom—conferred by both critical indifference and collegial laxity— to pursue whatever artistic direction her inquiries took. As Antin observed, "I invent myself so freely. And I'm inventing histories all the time . . . That's also why I love Southern California. It's easier to believe those things—and act on them—here than back East."[11]

Making so much of this contrast between Kosuth and Antin is extrava-gant, irrelevant to the artists, and quite surely a bit trumped up. Yet the paradigm of the contrast—looking inward and analytically at the nature of art and its critical issues versus looking outward and intuitively to the world through art—is real and true, and it demonstrates the virtual polarities of approaches along a continuum of Conceptual art making in the United States at the time. Many of the most interesting Conceptual artists working in California were impelled to the end of the spectrum that was more narrative, theatrical, romantic, utopian, and idealistic in its aspirations; and many of the American artists who were attracted to that end of the spectrum sooner or later gravitated to California to make their art.

John Baldessari, another of the first concept-based artists working in California, had in fact planned to be a painter, but after a confused and meandering early career, he found himself increasingly fascinated with the photographs that he had taken as "sketches" for landscape paintings. In 1966 he began applying light-sensitive photoemulsion to the surface of his blank canvases and developing enlarged snapshots on them in a darkroom, later annotating the images with text that he painted on their surfaces.

In his photoemulsion works from 1966 to 1969, Baldessari focused his attention, and his camera lens, on the banality in and around his birthplace, National City, California, a dusty little suburban outpost of San Diego, near the Mexican border. He recorded, with the neutrality of an autopsist, the most inhumanly neutral cityscapes imaginable: a stucco box of a building housing the Econ-o-Wash at 14th and Highland; a Chevrolet turning the corner at 4th and C in Chula Vista; an asphalt car lot on 30th and National. Annotating each picture is a caption duly identifying its nondescript locale with almost ceremonial duty. Were photo-realist painter Robert Bechtle, from San Francisco, or East Coast–based Robert Cottingham to have used these same subjects, the images would have had a more Pop-y good humor about them, as well as the power to engage and amuse the viewer with their technical handicraft; but Baldessari is far more clever and deadpan. These photographic images seem as if they were snapped accidentally, recording a virtual absence of subject matter, or at least "conventional" subject matter, leaving the spectator to wonder at his deliberateness in issuing these unfathomably "dumb" pictures. They leave the viewer with an unrequited desire for "legitimate" subject matter, which desire is the consistent drive that runs through all of Baldessari's art from these earliest works to the present.

One of the National City works, without any image, is even titled *Subject Matter* (1967–68) and consists entirely of the following text:

SUBJECT MATTER

LOOK AT THE SUBJECT AS IF YOU HAVE NEVER SEEN
IT BEFORE.
EXAMINE IT FROM EVERY SIDE, DRAW ITS OUTLINE
WITH YOUR EYES OR IN THE AIR WITH YOUR HANDS,
AND SATURATE YOURSELF WITH IT.

Like the photoemulsion images of National City, this text-as-subject is similarly unexplained and without context. Yet it is steeped in sly irony and in a longing for significant, consequential "Meaning" that can be discovered like a revelation—seen again—and intuitively described, surrendered to, and exulted in. The text could come from some teach-yourself-to-be-an-artist handbook—in his early work Baldessari was always dismantling art school bromides about the "right" way and the "wrong" way to make art — or from some other well-intended self-help pamphlet. Baldessari's art is so deadpan that it is hard to know with surety if he is being wiseass, wry, or wistful about the vacancy of "Meaning"; the artist no doubt would assert that he is simply

being realistic and existentially correct and that the notion of "Meaning," like that of "Truth," is vacant.

By 1970, having completely abandoned the practice of painting, Baldessari cremated all the leftover paintings still in his studio. To mark his renunciation, he planned *The California Map Project*—what critic Coosje van Bruggen describes as "a grand liberating gesture"[12]—that began not in the artist's studio but in an airplane as he observed the features of the land, which looked like a rendering of a map. Baldessari transposed the ten letters of the word CALIFORNIA from a printed map to their actual locations on the ground. Setting out in Southern California, Baldessari and two friends, George and Judy Nicolaidis, located the site in Joshua Tree National Monument, in the Mojave Desert, to situate the terminal letter *A*. They then worked their way north to Shasta Lake, near the foothills of the Trinity and Sierra Nevada mountain ranges, to place the initial *C*. They fabricated large-scale letters out of a mix of materials they brought with them—pigments, fabric, yarn—and other materials—logs, rocks, a telephone pole—they found at the appointed sites. Baldessari later described the exercise as "an attempt to make the real world match a map, to impose language on nature, and vice versa."[13] This is a bold aspiration indeed, echoing such Old Testament concepts as man's dominion over nature and the doctrine of nomination (which holds that to name something is to comprehend and virtually to control its nature), as well as the more down-to-earth conception of the land, common among real estate developers, as so much acreage to be allotted into plots with the baldness of a schoolmarm parsing a sentence. Though Baldessari had for several years used text and linguistic constructs in his photoemulsion works, his grand gesture in *The California Map Project* was his appropriation of language itself, the principal mode of distinctly human intelligence, as his medium.

For more than a decade, Baldessari continued to make photographs that he combined in random juxtapositions or arranged in specific sequences to hint at obscure narratives, such as a pointing finger choosing between two pea pods, leaving it to the viewer to construct, or construe, the basis of the choice. Such works do not involve language, as such, but depend entirely for their effect on the viewer's mental processes, which are largely rooted in the use of language. Baldessari found his métier in the photocollages of the 1980s and 1990s, which often utilized film stills. These works do not usually employ words, except in their titles, which often evoke verbal and visual puns. Generally they combine an array of pictures that are sometimes connected by colored lines or that are partly obscured by large, flat rounds of color. The

photocollages are intensely "picturesque," tantalizing the eye, and the mind's eye, with a rebus of quizzical and thought-provoking images that, in juxtaposition, seem to suggest some codified message or some organized signification. They urge interpretation—they demand it of the viewer—yet they confound all attempts to conjure any sensible meaning. It is all but inevitable to feel both amused and frustrated by Baldessari's visual information games. They can seem an empty tease—until it is realized that the pictures and colored dots and connecting lines are more or less incidental components, like words or phrases in verbal language, and that the signification (if any) is in the mind of the beholder and is a mental activity, not a physical fact. Any meaning, or impulse to making meaning, is the viewer's predilection. The real focus for Baldessari, it must be acknowledged, is not the found images of the film stills and the colored dots and connecting lines but what might be called "habits of mind." Ultimately, Baldessari's incessant subject matter is nothing less than the habitually searching source of subject matter itself: human consciousness.

Influences on Baldessari were Edward Ruscha's paintings, works on paper, and conceptual illustrated books. Ruscha had moved to Los Angeles from Oklahoma City in 1956 to study graphic design at Chouinard Art Institute. Graduating in 1960, he had at his command the tools and modes of commercial art—what critic Christopher Knight calls "the 'debased' visual language spoken by mass culture"—and a strong interest in vanguard art, particularly the early work of Jasper Johns.[14] Ruscha's art, from the early 1960s to the present, has always been language based, and it often includes boldly rendered words or phrases or incorporates the familiar visual language of icons, trademarks, and maps—all units or systems of signification as they are normally used. However, by presenting such normally meaningful information cleaved from any context or relevant situation that might explain the use of such signifiers, Ruscha bleaches away the credence—our belief in the possibility—of the meaningfulness that signifiers usually bear. Despite the technical bravura, the brilliant hues and spectral glow (or a starkly luminous gray in many recent works), and the pageantry of scale (all calling heightened attention to whatever announcement the work portends), nothing adds up. Ruscha—an interactive artist if ever there was one—breaks a compact of good faith with his viewer, successfully provoking an uncanny response somewhere between humor and anxiety. With a playfully ironic gravity of purpose and unsettling calm detachment, he chronically confutes the viewer's ingrained presumption that the words presented with such painstaking ceremony have meaning. His words are without thoughts.

"WORDS WITHOUT THOUGHTS NEVER TO HEAVEN GO" reads the inscription in Ruscha's 1985 eight-panel mural for the rotunda of the Miami-Dade Public Library in Miami, Florida. The words are Shakespeare's, or more specifically, those of the villainous Claudius, murderer of his brother and successor to the throne. In *Hamlet*, act 3, scene 3, Claudius appears on his knees praying to heaven for forgiveness; but Claudius does not have penance in his steel-stringed heart and knows that empty words without the conscience to back them up will not be heeded by God. He rises from his prayer with full knowledge of his perfidy and perdition: "My words fly up, my thoughts remain below. Words without thoughts never to heaven go."

"It is a quotation that is profound and yet simple," Ruscha commented in his proposal for the project. "For me, it burns with curiosity."[15] We can easily accept Ruscha's inscription as a literary homage to Shakespeare and all that the Bard intended by it, which would be a fine response in the setting of the library. But it is more interesting to speculate on the burning curiosity it provoked in Ruscha, who had a different intent from Shakespeare, but one equally imposing in the setting of a library, in questioning the efficacy of language and perhaps the existence of heaven as well. In normal use, words are invoked to embody meaning, but in Ruscha's impish and impertinent art, words—the fundamental elements of language and verbal communication and all literature—are used to undermine the very possibility of meaning. Used as if in a vacuum, words founder. They signify nothing. As for heaven, there is little reason to suppose that Ruscha thinks much about such things in

relation to his art, or perhaps even in relation to his life. Even when painting the image of a majestic mountain, Ruscha represents it in a physical—an almost metaphysical—void. His numerous maplike landscapes of the vast Los Angeles grid are spatially disorienting—the opposite of maps—and seem surrounded by silence; boulevards course anonymously through the limitless noir space, both depicting a recognizable place and evoking its unknowable soul. Ruscha's is a melancholic sort of idealism in California Conceptual art. No American painter of the sublime—not Albert Bierstadt, not Thomas Cole, not Edward Hopper—portrays as convincing an existential void as does Ruscha, this most darkly poetical of latter-day American painters.

While the art of Baldessari and Ruscha appears to be about the absence of subject matter and meaning, it is clear that the subtext of their art is the very activity of the mind and its restless desire to seek and possibly to find meaning, even where there may be none. They had a confrere in Alexis Smith, an artist somewhat junior to them, who has said of her art that "the impulse to tell stories is generated more by a search for meanings than by a narrative need . . . For me, stories are an extended series of meanings. I think I can look at things and see relatedness, that is, see instinctually how something could be a metaphor for something else—how images and objects fit together or how people generate stories, words, and objects. All of these things are extensions of how people experience the world."[16] Smith had a penchant for finding and coaxing meaning out of the merest snippets and oddments of popular culture—old magazine photos, thrift-shop knickknacks, nostalgic bits of 1950s and 1960s Americana—and in fact, she had been making little collages from clipped magazine pictures and words since childhood. By 1971, a year after she graduated from the University of California at Irvine, Smith had become earnest in her collage making, and she quickly earned a following. In 1972 she started to show regularly in group exhibitions at galleries and museums around California, and by 1974 she had her first solo exhibition in Los Angeles. Her work from the period generally consisted of magazine pictures combined with whimsical trinkets and found objects mounted on paper and often counterpointed with words, phrases, or even passages of typewritten text quoting American writers such as Henry Wadsworth Longfellow, Walt Whitman, Raymond Chandler, and Jack Kerouac.

"The artists whom I really relate to or feel strongly about are not visual artists. Rather they're quirky American geniuses like Isadora Duncan, Frank Lloyd Wright, Thomas Edison, Gershwin, and Whitman. For me, they represent values of courage and originality and personal vision: they reinvented

their forms because they refused to accept the traditional definitions of the things they wanted to do. They did their work through a weird hybrid of ignorance and naiveté and chutzpah and imagination. That's what I respond to, and that's a particularly American tradition."[17] It is a characteristic of early concept-based art in California that it roved so far from the distinctly visual art issues and the discourse that seemed to propel so much contemporaneous work on the East Coast.

How very opposite were the aspirations and dreams embodied in Smith's concept-based art from those that drove her East Coast counterparts. Sol LeWitt, for example, strove in his serial drawings to depersonalize his art in every way, as by using grids, arithmetic functions, and systems or permutations—what he called a "plan"—so that "arbitrary or chance decisions would be kept to a minimum, while caprice, taste, and other whimsies would be eliminated from the making of the art . . . To work with a plan that is preset is one way of avoiding subjectivity."[18] LeWitt's genius was to construe his art as a discipline and to specify it (from the Latin word for species)—that is, to distill and clarify and delimit its aim. Donald Judd, though not a Conceptual artist, had described his similar objective to create "*specific* objects"[19] whose sole content was their physical form and the process of its manufacture, and nothing extraneous to that. And Robert Morris had written of the theoretical possibility of creating a work of art so specific that it had "only one property"[20] (an idea that Baldessari parodied in a text painting of 1967–68 that read, "A WORK OF ART WITH ONLY ONE PROPERTY"). Alexis Smith, for her part, sought to make hybrids with multiplicities of culturally shared and myriad personalized meanings.

In the early years of her career, Smith was an intimist; her works were small, handcrafted, and cute. But, rooted in language, metaphor, popular culture, and her innate inclination to "search for meanings," even the most intimate works contained the genetic code toward an ever-increasing complexity. The works became bigger and more wrought; they evolved from single pages to handheld books to storyboards that stretched across the wall to multiroom installations. Her subjects became commensurately more complex and expansive, progressing from a bobby-soxer's fantasies of romance and Hollywood fame to meditations on fate, mortality, and morality. In 1987 Smith completed a specially commissioned mural titled *Same Old Paradise,* which appropriated on a behemoth scale—it was more than sixty feet long— the typical visual vocabulary of orange crate labels from earlier in the century. Smith depicted a valleyful of Edenic orange groves hugged in the bosom of

the California mountains, but introduced
the disturbing image of a snake whose
body mysteriously takes form right out of
the two-lane highway that courses through
the orchards. She clearly had moved into
culturally vast territory.

One of the richest works of recent
public art in the United States is Smith's
Snake Path (1988–91), in the Stuart
Collection at the University of California,
San Diego. It is a 560-foot-long walkway
about ten feet wide, surrounded by a field
of trees, grasses, and patches of chaparral.
It meanders from the bottom of a hill up
to the entry plaza of the university's
research library. Its surface is made of
variegated hexagonal slate tiles that seem
at first to form a decorative pattern of
wavering bands; but as pedestrians make
their way up the hill, it becomes apparent
that the patterning mimics the scales of
snakeskin; and then it becomes clear that

Alexis Smith, Study for
Snake Path, 1988–91
Stuart Collection,
University of
California, San Diego

the path itself represents a vast serpent leading the way out of the garden.
No one with the slightest acquaintance with Judeo-Christian mythos can fail
to grasp the allegorical significance of the journey that Smith has plotted
from Eden Garden to the fruits of the tree of knowledge, which God forbade
Adam and Eve from tasting. Some distance along the way, the snake undulates
toward a large stone book on whose open pages are engraved perhaps the
most exalting passage from John Milton's *Paradise Lost*, in which the archangel
Michael delivers God's promise of a "Paradise within thee, happier far." After
coiling around a little arbor with apple trees and a bench, the head of the
serpent delivers strollers to the library, where they can get all the knowledge
they can assimilate and, thereby, redeem themselves. Thus does Smith make
pilgrims of all pedestrians whom she leads down (or up) a garden path. *Snake
Path* issues precisely from all of Smith's art that came before it; it is where her
strategy of combining a trinket with a bit of text back in 1971 led her.

The pattern repeats through more than two decades of concept-based
art in California. In San Francisco in 1970, Tom Marioni established the

Museum of Conceptual Art. Not a museum in any traditional sense, the space was a venue for socializing among the artist community with a weekly beer bash. In Marioni's conception, his medium was the very social fabric of the creative community. In 1975 Bonnie Sherk, reflecting the radical politics of the time and the growing national concern about the ecology, set *Crossroads Community/The Farm,* a utopian community, on nearly seven acres adjacent to the intersection of several freeway overpasses in San Francisco. The Farm included a "school without walls," open to all members of the surrounding neighborhood, a working farm with domesticated animals, performance spaces, and a flower garden. The ecological movement and West Coast Conceptualism proved to be fertile ground for other artists, such as Lita Albuquerque, Robert Irwin, Paul Kos, and James Turrell, whose early experiments with art in the natural landscape evolved from their interest in concept-based practice.

Helen Mayer Harrison and her husband Newton Harrison were among the very first artist-activists to manifest their ecological concerns as art. In 1970 they began collaborating and developed a format they called "the ecological argument," a sort of textual Socratic dialogue of questions and answers between an anonymous scientific "voice" and an artistic one. (Interestingly, Helen Mayer Harrison had trained as a scientist—a psychologist—and Newton Harrison had trained as an artist.) The dialogue form is a highly poised positioning that recognizes the interdependence, as well as the limits, of both spheres of human knowledge—the scientific and the artistic—in constructing an idealized vision of humanity in harmony with nature. This is nowhere better articulated than in *The Lagoon Cycle,* a multipart project they began researching in 1972 and continued developing and revising through 1984. *The Lagoon Cycle* investigates the life cycle and mating behavior of the *Scylla serrata* crab, whose natural habitat is endangered. The Harrisons' practical aim was to find ways of breeding the crab in artificial lagoons, but their research and its presentation were heavily laden with poetics, metaphor, and philosophy.

In most of their art, the Harrisons use the form and structure of scientific research—or at least they exploit its appearance, enlisting all manner of charts, maps, tables, and a host of other data—as the conceptual vehicle to launch a utopian vision. But while the organization of their art resembles the rationality of the scientific method, with its logical presentation of hypothesis, its copiously annotated supporting data, and its finely argued conclusion, there is in fact a madness to their scientific method. In their aspiration to reform or to remedy the planet's ailing ecology, the Harrisons do not argue

for, say, the implementation of regulatory measures or tolerable levels of pollutants or limitations on the development of the wilderness or other predictable steps, but for nothing less than the wholesale reorganization of human enterprise throughout the world to bring it into conformance with nature and what may be called "natural law": a set of principles thought to derive from nature and which are ethically binding on human society.

The Harrisons acknowledge that their vision necessarily entails reforming the world's economies, which requires changing innumerable societies, which in turn calls for fundamental reformation of most of the world's cultures and their historically ingrained ethical philosophies, value systems, and religions. A formidable goal, to be sure. Theirs is a dreamwork, a meditation on civilization's relationship to nature and on the morality of that relationship. It is difficult to imagine a more encompassing, a more profound, or a more quixotic aspiration than the quest embodied in their art. It is daunting to consider that the Harrisons have been commissioned by the Schweisfurth Stiftung (Foundation) and Hannover 2000 to present a project for consideration by the Deputies of Culture of the Parliament of the European Union. Titled *Peninsula Europe,* it is an immodest proposal for a new pan-European ecological policy and a master plan for the twenty-first century. Newton Harrison mused that "this kind of plan couldn't have come out of Europe or even most of America; they had to look in California."[21]

If these traits were perceived at the time as mere "regional niceties" (to use Plagens's apt phrase) of New York art—a sort of local coloration of mainly local note—subsequent history reveals that they were prescient of larger and more prevalent things to come. It appears today that Conceptual art in California in the 1960s and 1970s was less a variation on East Coast art than an alternative mode of creating art—an alternative that became the dominant mode in international art throughout the 1980s and well into the 1990s. It was powerfully influenced by and shared many of the aspirations of the feminist movement in art, which arguably was birthed in studios, art collectives, and encounter groups in California in the late 1960s. Conceptual art in California, like the feminism of the period, was often intended as a quest for human development at every level: personal, social, political, spiritual.

Is there, then, a case to be made for a "California" Conceptual art? It would be hollow braggadocio to assume that California had a monopoly on a certain mode of thinking about and making art, even Conceptual art. The romanticism evinced in California Conceptual art was not exclusive to the place: the preeminent German Conceptual artist and political proselytizer

Joseph Beuys, for example, with his social ideology of individual citizens working together to build a utopia while believing independently in a holistic universe, was as romantic, visionary, and mystical as any modern artist—or any modern thinker, for that matter—could be. Even in hard-boiled New York, no less a principal ideologue than Sol LeWitt asserted, famously, that "Conceptual artists are mystics rather than rationalists."[22] And within California there were many distinguished artists like Michael Asher and Allan Sekula, or later-generation Conceptualists such as Steve Prina and Chris Williams, whose art was fundamentally based in theory. The purport of this argument is not to advance a bogus essentialism that segregates California Conceptual art from the many strains of Conceptual art that were being explored internationally at the same time.

Yet for all the fluidity of practice and the elasticity of terms and concepts, the notion—the evidence—persists that there was at the very least a certain tenor, a certain timbre, of art studio activity among Conceptual artists in California in the late 1960s and throughout the 1970s and into the 1980s. While much of New York Conceptualism tended to refine and define itself more and more carefully and accurately, California Conceptualism yearned toward something more restless, more vague and ineluctable. If it did not always result in an art preoccupied with the sublime, it recognized and was motivated by sublimely expansive desires and a quest for new possibilities for a brave new art. It is the true temper of the American tradition in art. California artists frequently led the way in bringing a stunning, often stupefying, formal and technical innovation to the broadest range of content in new art. The formative thrusts of California Conceptualism seem today to have been far more innovative and fertile with possibility than most other American art of the period. Indeed, what many observers commonly refer to as the "global style" of contemporary art in the 1980s and 1990s—the "intermedia" art forms that so willfully embrace an infinite range of content—got its most unfettered, most venturesome, most energetic running start in the peculiar ambitions, the idealistic aspirations, and the naïveté of California Conceptualist artists of the 1960s and 1970s.

Howard N. Fox is curator of modern and contemporary art at the Los Angeles County Museum of Art. His exhibitions at LACMA include *Robert Longo* (1989), *A Primal Spirit: Ten Contemporary Japanese Sculptors* (1990), *Lari Pittman* (1996), and *Eleanor Antin* (1999).

1 Peter Plagens, *Sunshine Muse: Art on the West Coast, 1945–1970* (1974; reprint, Berkeley and Los Angeles: University of California Press, 1999), 9–10.

2 Ibid., 106.

3 Barbara Rose, "Los Angeles: The Second City," *Art in America* 54 (Jan.–Feb. 1966): 110–15.

4 Rosalind Krauss, "Overcoming the Limits of Matter: On Revising Minimalism," in James Leggio and Susan Weiley, eds., *Studies in Modern Art 1* (New York: Museum of Modern Art, 1991), 123–41; 124, 133.

5 Brian O'Doherty, *Inside the White Cube: The Ideology of the Gallery Space* (Santa Monica: Lapis Press, 1986).

6 Peter Wollen, "Global Conceptualism and North American Conceptual Art," in *Global Conceptualism: Points of Origin, 1950s–1980s*, exh. cat. (Queens, N.Y.: Queens Museum of Art, 1999), 85.

7 Quoted in Kynaston L. McShine, ed., *Information,* exh. cat. (New York: Museum of Modern Art, 1970), 69.

8 Ibid.

9 Quoted in "A Dialogue with Eleanor Antin," in *Eleanor Antin,* exh. cat. (Los Angeles: Los Angeles County Museum of Art and the Fellows of Contemporary Art, 1999), 202–3.

10 Ibid.

11 Ibid., 208.

12 Coosje van Bruggen, *John Baldessari,* exh. cat. (New York: Rizzoli in association with Museum of Contemporary Art, Los Angeles, 1990), 44.

13 Ibid.

14 Christopher Knight, "Ruscha in Context: In the Beginning Was the Word," in *Edward Ruscha: Words without Thoughts Never to Heaven Go,* exh. cat. (Lake Worth, Fla.: Lannan Museum, 1988), 53.

15 "Appendix C: A Proposal by Edward Ruscha for the Circular Ring and for the Lunettes of the New Miami-Dade Public Library," in *Edward Ruscha: Words without Thoughts,* 133.

16 Richard Armstrong, "Interview with Alexis Smith," in *Alexis Smith,* exh. cat. (New York: Rizzoli in association with Whitney Museum of American Art, 1991), 13.

17 Armstrong, "Interview with Alexis Smith," 15.

18 Sol LeWitt, "Paragraphs on Conceptual Art," in Alicia Legg, ed., *Sol LeWitt,* exh. cat. (New York: Museum of Modern Art, 1978), 167.

19 Donald Judd, "Specific Objects," in *Arts Yearbook 8: Contemporary Sculpture* (New York: Art Digest, 1965), 74–82.

20 Robert Morris, "Notes on Sculpture, Part I," *Artforum* 4 (Feb. 1966): 44.

21 In discussion with the author, July 13, 1999.

22 Sol LeWitt, "Sentences on Conceptual Art," in Legg, *Sol LeWitt,* 168.

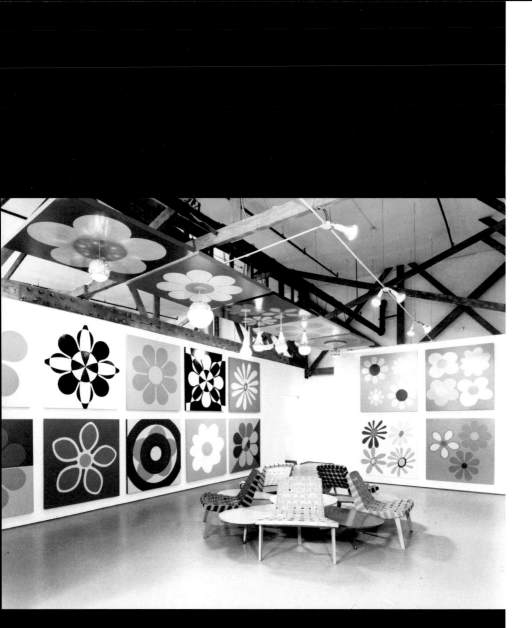

Jim Isermann, *Flowers,*
installation view, 1986
Photograph © Anthony
Cuñha, courtesy of
Richard Telles Fine Art

Lynn Zelevansky

A PLACE IN THE SUN:
THE LOS ANGELES ART WORLD AND THE
NEW GLOBAL CONTEXT

A faint mist cast gauzy nets across the horizon heralding another perfect day.
It was Christmas again, another balmy golden California Christmas.
Raymond Chandler, quoted by Alexis Smith, *Sea of Tranquillity*, 1982

It has often been said that, because of its inextricable ties to Hollywood,
Los Angeles is a city of fantasy and imagination, experienced—even by those
who know it intimately—through the illusory filter of its image in novels,
films, and television. These constructions of L.A., with their connection to
personal vision and folly, may exacerbate a tendency to romanticize the past.
When as a relatively new arrival (I had been here four years) I first contem-
plated this essay, a friend cautioned that people see L.A. history from the
perspective of their moment of entry—the point when they actually took
up residence here.[1] Her warning implied that memory and experience could
be obliterated with particular ease in this beautiful, seductive, and often
fictionalized city.

I moved to L.A. in late February 1995, after a lifetime in New York and
following a succession of cataclysmic events that deeply affected Southern
California. Los Angeles was recovering from an economic recession, the riots
of 1992, the fires of 1993, and the Northridge earthquake of 1994. The economy
dictated low real estate values and, perhaps because of their relative youth,
gave major cultural institutions a tenuousness unknown on the East Coast.[2]
I had been coming to L.A. regularly for about ten years and thought I knew
the city; in fact, I was familiar only with Santa Monica, West Hollywood, Mid-
Wilshire, and the area of downtown that houses the Museum of Contempo-
rary Art. Similarly, I thought I had some knowledge of the art scene here but
quickly discovered that I was aware of only a single, thin layer of it.

Despite the difficulties of the recent past, as I arrived the Los Angeles art world was becoming an international force. This young but vital scene had long produced disproportionate numbers of compelling artists, but the city had lacked the artistic infrastructure to draw an aspiring avant-garde on a scale that Paris did before World War II and New York did afterwards. In the 1980s, many of L.A.'s most exciting younger artists still felt the need to move to New York for the sake of their careers. There, the national enveloped the regional and they were identified simply as "American." As the decade wore on, however, a few who elected to stay were able to develop and maintain international profiles from a Southern California base.[3] In the nineties, a strong contingent of artists who remained in L.A. achieved prominence on the East Coast and abroad.[4] Others began to move here, seeing Los Angeles as a viable alternative to New York.[5] Although still low on powerful commercial galleries and critical press, L.A. was recognized in international exhibitions, catalogues, and articles as one of the most exciting places in the world for the production of contemporary art.[6] The essay that follows is an attempt to understand this complex and continually changing cultural dynamic.

ACCORDING TO THE CHILEAN ART CRITIC Nelly Richards, for modernists unifying philosophical and aesthetic truths were synthesized "at the centre [New York and the Western European capitals], which radiated the light of wisdom and knowledge towards a periphery shadowed in deficiency."[7] The periphery she addresses is Latin America, but the idea applies equally well to California and other cultural enclaves. Provincialism in the arts for a long time has connoted a reworking of out-of-date trends that originated in Paris, Berlin, or New York and were only partially digested by distant communities. The irony of Richards's statement lies in the simplistic analysis that she parodies, which assumes that information flows exclusively in one direction. Like certain other regional hubs, Los Angeles has not, for a long time, fit the traditional model.[8]

Even during World War II, emissaries from east of the Mississippi, such as Museum of Modern Art curator Dorothy Miller, traveled to the West Coast to bring back works to show.[9] By the 1960s, Los Angeles art was identified by certain trends originating here, notably the L.A. Look (or Finish Fetish) and Light and Space. Both were associated with the Southern California climate and landscape. Light and Space artists created often exquisitely beautiful, ethereal installations that explored the effects of light on three-dimensional surfaces. Finish Fetish artists shared an involvement with technological

processes and materials with many of their New York counterparts, but they
expressed this concern differently. Their use of brightly colored industrial
plastics and paints referred to local sociocultural phenomena such as the
ubiquity of automobiles and the popularity of surfing. What the venerable
curator Henry Hopkins termed the "clean side" of the city's aesthetics came
to epitomize Southern California.[10]

However, the range of art produced in Los Angeles during the 1960s and
1970s was actually quite diverse. The flip side of Finish Fetish was California
Assemblage, represented in L.A. by figures such as Edward Kienholz, Wallace
Berman,[11] George Herms, and Llyn Foulkes. Deliberately dark and messy and
made from the detritus of daily life, it was part and parcel of Beat and hippie
culture and often carried a political or social charge. However, while Assem-
blage has been a vital tradition in L.A., it has also been associated with Dada
in Europe and neo-Dada in New York and is as much a product of Northern
California as Southern.[12] Similarly Conceptualism, feminist art, and body or
performance work were international art trends to which Los Angeles made
significant contributions.[13] The work of Light and Space artists such as Robert
Irwin and James Turrell was sometimes conflated with the Finish Fetish group
and sometimes understood as a spin on New York Minimalism.[14] Only Finish
Fetish was called the "L.A. Look," a term that simultaneously suggested the
superficial world of fashion and underscored its connection to the city.[15]

In the 1960s, when curator Anne Ayres moved to Los Angeles, she found
it to be "a stupendous Pop art tableau."[16] It makes perfect sense then that L.A.
became identified artistically with work of that decade. Ayres describes "Finish
Fetish" as "those glossy, glamorous, 'stylish' objects . . . [whose] astonishing mix
of Pop and Minimalism . . . seemed perverse in [its] blatant
hedonism."[17] Certainly the L.A. Look's
unabashed pleasure in materials and color and
its inclination to meld nature and geometry,
metaphor and object, was in sharp contrast to
the systemic rigor and purposeful "difficulty"
of New York Minimalism. To take one
instance: Clouds float within the pure outlines
of a ten-inch resin cube from 1966 by Peter
Alexander. Blue and gold tones within
the plastic suggest that we are looking
not at a seascape but at an actual
piece of California, a bit of sunset that

Peter Alexander,
Cloud Box, 1966
© Peter Alexander,
private collection

miraculously has been captured and preserved. It is as if Alexander had conflated the rigorous forms of New York Minimalism with one of those souvenirs that purports to contain air or sand from a sacred site. Today the idea that we are looking at a piece of Southern California from the sixties imparts the sweet, sad resonance of a vanished moment.

The dominance of Finish Fetish had its negative side. John Baldessari recalls a time when the L.A. Look so pervaded the Southern California scene that there was little room for anything else. During the late sixties and seventies, he used his position as a professor at California Institute of the Arts to create a supportive milieu for alternative forms, inviting like-minded artists from elsewhere (most of them conceptually oriented) to teach at or visit the school: "We were such an island here; I made a point of hiring New York and European artists to complicate the mix. I felt there had to be more than plastic in L.A."[18] He made certain that his students heard about artistic developments in other places and encouraged them to move to New York upon graduation, because he believed that there would be no support for them here.[19] One of his students created and ran an exhibition space at the school called Gallery A402, after the room it occupied. Dan Graham, Art and Language, Daniel Buren, Lawrence Wiener, Joseph Kosuth, and Hans Haacke were among those who showed there. Baldessari does not believe that most of those artists otherwise could have exhibited in Los Angeles at the time.[20]

The association of Finish Fetish with L.A. was so enduring that, more than a quarter of a century after those artists had emerged, the Museum of Contemporary Art's chief curator Paul Schimmel mounted his 1992 exhibition *Helter Skelter* in perhaps inevitable opposition to that type of work. By this time, some of L.A.'s most internationally prominent artists—Mike Kelley and Paul McCarthy, for example—were emphasizing the turbulent underpinnings and psychosexual energies roiling beneath the surface of this Edenic locale. The exhibition included somewhat varied aesthetic approaches, but its title made reference to the Beatles' song and the murderous rampages of Charles Manson and his gang that it inspired, emphasizing violence and emotional dislocation.[21] Schimmel wrote in his catalogue essay that much of the work in the show manifested a "sense of psychological alienation, dispossession, and disorder . . ."[22] He wanted the exhibition to demonstrate that Los Angeles had an authentic culture of its own and that, "in this case, 'regional' art need not bear the burden of provincialism."[23] His strategy worked; in New York and elsewhere, *Helter Skelter* marked the beginning of a new level of recognition of Los Angeles as a vital center for contemporary art.

While disputing one clichéd notion of Los Angeles art, *Helter Skelter*
unwittingly supported another provincial stereotype. Embodied in the juxta-
position of Finish Fetish and Assemblage, this was the idea that Los Angeles
could be reduced to oppositions between beauty and ugliness, Hollywood fan-
tasy and gritty social reality, emotional heat and hipster cool. Exhibitions of
the eighties and nineties such as *L.A. Hot and Cool,* mounted at MIT's List
Visual Arts Center in 1987, and *Sunshine and Noir,* conceived and executed at
the Louisiana Museum in Denmark ten years later, perpetuated the same con-
struction. Such unnuanced dichotomies are by nature false,[24] but the contrast
between continual sunshine and emotional and intellectual darkness is espe-
cially difficult to counter because it is tied to entrenched images of Los Angeles.

The title *Sunshine and Noir* was taken from the name of a chapter in
Mike Davis's influential treatise on Los Angeles, *City of Quartz.*[25] Davis,
himself a mythologist of false dichotomies, excels at evoking familiar but
compelling images: Inextricably linked to Hollywood, characterized by physi-
cal beauty and idyllic weather as well as a lack of breeding and an inordinate
hunger for money, Los Angeles "has come to play the double role of utopia
and dystopia for advanced capitalism."[26] He describes in familiar terms "the
destruction of intellectual sensibility in the sun-baked plains."[27] Seduced by
the promise of economic reward, talents are wasted, trivialized, destroyed:
"Fitzgerald reduced to a drunken hack, West rushing to his own apocalypse,
. . . Faulkner rewriting second-rate scripts, Brecht raging against the mutila-
tion of his work."[28] Davis's book, first published in 1990 and issued in paper-
back two years later, was perfectly timed, as was the exhibition *Helter Skelter,*
which opened in January 1992. Given the natural and social disasters that
occurred here between April 1992 and January 1994, dystopic images seemed
to predominate in Los Angeles during the first half of the nineties.

If all these notions about Los Angeles and its art are now and always
have been far too limited to convey the nature of the city and the breadth and
depth of work produced here, their persistence may be the result of L.A.'s
unique origins. A complex social environment with a rich multicultural
legacy, it was defined from its development in the late nineteenth century
onward by the boosterism of real estate interests.[29] Built after World War II to
resemble the suburban mecca (or consumer utopia) that it later mythologized
in television comedies such as *Ozzie and Harriet* and *Leave It to Beaver,* it has
long been perceived as lacking culture and history.

And in fact Los Angeles is an anomaly—a world city without a signifi-
cant publishing industry. Consequently, a broad-based and consistent record

of its rich intellectual and cultural life has been lacking.[30] Even today, there is little art press, and galleries have a difficult time surviving.[31] In New York, Paris, London, or Tokyo the myriad newspapers, news and fashion magazines, and cultural journals that regularly air opinions on art see themselves as national or international. However, they actually have a strong local bias, acting as boosters for their city's culture. In contrast, L.A.'s dominant contribution to communications is made through the entertainment business, which, with its truly global market and the transient lifestyle of much of its top talent, has no motivation whatsoever to think locally.

In contrast to the paucity of critical activity, L.A.'s major art institutions, including the J. Paul Getty Trust, the Los Angeles County Museum of Art, the Museum of Contemporary Art, and the UCLA Armand Hammer Museum of Art and Cultural Center, have enjoyed considerable growth in recent decades.[32] This development has broadened and deepened the city's cultural profile and created a generally more sophisticated, art-friendly environment. The institutions involved with contemporary art have supported Los Angeles artists through exhibitions and acquisitions programs, although often not to the extent desired.[33] It seems logical that young Los Angeles art institutions, situated on the western edge of the North American continent and eager for global recognition, at times may have emphasized their international profile over the need to serve their immediate communities. Through the 1980s they would have been keenly aware of the stigma that, everywhere but New York, was attached to "local" (read "provincial") art and designed their programs accordingly.[34]

But even under the best of circumstances, museums only provide part of the support needed for contemporary art. In the absence of a diverse critical press and a strong art market, since the 1920s the schools have been the glue that has held the Los Angeles art world together. According to critic Michael Duncan, writing as early as 1994, "L.A.'s resurgence is attributable to the competitive nature of the five strong art schools (CalArts, Otis, UCLA, the Art Center, and Claremont) and to the fact that so many younger artists now move here rather than New York for cheap studio space."[35] In Los Angeles many of the best-known artists teach (which is not the case in New York), and it is still true that most artists in town can trace their roots back to one of the schools here. The schools employ artists, supply social cohesion, and populate and enliven the scene. In the face of a lack of published criticism, they have offered a sophisticated theoretical discourse. Of course, institutions' philosophical and aesthetic agendas can be oppressive in their own right, and the

schools in Los Angeles have as frequently provided principles against which
to react as they have structures within which to create.[36] Nevertheless, they
remain the art world's most significant sites of argument and community.

Although the scarcity of critical press of necessity limits the variety of
opinions expressed, artists have found freedom in the remove from what pho-
tographer Judy Fiskin terms the "thick dialogue" of New York.[37] Alexis Smith
for one finds the lack of a broad audience positive for artists and their work.
She sums up the situation succinctly, saying, "What we do really well is pro-
duce art. What we don't do well is what you do with it after it's made—write
about it, collect it, believe in it."[38] Despite whatever orthodoxies the schools
may have propounded, and perhaps because neither commerce nor criticism
impact its art world that strongly, Los Angeles has accommodated idiosyn-
crasy extremely well. Artists outside the mainstream often have been able
to sustain their work and maintain a public life here. Their visions have made
a more exciting mix of aesthetic possibilities.[39] Through the 1990s the city
offered the time necessary to develop and deepen an artistic vision, away from
the insistent demands of the New York and European markets.

It is significant that Los Angeles's artistic importance has coalesced when
the didacticism characteristic of much influential art of the eighties has—at
least for the moment—come to seem stodgy: overly proper in its adherence to
an explicitly postmodern or politically correct agenda. At the same time, many
younger artists in Europe and the United States are giving priority to the visual
as opposed to the conceptual and demonstrating an interest in what was once
denigrated as "formalism." In the last five to seven years, art in Los Angeles has
been critically apprehended through an internationally influential discourse
on beauty, pleasure, and sentiment. Notions such as these, implicitly consid-
ered suspect, generally were not entertained in the 1980s.[40] An early exhibition
to explore such themes was *La Belle et La Bête: Un Choix de Jeunes Artistes
Americains,* presented at the Musée d'Art Moderne de la Ville de Paris in 1995.
In her catalogue essay, curator Lynn Gumpert notes that the seventeen artists
in the show "share a fascination with both the beautiful and the grotesque"
and that "they are not alone; beauty is once again a subject of interest and
heated debate in American contemporary art circles. Banished from critical
discourse in the 1970s and 1980s, beauty is being contemplated anew, often in
conjunction with its opposite, ugliness."[41]

That same year, Klaus Kertess organized the Whitney Biennial around
the notion of metaphor, in purposeful opposition to the literalness that
was fundamental to Minimalism, Pop art, and much that came after them.

Lari Pittman, *Spiritual and Needy,* 1991–92
Courtesy of Alice and Marvin Kosmin

("Literalness" in this sense implies that the physical object is the exclusive site of meaning, rejecting metaphor, illusionism, and the artwork's traditional role as a representation of the actual world.)[42] Regarded as an antidote to the much-maligned "multicultural blitzkrieg" of the 1993 biennial, this exhibition stressed an attribute every bit as amorphous and romantic as beauty: "sensibility."[43] Fatigue with the excesses of theoretically based art is evident in critic Ken Johnson's comments that the theme of metaphor countered "the discipline imposed by some of the scholars of Babel," and that in their efforts to extract sociopolitical content from art, such theorists too often have eliminated "the needs, desires, and metaphorical ambiguities from art's body, causing a kind of hermeneutically induced anorexia."[44] Johnson noted that the show exhibited a "New York–centric pluralism" despite the inclusion of artists from Canada and Mexico and from "such *outlying art centers* as Los Angeles, Chicago, and Austin [italics mine]."[45] He also remarked on the presence of more traditional work, notably painting.[46]

Los Angeles would have to wait until 1997 to be highlighted in a Whitney Biennial. According to critic Brooke Adams, that exhibition's "emphasis on photography, installations, film and video, its showcasing of L.A. artists both established and emerging, and its cooled-out, laid-back tempo,... broadly conform[ed] to the new rhythm of creation in the decentered, off-on-your-own 'nineties." Further illuminating the way that prevalent notions about Los Angeles dovetailed with fashion in art at the time, the show was thought to be sparked by "a post-PC attitude of laissez-faire fluidity toward issues of sex, gender, race, and nationality."[47]

The association of Los Angeles with visual gratification seemingly unattached to social and political concerns (visual hedonism, if you like) in a sense simply updates the cliché of L.A. as the home of slick, colorful Finish Fetish art. Much of the most compelling work emerging in New York in the middle nineties—lush and accessible paintings by John Currin, Elizabeth

Peyton, and Lisa Yuskavage, for example, or unabashedly beautiful, even lyri-
cal objects and photographs by Gabriel Orozco—embrace visual gratification
and sentiment as much as any work from L.A., but Los Angeles has been seen
as a hub of such concerns. Formally engaging and sophisticated paintings by
Lari Pittman, Laura Owens, Monique Prieto, and Kevin Appel have become
emblematic of this aesthetic, as have furniture and housewares cum sculpture
created by Jorge Pardo and Jim Isermann. Isermann's frequently handmade,
brightly colored, and exuberant objects pointedly refer to L.A.'s long associa-
tion not just with design but also with craft. Blurring the distinction between
fine and applied art, they recall 1960s ceramics by Kenneth
Price as well as John McCracken's wood planks of the same
decade, coated with shiny plastic in Pop colors such as
bubble-gum pink.

 Los Angeles artists have been thought of as—and in
some cases looked down upon for—"doing rather than
thinking."[48] They have been seen as lacking the intellectual
backbone of East Coast artists, just as L.A. itself lacked the
intellectual infrastructure of New York. Since in New York
the understanding, appreciation, and promotion of new art
have depended greatly on the analysis that surrounded it,
it follows that the perception of superficiality in relation to

Ken Price, *Gold*, 1988
© Ken Price, photo-
graph © Museum
Associates/LACMA

John McCracken, *The
Absolutely Naked
Fragrance*, 1967
© John McCracken,
photograph courtesy
of L.A. Louver Gallery

L.A. art has been due, in large measure, to the lack of critical press here. It is thus highly significant that the ideological framework for the contemporary focus on the visual—the first critical trend to highlight Los Angeles—has come not from Europe or New York, but from the western United States. It is an approach that, by (somewhat defensively) endorsing ideas of visual pleasure and popular entertainment, makes a virtue out of what was seen, in the corridors of power, as a vice.

This is the first time that an internationally influential art ideology has emerged from California. Even in the sixties, when *Artforum* was (for less than two years) published in Los Angeles, the mode of analyzing Finish Fetish used by its then contributing editor, John Coplans, bore the unmistakable stamp of the East Coast. In order for Californians to be taken seriously, Coplans apparently felt the need to use the stripped-down style, concentration on phenomenological description, and specific language characteristic of writings by artist and theorist Donald Judd.[49]

Today's advocates of visual gratification no longer feel the need to describe art from Southern California in the theoretical terms of New York or Europe. Rather, they place Los Angeles in the forefront of current practice, putting the formal and sensual attributes of a work before its extra-art implications. The most eloquent voice for this position is Dave Hickey, whose timely 1993 book *The Invisible Dragon: Four Essays on Beauty* set the parameters for the discussion internationally. Hickey proclaimed that "in images, . . . beauty was the agency that caused visual pleasure in the beholder; and any theory of images that was not grounded in the pleasure of the beholder begged the question of their efficacy and doomed itself to inconsequence."[50] A group of writers shares his agenda, among them *Los Angeles Times* critics Christopher Knight and David Pagel and the editor of *Art Issues,* Gary Kornblau, whose press published Hickey's book. Knight, in the introduction to an interview with Kornblau, credits Kornblau with helping to ignite "the surprising recent debate about the once-taboo subject of beauty's role in contemporary art."[51]

This emphasis on "beauty" is often accompanied by a national and regional chauvinism that is not wholly unexpected, given the historical dominance of Europe and New York. Hickey tells us that "Europeans (who no longer have any concept of cool) do irony best, while Americans (who are only now learning to dissemble with aplomb) are best at cool."[52] He suggests that "the [unhappy] fate of cool American art in the nineteen seventies, after its apotheosis in the sixties, may be attributed to the European turn of critical

fashion during those years."[53] Gary Kornblau adds a Southern California spin
in reviewing an ambitious presentation of Conceptual art at MOCA: "It's not
surprising that much of the art in the exhibition which still holds us was
made by artists who worked in Southern California . . . for here creativity is
primarily the domain of the popular, not fine arts."[54]

The writers in question never actually define beauty. To explain it as the
agency that causes visual pleasure, as Hickey does, is almost tautological and
reveals nothing: What gratifies one person visually may leave another cold. As
New Yorker critic Peter Schjeldahl tells us, "Beauty is not a concept . . . [It is] in
the eye—and the brain and the gut—of the viewer."[55] Notions such as beauty
or sensibility are intellectually suspect precisely because, by definition, they
appeal to a realm that can only be validated individually. Therefore, a rhetori-
cal flourish is all that is required to justify them. Once justified rhetorically,
they are malleable and can be linked to ideologies from democracy to fascism.[56]
In the art arena, if there is no standard against which the concept of beauty
can be measured, then power in the hands of the critic is unchecked. His or
her authority—presumably based on heightened taste and sensitivity (con-
noisseurship)—can, like a belief in God, be questioned but logically cannot
be denied. The situation is particularly problematic in Los Angeles, where
Knight, Kornblau, and their associates occupy most of the very few critical
platforms available. Hickey himself made this point when, fostering his image
as an iconoclast, he recently came out against consensus in art, stating that
"if two art critics agree, there's no reason for one of them to be there."[57]

Given the city's unique and long-standing relationship to the issue, it is
not surprising that the debate on beauty is nowhere more politicized than it
is in Los Angeles. The artistic population of L.A. is more diverse than ever,
and recently some artists and their supporters with other points of view have
begun to critique the notion of beauty put forth by Hickey and his colleagues.
Philosopher Sande Cohen cautions that, for the writers associated with Hickey
and *Art Issues,* "works of art are not subject to economic categories, most
especially commodification. One of the chief premises of this . . . criticism is
that evaluative language and economics are brought together as categories that
a work of art *refutes* in its very 'objectness.'"[58]

Margaret Morgan has characterized the current discussion of beauty as
an "ideological shift away from a visual arts culture in which intellect, activism
and analysis are deemed worthwhile to one in which localized and depoliti-
cized arguments about taste and beauty dominate." She adds, "In historical
cycles of even the past thirty years, it is easy to trace the fashionability of ideas

Jason Rhodes and
Jorge Pardo, *#1 Nafta
Bench,* 1996
Collection of Rosa and
Carlos de la Cruz

and the machinations of a market more interested in blandness, sensation and decor."[59] While ultimately this may be accurate, it is also true that all influential trends—even the most intellectual—exist as part of the same market-driven dynamic. If today the market is invested in sensation, tomorrow it may turn to some new form of theory, as it has in the past.

In addition, even relatively recent experience demonstrates that shifts in artistic trends are rarely as extreme in retrospect as they appear at the time they are happening. (Consider the now-evident relationship between Abstract Expressionism and early Pop art[60] or the fact that the seeds of post-Minimalism were present in Minimalism from the beginning).[61] The current swing of the pendulum has been characterized as a return to formalism.[62] However, formalism never disappeared. Take as examples from the 1980s the visually exacting work of L.A. Conceptualist Stephen Prina or the graphically punchy combinations of words and images by New Yorker Barbara Kruger. Similarly, consciousness of precedent, which characterizes much postmodern production of the 1980s and early 1990s, is not absent today.[63] It is just less dominant in current art than it was ten years ago. For instance, the elegant and moving films and photographs of L.A.'s Sharon Lockhart refer to such diverse sources as Renaissance portraiture, Japanese prints, and French New Wave cinema. Her most ambitious projects, done in Brazil and Japan, are both visually and theatrically compelling in their own terms, but they also explore form and meaning in reference to ethnographic film. Thus the change we are seeing is

one of emphasis; it is a question of the relationship between aesthetic and intellectual components within a work.

In fact, today's art world diverges from the recent past less in its concern for form than in the nature of its pluralism—the fact that artists who paint, sculpt, photograph, or practice updated types of Conceptualism or installation can exhibit comfortably in the same space. Theirs is a post-postmodernism (or a late postmodernism) that rejects orthodoxy and "takes pleasure in the confusion of boundaries."[64] These artists do not just embrace collaboration, they have no qualms about melding very different aesthetics. Thus, *#1 Nafta Bench* (1996) combines Jorge Pardo's sleek, quasi-modernist designs that straddle the line between furniture and sculpture with Jason Rhoades's accumulations of commonplace objects. Conceived by an Anglo and a Latino, it was made of parts created by craftsmen in Mexico and by industrial processes in the United States. Formally compelling and playful though it is, political and theoretical dimensions are evident in its title, which underscores and illuminates the work's mode of fabrication, its satirical content, and its implicit rejection of heroic notions of the individual creator.

#1 Nafta Bench addresses certain issues that were current a decade or two ago, but it approaches them with a very different attitude.[65] In the 1980s and early 1990s much of the most influential art demanded a theoretical analysis informed by feminism, multiculturalism, queer theory, or Marxism (often expressed in the artist's keen awareness of the commodity-based system within which she or he functioned).[66] It is that didacticism—the insistent connection to specific theoretical issues—that has, for the moment, come to seem old-fashioned. Today, even the postmodern notion that all values are contingent and changeable, rather than universal and enduring, can be seen as an important tenet of what—ironically—became its own pervasive orthodoxy. The desire on the part of some younger artists to fully and openly embrace formal issues seems to be a stand not just against the oppressive aspects of eighties political correctness but against dogmatism of all kinds. For them, fervent theoretical positions, even those advocating the lack of fixed meanings, hold little sway.

The multifaceted pluralism of the current crop of artists is also a reflection of an increasingly contingent and fragmented environment. Art writer and professor Kobena Mercer warns against "the seductive attraction of abstract polarities like the local and the global because they give an illusion of theoretical mastery over an unstable world of risk and uncertainty."[67] (The same could, of course, be said about "sunshine and noir"). In addition, in

contemporary discourse there is a tendency tacitly to elevate the global above the local. With these caveats in mind, it is nevertheless the case that in the last two decades, many people have become increasingly migratory. In addition, the development of a seemingly borderless electronic communications network has intimately and profoundly affected huge populations. The art world has seen a proliferation of biennial and triennial exhibitions in Africa, Asia, Europe, and Latin America that have made a whole class of artists into nomads. As artists travel more and more to make work and advance their careers, curators, dealers, and collectors follow. The truth is that few of us in the art world are as tied to a local milieu as we once were.

This globalization has affected Los Angeles, sending its artists and art professionals abroad in greater numbers and with increased frequency, and making the city's aesthetic production more accessible to those who live at a distance from it. It is not just that ease of travel and communications have made the world smaller; it is that global trade and media have brought notions of world culture to our television and computer screens. Locations at a remove from our own have become more broadly intriguing, and we are more likely to act on our interest. Like other "outlying centers," Los Angeles has become a newly important stop on the world art tour.

Globalization also makes it increasingly clear that centrality is itself a construction, since every location is marginal to someplace else. Today, New York is more a crucial marketplace for art than an essential location for its production. The shared and growing realization that art can come from anywhere to an economic clearinghouse is probably at the heart of much of the current traffic in culture. That said, it is also true that Los Angeles's physical distance from other intellectual centers continues to shape its art and life.

IT WAS ONLY AFTER I MOVED TO LOS ANGELES that I was forcefully struck by the city's geographically imposed cultural insularity. Suddenly I felt isolated. Breaking news of international artistic trends was not, and still is not, as readily available here as it was, and is, in New York. Oddly enough, in my years of visiting Los Angeles it did not occur to me that the second most important city for contemporary art in the United States was in some ways as remote as Havana or Johannesburg. This may have been because, under certain circumstances and in some cosmopolitan centers, the periphery can be good for art making. For artists in Southern California there has been a combination of freedom and visibility that would have been impossible where economic and critical imperatives were more pressing. Indeed, L.A.'s

successful accommodation to marginality is one of the attributes that makes
it ideally suited to the emerging global culture.

So it is not accidental that Los Angeles has been recognized as one of
the most important locations worldwide for contemporary art in the era of
globalization. The city's artistic moment has been defined by wide-ranging,
high-quality art making, associations with beauty and pleasure, institutional
maturation, and even the presence of an ideology to support some of its more
high-profile production. All of this has occurred in a locale that manifests a
"posturban" sensibility, where "subjectivity is rendered heterogeneous,
nomadic, and self-critical."[68] Today, technology threatens to replace public
space with virtual space. In such a situation, centers and peripheries equally
would become portals or transfer points. Los Angeles, on the western edge of
the North American continent, far from other cultural hubs, a decentralized
metropolis whose intellectual life is diffused, taking place in a hundred dif-
ferent pockets of activity within the region, is almost designed to function
in this way. Already a "vagabond environment … that refuse[s] the common-
places of hearth and home,"[69] it is probably the ideal cultural matrix for the
twenty-first century.

Lynn Zelevansky is curator of modern and contemporary art at the Los Angeles County Museum
of Art. She was co-curator of *Love Forever: Yayoi Kusama, 1958–1968* (1998) and curator of
Robert Therrien (2000).

1 My thanks to Judy Spence
for this observation.

2 In the early 1990s many
museums were in serious
financial straits. The Brooklyn
Museum, the Detroit Art
Institute, and the Whitney
Museum of American Art
come immediately to mind.
However, in New York there
was a sense (right or wrong)
that the powers that be would
never allow these museums
to falter. In my experience,
there was less confidence of
this in Los Angeles.

3 This had also been the case
for a handful of earlier artists,
John Baldessari, Chris Burden,
Robert Irwin, and Ed Ruscha
among them. Internationally
prominent artists of the 1980s
who worked in L.A. include

Jonathan Borofsky, Mike
Kelley, Paul McCarthy, and
Charles Ray.

4 For example, a look at *Art in
America*'s yearly exhibition
summary for 1998 reveals that
two younger generations of
Los Angeles artists were well
represented in New York,
often in the city's better-known
galleries.

5 Jacob Hashimoto moved
here from Chicago in 1997, for
example, choosing Los Angeles
over New York because he
believed it was "kinder to young
people." He also admired work
by L.A. artists such as Laura
Owens, Francis Stark, and
Jorge Pardo and wanted to be
part of the "cultural atmos-
phere that made them think
that way." Telephone interview

with Jacob Hashimoto,
Dec. 1, 1999.

6 In summer 1997 the
Louisiana Museum of Modern
Art in Humlebaek, Denmark,
organized *Sunshine and Noir:
Art in L.A., 1960–1997*. The
exhibition traveled to the
Kunstmuseum Wolfsburg in
Germany and the Castello
di Rivoli in Italy before
finishing its tour at the UCLA
Armand Hammer Museum of
Art and Culture in L.A., where
it was largely reconfigured.

7 Nelly Richards, "Postmodern
Decenteredness and Cultural
Periphery: The Disalignments
and Realignments of Cultural
Power," in Gerardo Mosquera,
ed., *Beyond the Fantastic:
Contemporary Art Criticism
from Latin America* (London

and Cambridge, Mass.: Institute of International Visual Culture and the MIT Press, 1996), 265.

8 I am thinking especially of the São Paulo/Rio de Janeiro axis, which, in the second half of the twentieth century, has had a remarkably sophisticated and influential art scene.

9 Dorothy Miller began her important series of "Americans" shows in 1942. This was the period of the WPA, the Depression-era government agency that gave work to artists around the country. The currency of regionalism in the art world of that time is reflected in the title of the first exhibition: *Americans 1942: 18 Artists from 9 States*. There were no New Yorkers in the show, which raised hackles locally. Los Angeles artists included were Rico LeBrun, Helen Lundeberg, and Knud Merrill. See my essay "Dorothy Miller's *Americans,* 1942–63" in *Studies in Modern Art 4, The Museum at Mid-Century: At Home and Abroad* (New York: Museum of Modern Art, 1994).

10 See interview by William R. Hackman with Henry Hopkins, *Sunshine and Noir* (Humlebaek, Denmark: Louisiana Museum of Modern Art, 1997), 146–47.

11 Berman, who was a highly influential figure in Los Angeles into the 1960s and 1970s, moved to San Francisco in 1957 after his Ferus Gallery exhibition resulted in a conviction and fine for obscenity.

12 See *The Art of Assemblage* (New York: Museum of Modern Art, 1961).

13 Teaching at the California Institute for the Arts, Conceptualists John Baldessari and Michael Asher had a major impact on the development of visual art nationwide; Miriam Schapiro and Judy Chicago founded a feminist art program at CalArts in 1970, a year after Schapiro had formed the

first such curriculum at Fresno State College in Fresno, California; and Chris Burden and Bruce Nauman explored the implications of performance.

14 In her essay "Overcoming the Limits of Matter," Rosalind Krauss explicitly distinguishes Irwin and Turrell from the New York Minimalists. She dubs Light and Space the "California Sublime" in *Studies in Modern Art 1: American Art of the Sixties* (New York: Museum of Modern Art, 1991): 131, 133.

15 Occasionally I have seen other forms of 1960s art (principally Light and Space) referred to as the L.A. Look. However, I am using Anne Ayres as my authority. See Anne Ayres, "The Long Haul," in Lars Nittve and Helle Crenzien, *Sunshine & Noir: Art in L.A., 1960–1997* (Humlebaek, Denmark: Louisiana Museum of Modern Art, 1997), 164.

16 Ayres, "The Long Haul," 161.

17 Ibid., 164.

18 "Plastic" is a reference to Finish Fetish. Notes from telephone conversation with John Baldessari, Nov. 29, 1999.

19 Baldessari's students at CalArts included Ashley Bickerton, Barbara Bloom, Troy Brauntuch, Kate Ericson, Mel Ziegler, Eric Fischl, Jack Goldstein, Matt Mullican, and David Salle.

20 Notes from telephone interview with John Baldessari, Nov. 29, 1999. Baldessari remembers that Gallery A402 would appear on the resumes of prominent European artists, and people would assume that it was a prestigious art venue.

21 Other artists in the show were Chris Burden, Meg Cranston, Victor Estrada, Llyn Foulkes, Richard Jackson, Liz Larner, Manuel Ocampo, Raymond Pettibon, Lari Pittman, Charles Ray, Nancy Rubins, Jim Shaw, Megan

Williams, and Robert Williams.

22 Paul Schimmel, "Into the Maelstrom: L.A. Art at the End of the Century," in *Helter Skelter: L.A. Art in the Nineties* (Los Angeles: Museum of Contemporary Art, 1992), n.p.

23 Ibid.

24 Anne Ayres's essay for *Sunshine and Noir* lists numerous prominent L.A. artists just from the 1960s who do not fit into either category (Ayres, 161–69).

25 Davis's chapter heading is actually "Sunshine or Noir," underscoring the dichotomous nature of the idea.

26 Mike Davis, "Sunshine or Noir," in *City of Quartz: Excavating the Future in Los Angeles* (New York: Vintage Books, 1992), 18. Davis notes that Bertold Brecht thought that Los Angeles symbolized both heaven and hell.

27 Ibid., 15.

28 Ibid., 18.

29 In 1945 author Carey McWilliams drew a comparison between the Gold Rush in Northern California and "the real-estate-oil-and-motion picture boom" that shaped Southern California between the 1880s and the 1920s. Carey McWilliams, *Southern California: An Island on the Land,* as cited in Sam Hall Kaplan, *L.A. Lost and Found: An Architectural History of Los Angeles* (New York: Crown, 1987), 63.

30 Over the years L.A. has hosted publications such as (very briefly) *Artforum, LAICA Journal,* and *Visions,* but all of them have come and gone (*Artforum,* of course, to New York). We now have *Art Issues* and the North American edition of *Art and Text,* as well as energetic smaller efforts such as *X-Tra,* but these journals are few and are limited in scope.

31 Commercial interests, including some wealthy and

powerful dealers, bolster the New York art world, while Los Angeles's galleries, which number about a quarter of those in New York, are comparatively modest operations. Interestingly, the actual number of public dealers in Los Angeles was almost unchanged from 1989 to 1998 despite the increased commercial viability of the work produced here. According to the *Art in America* annuals for 1989–90 and 1998–99, there were 113 galleries in 1989–90 and 109 in 1998–99.

32 MOCA opened in 1983 in a downtown warehouse renovated by Los Angeles architect Frank Gehry. The structure, now known as the Geffen Contemporary, was conceived as a temporary facility but, due to its popularity, was made permanent. In 1986 MOCA opened its more formal main building on Grand Avenue. The same year, LACMA inaugurated the Robert O. Anderson Building for twentieth-century art, and in 1988 LACMA opened its Japanese Pavilion. Also in the eighties, the J. Paul Getty Trust established its various institutes, which were all fully operational by the end of the decade. The Armand Hammer Museum and Cultural Center opened to the public in late 1990. UCLA assumed management of it in 1994 and, under the university's auspices, it has had an eclectic program with a strong contemporary component. In late 1997 the extravagant new Getty Center opened to great fanfare.

33 L.A. dealer Rosamund Felsen recalls that MOCA was formed in response to the demise of the Pasadena Art Museum as well as to a perceived lack of support for contemporary art in general and L.A. art in particular at the Los Angeles County

Museum of Art (conversation with Rosamund Felsen, Santa Monica, Nov. 27, 1999). Collector Ruth Bloom, who ran galleries in Los Angeles from 1987 to 1995, believes that the situation continued into the 1990s. She remembers a meeting between local dealers and LACMA's curators at which gallerists expressed disapproval of the institution. Their response, she says, was "really about the museum disrespecting the value of what was happening locally." Bloom believes that the meeting, called by the museum, took place in 1994. Bloom ran Meyers Bloom Gallery from 1987 to 1992 and Ruth Bloom Gallery from 1992 to 1995 (notes from conversation with Ruth Bloom, Los Angeles, Sept. 21, 1999).

The Museum of Contemporary Art began with a strong representation of art from Los Angeles. In 1983, one out of the museum's two shows was Los Angeles based; in 1984, six out of twelve featured artists from L.A.; in 1985, five out of six did the same. Almost all of the museum's early series of one-person shows, "In Context," featured local artists. By the end of the decade, with the opening of the Grand Avenue building, the percentages had shifted. In 1988 approximately six out of twenty shows involved local artists; in 1989 one out of twelve; in 1990, three out of sixteen; in 1991, none of the fourteen exhibitions that the museum mounted were by L.A. artists. Between 1990 and 1997, MOCA averaged two to three exhibitions a year by Los Angeles artists out of approximately sixteen shows, a fairly strong representation.

From 1980 to 1997, LACMA averaged two exhibitions out of approximately twenty-five a year on Los Angeles art.

34 The very term "local artist"

was pejorative and it was not only museums that resisted it. Internationally known artists such as Ed Ruscha, who worked in L.A., also resented the label. He notes "a fear among artists, and I think rightly so, of being characterized by the city ... Some artists wince when they're described as L.A. artists ... I feel that most artists would be doing the same work if they lived ... anywhere else in the United States" (quoted in Amy Gerstler, "Art Attack," *Los Angeles* magazine, Nov. 1998: 102).

35 Michael Duncan, "L.A. Rising," *Art in America* 82, no. 12 (Dec. 1994): 72. Other important programs are at the University of California, Irvine, the University of Southern California, and the California State Universities at Long Beach, Northridge, and Riverside. The notion of the art schools cohering the L.A. art community has become something of a commonplace, although the way the schools function within the community is rarely analyzed. Recently, there have been several articles in the national press about this. See, for example, Andrew Hultkrans, "Surf and Turf," *Artforum* (summer 1998): 106–13, 146.

36 For example, Rachel Lachowicz states that her strategies for art making developed partly as a defense against the classroom critiques at CalArts. See Lynn Zelevansky, *Sense and Sensibility: Women Artists and Minimalism in the Nineties* (New York: Museum of Modern Art, 1994), 21. Rubén Ortiz-Torres's work also is in part a response to CalArts, which he characterizes as "a fundamentalist and dogmatic conceptual art school that did not allow me to create the paintings I wanted to make" (David Pagel, "Rubén Ortiz-Torres," *Bomb*

[winter 2000]: 19).

37 Telephone conversation with Judy Fiskin, July 5, 1999.

38 Telephone conversation with Alexis Smith, Nov. 4, 1999.

39 For an example of this, see Lynn Zelevansky, "No Title: The Work of Robert Therrien," in *Robert Therrien* (Los Angeles: Los Angeles County Museum of Art, 2000), 77, n. 91.

40 See Dave Hickey, *The Invisible Dragon* (Los Angeles: Art Issues Press, 1993). Hickey claims that in the American art world of 1988, beauty signified "the corruption of the market" (12–13).

41 Lynn Gumpert, "Beauty and the Beast," in *La Belle et La Bête* (Paris: Musée d'Art Moderne de la Ville de Paris, 1995), 101. Gumpert included four younger L.A. artists in her show: Doug Aitkin, Martin Kersels, Sharon Lockhart, and Catherine Opie.

42 This idea, originating in early modernism, was important for many influential artists of the sixties. It was what Frank Stella meant when he famously said, "My painting is based on the fact that only what can be seen there is there ... What you see is what you see." Bruce Glaser, "Questions to Stella and Judd," in Gregory Battcock, ed., *Minimal Art: A Critical Anthology* (Berkeley and Los Angeles: University of California Press, 1995), 158.

43 Jan Aviglos, "1995 Biennial, Whitney Museum of American Art," in *Artforum* 33, no. 10 (summer 1995): 100.

44 Ken Johnson, "Big Top Whitney," *Art in America* 83, no. 6 (June 1995): 39.

45 Ibid.

46 Ibid., 41.

47 Brooks Adams, "Turtle Derby," *Art in America* 86, no. 6 (June 1997): 35.

48 Peter Schjeldahl, "Ken Price's L.A. Edge," *Art Issues* 48 (summer 1997): 17. Schjeldahl's

take is positive; he finishes his thought: "and then, having done, realizing with pleasant surprise that every possible itch of thought has somehow been scratched." Nonetheless, it is remarkable how persistent this stereotype is.

49 Coplans's essay for *Five Los Angeles Sculptors: Sculptors Drawings/Los Angeles New York* (Irvine: Art Gallery, University of California, Irvine, 1966) is a case in point. It is very close in tone to Donald Judd's 1965 essay "Specific Objects" in *Art Theory,* Charles Harrison and Paul Wood eds. (Oxford, Eng., and Cambridge, Mass.: Blackwell Publishers, 1996), 809–13. Coplans claims that Finish Fetish artists are, like Minimalists, "without any group affiliation" or "programmatic bias," and that they do not draw inspiration from "earlier European geometric modes of expression." Like the New Yorkers, they suppress surface quality to the overall image, which is a single, sometimes repeated element. He also notes certain differences: the L.A. artists stress craftsmanship and create reflective surfaces that are "not renunciative as in geometric art, but highly sensuous and lyrical" (Coplans, Irvine, 3). Coplans says that the Californians' work is characterized by "an acute consciousness of the relationship between the observer and the locus of the art work" (Coplans, Irvine, 5). This idea actually anticipates Michael Fried's famous essay "Art and Objecthood," which appeared in *Artforum* in June 1967. *Artforum* was published in Los Angeles from Oct. 1965 to May 1967. Today Coplans is well known for his photography.

50 Hickey, *The Invisible Dragon,* 11.

51 Christopher Knight, "Crossroads/Gary Kornblau/

Looking at the Future with Influential Figures in the World of Arts and Entertainment," *Los Angeles Times,* Jan. 7, 1999. The interview marked the tenth anniversary of *Art Issues,* a publication with which Knight had been associated since its inception.

52 Dave Hickey, "Simple Hearts: American Cool," *Art Issues* (Jan.–Feb. 1999): 12. This statement is but one example of Hickey's tendency toward polemical excess.

53 Ibid., 13.

54 Gary Kornblau, "1965–1975: Reconsidering the Object of Art," *Art Issues* (Jan.–Feb. 1996).

55 Peter Schjeldahl, "Beauty Contest," *The New Yorker* (Nov. 1, 1999): 108.

56 In her recent book *On Beauty and Being Just* (Princeton: Princeton University Press, 1999) philosopher Elaine Scarry attempts to connect aesthetics with notions of ethics and democracy. However, as Stuart Hampshire notes in the *New York Review of Books* (Nov. 18, 1999), "justice is not open to the senses and is not material" and "there have been societies in which many beautiful things were created and enjoyed and in which republican values, and the rudiments of justice and fairness as we understand them, were unimaginable."

57 Hickey quoted in Todd S. Purdum, "Unsettling the Art World for a Living: A Critic Resurrects Beauty as a Standard and Finds It in Unexpected Places," *New York Times,* Sept. 4, 1999.

58 Sande Cohen, "Hide Your Commodification: Art Criticism and Intellectuals in Los Angeles or Language Denied," *Emergences: Journal for the Study of Media and Composite Cultures* 9 (1999): 357.

59 Margaret Morgan, "Theory in Practice," *X-TRA* 2, no. 4 (summer 1999): 20.

60 See Russell Ferguson, ed., *Hand-Painted Pop: American Art in Transition 1955–62* (Los Angeles and New York: Museum of Contemporary Art and Rizzoli International Publications, 1992).

61 See, for example, *Sense and Sensibility*.

62 See, for example, Lane Relyea, "Virtually Formal," *Artforum* 37, no. 1 (Sept. 1998): 126–33.

63 See James Meyer, "Nostalgia and Memory: Legacies of the 1960s in Recent Work," *Painting, Object, Film, Concept: Works from the Herbig Collection* (New York: Christie's, 1998). Meyer quotes Thomas Crow: "Consciousness of precedent has become very nearly the condition and definition of major artistic ambition" (32).

64 Donna Haraway, *Simians, Cyborgs, and Women: The Reinvention of Nature* (New York, Routledge, 1991), 150.

65 This approach could have been influenced by the previous generation, for whom postmodernism's critique of the author as an ideological construction (in the terms laid out by Roland Barthes and Michel Foucault) and of modernism's quest for authenticity and originality was widely influential.

66 The work of numerous artists could be cited. Some examples are Sue Coe, David Hammons, Byron Kim, Barbara Kruger, Sherrie Levine, Robert Mapplethorpe, Richard Prince, Lorna Simpson, Carrie Mae Weems, Fred Wilson, and David Wojnarowitz.

67 Kobena Mercer, "Intermezzo Worlds," *Art Journal* 57, no. 4 (winter 1998): 43.

68 Anthony Vidler, *The Architectural Uncanny: Essays in the Modern Unhomely* (Cambridge, Mass.: MIT Press, 1996), xiii.

69 Ibid.

Acknowledgments

David Joselit, Laurie Winer, and Paul Zelevansky read this essay in progress and made incisive comments. A number of individuals consented to be interviewed, lending their time and expertise to the project: I would like to thank John Baldessari, Ruth Bloom, Rosamund Felsen, Judy Fiskin, Peter Frank, Jacob Hashimoto, Martin Kersels, Paul Schimmel, Alexis Smith, and Judy Spence. I am also grateful to Carol Matthieu, curatorial administrator in LACMA's department of modern and contemporary art, who taxed an already busy schedule to provide crucial research, and to Thomas Frick, editor in the museum's publications department, who edited the essay with his accustomed skill and sensitivity.

HERE ... WHERE WE RUN OUT OF CONTINENT

Joan Didion

BORN FREE
AND EQUAL

PHOTOGRAPHS OF THE LOYAL
JAPANESE-AMERICANS AT
MANZANAR RELOCATION CENTER
INYO COUNTY, CALIFORNIA

BY ANSEL ADAMS

NEW YORK · 1944 · U. S. CAMERA

Ansel Adams, frontis-
piece and title page
from *Born Free and
Equal: The Story of
Loyal Japanese
Americans*, 1944
Mr. and Mrs. Allan C.
Balch Art Research
Library, Los Angeles
County Museum of
Art, © 2000 by the
Trustees of the Ansel
Adams Publishing
Rights Trust. All rights
reserved

Karin Higa and Tim B. Wride

MANZANAR INSIDE AND OUT:
PHOTO DOCUMENTATION OF THE JAPANESE WARTIME INCARCERATION

When U.S. General John L. DeWitt, head of the Western Defense Command, bluntly uttered the now-infamous remark "A Jap's a Jap . . . it makes no difference whether he is an American citizen," he summed up a prevailing attitude regarding race in the months immediately following the Japanese attack on Pearl Harbor. Sentiment, loyalty, identification, any kind of behavior that followed was presumed to derive not from individual agency or community expression but, a priori, from racial type. American citizenship was meaningless in the face of the Japanese race. After all, according to DeWitt, "You can't change him by giving him a piece of paper." On February 19, 1942, not two and a half months after the entry of the United States into World War II, President Franklin Delano Roosevelt issued Executive Order 9066. This order began the largest removal and confinement of citizens in the history of the United States, affecting all persons of Japanese descent living in the western states.

The events leading directly up to the incarceration of Japanese Americans began months before the official entry of the United States into the world war. As Americans across the country listened with shock and horror to the news of the attack on Pearl Harbor of December 7, 1941, the State Department had already begun preparing for war with Japan. Tensions between the two nations had escalated, and as early as September 1941, war had seemed imminent, and the question of Japanese American loyalty required analysis.[1] Envoy Curtis Munson was charged with investigating and assessing the loyalty of the Japanese American community in Hawaii and the mainland. Japanese immigrants were long considered unassimilable, both culturally and politically; even so, Munson's report concluded that the Japanese American community posed little threat to United States security. A small number of individuals in the different military districts could be classified as dangerous, but the Nisei (first American-born generation) showed "a pathetic eagerness to be

Americans"—which, in fact, they were.[2] By the morning of December 8, the
FBI had rounded up nearly 800 people in Hawaii and the mainland; by the
end of the year, the count would increase to 1,200—far exceeding the number
initially reported by Munson. No new intelligence emerged that would suggest
an increase in the potential for Japanese American espionage, and Munson
himself reiterated the conclusions of his report to the president in the days
following Pearl Harbor. However, the public outcry over Japanese military
action against a territory of the United States created a climate of fear and
hysteria that led the State Department to disregard its own findings.[3] All "alien
enemies" in the Western Defense Command Zone were ordered to surrender
cameras, radio transmitters, and shortwave receivers, and in the early weeks
of 1942, the FBI actively publicized in the popular media the seizure of "con-
traband."[4] Executive Order 9066 made no explicit reference to mass incarcera-
tion. Rather, it authorized the establishment of military areas where "any or
all persons may be excluded," and it stated that the control of these areas was
at the discretion of the military authorities.[5]

While the headlines of popular newspapers tracked the "Jap" victories in
the Pacific and eastern Asia, the fear of Japanese American espionage contin-
ued to be openly expressed, especially through the yellow-baiting publications
of the Hearst media empire. Among Japanese Americans, the question of
the community's future was hotly debated both in the public arena of the ver-
nacular presses and privately within the family unit. All the while, possession
of items that could suggest any tie to Japan—letters written in Japanese,
Japanese clothes, and, most significantly for visual historians, photographs
that depicted anything "Japanese"—were hastily thrown into the fire.

The first of the incarceration orders was issued in February 1942; it
affected the communities of Terminal Island in Long Beach Harbor and
Bainbridge Island in Puget Sound. Both communities were given forty-eight
hours to pack up and leave. By September 1942, all Japanese Americans living
on the West Coast were incarcerated, first in sixteen temporary detention
centers primarily located on the grounds of racetracks and fairgrounds in
California, Oregon, and Washington. By the end of 1942, all had been trans-
ferred to one of the ten concentration camps administered by a newly formed
civilian agency, the War Relocation Authority (WRA). Ultimately, more than
120,000 people served time in temporary centers and WRA camps.[6]

The images of the evacuation and internment process, much like the
process itself, were tightly controlled and surprisingly narrow in their scope
and in the manner in which they were disseminated. While newspapers and

magazines were provided relatively free access in their coverage of the evacuation procedure, by the time the assembly centers and then the concentration camps were in full operation, the images were strictly controlled by the military and the WRA. As a result, beyond the images that were included in newspapers, pamphlets, and editorials, the published photographic record of the largest civilian relocation in United States history is substantially contained in three disparate bodies of work: a "Pictorial Summary" that accompanied the *Final Report* of the Western Defense Command; Ansel Adams's exhibition and subsequent book *Born Free and Equal: The Story of Loyal Japanese Americans;* and two high school annuals, *Our World* and *Valediction*, produced in the camp at Manzanar.[7] This photographic record of the period, both official and personal, presents a complicated story, excessive in its accumulation of detail and yet wholly incomplete. Obviously, each body of work gives us a filtered glimpse of the experience: one from the military/government perspective, one from a private citizen given access by virtue of his standing as an artist, and one provided by the internees themselves. Also understandably, each in its own way deals in visual terms with the immediacy of the world war; the tumultuous upheaval precipitated by the social climate of California; and the economic, political, social, and personal crises that the process itself created. But while each selection of images has its own reason for being, its own manner of presentation, and its own agenda, there is consistency in some of the modes in which the images function.

In June 1943, a document bearing the official title *Final Report: The Japanese Evacuation from the West Coast, 1942*, was delivered to the office of Secretary of War Henry L. Stimson. Long awaited and once aborted, the report furnished a chronology and justification of the actions undertaken pursuant to Executive Order 9066.[8] The report covered the period of activity from the signing of the order until the WRA assumed authority over the relocation centers.

While the report was signed and submitted by General DeWitt, it was in great part compiled by Colonel Karl R. Bendetsen.[9] Bendetsen had previously strategized how the evacuation and incarceration of the Japanese American population could be accomplished without the hindrance of problematic issues of a strictly racist interpretation or of constitutional law. Bendetsen's plan rested on the issuance of Executive Order 9066—also authored by him—which would mandate the establishment of geographic areas from which any and all people could be excluded on the basis of "military necessity."[10]

The Western Defense Command was commissioned to formulate and implement the domestic strategies of the war effort in the western states. Its principal charge was to oversee the evacuation and incarceration of all citizens of Japanese ancestry from the coastal zones. It devised strategies of conduct and organization that, from its perspective, were critical to the national defense. Yet within those strategies were systemic flaws with regard to constitutional rights and ethics, and at the time of the report's publication, they were facing Supreme Court challenges. The *Final Report* was produced, therefore, both as a justification of the expenditure of resources and as an answer to judicial challenges.[11] The *Final Report* reasserted the justifications of the exclusion order: the interception of signals from shore to enemy submarines; arms and contraband found by the FBI in raids on the homes and businesses of ethnic Japanese; dangers to the ethnic Japanese from vigilante groups; concentration of ethnic Japanese around or near militarily sensitive areas; proliferation of Japanese ethnic organizations that might shelter pro-Japanese attitudes and activities; and the socially unsettling presence of Kibei (Nisei who were born in the United States but educated in Japan). The report then provided an overview of the Western Defense Command's deployment of resources to the assembly center operation.

Appended to the text of the *Final Report* was a seventy-seven-page "Pictorial Summary," consisting of photographs, each with an accompanying caption. Of the one hundred forty-nine images included in the report, ninety-two were gleaned from photography archives established by the U.S. Signal Corps, six from the Army Corps of Engineers, thirty-one from the Wartime Civil Control Administration, and two from the WRA. Eighteen additional images were supplied by West Coast newspapers and picture service agencies. While the images were for the most part taken by unidentified military personnel or by stringers, some were taken by well-known photographers, including Dorothea Lange, who was employed on the strength of her work with the New Deal agencies of the 1930s. The "Pictorial Summary" provides a photographic chronology of the Western Defense Command's operation. The summary documented the construction of the assembly centers, the process of notification and evacuation, the preparation and general administration of infrastructure systems, the work and recreation opportunities available to the inmates of the centers, and the construction and preparation of the subsequent relocation centers.[12] The framers of this visual monologue included images that most convincingly demonstrated the organizational efficiency and humanity of the evacuation effort on the part of the War Department. The

illustrations in the "Pictorial Summary" functioned much like those in an annual business report or in a traditional family album. The authors of the *Final Report* relied on the presumptive truth of the images as well as on the familiarity of the family album format to bolster the congratulatory and defensive tone of their summary.

The images of the "Pictorial Summary" were included in the *Final Report* to support the text. Besides providing evidence of the army's successful management of the situation, because the internment of Japanese Americans was both a political and a military crisis, images were selected for inclusion in the summary that would portray the command's efficiency as well as help mold favorable public and legislative opinion. The pictures lent an emotional and psychological immediacy to the facts as they were recounted in the report, and they illustrated not merely a series of events but the authority by which those events were undertaken. The assembly facilities are consistently photographed with an expansive symmetry and a rigid organization that recalls a modernist visual vocabulary. Photographs of communal kitchens, laundry rooms, and housing areas feature repeated elements that stretch row upon row toward a single vanishing point. These images are accompanied by captions that incorporate adjectives such as "modern," "essential," and "well-equipped."

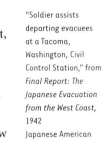

"Soldier assists departing evacuees at a Tacoma, Washington, Civil Control Station," from *Final Report: The Japanese Evacuation from the West Coast,* 1942
Japanese American National Museum, gift of Dr. and Mrs. Charles K. Ferguson (91.116.1)

The coupling and mutual reinforcement of image and text not only speak to the organization and care with which each facility was constructed but also imply the vast number of elements in other facilities similar to those pictured. The strategy seeks to celebrate and conflate the quality and the scale of the army's operation.

Because the photographs in the "Pictorial Summary" were organized in a manner reminiscent of a family album, the viewer is led through the narrative of the evacuation and internment process as if participating in some form of collective memory. The images repeatedly engage the viewer on a level that negates the tragic reality and consequences of the operation. The viewer is consistently met with smiling faces: smiling military personnel enforce the evacuation;

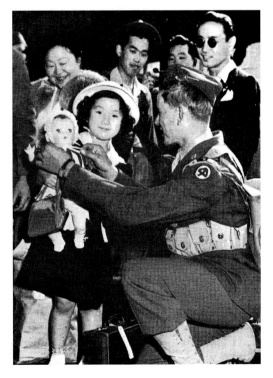

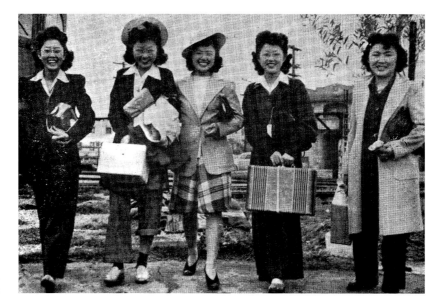

"Group of young Japanese girls arriving at a Long Beach, California, railroad station," from *Final Report: The Japanese Evacuation from the West Coast,* 1942 Japanese American National Museum, gift of Dr. and Mrs. Charles K. Ferguson (91.116.1)

smiling Japanese Americans are transported, baggage in hand, from their homes; smiling government agency workers assist in the disposal of assets; smiling groups of internees prepare domestic spaces, work, and play in the centers. The images testify to an overall sense of cooperation and camaraderie that pervaded the evacuation and internment process. They bespeak an efficient optimism and tacit agreement with the process and the situation by military and government personnel, as well as by the evacuees, who—rather than appearing to be forcibly and suddenly removed from their homes and businesses—seem to be embarking on a planned holiday excursion. The photographs deny any sense of personal or social hardship and serve to forestall criticism of mistreatment or unfairness. Above all, the images become witness to a cooperative undertaking in which those who have been incarcerated are both justifiable victims and willing participants.

And yet, despite this presumptive participation, the Japanese Americans are visually accorded neither the ability nor the need to participate in the management of their situation. Captions and images consistently attest to the control and stewardship of the evacuees by the army. A singularly overt example of military authority is seen in a full-page image of an unsmiling soldier looking directly at the viewer from a "watch tower," his back to the camp. The caption explains that the military presence provided "external security" and that the towers were "erected at strategic points and a watch kept for fires and other dangers."[13] The image, in conjunction with the coded caption, affirms one of the initial justifications for the evacuation and internment—fear for

the evacuees' safety. Additionally, it visually demonstrates an almost paternal-istic military control of the centers. This demonstration of control is woven into the entire "Pictorial Summary." Each spread of images features at least one reference to this control—whether in the appearance of a European American in an obvious position of oversight or in the inclusion of ubiqui-tous phrases such as "Caucasian supervision" or "is provided for the evacuees" in the captions. The exceptions to these parental reinforcements occur only in spreads that depict hobbies, sports, and other leisure activities, where not a single image or mention of "Caucasian" or "supervision" is found. In other words, the exceptions are situations that are viewed as more childlike and therefore nonthreatening to the military. The control the military asserted over the camps and the use of photographs taken of the camps shifted as the WRA assumed stewardship of the relocation centers—as they were now called. Cameras and other photographic equipment were still considered con-traband, but exceptions were being granted. Most notable were the exceptions made by administrator Ralph P. Merritt in the Manzanar camp, located in California's Owens River Valley.

"Guard on duty in watch tower at Tanforan (California) Assembly Center," from *Final Report: The Japanese Evacuation from the West Coast,* 1942
Japanese American National Museum, gift of Dr. and Mrs. Charles K. Ferguson (91.116.1)

By the time the evacuation process had begun, Ansel Adams, in the company of Edward Weston, Dorothea Lange, and Imogen Cunningham, was one of the most notable art photographers in California. As a founding mem-ber of Group f/64, he was perhaps the most vocal and high-profile proponent of an aesthetic that defined the course of art photography for two generations of American photographers. By 1942 his accomplishments and reputation as an educator, lecturer, writer, theo-rist, and activist placed him at the fore of a newly emerging American photographic elite. It is of interest, then, to observe Adams as he attempted to reconcile his art with his desire to contribute to the Allied war effort in the aftermath of the Japanese attack on Pearl Harbor.

Adams was ineligible for active duty when the United States entered World War II, although he did volunteer his services in ways that were linked to his knowledge of the Sierra Nevada Mountains and of photography. Because Yosemite Valley was being utilized at the time as a training destination for troop and equipment

deployments, Adams often found himself both tour guide and documentarian for the participating personnel. He was intermittently called upon to conduct training sessions in both field photography and darkroom techniques, and he also printed classified intelligence images of Japanese troop and equipment locations for Army Intelligence. However, while close friends Edward Weston and his wife, Charis, volunteered their time with the Civil Air Defense in Carmel and while pioneer photography curator Beaumont Newhall was on a tour of duty in Africa and Europe, Adams was frustrated in his attempts to make a substantive contribution. Certain that his efforts should include his photographs, he was at a loss to find a project that would have a meaningful impact as well as showcase his talent and artistry.

His opportunity arrived in the form of old friend and former Sierra Club cohort Ralph Merritt, who had recently taken over the administration of the Manzanar Relocation Center. Merritt "proposed a photographic project where I [Adams] would interpret the camp and its people, their daily life, and their relationship to their community and their environment. He said, 'I cannot pay you a cent, but I can put you up and feed you.' I immediately accepted the challenge and first visited Manzanar in the late fall of 1943."[14] The images that Adams produced during his trips to Manzanar in 1943 and 1944 were exhibited at the Museum of Modern Art, New York, in November 1944,[15] after having been previously displayed in the camp itself in January.[16] That same year, *U.S. Camera* published a book of photographs drawn from the exhibition, *Born Free and Equal: The Story of Loyal Japanese Americans*. Adams intended his images for "the average American . . . Throughout this book I want the reader to feel he has been with me in Manzanar, has met some of the people, and has known the mood of the center and its environment—thereby drawing his own conclusions—rather than impose upon him any doctrine or advocate any sociological action. I have intentionally avoided the sponsorship of governmental or civil organizations . . . because I wish to make this work a strictly personal concept and expression."[17]

However neutral Adams may have intended his images, and whatever measures he took to protect their neutrality, he was nevertheless an outsider presenting his viewpoint of the camp. Adams undertook the project with a personal agenda in mind, and his view was formed under the constraint of certain cultural and political assumptions. These assumptions affected the manner in which he conceived his images, as well as how they were received by his intended audience. Foremost among them was an innate trust in the official story, as relayed by government and military leaders.

Adams had overtly expressed his opinion that business was not to be trusted when he stated that "there is great opposition out here [in California] to all Japanese, citizen or not, loyal or otherwise, chiefly coming from reactionary groups with racial phobias and commercial interests. Of course the fact remains that an American citizen with assured loyalty has all the rights that you or I have, but the big-business boys have the unfortunate gift of vaporizing the Constitution when their selfish interests are concerned."[18] Adams's distrust of business, however, did not extend to government policy. He, along with the majority of the general public, easily accepted the concepts of military necessity and the possibility of an objective determination of "alien loyalty"—concepts that served as the primary justifications for the evacuation and internment. Adams grandly proclaimed that "the distinction between the loyal and dis-loyal elements must be made crystal-clear, and the emphasis on the Constitutional rights of loyal minorities placed thereon to support one of the things for which this war is all about. The War Relocation Authority is doing a magnificent job, and is firm and ruthless in their definitions of true loyalty."[19] In this light, the actions mandated by Executive Order 9066 were indeed unfortunate but nonetheless justifiable. Taken one step further, it could be rationalized that while the wholesale relocation of a group of primarily American citizens was a difficult and unfair solution during a time of war, it was also an understandable price to pay. Thereby, in a classic catch-22, unwillingness by Japanese Americans to accept the abrogation of their rights as citizens would call into question their very right to citizenship. In a 1943 letter to curator Nancy Newhall while in the midst of the project at Manzanar, Adams tacitly acknowledges this assumption when he describes his work as an attempt to "clarify the distinction of the loyal citizens of Japanese ancestry, and the dis-loyal Japanese citizens and aliens (I might say Japanese-loyal aliens) that are stationed mostly in internment camp.[20]

Using a narrative format that might also be classified as cinematic, *Born Free and Equal* incorporates a sequence of sixty-six images with accompanying captions and explanatory text. The material is presented in much the same way that a photographic essay might have been in a picture magazine of the period, such as *Life*. The structure of words and pictures is designed to lead the viewer in an expository manner toward a prescribed response and conclusion. In order to accomplish this, Adams arranged his images into three major sections, which are supported by smaller but strategic subsections that function as introductions, punctuations, and transitions to the whole. Broadly outlined, the larger sections consist of a series of landscapes, followed by a

section of genre images, and finally a suite of military portraits. It was important to Adams that his essay convey what he felt was the correct tone. As he remembered the process later, "I was profoundly affected by Manzanar. As my work progressed, I began to grasp the problems of the relocation and of the remarkable adjustment these people had made. It was obvious to me that the project could not be one of heavy reportage with repeated description of the obviously oppressive situation. With admirable strength of spirit, the Nisei rose above despondency... This was the mood and character I determined to apply to the project."[21]

The initial landscape section establishes location and functions as a leitmotif that surfaces intermittently throughout the entire sequence of images. This motif is also central to Adams's interpretive agenda: "I believe that the acrid splendor of the desert, ringed with towering mountains, has strengthened the spirit of the people of Manzanar."[22] Adams inserted this verbal affirmation of his belief in the spiritual power of the land in support of images consistent with those for which he had gained celebrity and artistic distinction. At the outset, he employs dramatic and majestic interpretations of the natural landscape of the Owens River Valley to indicate his position as an artist in the dialogue. Thus, he immediately establishes that *Born Free and Equal* is above all an expressive and artistic undertaking consistent with his work as a whole. From this perspective, the work escapes Adams's own damning classification of being mere documentary or reportage and therefore "barren of human or imaginative qualities."[23]

Adams's agenda—despite his previous protestations of neutrality—is sentimentally evinced in the frontispiece and title page, which depict a young Japanese American man pensively staring across a wide landscape in which cultivated fields give way to the foothills and mountains of the eastern Sierra. With the exception of the oblique reference supplied by the cultivated cornfield, there is no evidence of the camp in the image. Never in the entire essay

does the barbed wire that surrounded the camp or the surveillance guard towers that ringed the compound appear.[24] The mountains that stretch across the horizon seem to be the only barrier between the prisoners and their former lives. The image affirms the intimate relationship between the incarcerated Japanese Americans and the land, emphasizing the reflective longing of the lone figure who looks across the land back to his life before incarceration. The image provides a stoic psychological context for the pictures that follow.

The landscape section gives way to a long sweep of genre images that portray everyday activities and social situations with which Adams's audience would easily identify. Photographs of family life, work, education, recreation, worship, and community spirit are engineered to stress the commonality of those in the camps with those outside of them. Adams's agenda is furthered as he includes images such as that of a smiling young Japanese American girl, under which the caption "An American School Girl" appears. He signals his intent to reintegrate visually the people held at Manzanar with the general American population.

The genre section is punctuated throughout with single portraits, and it is interrupted twice by small three-picture sequences. The first is an extended look at members of a single family; the next is a character sketch of one young nurse shown in a formal portrait, a scene at work, and one at play. Viewers were thereby encouraged to relate to these people as personal acquaintances and to develop a sense of familiarity. A more substantial interruption to the genre section is an almost typological sequence of ten male portraits. Adams seems to be inviting both scrutiny and comparison in this suite of portraits. By highlighting each person's individual features, style, and character, Adams challenged his viewers to question their adherence to racial stereotyping.

The last, and smallest, of the sections is a series of six portraits of Japanese Americans in the military; these serve to integrate the Manzanar experience into the broader national experience of the war effort. If the earlier section sought to prove that not all Japanese Americans looked alike, here—using the

Ansel Adams, "An American School Girl," from *Born Free and Equal: The Story of Loyal Japanese Americans*, 1944 Mr. and Mrs. Allan C. Balch Art Research Library, Los Angeles County Museum of Art,

surest symbol of patriotic loyalty at the time, the uniform of the armed forces—he refutes the link between people of Japanese heritage and the enemy. In a coup de grâce, Adams ends his photo-essay with an uncaptioned portrait of a Japanese American man. Tightly cropped and directly facing the viewer, the image is confrontational in its severity. If one accepts Adams's statement of intent and his essay strategy, then this final image is a shaming appeal to the conscience of the artist's fellow citizens. Adams is challenging the dominant European American population to acknowledge its racial stereotyping and to provide for the reintegration of Japanese Americans into the social fabric.

Adams was both praised and criticized for his work at Manzanar. Dorothea Lange presented the most critical appraisal of his project, calling the ultimate result "shameful" in its timidity but acknowledging that "it was far for *him* [Adams] to go."[25] Yet the incarcerated Japanese Americans at Manzanar were for the most part very pleased with the work Adams did in the camps, even purchasing prints from the exhibition there.[26] The exhibition at the Museum of Modern Art in New York was well attended and even prolonged beyond the original closing date to accommodate public demand. Adams's photographs were the most notable extended body of images available to the public to portray the "realities" of life in the concentration camps until the work of Japanese American photographer and Manzanar inmate Toyo Miyatake came to light.[27]

Miyatake played an important role during Adams's visit to Manzanar, allowing Adams to use his darkroom and introducing him to both the physical site of the camp and the people. Photographs of Miyatake and his family are even featured in the exhibition and publication of *Born Free and Equal*. Miyatake was the de facto photographer of Manzanar. He had snuck a lens and film holder into the camp and found a carpenter friend who used a threaded pipe and scrap wood to construct a wooden camera secretly. In the initial months of incarceration, Miyatake photographed clandestinely with film smuggled from Los Angeles. The camps were laid out on grids designed to maximize order and surveillance and to minimize privacy. Each of the thirty-six "blocks" of Manzanar had communal latrines, a mess hall, and fourteen barracks, which, in turn, were divided into compartments housing as many as five families. Hence, it is not surprising that Miyatake's secret activities were easily discovered by the Manzanar administration. But rather than punish Miyatake, Manzanar director Ralph Merritt allowed him to set up an officially sanctioned photography studio as part of the comprehensive

inmate-run Manzanar Cooperative. The ironing building of Block 30 became
the home of the studio. To follow the letter of the law, which prohibited
the ownership and use of photographic equipment by Japanese Americans,
Merritt required that a European American activate the camera's shutter.
The official photographer was actually a series of people graciously lent by
Merritt's office who complied with instructions from Miyatake. After a few
weeks, Merritt abandoned this requirement, and Miyatake was essentially
free to photograph as he wished.

Born in Japan in 1895, Miyatake immigrated with his family to the
United States in 1909. At twenty-one, he began his formal study of photogra-
phy with Harry Shigeta, and he later opened his own photographic studio
in the Little Tokyo section of Los Angeles in 1923. Throughout the 1920s and
1930s, Miyatake took portraits and photographed weddings and funerals,
thus documenting Japanese American life. At the same time, he and other
Japanese photographers—many of whom were key members of the Japanese
Camera Pictorialist Club (Miyatake was not an official member)—produced
some of the more significant photographs in California.[28] Miyatake partici-
pated in international and national photography salons, photographed the 1932
Olympics as a correspondent for the *Asahi Shimbun,* and produced a remark-
able series of photographs of the choreographer Michio Ito.[29] Miyatake's asso-
ciation with the Shaku-do-Sha, an interdisciplinary group of painters, poets,
and photographers based in Little Tokyo and "dedicated to the study and
furtherance of all forms of modern art," provided a vehicle for discussion,
exhibition, and support for artists in Little Tokyo.[30] These activities included
exhibitions of Edward Weston's work during the 1920s. Miyatake's profound
and frequent connections with individuals and activities apart from the ethnic
enclave of Little Tokyo gave him a special position as both insider and out-
sider in his photographic practice.

In Manzanar, Miyatake's services were immediately sought out. The
studio essentially began where it left off before the war. The high demand
necessitated a system of rationing, whereby coupons were distributed to block
managers, who then disbursed these to families based on particular events:
weddings or the departure of a son for service in the U.S. armed forces ranked
high in priority. In addition to photographing family rites, Miyatake roamed
the camp and its environs in his trademark black beret making photographic
notes on the physical natural and built surroundings. The incongruity of a
fully functioning photography studio within the confines of a concentration
camp attests to the strange dichotomies that characterize the incarceration.

Matsuno, Hideko
Herbert Hoover
Matsuno, Isao
San Pedro
Matsuoka, Kiyoshi
Thomas Jefferson

Matsuoka, Lucille
Thomas Jefferson
Matsuzawa, Fumiko
Theodore Roosevelt
Minato, Mike
Los Angeles

Miyamoto, Frank
Theodore Roosevelt
Miyatake, Atsufumi
Theodore Roosevelt
Mizumoto, Michiko
San Pedro

Morimoto, Irene
University
Morita, James
Elk Grove
Motoike, Sam
Linden Union

Motoike, Sadao
San Diego
Murata, Mamoru
San Pedro
Nagai, Kazuko
Venice

Nagano, Aiji
Susan M. Dorsey
Nakaji, Kobei
San Pedro
Nakamura, Mitsuru
Theodore Roosevelt

Nakashima, June
Glendale
Nakashima, Sumiko
Theodore Roosevelt
Nakashima, Tadahiro
Thomas Jefferson

Nakata, Kenneth
Bainbridge
Nakayo, Yutaka
Venice
Nanashi, George
Elk Grove

Nishi, George
San Fernando
Nishimura, George
University
Niwa, Uzimoto
University

Noda, Haruko
San Fernando
Noda, Yasuko
San Fernando
Nomura, Ayako
North Hollywood

Nomura, Fujiko
University
Odahara, Grace
University
Ogawa, Chiyoko
San Pedro

Ogawa, Ernest
Theodore Roosevelt
Ogi, Haruko
Gardena
Ohara, Teiji
San Pedro

Our World, Manzanar yearbook, 1944 Japanese American National Museum, gift of Helen Ely Brill (95.93.2)

On the one hand, the government took great pains to exclude and incarcerate Japanese Americans, stripping them of the most basic civil liberties. On the other hand, the infrastructures within the camps simulated those of a free city.

When the high school initiated ambitious plans for creating a "real" yearbook, Miyatake and the studio were the crucial elements. The resulting publication embodied the first opportunity to see the comprehensive photographic record of Manzanar created by Miyatake. Over 1,000 copies of the yearbook were presold to the students and other inmates months before the publication; this group constituted more than 15 percent of the Manzanar population. The Manzanar High School was a responsibility of the camp administration and, as such, was an official arm of the WRA. The yearbook of 1944, *Our World,* has all the hallmarks of a midcentury high school annual, with only oblique references to the world war and the circumstances that produced this "city" in the desert. The voice of its teenage editors clearly emerges, as evidenced by the first sentence of the foreword, which begins by stressing that "the students and faculty have been trying to approximate in all activities the life we knew 'back home.'" And indeed, in what follows, the student editors of *Our World* strove to create in pictures and words a world seemingly unmarked by the ravages of war and the abrogation of rights represented by the incarceration. The students also explicitly aimed for *Our World* to be a "history book of Manzanar, with the school emphasized as the center of the community."

The yearbook represented a tremendous organizational and financial feat. Measuring twelve inches high and nine inches wide, its heavy stock cardboard cover and seventy-five pages convey an aura of stability and longevity at odds with the facts of Manzanar and the high school's

recent vintage. While funds were allocated for annuals as part of the school's budget, the student editors used their entrepreneurial skills (such as preselling the book) to leverage the initially modest amount of money. Despite the strong sense of student control, involvement, and funding, the fact remains that the yearbook bore a direct relationship to the official administration of Manzanar. The first fifty pages are devoted to the activities of the high school: the classes, activities, clubs, boys' and girls' sports. By and large, the layout and photographs follow the conventional language of a high school annual: the camp and school administrators are shown at their desks; pages of collaged photographs give the effect of snapshots taken throughout the year; and small head shots of smiling faces depict well-groomed youngsters in regulated rows. (One anomaly: under each student's photograph, after the name, a second line lists his or her "home" high school.) In the "Activities" section, the Baton Club is shown in full costume, the future farmers hold rabbits in their arms, a young journalist reads *Life* magazine, and students in the drama production are photographed performing.

The second section of the annual turns its focus on life beyond the high school. It begins with the section "Democracy," which bears the caption "democracy at work" under photographs of a town hall meeting of block managers (with an American flag prominently displayed on the wall), a group of Nisei soldiers, and the Manzanar police. The following pages cover "Industry," "Agriculture," "Religion," and other aspects of life in Manzanar. It is difficult to reconcile the severe and harrowing experiences of incarceration with a seemingly contradictory picture of utter normality. Inmates experienced anxiety about their future coupled with the daily reminders of their losses of freedom, livelihoods, and possessions, as well as (though unquantifiable) their dignity and sense of individual agency. Yet life proceeded in a hyperreal enactment of business as usual. In addition to the experiences of births, deaths, weddings, and funerals, there were inmate-run farms; a cooperative store; a research laboratory; the *Manzanar Free Press* newspaper; a garment factory; an orphanage; a hospital; an internal system of government; Buddhist and Catholic and other Christian churches; ball games; and an inmate-created garden. Representations of all these aspects of daily life were part of *Our World*.

Miyatake and his studio took the vast majority of the photographs in *Our World*, though a few images were supplied by Ansel Adams. The incorporation of both Adams's and Miyatake's photographs provides one way to track how the form of the yearbook presents a specific context that changes the

meaning of the individual image. High school yearbooks are about conventional stories: the exuberance of youth transformed through education and friendship into adulthood. *Our World* contains the self-conscious "memories" of the experience, already considered in the past tense, as the book simultaneously exists in the present. This conscious fashioning of the experiences of youth takes on greater weight in the context of the concentration camps. The incarceration was predicated on visual identification of the enemy. Japanese Americans, especially Nisei, internalized the surveillance of the outside world so that the performance of "Americanness" takes place at all times. Young Nisei were clearly aware that their ancestry marked them as different, a difference that was cast pejoratively. The success of Miyatake's contributions to *Our World* hinges on his canny ability to service his "clients"—the students—at the same time his photographs provide a richness of detail that heightens the irony that their "all-American" experience is taking place in confinement. In *Our World,* Miyatake avoids both direct critique and sentimental juxtapositions of signs of freedom with signs of containment. Instead, the photographs register as naive documentation, seemingly without artful constructions or a documentary edge that reveals hidden truths. In using the conventional language of yearbook illustration, Miyatake succeeds in highlighting what might be missed although in plain sight, producing implicit meanings in addition to creating conventional yearbook illustrations. The excess of information in the photographs duplicates the excessive attempts to be "normal" and, in the process, underscores the absurdity of the incarceration itself.

Our World, Manzanar yearbook, 1944 Japanese American National Museum, gift of Helen Ely Brill (95.93.2)

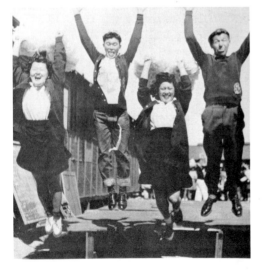

the classes

The ability of Miyatake's photographs to serve as more than artifactual documentation is made explicit by comparisons with other photographs of Japanese Americans in the camps. Restrictions against Japanese Americans owning or operating cameras continued, but by the middle years of the incarceration, snapshots, as well as formal photographs of camp activities, were increasingly common. It is unclear how many of these photographs were produced by Japanese Americans and how many were the work of European American staff or the camp administrations. While these

photographs succeed in capturing moments of individual and collective experience, they do not possess the formal rigor of Miyatake's work. Miyatake employs the standardized language of the snapshot and group picture, but in his emphasis on the telling details, the photographs contain an added layer of information, one that subtly critiques the experience.

The photo-essay that opens *Valediction*, the yearbook of the Manzanar High School class of 1945, demonstrates this skill and perhaps most explicitly reveals the ways in which Miyatake's photographs operate. Unlike the large-scale *Our World*, *Valediction* modestly documents the final graduating class of Manzanar. Its construction-paper cover and staple-bound pages lack the weight or ambition of *Our World*. Much had changed in the intervening year. The United States was clearly heading toward victory, and hostility against Japan was lessening. The all–Japanese American 442nd Regimental Combat Team's success and valor in Europe served as incontrovertible proof of Japanese American loyalty, resulting in a less fervent, less desperate emphasis on hyper-Americanism than had characterized the earlier year. With the exclusion orders authorizing incarceration officially lifted, the Manzanar population continually declined, as more inmates relocated to the Midwest and East. War would soon be over. Manzanar would cease to exist.

An elegiac tone tinged with a more nuanced criticality pervades *Valediction*. The first page features a Miyatake photograph of an empty road, curving and receding into dark shadows. The majestic peak of Mount Williamson towers over the solemn road. The following spread features this text:

In these years of strain and sorrow one may easily become discouraged and think of the future only as an empty dream. If we are to meet the world with its difficulties and trials, we must not let ourselves be
"Made weak by time and fate."
Rather like the mariners in "Ulysses" we must
"Be strong in will to strive, to seek, to find and not to yield."
So . . . to the Future with its joys and its sorrows . . . not to goals that are found only in the minds of youths but to the achievement of these goals this book is dedicated.

On the page facing this text, a photograph depicts in the foreground the wheel of a tractor whose spokes form an iron enclosure; in the background are the barracks and snowcapped mountains. A barbed wire fence, rough-hewn electrical poles, and the wires strung between them create a diagonal thrust that contrasts with the massive, rectangular forms of the barracks and

with the circular iron wheel. This interlocking web of barriers is captioned with the text "from 'Our World.'"

Turning the page, the viewer is confronted with the arm of a young person (the model was Miyatake's son Archie) holding a wire clipper—at the moment before cutting—to the taut barbed wire of a fence. A guard tower looms in the background. The caption reads, "through these portals." On the facing page, the caption continues, "to new horizons," with a photograph of a young couple stepping forward with a suitcase in hand. This attractive, well-dressed couple is shot from a low camera angle to suggest a fresh-faced monumentality. Miyatake is careful to situate the tableau in the physical context of Manzanar—the Manzanar sentry station is clearly visible.

In these pages, photographs similar to ones found in *Our World* take on new meaning through their clearly articulated and simple layout. The text alludes to the literal product of *Our World* and plays on its multiple meanings while explicitly raising the difficulties forthcoming for the inmates now that they must return to the hostile environment that had previously excluded them. Archie Miyatake recalls that his father created these photographs before it was decided to use them for the yearbook. It is clear that the photographs carefully craft a narrative of future ambiguity, enclosure, and isolation, followed by direct action and a hopeful future. All the while, the motifs and elements depicted in the photographs are the stock images that made up Manzanar. Miyatake uses these components, but through subtle manipulations of composition, camera angle, lighting, and sequencing, he creates another narrative that produces additional meaning.

The Manzanar High School yearbooks, Ansel Adams's *Born Free and Equal*, and the *Final Report* issued by the Western Defense Command each employ specific pictorial and format strategies. In each case, the formats contribute to the manner in which the images and the ideological intent of the publishers are received. These programmatic approaches capitalized on the fact that images in a sequence carry with them familiar and accepted responses that have been built up through their widespread use. Family albums tell a specific kind of chronological, genealogical, interpersonal, and relational history; scrapbooks and yearbooks convey a temporal and experiential narrative; annual reports and sociological studies rely on the photograph as a carrier of presumptive truth in order to support data pictorially. The choice of a presentation format is established as much by the organizer of the images as by the intended viewer. Each format produces specific responses that can be relied upon to produce a desired result.

And yet, as disparate as their appearances and intents may have been, all three of these pictorial records share a common element: an attempt to reconcile race and citizenship through visual representations in photographic form, almost in response to General DeWitt's callous remarks. The "Pictorial Summary" relied on the presumed truth of the photograph and on the familiarity of a chronological narrative format common to family albums to provide a straightforward assertion of the images as incontrovertible evidence and justification of the evacuation. Underlying this strategy is the assumption that race took precedence over citizenship in a determination of loyalty. In contrast, Adams emphasized the importance of citizenship over race, as he exploited the proselytizing nature of the narrative photographic essay format. By virtue of its consistent point of view, pictorial authority, and inductive movement from the specific to the universal, the essay inexorably elicits from its audience a preordained response. His essay addresses a crisis in social conscience that would allow the nullification of the rights of Japanese American citizens. Miyatake's photographic contributions posit the drive to retain an American identity in the face of assaults on personal liberty, property, and political identity in the camps. Miyatake captures the relentless optimism and belief in American ideals among the incarcerated. At the same time, his photographs hint at the self-conscious fashioning of young Japanese American identity.

Tim B. Wride is associate curator of photography, Los Angeles County Museum of Art, and an adjunct faculty member at California State University, Fullerton. He curated the exhibition *Retail Fictions: The Commercial Photography of Ralph Bartholomew Jr.* (1998). Forthcoming projects include *Tres Generaciones: Photography in Castro's Cuba* and *Pirkle Jones: A Retrospective.*

Karin Higa is director of the curatorial and exhibitions department and senior curator of art at the Japanese American National Museum. She organized the museum's exhibitions *The View from Within: Japanese American Art from the Internment Camps, 1942–1945* (1992) and *Bruce and Norman Yonemoto: Memory, Matter, and Modern Romance* (1999).

from "Our World"...

through these portals ...

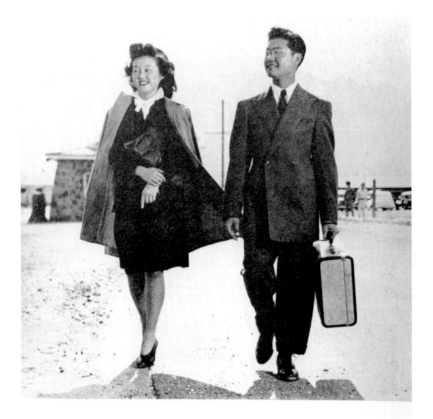

. . . to new horizons

1 Michi Weglyn, *Years of Infamy: The Untold Story of America's Concentration Camps* (New York: William Morrow and Co., 1976), 34.

2 Ibid., 41.

3 Ibid., 33–53.

4 Peter Irons, *Justice at War: The Story of Japanese American Internment Cases* (New York and Oxford: Oxford University Press, 1983), 30. The term "alien enemies" referred to Japanese immigrants, who were forbidden by law to become naturalized citizens, as well as to German and Italian immigrants.

5 Ibid.

6 A note on terminology: We use the term "concentration camp" to refer to the ten War Relocation Authority camps euphemistically called "relocation centers." Concentration camp is the preferred term of historians and was popularly used during the period by government officials including President Roosevelt and General Dwight D. Eisenhower. "Internment camp" refers to the Justice Department–administered camps created for the detention of "alien enemies." See Raymond Y. Okamura, "The American Concentration Camps: A Cover-up through Euphemistic Terminology," *Journal of Ethnic Studies* 10, no. 3 (fall 1982): 95–108.

7 *Final Report: The Japanese Evacuation from the West Coast, 1942* (Washington, D.C.: U.S. Printing Office, 1943). Ansel Adams, *Born Free and Equal: The Story of Loyal Japanese Americans* (New York: U.S. Camera, 1944). *Our World* was initiated by Manzanar High School journalism teacher Janet Goldberg and carried out by student editor in chief Reggie Shikami in 1944. A facsimile edition, edited by Diane Honda, was published with funds provided by the Civil Liberties Public Education Fund in 1998. *Valediction* was initiated and published by the Associated Student Body of Manzanar High School in 1945. It should not be forgotten that visual records in other media were produced in all of the camps. It must also be noted that additional photographic records were made, such as clandestine photographs taken by camp guards and staff, as well as images taken by other photographers working on in-house camp publications. These images, however, were distributed narrowly—if at all—and are not included within the scope of this inquiry.

8 Members of both the War Department and the Department of Justice were to have been accorded an approval of the report before publication. The original version of the *Final Report* met with opposition from Assistant Secretary of War John J. McCloy. Changes were made in order to obscure blatant racial references and stereotypes that had been inserted into the record by General DeWitt. After the offending passages had been amended, all original copies of the document were destroyed, and the revised version was resubmitted as the official version. (See Richard Drinnon, *Keeper of the Concentration Camps: Dillon S. Meyer and American Racism* [Berkeley and Los Angeles: University of California Press, 1987], 256–57). Representatives from the Department of Justice had concerns not only about the report's potential as a political liability but also about the wording of the report, which could have undermined their Supreme Court defense of the constitutionality of the evacuation-incarceration process.

9 Bendetsen was a civilian when the evacuation and internment strategy was formulated. By the time the *Final Report* was issued, he held the position of chief of the Aliens Division of the War Department, later becoming assistant chief of staff in charge of civilian affairs of the Western Defense Command.

10 Weglyn, *Years of Infamy*, 69–70.

11 For a complete analysis of judicial challenges to the evacuation and internment, see Irons, *Justice at War*.

12 In the case of the Manzanar facility, what initially began as an assembly center under the supervision of the Western Defense Command was subsequently continued as a relocation center under the administration of the WRA.

13 *Final Report*, 444.

14 Ansel Adams, *Ansel Adams, An Autobiography* (Boston: Little, Brown and Co., 1985), 258.

15 The exhibition *Manzanar: Photographs by Ansel Adams of a Loyal Japanese American Relocation Center* was not without its share of controversy and was ultimately held in a basement gallery of the museum. See Jonathan Spaulding, *Ansel Adams and the American Landscape: A Biography* (Berkeley and Los Angeles: University of California Press, 1995), 208–9.

16 The exhibition of Adams's images of Manzanar was held in the camp's Visual Education Museum, a converted barracks.

17 Adams, *Born Free and Equal*, 9.

18 Mary Street Alinder and Andrea Gray Stillman, *Ansel Adams: Letters and Images, 1916–1984* (Boston: Little, Brown and Co., 1988), 144.

19 Ibid., 144–45.

20 Ibid., 144.

21 Adams, *Ansel Adams: An Autobiography*, 260.

22 Adams, *Born Free and Equal*, 9.

23 Ibid., 112. Adams would emphasize this distinction throughout his career. He and Dorothea Lange worked together on a project for *Fortune* magazine in which they photographed "the flux of humanity in the great shipyards at Richmond, California." Speaking later of the project and of Lange, Adams noted, "At Richmond I was exposed to a cross-section of sheer brutal life that exceeded anything in my experience. Dorothea Lange and I worked on the interpretive problems for *Fortune*. Dorothea is a superb person and a great photographer *in her particular field*" [emphasis added]. See Alinder and Stillman, *Ansel Adams: Letters and Images,* 154.

24 Indeed, the use of images that included these elements was forbidden by WRA policy.

25 Karin Becker Ohrn, *Dorothea Lange and the Documentary Tradition* (Baton Rouge: Louisiana State University Press, 1980), 148.

26 "Pictures Available," *Manzanar Free Press,* Apr. 29, 1944, 2.

27 See Graham Howe, Patrick Nagatani, and Scott Rankin, eds., *Two Views of Manzanar: An Exhibition of Photographs by Ansel Adams and Toyo Miyatake* (Los Angeles: UCLA Wight Art Gallery, 1978). It should also be noted that the husband-and-wife photographic team of Hansel Mieth and Otto Hagel also produced a little-seen but highly praised body of work done under the auspices of *Life* magazine at the Heart Mountain Camp, soon after Adams's work was done at Manzanar.

28 See Dennis Reed, *Japanese Photographers in America, 1920–1945* (Los Angeles: Japanese American Cultural and Community Center, 1985); and Dennis Reed, "Southern California Pictorialism: Its Modern Aspects," in Michael G. Wilson and Dennis Reed, *Pictorialism in California: Photographs, 1900–1945* (Los Angeles: J. Paul Getty Museum and Huntington Library, 1994).

29 See Helen Caldwell, *Michio Ito* (Berkeley and Los Angeles: University of California Press, 1972).

30 Karin Higa, *The View from Within: Japanese American Art from the Internment Camps, 1942–1945* (Los Angeles: Japanese American National Museum, UCLA Wight Art Gallery, and UCLA Asian American Studies Center, 1992), 30.

Mark di Suvero,
Peace Tower, 1966
Courtesy of Paul
Karlstrom

Peter Selz

THE ART OF POLITICAL ENGAGEMENT

Ever since Immanuel Kant's categorizations, generally art has been confined to the aesthetic realm as a disinterested sort of discourse, disembodied from the social and political world. Nevertheless, there have been those who believed that, according to the tenets of men like Bertolt Brecht and Walter Benjamin, artists can be active participants in potential political change.

In the years after World War II free expression for artists and writers was repressed by blacklisting and imprisonment, instigated by the hearings of Senator Joseph McCarthy before the House Un-American Activities Committee. This pernicious censorship of art with political content was undoubtedly one reason for the singular emphasis on formalist art and art criticism during succeeding decades. There were, however, artists who evoked in their work the atomic bombings of Hiroshima and Nagasaki and the graphic disclosures of the Nazi death camps. Others felt the need to respond to the ever-present danger of nuclear war, the seemingly endless war in Vietnam, the race riots and political assassinations, with compelling, sharp-edged visual accusations. This was especially true on America's edge, in California, a state where political activism and critical dissent were increasingly prevalent, especially during the tumult of the 1960s.

Two Los Angeles artists who were pivotal in this regard—Rico Lebrun and Hans Burkhardt—immigrated from Europe. Lebrun (1900–1964) was born in Naples and studied classical antiquities, Renaissance frescoes, and Baroque buildings. In 1924 he left Fascist Italy; he worked in New York for several years and then came to Southern California in 1938. Before the war he had produced paintings and drawings of eloquent virtuosity. After the war, however, he felt compelled to communicate his grief about the horrors of war and human destruction. He set out to create a series of drawings and collages and a monumental triptych on the theme of the Crucifixion, which he used

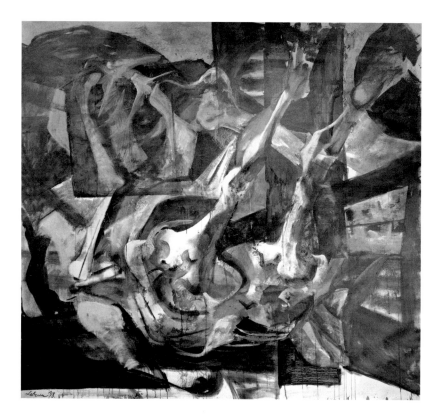

Rico Lebrun, *Study for Dachau Chamber,* 1958
Photograph © The Jewish Museum, New York, gift of Constance Lebrun Crown

in order to express human cruelty and suffering. To re-create the iconic subject of the death on Mount Calvary was certainly a courageous act for a twentieth-century artist, especially at a time when abstraction was de rigueur in American painting. The triptych and its studies were originally exhibited at the Los Angeles County Museum of Art in 1950, and a film was made of its installation.

This series was followed by Lebrun's response to an event of human agony in his own time. When he saw photographs of the victims of the Holocaust, Lebrun felt compelled as a painter to react to the event, knowing, as Susan Sontag later remarked, that photographs "do not keep their emotional charge."[1] Theodor Adorno, the politically engaged social philosopher of the Frankfurt school, subsequently declared in a famous remark that it would be barbarous to write poetry after the Holocaust,[2] and very few painters and poets dared to turn to it as a theme of their work. Lebrun wanted these pictures of agony and despair also to express the belief that "the human image, even when disfigured by the executioner, is grand in meaning."[3]

A painting such as the brutal *Study for Dachau Chamber* (1958) belongs to the great tradition in Western art from Francesco Traini's frescoes in Pisa

to the tragic works by Grünewald, Goya, and Picasso. Far from depicting the scene realistically, Lebrun placed the bodies in centrifugal motion. With a mid-twentieth-century conception of time, he made use of cinematic framing devices to link the thrusting and pushing bodies and limbs into a fragmented whole. He leaves it to viewers to decipher the meaning of these cataclysmic scenes. Lebrun had to immerse himself in this unspeakable tragedy because he was "first a man, second a draughtsman." He needed to "find out for myself that pain has a geometry of its own; and that my being, through a revulsion against all tolerable and manageable skill, wanted to speak out in a single shout."[4]

Hans Burkhardt (1904–1994) was born in Basel and came to New York in 1924, where he studied with Arshile Gorky and befriended Willem de Kooning. In 1937 he moved to Los Angeles, painting abstract canvases expressing conflict. Repulsed by the growth of Fascism in Europe and the suppression of free thought in Hollywood, he extended the structures of Abstract Expressionism into the realm of political engagement. During World War II he produced works like *War, Agony in Death* (1939–40). In this painting the central motif is a tank with a beastly humanoid figure emerging from it, which seems to ingest bones with its fiery mouth. In 1939 Burkhardt painted a gruesome work, *The Death of Hitler*. In 1941, years prior to the world's awareness of the extent of Nazi atrocities, he painted canvases of concentration camps. And long before Americans knew what was in store for the country, he hung Ronald Reagan in effigy in two spooky gray paintings, *Studio Scab (Ronald Reagan)* and *Ronald Reagan (Blood Money)*, both of 1945, when the future president of the United States served as president of the Screen Actors Guild and aided the McCarthy agenda before the House Un-American Activities Committee. The paintings reveal the artist's acute perception of and response to social and political issues.

During the Vietnam War Burkhardt made several apocalyptic paintings, such as *My Lai* (1968), in which a potent gray surface, covered by a heavy scraped and scuffed impasto, serves as the ground for a number of human skulls and parts of skulls, as well as a stamped Mexican crucifix, all embedded in the textured field. This work creates an unforgettable awareness of destruction and death. The series also includes a number of Monuments to Dead Soldiers, in which the artist, employing the Crucifixion theme, stuck rusty spikes onto the cross and painted a burst of flaming colors in the place of the crucified body. In an essay on Burkhardt's paintings of catastrophes Donald Kuspit argued that these images are "among the greatest war paintings—especially modern war paintings—made," summarizing "the brutality and

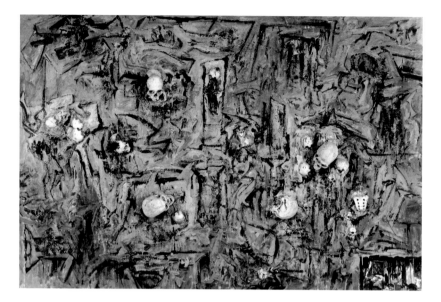

Hans Burkhardt,
My Lai, 1968
Courtesy of Jack
Rutberg Fine Arts, Inc.

inhumanity not only of the Vietnam War, but also of the twentieth century as a whole."[5] As the history of wars continued, Burkhardt continued to make powerful political paintings. Among the most poignant is the series called Desert Storm, in which he refigured the American flag by placing a Mexican crucifix, or rotten burlap, or crosses made of rope or rusty nails in the field reserved for the stars.

In Northern California at the time, Bruce Conner made highly significant narrative statements, both in films and in assemblages. Conner was born in McPherson, Kansas, in 1933 and arrived in San Francisco via Wichita, Brooklyn, and Lincoln, Nebraska. In the first of his many collage films, *A Movie* (1958), Conner's strategy was the appropriation of film footage from newsreels, westerns, girlie films, German propaganda, and other sources. The assembled images, which included the atomic blast at Bikini Island, resulted in a film that caused viewers to apprehend the speed, violence, and lust for power embedded in our culture.

Conner also used scavenged materials for assemblages such as *Child* (1959), which is the image of a shrunken, grotesquely gnarled, and mutilated man-child modeled in wax. The figure is wrapped in nylon hose and tied to a high chair; a horrendous cry seems to come from the hole that has taken the place of a mouth. This work was made in outrage at the death sentence given to Caryl Chessman. Chessman was arrested in Los Angeles for rape and robbery, but claimed that the confession he signed was due to police brutality. He was sentenced to death on a legal technicality. In spite of worldwide protest

and eight stays of execution, the State of California sent Chessman to the gas chamber. The death penalty is here reviled by Conner as a relic of barbarism that mocks society's claim to civilized status. This mordant sculpture is so disturbing that it is almost never on view at New York's Museum of Modern Art, which acquired it soon after it was made.

Born in San Francisco in 1934, Peter Saul studied at the California School of Fine Arts (now the San Francisco Art Institute) and returned to the Bay Area in 1964, after living and working in Europe for eight years. He remained in the Bay Area for another eight years and then moved on to New York and Texas. Upon his return from Europe, Saul discovered Day-Glo paint and decided that this bold pigment provided the appropriate vehicle for his polemical visual narration. His shrill, wild pictures, full of pornographic virulence and monstrous exaggerations, were meant to scandalize viewers—not an easy task when people saw the slaughter in Vietnam on the TV screen nightly. Enraged by the American atrocities, Saul started his violent antiwar paintings in 1965, focusing on rape, torture, and blood. "My idea of a soldier," he wrote in 1967, "is a dirty freak . . . his object is to get around the enemy, to sneak into his camp, rape his women, commit perversion on children . . . In my view [war is] a filthy pervert's game."[6]

Irving Petlin (b. 1934), who had studied at the Art Institute of Chicago and at Yale University with Josef Albers, arrived in Los Angeles in the 1960s to teach at UCLA. His art, deeply influenced by the sensibility and imagination of Odilon Redon, as well as by personal memory and contemplative fantasy,

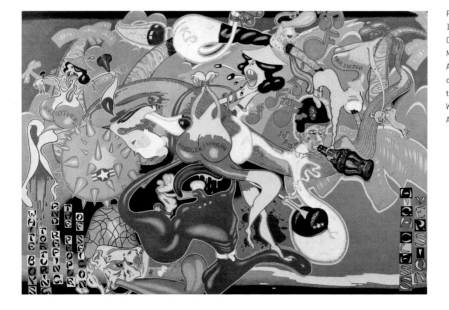

Peter Saul, *Saigon*, 1967
Collection of Whitney Museum of American Art, New York, purchase with funds from the Friends of the Whitney Museum of Art, 69.103

Irving Petlin,
The Burning of
Los Angeles, 1965/67
(one of four panels)
Photograph © 1994
D. James Dee

rarely turned to political statements. But living in Los Angeles in the mid-
sixties he "had this very strong feeling that this was a cauldron of racial sepa-
ration and hatred that would one day explode. [My wife] Sarah and I would
go to Watts to listen to music and dance. The last time we went there we were
the only whites and I knew that it was the last time we could come. I started
[*The Burning of Los Angeles*] shortly after; it actually was begun six months
before the Watts riots."[7] Artists may not have the gift of prophecy, but some
do seem to be able to sense the pulse of the time. This ambitious four-panel
polyptych (1965–67), measuring fifteen feet across, depicts black men in
positions of combative action. They are immersed in a surface facture that
suggests an eerie expanse of flames. Petlin's moral and aesthetic vision may
come across more strongly here because nothing is defined distinctly; it is
evocative on a more basic level.

Petlin was also a central figure in the group of artists who erected the
Peace Tower in Los Angeles in 1966. The tower was put up in a vacant lot at the
corner of Sunset and La Cienega Boulevards, very close to the lively art gal-
leries of the time—Eugenia Butler, Ferus, Felix Landau, Esther Robles, David
Stuart, and Nicholas Wilder. The tower was an undertaking of the Artist
Protest Committee, which a year earlier had been instrumental in placing an
advertisement in the *New York Times* protesting United States involvement
in the Vietnam War. Signed by 500 artists and critics, the ad ended with the
statement, "American artists wish once more to have faith in the United States.
We will not remain silent in the face of our country's shame."[8]

A large number of Los Angeles artists, including Larry Bell and Craig
Kauffman, joined Petlin. John Weber, then director of the Dwan Gallery, got
in touch with Mark di Suvero, who designed and constructed the *Peace Tower;*
shaped as a tetrahedron, it rose to a height of eighty-four feet. Petlin, Susan
Sontag, and the former Green Beret Donald Duncan spoke at the dedication.
Telegrams were dispatched by Jean-Paul Sartre, André Masson, and Matta.
Artists from all over had been asked to send small paintings to be mounted
on a 100-foot-long billboard at the foot of the tower. Depots were established
in various cities to collect the works, and over 400 panels were received from
artists of many generations. They included Rudolf Baranik, Paul Brach, James
Brooks, Philip Evergood, Judy Gerowitz (now Judy Chicago), Leon Golub,
Philip Guston, Eva Hesse, Donald Judd, Jack Levine, Roy Lichtenstein, Robert
Motherwell, Alice Neel, Louise Nevelson, Philip Pearlstein, Ad Reinhardt,
James Rosenquist, Moses Soyer, Raphael Soyer, Nancy Spero, Hedda Sterne,
George Sugarman, and Adja Yunkers. Petlin commented, "The idea of an

'offering' like this in a public place drew every kind of right wing maniac to try to destroy it. We defended the tower night and day against attacks, and were helped by a rotating gang of young men from Watts. The tower stood, not a single panel was damaged, and when our four-month lease ran out we had to take it down as no museum or public institution was brave enough to accept it as a gift."[9] It took five more years before *Art in America* finally reported on the *Peace Tower;* it was featured on the cover of the November-December 1971 issue, when public opposition to the war made the editors feel such prominence was safe.

Edward Kienholz (1927–1994), when approached to join in the production of the tower, refused to do so, "identifying, as many did, with the working-class macho GI."[10] But in 1968 he produced two significant antiwar installations, *The Portable War Memorial* and *The Eleventh Hour Final*. Kienholz was born in Fairfield, Washington, and grew up on the family farm. He worked as a hospital attendant, as a dance band leader, as a carpenter, and in a Las Vegas club. In 1957, in partnership with Walter Hopps, he opened the avant-garde Ferus Gallery in Los Angeles. He was self-taught as an artist, but having seen folk-art tableaux in churches and grange halls in rural Washington, he constructed *Roxy's* in 1961. This is a human-scale room, re-creating a Las Vegas brothel of the war years. A portrait of General MacArthur saluting hangs on the wall above grotesque and mangled mannequins of the madam

and the prostitutes, both dressed and naked. This work, he wrote later, was based on adolescent memories, but it may also be a product of a moralist working in the American puritanical tradition. Prior to *Roxy's,* Kienholz had also created a work relating to the Chessman execution. Punning on the Sacco-Vanzetti case, an earlier politically motivated miscarriage of justice, he called it the *Psycho-Vendetta Case.* As he commented on this piece, which called for audience participation, "It's just a box that swings open . . . and when you open it, it's Chessman shackled with just his ass exposed . . . and it says, 'If you believe in an eye for an eye and a tooth for a tooth, stick your tongue out.'"[11]

Kienholz proceeded to make other critical installations dealing with illegal abortions, youthful fornication, and the despondency of old age. Shocking in their realism, these tableaux are scathing narrative confrontations addressing social hypocrisy in terms reminiscent of the biting symbolism in Luis Buñuel's films. *The Eleventh Hour Final* (1968) represents an average living room, with wood paneling, table lamp, coffee table, and television set. A remote control is provided for the implicated viewer looking at the mute TV screen (which, however, cannot be changed). The screen displays the body counts of "American dead," "American wounded," "enemy dead," and "enemy wounded." The dismembered head of an Asian child with ominous glass eyes stares out of the console, which, made of concrete, resembles a tombstone.

Harold Paris, *Kodesh-Hakodshim,* 1972 Collection of the artist, courtesy of University of California, Berkeley, Department of History of Art

While Kienholz made narrative sculptural tableaux, Harold Paris's rooms were eloquently silent abstractions. For several years in the 1960s and 1970s he worked on a ritualistic reduction chamber, the *Kodesh-Hakodshim.* It was an environment of all the beautiful objects he could fashion, pieces of black and white rubber, mysterious forms cast in black and white Formica. Then, after an extended period of expending his mental and physical energy on this large work, he sealed it hermetically, an act recalling the funerary chambers of Egyptian kings. He intended it, as he said, to be a "mourning gesture for the losses of our time . . . Buchenwald, Vietnam, Kennedy, and King . . . faced with the morality of our

time I felt as an artist that I just couldn't make things on easels or stands any more.[12]

Protesting the war in a less esoteric and more direct mode, many artists turned to political posters to convey their messages. Whereas the civil rights and the free speech movements produced almost no expression in this medium, the Vietnam War sparked a great flood of political protest posters. The early ones were primarily silk-screen posters by individual artists, such as Rupert García at San Francisco State University and Malaquias Montoya at his Berkeley workshop. President Richard Nixon's incursion into Cambodia in May 1970 ignited not only nationwide protests but sparked the unprecedented production of antiwar posters, as community poster workshops were organized throughout the state. In Los Angeles some of the early workshops were Peace Press, Group Graphics, Mechicano Art Center, and Self-Help Graphics.

Perhaps the most compelling poster to emerge from this activity was based on Robert Haeberle's color photograph of the My Lai massacre, which had been reproduced in *Life* magazine, and an interview that journalist Mike Wallace had conducted with one of the killers. Irving Petlin, assisted by Fraser Daugherty and Jon Hendricks, produced the poster in offset color lithography with the legend *"Q: And babies? A: And babies"* overprinted on the death scene.

Fraser Daugherty, Jon Hendricks, and Irving Petlin, *And Babies?*, 1970
Courtesy of Peter Selz

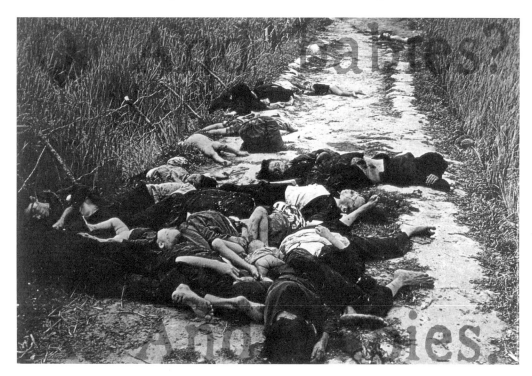

Fifty thousand copies were printed and distributed worldwide, some of them by the Art Workers Coalition in front of Picasso's *Guernica* at New York's Museum of Modern Art. Soon poster artists began addressing other political concerns, including feminism, racism, homophobia, and ecology. García's DDT (1969) shows a little girl crying and running through a large space that is the blue-gray color of smog, while the large letters DDT threaten her (and our) existence.

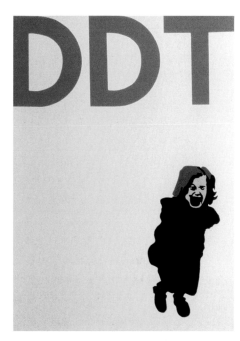

Rupert García, *DDT*, 1969
Courtesy of the artist

Susan Sontag has noted that "throughout the history of the poster, theatricality has been one of its recurrent values—as the poster-object itself may be viewed as a kind of visual theatre in the street."[13] This remark is even more true of street murals. The mural movement was very much a part of the rebellious sixties. It had its antecedents in the 1930s, when Los Tres Grandes painted murals in California: José Clemente Orozco at Pomona College in Claremont, David Alfaro Siqueiros on Olvera Street in Los Angeles, and Diego Rivera in San Francisco. Rivera, in turn, inspired muralists of the WPA and other federal art projects, exemplified in California by the once-controversial frescoes that were painted by some thirty San Francisco artists, under the direction of Victor Arnautoff, to decorate Coit Tower on Telegraph Hill. After a considerable lapse of time, muralism in the United States was revived by a group of black artists who produced the *Wall of Respect* on the South Side of Chicago in 1967 as part of the civil rights struggle. The public art of community murals quickly spread to California. A true grassroots phenomenon, the murals were made by Latinos, blacks, and women, often local residents working under the guidance of trained artists.

The early works of the mural renaissance, by Chicanos, were displays of the liberation from the colonialism of racial, class, and cultural oppression that had prevailed ever since California had been conquered in the Mexican-American War. Civil rights and pride in La Raza were among the main themes, as was the struggle of the farmworkers organized by Cesar Chavez. A strong and compelling example was *Emergence of the Chicano Social Struggle in a Bi-Cultural Society* (1969–70), done by Esteban Villa and a group of students in the Washington neighborhood of Sacramento. In the central section of the

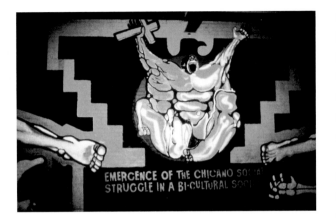

EMERGENCE OF THE CHICANO SO
STRUGGLE IN A BI-CULTURAL SOC

Esteban Villa,
Emergence of the
Chicano Social Struggle
in a Bi-Cultural Society,
1969–70
Photograph by Robert
Sommer

mural, we see the black eagle of the farmworkers with a multicolored man emerging from its body. The man, echoing the posture of the crucified Christ, has his arms raised toward the sky, and he holds a cross in one hand.

Soon, as one observer reported, "hundreds of murals appeared on a variety of surfaces such as fences, garage doors, windows, and most frequently on walls. These painted surfaces were covered with a profusion of images and symbols in bright colors relating to gang warfare, drugs, the Catholic Church, police brutality, oppression, Mexico, nationalism, war, education, the family, the farmworkers, revolution, and Chicano independence."[14] By 1974, murals were accepted in the art community. A group of Chicano artists calling themselves Los Four (Roberto de la Rocha, Gilbert Luján, Frank Romero, and Carlos Almaraz), who incorporated images of the barrios in their work, were given an exhibition at LACMA, and official government agencies recognized murals as part of the percent-for-art programs.

There was political art in galleries and museums, posters were everywhere, and there were murals on the walls of the cities—but there was still the sky. When in 1968 students near the campus of the University of California at Berkeley attempted to turn an empty lot into a park, they were ejected by the police, and the battle for People's Park became a focal point of student protest and resistance. A large number of people were injured, and a rooftop bystander was mortally wounded by the National Guard. Many students and a large number of faculty demonstrated. Governor Ronald Reagan ordered the National Guard to drop tear-gas bombs on the demonstrators. Sam Francis, a concerned alumnus as well as a celebrated painter, hired a helicopter to fly over the demonstrators and the police. The banner flying from its tail read, "Let a Thousand Parks Bloom."

Peter Selz is professor emeritus of art history, University of California, Berkeley. Among his many books are *German Expressionist Painting* (1957), *Art in Our Times* (1981), and *Beyond the Mainstream* (1997).

1 Susan Sontag, introduction to *The Art of Revolution: Castro's Cuba, 1959–1970* (New York: McGraw-Hill, 1970), xxi.

2 Theodor Adorno, *Cultural Criticism and Society* (London: Neville Spearman, 1964), 150.

3 Rico Lebrun, statement in Peter Selz, *New Images of Man* (New York: Museum of Modern Art, 1959), 97.

4 Ibid.

5 Donald Kuspit, *Catastrophe According to Hans Burkhardt* (Allentown, Pa.: Muhlenberg College, 1990), n.p.

6 Peter Saul, "Letters to His Dealer," in *Peter Saul* (New York: Allan Frumkin Gallery, 1986), n.p.

7 Irving Petlin, letter to the author, May 1999.

8 *New York Times,* June 27, 1965.

9 Petlin, letter to the author.

10 Paul Wood et al., *Modernism in Dispute: Art since the Forties* (New Haven, Conn.: Yale University Press, 1993), 118.

11 Edward Kienholz, *Edward Kienholz,* interview by Lawrence Wechsler, 2 vols. (Los Angeles: Oral History Program, University of California, Los Angeles, 1977), 223–24.

12 Harold Paris and Sheila B. Braufman, "Kaddish for Little Children," in *Breaking the Mold: Harold Paris's Legacy of Innovation* (Berkeley: Judah L. Magnes Museum, 1995), 12.

13 Sontag, introduction to *The Art of Revolution,* x.

14 Marshall Rupert Garcia, "La Raza Murals of California, 1963–1970: A Period of Social Change and Protest," master's thesis, University of California, Berkeley, 1981, 74.

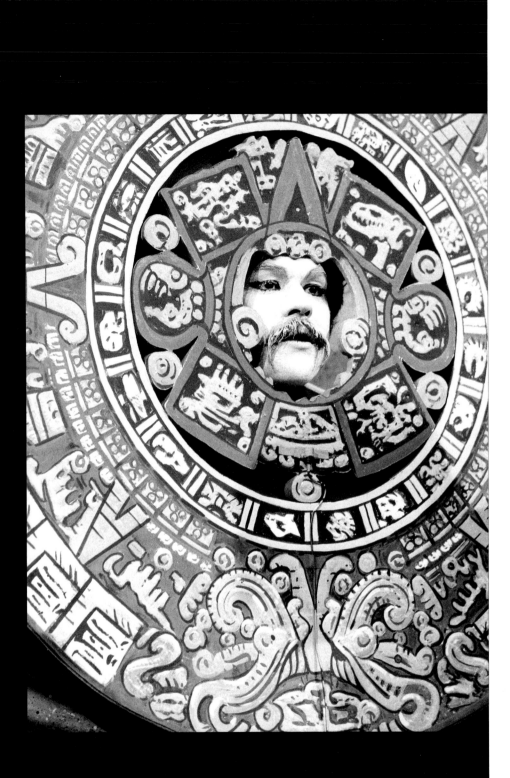

Luis Valdez in Aztec
calendar, from the
film *Los Vendidos*,
1972
Photograph courtesy
of the artist

Chon A. Noriega

FROM BEATS TO BORDERS:
AN ALTERNATIVE HISTORY OF CHICANO ART
IN CALIFORNIA

in 1492, an Aztec warrior
named Noctli Europzin Tezpoca
departed from the port of Minatitlán
with a small flotilla of wooden rafts.
3 months later
he discovered a new continent
& named it Europzin after himself.
in November 1512,
the omnipotent Aztecs
began the conquest of Europzin
in the name of thy father Tezcatlipoca
lord of cross-cultural misconceptions

Guillermo Gómez-Peña, "Califas"

The wall bore freshly painted skulls at opposite ends, which grinned ironically in
the darkness, appearing briefly as the headlights of speeding cars illuminated
them and the slogan which spanned the entire length of the wall.
The police officer demanded a full explanation and an immediate confession.
The slogan was painted to resemble the bold headlines of a newspaper:
YANQUIS DEPORTED! EUROPE SINKS!

Harry Gamboa Jr., "No Alibi"

First things first. Cause, then effect. But what if our commonsense history was wrong, not as a matter of interpretation, but simple chronology? What if absurdly hypothetical statements put things in the right order—Z came before Y came before X, and the other letters never happened—yet every document proved otherwise, leaving you and your history undocumented? Would you take a giant eraser and erase the U.S.–Mexico border?[1] And then what would you draw, if not another line in the sand?

If the opening passages by Guillermo Gómez-Peña and Harry Gamboa Jr. appear outrageous, they also suggest the difficulty of writing alternative histories.[2] By their very nature, such histories upset the order of things, introducing a complicating "meanwhile" to the existing chronology. Meanwhile, other things were happening . . . For Gómez-Peña and Gamboa, then, the history of Chicano art in California requires more than the straightforward presentation of overlooked facts. In order for that "meanwhile" to be taken into account and become an integral part of the history that is told, historiography itself must be challenged. Toward that end, both artists backdate California history to the Conquest of Mexico. In this manner the nation-state ceases to be the measure of all things; or, at the very least, U.S. territorial claims are made relative to the prior claims of the indigenous, Spain, and Mexico. But Gómez-Peña and Gamboa also rewrite the Conquest of Mexico so that it provides an allegorical reversal of power relations, a sort of "shoe on the other foot" speculation. What if the Aztecs conquered Europe? What if Anglos were deported to Europe? But what makes this rhetorical strategy particularly noteworthy is that it is offered as historical commentary: Gómez-Peña's poem served as the narration for Philip Brookman's documentary on Chicano art in California, *Mi Otro Yo (My Other Self)* (1988); and Gamboa's absurd narrative about a Chicano on the L.A. freeways was published as an opinion piece in *New Art Examiner* (1991). While not vested in an empirical past, their "fictional" writings aim at nothing less than changing the historical thinking that underpins our contemporary social relations and public policies.

In the end, both artists are engaged in a two-step between identity politics and the dominant culture, content with neither extreme, yet finding in each a necessary starting point. Their allegorical reversals are an attempt to make this dialectical relationship visible, if not transparent, but only so that it can be subverted. In the three case studies that follow, I consider similar instances of such a "two-step" in Chicano art of California: a Chicano film in the Beat tradition in the 1960s, the rise of Conceptual art in East Los Angeles

in the 1970s, and public art along the U.S.–Mexico border in the 1990s. In each instance the artists challenge historical thinking, in large part by subverting this dialectical relationship between identity politics and the dominant culture as well as the one between the barrio and the art movements that seemed to pass them by like the freeways that cut through East Los Angeles.

"YOU MUST IDENTIFY YOURSELF"

In 1959 *Pull My Daisy* ushered in a brief period of underground film rooted in Beat aesthetics—with its inherent clash between disengagement and celebrity, spontaneity and posing. Produced by Robert Frank and Albert Leslie, the film depicts a rather romantic and clichéd slice of bohemian life in which beatniks, a bishop, and jazz musicians descend upon the apartment of a railroadman and his family. By way of spontaneous poetry, musical performance, and philosophical "blowing," the film pits the heterosexual domestic sphere against homoerotic male bonding out on the town. Jack Kerouac provides the voice-over narration, based on his play about Neal Cassady's home (*The Beat Generation*), while the film itself features Beat writers Allen Ginsberg, Gregory Corso, and Peter Orlovsky, as well as painters Larry Rivers and Alice Neel. *Pull My Daisy*—along with John Cassavetes's *Shadows* (1959)—was a commercial and critical success, inspiring Hollywood knockoffs as well as independent feature productions from Shirley Clarke to Andy Warhol.[3]

In 1966 Fresno native Ernie Palomino's own film, *My Trip in a '52 Ford*, marked an end to Beat poetry and underground film, signaling the way in which the Beats lost ideological force with the rise of diverse social protest movements by the mid-1960s. In the process, it also offered a eulogy to the extensive and unacknowledged presence of Chicano writers and artists in and around that movement: Omar Salinas, José Montoya, John Rechy, Palomino himself, Luis Valdez, and Oscar Zeta Acosta, just to name a few. These Chicano writers had either studied under more established Beat poets or been influenced by their work; and, in many ways, the Beats provided a necessary counterbalance during the Chicano writers' own transition from barrio to college. By the mid-1960s, however, Chicano writers would reject Beat disengagement and postwar avant-garde aesthetics in favor of the Chicano civil rights movement and an aesthetics rooted in cultural nationalism. The connection between the Beat and Chicano art movements—one that can still be heard, for example, in any poem by José Montoya ("El Louie" [1972] being the most famous)—never made it into the history books, as scholars of each movement articulated self-contained and sui generis borders.

Since Luis Valdez's film adaptation of the poem *I Am Joaquin* (1969), the notion of a Chicano cinema has been framed within the political discourse of the Chicano civil rights movement. In fact, despite earlier Chicano-produced works, *I Am Joaquin* is considered the "first" Chicano poem and film because it established this context and exerted a profound influence on the emerging Chicano political rhetoric and cultural politics of the late 1960s and early 1970s. Throughout the 1970s Chicano filmmakers and collectives worked within a binarism of reform and revolution, on the one hand advocating access to U.S. television stations and film studios, while on the other hand theorizing their work as the "northernmost expression" of New Latin American Cinema.[4]

In the same period, however, a different type of Chicano film practice was taking shape that neither sought access to the industry (reform) nor rooted itself in a radical politics (revolution). Instead these filmmakers produced low-budget films drawn from personal or local experience and situated within the context of the American avant-garde or "underground" film. Inspired by Sheldon Renan's *An Introduction to the American Underground Film* (1967) as well as by regional screenings of avant-garde films, Chicanos were among the "fantastic numbers of people" who started shooting and screening their own underground works in the late 1960s and early 1970s.[5] Renan defined the underground film as a "dissent" located in personal expression and noncommercial practices:

The underground film is a certain kind of film. It is a film conceived and made essentially by one person and is a personal statement by that person. It is a film that dissents radically in form, or in technique, or in content, or perhaps in all three. It is usually made for very little money, frequently under a thousand dollars, and its exhibition is outside commercial film channels.[6]

The underground film, as David E. James notes in *Allegories of Cinema*, has been faulted for its "repression of a materialist analysis of society and culture" in favor of disengagement.[7] Even so, these films did generate alternatives to Hollywood and society at large, most notably in Beat subculture, Warhol's Factory, and the personal films of Maya Deren, Stan Brakhage, and Jonas Mekas, among others. But given its antithetical positioning, as James argues, underground film did not so much become an autonomous and authentic cinema as it did a "countercultural activity" deeply engaged with and extremely vulnerable to Hollywood.[8]

While Chicanos faced a similar dynamic, wherein their resistance was subject to recuperation within the dominant culture, racial and cultural

difference complicated matters in two ways. First, Chicano filmmakers quickly found that their rejection of the commercial cinema would not be coopted, assimilated, and commodified. Second, their largely unacknowledged participation in the avant-garde revealed the underlying limits of its own stylistic and thematic heterogeneity vis-à-vis Hollywood. In both cases, what Chicanos came up against was the fact of racial homogeneity. Perhaps for these reasons, Chicano underground filmmakers often registered a critique of the very styles they used. Severo Perez's *A Day in the Life: Or Mozo, an Introduction into the Duality of Orbital Indecision* (1968) parodies the trance film by making the usual somnambulist a marijuana smoker. Ernie Palomino's *My Trip in a '52 Ford* uses racial masquerade and anthropomorphic furniture in his Beat poetic narrative. And Willie Varela democratizes the lyrical film by chronicling his vision of the Chicano domestic sphere.[9]

While scholars continue to locate the alternative cinemas of racial minorities either after or outside the canonical underground period (1959–66), there has been a rediscovery of an increasing number of exceptions. These include Raphael Montañez Ortiz's recycled films of the late 1950s (made from newsreels and Hollywood Westerns), William Greaves's *Symbiopsychotaxiplasm: Take One* (1968), and the works of Palomino, Perez, and Varela.[10] Still, several factors resist efforts to see avant-garde and ethnic cinemas as coincident rather than as sequential, not the least of which is that these filmmakers' work does not appear to fit the cultural logic of later ethnic cinemas but, rather, belongs to the existential subjectivity of underground film. In fact, with the exceptions of Ortiz and Varela, most of these filmmakers became "ethnic" by deciding to leave the avant-garde and shift to ethnic-identified documentary and narrative by the end of the 1960s.

In this respect *My Trip in a '52 Ford* offers an appropriate coda to the Beat underground film, a period David James ends in 1966, citing the summer release of Warhol's *The Chelsea Girls* and the eruption of riots in Chicago, New York, and Los Angeles.[11] Palomino's film expresses a Beat critique of materialist culture in its allusion to John Clellon Holmes's Beat novel *Go*, its jazz score and Beat poetic narration, and its depiction of San Francisco's nightlife and the "square" workaday world. But it also captures the ambivalence of nonwhite participation in the Beat movement. In fact, Palomino would later reject his work between 1960 and *My Trip in a '52 Ford* as *gabacho*, or "white" art—dismissing this work for its reliance on found-object sculpture and Beat poetry—and dedicate himself to teaching in a Chicano studies program at Fresno State College.[12] An extended reading of the film will reveal

the underpinnings of this ambivalence and its significance for Chicano and Beat art histories.

My Trip in a '52 Ford, Palomino's M.A. thesis project at San Francisco State College, uses his found-object sculpture as characters in a Beat narrative set in San Francisco. The twenty-six-minute film begins with Mary Go, a 1952 Ford, being driven by Palomino until she breaks down, whereupon she is liberated from pure functionalism ("at last I'm free"). The voice-over, accompanying shots of a junkyard, explains that her parts are reincarnated as various children, who will be the main characters of the film: George Go, a "grotesque truck" made from a car radiator and golf bag; Dorothy Dresser, a prostitute made from a dresser and sink; Carol Chair, a housewife made from a chair covered with dishes; Steve Stove, a marijuana-smoking Beatnik made from a stove; and the Great Wild Bird, fashioned from the hood ornament, which acts as a messenger for the "Great Go Father" (a sort of Beat god invoked near the end of the film). The irony, of course, is that most of these "children" are made from furniture and not the '52 Ford.

As it follows the course of a day, the film provides character sketches, usually by having each child meet and comment upon the next one, but also through poetic voice-over descriptions. The Go children are identified as "ghosts" of their social and mechanical functions within the terms of traditional gender roles. The film depicts a series of oppositions along these lines. Whereas George Go—described in the voice-over as a caricature of the "idea of an automobile"—embraces functionalism, Steve Stove exemplifies Beat disengagement, proclaiming, "No hope-ah without dope-ah." Dorothy Dresser and Carol Chair play their roles in terms of male needs and desires, the former described as a prostitute, the latter as a traditional housewife.[13] In this way, the film acts out a square-Beat dichotomy for the male and female characters. But despite these differences and even conflicts, the Go children assert their sameness, insofar as their design and character are determined by the social roles they play. As Carol Chair says about the dishes and saucers attached to her, "their function is a part of my design." In the film's climax, the Great Wild Bird appears before a stoned Steve Stove and pronounces itself the "true ghost," since it "does not reflect a character" as do the others. As the manifestation of "all that intellectually is visual," the Great Wild Bird asserts its essential difference: "We are not the same, Steve Stove." What is interesting here is that the film places the Beat characters under the same critique as the straight ones: both are delimited by their social roles; neither has access to the transcendent realm signified by the Great Wild Bird.

The film's denouement depicts scenes from different parts of San Francisco the next morning. Steve Stove is shown on a downtown sidewalk, as white office workers walk past him in wonder. The film then cuts to the junkyard, where black workers crush and cut up cars. There, Mary Go again proclaims, "At last I'm free, now I am going as I please, soon we shall be one again." This statement is explained in the next scene, where Palomino's project—the basis for the film—is presented as a Beat fiction involving actual actors. On a building rooftop, a "Chinese student" named Jesse Wong confronts a "Negro janitor" named Bill Chair (Carol's husband). Wong, played by Palomino, is trying to reassemble Mary Go and her children into a trailer. He sings, "My trailer is a sweet chariot coming for to carry them home." When Bill, played by a white actor, calls him crazy, Jesse responds, "No, we're not, we're the same, Bill Chair," and the film ends. The final credits appear over a shot of Palomino's MFA exhibition of the found-object sculptures used to depict the Go children.

The film's message of "sameness" reduces both character types and racial classifications to a question of role playing, offering a satire of Beat exceptionalism itself.[14] In many ways the film identifies the gender biases and race-based class fantasies that underpinned Beat nonconformity and disengagement. The irony of Palomino's refrain, "We're the same," echoes within a movement that proclaimed its categorical difference from society but used that society's own racial stereotypes in order to establish that difference.[15] In confronting Bill Chair—the white "Negro" as ostensibly working-class but also as homonym for the chair of Palomino's department—Palomino likewise engages in racial masquerade as a "Chinese" student. His declaration of sameness conflates his receipt of an advanced degree (when the student is accredited the "same" as the chair) with the racial masquerade of the Beat poets. Like Steve Stove, who had what the Great Wild Bird called a "queer relationship with the Go family," Palomino was somewhat at odds with the Beats. His own racial difference precluded using racial difference as a metaphor for dissent by disengagement. Neither white nor black, Palomino refused the demand of the Great Wild Bird—that "you must identify yourself"—answering instead, "We're the same."

While *My Trip in a '52 Ford* marked the end of Palomino's so-called *gabacho* period, it also established the terms upon which he would be identified as a Chicano artist by none other than Luis Valdez. In a three-page interpretation, Valdez called the film "a brilliant work of art," linking it to the Chicano movement because it rejects ethnic classification: "It is not, perhaps,

the vision that one would expect from a 'chicano' artist, but its very rejection of ethnic (or any other) classification identifies it as a work created by a man very much concerned with the entire question of identity."[16] For Valdez, the film moves beyond the "moralistic platitudes" about the "oneness of man," replacing such liberal humanism with the "oneness of everything." In so doing, he asserts the arbitrariness of race, but as a physical and metaphysical insight, not a moral and political one. Having localized humanist discourses within the universe, and thereby identifying the particular and the universal as never more than human responses to the universe, Valdez ends by explicitly linking particular concerns about racism to universal ones about human creativity. It was a subtle maneuver within liberal humanism itself, one that allowed one Chicano artist to advocate another for speaking about the human condition and the world at large:

Palomino's concept of existence frees people as well as things to be something other than function, routine or habit would dictate. Thus a rusting '52 Ford may become a mother, a man can be husband to a chair, a white can be a black, Palomino can state (as he does in the film credits) that his film was written by J. P. Wong, etc.

In a sense, the film is one Chicano's response to a world that tried to stereo-type him. In a greater sense, it is a human response to everything in life that restricts the creative spirit of the universe. And that is a greater trip than most of us have ever taken in a '52 Ford.[17]

However, it is a trip taken but once. In his interpretation, Valdez read Palomino's abstract narrative as a Chicano response because it addressed the spurious nature of any and all classification systems, including race. Valdez's own work followed the same transcendent impulse but employed a very different strategy, proclaiming the universal appeal and relevance of his own culture-specific narratives: *Los Vendidos: The Sellouts* (1972), *Zoot Suit* (1981), *La Bamba* (1987), and *La Pastorela: A Shepherd's Tale* (1991). If Valdez could appreciate Palomino's work as a Chicano response, Palomino did not, nor did there appear to be an audience for either Palomino's film or Valdez's interpretation (which remains unpublished). In a sense, they both defied classification and paid the price. The work of both Palomino and Valdez was soon subordinated to their locations within the identity-based sectors of educational institutions and the film industry. In the words of the Great Wild Bird, "You must identify yourself." And when they did, they could not be Beat.

ORPHANS OF MODERNISM

In the United States there is the Conceptual art that started in the museum and the one that remained outside. Recent publications have complicated this history.[18] One neglected strand within politically motivated Conceptual art traces its origins to East Los Angeles in March 1968, when 10,000 high-school students staged walkouts—which they called "blowouts"—in protest against racist school policies and inadequate education. For the next two and a half years these and other protests for social equity were met with police provocation and biased media coverage, culminating in the police riot at the Chicano Moratorium against the Vietnam War on August 29, 1970. That event, which resulted in the fatal police shooting of journalist Ruben Salazar, was duly filmed by the Los Angeles County Sheriff's Department and then broadcast in edited form on local television during live coverage of the inquest hearings. It is out of this training ground that Chicano Conceptual art—as well as Chicano cinema—emerged.

In 1972 Harry Gamboa Jr.—who had been an organizer of the blowouts and became a writer in the midst of the moratorium—approached the Los Angeles County Museum of Art (LACMA) about including Chicano art in its exhibitions. Knocking on doors, he finally reached a curator who promptly told him, "Chicanos don't make art, they're in gangs."[19] That night Gamboa returned with Gronk and Willie Herrón, and the three artists

Asco, *Spray Paint LACMA,* 1972
Photograph © 1972
Harry Gamboa Jr.

Asco, *Walking Mural,*
1972
Photograph © 1972
Harry Gamboa Jr.

spray-painted their signatures on the museum itself. In claiming the museum
as their Conceptual art, they achieved the first Chicano exhibition at LACMA,
albeit one that could not be inside LACMA.[20] The museum became at once a
Chicano art object and the product of Chicano gang activity. The conundrum
of exhibiting the museum inside the museum provided the perfect allegory
for keeping Chicano art outside the museum's walls: such things are simply
impossible.

The next day Gamboa photographed Patssi Valdez standing beside the
signatures. The photographic document did not enter the museum, nor did
it circulate in the mass media; rather, as neither beauty nor truth, *Spray Paint
LACMA* (as both document and action) hovered somewhere in between, as
the four artists developed a Conceptual art that not only placed the idea over
the object but insinuated various actions into conflicted and restricted social
spaces in East Los Angeles.

These four artists formed the Conceptual-art group Asco (1972–87).
The group's art had neither the imprimatur of museums nor the support of
the art market. If in Conceptual art the idea prevails over the object, documen-
tation nevertheless secures that idea to the object-driven system that Concep-
tual art challenges. And so, for the most part, Conceptualism has been an
insider's critique articulated through a well-documented exhibition history.

But Chicanos were excluded from the museum. Thus, with the exception of *Spray Paint LACMA*, Asco turned from the museum to the streets, from the art world to a community engaged in social protest.

In the early 1970s Asco members engaged in Conceptual art that was notable for the way in which it recoded so-called "subversive" acts—street protest, graffiti, leaflets—as performance, a move that allowed the group to reclaim public space, articulate a political critique, and have its message circulate within public discourse.[21] At the time, police had restricted Chicano public space, first by provoking several demonstrations against police violence, then in the cancellation of the annual Christmas parade in East Los Angeles. In response, Asco staged two Christmas Eve processions down Whittier Boulevard, wherein last-minute shoppers were caught in an impromptu communion between consumerism and death. In the first, *Stations of the Cross* (1971), Pontius Pilate aka Popcorn (Gronk), Christ-as-*calavera* or skeleton (Herrón), and a zombie/altar boy (Gamboa) walked one mile among the confused and hostile consumers before placing a cardboard-box cross at the final station, a U.S. Marine recruiting station, blessing the site with unbuttered popcorn. The pun on "stations" conflated Christianity and Vietnam around the trope of a spiritual sacrifice in the name of consumerism—hence, *station* as social position, a place for service, and a bastion against communism. But Asco also planned the event as an intervention against the newspapers and television stations that glossed over the political upheaval and social unrest in East Los Angeles. In the end, *Stations of the Cross* found another mode of communication that could circumvent the mass media: the informal one of rumor and innuendo that attended the performance.

The following year, Asco turned its attention to Chicano nationalism itself, parodying the static quality of its mythology, iconography, and politics as represented in muralism. In *Walking Mural* (1972), Asco members marched down Whittier Boulevard dressed as absurd mural characters: Patssi Valdez as the Virgen de Guadalupe-in-Black; Willie Herrón as a mural consisting of multiple faces; and Gronk as an X-mass Tree made from three inverted chiffon dresses. Gamboa filmed and photographed the procession. The performance critiqued muralism as an inadequate strategy for reclaiming public space, especially given the incongruity between the usual mural images from the Conquest of the Americas and the present-day social drama that unfolded in front of them on the streets. In a wry commentary, Herrón's tortured mural faces—perhaps a veiled reference to the tripartite "mestizo head" then used by artists to symbolize the racial mixture of Spanish and indigenous people in

the Americas—become so bored with their place within the racial mythology of Chicano nationalism that they walk off the wall and into the streets.

The performance also presented characterizations that suggested how nationalism occluded issues of gender and sexuality within the Chicano movement. But Asco did not simply try to reform Chicano identity by questioning the authenticity of nationalist stereotypes or by adding more social categories to the mixture. In other words, Asco did not attempt to supplant the Virgen de Guadalupe with the more "authentic" Chicana of their day—the late 1960s "Jetter" dressed in black, who used high fashion and fast language to resist the role of victim. Nor did Asco try to supplement the traditional gender roles of the Chicano movement's straight and gay *veteranos* with its own style of youth-oriented "gender diffusion." Instead, *Walking Mural* argued for both and neither by collapsing these contending images onto each other. Thus, Patssi Valdez became the Virgen de Guadalupe-in-Black, while Gronk's X-mass Tree embodied an elaborate pun that placed taking up a minority identity (ex-mass) within a secular-cum-camp version of Christmas, Catholic mass, and mass culture. In the same way that Gamboa worked with verbal puns in his written work, Asco's performance broke with the naive realism that undergirded cultural nationalism, with its search for the real Chicano and the right politics, and presented Chicano identity as performative.

But, it is important to note, Asco did not imply that Chicanos performed identity, with the inference that one can choose better or worse roles to play. In fact, what makes the group distinct is that it was not vested in identity politics in the first place. For Asco, what made Chicano identity performative was not that it named itself against all odds as an act of defiance, but that it was constituted within a set of social relations largely defined by the mass media and the corporate liberal state. As such, Asco saw identity as less a question of form and content—that is, a proper name—and more a question of the context for speaking and being heard. Straight description would not work because of the ways in which the public had been conditioned to receive information.

Asco refined its politics of negation by turning its attention to the Chicano civil rights movement's efforts to integrate the mass media and thereby change the national imagination. In the early 1970s, Chicano student activists and would-be filmmakers promulgated "Chicano cinema" as a way to bring positive images of Chicanos to the film medium. While a broad-based media reform movement resulted in minority public affairs shows on network and public television between 1968 and 1974, Chicano cinema never quite made it to Hollywood. For its part, Asco went for a special effect that

had no apparent cause, replacing Chicano cinema with the No Movie. As
S. Zaneta Kosiba-Vargas explains, "Asco understood that racial discrimination
limited their access to the American television and film industry and
responded by creating and promulgating the illusion of success against a
backdrop of Hollywood-style glitter and glamour."[22]

The No Movies took various forms, although always with Gamboa's
camera in mind: performance pieces, published interviews, mail art, and
media hoaxes. The latter included press packages for nonexistent films and
events sent to European and Latin American newspapers. The stories were
then picked up and recycled by U.S. newspapers otherwise indifferent to cul-
tural events in the barrio, thereby reaching a potential international audience
in the millions.[23] For the most part, the No Movies isolated a single 35 mm
image as if it were a still from an actual movie and thereby conjured up the
"before" and "after" of an implied narrative. Gamboa often placed explana-
tory texts beneath these images, in the same way that the LAPD had done to
secure a narrative to its visual evidence against Chicano activists, himself
included. These No Movies were then photocopied and distributed, often with
the phrase "Chicano Cinema/Asco" stamped across the front, identifying them
as artifacts of an otherwise unseen ethnic film movement. Asco could thus
forgo the cinematic apparatus but still use cinematic discourse (as circulated
by the press and word of mouth) in order to "project a concept" before a
global audience.[24] These efforts insinuated themselves into the mass media,
operating like a computer virus, the glitch in the system that, however briefly,
reveals the system as system.

If Asco questioned the idea of the media as inherently objective, it
did not so much reject truth claims as identify them as rhetorical strategies
within public discourse. As Gamboa explains about the No Movies, "They
were designed to create an impression of factuality, giving the viewer informa-
tion without any of the footnotes."[25] Or, as Gronk notes, "It is projecting the
real by rejecting the reel."[26] Central to this attempt to project the real was a
political investment in form itself. In this way, the No Movies share affinities
with Sheldon Renan's notion of "expanded cinema," wherein "the effect of
film may be produced without the use of film at all," an idea developed fur-
ther by Gene Youngblood.[27] In contrast to expanded cinema, however, Asco
was not after the mere "effect" of cinema but, rather, a conceptual critique of
minorities' limited access to the mass media. As Gamboa explains: "It was
sort of like a political protest based on the economics of financing films, and
also based on the reality that maybe I only did have five dollars."[28]

BUT WITH TEN DOLLARS . . .

It is always about money and power and the way in which they circulate through institutions. From the vantage point of California, it is apparent that the "border conflict" of the late twentieth century evinced a two-part shift in museums and public culture. In the first part, rights-based movements opened up the electoral process and social institutions, culminating in the Civil Rights Act (1964) and Voting Rights Act (1965), then followed by a state-sponsored and state-regulated public sphere within which to accommodate this inclusiveness, most notably through affirmative-action programs. But this intervention actually spread much farther, from the creation of public television to increased support for the arts, neither of which was particularly diverse or inclusive. If civil rights legislation resulted in universal rights and suffrage, the state played an equal role in expanding the public sphere to incorporate racial and sexual minorities now granted the rights of full citizenship. But it did so in a calculated way that maintained class and racial stratification: in effect, white middle-class artists went to the National Endowment for the Arts (NEA); minority and working-class artists went to the Comprehensive Employment and Training Act (CETA). When these distinctions broke down in the early 1980s, largely due to the dismantling of CETA and similar programs, the culture wars began.

In the second part, a market-based approach to social issues emerged in the late 1970s and has been official state policy since the 1980s. Ironically, while government support for the arts decreased, its significance increased, serving as the staging ground for ideological conflicts over the public sphere. Racial and sexual minorities received the lion's share of the attention in the press and public debate, but the real change had less to do with minorities per se than with the role of the federal government in securing public institutions to serve a diverse nation. In short, inclusion required either more space to accommodate the new groups knocking at the door or that whites accept the possibility that the public sphere they once claimed as their own might no longer be their exclusive domain. The former proved economically unsustainable, first in a Cold War economy and, then, a global one; the latter proved politically untenable for a still largely white electorate.

It is within this context that censorship of the arts emerged as a defining issue in the late 1980s. While these struggles have been well documented as a cultural war between the Left and Right over public funding, what remained unnoted was the implicit assumption that expression and censorship were the mirror image of each other, not just in a given case, but in all instances.

In other words, all would-be censors were alike and could be lined up on one side of the border, while the art community was all alike and could be lined up on the other side of the border. By the late 1980s, however, arts advocacy shifted strategy from a defense of free expression to an economic rationale for the arts sector and its governmental support. Function determined existence: the NEA annual budget is equivalent to the amount spent by the Pentagon in five hours yet provides a needed stimulus to the $3 billion non-profit arts industry, an industry that employs 1.3 million workers and generates $5.4 billion in local, state, and federal tax revenues. Framed in this way, such an argument was congruent with that of groups against affirmative action and immigration: any notion of a social function or of the commonweal is replaced by the market. Once advocates started arguing for art on the basis of its tax revenue, their appeal, while directed at the political representation system, essentially linked aesthetics to corporate liberalism.

This congruence, more than anything else, explains why the arts establishment rejected *Art Rebate,* the 1993 public-arts work in which David Avalos, Elizabeth Sisco, and Louis Hock refunded $10 bills to 450 undocumented workers along the border between San Diego and Tijuana. Based on the fact that such workers pay more in taxes than they receive in public services, *Art Rebate* used the refunds to stimulate public discourse over the role of immigrant labor in the economy and social imagination. The heated controversy over *Art Rebate* signaled the end of the expression/censorship paradigm, exposing its underlying racial exclusiveness, while it also brought Avalos's career as a border artist full circle.

In 1984 he had been instrumental in the formation of the Border Art Workshop/Taller de Arte Fronterizo (BAW/TAF), which articulated an "art of place" along the San Diego–Tijuana border.[29] Border art was quickly coopted as a concept used at the national level to provide a language with which social institutions and governmental agencies could step down from besieged civil-rights policies based on addressing the needs of discrete minority groups. In this respect border art served the purposes of institutional multiculturalism, even though it had emerged to represent the experiences of Chicanos and undocumented Mexican workers. In short, it gave a new patina of racial diversity to general funding categories that still favored the mainstream institutions, most notably in the *La Frontera/The Border* exhibition at the Museum of Contemporary Art in San Diego. The museum had borrowed BAW/TAF concepts and language, but only belatedly included members in the actual planning.[30] The concept of the border also provided a language for corporate capitalism,

explaining the new global conglomerates in benign terms, while also weaving together Fordism and flexible accumulation—or, in terms of consumption, mass and niche marketing. In other words, everyone could make "a run for the border," as Taco Bell urged, even if some had a more difficult time crossing.

Avalos had left BAW/TAF in 1987, but he remained committed to an "art of place" along the U.S.–Mexico border. In *Art Rebate,* he and the other artists directly addressed the cooptation of "border art" as a defunding concept for minorities, while they raised the stakes within the ongoing censorship debates. The *New York Times* took the bait. In a vehement editorial it argued that whereas Mapplethorpe was an "outrageous but legitimate artist," Avalos and company were a "small bunch of loonies" who threatened to undermine liberal efforts to defend the rights of real artists. What was unreal about this art—that is, what made it "non-art"—is that it raised issues of racism and immigration in relationship to cultural capital at precisely that moment when the art world was subordinating its advocacy of free speech to the same economic rationale used for nativist and nationalist ends. Rather than erase the border, Avalos, Sisco, and Hock drew out its underlying conflicts and complicities, declaring that it was here that art belonged.

David Avalos,
Elizabeth Sisco, and
Louis Hock, *Art Rebate*
transaction receipt,
1993
Photograph courtesy
of the artists

David Avalos,
Elizabeth Sisco, and
Louis Hock, *Art
Rebate,* 1993
CNN reporter inter-
views "undocumented
taxpayers"
Photograph courtesy
of the artists

CONCLUSION

Chicano artists have had a significant involvement in the avant-garde since at least the 1960s. If I drew a distinction earlier in this essay between the barrio and the major art movements, I also used an ambivalent metaphor, likening these movements to the freeways that cut through East Los Angeles. If their purpose was to bypass the barrio in order to reach other end points, they did so in a rather painful way. It is little wonder, then, that Chicano artists associated with the civil rights movement of the 1960s and 1970s would reject both the academic and avant-garde styles of their day and turn to an aesthetics rooted in cultural difference. But not all artists. As did other Latino experimental filmmakers, Ernie Palomino worked within the avant-garde, placing his own self-representation into critical dialogue with his peers' racial masquerade. Asco concerned itself with the two forces then limiting social mobility and self-representation in the barrio: the mass media and the police. David Avalos, Elizabeth Sisco, and Louis Hock continued this project in the 1990s, using art in order to incite public discourse on immigrant labor and taxes. In the process they also exposed the racial presumptions inherent in the art world's own struggle against censorship of public-funded art projects—projects paid for, in part, by undocumented workers. But above all, these various artists attempted to subvert the border that separated their work from other art practices and that separated the Chicano community from the national imagination. In that sense, their work challenged the historical thinking that kept these things apart.

Chon Noriega is associate professor of critical studies, Department of Film and Television, University of California, Los Angeles. He has curated art exhibitions for the Whitney Museum of American Art, the Mexican Museum, and the Santa Monica Museum of Art, among others. He is the author of *Shot in America: Television, the State, and the Rise of Chicano Cinema* (2000) and editor of six books, including *Urban Exile: The Collected Writings of Harry Gamboa Jr.* (1998) and *I, Carmelita Tropicana: Performing between Cultures* (2000).

1 As Gronk proclaimed in an 1980 interview, "On two separate TV appearances I declared that I would erase the Mexico/U.S. border with a giant eraser." See Harry Gamboa Jr., *Urban Exile: Collected Writings of Harry Gamboa Jr.,* ed. Chon Noriega (Minneapolis: University of Minnesota Press, 1998), 47.

2 Guillermo Gómez-Peña, "Califas," (1987), in *Warrior for Gringostroika* (St. Paul, Minn.: Graywolf Press, 1993), 67–74; Harry Gamboa Jr., "No Alibi" (1992), in *Urban Exile,* 458–61.

3 See David E. James, "Underground Film: Leaping from the Grave," in *Allegories of Cinema: American Film in the Sixties* (Princeton, N.J.: Princeton University Press, 1989), 85–165; and Parker Tyler, *Underground Film: A Critical History* (1969; reprint, New York: Da Capo Press, 1995).

4 Jesús Salvador Treviño, "Chicano Cinema Overview," *Areito* no. 37 (1984): 40.

5 The quotation is from Sheldon Renan, *An Introduction to the American Underground Film* (New York: Dutton, 1967), 18. Renan does not make explicit reference to Chicanos, however.

6 Ibid., 17.

7 James, *Allegories of Cinema,* 99. The most influential account of this period remains P. Adams Sitney's *Visionary Film: The American Avant-Garde, 1943–1978,* 2nd ed. (Oxford: Oxford University Press, 1979).

8 James, *Allegories of Cinema,* 99–100.

9 Sitney defines the trance and lyrical films in *Visionary Film*: "The trance film was predicated upon the transparency of the somnambulist within the dream landscape. The perspective of the camera, inflected by montage, directly imitated his consciousness" (64). "The lyrical film postulates the filmmaker behind the camera as the first-person protagonist of the film. The images of the film are what he sees, filmed in such a way that we never forget his presence and we know how he is reacting to his vision" (142).

10 In the period before 1975 other Latino experimental media artists included Puerto Rican video artist Edin Vélez, who produced his first work in 1969, the Chicano art group Asco, which formed in 1972, and Chicana filmmaker Esperanza Vásquez, who briefly worked in an experimental mode in the early 1970s. On Greaves, see Scott MacDonald, "Sunday in the Park with Bill: William Greaves's *Symbiopsychotaxiplasm: Take One,*" *The Independent* 14, no. 4 (May 1992): 24–29. On Ortiz, see Scott MacDonald, "The Axeman Cometh: Raphael Ortiz's Avant-Garde Alchemy Moves into the Digital Age," *The Independent* 17, no. 8 (Oct. 1994): 26–31; idem, "Media Destructivism: The Digital/Laser/Videos of Raphael Montañez Ortiz," in Chon A. Noriega and Ana M. López, eds., *The Ethnic Eye: Latino Media Arts* (Minneapolis: University of Minnesota Press, 1996), 183–207; and Chon A. Noriega, "Sacred Contingencies: The Digital Deconstructions of Raphael Montañez Ortiz," *Art Journal* 54, no. 4 (winter 1995): 36–40. On Vélez, see Lillian Jiménez, "Puerto Rican Video Artist: Interview with Edin Vélez," *Jump Cut* no. 39 (June 1994): 6, 99–104.

11 James, *Allegories of Cinema,* 94.

12 Jacinto Quirarte, *Mexican American Artists* (Austin: University of Texas Press, 1973), 96.

13 The description of Dorothy Dresser is the most blatant caricature, evoking sexist and racist stereotypes: "She had the majesty of an outdoor toilet and the fat warmth of a Mexican woman cooking tortillas over a stove named Rosa. The perfect female, vain with marvellous physical comforts, embracing everyone who looked at her. The very filth pouring through her body, sifting, churning on its downward voyage to the great drain between her legs. She adorns herself and suddenly becomes the ghost of an apparition." It is Dorothy Dresser who speaks against this description in her confrontation with the upright Carol Chair, pointing out, "Baby, we're the same."

14 I am indebted to Rebecca Epstein's reading of the film in terms of its satire of Beat counterculture, "Beating on the 'Beats' in Ernesto Palomino's *My Trip in a '52 Ford*" (paper presented to the UCLA Department of Film and Television, Nov. 30, 1995).

15 On the Beats' neocolonialist figuring of Latin America, see Manuel L. Martínez, "'With Imperious Eye': Kerouac, Burroughs, and Ginsberg on the Road in South America," *Aztlán: A Journal of Chicano Studies* 23, no. 1 (spring 1998): 33–53.

16 Luis Valdez, "*My Trip in a '52 Ford* by Ernie Palomino: An Interpretation," unpublished manuscript, Ernesto R. Palomino Papers (CEMA 6), box 1, folder 10, California Ethnic and Multicultural Archives, Donald Davidson Library, University of California, Santa Barbara.

17 Ibid., 3.

18 See, for example, Jane Farver, *Global Conceptualism: Points of Origin, 1950s–1980s* (New York: Queens Museum of Art, 1999).

19 See Gamboa, *Urban Exile;* and S. Zaneta Kosiba-Vargas, "Harry Gamboa and Asco: The Emergence and Development of a Chicano Art Group,

1971–1987," Ph.D. diss., University of Michigan, 1988.

20 Two years later, LACMA would exhibit the work of Los Four (Carlos Almaraz, Roberto de la Rocha, Gilbert Luján, and Frank Romero). See Reina Alejandra Prado Saldivar, "The Formation of a Chicano Art Canon: Narrations and Exhibitions of Los Four, Asco, and Self-Help Graphics," master's thesis, Tucson: University of Arizona, 1997.

21 Performances include: *Stations of the Cross,* 1971; *Walking Mural,* 1972; *Spray Paint LACMA,* 1972; *Dia de los Muertos,* 1974; *First Supper (After a Major Riot),* 1974; *Instant Mural,* 1974; and *Decoy Gang War Victim,* 1974. Gamboa discusses these performances in his essay "In the City of Angels, Chameleons, and Phantoms," in *Urban Exile.*

22 Kosiba-Vargas, *Harry Gamboa and Asco,* 141.

23 As Gamboa explains, "One might as well just forgo that format [commercial cinema] and try to reach as broad an audience as you can, and maybe do it for five dollars." Gamboa, interview by the author, tape recording, May 27, 1991.

24 Gamboa, *Urban Exile,* 44.

25 Harry Gamboa Jr., "Harry Gamboa Jr.: No Movie Maker," interview by Marisela Norte, *El Tecolote,* n.d. (c. 1983): 3.

26 Quoted in Gamboa, *Urban Exile,* 27.

27 Renan, *An Introduction to the American Underground Film,* 227–53; and Gene Youngblood, *Expanded Cinema* (New York: Dutton, 1970). In their early years, Asco members appear to have been generally unaware of events in the art world, responding instead to their more immediate environment: the Chicano working class in East Los Angeles and American mass culture. For his part, Gamboa engaged in only casual and sporadic reading until 1970, when, having dropped out of college, he began to teach himself. He did not start reading about art until 1974, by which time he had developed his voice as an artist. Thus, while Gamboa may have read Youngblood's articles on expanded cinema in the *L.A. Free Press* in the late 1960s (which Gamboa can neither confirm nor deny), they would have been a haphazard and unnoticed influence on the development of the No Movies.

28 Gamboa interview.

29 Jo-Anne Berelowitz, "Conflict over 'Border Art': Whose Subject, Whose Border, Whose Show?," *Third Text* 40 (autumn 1997): 69–83.

30 Ibid. See also the account in *La Frontera/The Border: Art about the Mexico/United States Border Experience* (San Diego: Museum of Contemporary Art and Centro Cultural de la Raza, 1993).

Acknowlegments

I am grateful for research support from the UCLA Institute of American Cultures and the University of California Institute for Mexico and the United States (UC MEXUS). Thanks to Shifra Goldman for sharing her files on Ernie Palomino and to Kathleen McHugh, Vivian Sobchack, and Thomas Frick for their insightful comments on earlier versions of this essay.

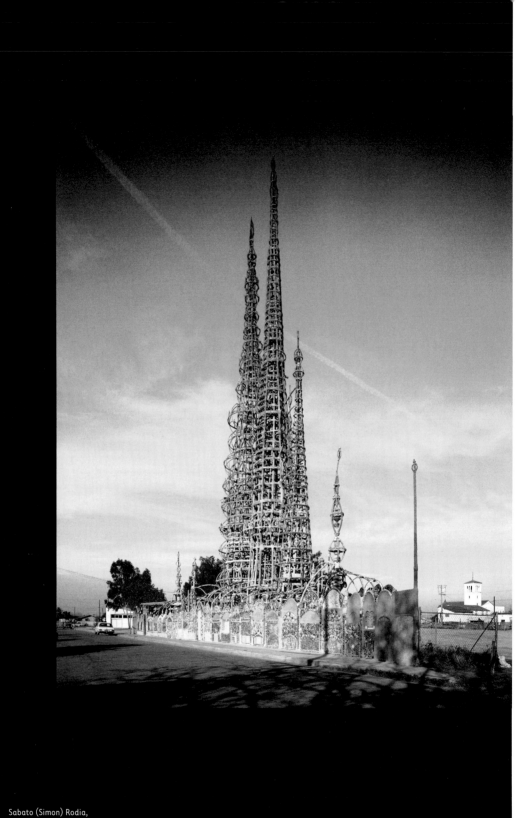

Sabato (Simon) Rodia,
Watts Towers
Photograph © 1997
Marvin Rand

Sarah Schrank

PICTURING THE WATTS TOWERS:
THE ART AND POLITICS OF AN
URBAN LANDMARK

On East 107th Street in Watts, a working-class African American and now increasingly Latino section of Los Angeles, stands an unusual architectural work known as the Watts Towers. Almost one hundred feet tall at its highest peak, the structure has attracted international attention, appearing in hundreds of newspapers and art journals; it is one of California's most famous urban landmarks.[1]

The site, located on a triangular lot south of downtown Los Angeles, off the Harbor Freeway, contains a hand-built "city" of seven towers, fountains, a 140-foot-long wall, a gazebo, a "ship," and a garden. All of these objects are made of twisted, intertwined steel, coated with cement encrusted with mosaics of tile, broken glass, tool imprints, found objects, and shells.[2]

Sabato (Simon) Rodia, an Italian immigrant who made his living as a tile setter, spent thirty-three years building the towers by bending steel with railroad ties, gathering shells and garbage from Southern California beaches, collecting tiles from his workplace, and constructing pulleys, which he used to climb and coat the steel base with thousands of pounds of cement. He then pressed tools, bottles, tiles, and miscellaneous objects into the cement to create designs and embellish the glittering towers for which the sculpture is most famous. One day in 1954 Rodia deeded the property to a Mexican neighbor and moved to Northern California, never to see his towers again. He turned up a few years later in a boardinghouse in Martinez, California, was interviewed by art history students, and made an appearance at a discussion of his work at the University of California, Berkeley. He died a few years later, in 1965.[3]

Why Rodia built this "city" at all has been the source of great specula-tion ever since he began work on the project in 1921. Local newspapers inter-preted the towers as an homage to Rodia's adopted homeland, a gift to America. Art critics have deemed Rodia an outsider artist, spontaneously spinning his steel and cement like a spider, arms encrusted with broken glass

like the very sculpture he was building. No one is even sure why he left Los Angeles, although surviving interviews imply that it was because of aging and his deteriorating relationship with the neighborhood.[4] After Rodia left Watts, his next-door neighbors tried to turn the towers into a taco stand but failed to get the necessary building permit. The towers stood in vandalized disrepair until two friends, William Cartwright and Nicholas King, bought the property and formed the Committee for Simon Rodia's Towers in Watts in 1959.[5]

The history of the Watts Towers is overwhelmingly a history of its representation. Whether portrayed in newspapers or art journals as a public safety hazard, an important international artwork, a metaphor for African American community, a symbol of urban redevelopment, or a tourist destination, the towers exist as a series of predefined images. Moreover, how we see and understand the Watts Towers is closely linked to the racial politics of Los Angeles and to the broader post–World War II experience of Southern California. This point is underscored by the fact that while some Angelenos know of the towers, most people who visit them are not from California at all. The location of the towers in Watts—a neighborhood best known for poverty and the 1965 Watts uprising—has proven a deterrent for local visitors. The troubled relationship between Watts and greater Los Angeles has often led the towers' protectors to try to separate them symbolically, if not physically, from the surrounding neighborhood. Conversely, neighborhood activists and community leaders historically have linked the neighborhood to the towers in order to attract funding for community services. By constantly being invested with new political and cultural meaning, the Watts Towers have become a commentary on the historical changes happening around them.

The towers were first endowed with symbolic and political value in the late 1950s, when they became the center of a grassroots effort led by the Committee for Simon Rodia's Towers in Watts—mostly composed of white, middle-class art students, artists, architects, and engineers—to save them from destruction by the city's Building and Safety Department. Unclear about what they were and finding no building permit, the department had issued an order in 1957 to "remove the dangerous towers." Because of vandalism that had occurred after Rodia's departure from Los Angeles, the city government declared the property unsafe and a public hazard. Neighbors reported to investigating students that neighborhood teens made sport of throwing rocks and chipping away at the bottles and tiles pressed into the towers' mortar, probably searching for treasure rumored to be hidden in the structure. At a

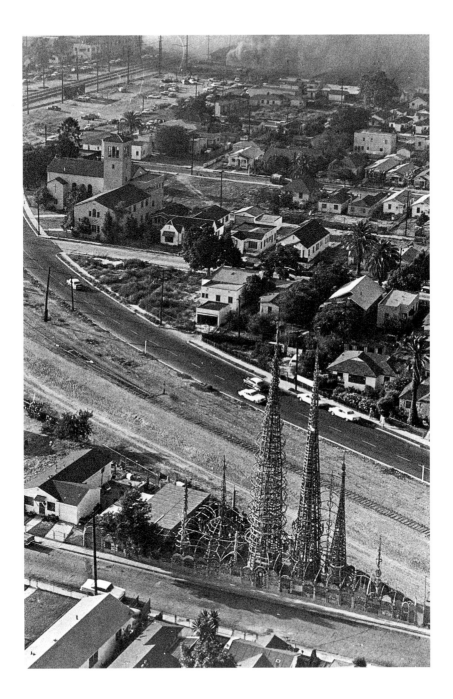

Sabato (Simon) Rodia,
Watts Towers, 1965
Photograph by Roger
Coar

July 1959 public hearing, deputy city attorney W. E. Wilder argued that the towers' workmanship was of "poor quality" and that they had begun "to deteriorate rapidly in recent years." He added that "the structures are broken in places and in danger of collapsing." Assured of the towers' strength, how-ever, the committee defending them suggested that if they could withstand a 10,000-pound-pull stress test, the city should allow them to stand. On October 10, 1959, the widely publicized test was held, and the towers survived intact. The next day H. L. Manley, chief of the Building and Safety Department, announced that the city would drop its efforts to have them torn down. For the moment, the towers were saved.[6]

Though the rhetoric was of public safety and concern for neighborhood children who might be tempted to climb the towers, Watts had been targeted in the late 1950s as a slum-clearance area. A day after the stress test, the *Los Angeles Examiner* reported that the area east of Central Avenue on 103rd Street was the subject of municipal "housing rehabilitation." About two blocks from the towers almost 3,000 properties, most of which were private African American residences, were slated to be cleared as part of a program "to clean up slum and blight conditions."[7] Such urban-renewal efforts imply that the towers represented less a safety hazard and a threat to neighborhood children than a hindrance to slum-clearance procedures. Slum clearances were part of postwar urban renewal programs instituted in cities across the country. Urban renewal usually meant supporting white suburbs at the expense of minority neighborhoods. For example, the federally funded highways built in the 1950s (such as Los Angeles's Harbor Freeway), which allowed suburbanites automo-bile access to and from the city, cut through poor areas, destroying already limited low-income housing, obliterating public space, and forcing property values to plummet. Like Bunker Hill and Chavez Ravine, other famous land-marks and neighborhoods destroyed by urban renewal in Los Angeles, the Watts Towers were simply in the way.[8]

As part of the drive to save the towers from demolition, an international campaign of letters and petitions was launched by the Committee for Simon Rodia's Towers in Watts, in order to define them not as an eccentric curiosity but as artwork. The hope was that if the towers could be understood as art rather than as an unusual novelty, then perhaps the City of Los Angeles would grant them civic-landmark status, ensuring their protection. In the process, a new representation of them emerged hand in hand with a new California art aesthetic based on junk. Whereas in the 1930s the towers could only be seen and understood as crazy or grotesque local curiosities, in the 1950s new

movements in art and criticism made it possible to view the same creation in a new way. In fact, in 1951 Rodia's towers appeared on the cover of *Art and Architecture* magazine and subsequently turned up in European art journals.[9]

While the heart of the American avant-garde in the 1950s was New York City, Southern California was an important center of the assemblage and junk-art movements. Exemplified by the work of Wallace Berman, George Herms, Edward Kienholz, and Noah Purifoy, Abstract Expressionism in California seemed to crawl out of paintings and off the walls and found itself rearticulated in three-dimensional sculptures assembled from discarded objects like driftwood, newspaper, old clothes, and garbage. Between the energy of Abstract Expressionist canvases and the shiny newness of the L.A. Look's car paint and fluorescent surfaces lay an art made from the debris of postwar affluence. Art historian Thomas Crow suggests that Rodia's towers were a direct influence on the work of other California assemblage artists. Crow writes that "California artists, largely excluded from participation in any real art economy, were regularly drawn to the cheap disposability of collage and assemblage ... recycling the discards of postwar affluence into defiantly deviant reconfigurations."[10] In a similar vein, art critic Lawrence Alloway has pointed out that junk art is city art.[11] It is in urban areas that the quantity and

Sabato (Simon) Rodia, Watts Towers, c. 1962 Photograph © Seymour Rosen, courtesy SPACES

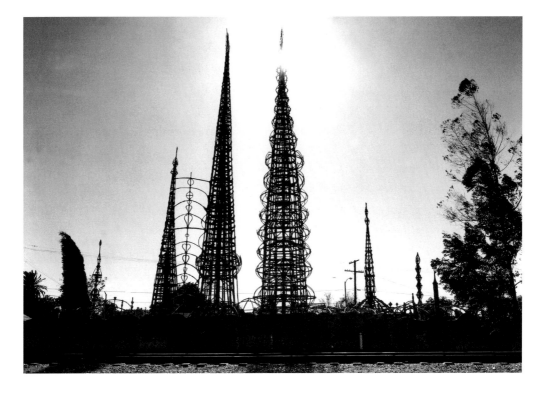

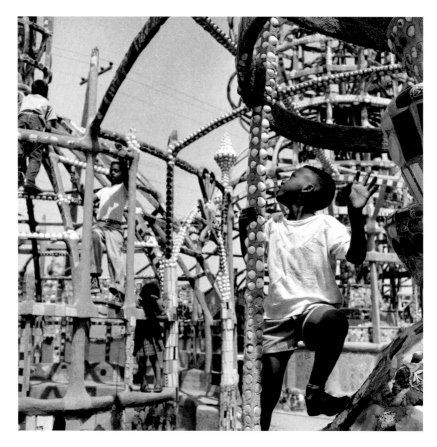

Sabato (Simon) Rodia,
Watts Towers, 1958
Photograph by William
Claxton

variety of discarded materials needed to build creations such as Rodia's can
be most readily found.

Nonetheless, while the towers are fundamentally an urban creation,
images used to define and defend them as art did not always emphasize their
urban surroundings. In photographs exhibited by the Museum of Modern
Art (1961) and the Los Angeles County Museum of Art (1962), the towers
sometimes appeared in an almost rural setting.[12] Yet much of the power of
Rodia's project is in understanding that he gathered the urban debris of his
neighborhood and workplace. He then recycled this debris into a spectacular
artwork that he named Nuestro Pueblo (our town), thereby claiming a piece
of Los Angeles for himself and his neighbors. Richard Cándida Smith writes
that while Rodia's work offered a symbolic home for the residents of Watts,

the setting . . . offered no escape from urban reality. Nuestro Pueblo confronts its
visitors with images of the jumble of urban life: the towers reflect both church
spire and the modern skyscraper and the stalagmites, both a cactus garden and

apartment buildings rising up from the ground; the arbor with its incised design
speaks interchangeably of parks, the industrial worlds of automobile parts and
construction tools, agricultural products, and pure purposeless beauty. [13]

The campaign by the Committee for Simon Rodia's Towers in Watts to
achieve municipal recognition of the towers was successful. On March 1, 1963,
the Municipal Arts Department determined the towers "to be worthy of
preservation as a historic-cultural monument.[14] Although Rodia's personal
representation of a city received a nod of acknowledgment from the City of
Los Angeles, and important American museums accepted the towers as "a
masterpiece of assemblage," the State of California rejected them as a land-
mark. As late as June 1965, the California Department of Parks and Recreation
concluded that "the Simon Rodia towers are definitely a sort of bizarre art
form ... However, their preservation is not a matter of statewide concern."[15]

Two months after California rejected the Watts Towers as a state land-
mark was the famous August of the Watts rebellion, one of the largest civil
disturbances in American history. Violence broke out during a scuffle between
police and onlookers after the arrest of Marquette Frye for drunk driving. The
ensuing riot was, in large part, a frustrated response to high unemployment,
the lack of social services, a history of police violence, and a dearth of public
transportation in a neighborhood where fewer than 20 percent of the residents
owned cars. After six days of fires, looting, and the throwing of rocks and
bottles, 34 people were dead, 900 injured, and over 4,000 arrested.[16] While the
state's refusal to fund the towers may have gone unnoticed by Watts residents,
the state's policy also meant refusing to fund an accompanying community
center that would have included a park, music and dance rehearsal studios,
adult and children's theaters, an exhibition space, and other public cultural
facilities.[17] The lack of any such services was one of the reasons for frustration
in Watts.

The Watts rebellion forever changed national perceptions of American
urban race relations, dulled Los Angeles's sunshine image, and reoriented
how Rodia's creation would be publicly represented: The Watts Towers now
emerged as a symbol of black community. Whereas before the riot, they could
be represented in isolation from their urban environment, the 1965 disturbances
forced Watts into the national consciousness in such a profound way that the
towers, by virtue of geography, became charged with political significance
beyond a preservation struggle with municipal authorities. In fact, competing
interests, from neighborhood activists to urban developers, tried to harness

the towers as a political symbol of "blackness" and "black community" as a way of lending legitimacy to their particular causes.

A relationship between Rodia's towers and the surrounding neighborhood had been articulated prior to the Watts riots. In 1959 the Committee for Simon Rodia's Towers in Watts bought a cottage next door to the towers and offered free art classes to neighborhood youth, thereby founding the Watts Towers Art Center. In 1961 two African American artists, Noah Purifoy and Judson Powell, were hired to direct the center. In interviews, Purifoy has stated that the goals of the center were not to build a community project or to "fix" Watts but to provide a safe place for black youth to learn about the creative process. Purifoy was reluctant to identify the art center as a community center, because he recognized that neighbors might see it as one more government agency throwing money in the wrong direction, a local intrusion akin to urban renewal. The Watts Towers Art Center was, in fact, granted federal funds in 1964 to operate programs for local teens as part of Teen Post, a program funded through Lyndon Johnson's War on Poverty.[18]

After the Watts rebellion, the municipal government became more interested in the connection between the towers and the surrounding area. For example, in 1966 the City of Los Angeles provided a fifteen-acre site for the large-scale community art center, a proposal that had been refused by the state the year before. In the proposal, the committee insisted that the center be run by blacks, arguing that "federal or local support cannot be expected unless greater Negro participation is achieved."[19] Before the rebellion, supporters' rhetoric removed the towers from a working-class, minority context, placing "art" above the neighborhood. The Watts revolt, however, established a political connection between the towers and the surrounding area. For both the towers' protectors and artist-activists like Purifoy, Powell, and John Outterbridge (who served as director of the Watts Towers Art Center from 1975 to 1992), this connection opened up a way to funnel federal funds to the neighborhood and the towers. The Watts Towers Art Center did not, however, attract much federal financial support. Work on the large complex of building and facilities did not begin until 1998, and private donations were insufficient.

After sixteen years of trying to maintain the towers on private donations, in 1975 the Committee for Simon Rodia's Towers turned them over to the municipal government because it could no longer afford to maintain them. The city promised to do so and hired a contractor to make repairs. Untrained in the skilled work needed to reinforce Rodia's unique structure, the contractor and his associates badly damaged the towers, performing what

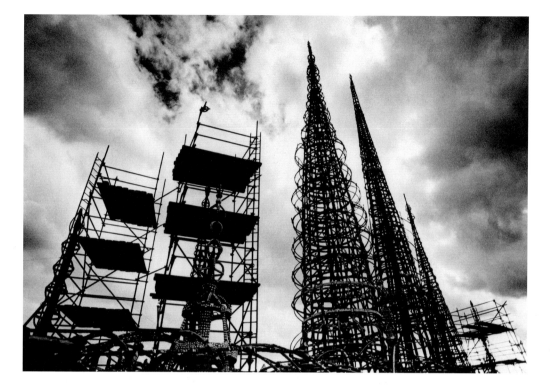

is known as a "savage restoration," whereby a work of art or historical land-
mark is "preserved" in such a way as to destroy or irreparably damage the
original work. What the 10,000-pound stress test of 1959 could not do was
achieved sixteen years later by chipping away the mosaics, ripping apart
the foundation, attempting to pour plastic onto the face of the towers, and
leaving flammable waste in barrels at their base. Fortunately the towers did
not explode, and the Center for Law in the Public Interest sued to force the
city to stop the damaging "restoration" and pay reparations. In a complex
lawsuit that would finally end in 1985, the towers were proclaimed a California
Historic Park, and restoration was assigned to the city's Cultural Affairs
Department.[20]

 The damage to the towers by a negligent municipal government
reflected the national attitude toward the inner city in the 1970s—a lack of
empathy and respect combined with diminished financial support. The con-
servative backlash against the social upheavals and political revolution of the
1960s was especially strong in California, as exemplified by the passage of
Proposition 13. Under the guise of limiting property taxes, the proposition was
an active effort on the part of white homeowners to stop the funding of schools,
housing, and public services in inner-city neighborhoods such as Watts.[21]

Sabato (Simon) Rodia,
Watts Towers, 1988
Los Angeles Times
photograph by
Thomas Kelsey

The devastating social effects of neglecting the inner city in favor of predominantly white suburbs became an important theme in American social life in the 1980s and early 1990s. This theme was also played out in popular culture, particularly in movies in which white viewers could experience the ghetto in the comfort of a theater or living room. In a perverse case of art imitating life, the damaged Watts Towers appear in the movie *Colors* (1988), directed by Dennis Hopper, which deals with gang violence in South Central. Gang members fleeing the scene of a drive-by shooting are chased through Watts by cops. The neighborhood is flagged for knowing viewers by a long shot of the towers; the scene climaxes with the getaway car crashing into them and exploding, blowing both the towers and the gang members sky high. Hopper uses the Watts Towers metaphorically to show how the black community is torn apart by gang warfare, police violence, and drugs. With Hollywood special effects on his side, Hopper smashes and incinerates what the municipal government never could quite manage to: the towers and what they have popularly come to represent—black community. Then, in another twist, the towers appear once more in their former splendor at the end of the film.[22]

Ricochet (1991), starring Denzel Washington, uses the towers as an encoded symbol of black community and even black power in Los Angeles. Washington plays an ambitious assistant district attorney from South Central, which is symbolized by the towers and rapper Ice-T. In a bid for the mayor's office, Washington takes up the cause of the Watts Towers Art Center, fictionalized in the film as the Towers Community Center. Meanwhile, Washington makes headlines by putting away a white racist serial killer and presumed child molester. The criminal escapes and seeks revenge by subjecting Washington to many humiliations, all of which misrepresent him as a stereotyped African American male: meandering, drug using, stealing, crazy. Washington overcomes his nemesis by impaling him on one of the towers. The protagonist redeems his own identity, destroys the evil white killer, and saves the Towers Community Center, all with the help of the towers themselves.[23] These widely viewed films use the Watts Towers to signify black Los Angeles and to comment on the effects of the economic policies of the Reagan administration.

Whereas movies have showcased the Watts Towers as a significant symbol of black Los Angeles, the press has used them to obscure the racist power relations that defined living conditions in South Central. For example, in the wake of the international attention attracted by the 1984 Olympics, an editorial in the *Herald-Examiner* stated that "no symbol in Los Angeles carries more meaning than these sparkling spires. A testimony to immigrants' dreams . . .

today that vision towers over Watts, high above the railroad tracks, the little
houses and the human struggle—a tribute to a community's inner strength."[24]
This commentary, along with photographs in the paper that rarely showed the
neighborhood, served to separate the "towers as community" symbol from
Watts itself. Moreover, the romantic mythology surrounding an immigrant
constructing such a monument obscured Watts's new immigrants, those from
Mexico and Central America. It is, however, this "community" symbol, towering
far above the struggles and inequities of life on the ground, that captured the
imagination of much of Los Angeles's liberal establishment and helped mobi-
lize the successful efforts to protect the towers from vandalism and demolition.

As in previous decades, the political climate of the 1990s helped formu-
late new images of the towers. In the fall of 1991, the Watts Redevelopment
Project used the towers to decorate the cover of a project report. The towers
stood for all that Watts could be: economically viable, politically connected.
Historian William Fulton has pointed out, however, that many African
Americans did not support this 1991 Community Redevelopment Agency
(CRA) project because they saw it as one more urban renewal program among
those that had done so much damage in Los Angeles.[25] It is yet another ironic
twist that proponents of urban renewal would use the towers as a symbol of a
rejuvenated black neighborhood, when urban renewal in the 1950s helped
destroy Watts as an economically viable minority neighborhood and led to
the early efforts to tear down the towers in the first place.

The 1991 CRA project evaporated in the aftermath of the brutal beating
of Rodney King by officers of the Los Angeles Police Department and the sub-
sequent "not guilty" verdict that sparked looting and violence across a wide
band of southern Los Angeles. With riots focusing national attention again
on Los Angeles's black neighborhoods, the failure of programs, grants, and
contracts that followed the rebellion of 1965 was highlighted. James Woods,
founder of the Studio Watts Workshop, another community arts program
in South Central, has said, "If funding had concentrated on establishing insti-
tutions rather than temporary programs, we could have accomplished much
more." Short-term funding of community art could not maintain such pro-
grams, any more than fixing Watts Towers could "fix" Watts.[26]

At the time of writing, the Watts Towers are still under scaffolding.
Conservation continues with institutional funding from sources like the
Getty Conservation Institute, as well as private donations. The Watts Towers
Arts Center, under the direction of Mark Greenfield, still offers classes, mounts
exhibitions, and hosts art and music festivals.[27] Since the summer of 1999,

Watts and the towers have become a state-recognized tourist attraction. Through the nonprofit Watts Labor Community Action Committee and the California Council for the Humanities, local activists have organized bus tours of Watts, with an extended stop at Rodia's towers. The hope of tour organizers is that by educating outsiders on the cultural merits of the area, commercial interests might consider local investment. Despite progress on the towers, Watts is not attracting much business. President Clinton visited the neighborhood in July 1999 as part of a national tour of economically depressed areas. Work on the community art center, rejected by the state in 1965, began in 1998, but the project is riddled with design problems and moves slowly. Moreover, Watts faces new problems as its Latino population has overtaken the African American one. The new residents are also poor, and the area's social services are ill equipped to handle Spanish-speaking clients.[28]

In popular culture, however, the towers have been recontextualized again. Neither situated as artwork nor symbolizing a neglected minority neighborhood, they have appeared in a Levi's jeans ad.[29] A young hipster sits on a stool in the lot behind the towers holding a sign that says "Restoration, Rejuvenation." The use of the Watts Towers by Levi's as an icon of popular culture takes them out of their historical and geographical context. As Ice-T says at the end of *Ricochet*, "If you want to know who got the power, bring your ass to the tower." In this case, the "power" is held by a multinational corporation that profits by cashing in on a real social and political history. Whereas in previous decades the Watts Towers themselves were harnessed by competing interests to symbolize black community, Levi's harnesses the entire history of Watts to sell jeans.

For over forty years the Watts Towers have held a place in California's popular imagination and in the international image of the state. This phenomenon certainly attests to the power of Rodia's vision, as well as to the efforts of those who have successfully saved the towers from destruction and of the local activists who have maintained the Watts Towers Art Center. Their longevity as an ever-changing cultural and political symbol is due to the historical connections between the towers, the neighborhood of Watts, and race relations in postwar urban California. It is because of this complex historical context (not despite it) that there is power in the towers. A work of art, particularly one that has had a place in the popular imagination, does more than merely reflect historical developments. The Watts Towers, as an object of cultural investment, are constantly recontextualized and thus made to comment on the social, cultural, and political changes happening around them.

Sarah Schrank is a Ph.D. candidate completing a dissertation titled "The Art of the City: The Politics of Civic Identity and the Visual Arts in Los Angeles" in the Department of History, University of California, San Diego. Her work addresses the social and political relationships among urban growth, public space, and controversial cultural expression in post–World War II America.

1 In his famous celebration of the city, *Los Angeles: The Architecture of Four Ecologies* (Middlesex: Penguin, 1971), Reyner Banham wrote, "Alone of all the buildings in Los Angeles, [the Watts Towers] are almost too well known to need description. They are unlike anything else in the world."

2 Bud Goldstone and Arloa Paquin Goldstone, *The Los Angeles Watts Towers* (Los Angeles: Getty Conservation Institute, 1997); Calvin Trillin, "I Know I Want to Do Something," *New Yorker,* May 29, 1965, 72–120; Leon Whiteson, *The Watts Towers of Los Angeles* (Oakville: Mosaic Press, 1989).

3 Goldstone and Goldstone, *The Los Angeles Watts Towers*; Jeanne Morgan, "My Life with the Watts Towers," Jeanne Morgan Papers, Archives of American Art, Smithsonian Institution, West Coast Regional Center, the Huntington Library, San Marino, California; Calvin Trillin, "I Know I Want to Do Something"; Whiteson, *The Watts Towers of Los Angeles.* Rodia has been called Sam, Simon, and Sabato. According to most accounts he went by Sabato, which is how I refer to him, although the City of Los Angeles officially uses Simon.

4 "Immigrant Builds Towers to Show His Love for U.S.," *Los Angeles Times,* June 8, 1952; Paul V. Coates, "Confidential File," *Los Angeles Mirror-News,* Oct. 4, 1955; Richard Cándida Smith, "The Elusive Quest of the Moderns," in Paul Karlstrom, ed., *On the Edge of America: California Modernist*

Art, 1900–1950 (Berkeley and Los Angeles: University of California Press, 1996).

5 Goldstone and Goldstone, *The Los Angeles Watts Towers;* Morgan, "My Life with the Watts Towers"; Trillin, "I Know I Want to Do Something"; Whiteson, *The Watts Towers of Los Angeles.*

6 "Are They Fine Art or Junk?," *Los Angeles Examiner,* April 3, 1959; "Hearing to Preserve Watts Towers Opens at City Hall," *Los Angeles Examiner,* July 7, 1959; "Watts Towers Pass Safety Test," *Los Angeles Examiner,* Oct. 11, 1959; Hearst collection, Regional History Center, University of Southern California; interviews with Rodia, Jeanne Morgan papers.

7 "L.A. Shows World How to End Slums," *Los Angeles Examiner,* special edition reprint, Oct. 11–12, 1959; California ephemera collection 200, box 61, Department of Special Collections, University of California, Los Angeles.

8 See George Lipsitz, *The Possessive Investment in Whiteness: How White People Profit from Identity Politics* (Philadelphia: Temple University Press, 1998); Norman Klein, *The History of Forgetting: Los Angeles and the Erasure of Memory* (London: Verso, 1997).

9 "Flashing Spires Built as Hobby," *Los Angeles Times,* Oct. 13, 1937; "Glass Towers and Demon Rum," *Los Angeles Times,* Apr. 28, 1939; Jules Langsner, "Sam of Watts," *Arts and Architecture,* July 1951, 25–30; Barbara Jones, *Follies and Grottoes* (London:

Constable, 1953), 278; Ulrich Conrads, "Phantastische Architektur Unterströmungen in der Architektur des 20 Jahrhunderts," *Zodiac* 1959, 117, 137; John Craven, "Les Tours de Watts," *Connaissance des Arts,* Apr. 1966, 110–13.

10 Thomas Crow, *The Rise of the Sixties: American and European Art in the Era of Dissent* (New York: Harry N. Abrams, 1996), 25.

11 Lawrence Alloway, cited in William C. Seitz, *The Art of Assemblage* (New York: Doubleday, 1961), 73.

12 *Committee for Simon Rodia's Towers in Watts,* exh. cat. (Los Angeles: Los Angeles County Museum of Art, 1962), 6.

13 Cándida Smith, "The Elusive Quest of the Moderns," 31.

14 Municipal Arts Department, *Cultural Heritage Board Document.* California ephemera collection 200, box 163, Department of Special Collections, University of California, Los Angeles.

15 State of California, Department of Parks and Recreation, *Watts Towers Study,* 1965, 3. In an interview with the *New Yorker,* an unnamed Los Angeles County Museum of Art curator succinctly explained the problem: "Los Angeles has a reputation for being crazy anyway and I think that's why the city might have been a little slow in recognizing the towers. Here is a city whose only art monument is a group of towers built of junk by 'some nut.' They'd rather have St. Patrick's Cathedral." The towers were officially designated a Los Angeles Cultural

Heritage Monument in 1963. Their current status as a National Landmark was achieved in 1990.

16 John Mack Farragher et al., *Out of Many: A History of the American People,* vol. 2 (Upper Saddle River, N.J.: Prentice-Hall, 1997), 44; Gerald Horne, *Fire This Time: The Watts Uprising and the 1960s* (Charlottesville: University Press of Virginia, 1995).

17 State of California, Department of Parks and Recreation, Division of Beaches and Parks, *Watts Tower Study: Requested by House Resolution No. 464, Statutes of 1965.* June 1965, map inset.

18 Noah Purifoy, "African-American Artists of Los Angeles," oral history transcript, interviews by Karen Anne Mason (Los Angeles: Oral History Program, University of California, Los Angeles, c. 1992); Morgan, "My Life with the Watts Towers"; Dale Davis, John Outterbridge, and Cecil Ferguson, transcript of interview, July 29, 1994, John Outterbridge papers, Archives of American Art, Smithsonian Institution, West Coast Regional Center, the Huntington Library, San Marino, California.

19 "The Simon Rodia Workshops," Committee for Simon Rodia's Towers in Watts, collection 1388, box 2, folder 1, Department of Special Collections, University of California, Los Angeles.

20 "Suit Assails City's Handling of Watts Towers, Calls for Private Ownership." *Los Angeles Times,* Oct. 27, 1978; *Los Angeles Times,* Apr. 24, 1979; "Private Boost for Watts Towers," *Los Angeles Times,* Feb. 22, 1985; Committee for Simon Rodia's Towers in Watts, collection 1388, box 9, folder 5, Department of Special Collections, University of California,

Los Angeles; Goldstone and Goldstone, *The Los Angeles Watts Towers,* 100–3.

21 Mike Davis, *City of Quartz: Excavating the Future in Los Angeles* (New York: Vintage, 1992), 182–86.

22 *Colors* (1988, MGM), dir. Dennis Hopper.

23 *Ricochet* (1991, WB), dir. Russell Mulcahy.

24 "Save the Watts Towers," *Los Angeles Herald-Examiner,* Apr. 22, 1985; John Outterbridge papers.

25 Community Redevelopment Agency, City of Los Angeles, *Watts Redevelopment Project Biennial Report,* Nov. 4, 1991; John Outterbridge papers; William Fulton, *The Reluctant Metropolis: The Politics of Urban Growth in Los Angeles* (Point Arena, Calif.: Solano Press, 1997), 297.

26 Daniel B. Wood, "Activists Build Culture from the Ground Up," *Christian Science Monitor,* June 8, 1992.

27 Elizabeth Christine Lopez, "Community Arts Organizations in Los Angeles: A Study of the Social and Public Art Resource Center, Visual Communications and the Watts Towers Art Center," Ph.D. diss., University of California, Los Angeles, 1995, 49.

28 Matea Gold, "A New Watts Awaits Visit by President," *Los Angeles Times,* July 7, 1999; Steve Schmidt, "Watts Shows Off New Look; Tourists Invited to Site of '65 Riots," *San Diego Union-Tribune,* Aug. 29, 1999; Paul Chavez, "Promises Linger in Watts: Despite Federal Pledge to Help, Area Still a Blight," *San Diego Union-Tribune,* Nov. 4, 1999.

29 Levi's advertisement, *The Big Issue,* summer 1999, 20–21.

Acknowledgments
The research for this project was made possible with grants from the Huntington Library, the Historical Society of Southern California, and the Department of History, University of California, San Diego. Special thanks are due to the staff of the Archives of American Art, West Coast Regional Center, including director Paul Karlstrom, Marian Kovinick, Phil Kovinick, and Barbara Bishop. Jeff Rankin, Octavio Olvera, and Anne Caiger were exceptionally helpful in the Department of Special Collections, University of California, Los Angeles. The author extends grateful thanks to Dace Taube, at the Regional History Center, University of Southern California. Finally, thanks to Noah Purifoy, who patiently answered my questions, and shared insight, artwork, and wine with me at his home in Joshua Tree.

La Californie, sheet
music cover, c. 1850
California History
Room, California State
Library, Sacramento

Norman M. Klein

GOLD FEVERS:
GLOBAL L.A. AND THE NOIR IMAGINARY

About 1915, across the gully behind the old Sennett studios, a Serbian family used to make its own wine and watch the setups between shots.[1] Occasionally movie actors drifted by. They saw Gloria Swanson at sixteen and a Sennett bathing beauty ("a tiny, tiny lady, little feet like a beautiful child"). Tom Mix would ride south along Glendale Boulevard. One time, Douglas Fairbanks in a limousine stopped Johnny Dukitsch, the son of this Serbian family, who struggled uphill on a bicycle to deliver newspapers. Smiling broadly, Fairbanks told the boy to stow the bike and ride in comfort for once. For months, Mabel Normand kept offering to buy a feather boa for Mrs. Dukitsch, but Mrs. D. merely looked the star up and down, averted her eyes, and walked away.

One day, the boy noticed the Sennett people digging a hole at the edge of the hill. He woke up at dawn to see what they were shooting. Ben Turpin was thrown into the hole. For ten minutes, the crew "fussed." Then, with cameras rolling, Turpin leaped out of the hole, crossed his eyes, and screamed, "Gold!"

I am continually reminded of this story as I research the transition of Los Angeles into a global "imaginary," a fantasy for sale around the world. One old-timer, reminded of Keystone comedies shot in Echo Park, told me that "movie folks were panning on the hillsides." My sources often lead me back to the California Gold Rush and to the gold fevers that followed.[2] The huge Comstock silver lode (1859) enriched the Big Four in San Francisco, the men who ran the railroads and dominated California business into the 1890s—all the way down to Los Angeles. Silver strikes in Nevada also made Lucky Baldwin rich enough to buy more than one town in Southern California and live like a baron. But these were the infinitely lucky. Most of all, the losers left their mark on what became global fantasies. In the 1850s many disheartened forty-niners drifted south to Los Angeles, then known as the

most violent cow town in California. After mixed luck, many then returned
to San Francisco during the Civil War. Gold fever stood in for the losers, men
panning by a stream, lost in their faded dreams; or snow-blinded, mad with
cabin fever during the Klondike strike that Jack London describes.

Indeed, like a recurrent malaria, gold fever as imaginary lingered for
decades in living memory, even in Los Angeles, particularly when another
"rush" took place—the largest tourist in-migration in American history, from
1885 to 1888. The population of Los Angeles quadrupled in those three years.
Dozens of towns were invented; a few were never built, though con men took
the suckers' money anyway. Fast money roared in, then evaporated. Certainly
the memory of 1849 was inescapable in the minds of people who witnessed
that real estate bubble. It disappeared as fast as the gold had by 1851, crashed
many small investors, threatened to bankrupt Los Angeles itself. Indeed, the
verb *to rush* took on an insidious and unstable aspect, "to speculate," "to
peg away," "to scheme," rather than stick with stable businesses like farming
or mining.[3]

Of course, once the citrus industry had vastly expanded by 1907, gold
fever simply was remystified as agrarian:[4] "Soon the idea of cultivating oranges
[in Los Angeles] became a craze . . . comparable to the gold-mining mania of
the previous decades."[5] But tropes about the Gold Rush mania are even more
apparent during Los Angeles's oil and real estate boom of the early 1920s.[6]
Then in the 1930s, "degenerate" hobos (Arkies and Okies) are condemned as
"modern forty-niners,"[7] the lumpen Hoovervilles like mining camps, and the
Joads come to pick.[8] In Hollywood films, such as *The Call of the Wild* (1935),
San Francisco (1936), and *Honky Tonk* (1941)—and in Gable's film persona
actually—the mining camp is portrayed as a seedbed of amorality, not unlike
the crooks' nightclubs or grimy rooming houses of film noir. Clearly, the links
between San Francisco gold fever and the birth of L.A. noir are palpable. To
not know when to stop, to be blinded by a sack of dust is exotic Americana;
it converts easily into noir metaphor. At a dank rooming house, after the rush
has died, two men refuse to leave. Like pharaohs dressing for the afterlife, they
drag their dreams down with them. Or like hard-boiled detectives, they are
outsiders afflicted with good intentions. They will not stop pawing into prob-
lems that should stay buried. In 1985 Robert Towne said that his screenplay
for *Chinatown* (1974) continues the spirit of the Gold Rush, the bad fixes and
amoral jouissance that are the foundation of noir storytelling.[9]

In fact, the cultural wars between San Francisco and Los Angeles
may have added fevers of their own, a dark rage inside the Golden State.[10]

The rivalry began essentially in 1876, when the Union Pacific set up in Los Angeles,[11] and Charles Crocker (who built his first fortune selling dry goods to miners)[12] warned businessmen that he would make weeds grow on Main Street if they did not follow orders. The rivalry grew even fiercer during the harbor fight between the two cities (1892–98),[13] with Ambrose Bierce up in San Francisco writing poison about Collis B. Huntington trying to crush Los Angeles.[14] These are warring mythologies—Manhattan by the Pacific versus the Iowa Picnic in Los Angeles. And yet, the sum of these inform literary chronicles across the state, from Frank Norris's *McTeague* (1899) to Nathanael West's *The Day of the Locust* (1939). The main characters relive essentially the same hopeless fever. They restate the bile and hokum that drive each rush and each collapse.

Also in cinema, many of the same dark myths drift up and down the state, with Los Angeles and San Francisco tarred by the same brush in classic noir and neo-noir alike, from *Dirty Harry* (1972) to *L.A. Confidential* (1997). In *DOA* (1949), the two cities share double billing. An accountant from

Pickford-Fairbanks Studios, Los Angeles, c. 1926
University of Southern California, Department of Special Collections, California Historical Society

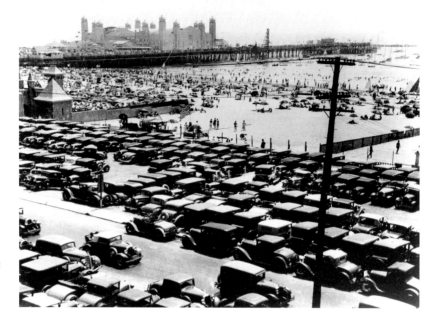

Santa Monica Pier,
c. 1934
University of Southern
California, Department
of Special Collections,
California Historical
Society

Banning, Frank Bigelow, heads north to San Francisco for a fast weekend. At a jazz club by the water, he is poisoned. Enraged, he hops a plane to Los Angeles to hunt for his murderer. We only know the killer is a businessman who deals in rare metals, the man with a scarf who slipped "luminous toxin" into Bigelow's drink. The toxin itself actually glows in the dark—a sickly fluorescence, a drinkable ore. Bigelow sweats toward his death while he contracts another fever as well. He turns as ruthless as the gangsters he faces. At the climax, he grins sadistically while he fires all six bullets from his pistol into the culprit's body. We watch him descend inside the coils of the Bradbury Building downtown, a fitting climax for two cities that share a psychic geography: the interior of the Bradbury resembles a San Francisco street caught like a moth inside bottled light.

Indeed, the "golden" dream of California can also be reread as noir irony. Take Robert Frost's "A Peck of Gold" (1928), for example:

> *Such was life on the Golden Gate:*
> *Gold dusted all we drank and ate,*
> *And I was one of the children told,*
> *"We all must eat our peck of gold."*

More to the point, speaking of a full dose of the California Dream, was the legacy of gold fever uplifting or ruthless?[15] What happened to laissez-faire

madness after the easy placer gold was picked? The darker side of Wagons West is crucial to the gold-fever capitalism, for a state that prided itself on "the second chance" but also on the cannibalism at Donner Pass—survival at all costs. When a boom/rush ends, something very perverse lingers, like the smell of old smoke. That moment after is essential to the aura of noir. Dashiell Hammett's Continental Op walks into the Flood Building on 870 Market Street[16] but leaves as Raymond Chandler's Philip Marlowe from the Belfont Building in Los Angeles. The rooms inside each are haunted by booms gone bust—Hammett by the political shocks after World War I, Chandler by the Great Depression. The characters in their novels reenact the scurrying after the quick money fades. This is a very atavistic, entropic form of story, filled with "golden" fetishes such as the Maltese Falcon and the Brasher Doubloon.

In Hammett's *Red Harvest* (1929), Poisonville, a mining town in Utah, is turned into a ghost. Con men and women reenact a gold fever, but they have almost nothing at stake anymore, except their own disappearance. In Chandler's story "Goldfish" (1937), the town of Tumwater, up near Tacoma, Washington, has been abandoned by the timber industry. Chandler offers the image of goldfish dying in a bowl, like gold fillings in a decaying mouth— past the "broken asphalt paving, a Chinese restaurant, a boarded-up movie house, a pawnbroker's establishment." At the smoke shop, like stragglers panning for gold, flies buzz inside the showcase. The last of the stragglers, "a tall thin man with a long nose and no chin, plays pool by himself, with a dead cigar in his face."[17]

THE FIRST STAGES OF GLOBAL CALIFORNIA

News of the California discovery was diffused . . . as widely as the nineteenth-century newspapers could spread it . . . The California gold rush was therefore, the first gold rush to set in motion a worldwide mass migration.
Carey McWilliams, *California: The Great Exception* (1949)[18]

We enter the world of Euro-American noir in the nineteenth century: 30,000 French, German, and English traveled to the gold fields. Many reported back on their disasters. A California phantasmagoria was visualized, about fleeting fortunes and desperate greed. "Nearly all [the French prostitutes in the Gold Rush] were streetwalkers of the cheapest sort. But out here, for only a few minutes, they ask a hundred times as much as they were used to in Paris."[19] In Second Empire France, the Gold Rush also took on the mystique of peasants in exotic places, the myths of *paysans de Paris*[20] (yokels out of their depth),

but set out in the wilds. The famous illustrator Gustave Doré imagined gold miners who resembled workers from Strasbourg, where he was born, though he preferred the fancy boulevards of Paris.[21] He dressed his Strasbourgeois like "American" miners about to sit down to a French meal. California became an extension of the Old World.

Also, European versions of the California gold and land rushes refer to the shocks of capitalism and dreams that turned to panics after 1848. Above all, the fever stood in for European imperialist rivalries, particularly the international growth of railroads and banking—a colonialist visual vocabulary. Drawings of California and the West often lifted poses from travel adventures about the invasions of Africa, Asia, and the Americas. California became an allegory for capitalist excess, for overspeculation and boom fevers that led to bank failures, colonial misadventures[22]—and dead mines.[23]

We transfer gold fever into the year 2000. Another imaginary California (particularly a Global L.A.) has been visualized across the world—on film, in shops, across the Internet. In effect, it is a place without a geographical site. Its very absence makes the gold fever around it even fiercer, part of what I call "the industrialization of desire." It even carries its own brand of cabin fever, a global obsession with enclaving and urban paranoia, as well as a romance with surveillance, with "watching out for your goods."

Imagine Global L.A. as a shopping mall longer than the Great Wall of China. In fact, it is too diffuse for walls. It spans continents. Many Asian and European "residents" of Global L.A. speak a vocabulary of only 900 words, a British invention of the 1930s originally called BASIC English. Now it is an L.A. dialect for media export and the Internet, for business conferences as well as graffiti—implemented by phrases from MTV, Hollywood films, and global tourism. Like Jonathan Swift's floating island of Laputa, people in Global L.A./California can fish off the edge as the island makes its circuit. But in the spirit of instantaneous culture, in fact, on the island of email that is Global L.A. (or West Coast North America: L.A./San Francisco/Silicon Valley/Seattle), one never leaves, only arrives.

When I ask Germans about this Global L.A., they often refer me back to the nineteenth-century potboilers by Karl May (again, modeled on the myths of the Gold Rush). May's alter ego, Old Shatterhand, was a German frontiersman brought up among Indians. His ally, the Apache chief Winnetou, spoke fluent German, read Longfellow.[24] Here, in Germanic inversion, May presented Americans as barbaric but the Indians as cultivated, like transplanted Europeans —as if the Europeans civilized the New World; and now the Americans are

barbarizing it. Similarly, the heroes and Indians in Gustave Aimard's novels speak French, even follow the rules of combat set up by Napoleon.[25]

Today, both the European and American variations of gold fever—the noir and pan-colonial—have combined into a Wagons West for transnational capitalism. This hybrid is packaged as an imaginary for sale. "Global California" helps to fuel international business marriages between film companies and telephone companies, between the software and war industries, between so-called digital service industries and auto and shipping and oil. Noir myths of gold dust and land booms take on what I call a catholicity (like a liturgy in the Catholic Church): Do you have the courage to jump in? They operate like a Jesuitical ideology, a style and attitude for the new Electronic Baroque.

They help provide a shared sense of value, because there is indeed a direct link between the imaginary Gold Rush and the boosterism in Los Angeles during the 1890s, also with movie glamour exported during the boom of the 1920s.

With vastly improved marketing, the myths that evolved into Global L.A./California have literally taken flight—like magazines at a busy airport or five-color brochures from a software company. From the *Los Angeles Times* in 1997: "Many saw the Internet as the cyberspace equivalent of the California gold rush, and having invested millions of dollars, they have been stunned to see the glitter of early growth turn into fool's gold."[26]

But of course, this is speculation, a look at signifiers. To find manifest causes for Global L.A., I had to dig into economic and political history. It appears that this new Y2K version of gold-fever noir, Global L.A., was a product of the final decades of the Cold War (1962–89). Then, it was formally launched, like a ship without a port, a *Flying Dutchman* after the Berlin Wall went down. Since 1989, the collective memory of Global L.A. has expanded almost into a patois across Europe, east Asia, and always Latin America.

Strip mall, Los Angeles, c. 1996
Photograph © Dennis Keeley

One can even dress for the occasion. I remember in 1996 in Stockholm, where I gave some talks, I was shuttled to the German Embassy for a dinner of hors d'oeuvres, somewhat formal. But I had forgotten to take my Scandinavian shoes, only had white sneakers. That made me essentially the ambassador without portfolio for Global L.A., and for gold fevers. A Polish diplomat spotted

me, pointed at the sneakers, ran over. "Los Angeles!" he cried. "I spent two years in L.A. I met Steven Spielberg. We were invited everywhere. Of course, it wasn't me. My wife was very beautiful. But I set up an anthology about movie directors, with Spielberg in it. It was huge in Poland, though the former government never paid me a cent of royalties. [*An audible sigh*] After two years, we had to leave . . . to save my marriage."

Recently, I have been a "talking head" in German documentary films about Los Angeles. I ask the director, Eckhardt Schmidt, to show me his Los Angeles, his version of the Sunset Strip, of the beach, of the canyons. I realize that these are international colonies. I see trophy wives of practically every nationality. The Sunset Strip, the Santa Monica boardwalk become international waters on land, tourist promenades.

But I always try to remind visitors to Global L.A. of the poor relations, of immigrants in poor districts. I go to MacArthur Park, west of downtown. The streets there resemble Guatemala. The stores service immigrants so recently arrived—and so clearly at vast risk. I see how easily they can be financially gutted like a fish. Essentially, this neighborhood belongs to the transnational economy more than to the United States. Wages here too are drastically lower, more on a scale with the Pacific Rim than with Los Angeles. The vendor economy survives—no latte in sight. The subway has a fancy station nearby, but more than "three minutes out of downtown," it reminds me of a train stop deep inside India during the colonial era. Thus, to say that these streets are America, or even Central America, is difficult. They belong to the mutable, portable investment patterns that feed Global L.A. In the right light, they can be photographed as an exotic postcard. Rugs hang over naked cinder blocks in front of a "colonial" strip mall. That postcard could be sent to Europe and pass for a barrio in Guatemala.

The spectrum of Global L.A. phenomena is immense, from architecture to tourism to media to raw sweatshops to the Internet—all echoing an imaginary city that speaks English but "looks" like an exotic noir journey. It is a massive process that will transform world culture—and California culture—over the next half century, I suspect. Simply as an introduction, though, let me list the cogent features of updated gold fever, Global L.A., circa 2000.

L.A. NOIR AS TOURIST MAP UCLA Professor Stephen Mamber and I are working on a digital map of noir movies set in Los Angeles. The L.A. Basin floats on the monitor like a Renaissance terra incognita. But instead of putti standing in for trade winds, you find icons. Click on a small armored car, and you upload scenes from *White Heat* (1949), *Criss-Cross* (1948), and *Heat*

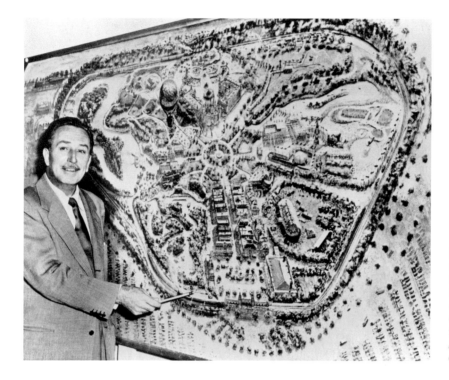

Walt Disney with map
of Disneyland, c. 1955
University of Southern
California, Department
of Special Collections,
California Historical
Society, The Hearst
Los Angeles Examiner
Collection

(1995)—movie heists by armored car from the Valley to the oil fields of
San Pedro. Click further to find the locations, then the neighborhoods hidden
behind the films. This imaginary map is as familiar to Europeans as it is
to Americans: L.A./Paris in French New Wave cinema of the 1960s; L.A./
Manhattan in *Mean Streets* (1973); L.A./Berlin in German Neo-Expressionist
films of the 1970s. In the United States certainly, television news increasingly is
broadcast as noir cinema. News of violence is shot like handheld excursions
into neo-noir—for example, the massive shoot-out in North Hollywood
after the robbery of a Bank of America in 1997. I had students compare the
television coverage (triangulated by helicopter and on the ground) to scenes
from *Heat*. They agreed that the movie looked more "realistic" but, most
stridently, that the film grammar was essentially identical.

Racist paranoias are reinforced by this noir map. What, for example, is
the impact of "gangsta" films on real estate and investment values in South
Central Los Angeles—much less the worldwide, wall-to-wall coverage of the
uprising of 1992? A case in point, from *The New Leader*, in England (May 2,
1992): "Another reaction to the Los Angeles explosion in Europe is unease and
a demand for tighter controls on immigration from Africa and Asia,"[27] com-
ments that echo those made after street riots and lootings in London, Paris,

and Berlin during the 1980s. But in simplest terms, Los Angeles is the zone of death for global fantasy. From *Independence Day* (essentially a German film: German director, design team, and financing)[28] to shoot-'em-up computer games, L.A. sites are used often when cyber murders take place—usually that means somewhere inside the eight miles from City Hall to the La Brea tar pits. I remember watching *Independence Day* when it opened in the summer of 1996, and the audience stood and cheered as downtown was incinerated by alien invaders—not the first "end," in this case an homage to the *War of the Worlds* radio broadcast (1938) and to the film (1953), which is highlighted by the incineration of cine-icon L.A. City Hall by Martian artillery.

In a placeless Global L.A., the world does not end at a physical place, not on the plains of Megiddo (Armageddon). It "ends" on videotape. The tape begins during the uprising of 1992. Then it "loops" for fifty years, in movies and in broadcast news. Every few months another burning street is added: from Bosnia, Chechnya, Indonesia; class warfare in Berlin, Moscow, London. On December 1, 1999, police in Seattle crack heads in what becomes the first civil disturbance of the world trade era. Quickly CNN cameras switch to London for another anticapitalism rally. Eventually all crowds fighting police will be montaged into the same imaginary city. Featuring an exotic cast, the

Future City, by visual futurist Syd Mead for *Automobile Quarterly,* 1976
© Syd Mead, Inc., www.sydmead.com

"Mob at the End of the World" runs like a series on the History Channel; or like a fireworks display at the edge of a real battlefield.[29] At the same time, however, every poor district in every city loses a part of its collective history. Myths of poverty and urban rebellion are franchised, and the local facts are ironically erased.

During the uprising of 1992, "as Mikhail Gorbachev flew in for his meeting with ex-president Ronald Reagan in Los Angeles last weekend, he saw armed troops and armored vehicles on the streets. It must have looked eerily like the scene he missed in the old Soviet capital during last year's Moscow coup, only worse. Mr. Gorbachev . . . cannot but see the irony of Los Angeles today."[30]

MIGRATORY LABOR As in MacArthur Park, an "electronic feudalism" creates "roaring" camps as migratory as those of the Gold Rush—ethnic "subaltern" enclaves, for cheap labor at globally competitive prices, from Orange County to the high desert, throughout the state.[31] On an ethnographic map, they resemble tiny fiefdoms in the Holy Roman Empire during the fifteenth century; or balkanized, warlord kingdoms in Moscow, Asian Russia, or the former Yugoslavia. They owe fealty to capital investors, who treat any location as a colony. Pan-colonialism has matured, and Los Angeles is its New Byzantium. In 1936 the French writer Blaise Cendrars used the term *New Byzantium* for L.A./Hollywood, "the land of the fourth dimension."

Whatever goes on there immediately takes on such proportions that everything becomes vertiginous, and life itself—through the multiplication of a million bits of news and small but very precise details, cut into facets, each reflecting the other into infinity and deluding out of sheer repetition—in no time at all seems to have become unreal, a myth.[32]

GHOST TOWNS WITH GOOD LATTE Los Angeles has always specialized in shrinking other cities into movie sets for tourists. That has now become a sign of Global L.A.—in architecture and urban planning (e.g., Las Vegas casinos). I call it upscale tourist trompe l'oeil: Does the Eiffel Tower in Japan look more "real" than the one in Vegas; or more real than the Grauman's Chinese Theatre in Orlando? Compared to what? someone asks. In Global L.A., tourist imaginaries of cities can be condensed into destination resorts only a few blocks long, like theme parks in Osaka, or the 900 shops, indoor beach, skating rink, submarines, and Columbus's *Santa Maria* at the West Edmonton Mall in Alberta, Canada. In Vegas, dealers wait under the awnings of false Delancy Street at the New York–New York casino. In many towns of the Midwest, a

Deco Main Street is gingham-dressed like Disneyland. At exurbs, old ranching streets are shined like bad movie sets of the 1950s. Up in the Mother Lode country, at the site of the Gold Rush, the world of mining-camp yogurt parlors and themed T-shirts awaits.

Thus, Global L.A. is synonymous with global tourism, with its own history, dating back to the Thomas Cook tours and the World's Fairs of the nineteenth century. When I lectured on Global L.A. while inside the Ring district in Vienna, I was reminded that tourist in-migration has flourished there since the 1880s. In Rome it has flourished since the fourth century. And now at the millennium, Rome scrubs off the diesel stains to become a shopper's pilgrimage for the birth of Jesus. For Jubilee, more than 200 churches have been restored; a *vedute ideate*[33] where an entire city becomes a transnational mall. However, California leads the charge toward pan-colonial tourism and is the historicized imaginary cited most often—in store signage in Europe and Asia, in graffiti (many Europeans identify both of these as "L.A./ MTV English"). In other words, for those who understand Global L.A., tagging merely adds spice to shopping. L.A.-style balloon graffiti mixes with inflated prices to complete the experience for global cognoscenti along the imaginary Sunset Strip, or the Corso in Rome.

THE GLOBALIZATION OF LOCAL MEMORY Increasingly, the global economy is merchandising any memory it can find on the street. Any stretch of buildings with historic continuity can be themed, given a suburban spin. That includes Times Square in Manhattan, Piccadilly Circus in London, or Colorado Boulevard in Pasadena. Each has its share of advanced suburban amenities, genteel feudal kingdoms. With the shrinkage of national governments here and in Europe certainly, the services to cities have been underfinanced. In order to build a tax base, practically every city is turning to themed spaces. The cost of leases jumps. Older businesses cannot pay. Large franchise companies move in. Ultimately we live in a world where we all become tourists in our own cities.

MOVIES AS COLLECTIVE MEMORY As mentioned earlier, this shift toward a placeless Global L.A. sped up amazingly in the 1990s, particularly since the Berlin Wall went down. In Germany, unlike a decade ago, French films can rarely be found in mainstream cinemas. At this writing (September 1999), as usual, eight of the top ten films are American (Los Angeles–identified) in Australia, Brazil, France, Germany, Italy, Japan, Spain, Sweden, and the U.K.[34] That means that well over 50 percent of "Hollywood's" box office comes from

CityWalk, Universal
City, 1990s
© Jerde Partnership

abroad. In sum, the Hollywood product is more a placeless export than ever
before, simply to stay profitable. Movies are an advance phalanx for global
tourism. They license global memory, but whose memory? This is much the
way that 75 percent of the Internet is in English; but whose English? Global
media identity and local spatial identity have merged to a degree impossible
twenty years ago—and they are very much identified with Los Angeles (also
now one of the most internationalized architectural markets in the world).

GLOBAL L.A. ENGLISH It seems fair to say that L.A. tropes can be grown
anywhere, since 750 million people are currently studying English, and 600
million already speak it. In mass culture, BASIC English merges with Global
L.A. and forms a marketing cloud that helps bind transnational corporations
across continents—what I mean by a licensed movie-cyber imaginary.

 Digital sprawl is associated with the entire West Coast. Cyber capitalism
flourishes heroically, from Silicon Valley up to Seattle (also in Silicon Alley, in
Manhattan, and, importantly, in Austin and Boston). But more remarkably,
cyber West Coast investments are spreading into east Asia and India, and they
are now colonizing Ireland (actively shifting toward digital industry) as well as
Poland. The shocks of this deterritorialization have reinforced the erosion of
wages, brought vast pools of immigrant labor from Latin America (Europe as

well), and generated hundreds of MacArthur Parks. In this floating Global L.A., wages are cheaper at the low end certainly; the class structure is wider. At the same time, at suburbanized workstations across the world, consumers get to play colonial warlords inside a labyrinth of shoppers' choices. Internet shopping enhances tourism; this media tourism allows colonization to run more profitably.

SCRIPTING GOLD DUST As privatization speeds ahead in Europe and the United States, narratized architecture begins to dominate as an international style studded with L.A. references: scripted spaces with familiar global franchise store windows. A well-integrated scripted space requires partnerships among shopping, tourism, cinema, software, and pedestrian leisure. These are unified into feedback designed to make consumers feel more "intimate." It is a cybernetic mode of "pedestrian experience," from one global franchise site to another: multiplexes, cyber cafes, upscale fashion, and all of these often identified worldwide with Los Angeles.

Since the 1980s, both the Los Angeles School of architecture and design (the spectrum from Morphosis to the Jerde Partnership) and the competition across the world to outdo Disneyland have combined as a singular alternative to late modernist urban planning. Tourism meets suburbanism, even at the formerly suburban beach towns of Los Angeles. The new paradigm for urban life worldwide may be a kind of dense suburb, with a lot of eye candy on scripted "streets." As I often point out to students, any street that has historic coherence, from Times Square to the Rue de Rivoli, can be turned into a citywalk. In fact, wherever tourism has expanded, whether in Vienna or Santa Monica, a fussy glow has taken over the storefronts that is both urban and suburban. The malls, like medieval cities, have broken out of their walls and extended into the streets themselves.[35]

SPREADING THE GOLD FEVER: THE METROPOLITAN SUBURB Since 1970, postwar threads of light industry have vastly matured in Los Angeles, beyond simple warehouses along freeways. They are now hubs for exports, film production, software, aerospace. And clearly this is a global trend, toward the sprawling, digitized corporation (media, banking, steel, auto, etc.). We cross into the San Fernando Valley, once the classic model for white suburban fantasy. We see belts of high-rises, their own banking centers, and we find an industrial job base—nearby slums for cheap labor—in short, all the mess we associate with the downtown center they were designed to erase from memory.

THE FLOATING OFFICE The Pacific Rim has come of age. Indeed, California is still the eastern capital of the Pacific. But Global L.A. is also the placeless prototype for the corporation of the future. Imagine that all large businesses, from the auto industry to real estate, begin to resemble a software network in Silicon Valley. Workstations are atomized. Foremen and vigilant vice presidents seem to have disappeared. Surveillance takes on the cheerful ring of an answering machine that also gives orders. In Global L.A., economic power seems diffuse but is highly centralized, like a computer game of a war or of a city, a Photoshopped version of space. We enter this space as if inside a morph program. Outside, thirty cities blur into each other, from restaurants to street plans. But despite the blurring, inside our own bodies, we seem to be standing still, like avatars in a multiuser computer game. I call this "the hummingbird effect," so much instantaneous movement that we suddenly freeze in midair. We are strangely unprepared for what the program will bring next. After all, the decisions come from somewhere else. A banner advises us to wait for the next upgrade, and the fevers it will bring.

Norman M. Klein is professor of critical studies at California Institute of the Arts and the author of *Seven Minutes: The Life and Death of the American Animated Cartoon* (1993) and *The History of Forgetting: Los Angeles and the Erasure of Memory* (1997). Forthcoming projects include *The Vatican to Vegas: A History of Special Effects* and *Missing Los Angeles: A Guide to Ruins, Fragments, and Obliterated Structures*.

404

The Day of the Locust,
1975
Courtesy of Paramount
Pictures, © 2000
Paramount Pictures.
All rights reserved.
Photograph © Academy
of Motion Picture Arts
and Sciences

1 Based on interviews (1975–79) about the old Edendale movie industry that flourished in the 1910s. Some incidents from these appear in my books *Seven Minutes: The Life and Death of the American Animated Cartoon* (London: Verso, 1993) and *The History of Forgetting: Los Angeles and the Erasure of Memory* (London and New York: Verso, 1997).
2 Gold fever is often associated with the pathology of gold rushes, with the alienation, the ruthless disregard. See also *www.malakoff.com,* quote from James H. Carson, *Recollections of the California Mines* (1852; reprint, Oakland: Biobooks, 1950): "A Frenzy seized my soul: unbidden my legs performed some entirely new movements of polka steps, I took several … Piles of gold rose before me at every step; castles of marble, dazzling the eye with their rich appliances; thousands of slaves bowing to my beck and call; myriads of fair virgins contending with each other for my love, were among the fancies of my fevered imaginations. The Rothschilds, Girards and Astors appeared to me but poor people; in short, I had a very violent attack of the Gold Fever."
3 Samuel Storey, *To the Golden Land: Sketches of a Trip to Southern California* (London: Walter Scott, 1889), 35.
4 The mystique of gold rush, of course, implies the human hand violating nature, rather than watching seedlings turn into orchards.
5 Oliver Carlson, *A Mirror for Californians* (Indianapolis and New York: Bobbs-Merrill Co., 1941), 137. This is an odd, very compelling document. Clearly Carlson expresses sympathy for the left, circa 1940. However, by 1947 he joins the anticommunist crusade with the pamphlet *Red Star over Hollywood,* for the Catholic Information Society or, in 1953, *Handbook on Propaganda for the Alert Citizen,* for the Foundation of Social Research.

But that only makes his observations in 1940 and 1941 more useful. He obviously attended events run by leftist writers and actors during the late 1930s in Los Angeles—rare and strangely empathic information about the political ambience of the film world and unionism. While he proves a shrewd, sardonic observer, he also reveals many of the racist foibles of the time, about lazy Mexicans, etc.—a very useful piece of modernity, the "complexion" of 1941 as clearly as any book of the immediate prewar period in Los Angeles. (Though less brilliantly synthesized than the work of Carey McWilliams, Carlson's point of view expresses the range of values around 1940.) The years 1940 and 1941 were a strange moment for Los Angeles, right before the shocks of Pearl Harbor. The shadow of the Depression was still overwhelming; the fever for economic justice very current. It was indeed a sub-epoch of artificial calm. The war was seemingly far away, at the other ocean. Memories of 1920s boosterism remained vivid as well—downtown was still the center of the world, and the San Fernando Valley mostly farmland. One might call this the last breath before the next cycle, which led to globalization, to the vast industrial expansion during the war, to reliance on defense moneys. It also inhabits the moment shared by proto-noir films, such as *Citizen Kane* (1941), *The Maltese Falcon* (1941), *This Gun for Hire* (1942).
6 The phrases still linger from the 1920s—e.g., looking for "gold or oil or stardom," Steve Chalkins, "Homes Sprouting and Farms Dying," *Los Angeles Times,* Feb. 7, 1999 (part of a series, The Changing Suburbs).
7 Ibid., 163.
8 A reference to John Steinbeck's *The Grapes of Wrath* (1939).
9 Robert Towne, interview by author, Nov. and Dec. 1985.
10 See Gertrude Atherton, *California: An Intimate History* (New York: Harper and Brothers Publishers, 1914). Atherton compares the luxuriants in Southern California to the bustlers up in San Francisco, but she finds both cities thick with cranks, faddists, extremists, professional agitators, loafers. Somehow all of this leads to smothering praise of California anyway: the state is blessed with eternal life despite its moral ambiguities.
11 Also (but too complex for the argument in this essay), Los Angeles had its Wild West, gold-fever period in the 1850s, as the most "violent" town in the West, during the transition away from Californio control. Americans from the South mixed uncomfortably with the first wave of Yankees. It is difficult to explain precisely, however, what split Los Angeles into a war zone in those years. It had very much a mining town ambience—without the mining (except up in the high desert). The fading industry was in cattle—an enterprise that collapsed finally with the drought of the 1860s, when millions of cattle died. For a recent comparison of the San Francisco Gold Rush and Los Angeles of the 1850s, as well as discussion of the myths of violence in California, see John Boessenecker, *Gold Dust and Gunsmoke: Tales of Gold Rush Outlaws, Gunfighters, Lawmen, and Vigilantes* (New York: John Wiley and Sons, 1999), 322ff.

12 Kevin Starr, *Inventing the Dream: California through the Progressive Era* (New York: Oxford University Press, 1985), 200. Starr's California history series details the ironies of gold fever very carefully and gracefully.

13 L.A. leaders' struggle to get federal funds to pay for the dredging of San Pedro harbor, the key to climbing out from under the thumb of San Francisco and the Big Four— most of all Collis B. Huntington.

14 Bierce on Huntington in 1896: "[During the harbor fight with Los Angeles] Mr. Huntington was not idle: he had counter meetings, composed of the very scum of the earth, with a small contingent of Santa Monica (controlled by San Francisco interests) brought into Los Angeles free by trains." Many were frauds, jailbirds. One man signed false petitions 150 times. Others erased the words *San Pedro* from a rival petition and inserted *Santa Monica*—"the exuberant activity of unthinkable thieves" (Ambrose Bierce, *A Sole Survivor: Bits of Autobiography* [Knoxville: University of Tennessee Press, 1998], 263–64). Or: "The spectacle of the old man standing on the brink of eternity, his pockets loaded with dishonest gold which he knows neither how to enjoy nor to whom to bequeath" (p. 258).

Huntington made his first fortune by selling shovels to miners at highly inflated prices.

15 On the 150th anniversary of the discovery of gold at Sutter's Mill, the Oakland Museum of California inaugurated a series of exhibitions titled Gold Rush: California's Untold Stories. One exhibition, *Gold Fever: The Lure and Legacy of the California Gold Rush,* also traveled to the Autry Museum of Western Heritage,

Los Angeles. Among new studies on the Gold Rush and the spirit of capitalism, see Claire Perry, *Pacific Arcadia: Images of California, 1600–1915* (London: Oxford University Press, 1999); J. S. Holliday, *Rush for Riches: Gold Fever and the Making of California* (Berkeley and Los Angeles: University of California Press, 1999); Stephen Schwartz's virulent attack on communists in *California, From East to West: California and the Making of the American Mind* (New York: Simon and Schuster, 1998). My favorite historian's noir description of the Gold Rush, from Herbert H. Bancroft: "Thousands laid down their lives in the attempt [to find gold], for there were the lion's claws to tear the unsuccessful venture in pieces. Of rare celestial beauty was the face and bosom of the goddess as she laid men to their destruction" (cited in Michael Kowaleski, ed., *Gold Rush: A Literary Exploration* [Berkeley: Heyday Books, 1997], 377).

16 Edmund Shea, "Sam Frisco," *The City of San Francisco,* Nov. 4, 1975, 27.

17 Raymond Chandler, "Goldfish," in the collection *Red Wind* (Cleveland and New York: World Publishing Co., 1946), 166. Chandler also takes us to a rotting dental building in Tumwater, literally the "decay" of the city. See also my discussion of decay/blight as metaphor in L.A. urban planning documents during the early 1940s: *The History of Forgetting,* 38–44. In chapter 2, "L.A. Noir and Forgetting," I argue that noir literature in Los Angeles emerged out of the dark side of the 1920s boom, a kind of antitourism, the quick weekend, the amorality of quick money, of consumer speculation as cannibalism (seen in L.A. novels set in the film industry milieu as well).

The real estate boom in Los Angeles from 1921 to 1924 left many wounded and brought out a dark, marginalized side to the marketing of desire. Certainly other industries inspire noir inversions as well: when the rock turns over, the snakes appear. Needless to say, dark tales about gambling and casinos are vast enough to constitute a subfield—noir as the heart of the marketing itself.

One can see "pre"-noir as well, in travel books, such as T. S. Van Dyke's *Millionaires of a Day: An Inside History of the Great Southern California Land "Boom"* (New York: Fords, Howard and Hulbert, 1890): "All sorts of small fry that follow up the boom" (p. 180); a tourist's eyes "riveted on the Hotel de Boom, on some empty town-site . . . [Yet] in two years more every sign of boom would be covered up" (p. 179).

Indeed, noir is arguably the most consistent critique of capitalism in American mass culture, from the 1920s to early 1990s neo-noir and the remnants of cyberpunk today, e.g., the noir scenography of, say, *The Matrix* (1999).

See also the writings of Mike Davis, who applies the noir mode of address to intensive (and as I read his work, very careful) research into the power structure of Los Angeles and the West.

Beyond Davis's great importance to L.A. studies, the body of literature on L.A. literary noir is vast. One recent essay: Erik D. Curren, "Noir or Gothic: Visions of Apocalypse in the Depression-era L.A. Novel," *Southern California Quarterly* (spring 1996).

18 Carey McWilliams, *California: The Great Exception* (1949 [centennial year of the Gold Rush]; reprint, Santa Barbara: Peregrine Smith,

1976), 26. McWilliams also calls this "the first and, to date, the last poor man's gold rush in history," because tens of thousands managed to operate without massive mining companies, spreading the mystique of democratic wealth deeper than any other event of its sort in the nineteenth century. The comparisons between that rush and the cyber rush of the 1990s in Silicon Valley are obvious—tens of thousands of young "instant" millionaires strike a rich vein not far from the early gold fields. One result: cyber gold fever spreads across the world, with the noir reaction to come next (beginning with dark images of Y2K, followed by the anti–World Trade Organization rallies in Seattle and rallies during the political conventions in Philadelphia and Los Angeles in the summer of 2000).

19 Holliday, *Rush for Riches*, 413. The range of coverage in the European press was astonishing—from caricatures and articles to serial novels on the Gold Rush.

20 *Paysans de Paris* is also the title of a Surrealist novel by Louis Arragon (1928), an influence on Walter Benjamin's Arcades project. The term refers to a fact true of all major cities in western Europe: for generations, up to one-third of Paris was inhabited by rural immigrants. Thus, the French imaginary San Francisco exaggerates that contrast. The collapse of the French countryside (population declines as well as in-migration to Paris) is mythically restated in the myths about the gold fields in California.

21 Doré illustrated novels by Gustave Aimard, as well as those of the British adventure writer Mayne Reid, who actually visited the United States for a short time (unlike Aimard,

who never came to the States, or novelist Karl May, who came when he was an old man, in 1908—see note 24). See Reid's *L'Habitation du desert, ou Aventures dans les solitudes de l'Amérique* (Paris: Hachette, 1865). Doré also illustrated books on North America by geographer (second-generation geographer, actually) Victor-Adolphe Malte-Brun—for example, the pamphlets *Les Etats-Unis et le Mexique* (Paris: Hachette, 1862) and *L'Amérique* (Paris: Plon, 1865). When Doré illustrated the Australian outback, the men also were dressed like Strasbourg proletariats.

22 Many of the French authors who wrote about the Gold Rush later reported on the French occupation of Mexico in the 1860s. So too, in Germany and England, various cowboy novelists doubled as chroniclers of the invasion of Africa.

23 See also Blaise Cendrars, *Sutter's Gold* (New York and London: Harper and Brothers, 1926).

24 May began researching the American West while serving time in prison in Zwickau, Germany, for much of his young manhood. "Even some of his critics considered May's fantastic tales a trustworthy representation of the American scene" (Richard Crocroft, "The American West of Karl May," master's thesis, University of Utah, 1963, 26). Called the James Fenimore Cooper of Germany, he was admired by Albert Schweitzer, Albert Einstein, and Walter Benjamin and considered an influence on Heinrich and Thomas Mann. He was discussed at some length by Klaus Mann and by Karl Liebknecht, of all people (pp. 4, 5). He was also beloved by Adolf Hitler, who admired Winnetou's military finesse (see Albert Speer's *Inside the Walls of Spandau: The Prison

Diaries of Albert Speer* [New York: Macmillan, 1976]). See also Christopher Frayling, *Spaghetti Westerns: Cowboys and Europeans from Karl May to Sergio Leone* (1981; rev. ed., London and New York: I. B. Tauris, 1998); Jeffrey L. Sammons, *Ideology, Mimesis, Fantasy: Charles Sealsfield, Friedrich Gerstäcker, Karl May, and Other German Novelists of America* (Chapel Hill: University of North Carolina Press, 1998); Michael Petzel, *Karl May im Film* (Dachau: Vereinigte Verlagsgesellschaften Franke, 1980). There are a number of biographies in German, among them works by authors V. Bohm, H. Stolte, and M. Dittrich. The annual Karl May Festival draws tens of thousands of visitors each year, and up to 600,000 go annually to his homes in Elspe and Bad Segeberg.

25 Aimard was not nearly as popular as May, who became a great literary figure throughout Europe (statues, honors, street names). See Ray Allen Billington, "The Image of the Southwest in Early European 'Westerns,'" in *The American Southwest: Image and Reality* (Los Angeles: William Andrews Clark Memorial Library, UCLA, 1979).

26 David Shaw, "Internet Gold Rush Hasn't Panned Out for Most," *Los Angeles Times*, June 17, 1997.

27 Ray Alan, "L.A. as Seen from Europe," *The New Leader*, May 2, 1992. See also the following letter to the editor in the Manchester *Guardian Weekly*, May 3, 1992: "We may be tempted to view [the burning of L.A.] as a tragic problem for the U.S. but Europe and the world are inextricably bound into this corset of danger. The same tinder and matches are to be found everywhere . . . The world has been vulcanized by

the heat of racial tension . . .
a warning sign from Britain's
former American colony."

Similarly, when the Bosnian
crisis emerged in Europe, many
articles there and in the United
States cited the "balkanization"
of Los Angeles, sensing the
linkage between post–Cold
War nationalism and the L.A.
uprising of 1992.

28 *Independence Day* essentially
reflects the movie scene devel-
oping around Stuttgart and
Ludwigsburg in Germany.
I have even begun to wonder
whether the bombing of
Los Angeles in that film reflects
memories of the bombing of
Stuttgart in 1945.

29 I am reminded here of
Fabrizio at the edge of the
Battle of Waterloo, in Stendhal's
novel *The Charterhouse of
Parma* (1838).

30 Martin Walker, "Dark Past
Ambushes the 'City of the
Future,'" Manchester *Guardian
Weekly*, May 10, 1992. Title
from the opening line: "Amer-
ica's vaunted city of the future,
the megalopolis of the Pacific
Rim with its new Hispanic and
Asian trade and population,
has been ambushed by its past.
The unresolved legacy of the
Watts riot of 1965 spread out
from the confined anger of
the ghetto and cross the vast
sprawl of Los Angeles."

31 The deterritorialized labor
problems in the globalized
economy are very widely
discussed, particularly in the
books of Saskia Sassen (e.g.,
*The Migration of Labor and
Capital* [Cambridge:
Cambridge University Press,
1988]). A few other sources:
Mike Featherstone, ed.,
*Global Culture: Nationalism,
Globalization, and Modernity*
(London: Sage, 1990); Neil
Smith, "The Satanic Geogra-
phies of Globalization: Uneven
Development in the 1990s,"
Public Culture 10 (1997).

Finally, the globalized labor
crisis achieves media recog-
nition during the demonstra-
tions against the World Trade
Organization in Seattle,
December 1999.

32 Blaise Cendrars, *Hollywood:
Mecca of the Movies* (1936;
Berkeley and Los Angeles:
University of California Press,
1995), 98–99. I originally used
the term "New Byzantium" in
lectures, then in a newspaper
article back in 1986, then in an
anthology in 1990, and again
in *The History of Forgetting*
(1997). Recently I discovered
that Cendrars also used "New
Byzantium" (but more than
fifty years earlier) in this col-
lection of his articles on
Hollywood, written in 1936 for
the newspaper *Paris-Soir*.

33 *Vedute ideate* translates
usually as "imaginary view,"
particularly found in references
to the engravings by Piranesi
of imaginary Rome; but it
became very much a subindus-
try by the eighteenth century.
Also, the term *capriccio* or, in
French, *caprice* (for example,
in references to Jacques Callot's
series The Small Miseries of
War [1633]) has been used to
mean the impossible, implausi-
ble imaginary of a city, the
dark, ironic underside, as if in
a grotto (grotesque), including
ruins, human nature in crisis
(sieges, Inquisition), exag-
gerated archaeological fantasies.
Indeed, this tradition reminds
me of the Global L.A. phenom-
enon and how it is visualized.

34 *Hollywood Reporter*, intl. ed.,
Sept. 7–13, 1999, 83.

35 This image particularly
reminds me of Burbank,
where the downtown "village"
extended to the multiplex,
spread further, then opened
out the façade of the old mall
into the street itself—mostly
since 1985.

INDEX

Numbers in *italic* refer to pages with illustrations.